GREAT RIVERS
of the world

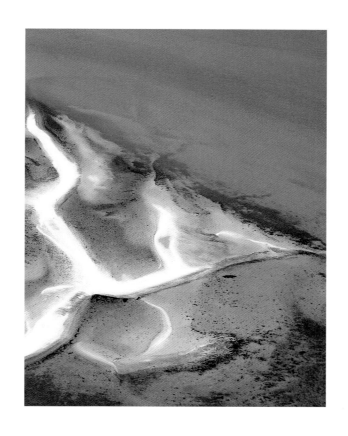

PAOLO NOVARESIO

vmb
PUBLISHERS

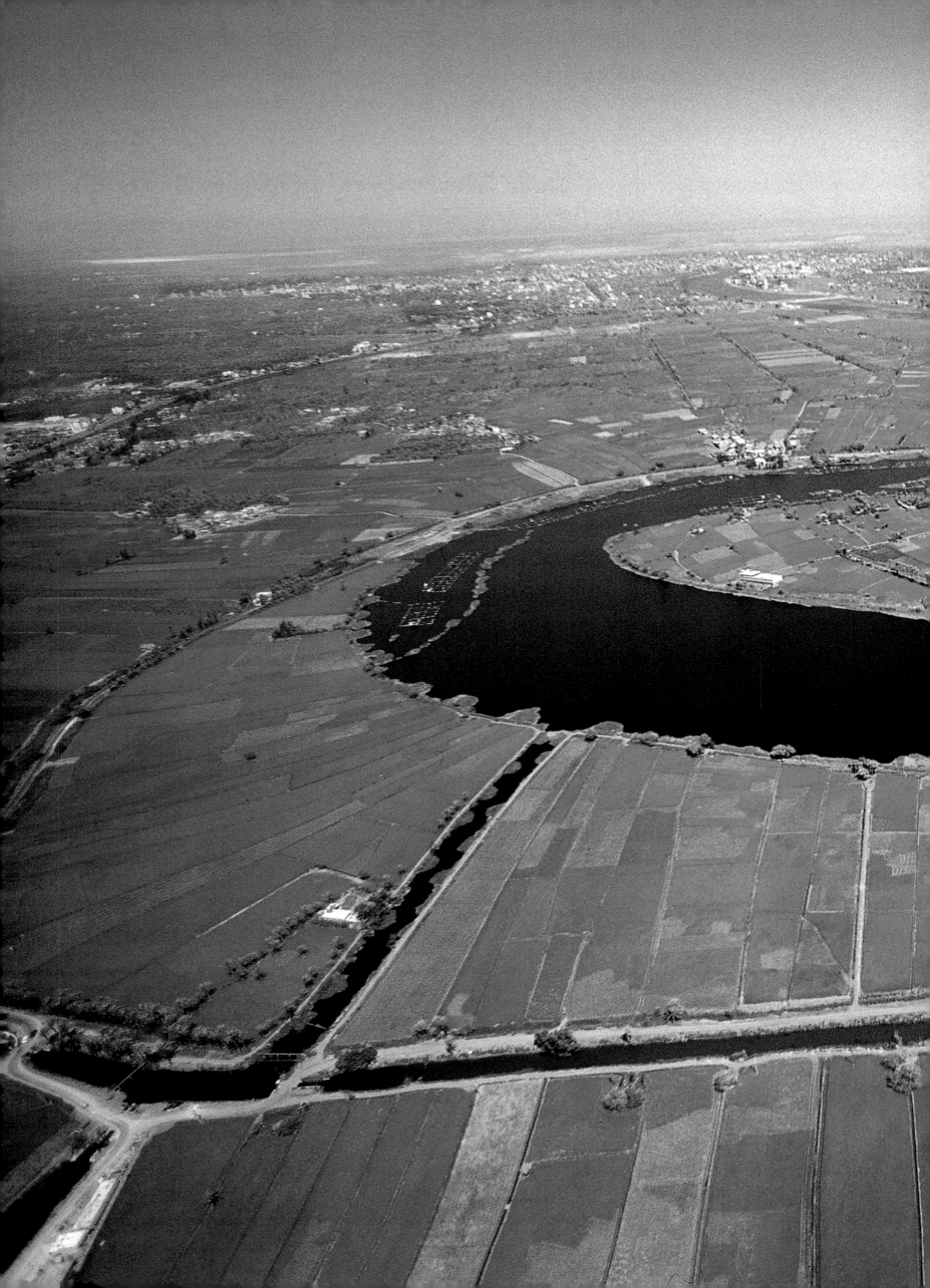

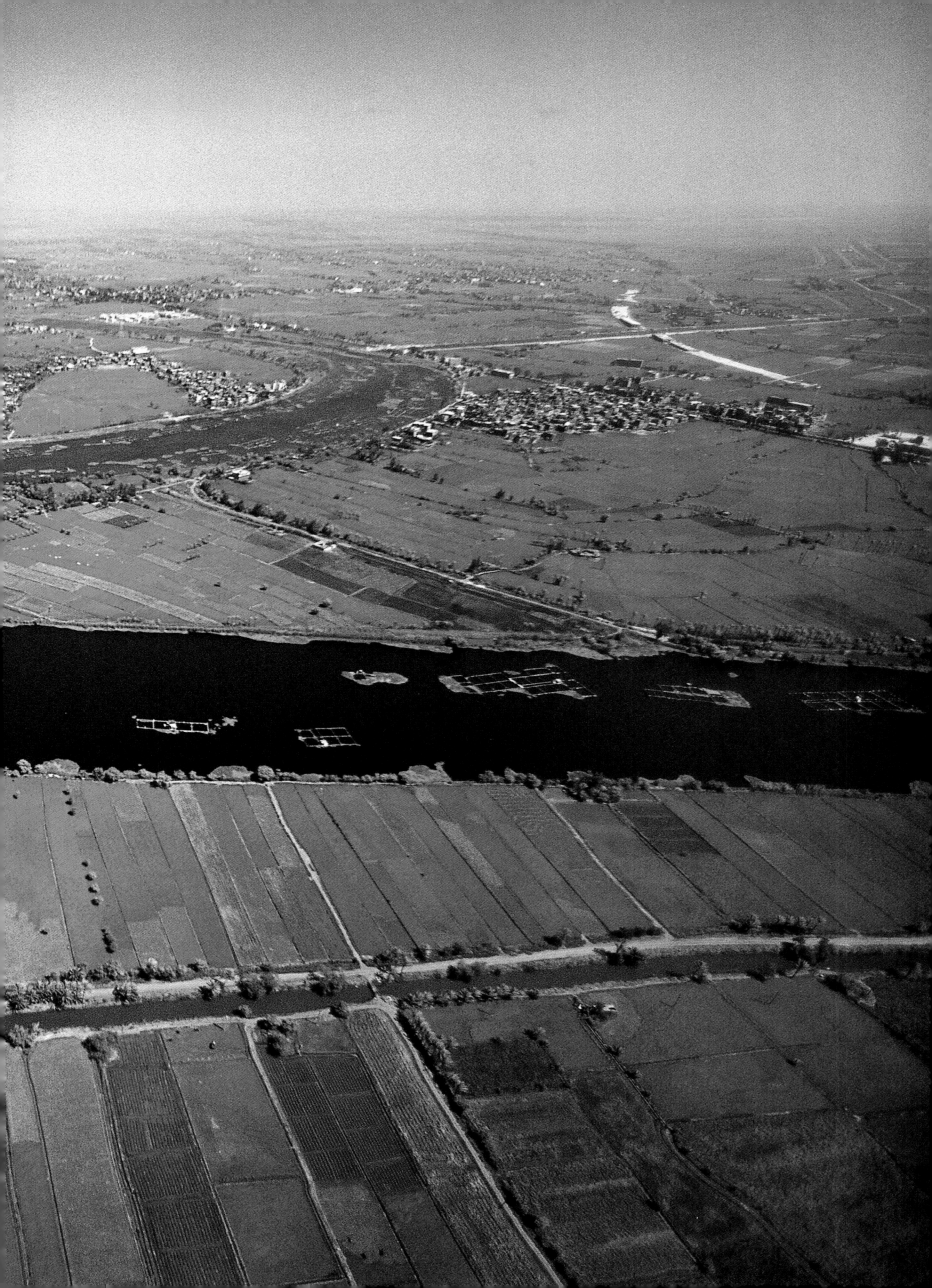

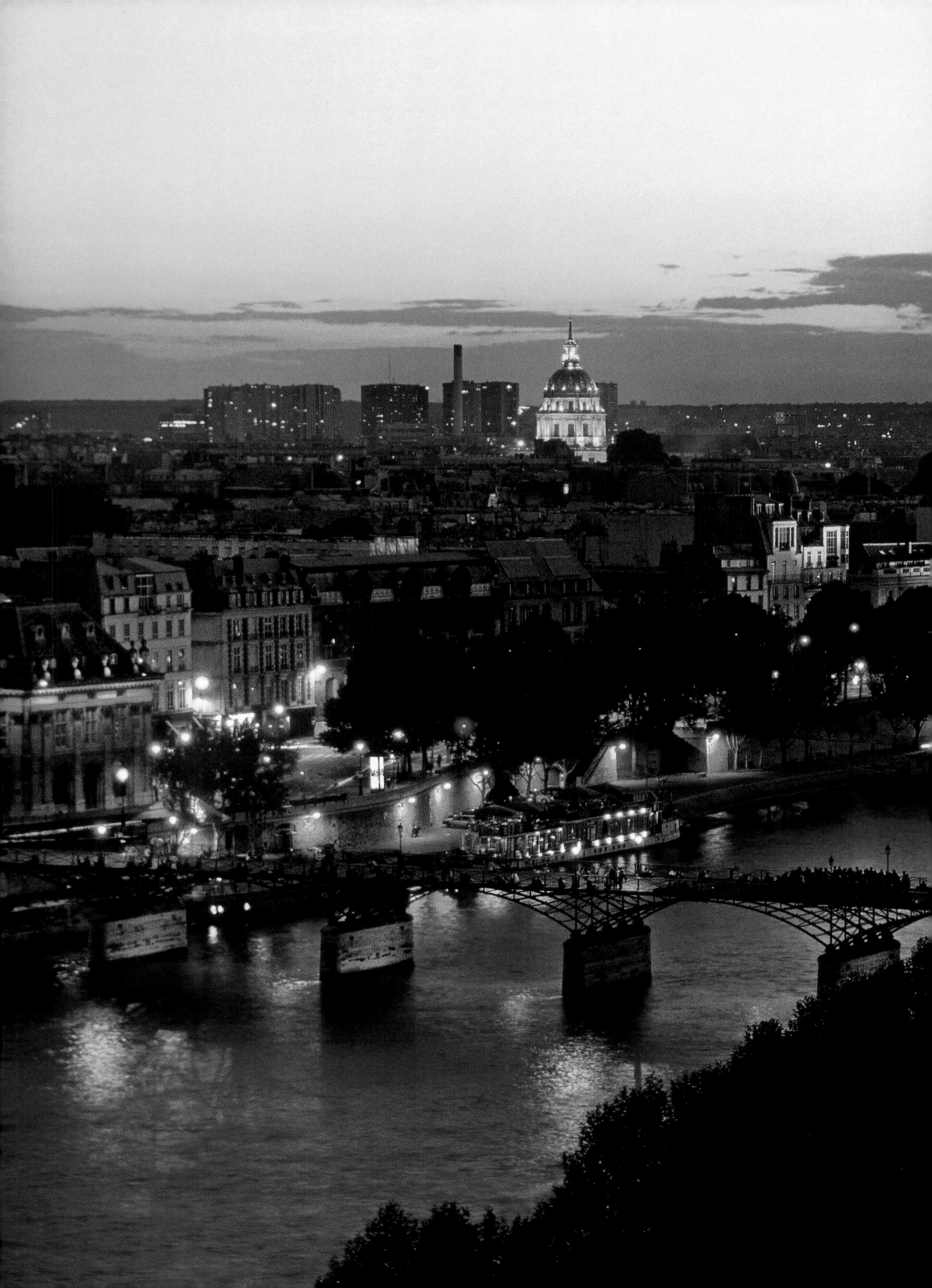

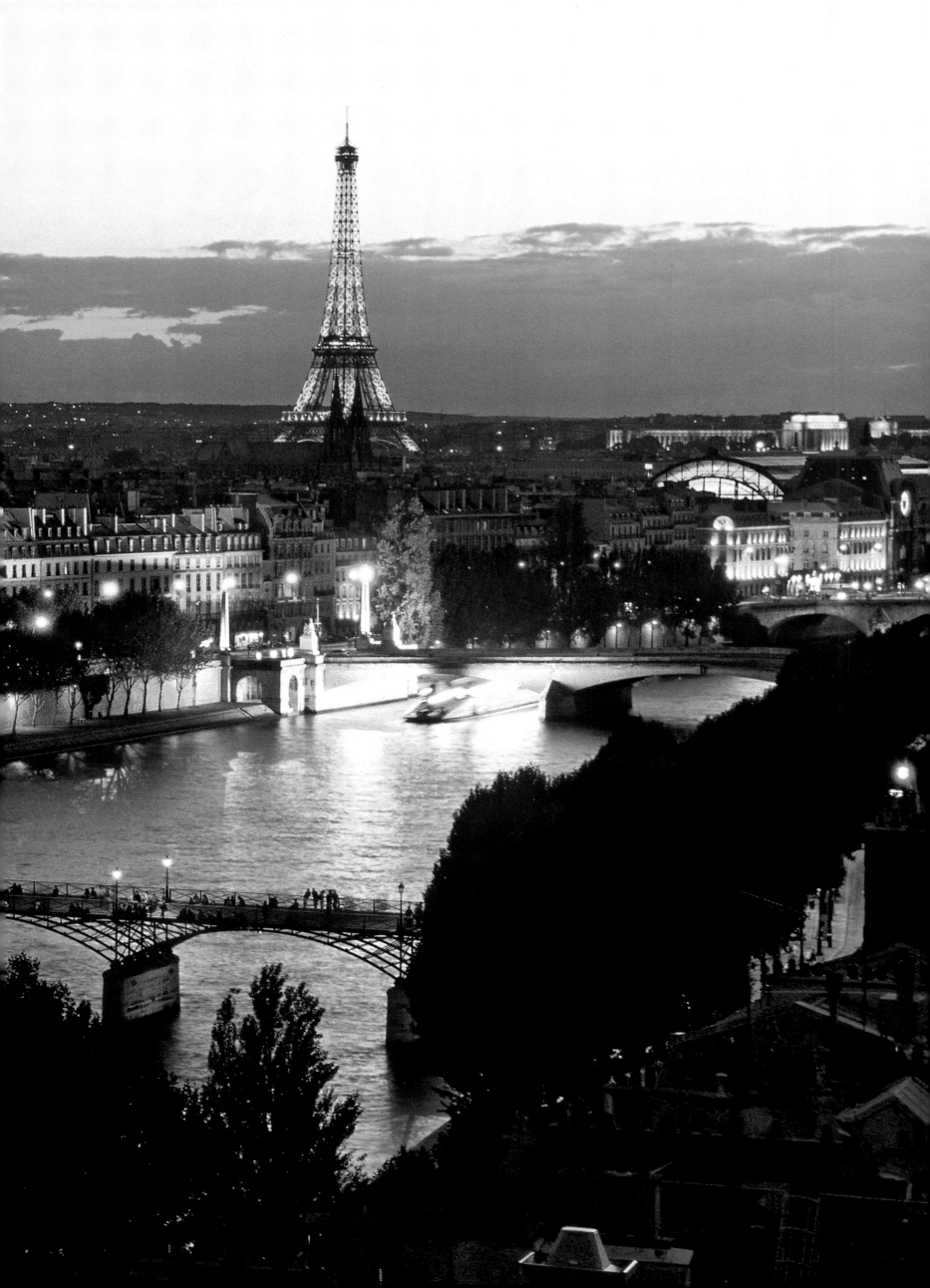

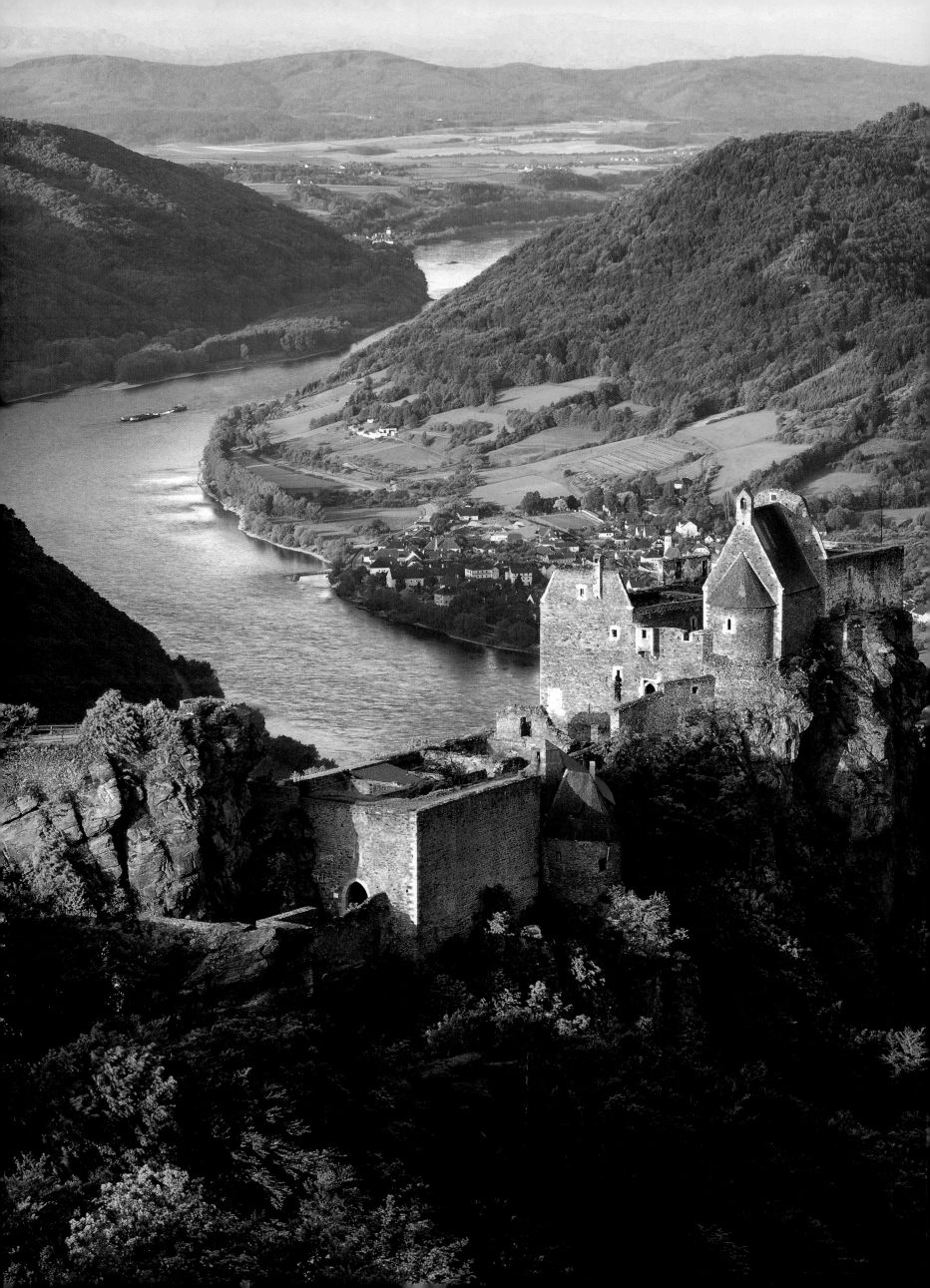

TABLE OF CONTENTS

TEXTS
Paolo Novaresio

PROJECT EDITOR
Valeria Manferto De Fabianis

COLLABORATING EDITORS
Laura Accomazzo
Novella Monti

GRAPHIC DESIGN
Paola Piacco

vmb
VMB Publishers®
An imprint of White Star S.p.A., Italy

© 2006 White Star S.p.A.
Via Candido Sassone, 22/24 - 13100 Vercelli,
Italy - www.whitestar.it

TRANSLATION: RICHARD PIERCE

ISBN-13: 978-88-540-0551-8

REPRINTS:
2 3 4 5 6 11 10 09 08 07

Printed in China
Color separation by: Chiaroscuro, Torino

INTRODUCTION

The dry desert rivers narrate stories to those who walk on their parched beds. We sift the sand underfoot. If the grains are round they are the result of wind erosion; if on the other hand they have an irregular shape that means they have been forged by water. On this kind of terrain it is not always clear that we are on a riverbed and where the river flowed. Only along the banks, which are sometimes miles away, is it easy to envisage the river. Here the water has left what could be called phantom strata: eroded rock, white lines of minerals, smooth hollows and grooves where the current was strong. The direction the creeping plants take tells you the direction of the river.

Rivers never die. It takes only one storm a year in the distant mountains to make a river swell again, if only for one night, with rapidly flowing water. The Tuareg, the shepherds and caravan leaders of the Sahara, have a saying: "Aman, imam," that is, "Water is soul." It does not matter if their rivers have a short life, since what they leave on the sandstone beds provides enough humidity for the vegetation to survive. From above, the dry rivers look like grass and plants flowing in a bed.

In one of these almost green rivulets I met a river genie. It was September, in the Ennedi massif in Chad. The river is called Archeï, which means "place always full of water." I saw only a huge valley with bent acacia trees and fragile bushes, but I knew that upstream the river becomes narrow and flows thread-like through the rocks for a few hundred feet every day of the year. Once the Archeï was a tributary of the immense Bahr el-Ghazal, the River of the Gazelles, which flowed northward parallel to the Nile, exiting from huge Lake Chad. Today, along this dry river, a few semi-nomadic people eke out a living on the dead sand dunes, while the lake is now a mere pool. However, rather recently – a thousand years ago and then in the 17th-18th century – the Bahr el-Ghazal once again flowed toward the basins of the northern desert, completely changing the life there. Scientists say that an increase in the level of Lake Chad of 933 feet (283 m) would be enough to make the Ennedi desert an oasis.

But to get back to my encounter, I met a girl there, a member of the Bideyat nomadic tribe, whose name was Aecha. She covered her face with the yellow plant shoots of a small broom she was using to gather tiny, round and almost black grains of wild millet. In two days of raking Aecha had gathered a small conical pile of seeds measuring about 28 by 14 inches (70 x 35 cm). "This year was unusually rainy," she said as soon as we managed to communicate. "The river will give us enough to eat." The great Persian poet Saadi from Shiraz wrote in 1292: "The torrent that rushes headlong from the mountains vanishes in the precipices, but the tiniest drop of dew is absorbed by the sun, which takes it up to the sky."

Despite the fact that all the rivers in the world amount to only a small portion of the 9600 cubic miles (40,000 cubic km) of fresh water available, they are more than mere waterways, for rivers mean kinetic energy. With their descending gradients they also represent potential power, before becoming waterfalls. Like human beings, rivers are born and have different origins. The Rhône River rises from a frozen brook in a glacier; the Volga has a marshy source. Rivers may flow out of an immense lake such as the Angara from Lake Baikal, or from a tiny lake like Itasca, which gives rise to the Mississippi. The headstream may pop out of the side of a mountain, as occurs with the Shenandoah and the Po, or emerge in asymmetrical fashion from a meadow, as does the Thames. And the sources of the Nile remained a mystery for well over 2,000 years, since the time of Herodotus, a mystery that had to be solved at any cost.

According to the dynamics of fluids, flowing water is a complex system that is extremely sensitive to its initial conditions and configuration: there is no system of equations able to describe the motion of a river, nor is it possible to make predictions concerning its course. The tiniest variations at the beginning of the river system produce chaotic behavior in mathematical terms. Rivers attract living organisms and at the same time are barriers. When humankind began to evolve in Africa, first in the forests and then in the savannas, the network of rivers isolated the various groups, accelerating the evolution of our species in a mosaic pattern: erect posture in one area, skillful manipulation in another, and the development of the cranium in yet another one. Then the rivers dried up, or changed course, which eliminated some barriers, thus allowing the groups of humans to produce new mixtures of genes and features.

And it precisely along the rivers (now dry) on the shores of the lakes of Africa that scientists have found fossils of the first humans, some as much as 4,000,000 years old. On the Nariokotome, a brook that empties into Lake Turkana in

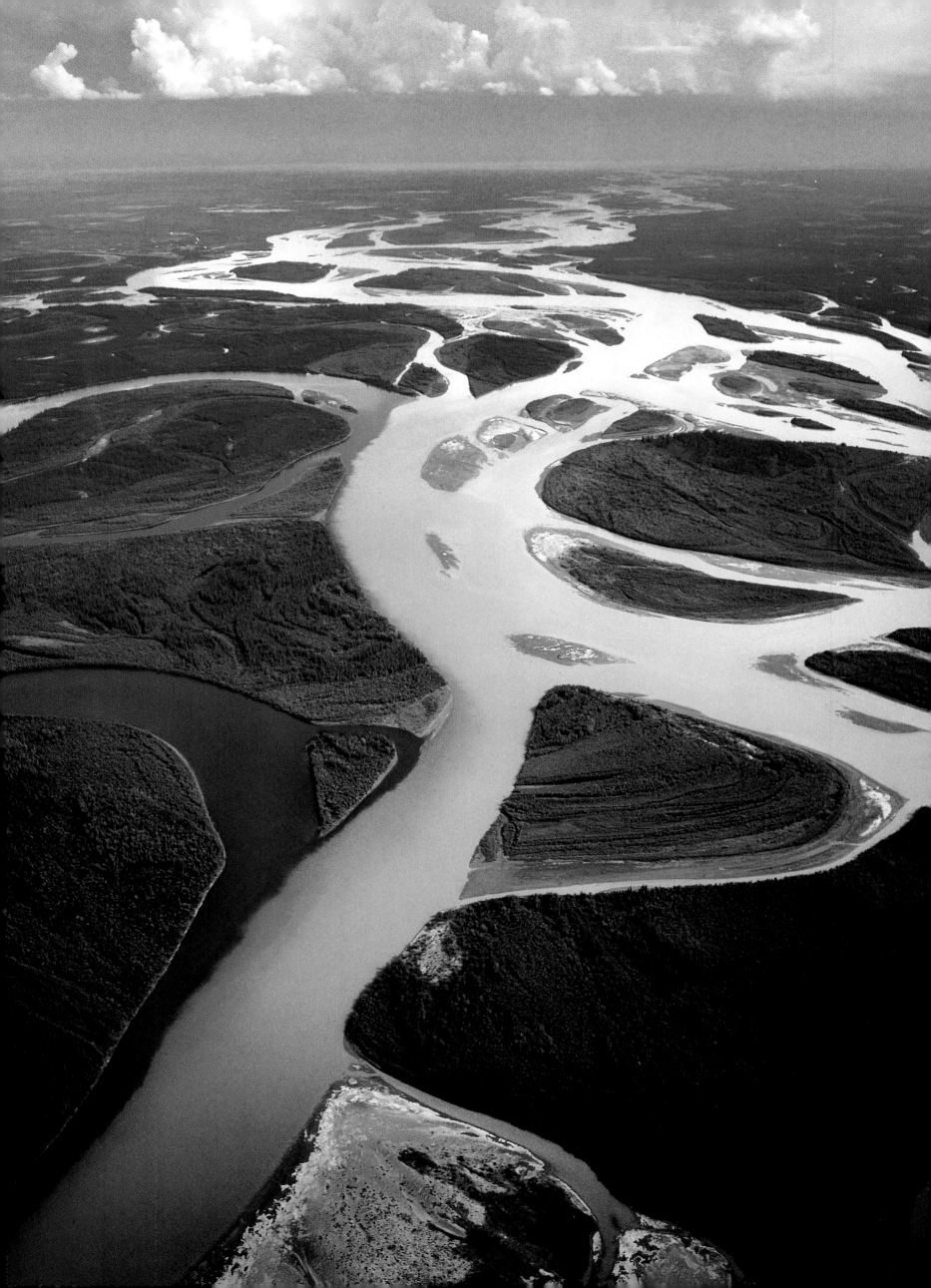

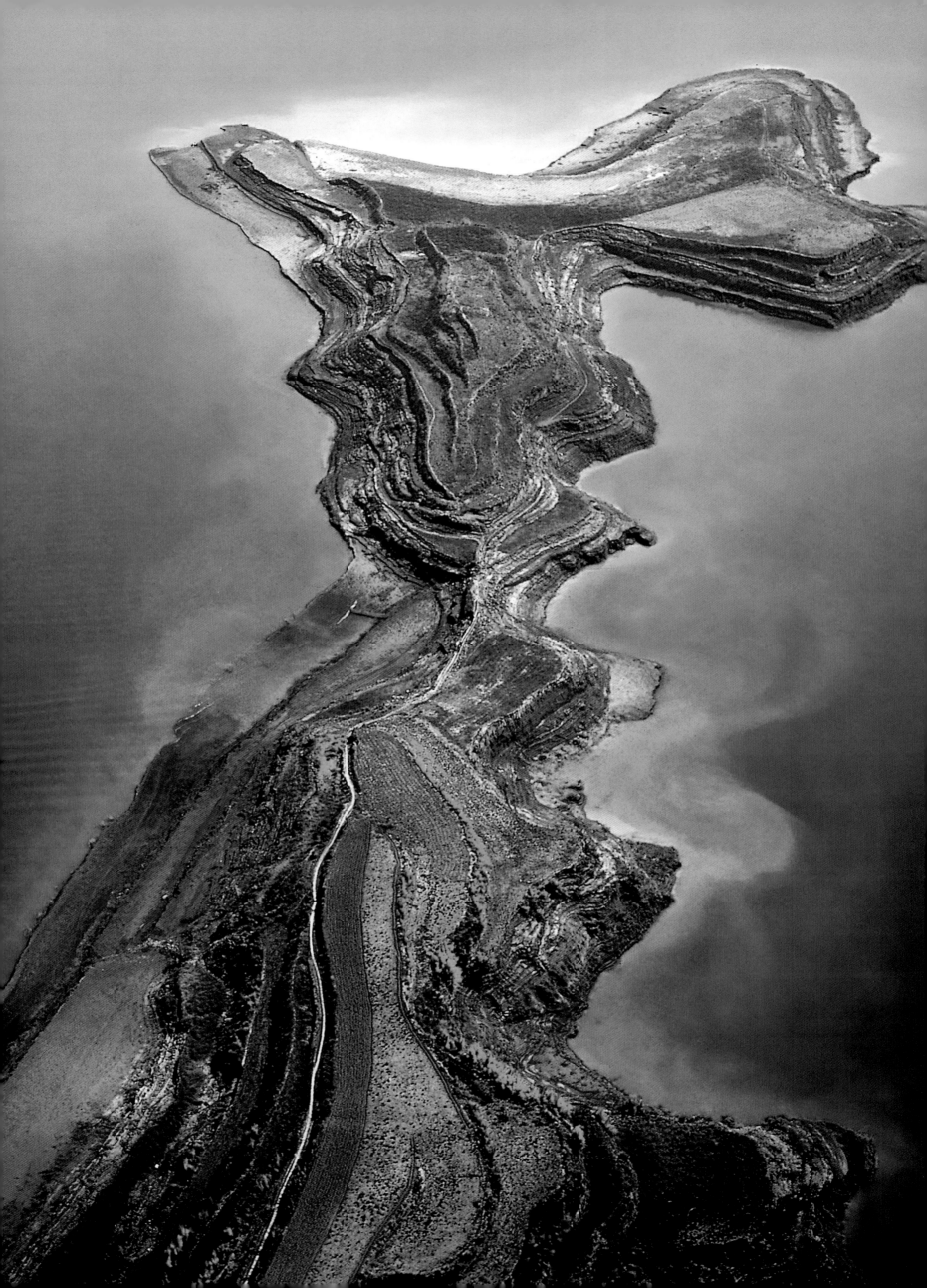

Kenya, a specimen of *Homo ergaster*, our fossil ancestor, was found. It was a nine-year-old boy who was extremely tall, 5.25 ft (1.60 m), who would have reached a height of almost 6.6 ft (2 m) had he lived longer. One day some 1.6 million years ago, the boy dragged himself to the river to drink some water. He had a high fever because of an abscess in an upper left molar (clearly seen in the fossil skull), and this is why he died. But the river consoled him by cooling him and then covering him with its sediment. Thanks to the river, the Turkana Boy became immortal as Fossil WT 15000, the most complete skeleton of a hominid ever found.

As often occurs with humans, some rivers flow into dead ends. In southern Africa, the Okavango River, its course altered by earthquakes, does not reach the Zambesi and dies out in an inland delta consisting of millions of small canals with transparent water that is the home of marvelous fauna. Proceeding along its course, the river becomes less powerful, the water slides on the bed rather than eroding it and ends up widening in the flatlands of Makgadikgadi, where the river turns into very white silt. One day, with a group of Bushmen, we tried to get there on foot, stopping beforehand to drink. The Australian Aborigines, on the other hand, have always known how to make use of periodic rivers that furnish the billabongs (temporary wells) around the Gibson Desert with water or, flowing westward from the Great Dividing Range in Queensland, supply the huge Artesian Basin of central Australia with underground water. The billabongs are hallucinatory rivers: they exist and don't exist, but those who are acquainted with totemic practices such as the hunter-gatherer Aborigines, know how to find the ancestor-rivers – and also how to survive.

The fact that rivers are part of the mythical universe is demonstrated by the thousands of glass beads (precious for their rarity) that the black Africans have since time immemorial cast into the beds of their rivers. The physical and spiritual energy of rivers has made them a tool of humankind. In keeping with a model of hydraulic society, it was the available supply of water drawn from rivers that generated large empires governed by authoritarian bureaucracies able to make vast areas productive. Architecture became monumental, the political system despotic: both these conditions served the need to keep constantly occupied and under control the huge number of laborers needed to construct and maintain the hydraulic structures. A Sumerian text from 4000 BC says: "Without coercion no city could be founded. The rivers would not come out of their beds." Typical hydraulic societies are the Mesopotamian and Egyptian civilizations, but from Babylon to New York the cities (hence the word "civilization") are situated along rivers and for rivers. It took only 100 years of human labor to shorten the Rhine by 75 miles (120 km).

The Missouri River is an uninterrupted chain of artificial lakes with levees that cannot be eroded: the chaotic movement of the waves is subdued by cement. The present-day construction of at least 500 dams per year means that over 60 percent of the river water in the world is now controlled and regulated by humankind. The concept of thirst is expressed by the Sahara Bedouins, people who wash themselves with sand even for their prayer ablutions (thanks to a special dispensation from Muhammad), as follows: "A man digs a well and finds water. Not satisfied, he continues to dig and finds only ashes."

Alberto Salza

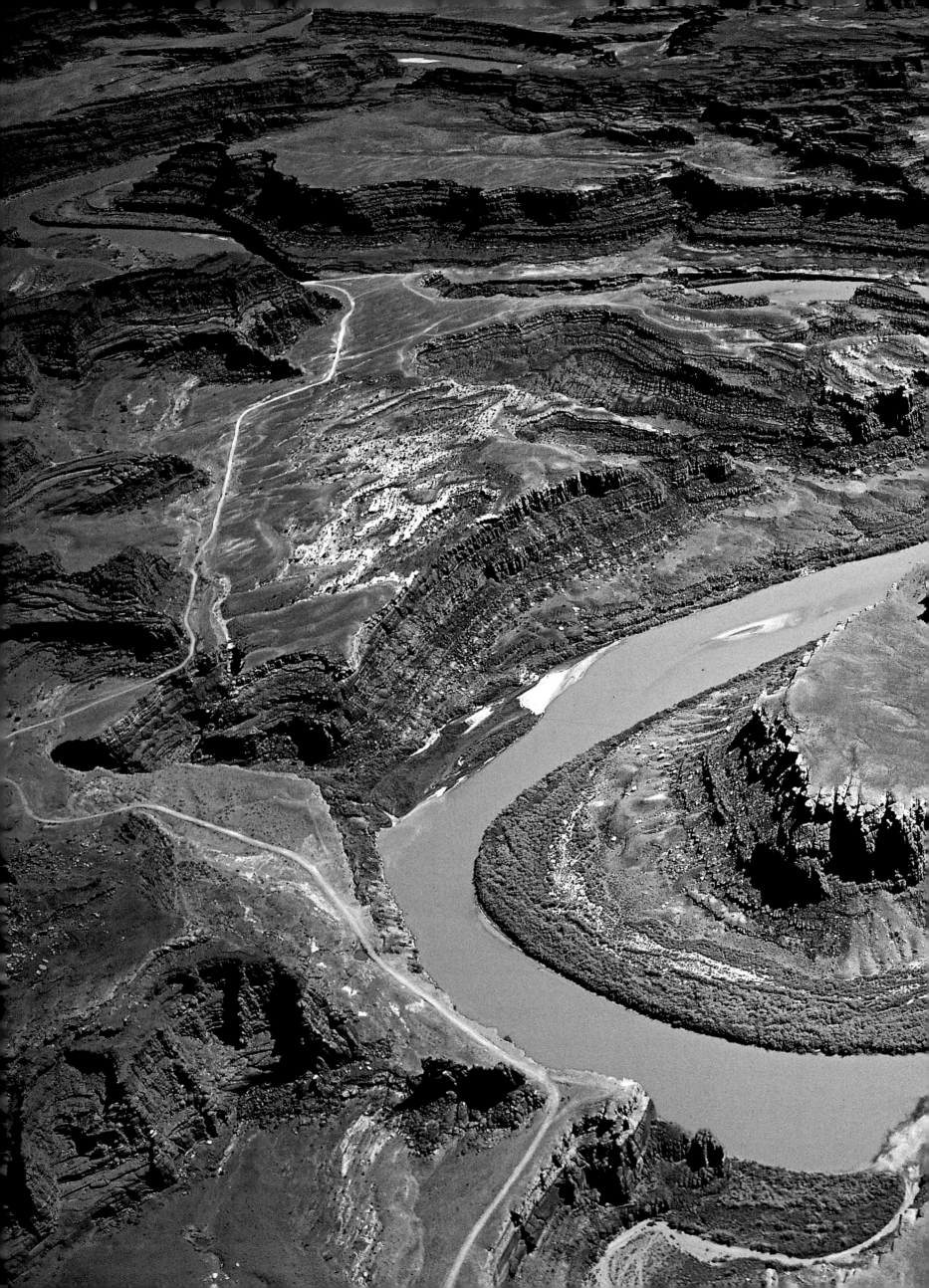

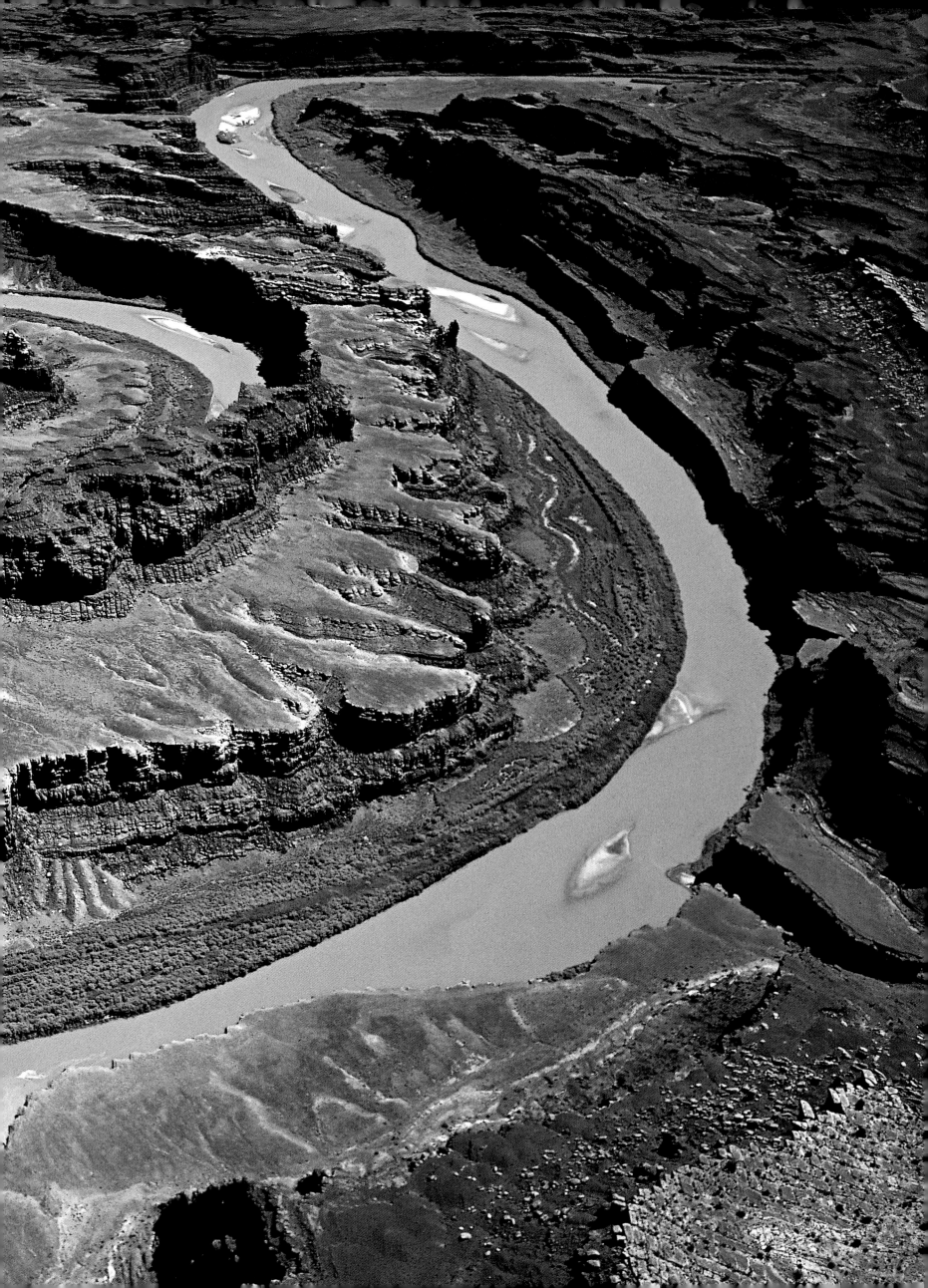

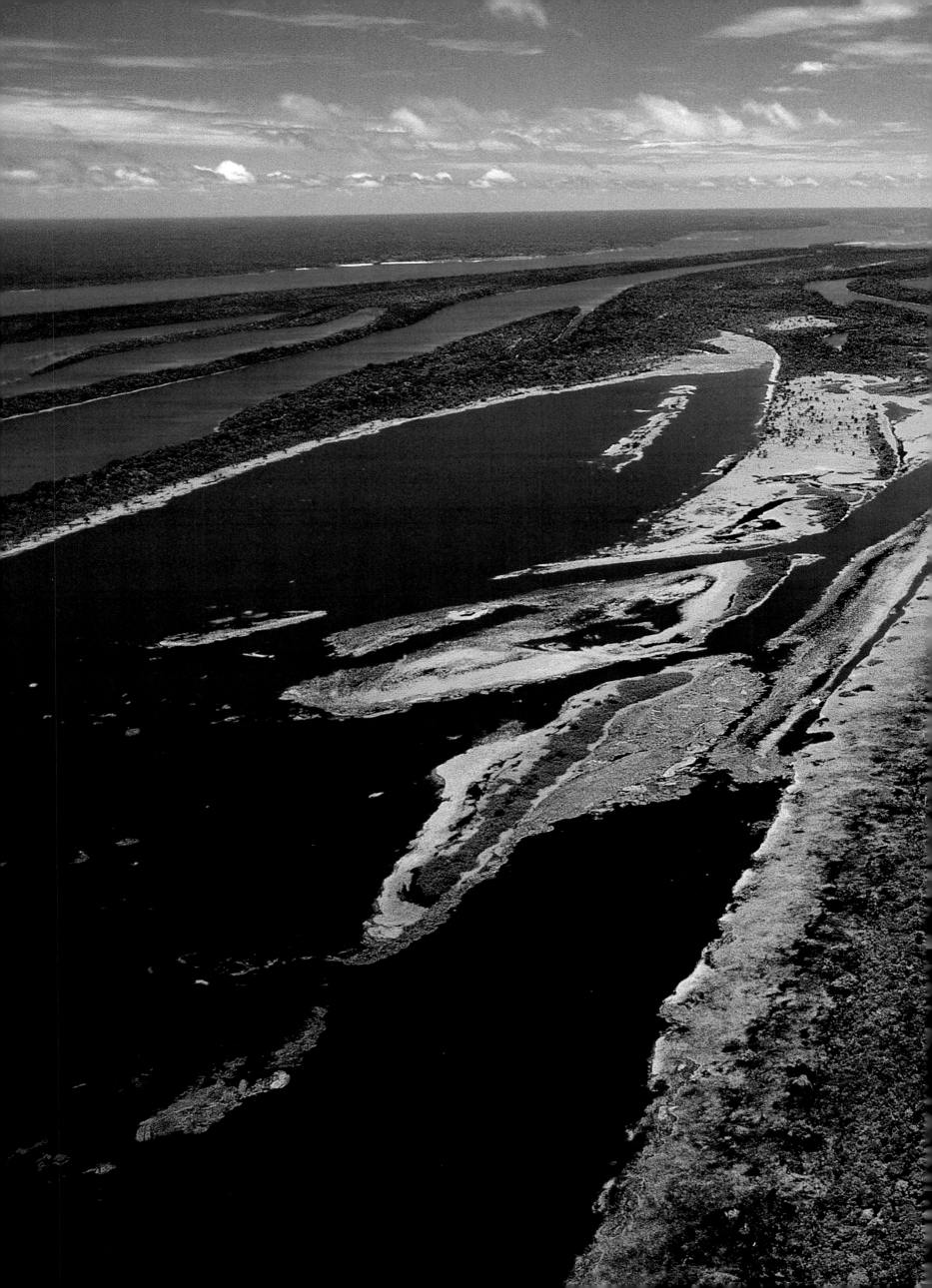

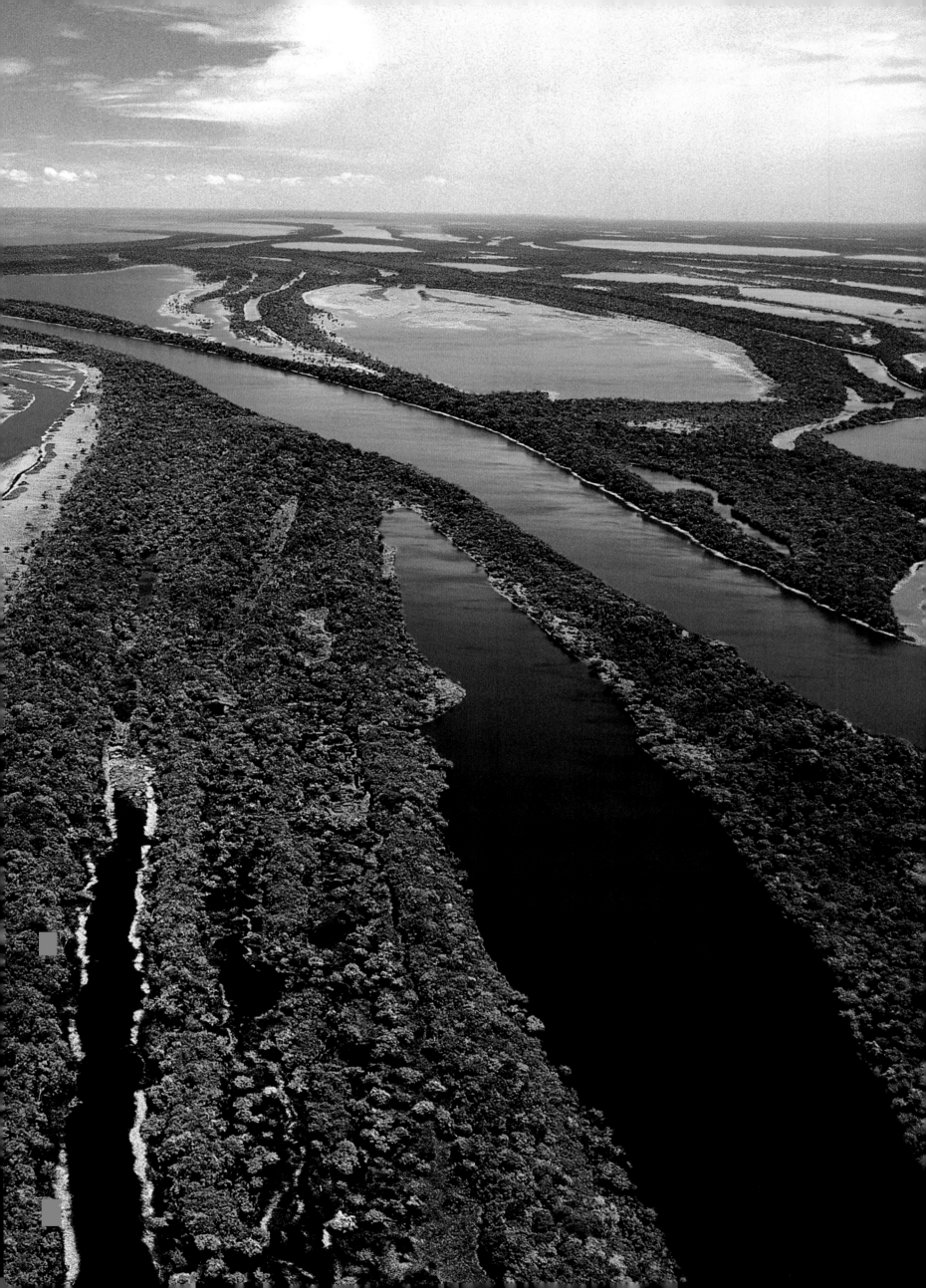

EUROPE

With the exception of the Danube, the most important European rivers flow through the large plain that stretches from the Ural Mts. to northern France without being interrupted by mountain ranges. This section of the continent has two major focal points from which rivers radiate: the mountain system that goes from the Alps to the eastern Carpathian Mts., and the hilly area of central Russia. The Volga, Dnepr and Don flow in the immense Sarmatian lowlands: the slight gradient makes these waterways suitable for navigation, but their economic importance is limited by the fact that they empty into enclosed basins such as the Black and Caspian seas.

The rivers that flow into the Atlantic are much more important as commercial routes: the Thames, Seine, Elbe, and above all the Rhine, which can be negotiated by large vessels as far as Basel and the Swiss border. Their deltas, which are exposed to the sea tides, host the main harbors in Europe: Le Havre, London, Hamburg, and Rotterdam can rightly be considered the gateways of the continent.

A network of artificial canals laid out during the Soviet period links the Volga River and the Baltic Sea, the Black Sea and the White Sea. Other canals, as well as a maze of secondary branches, connect the Rhine to the Seine and Danube, thus linking the industrial heart of the new European Union with the outlying and developing areas.

The waterway network in Scandinavia is negligible, since the rivers are either torrential or are mostly links among a multitude of lakes. The rivers on the Mediterranean, where rainfall is slight, generally have a limited discharge and are subject to dramatic low-water periods in the summer. The Ebro, Rhône and the Po – the only really large river in Italy – are the sole exceptions to this rule.

Over the centuries the major Europeans rivers have played the role of frontiers, areas of contact and mediation among different peoples, busy commercial routes, and means of migration. Large urban and industrial areas have risen up along their banks, greatly altering their natural features. Irresponsible exploitation has had grave consequences, such as the catastrophic floods that have afflicted the Po River Valley in the last decade. Until the 1960s the Rhine, Seine and Thames were among the most polluted rivers in the world, veritable open-air sewers. Since then the situation has changed for the better, and the first salmon have reappeared in the Atlantic estuaries, offering hope for the future. It is necessary and possible to live together with rivers. After all, the Europeans have done so for millennia.

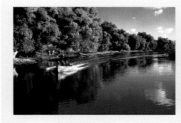
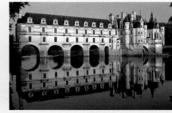
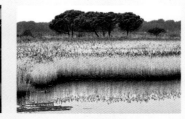

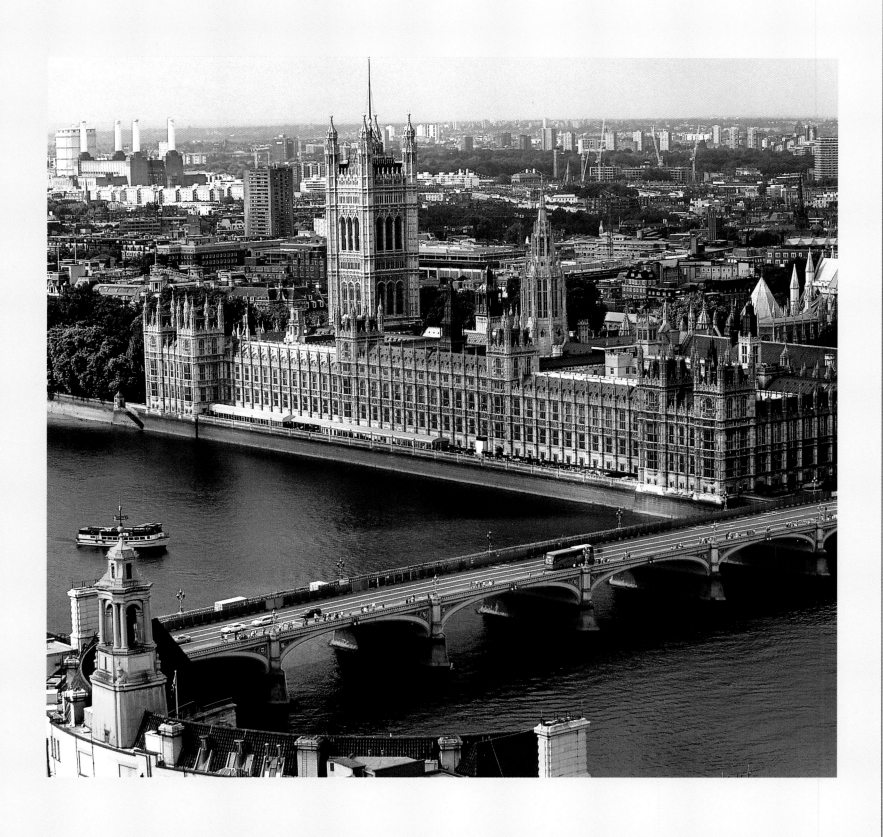

16 left A fishing boat goes down one of the branches of the Danube near its mouth, in Romania.

16 center The elegant Chenonceaux château on the Loire, France.

16 right The marshes created by the Po River in the Volano forest in the Emilia-Romagna region of Italy.

17 The Houses of Parliament and the Victoria Tower viewed from the Thames, London, England.

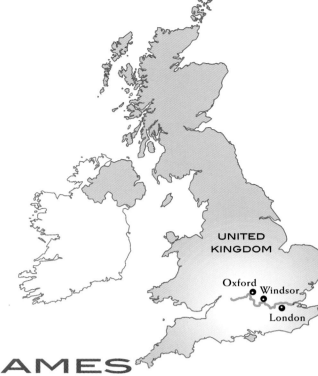

UNITED KINGDOM

Oxford ● Windsor
London

THE THAMES

THE ALLURE OF NOBILITY

The Thames River rises on the limestone highland of the Cotswold Hills, in Gloucestershire. But where, exactly? For a long time pinpointing the headstreams of the river was the subject of heated discussions between opposing parties. With typically British perseverance the matter was even discussed in Parliament: in 1937 it was officially established that the Thames begins at Thames Head, near the village of Kemble. The fact that the source is almost always dry is wholly secondary. In reality, the true Thames takes shape a few miles farther on, thanks to a series of small headstreams the merge near the town of Cricklade. Compared to the giants of Asia, Africa and America, the longest river in England seems little more than a brook. It is 211 miles (340 km)

long, has a rather modest rate of outflow, no truly important affluents to speak of, and would barely deserve being featured on maps. But for the English the Thames is much more than a waterway, an inland means of communication, or a fine place to spend one's leisure time; it is the very symbol of the nation, the emblem of a lifestyle, of a way of thinking and behaving.

The Thames is above all London, which until the first decades of the 20th century was the largest city in the world and the capital of an empire that ranged from southern Africa to Burma. The river has witnessed all the major events of English history from the time when Caesar's Roman legions laid out a city called Londinium in the mid-1st century BC. Invaders such as the Saxons, Danes and Normans went up the Thames and fought there. The Magna Carta, the first constitution in Europe, which laid the foundation for Western democracy, was signed near the riverbanks. The foggy, tranquil atmosphere of the river inspired painters such as Canaletto and Turner as well as a host of illustrious poets and writers, including Shelley, Dickens, Wilde, Kipling, Lewis Carroll and Kenneth Grahame. Handel sings its praises in his famous Water Music, and Jerome K. Jerome set the exhilarating adventures of his *Three Men in a Boat* there.

From the beginning of its course the Thames is fraught with fascination and memories. At Lechlade, about 19 miles (30 km) from the sources, the river becomes navigable thanks to a series of locks. Today most of the river traffic in this section consists of pleasure craft, but once the wharves of Lechlade hosted the large barges that went from London to the upper course of the Thames and vice versa, laden with all kinds of cargo. The dome of St. Paul's Cathedral in London was built with Lechlade stone.

Winding lazily through hills and green fields, the Thames

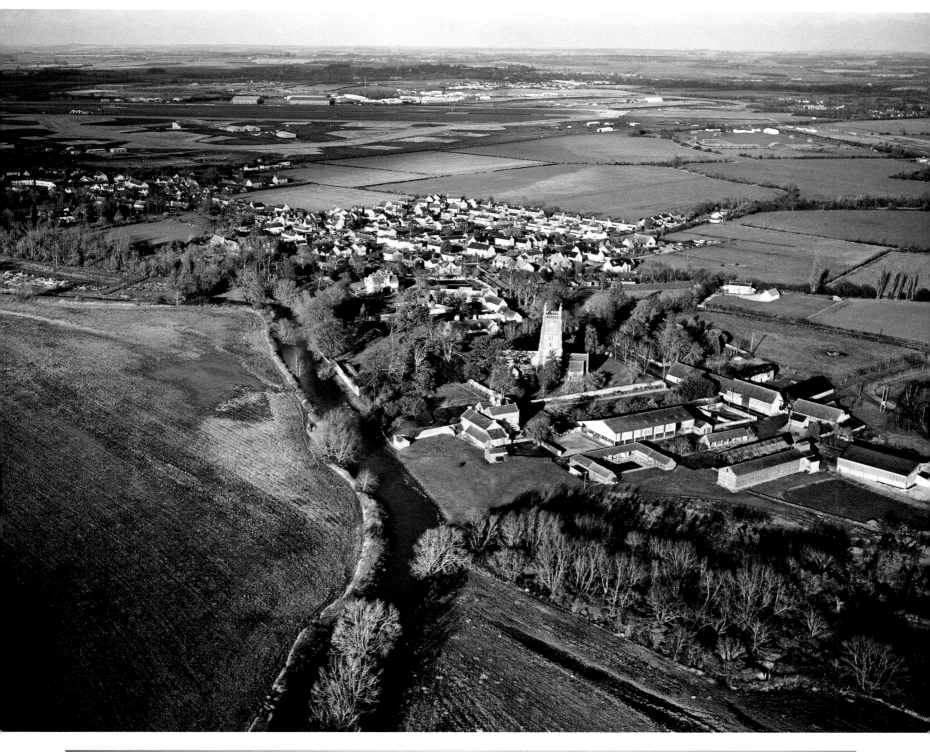

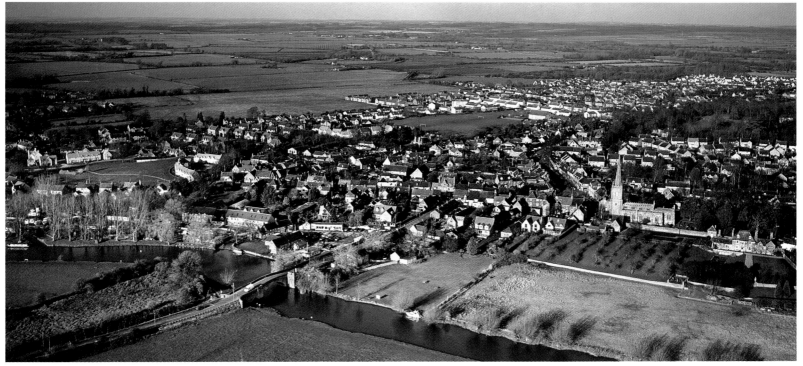

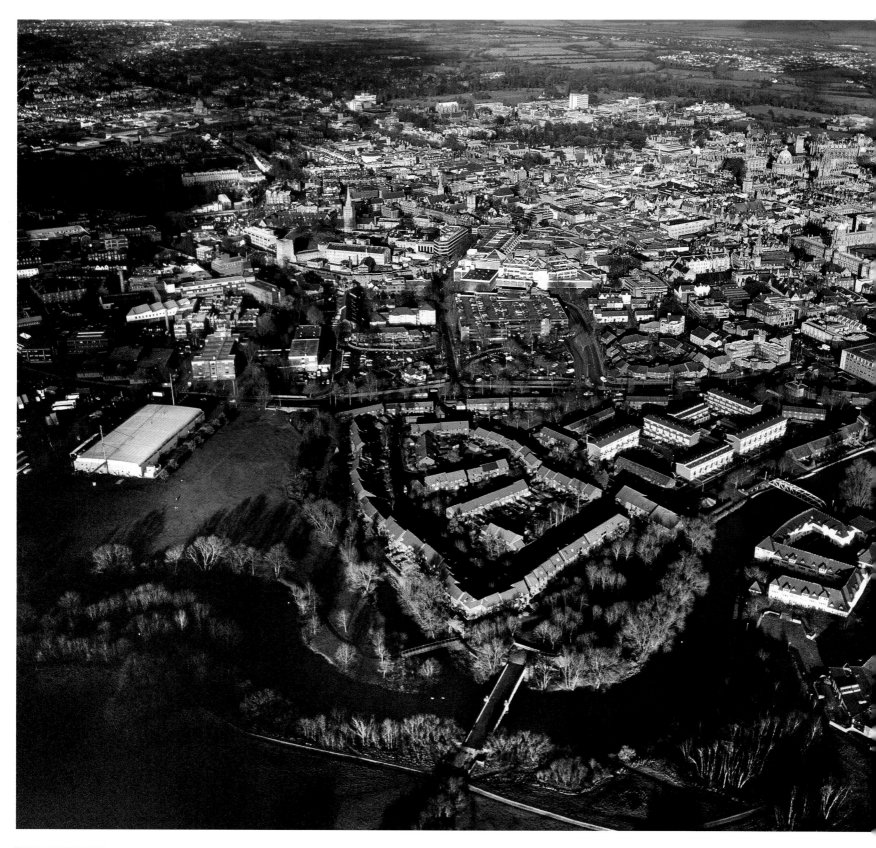

20-21 The ancient city of Oxford, situated at the confluence of the Thames and the Cherwell, is world famous for its prestigious university. The Bodleian Library, founded in 1450, is extremely interesting; it boasts a collection of over 1,500,000 books and precious manuscripts.

20 bottom In the vicinity of the town of Goring, in Oxfordshire, the Thames penetrates a gorge that lies between Berkshire Downs and the Chiltern Hills and then winds its way into a valley and heads toward London through a region that was once marshy and with few roads.

21 top The town of Henley-on-Thames, founded in the 12th century on the north bank of the Thames in Oxfordshire, was formerly an important trade center and has noteworthy monuments and vestiges of the past.

21 bottom In the idyllic setting of Oxfordshire the Thames is at its loveliest: the evocative landscapes created by the slow and tortuous flow of the river inspired poets and writers such as Shelley, Jerome K. Jerome and Lewis Carroll, the author of the famous novel Alice's Adventures in Wonderland.

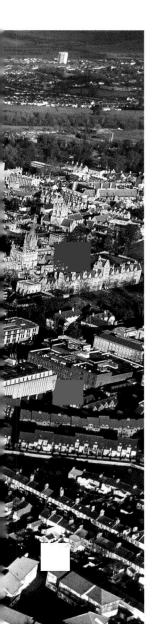

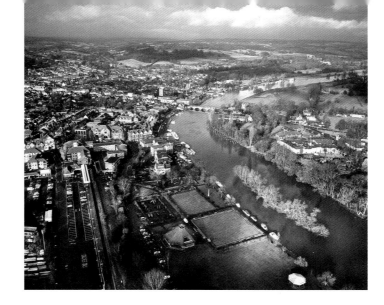

THE THAMES

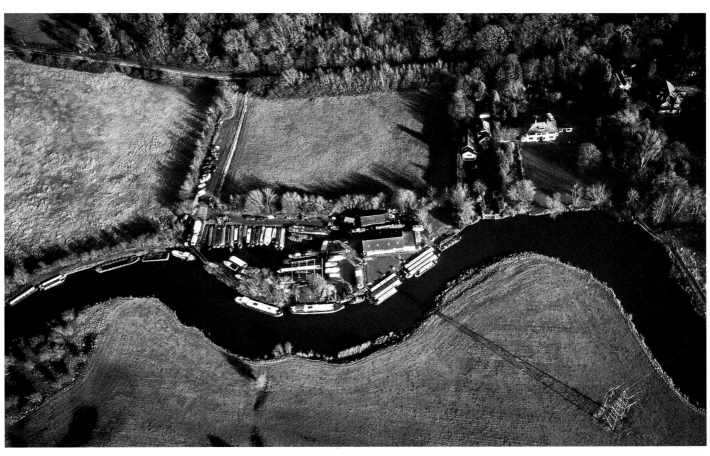

moves toward Oxford and its junction with the Cherwell. In this section nothing disturbs the placid flow of the river as it runs through a bucolic countryside that has been the same for centuries. Oxford is one of the most beautiful and interesting cities in Europe; its monumental university, the oldest in England, was founded in the 1200s and now has 39 colleges. Lacking in the list of illustrious figures who graduated from Oxford is Shelley: he was expelled for having published the pamphlet *The Necessity of Atheism*, which triggered a scandal. At Oxford, tradition is taken seriously and must be respected in all its aspects, including the rivalry with Cambridge both in the field of study and rowing races. Almost every year since 1829 the two universities have met in the historic boat race, traditionally rowed between Putney and Mortlake, where the Thames iis broad but also has a bend. The race, held in spring attracts thousands of fans, who are packed along the riverside and also on any available craft on the river itself.

One of the favorite pastimes of the English is to navigate on punts, the typical boats propelled by poles; men with straw hats and women dressed in white and armed with the inevitable parasol make one think of the past and the Thames as described by Jerome. Between Oxford and Windsor the idylls between the river and English literature become even more passionate: every bend, every meander under the shade of willow trees, and every village preserves moving and poetic memories. It seems that Jerome K. Jerome got the idea for his most famous book in a pub at Clifton Hampden, in the vicinity of Oxford, in 1889.

The setting for the story of the three men and the dog that go up the Thames – plagued by a myriad humorous complications – for a vacation in contact with Mother Nature, was well known to the author, who spent most of his life along the river. And Lewis Carroll's *Alice's Adventures in Wonderland* was conceived during a boat trip he took to entertain the young daughter of a friend of his.

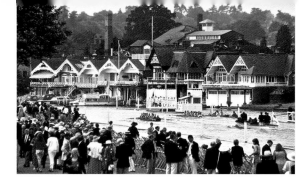

THE THAMES

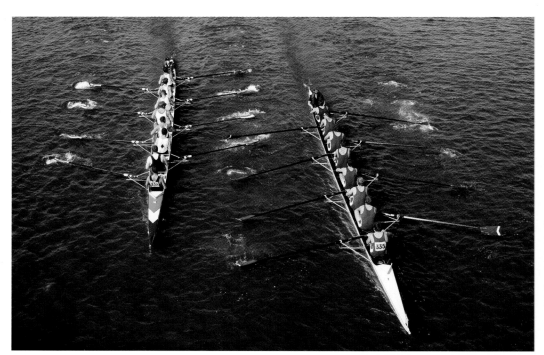

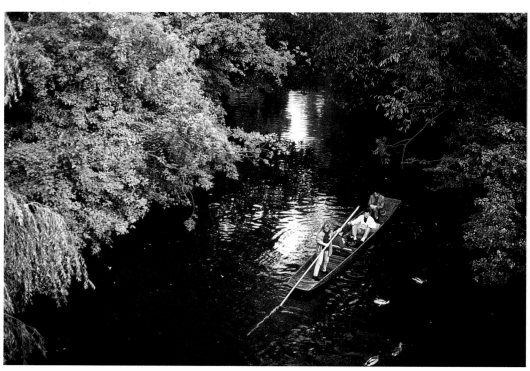

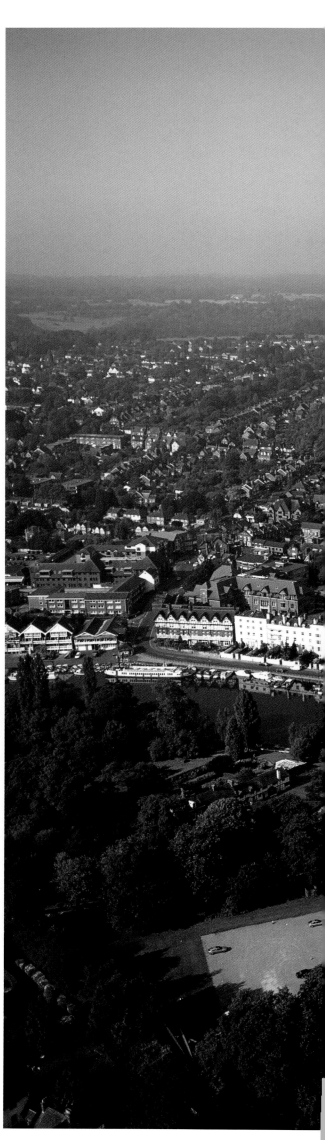

22 top and center Every year since 1829, with rare exceptions, the Thames has been the venue of the famous Oxford vs Cambridge boat race.

22 bottom Trips down the river on the characteristic punts, small boats propelled by a long pole, are one of the favorite pastimes of the Oxford University students. One of the most popular is the ride from Magdalen College down the Cherwell River as far as its confluence with the Thames at Folly Bridge.

22-23 A bridge with five arches built in 1786 connects the opposite banks of the Thames at Henley-on-Thames, in Oxfordshire. A museum dedicated to the river and to the sport of rowing reveals the strong, centuries-old relationship this town has with the Thames.

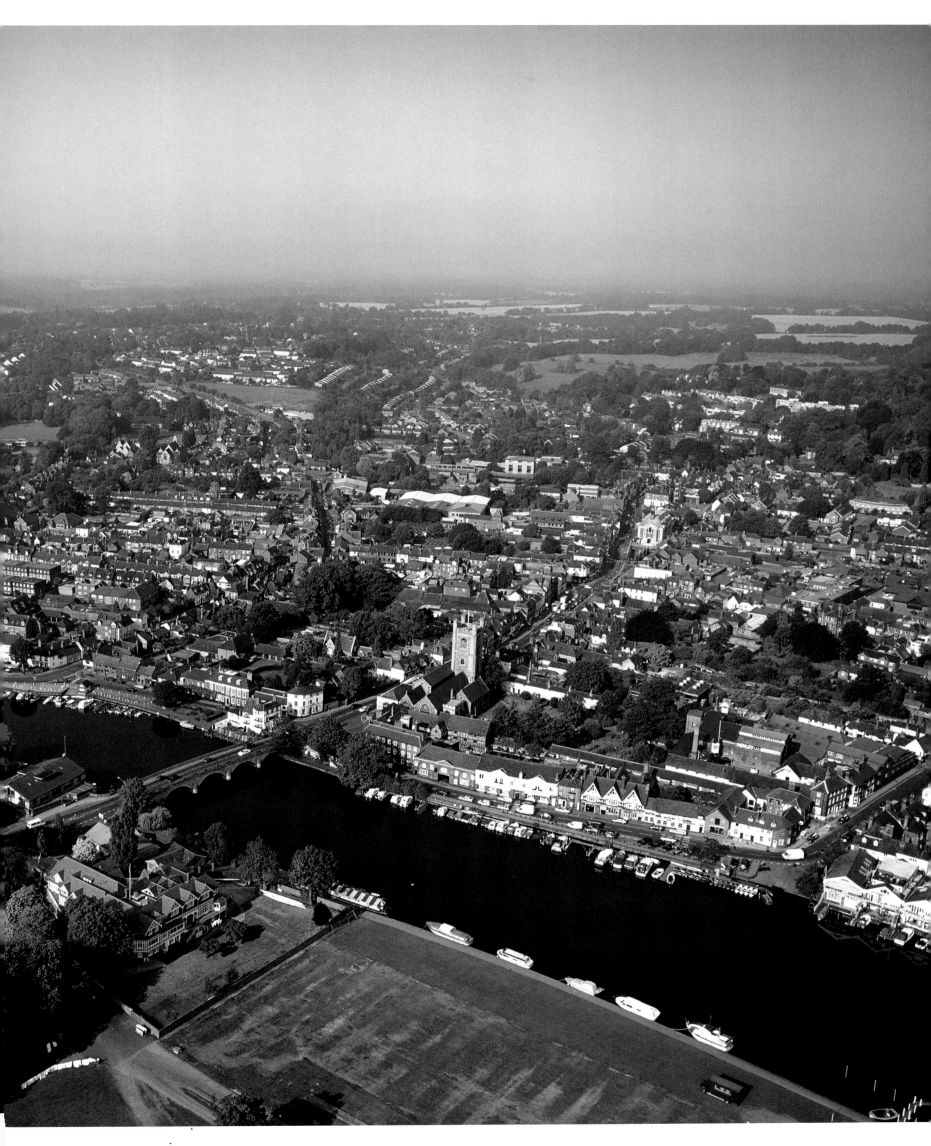

24 top *The village of Marlow, in Buckingamshire, has always been linked with great romantic poet Percy Bysshe Shelley, who lived there with his second wife Mary.*

24 bottom left *Reading, Berkshire's county town and the only industrial city in the middle course of the Thames, has many cultural institutions and a famous university.*

24 bottom right *Time seems to have come to a halt at*

Mapledurham, which is the historic home of the Blount family and the last watermill in operation on the Thames River.

24-25 *Hampton Court Palace, built on the banks of the Thames in 1515-20, was transformed into a sumptuous royal residence at the end of the 17th century by the*

famous architect Christopher Wren. The palace now houses paintings of the most famous Italian artists of the time, including Mantegna and Giorgione.

25 bottom *A group of swans on the calm waters of the Thames below Windsor Castle, which was begun around the year 1070 by William the Conqueror. The castle, constructed on a natural terrace that overlooks the river, was rebuilt and beautified in the following centuries.*

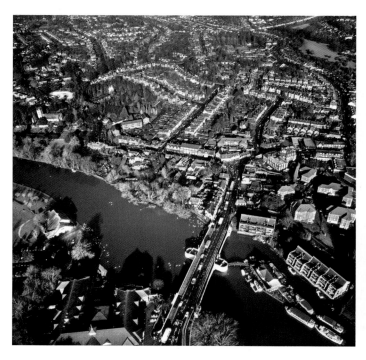

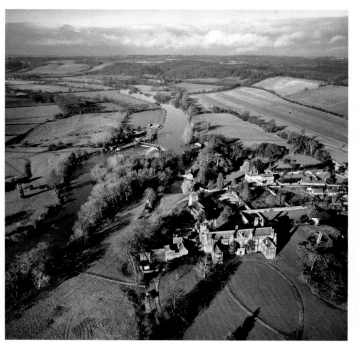

The girl had a curious personality: she loved to weave garlands along the banks of the Thames and saw white rabbits with pink eyes pop out of the grass and run past her.

Reading, the only industrial city on the upper and middle sections of the Thames, will always be known as the place where Oscar Wilde was imprisoned for homosexual offenses, followed two years later by his accuser, who was found guilty of false testimony. Farther down the river, at Marlow, Shelley found refuge for his tormented soul, while his wife Mary crafted her famous novel *Frankenstein* piece by piece and page by page.

Before Reading the bed of the Thames narrows as it passes through the Goring gorge, amidst the Chiltern Hills and the Berkshire Downs, an area rich in natural springs. The river is now in the London basin and flows slowly eastward in wide meanders through what in the past was a broad marshy valley.

Here the pastoral and agricultural Thames changes aspect and social class, becoming an aristocratic river. The members of the Royal Family and the leading exponents of the country's military, political and religious classes chose this area to build their sumptuous

residences, far from the overpopulated and unhealthy capital. The massive crenellated walls of Windsor Castle dominate the Thames from a natural rise. A huge park surrounds the edifice, which was founded by William the Conqueror in the later part of the 11th century and was remodeled and beautified in the following centuries. It is still the official residence of the royal family. Hampton Court, on the other hand, was turned into a museum. No expense was spared by Cardinal Wolsey, one of the wealthiest people in England, in the construction of this building in 1525, which was donated to Henry VIII a few years later. At the end of the 17th century it was completely rebuilt by the famous architect Christopher Wren, an extremely cultured person and the leading figure in the rebuilding of London after the disastrous fire of 1666.

Richmond, at the gates of London, was chosen as the residence of the Plantagenets, a dynasty that laid the foundation for the political development of the country. But it is between Hampton Court and Windsor that the weight of history makes itself felt even more. Two famous members of this family were Richard Lion-Heart and King John.

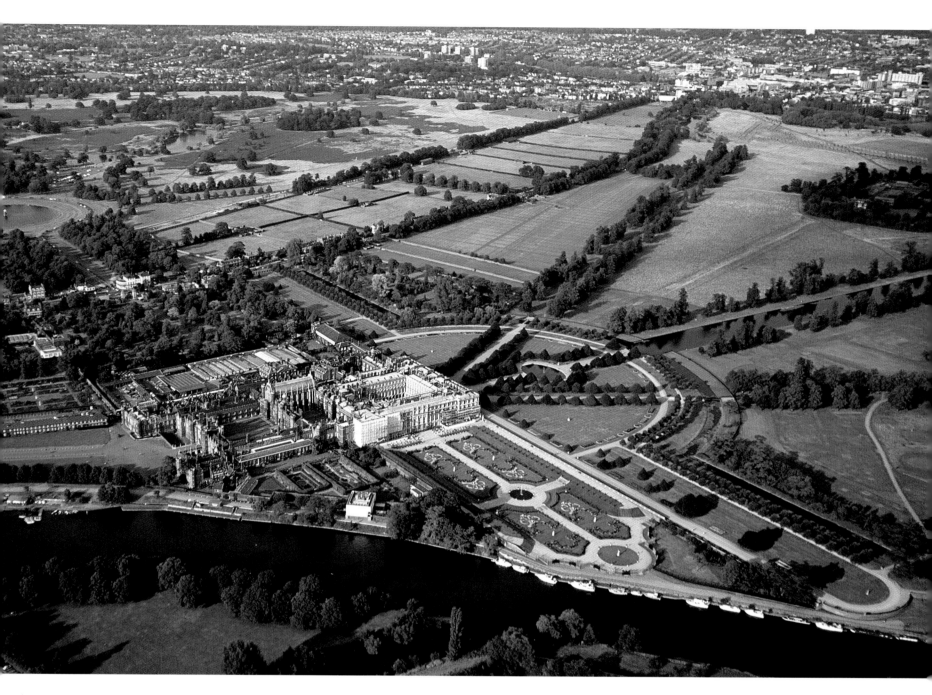

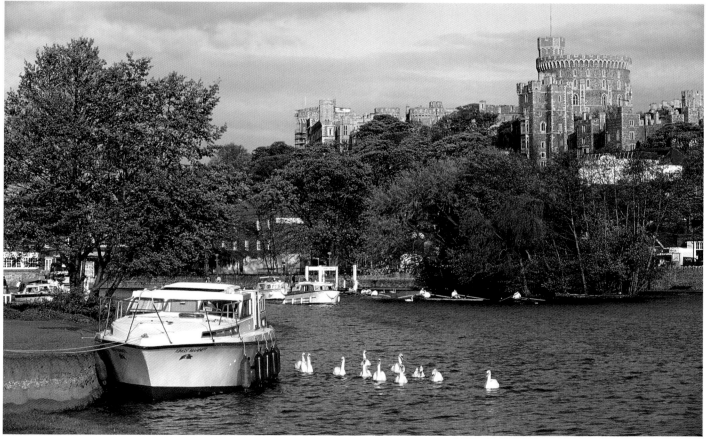

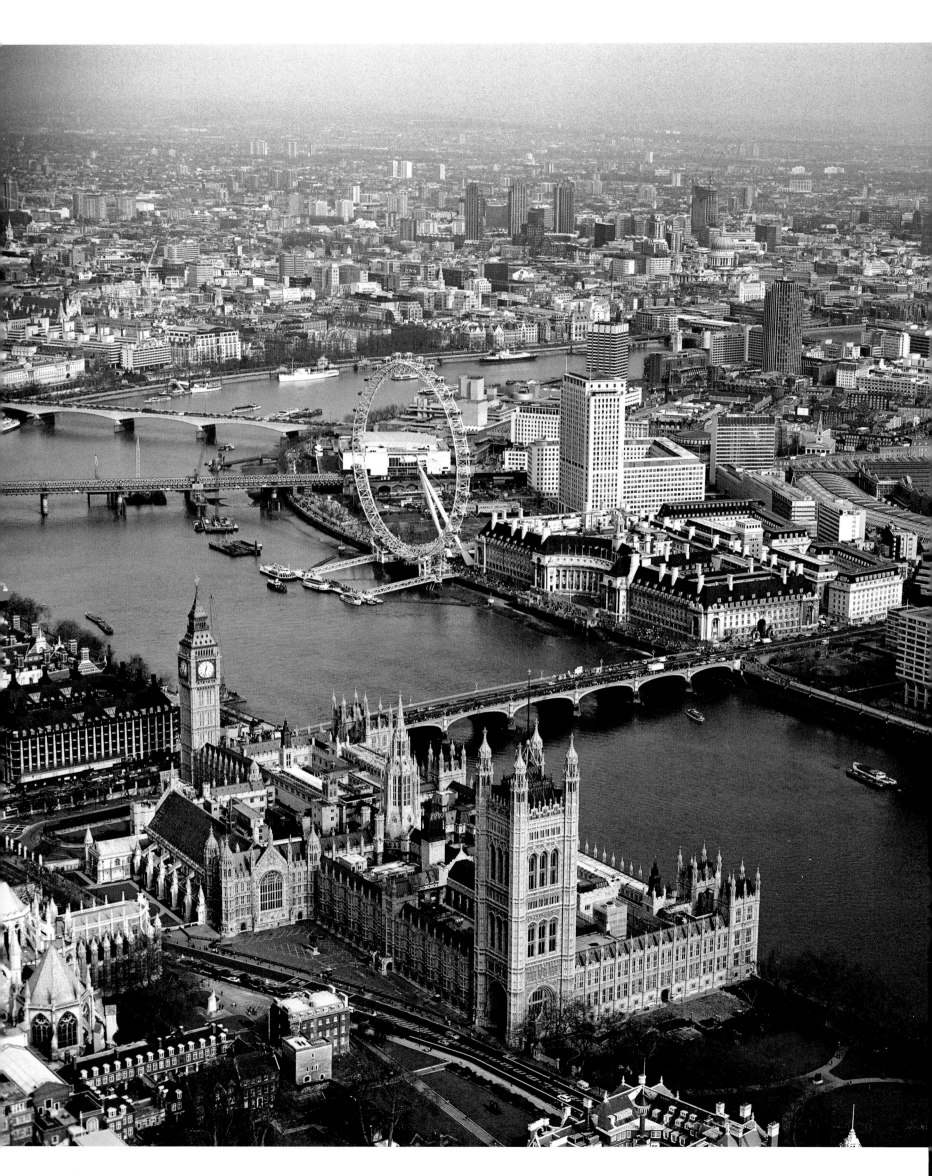

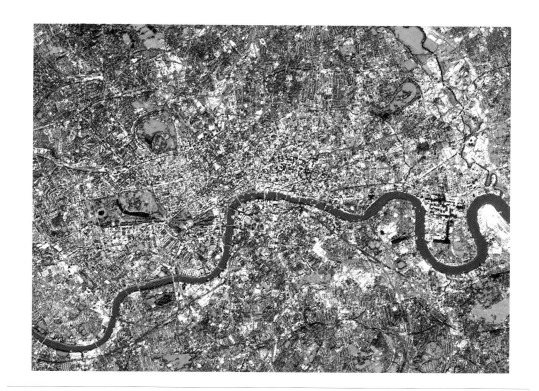

26-27 *The profile of the Houses of Parliament, with their marked Gothic or Elizabethan style, dominates London's West End, which lies along the left bank of the Thames.*

27 top *This satellite view of the Thames winding through London, clearly shows the large areas of greenery or parks in the heart of the*

city. Another characteristic feature of the city that can be seen in a wide bend in the river (at right), are the old East End docks.

27 center *St. Paul's Cathedral (at left), whose construction drew inspiration from the classical Palladian style, is one of the most impressive buildings in London.*

27 bottom *The Houses of Parliament, Westminster Hall and Big Ben are reflected majestically in the waters of the Thames. Westminster Bridge, one of the 27 that cross the river, connects the heart of London and the densely populated quarters that lie along the river's south bank.*

THE THAMES

The latter was forced by the English barons to sign the Magna Carta at Runnymede in 1215, in the setting of the open fields that border the southern bank of the Thames: for the first time in Europe, the dogma of royal absolutism was challenged and checked.

Several centuries earlier, the Saxons had crowned their bellicose kings at Kingston. The lock at Teddington, a short distance away, marks the beginning of the tidal part of the Thames, its estuary; this is 87 miles (140 km) long and its water level rises 23 ft (7 m) at high tide. But the tides can be even higher and may have devastating consequences. In 1953 London was flooded by the Thames; hundreds of people died and the damage was inestimable. In order to protect the city from any such exceptional events in the future, in 1982 a 60-ft (18-m) high mobile barrier was placed in the river at Woolwich, about 31 miles (50 km) from the the estuary.

The Thames crosses Greater London in a stone and cement bed. Here it is crossed by 27 bridges as well as by several railway and road tunnels. Famous buildings and monuments line the river: Westminster, the Tower, and Big Ben, symbols of a long-lived and illustrious civilization. But

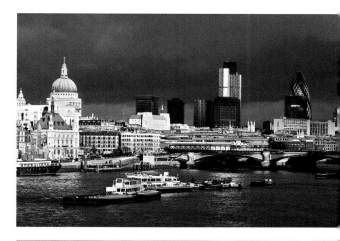

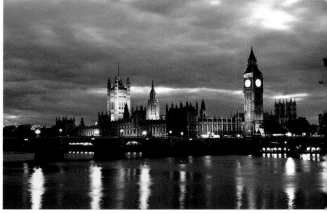

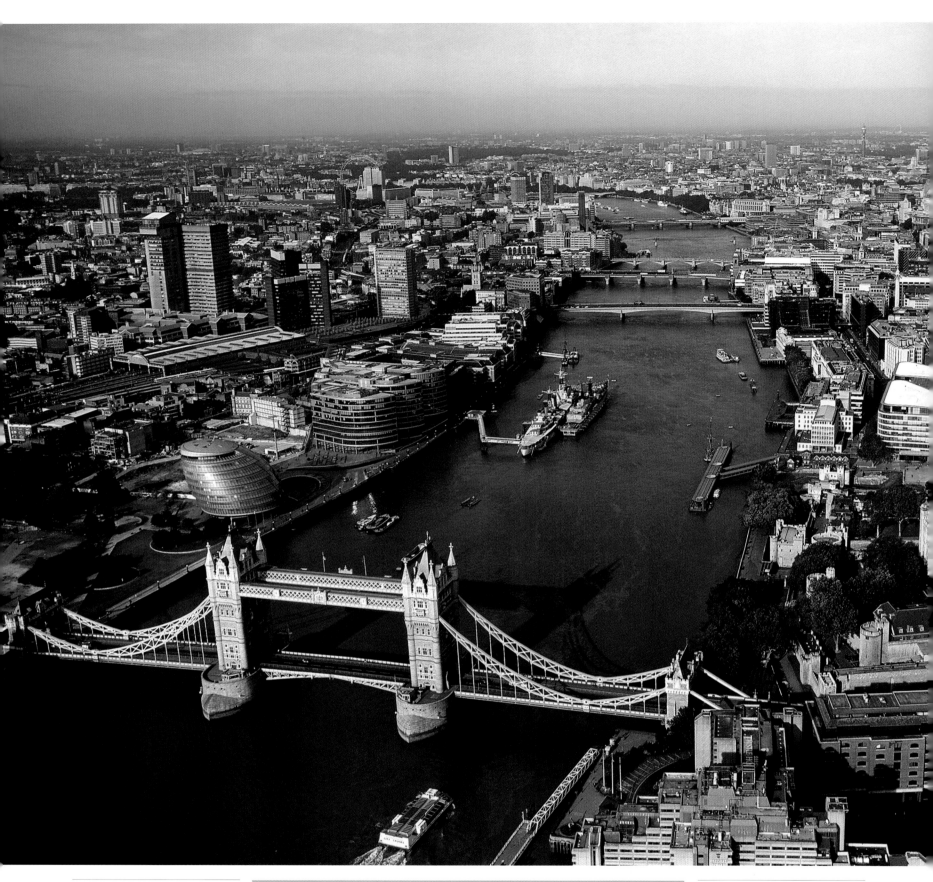

28-29 The commercial traffic on the Thames, which the poet John Mansfield once called "a grand liquid thoroughfare," has now become almost negligible. Tower Bridge, a true wonder of Victorian engineering, is now one of the most popular tourist attractions in London.

28 bottom The Docklands zone, which was once the unloading point for the cargo transported from all the corners of the British Empire, is now the site of offices and residential areas.

29 top The futuristic Millennium Dome, on its Thames-side site at Greenwich, east of London, is the largest dome ever built. Opened on 31 December 1999 with the participation of the royal family, this structure has surface area of over 8.6 million sq.ft (80,000 sq. m), most of which is taken up by exhibition areas.

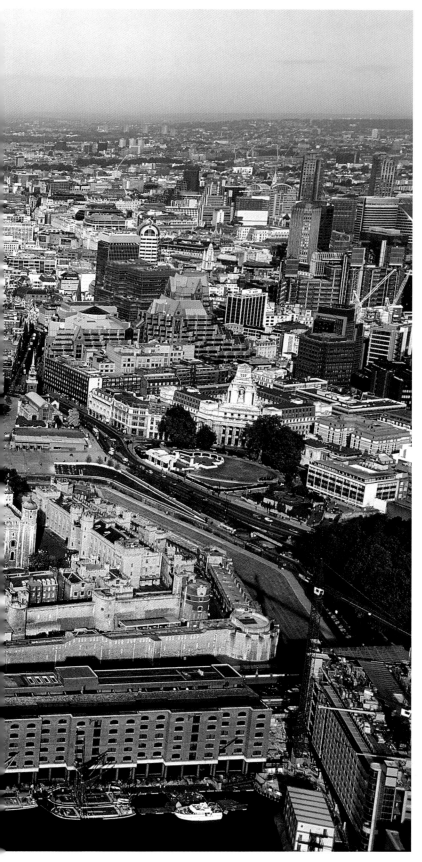

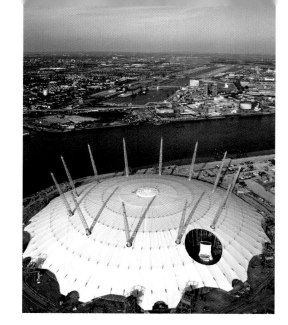

THE THAMES

29 bottom *The two roofed footways that connect the central towers of the London's Tower Bridge were closed for a long period but were recently restored and opened to the public.*

This famous bridge was built in 1894 and was provided with an ingenious mechanical lifting apparatus that made it possible to raise the roadways in only 90 seconds.

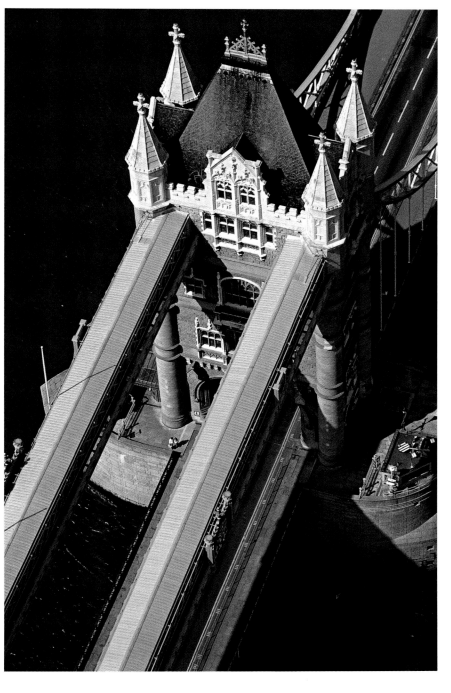

the "great road paved with water" and always filled with boats loaded with their cargo that went beyond the Tower Bridge, is now almost deserted. Most of the traffic has shifted toward Tilbury and the coastal ports, which can berth oceangoing ships. The old East End Docks, the grim setting for some of Dickens' novels and once the main clearing and sorting center of all the resources of the British Empire, have been converted into residential and office building zones. And the Thames, which was considered dead only a few decades ago, has taken on new life: the organic and industrial pollution that afflicted the river has been almost totally eliminated and the Atlantic salmon have begun to go upstream once again. At Gravesend the Thames loses itself in the embrace of the grey North Sea, "like the beginning of an endless waterway," as Joseph Conrad said.

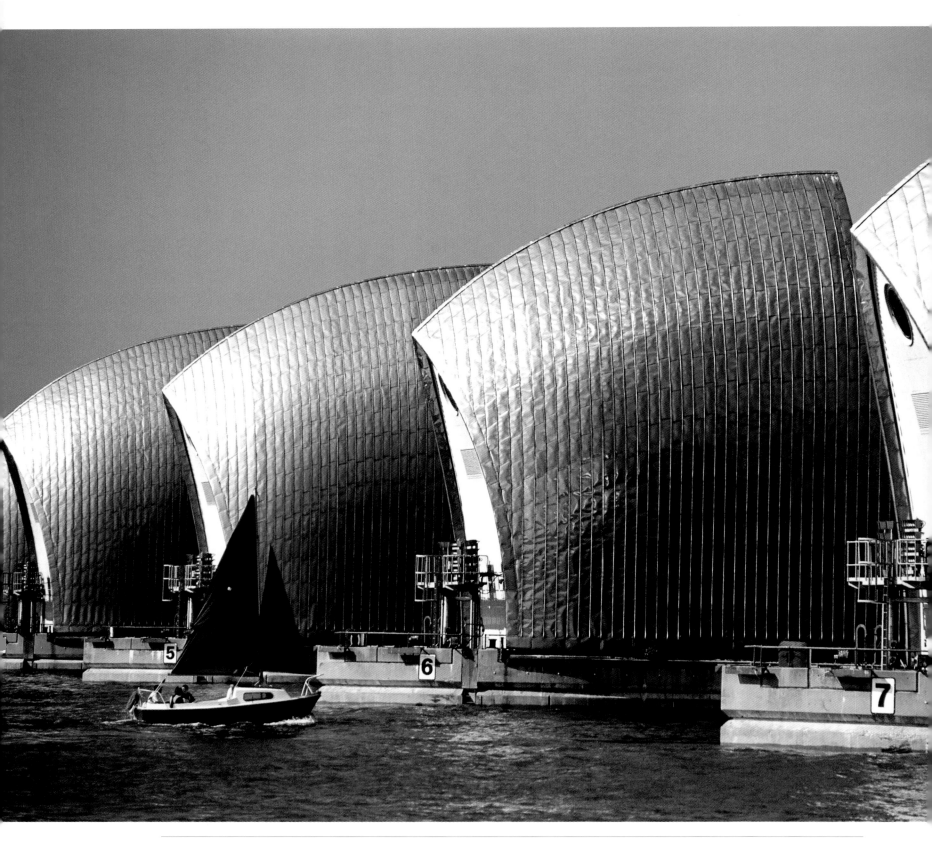

30-31 The Thames Barrier, at Woolwich Reach, was conceived to protect London from floods caused by unusually high tides. The construction extends for about 1640 ft (500 m) across the Thames.

31 top and center top Endless horizons characterize the Thames estuary, broad expanses where the river meets the freezing waters of the North Sea: a primeval landscape, a vast expanse of liquid that Joseph Conrad described as the beginning of a "water highroad that leads to the most remote confines of the Earth." The tide goes up the river as far as Teddington, about 18.5 miles (30 km) upstream from London.

31 center bottom Many historic edifices mark the urban landscape of the London suburb of Greenwich, which lies along the winding course of the Thames. The most interesting sights include the National Maritime Museum and the old astronomical observatory, where Edmund Halley studied the comet that was named after him.

31 bottom The Old Royal Naval College, considered one of the masterpieces of English Baroque architecture, overlooks the Thames River. Built in the late 17th century to a design by Christopher Wren, this building is now the home of Greenwich University and Trinity College of Music.

THE THAMES

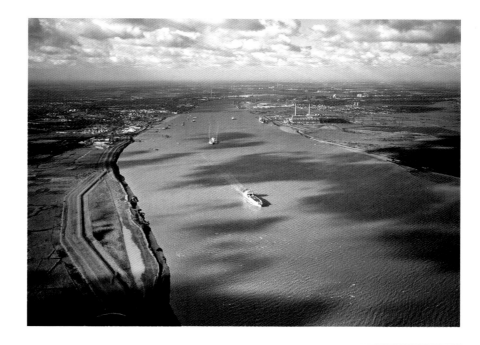

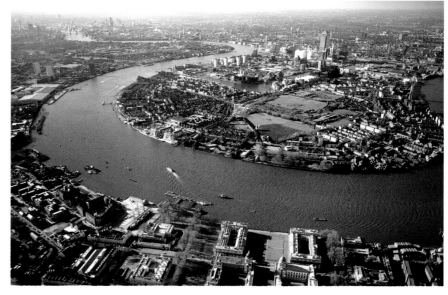

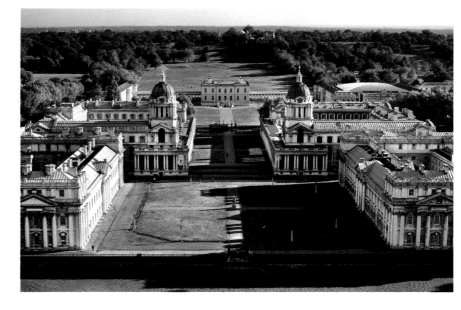

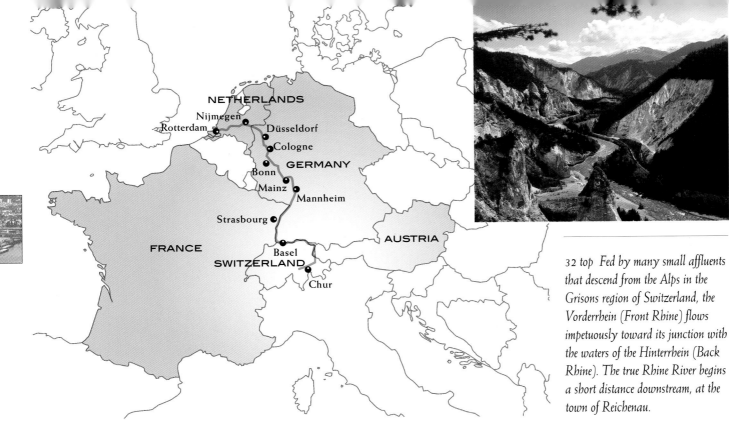

32 top Fed by many small affluents that descend from the Alps in the Grisons region of Switzerland, the Vorderrhein (Front Rhine) flows impetuously toward its junction with the waters of the Hinterrhein (Back Rhine). The true Rhine River begins a short distance downstream, at the town of Reichenau.

THE RHINE

THE ARTERY OF EUROPE

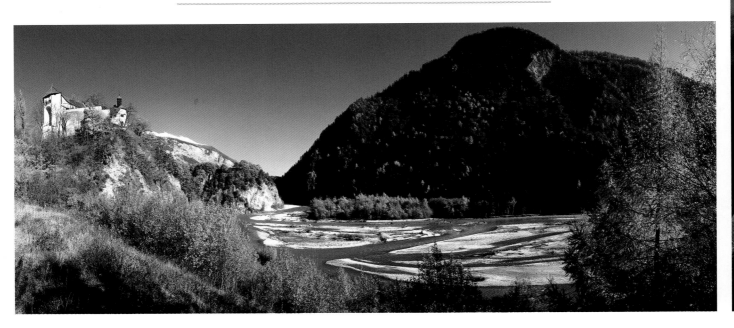

Every second, nine tons of goods pass through the docks of Rotterdam, at the mouth of the Rhine River, the largest port complex in the world: an amount three times that of Singapore and six times more than the cargo shipped through the docks of London. By itself, the dock used for mooring the new huge oil tankers, most of which come from the Persian Gulf, is as large as the entire port of Genoa. Besides petroleum, which is channeled directly to the refineries, the wharves of Rotterdam take in masses of wheat, produce, industrial products, metals, and building material. And above all, coal and iron ore, which are used to stoke the furnaces of the Ruhr region, the industrial heart of Germany. Rotterdam and all Holland owe their prosperity to the Rhine. Night and day, without a break, interminable rows of barges navigate down the river, which is the main artery of the European economy.

The Rhine is navigable as far as Basel, which amounts to 496 miles (800 km) into the interior, and a network of canals links it to all the other principal rivers in both Western and Eastern Europe. The Seine, Rhône, Elbe, Saône, and the Danube, and all their affluents, therefore become part of the immense continental waterway that begins at the Dutch ports – a waterway that connects Bucharest with Frankfurt, Marseille and Bordeaux with Amsterdam, and Berlin with Paris. Grafted onto this colossal network of river and canal communications is the host of roads and railways that cross the Rhine valley in all directions, following the ancient trade routes used to transport tin, copper and amber. The same routes were used in the following centuries by the Christian monks, who crossed over the Alps to preach among the pagan peoples of the North.

From prehistoric times to the modern age the river has been a powerful catalyst of culture and civilization that has assimilated and metabolized inspiration and contributions from different and seemingly irreconcilable worlds. The Rhine valley has witnessed the rise of famous cities and cathedrals, as well as revolutions in politics, law, art and religion. The life and works of Marx, Rembrandt, Beethoven, Gutenberg, Heine and Erasmus are closely connected to the cosmopolitan and vital

32 bottom At Rhazuns Castle in the Swiss Alps, the Back Rhine flows through an enchantingly beautiful landscape.
This part of the river begins its course in the glaciers of the Rheinwaldhorn, at an altitude of

about 9842 ft (3000 m), and then flows through a narrow gorge known as the Via Mala.

32-33 The snow-capped peaks of Piz Baduz, which rise 9842 ft (3000 m) meters above sea level,

are mirrored in the placid waters of Lake Tuma: the sources of the Front Rhine, the west branch of the Rhine proper, are in this lake situated in the St. Gotthard Pass area of the Swiss-Italian border.

Rhine region. But the Rhine has two faces, or better, two opposing vocations: it both unites and divides. Quite often in the course of history the river was a frontier, a boundary to be conquered or to defend at any price. The first fortifications along the Rhine valley were erected almost 2,000 years ago by Julius Caesar to protect the eastern borders of the Roman Empire. Alans, Vandals, Burgundians, Franks and Huns fought for dominion of the riverbanks, which witnessed the fall of the Roman Empire and the rise of the Carolingian dynasties.

The history of the Rhine is a succession of invasions and bloody wars. It was a passageway for the Norman marauders, a battlefield where the Papacy and emperors fought one another, an object of the expansionist aims of the French and Prussians, and the symbolic and strategic backbone of the burgeoning nationalism in Europe. In the first decades of the 20th century the Rhine was transformed into an iron and cement trench: from Basel to Karlsruhe the Maginot Line and the Siegfried Line, filled with machine-gun nests and protected by mine fields, faced one another ominously. In Germany the Ruhr

region, the hub of the powerful war machine, became a gigantic furnace in the service of Hitler. The grim roar of the trip-hammers at Essen, where the Krupp steel plants mass-produced cannons and tanks, heralded the most frightful war that ever struck Europe. And the Rhine was its tragic protagonist. Thousands of tons of bombs turned the prosperous cities of the Ruhr into heaps of burning ruins; the roads and railways were systematically destroyed and the river was the only means of communication between northern and southern Germany. Only in early March 1945, after long and bitter battles, did the Allies succeed in breaking through the front on the Rhine at Remagen, below Bonn. The capture of this last bastion opened the way to Berlin, and Hitler's suicide two months later marked the end of World War Two. Bonn became the new capital of Germany and the Rhine, no longer a bitterly disputed frontier, resumed its role as an international mediator.

Almost as if to underscore its ambiguous destiny, the river consists of two merging torrents, the Vorderrhein and Hinterrhein, that is, the Front Rhine and Back Rhine, both of

which rise in the Swiss Alps of the Grisons canton. The Back Rhine issues from the glaciers of the Adula massif, 7260 ft (2200 m) above sea level, and precipitates through a narrow gorge that the ancient Romans called the Via Mala. The second source comes from Lake Tuma, at the foot of the St. Gotthard Pass, and joins the Front Rhine near Reichenau, not far from the

660 ft to 1320 ft (200 m to 400 m) wide. A century of work was needed to adapt the river to the needs of humankind by shortening its course by about 62 miles (100 km). This does not mean that the Rhine has become innocuous. The major floods in 1993 and 1995, which overran vast regions of Germany and Holland, show how furious the harnessed river can become.

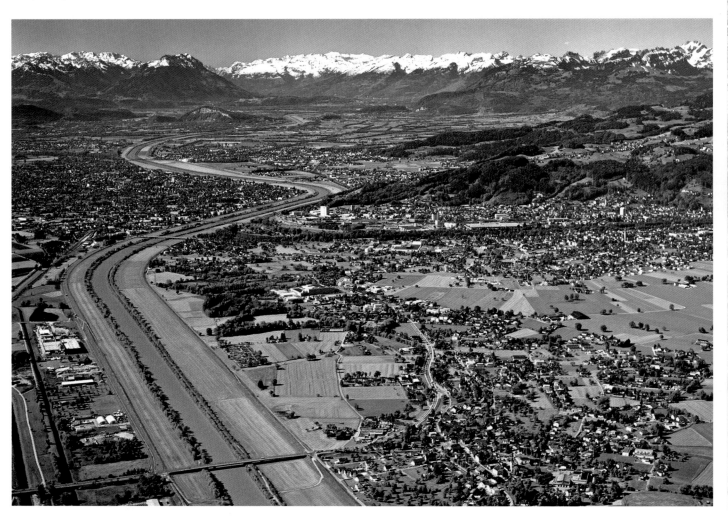

city of Chur. In the 43 miles (70 km) that separate it from Lake Constance, the Rhine has a gradient of about 4950 ft (1500 m); at the Austrian-Swiss border it is still an alpine river that flows rapidly among woods and green pastureland. Once out of Lake Constance it seems to calm down a bit and become a bit more 'mature,' as it were. But this is an illusion. A short distance farther on, at Schaffhausen, it becomes a bouncing youngster for the last time, rushing into a roaring falls amid whirls of foam and clouds of mist.

Now satisfied with having played this prank, it proceeds toward Basel, a large industrial center and Switzerland's only outlet to the sea. One of the leading figures of European humanism, Erasmus of Rotterdam, the author of *The Praise of Folly*, lived, worked and died here. At Basel the Rhine changes both direction and aspect: it turns sharply northward and becomes a huge navigable canal that flows in an artificial bed that is from

After Basel, the Rhine meanders through the large Rhine rift valley, which is embellished with the Black Forest and the low ridges of the Vosges Mts., crisscrossing the long stretch of the border between France and the German region of Baden. The rift valley, which resulted from the formation of the Alps 50 million years ago, accompanies the river for about 248 miles (400 km), up to the confluence with the Main. In its voyage through the plains of Alsace, the Rhine passes through Breisach, the ancient Roman city of Mons Brisiacus, and then arrives at Strasbourg, a major communications hub and flourishing commercial center. The spires of the Gothic Notre-Dame Cathedral dominate the profile of the Old Town, which has preserved its fascinating medieval atmosphere. Strasbourg, connected to the Marne, Rhône and Seine via a network of canals, is the home of the Central Rhine Commission, which establishes the rules of navigation along the river.

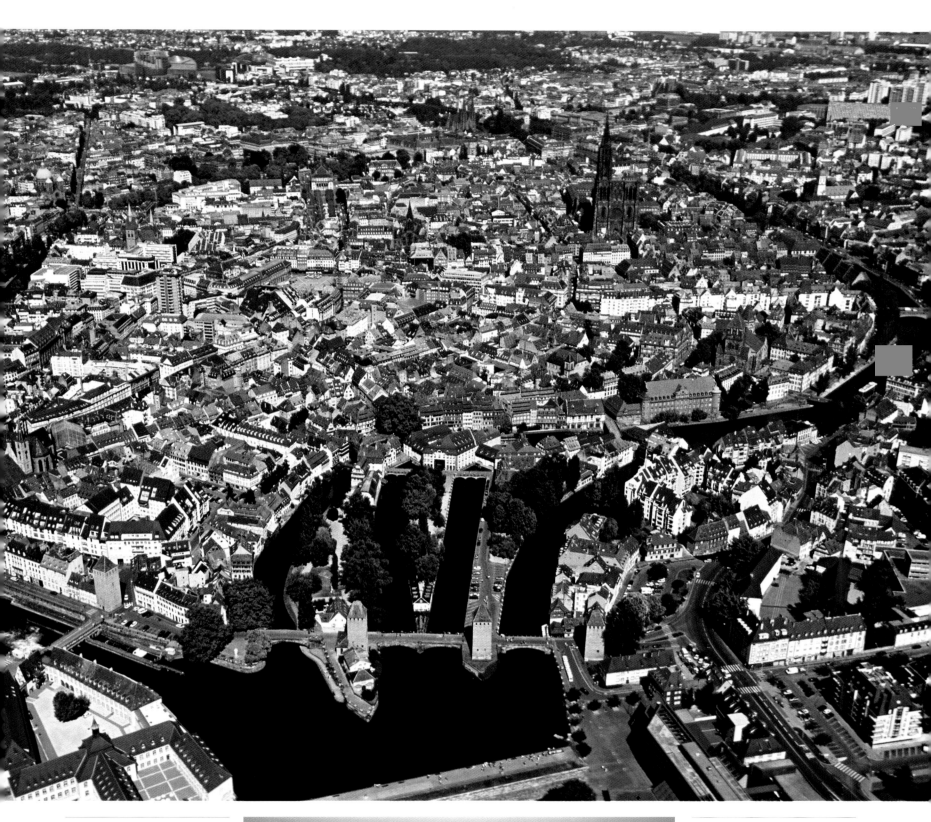

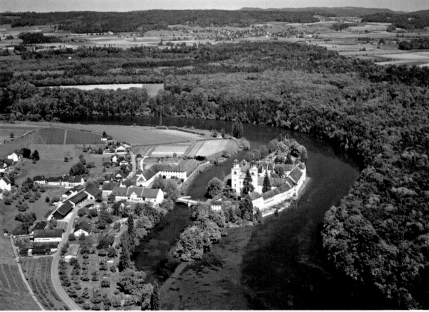

34 top Having passed through Lake Constance, which is a sort of regulatory basin, the Rhine flows toward the spectacular Schaffhausen Falls, near the Swiss-German frontier, where it plunges headlong for over 82 ft (25 m) amidst a blaze of mist and foam.

34 bottom Once past Chur, the Rhine enters a wide cultivated valley, becoming for a short stretch the border between Switzerland and Austria, and then gradually becomes less torrential as it flows toward Lake Constance.

34-35 The Rhine and a vast network of navigable canals are the basic factors in the commercial prosperity of Strasbourg, the capital of the French department of the Lower Rhine. The spires of Notre-Dame Cathedral dominate the historic center of the city.

35 bottom The village of Rheinau, situated in Switzerland near the border with Germany, lies along one of the large meanders formed by the Rhine downstream from the Schaffhausen Falls. On the island in the middle of the river is a Benedictine monastery.

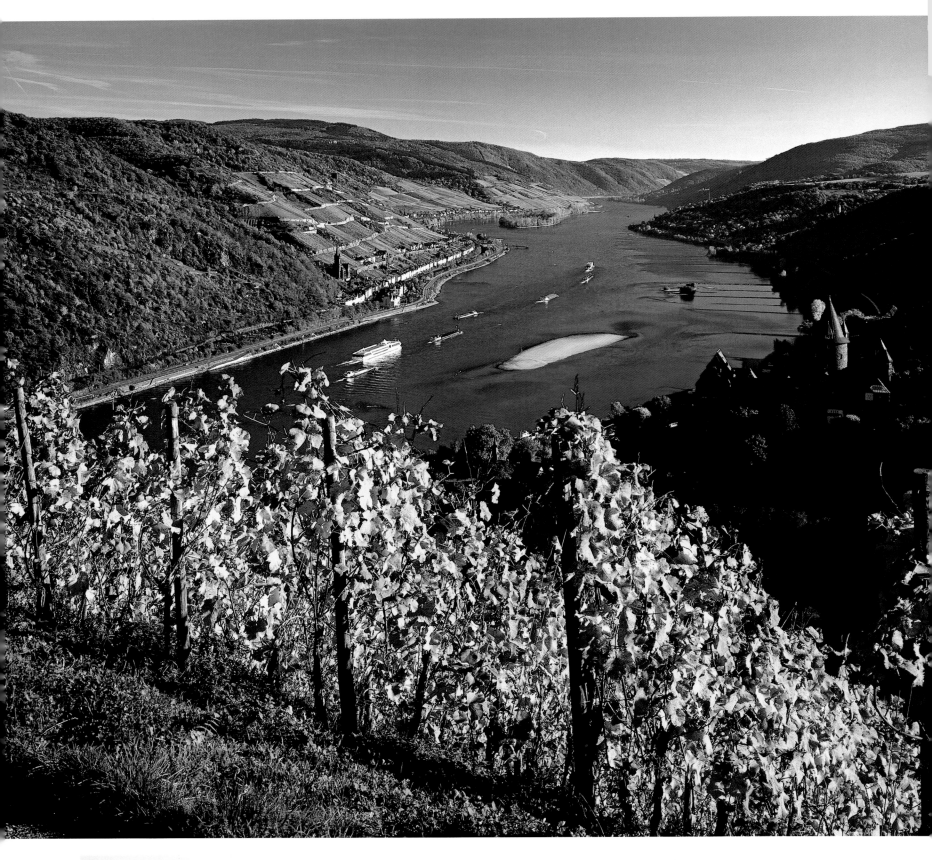

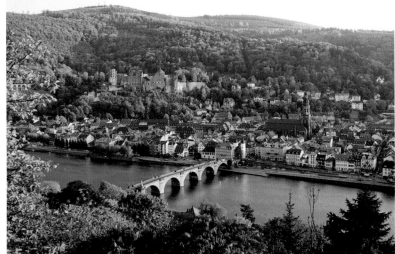

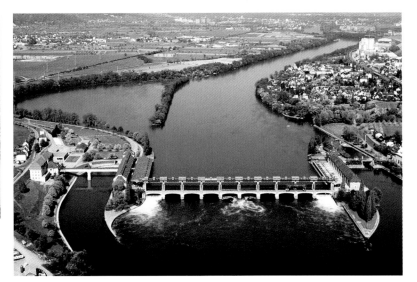

36-37 The steep valley formed by the Rhine when it crosses the massifs below Mainz is known in Germany as the legendary Heroes' Gorge, the landscape of which inspired Richard Wagner for some passages in his famous Ring cycle.

36 bottom left Situated on the Neckar River, a tributary of the Rhine, the city of Heidelberg is a major industrial and commercial center.

36 bottom right The sluices of a hydroelectric plant block the course of the Rhine at the Swiss city of Kaiseraugst, situated on the German border.

37 The castles and fortresses that rise up on the banks of the Rhine below Mainz, Germany, bear witness to the troubled medieval period in this region, when it was ruled by independent principalities.

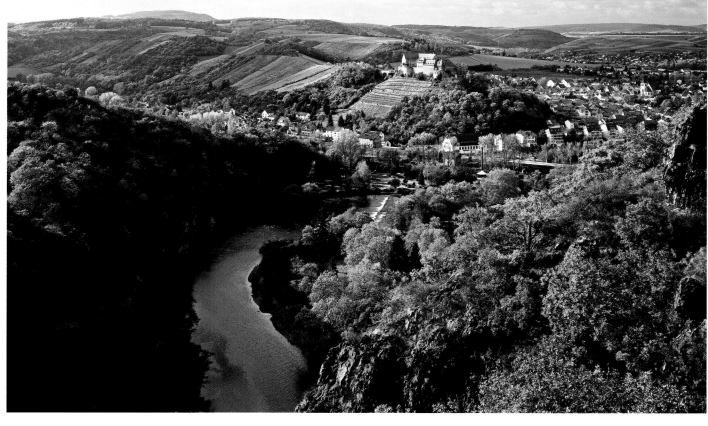

At Karlsruhe the river becomes German and will remain so up to the beginning of the delta. This is the glorious middle section of the Rhine, which flows past a series of famous cities and landmarks. There is turreted Speyer, the triumph of Romanesque architecture: the cathedral, one of the largest Romanesque cathedrals in Europe, houses the tombs of five emperors. This town is followed by Heidelberg, on the Neckar River, with its famous university. Then there is Worms, where in the bitterly cold March of 1521, during the Diet of Worms attended by the princes of Germany, Emperor Charles V tried to persuade Luther to recant his religious ideas. Generated by the reaction against the corruption of the clergy and sale of indulgences, the Reformation shattered the religious unity of Europe forever; Luther's theses spread rapidly along the Rhine, from Holland to Switzerland, splitting the continent into two diametrically opposed camps.

At Mainz the Rhine receives the Main River, which by means of a major canal laid out in 1922 links it to the Danube. Its discharge is now considerable and constant all year long, thanks to a perfect combination of factors: during the summer the river takes in the water from the thawed Alpine snow, while the Neckar, Main, Moselle, Saar and other affluents of the middle section of the Rhine provide it with a copious supply of water during the winter, when the Atlantic rains are more abundant. The fame of Mainz is connected to Johann Gutenberg, the inventor of printing with movable type, made of metal and all of the same height. The first printed book in history, the so-called Gutenberg Bible or 42-line Bible, printed in two columns in red and black, was published in 1452 by the Gutenberg print shop. In the years following, German printers spread the new art throughout Europe, triggering one of the greatest cultural revolutions in the history of mankind.

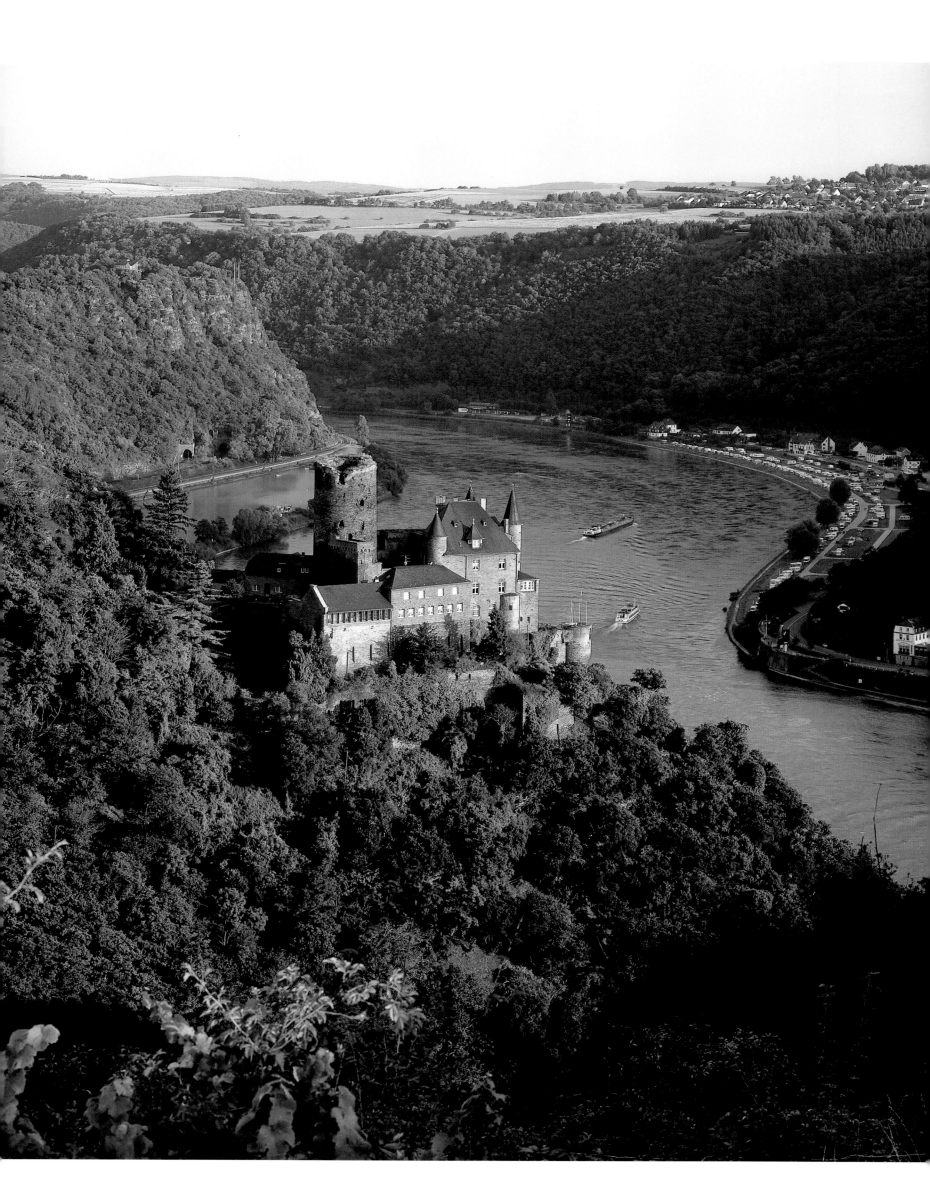

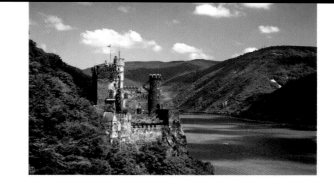

THE RHINE

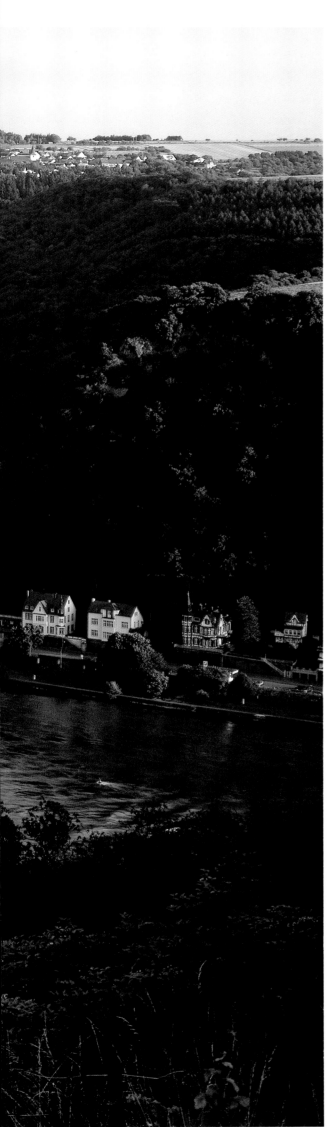

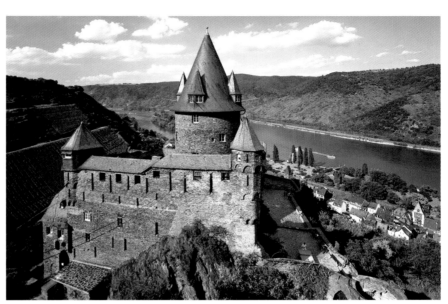

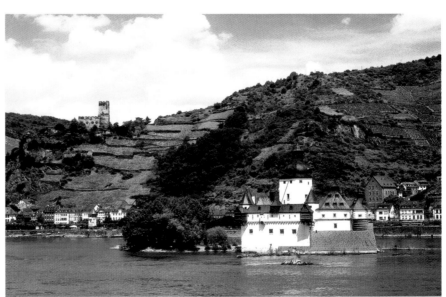

38-39 The Burg Katz, or Cat's Castle, dominates the Rhine between Bingen and Koblenz, in Germany. Built in the 14th century, destroyed by the French in 1806 and then rebuilt, the fortress is now a popular tourist attraction.

39 top The Rheinstein castle, which was rebuilt in the 19th century, rises up over the hills that surround the so-called Heroes' Gorge of the Rhine, the valley that cuts through the Taunus mountains for 18 miles (30 km).

39 center The castle of Stahleck, situated upstream from Koblenz, exudes a romantic atmosphere. Many of the Rhine castles have been converted into hotels, restaurants and museums.

39 bottom Pfalzgrafenstein, the fortress of Pfalz with a curious pentagonal shape, is one of the most fascinating edifices in the so-called Heroes' Gorge. Its position on an islet right in the middle of the Rhine made it easy for the local lord to exact tolls on those who used the river at this point.

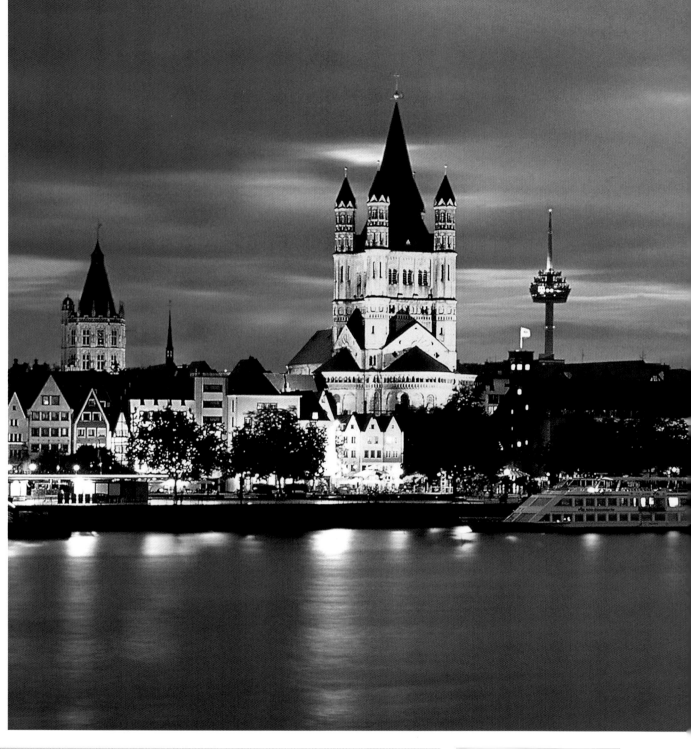

40-41 St. Peter's Cathedral is mirrored in the placid waters of the Rhine at Cologne, a lively river port and one of the most distinguished cities in western Germany. It took more than six centuries to build this colossal edifice, which was finally finished in 1880.

40 bottom Strategically situated at the junction of the Rhine and Moselle rivers, Koblenz is a leading industrial and commercial city. It was founded by the ancient Romans in 9 BC as a defensive outpost against the Germanic tribes but became prestigious and important only in the following centuries.

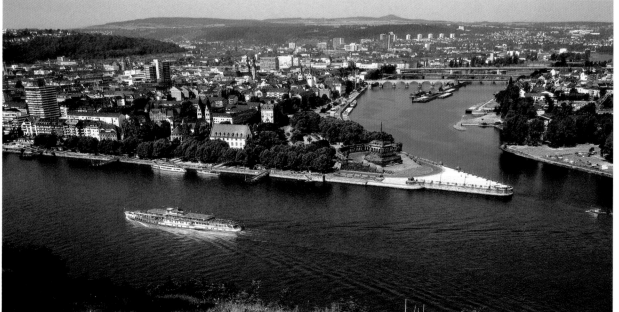

41 Mainz, the capital of the Rhine Palatinate, owes its prosperity to its enviable geographic position. Situated at the junction of the Rhine and Main rivers, Mainz is known for its prestigious cultural institutes and above all for the Printing Museum, dedicated to the work of Johann Gutenberg.

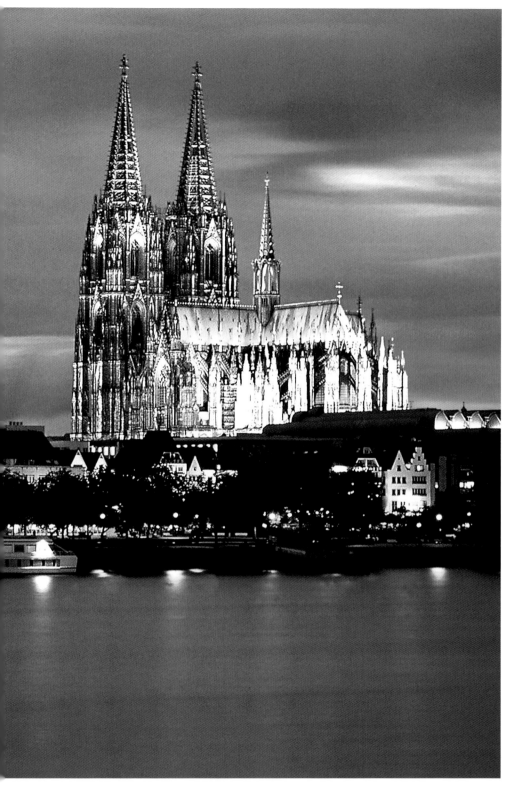

THE RHINE

History and legend interweave in the 34 miles (55 km) of the Heroes' Gorge, which is dotted with castles with evocative names: Burg Katz, Burg Maus, Rheinfels, Sterrenberg, Mauseturm, Drachenfels, and the disturbing polygonal fortress of Pfalz built on a islet in the middle of the Rhine. Lastly, there is Koblenz, at the confluence of the Moselle, the land of excellent wines thanks to the mild climate in this stretch of the valley, a sun-kissed area protected from the north winds by the surrounding mountains. Passing through a hilly region, the river reaches Bonn, the birthplace of Beethoven, and then Cologne. St. Peter's Cathedral, begun in 1248 and completed only in 1880, was miraculously spared by the Second World War bombardments, which razed one-third of the city to the ground.

From Cologne to the Dutch-German border the Rhine flows past a series of large cities and industrial centers. Leverkusen, Düsseldorf, Duisburg, Essen and Dortmund are really a single metropolis, one of the largest urban agglomerates

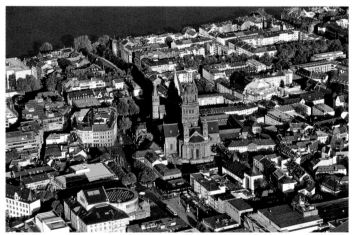

Once past Mainz, the Rhine faces the barrier of the Taunus range and the Rhenish Slate Mountains: at Binger Loch, instead of going around the obstacle, the river heads right for it, cutting its way through cliffs and slopes covered with woods and vineyards. This is the so-called Heroes' Gorge, the legendary land of the Nibelungen and of Siegfried, dragons and treasures that have been lost in depths of the river forever: the mythical hoard of gold of the Rhine, which inspired the first opera of Richard Wagner's Ring cycle, *Das Rheingold*. The Romantic movement, in search of a soul and a mythical identity, repopulated the gorges of the Rhine with supernatural beings who lived in the water and rocks: Lorelei, the siren who lures men to perdition and death, appears in poetry only in the early 19th century. Perhaps it was the echo that resounds on the rock faces of Lorelei, overlooking the Rhine from a height of 430 ft (130 m), which inspired the poem by Heine about the fatal girl.

in the world. In this section the river traffic becomes more intense, as the Ruhr receives raw material and gives back finished products at a frenetic pace. For decades, an unbelievable amount of pollutant material was dumped into the Rhine, changing the river into a boundless open-air sewer. Fortunately, in the last twenty years things have changed. The international Central Rhine Commission, founded in 1950 to protect the river, has enjoyed its first decisive success: after half a century of justified absence, the salmon have begun to reappear in the river together with other species that had not lived in the Rhine for many years.

After leaving the Ruhr region, the Rhine moves toward Holland. At Arnheim it splits into two distributaries, the Lek and the Waal, the latter of which receives the waters of the Maas. Silently, with aristocratic dignity, it then disappears in the vastness of the North Sea.

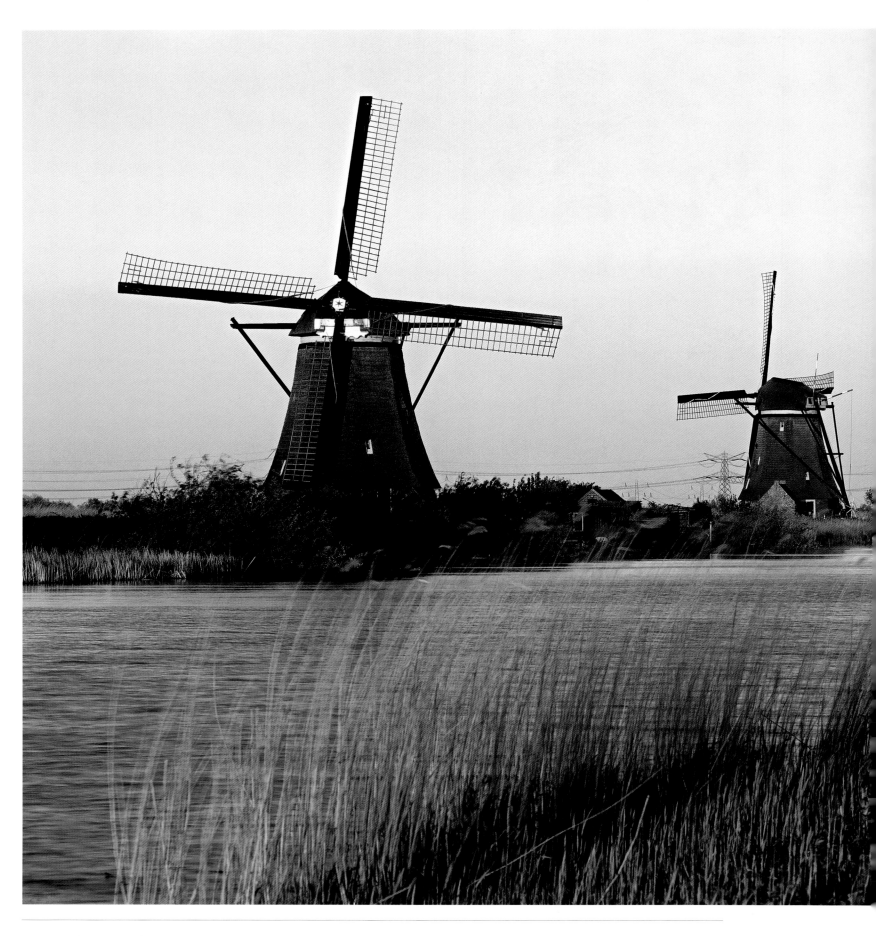

42-43 A characteristic feature of the landscape of Kinderdijk, near Rotterdam, are the rows of windmills. When it flows into the vast plains of the Netherlands the Rhine splits up into several branches and canals, taking in the waters of the Meuse River in a land that has been greatly modified by centuries of human labor.

43 top Futuristic architecture characterizes the modern city of Rotterdam, built in keeping with the most advanced town planning criteria. The city port, which extends around the mouth of the Rhine for dozens of miles, is now the largest in the world both in size and in the quantity of cargo handled.

43 center Delftshaven, the only remaining part of old Rotterdam, has become a true open-air museum surrounded by vast industrial zones. Standing out among the many historic buildings along the Voorhaven is the Oudekerk, the church frequented by the Pilgrims before they set off for the New World.

43 bottom Leiden, on the Old Rhine, has for centuries been the cultural and intellectual hub of the Netherlands. Its university, founded by William of Orange in 1575, is world-famous, as are the Lakenhal Museum and the National Ethnology Museum, which houses many rare and priceless archeological artifacts.

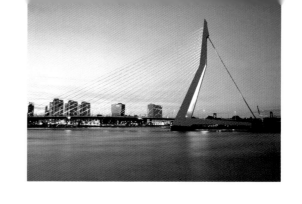

THE RHINE

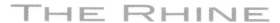

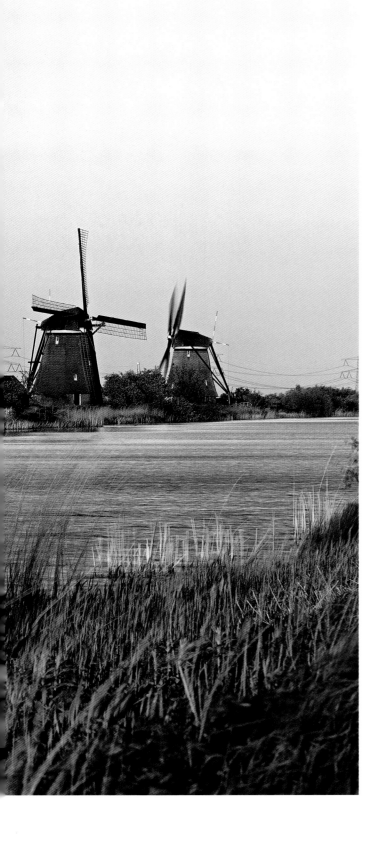

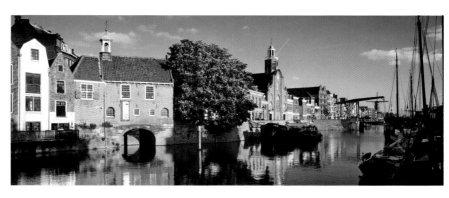

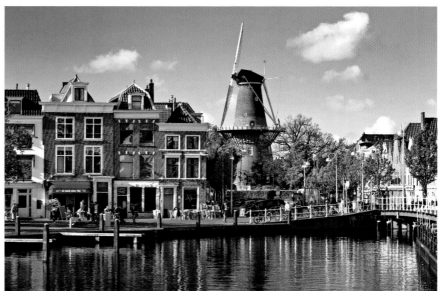

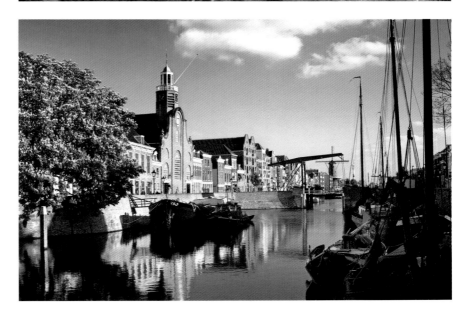

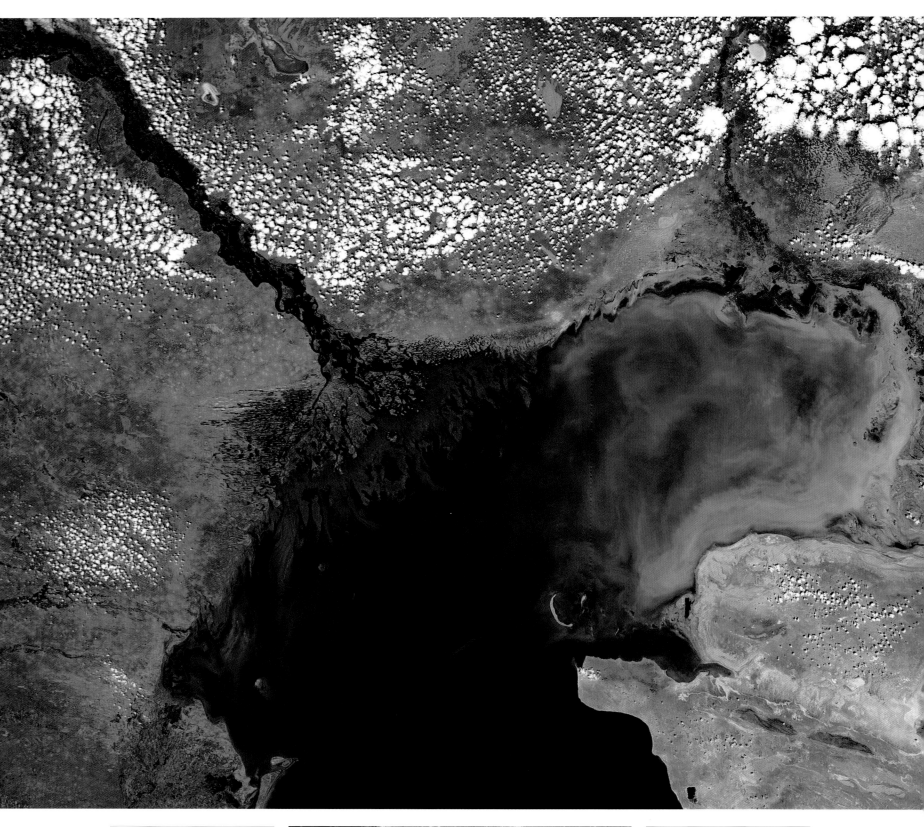

44-45 and 44 bottom These photographs clearly show the vastness of the delta of the Volga River, which, when it empties into the Caspian Sea, breaks up into a multitude of canals and radiates out over an area of 7725 sq. miles (20,000 sq. km). During the spring floods, which raise the level of the water from 6.5 to 16.5 ft (2 to 5 m), the apearance of the delta undergoes a drastic change, as can be seen in the photo at right: the sandy islands that formed after the recent lowering of the water level of the Caspian Sea, are submerged.

45 An aerial views of the entire course of the Volga River, from its source in the Valdaï hills to its mouth in the Caspian Sea. In this photograph one can easily spot the large reservoirs of Volgograd and Kuybyshev; in the lower left-hand part are Cimljansk Lake and the Don River.

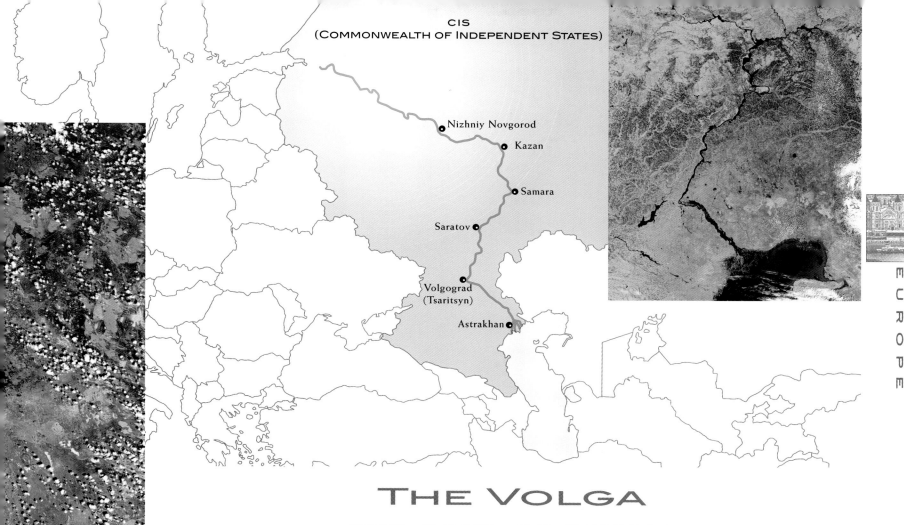

Nizhniy Novgorod

Kazan

Samara

Saratov

Volgograd
(Tsaritsyn)

Astrakhan

THE VOLGA
THE SOUL OF RUSSIA

This river rises in the Valdaï Hills, about 186 miles (300 km) as the crow flies from the Gulf of Finland. Enveloping Russia in a colossal embrace, the Volga crosses forests, steppes and deserts until it reaches the shores of the Caspian Sea. For the Russians it is the Mother Volga, the river around which the identity of the nation rose up and was consolidated. Only when Ivan the Terrible managed to wrest the Volga territory from the Tatar hordes by conquering the Mongol strongholds of Kazan and Astrakhan, was Russia truly a united nation. And the river, which is an ethnic and cultural boundary between Europe and Asia, was the base of the Cossack conquest of Siberia in the name of the czar. The banks of the middle and lower Volga were also the center of the peasant rebellions led by Stenka Razin in 1669-70 and by Pugachev in 1773-74. In the spring of 1918, Samara and Simbirsk, on the middle section of the river, witnessed the rise of the first pockets of resistance against Bolshevik power: revolutionaries and counter-revolutionaries waged a ruthless war to conquer the cities along the Volga. The bloody battles for control of Tsaritsyn underscored the skills and determination of one of the toughest and most callous Soviet leaders, in whose honor the city was later named: Stalingrad. And it was here that the Volga proved to be an insuperable barrier for Hitler's divisions. The defeat of the Germans marked a turning point in the Second World War and in the history of Europe.

The backbone of Russia, since the early Middle Ages the Volga has played the role of communications route between the northern and southern regions of the country. The river and its tributaries form a gigantic longitudinal axis that connects highly different regions, from the northern forests to the arid lands of the Caspian Sea. The climatic and environmental differences of these regions are reflected in their productive diversity, which from the outset has influenced the river traffic: petroleum and

industrial products have been added to merchandise such as lumber, wheat, wool and cotton. Thanks to the geological features of its basin, the Volga is navigable from its mouth almost to the headstreams. Despite this, its economic potential was greatly penalized by the fact the river issues into an inland sea that is isolated from the major modern trade routes.

The first attempts at linking the river with the Baltic Sea and St. Petersburg date from the time of the czars, but it was only in the 1930s that the Volga was drastically transformed. The new Soviet regime under Stalin launched a colossal project, the so-called Five Seas system, which was intended to connect the Volga, by means of a series of navigable canals, to the main rivers in Russian and then to the Baltic Sea, Black Sea, White Sea, Sea of Azov and Caspian Sea. At the same time, a chain of huge artificial basins would provide the Soviet Union with the hydroelectric power needed for its five-year plans of industrialization and would furnish enough water to irrigate vast stretches of unproductive land. After fifty years of continuous labor, the course of the Volga was completely changed. However, the hoped-for results did not materialize. The lakes created by the locks and dams in the uniform Samartian plain are rather shallow and too large; consequently, the power furnished by the dam turbines was much less than what had been foreseen and enormous areas of cultivable land were flooded. The level of the Caspian Sea, which is no longer constantly fed by the Volga River, has decreased by 82 ft (25 m). Furthermore, the dams blocked the migration of the sturgeon, which could not reach their reproduction habitats; their population was therefore drastically reduced, as was the production of the caviar made from the eggs of this fish.

The present-day Volga, controlled by numerous dams and at the service of the Russian nation, is no longer the wild river described by Chekhov and Gorki, both of whom traveled on its

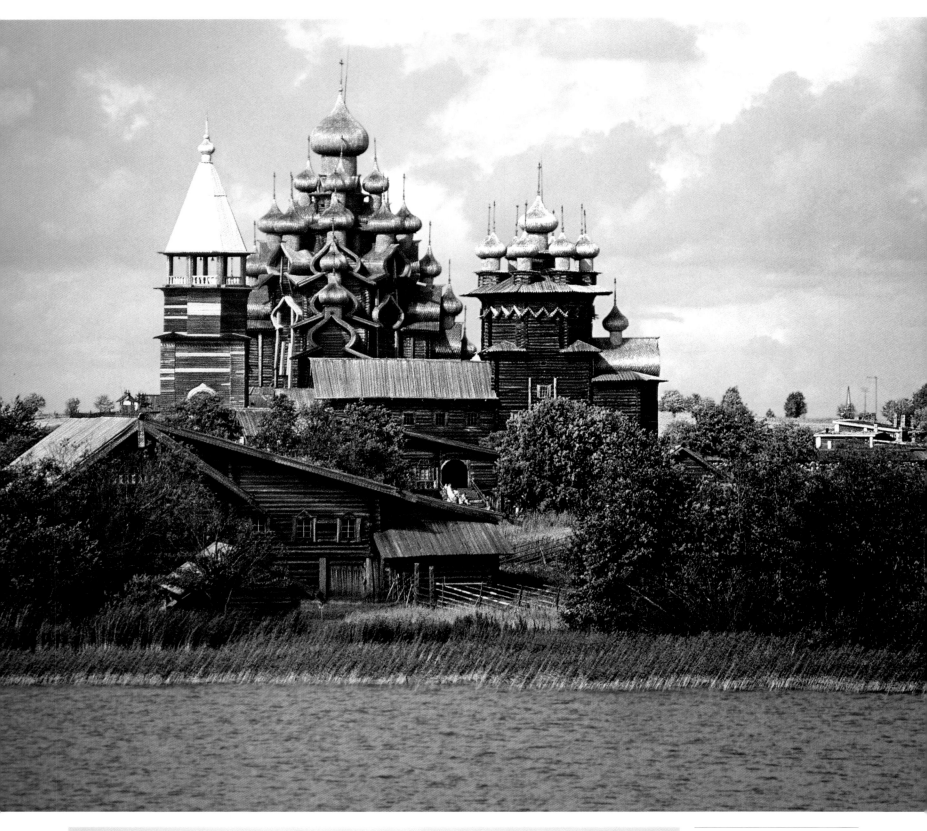

46-47 The island of Kizhi on Lake Onega has been converted into an open-air museum that offers an overall view of Russian history. A series of canals links the lake with the Volga and allows for river navigation toward the Baltic Sea and the White Sea.

46 bottom In this village in the
region northeast of Moscow, life
has retained its centuries-old
rhythm. Already at its source the
Volga is a full-fledged river that
makes its way into the immensity
of the Sarmatian plain.

47 The old wooden buildings,
windmills and scenes of everyday life
on the island of Kizhi, in Lake
Onega, inevitably lead one to think of
Russian rural life in the past. In
reality, for some time now the Lake
Onega region has been part of the

major commercial activities centered
around the Volga River. The gigantic
works carried out in the 1930s and in
the postwar period created a system of
navigable waterways that link the
Black Sea with the Baltic Sea and the
White Sea with the Caspian.

THE VOLGA

waters, the former during his honeymoon and the latter
working in the gallery of a boat in search of that humble,
desperate and destitute Russia so vividly portrayed in his novels.
A friend of Gorki in the adventurous years he spent at Kazan
was Feodor Chaliapin, who before becoming one of the world's
foremost operatic stars of all times, sang in church choirs. This
great bass spread the song of the Volga boatman throughout
the world; it was originally the song of the landless, poverty-
stricken peasants, the *burlaki*, who earned their living by pulling
the boats up the river with ropes. The painter Ilya Repin
immortalized their daily fatigue in his canvas *Volga Boatmen*:
behind the row of tattered, suffering men, the blue and gold
waters of the Volga seem to melt into the sky.

Art, history, politics and all the misery and dreams of Russia
are an integral part of the Volga. As if it were conscious of such
an oppressive destiny, the river is already in an adult stage when
it rises at an altitude of only 890 ft (270 m) above sea level. A
short distance after its sources it has all the earmarks of a full-
fledged plains river, wide and deep enough to allow small boats
to navigate in it. At Tver (Kalinin), before winding into the
Ivankovo reservoir, it is 660 ft (200 m) wide. An 80-mile (128-
km) canal built in 1937 links it to Moscow. A short distance
farther on the river flows into the lake at Rybinsk; other canals
radiate toward the Northern Dvina and the Onega and Ladoga
lakes, which in turn communicate with the White Sea and the
Gulf of Finland. From the confluence with the Oka River, near
Nizhny Novgorod, up to Volgograd the course of the Volga is
interrupted by a series of dams: the Kama River, arriving from
the Ural Mts., flows into the Volga in the immense Kuybyshev
Reservoir, which has a surface area of 2580 sq. miles (6450 sq,
km), that is, twelve times larger than Lake Constance. At Saratov
the last affluents abandon the Volga and tall trees give way to
the faceless expanse of the steppe. The connection with the
Don River, realized after World War Two, completes a navigable
system that is 9300 miles (15,000 km) long, running from one
end of Russia to the other and linking Archangel and the ports
of the Arctic Sea with Odessa, St. Petersburg and Astrakhan.

The first cities along the Volga rose up as trade centers that
benefited from both the inland and transverse traffic between
Asia and Europe. It was the merchants who built the numerous
churches at Yaroslavl with their characteristic onion domes. For
centuries Yaroslavl, Uglich and Kostroma, founded at the

beginning of the 12th century, played a leading cultural and
economic role in the region between the upper section of the
Volga and the Oka River, the nucleus of old Grand Duchy of
Muscovy. Uglich was the base from which Ivan the Terrible
launched the series of attacks that finally eliminated the power
of the Golden Horde forever. In the Kremlin of Uglich, Boris
Godunov assassinated Ivan's young son in the 1590s, thus
initiating the dramatic power struggle that afflicted Russia up to
the ascent of the Romanov dynasty. And precisely at Kostroma,
Godunov's hometown, Michael Romanov was crowned in 1613.

Farther down the river, where the Oka flows into the Volga,
is Nizhny Novgorod, the birthplace of Maxim Gorki. However,
it was at Kazan that this author wrote *My Universities* before
attempting to commit suicide by shooting himself in the chest.

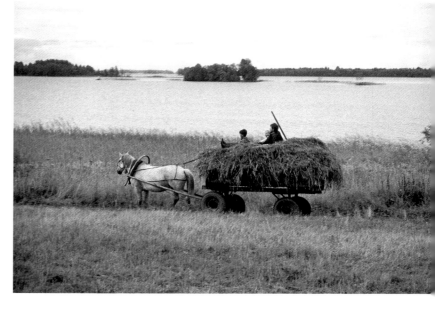

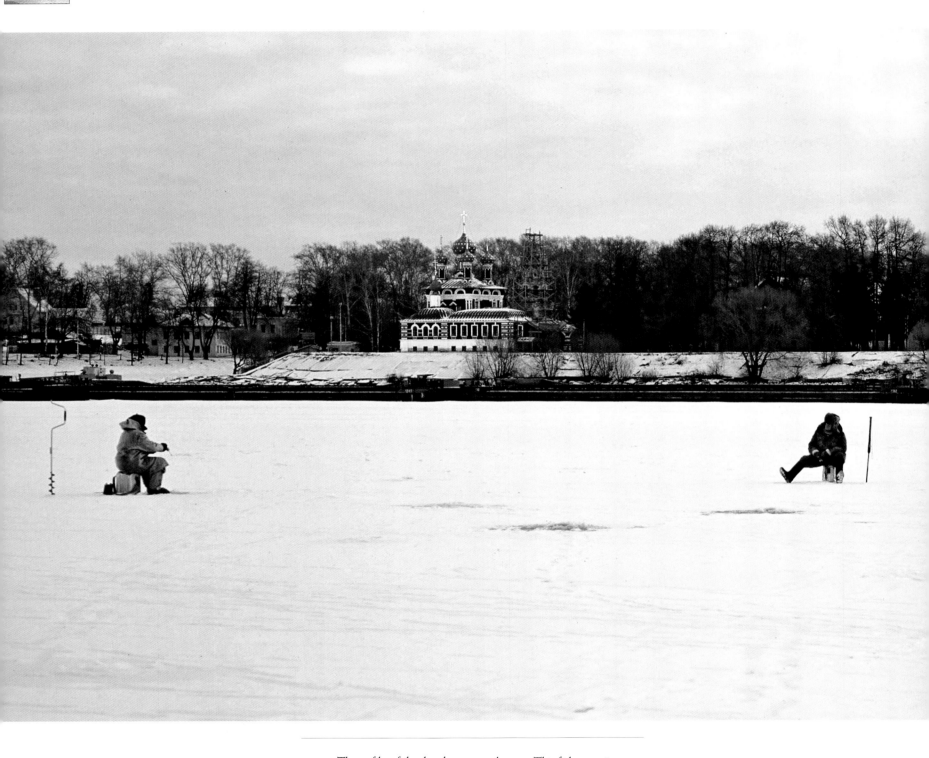

48-49 The profiles of the churches in Uglich stand out in the snow-clad terrain surrounding this city, which was founded along the Volga in 937. One of these churches is dedicated to the memory of Dimitri, the son of Ivan the Terrible and the victim of a dynastic power struggle that paved the way for Boris Godunov's ascension to the throne.

49 bottom This fisherman is armed with a large auger that he will use to bore a hole in the ice covering the Volga northwest of Moscow; he will then lower his fishing line into the freezing river. In the northern regions the river may freeze over for long periods, even as much as 200 days.

THE VOLGA

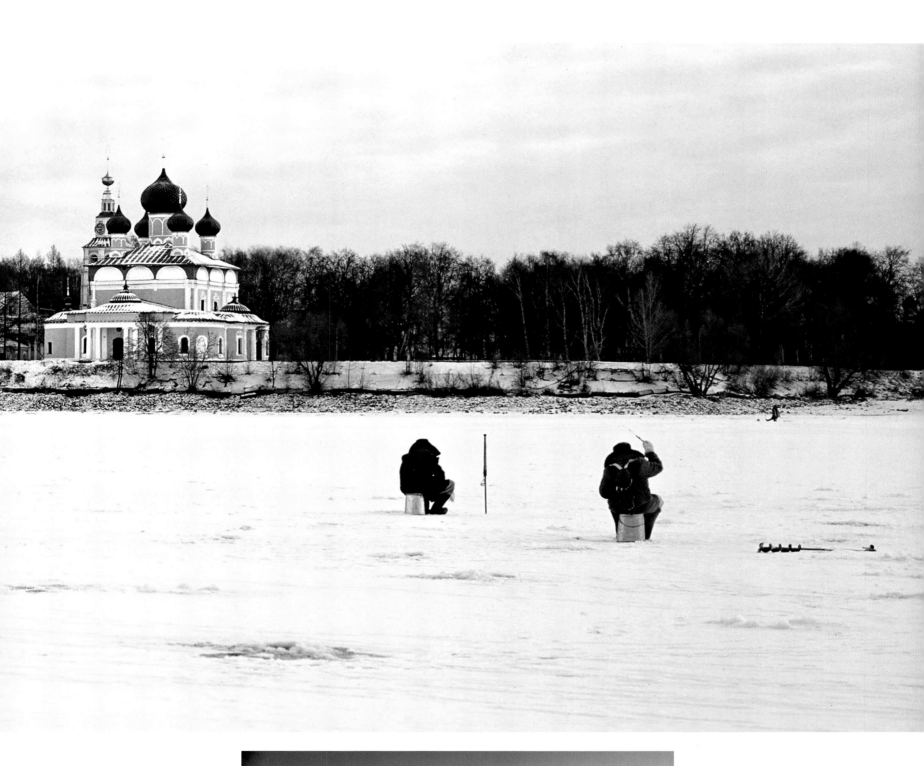

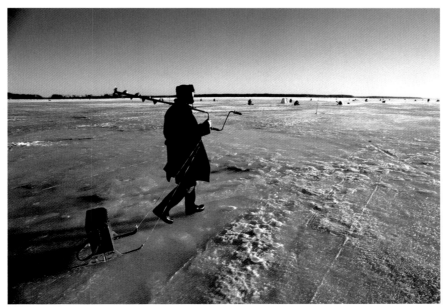

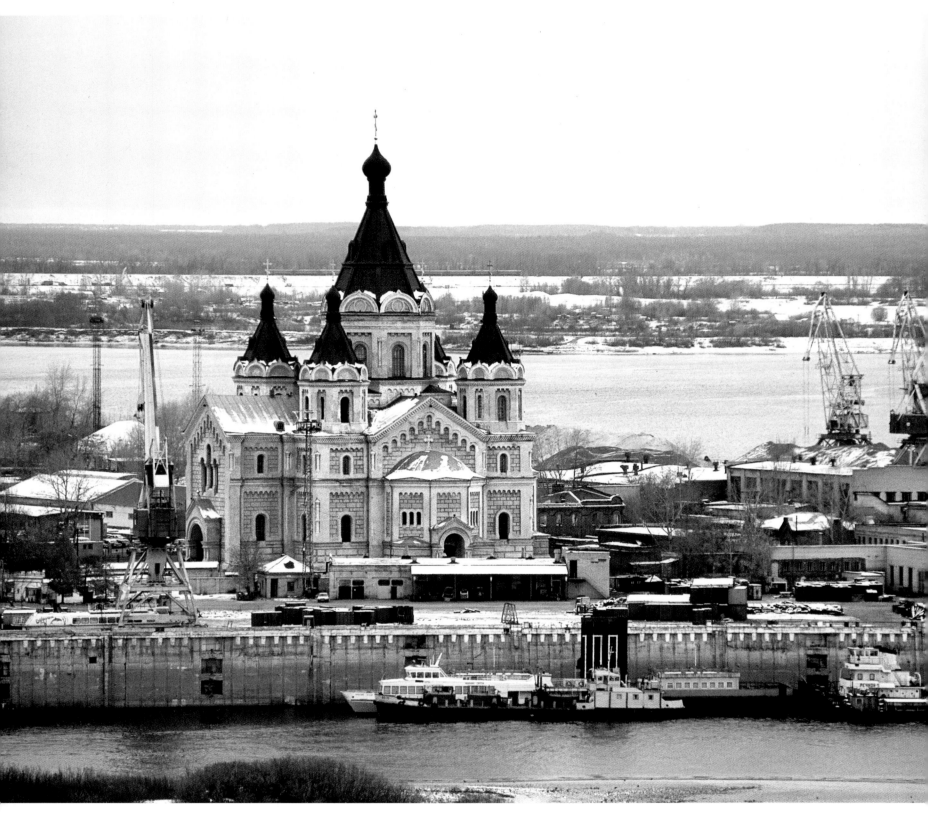

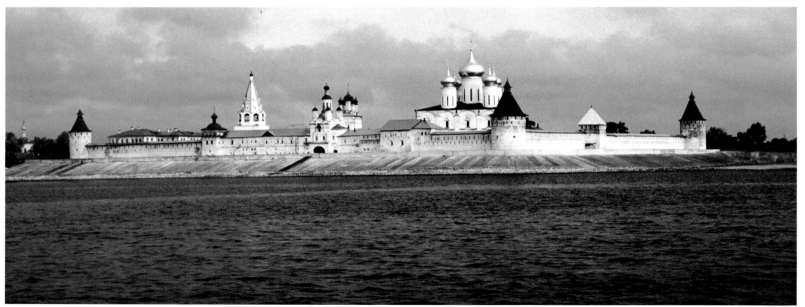

50-51 *A Russian Orthodox church towers over the office buildings and harbor facilities situated at the confluence of the Volga and Oka rivers, in the Gorki region. Industrial pollution is posing a serious threat to the very survival of the fish species that live in the Volga.*

50 bottom *The monastery of Makarev emerges like an apparition from the waters of the Volga, downstream from the city of Gorki. The sincere faith of the Russian people is attested by the profusion of religious buildings and icons, the sacred images that were worshipped by families in their homes.*

51 *Kazan, the ancient capital of the Golden Horde, still has traces of its past. In this photograph we can see the walls of the Kremlin ('fortress' in Russian) and the new mosque, which was built thanks to the contribution of Saudi Arabia to replace the one destroyed by Ivan the Terrible in 1552.*

THE VOLGA

Kazan, the capital of the Tatar Republic, marks the northern border of former Islamic dominion. Batu Khan, a descendant of Jenghiz Khan, turned this city into one of the nerve centers of the Mongol empire. The Tatars remained in Kazan even after the Russians conquered it and still make up the majority of the population. Tolstoy studied Philosophy and Oriental languages in this cosmopolitan atmosphere. Forty years later, at the same university, a certain Vadimir Ulyanov, better known as Lenin, was accused of subversive activity and expelled from the law school. Kazan, Kuybyshev (Samara), Saratov, Togliatti (Stavropol until 1964) and Ulyanovsk (formerly Simbirsk but renamed for Lenin as he was born there) are now important agricultural and industrial centers.

Peace and newfound liberty now reign along the Volga River. But a tragic, bloody trace of the past still remains at Volgograd: the grim ruins of a factory destroyed by bombardments and riddled by machine-gun bullets remind us that this city was once called Stalingrad. Hitler wanted to capture the city at all costs, and Stalin told his soldiers that they had to resist to the last man. For five months Stalingrad, which had become a heap of rubble, was the theater of bitter house-to-house fighting. The Germans surrendered in February 1943, and once again the Volga had saved Russia.

After Volgograd the river proceeds to the petroleum transportation port of Astrakhan and the Caspian basin, which lies 99 ft (30 m) below sea level. The Volga delta, a maze of waterways and canals that spread out for 124 miles (200 km), is an oasis throbbing with life. Beyond the shores of the river there is the desert. Much like a mirage, the horizon fades away toward the arid plains of Central Asia.

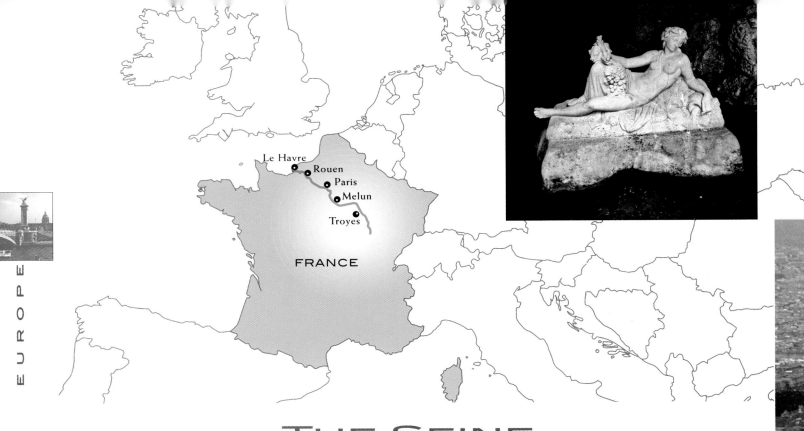

THE SEINE

THE CRADLE OF ART

his river rises in Paris. Not in the center of town and not even in the outskirts, but about 124 miles (200 km) as the crow flies from the boundaries of the French capital, in the Langres Plateau, among the soft hills of Burgundy.

The small wooded area that surrounds the source of the Seine was purchased in the 19th century by the municipality of Paris, and since that time it been under the city's

jurisdiction. This was a right and proper homage, because the prosperity and fortune of the French capital is mainly due to the river, and the Seine and Paris are inseparable.

Yet the Seine is certainly not the most important river in France, as both the Loire and Rhône are longer, nor does it occupy a central position that would make it the political and commercial hub of the country. Again, other cities such as Tours, Lyons and Orléans have surpassed Paris in wealth and prestige over the centuries. Although it has been relegated into obscurity several times, Paris has always managed to rise up again, becoming greater, more beautiful and more luminous each time. Paris is the very heart of France, the symbol of universality and excellence in art and culture, and

famous for the simple *joie de vivre* of its citizens. The great author Honoré de Balzac called it a "sublime vessel loaded with intelligence," a ship solidly anchored to the two banks of the river the passes through it.

The preeminence of Paris is due to its geographic position in the middle of the Seine basin. Like the bottom of a funnel, the city is the natural focal point of all the communication routes in the region. The Île-de-France plain, bounded by almost imperceptible hills, is in fact easily accessible from all corners of France. This central role was augmented by the system of canals that connect the Seine and the ports of the English Channel with the other French rivers and with the Rhine, the access to the important industrial areas of Belgium and Germany. And Paris itself rose up on the water: what the ancient Romans called the *oppidum Parisiorum*, the Celtic city of the Parisii, stood on the Île de la Cité, now occupied by the towering presence of Notre-Dame Cathedral. The river-based origin of the city is demonstrated by certain aspects of the town plan, which is laid out in some stretches along the old course of the river. The name of the Marais district is connected to the marshes that once covered the area, and Montmartre was one of the characteristic rises that bordered the Seine. The name of the Seine is also of Celtic origin, as it derives from the word *squan*, "sinuous" and "serpentine," which is a perfect description, since the river is 480 miles (775 km) long, but as the crow flies it is a little more than half that length from its sources to the sea. Its meandering course, especially in the Paris basin, is like a sinuous wave that repeats itself with perfection. The same word *squan* became Sequana, who was a goddess for the Gauls and whom the Romans assimilated in their mythology, even building a temple in her honor at the river source.

According to legend, the desperate tears the nymph Sequana shed while being chased by a lustful satyr were transformed into a river.

52 top Commissioned by
Napoleon III, the sculpure that
marks the source of the Seine
reminds one of the statue of the
Roman goddess Sequana.

52 bottom The square bell
towers of Notre-Dame
Cathedral rise up majestically
over Île de la Cité, the heart of
medieval Paris.

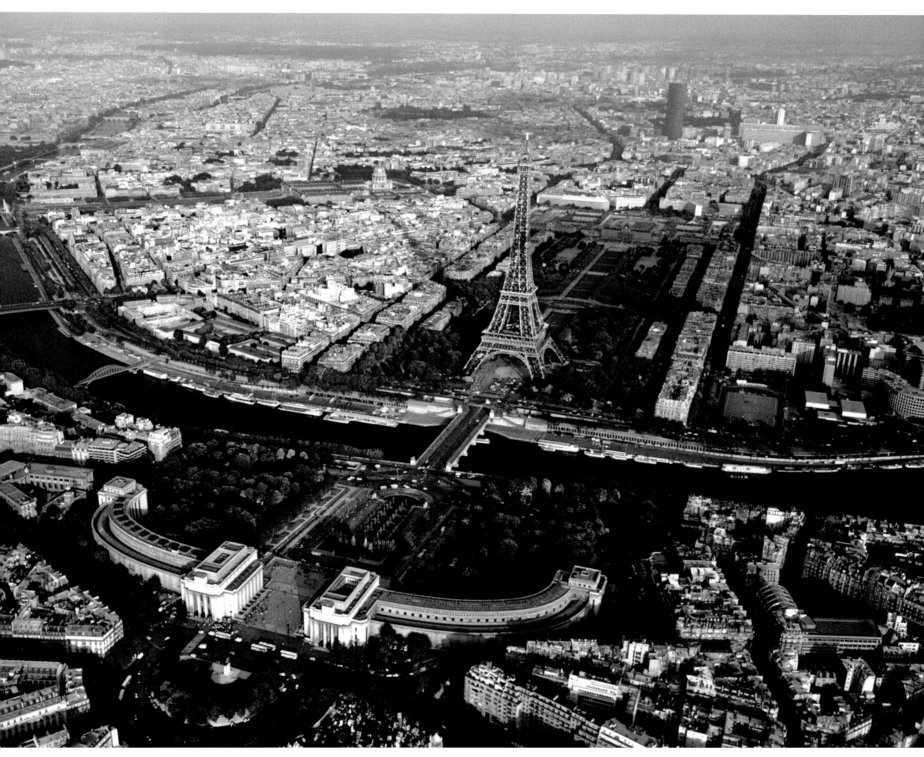

52-53 The Eiffel Tower,
considered one of the most
audacious achievements of 19th-
century engineering and the symbol
of Paris, was planned by adopting
the already tried and tested system
used for bridge piers. About 80,000
tons of iron were used in the
structure, which was finished on
31 March 1889.

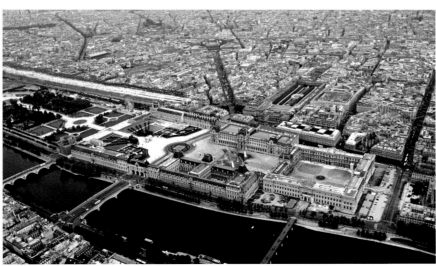

53 bottom The enormous Louvre
Museum complex on the right bank
of the Seine occupies a surface area
of about 50 acres (20 hectares)
and was initially used as the
residence of the kings of France.
Only in 1793, following a
deliberation of the Constituent
Assembly, was it converted into a
museum and opened to the public.
(The image captures the acrobatic
Patrouille de France flying over the
Louvre.)

From the interior of a rock-cut grotto, a statue of the divine girl watches over the transparent spring from which the Seine begins its run toward the valley at an altitude of only 1550 ft (470 m). About 9.5 miles (15 km) from here, on Mt. Auxois, Julius Caesar's legions defeated Vercingetorix in the Battle of Alesia in 52 BC, thus establishing a Roman hegemony over Gaul that lasted five centuries.

Although they were divided by tribal discord, the Celtic populations that lived in the Seine basin had a developed and

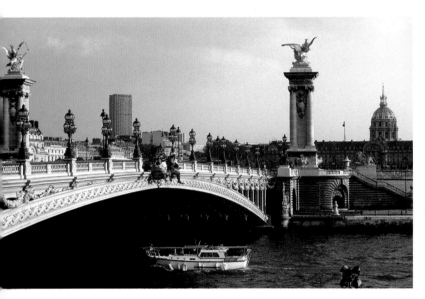

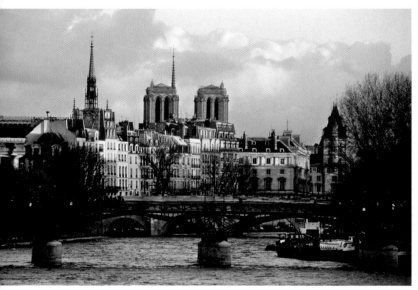

well-organized society. Trade with the Mediterranean countries flourished, as is demonstrated by archaeological finds. The so-called Vix Vase, found near Châtillon where the Seine receives the Douix and becomes wide enough to justify the erection of bridge, is almost certainly of Greek origin. This krater made of decorated bronze, over 5 ft (1.5 m) high and weighing 457 lbs (208 kg), is 2600 years old. How it ended up in the forests of northern France as part of the grave goods of a Gallic princess is still a mystery, one of the many the Seine jealously keeps.

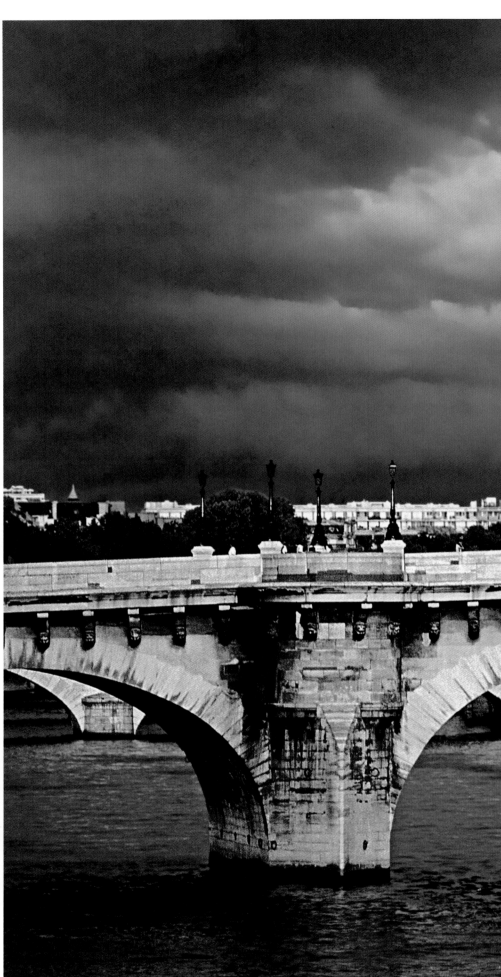

THE SEINE

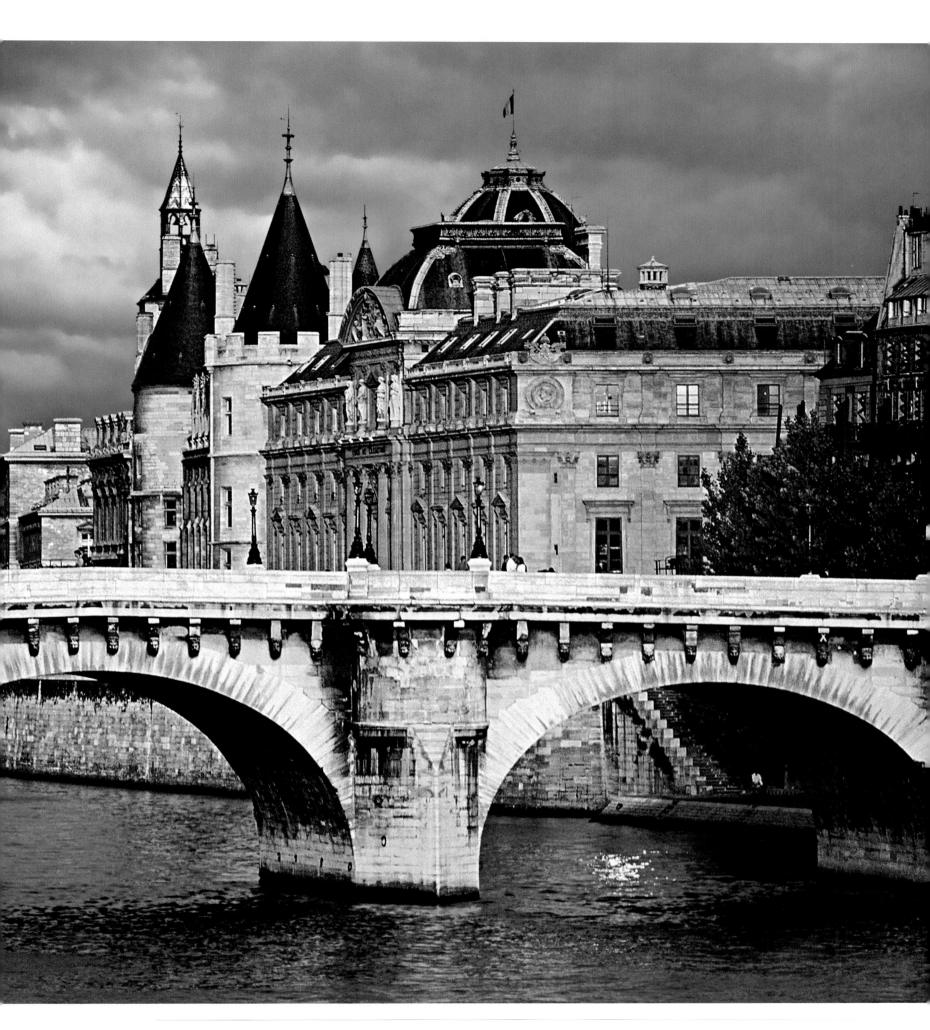

54 top The Alexander III bridge, erected in 1900 to celebrate the International Exposition and decorated with seventeen large piers surmounted by allegorical statues, represents the triumph of Belle Époque decorative art. In the background is the dome of the Hôtel des Invalides.

54 bottom The Seine and Notre-Dame Cathedral represent the quintessence of Paris. Pope Alexander III laid the first foundation stone of this gigantic edifice, which took 170 years to finish, with the contribution of thousands of artisans and workers. The basilica is 426.5 ft (130 m) long and 230 ft (70 m) high.

54-55 The Pont Neuf, one of the oldest bridges in Paris, was finished in 1604 during the reign of Henry IV. Consisting of two sections, it connects the banks of the Seine with the tip of Île de la Cité.

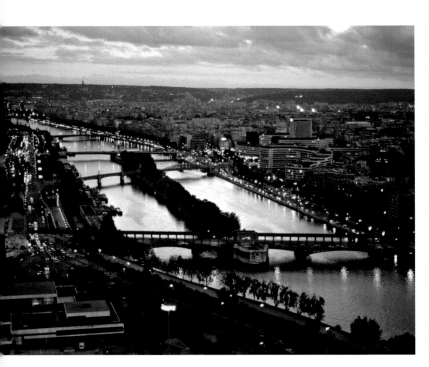

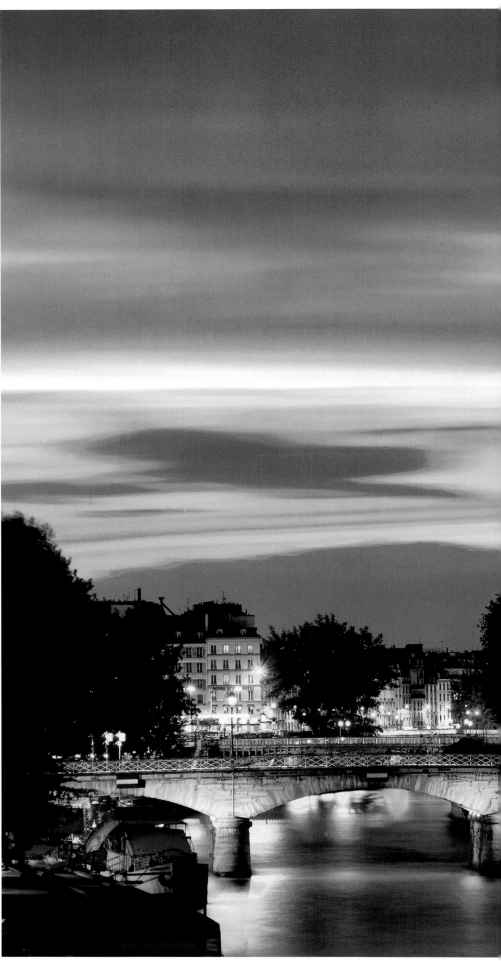

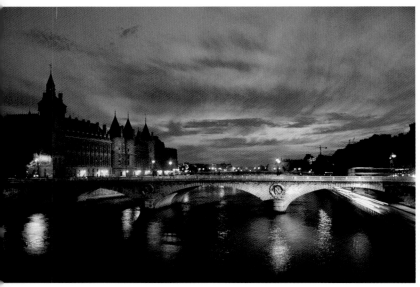

THE SEINE

56 top One of the typical bâteaux-mouches proceeds down the placid waters of the Seine toward the Pont Neuf, in the heart of Paris. Nowadays these boats are used only for water-borne tours of the city, but in the past they transported over 25 million people a year.

56 center Originally a camp for Celtic fishermen on the banks of the Île de la Cité, Paris is now one of the largest and most beautiful cities in the world. On the Île des Cygnes, seen in the middle of this photograph, is a replica of the Statue of Liberty.

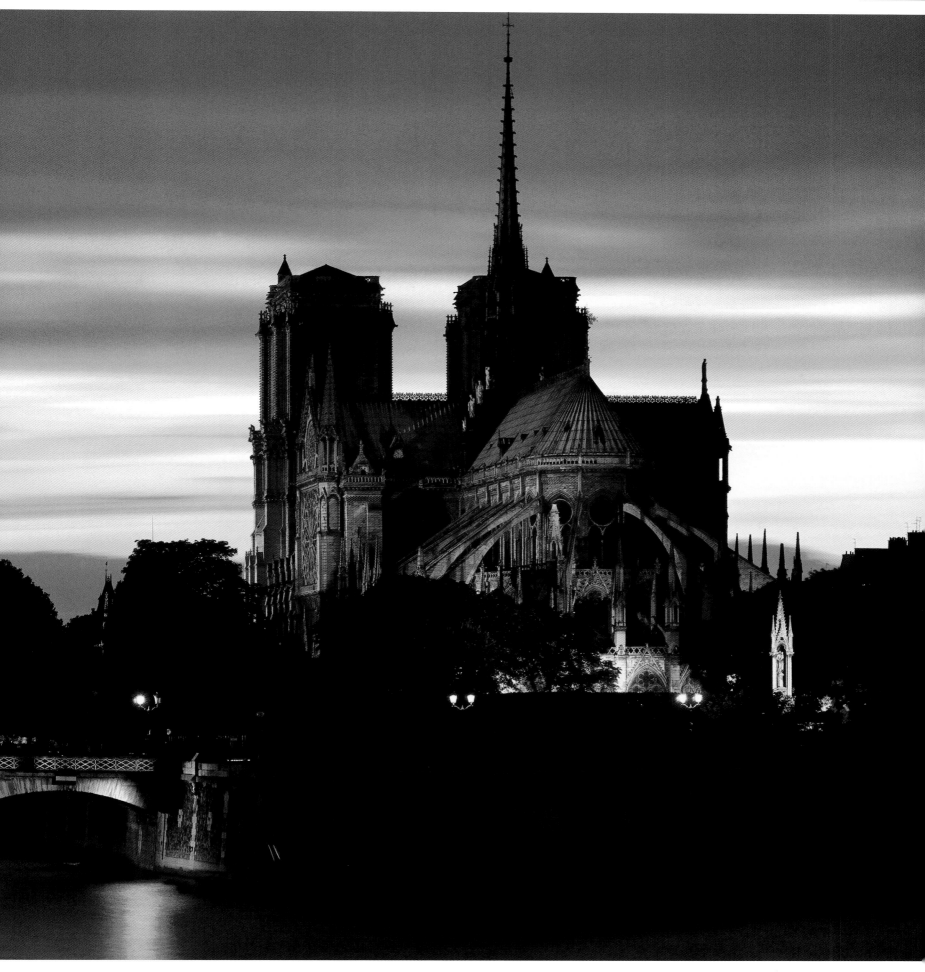

56 bottom Overlooking the Seine, the impressive Conciergerie dominates the western section of the Île de la Cité. An example of 14th-century French architecture, the Conciergerie became notorious as a prison during the French Revolution.

56-57 The spectacular profile of Notre-Dame stands out against the Parisian sky, illuminated by the sunset. In the interior of the basilica are important sacred relics, and also the mantle worn by Napoleon during his coronation.

58-59 Château Gaillard, at Les Andelys, overlooks the valley sculpted by the Seine among the rocky lowlands of Normandy.

58 bottom left and right The basin of the Seine, bounded by low hills and characterized by slight gradients, is all that remains of a sea gulf that in remote times extended as far as the outskirts of present-day Paris. In its lower stretch through the plains of Normandy, the river is broad and flows quietly, proceeding slowly toward its mouth in the North Sea. Gigantic meanders alternate with short straight stretches in open terrain that has been altered and shaped by centuries of labor on the part of Man.

59 Continuous barge traffic goes down the Seine from the estuary as far as Bar-sur-Seine, which is inland at a distance of 350 miles (560 km). Thanks to its slight gradient and regular water intake, the river is easy to navigate.

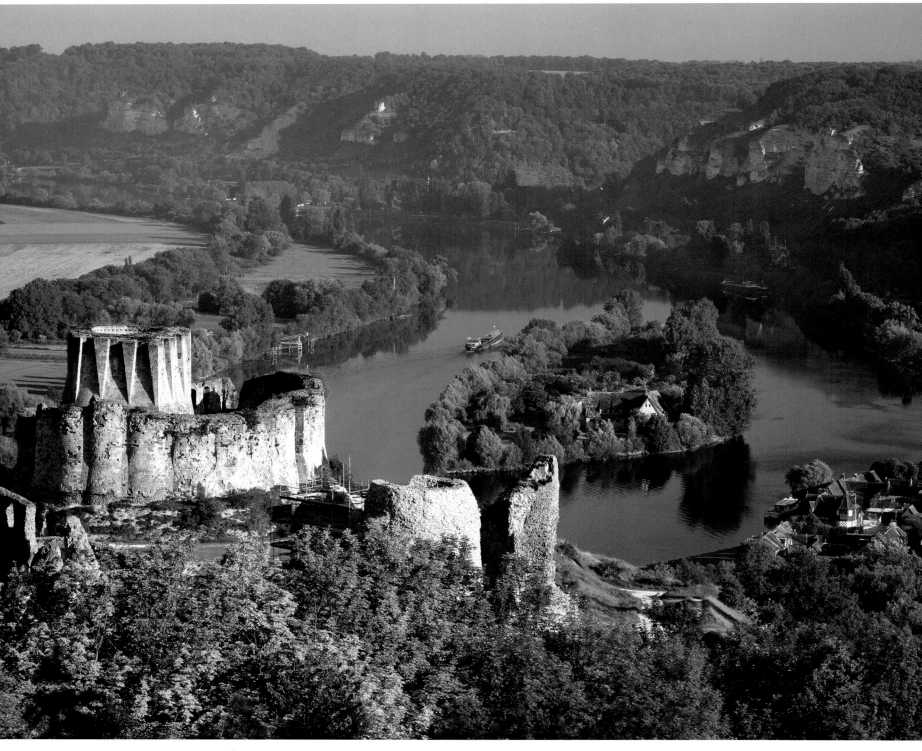

THE SEINE

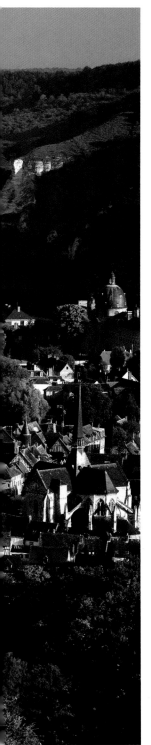

Having passed through Burgundy, the Seine moves toward the ancient city of Troyes, thus entering the Champagne region, home of the most famous wine in the world. It seems that the secret of champagne production, which is based on a particular method of natural fermentation and complex processing, was discovered in the 17th century by the monk Dom Pérignon. After Troyes, the Seine, now channeled and curbed by a series of locks, becomes navigable for commercial traffic. Flowing through open, undulating countryside, the river arrives at the confluence with the Yonne. At Fontainebleau the regular alternation of woods and farm fields gives way to much more aristocratic geometric patterns. Some of the leading European artists and architects of the time, from Benvenuto Cellini to Vignola and Rosso

Until then his ancestors had been content to go up the Seine every so often in their *drakar* craft to make violent raids on the coastal towns. Rollo, on the other hand, worked at consolidating his reign; he reclaimed long stretches of the lower course of the Seine, built embankments against flooding, and had the riverbed dredged to make it navigable as far as the port of Rouen.

The Seine has a regular water intake: rainfall is constant on the entire surface of the basin but is almost never excessive. In fact, high water levels are rather rare, at least compared to the average of the other European rivers, partly because of the slight gradient of the current. At Paris, 226 miles (365 km) from the English Channel, its course is only 82 ft (25 m) above sea level. From Saint-Germain-en-Laye to

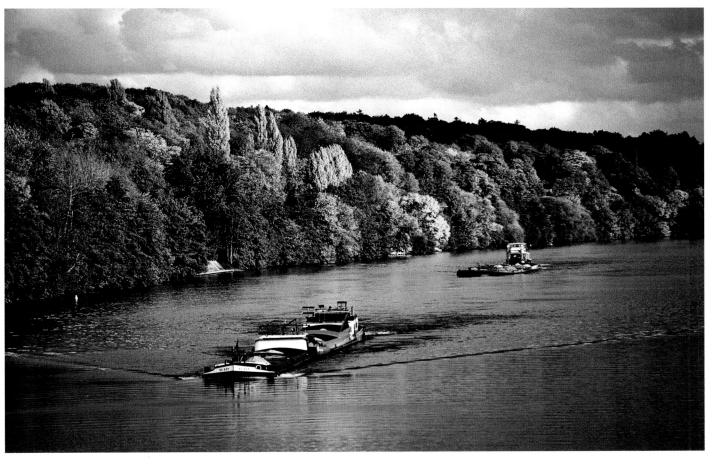

Fiorentino, took part in the construction of the majestic Fontainebleau palace, built in 1528 for King Francis I. The best experiences of the Italian and French Renaissance merged in the realization of the palace, which Vasari considered the glorious revival of a second Rome. In the following years the face of Paris changed and it became a true metropolis: the Louvre, Jardin de Plantes, Luxembourg Palace and many other monumental edifices date from that golden age in French history.

The banks of the Seine were also laid out anew and some of its affluents were made navigable. However, the first human changes on the river had been effected many centuries earlier. Already in the year 911 the Viking ruler Rollo grasped the importance of the river as a trade route to the interior.

the outskirts of Paris the Seine accentuates its winding flow, describing huge meanders in the vast plain that extends as far as the coast of the Channel. In this limestone lowland that was once covered with seawater, the erosive action of the river has cut a bed that is at times deep and embanked. In the areas where the riverbanks are steeper there are fortresses and castles, such as at Les Andelys, which is dominated by the ruins of Château Gaillard, built by Richard Lion-Heart to defend Rouen, the most anglophile French city. It was in fact at Rouen, before a court at the mercy of the English, that Joan of Arc was condemned to be burned at the stake, a form of torture used for witches and heretics. Her ashes were then cast into the Seine.

THE SEINE

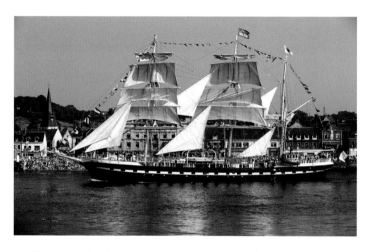

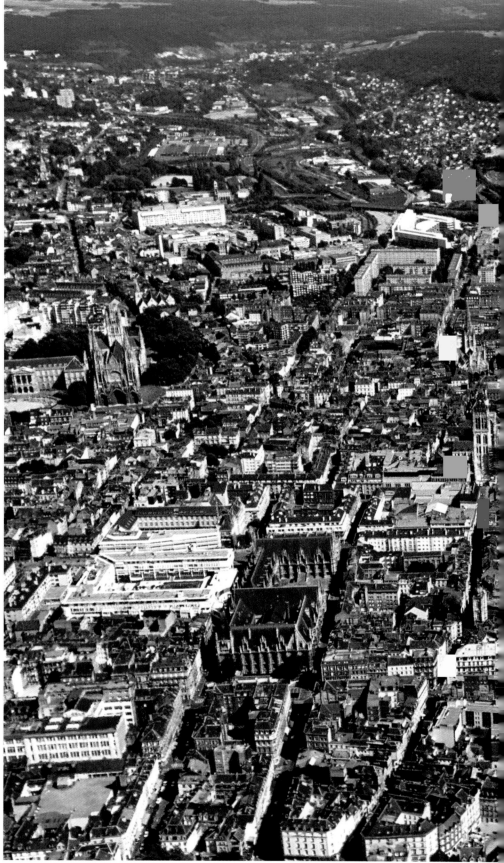

Rouen is the destination of ocean-going ships, at once a sea and river port: the tides, which occur four times a day, determine the traffic on the river. Thousands of barges move incessantly in the estuary and, by means of a system of inland waterways that are navigable for 5000 miles (8000 km), they distribute all kinds of goods to the farthest corners of France. The boatmen are bonded by a strong sense of solidarity. The barge is both a house and a work tool; all family life is lived on board, and often the work is handed down from father to son. Conflans-Sainte-Honorine, at the junction of the Seine and the Oise, is the capital of these river nomads. Besides workshops and ship repair yards, this locality has cafés, restaurants, markets, and even a floating church and hospital.

Under the high, pale sky of Normandy the Seine leaves behind the spires of the Rouen Cathedral, only to meet the Gothic style again at the splendid church of Notre-Dame in Caudebec-en-Caux. In 1858 at Honfleur, the old port that was abandoned in favor of the active Le Havre, the artists Boudin and Monet began to represent the effects of light in their oil paintings. Impressionism was thus born at the point where the Seine dies in the grey waters of the northern seas.

60 top Its depth of up to 33 ft (10 m) means that ocean-going ships can navigate down the Seine as far as the river port of Rouen, which lies about 75 miles (120 km) from the sea. Pilotage is obligatory for all vessels over 150 ft (45 m) long.

60 bottom Enthusiastic spectators greet the passage of this sailboat participating in a commemorative regatta on the Seine as it passes through Normandy. The first people to grasp the importance of the river as a means of penetrating the interior were the Vikings, who were here over ten centuries ago.

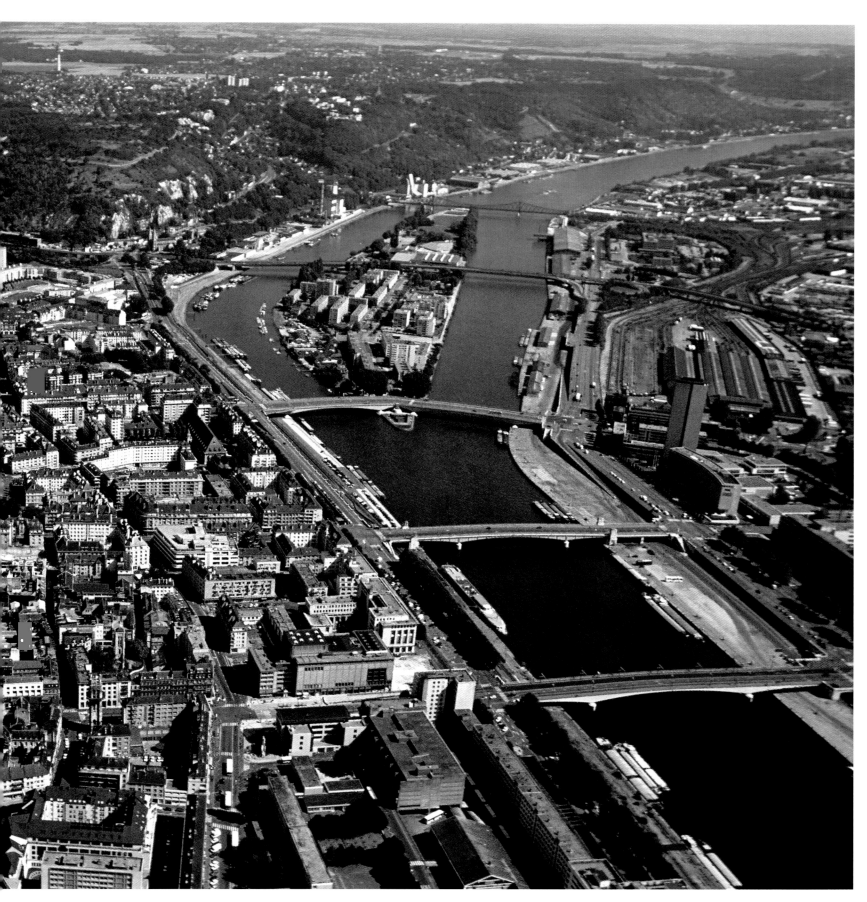

60-61 Rouen, the capital of the Seine-Maritime department and a busy river port on the estuary of the Seine, takes in from 3500 to 4000 cargo ships every year. The city, known as the site of Joan of Arc's martyrdom, boasts one of the most beautiful Gothic cathedrals in France.

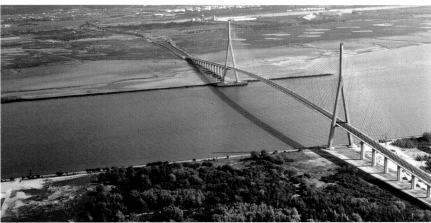

61 bottom The Normandy Bridge, which connects the two banks of the Seine near its mouth, is 1.3 miles (2.1 km) long and has a central span measuring over 2624 ft (800 m). Opened in 1995, it was built with state-of-the-art technology and is able to withstand winds of 185 mph (300 km).

THE LOIRE

ARISTOCRATIC BEAUTY

The wide arc described by the Loire River, from the Cévennes Mts. to the Atlantic coast, looks as if it had set out to divide France in two. In the Middle Ages, during the Hundred Years' War (1337-1453), the river was indeed an inland frontier: the English, allied with the Burgundians, dominated the north of France and the Seine delta, while to the south the French monarchy prepared to drive out the invaders and rebuild national unity. Since Paris was abandoned, the nerve center of the kingdom shifted to the shores of the Loire and remained there even after the English were defeated, up to the rise of the Bourbon dynasty. For this entire period the destiny of France was decided in the labyrinthine interiors of the Loire châteaux, which were transformed into luxurious residences and symbols of royal power. Many centuries later, during the time of the Franco-Prussian War, the river became the last defensive line against

the onslaught of Bismarck's troops. Then, at the beginning of the Second World War, the French Army tried to organize resistance to Nazi occupation by establishing a bridgehead along the fords of the Loire. In both cases these military actions failed. But General Patton, who was advancing toward the Rhine and the heart of Germany, used the swirling waters of the river to protect the southern flank of the Allied armies.

The great events of history that the Loire witnessed now seem remote to us, buried in the timeless tranquility of the French provinces. But the Loire has remained young and wild. In its 632-mile (1020-km) course it touches such important cities as Orléans, Angers, and Tours. Nantes, one of the most active port towns in France, lies on the river estuary, and canals link the Loire to the Seine, the Saône and the Rhône. And four nuclear power plants utilize its waters for cooling, which has alarmed environmentalists but is really nothing compared to the problems besetting the other great European rivers in this respect. There is no commercial traffic on the Loire and the large industrial areas are almost totally lacking there. It has very few dams and levees, and they are all located in the upper section of the river, checking its impetus.

The Loire River defies the norm: it is the only waterway in Western Europe that maintains its natural features from the source to the mouth. Up to the mid-20th century the seasonal farm workers had a stipulation in their contracts to the effect that they would not be obliged to eat salmon more than four times a week. Although they are not so abundant as they once were, the fish are still numerous and quite varied. Because of its beautiful natural scenery, art treasures and environmental qualities, in the year 2000 the Loire Valley was placed on the UNESCO World Heritage List.

The river rises at the foot of one of the volcanic peaks in the Ardèche department, which because of its typical conical

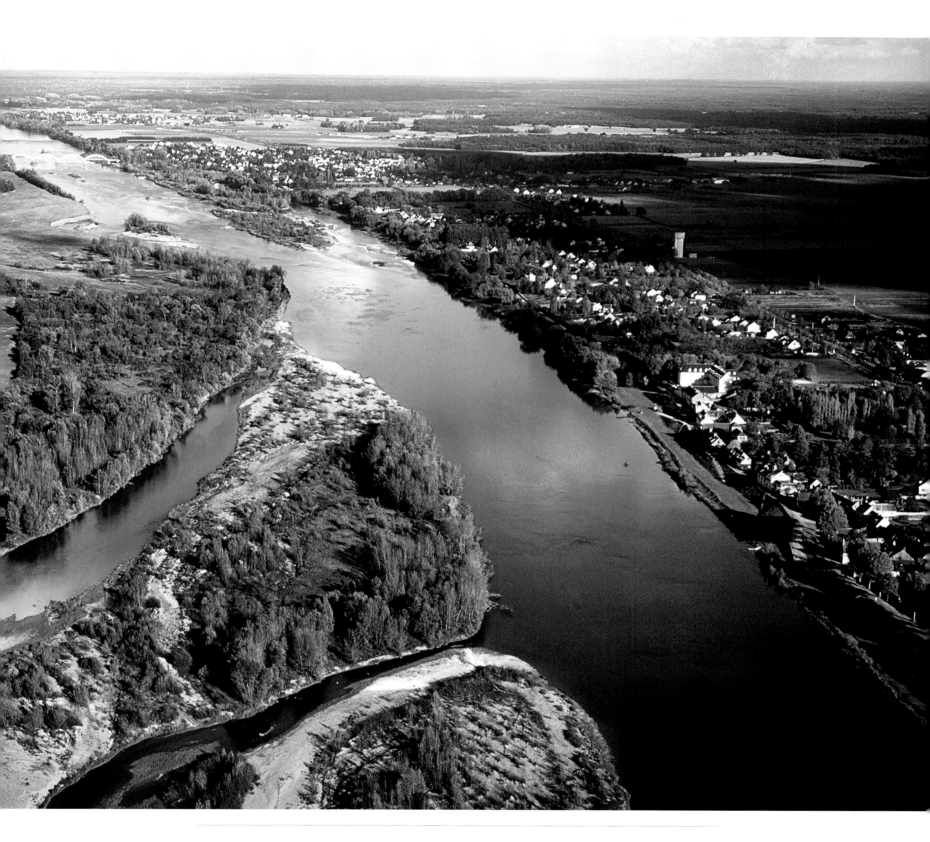

62 top After Orléans the Loire River, which in certain stretches becomes a sort of rapids, crosses fertile countryside where fruit and cereals are grown. The flour produced in large quantities by the Meung-sur-Loire mills was once transported along the river, giving rise to flourishing commerce.

62 bottom The Loire winds its way through the vast plains of central France amid incomparably beautiful natural scenery. There are very few artificial dams or sluices that regulate the course of the Loire, which is the only river in Europe that does not suffer from excessive economic and commercial exploitation.

62-63 The course of the Loire, which is broad and filled with sandbars that change their shape and position with every flood, wends its way among the fertile land in the Loire-et-Cher department. The uniformity of the landscape actually conceals an extremely rich and diverse historic and social reality.

64-65 *Near Nantes the Loire changes its appearance, shedding its guise of a wild, uncontaminated river. After its junction with the Erdre, its last affluent, it gradually widens, forming a long estuary that extends up to St.-Nazaire, where it then empties into the Atlantic Ocean.*

64 bottom *The stetch between Orléans and Tours is one of the most fascinating in the Loire Valley. Because of its striking beauty and history, and above all for its exceptional art treasures, in 2000 UNESCO placed the entire region on the World Heritage List.*

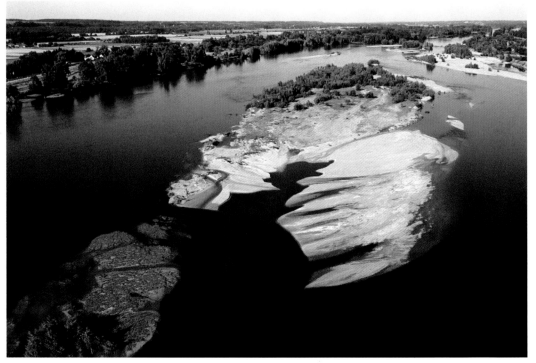

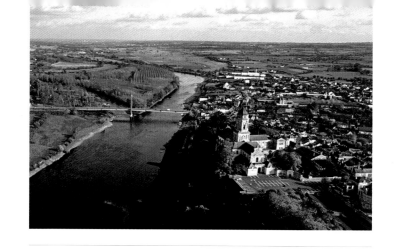

65 top The area traversed by the Loire near St.-Florent-le-Vieil is saturated with history: in March 1793 it was the venue of the beginning of the bloody civil war between the Catholic farmers of the Vendée and the new French Republic created by the French Revolution.

65 bottom Up to the early 20th century the transportation of goods and passengers on the Loire was used sailboats or steamboats, which traveled incessantly between Nevers and Nantes. The rise of the railway system marked the rapid end of river transport.

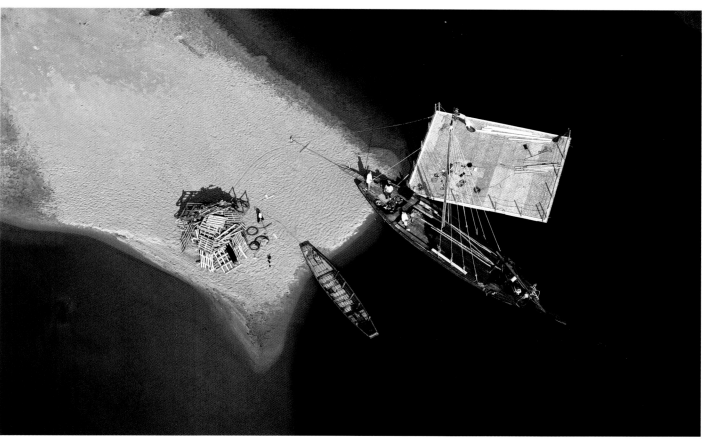

shape is called Gerbier de Jonc, or "Sheaf of Rushes." At a swift pace, the Loire flows downward, opening its way in a basalt bed among mountain pastures and the ruins of medieval fortresses. Its transparent and rushing waters reach Le Puy, a pilgrimage site known for its miraculous healing: indeed, it was a miracle that the imposing Romanesque cathedral built at the end of the 12th century escaped the anti-religious fury of the French Revolution. After Le Puy the scenery becomes less rugged; the hills are replaced by the humid Forez plain, which the river crosses by bouncing from one rapid to another. Little by little the Loire becomes wider and flows in a vast sandy bed, gradually growing mellow together with the surroundings, which become softer and softer and are now modeled by human hands. The buildings and churches pass almost inadvertently from the sober Romanesque style to soaring Gothic architecture, in a sort of ideal transition to the glories of the Renaissance.

Nevers, at the confluence with the Nièvre River, is known for its production of majolica: Luigi Gonzaga of Mantua, who was Duke of Nevers in 1565, introduced the sophisticated technique of glazed porcelain from Italy. A short distance farther on, the Loire receives a considerable amount of water from the Allier and proceeds toward Sancerre and La Charité. The 16th-century wars between Catholics and Protestants left massacres in their wake on these hills, which are now covered with vineyards and wrapped in thoughtful tranquility. In its huge bend northward the river touches the basin of the Seine, to which it is connected by means of the Briare canal.

The opulent, theatrical Loire, with its castles and courts, begins at Gien, keeping a low profile, as it were: the Gien manor is light years away from the luxury and frivolity of the Chambord and Chenonceaux châteaux, as well as from the military rigor of Sully, a few miles below. This latter was built at

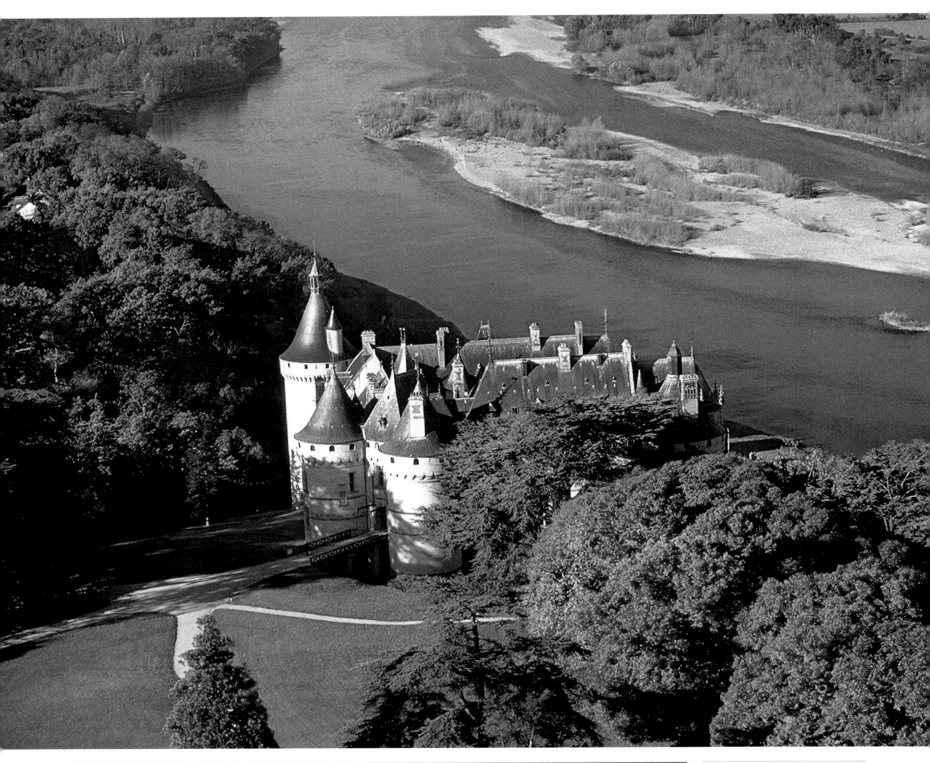

66-67 During the Renaissance the part of the Loire River Valley between Orléans and Tours became the political focal point of France. Kings, nobles and leading court officials chose it as their new home, building their sumptuous and elegant residences along the riverside.

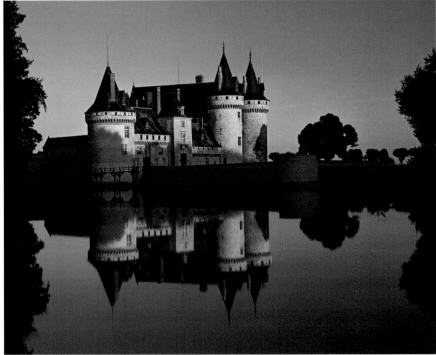

66 bottom Protected by its massive bastions and deep moats, the Sully-sur-Loire château is a perfect example of medieval military architecture. This fortress, which for four centuries belonged to the descendants of the Duc de Sully, is now the property of the Loiret department and is used as the venue of exhibitions and important cultural events open to the public.

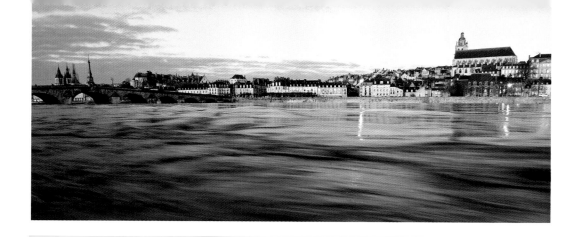

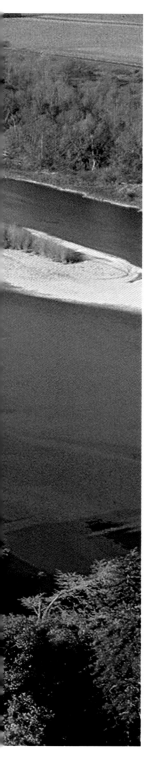

67 top In the past the flooding of the Loire was devastating. In 1856 the heart of Tours was awash and the river invaded the surrounding countryside, creating a lake 25 miles (40 km) long.

67 center Built in the late 14th century in the vicinity of one of the rare fording points of the Loire, the Sully-sur-Loire château was the residence of the Duc de Sully, the powerful finance minister of King Henry IV.

67 bottom The town of Gien lies on the banks of the Loire, at the foot of the large château built in 1484 for Anne de Beaujeu, daughter of Louis XI. This rather austere edifice is now the home of the International Hunting Museum.

THE LOIRE

the behest of Anne de Beaujeu, the daughter of Louis XI, immediately after the feudal wars that led to the unification of France, when parsimony and sobriety were much appreciated virtues: only the rhythmic succession of the geometric decoration in black and red attenuates the austerity of this edifice.

The Loire unexpectedly becomes working-class before arriving at Orléans, at Châteauneuf, home of an interesting naval museum. The golden age of river traffic was achieved in the mid-19th century, when 10,000 vessels navigated along the Loire, but this period came to a sharp halt a few decades later with the arrival of the first railways. In any case, navigation was by no means simple, as the river has an unstable regimen in which furious floods alternate with periods of severe drought. At Tours in the summer of 1933 the water level was so low that one could go to the other shore on foot with no trouble at all. The Loire then arrives at Orléans, whose name is linked with the exploits of Joan of Arc, crossing a region covered with forests and moors dotted with ponds and rich in game. Hunting, which had become a refined game, was one of the favorite pastimes of the illustrious tenants in the so-called Garden of France.

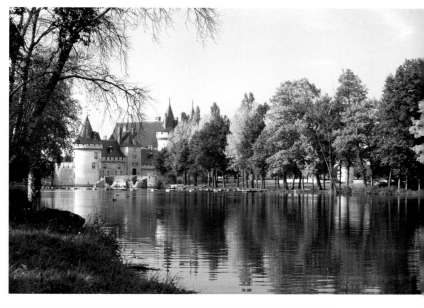

From Blois to Angers the course of the river boasts a series of sumptuous castles and châteaux: from Charles VII to Francis I, all the kings of France had their residences on the middle section of the Loire. Built not for defensive purposes but for the sheer pleasure of living, the Loire châteaux are the symbol of an epoch. A multitude of famous architects, landscape gardeners and artists – mostly Italians – transformed the sad medieval fortresses into masterpieces of Renaissance art and architecture.

Chambord is located in the middle of an estate that is as large as Paris: 400 rooms, 365 windows, a forest of monumental

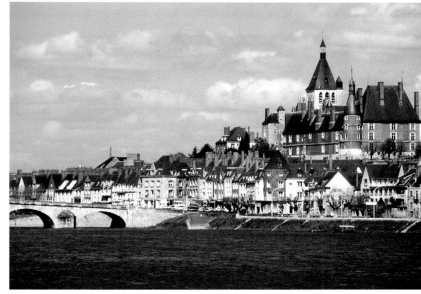

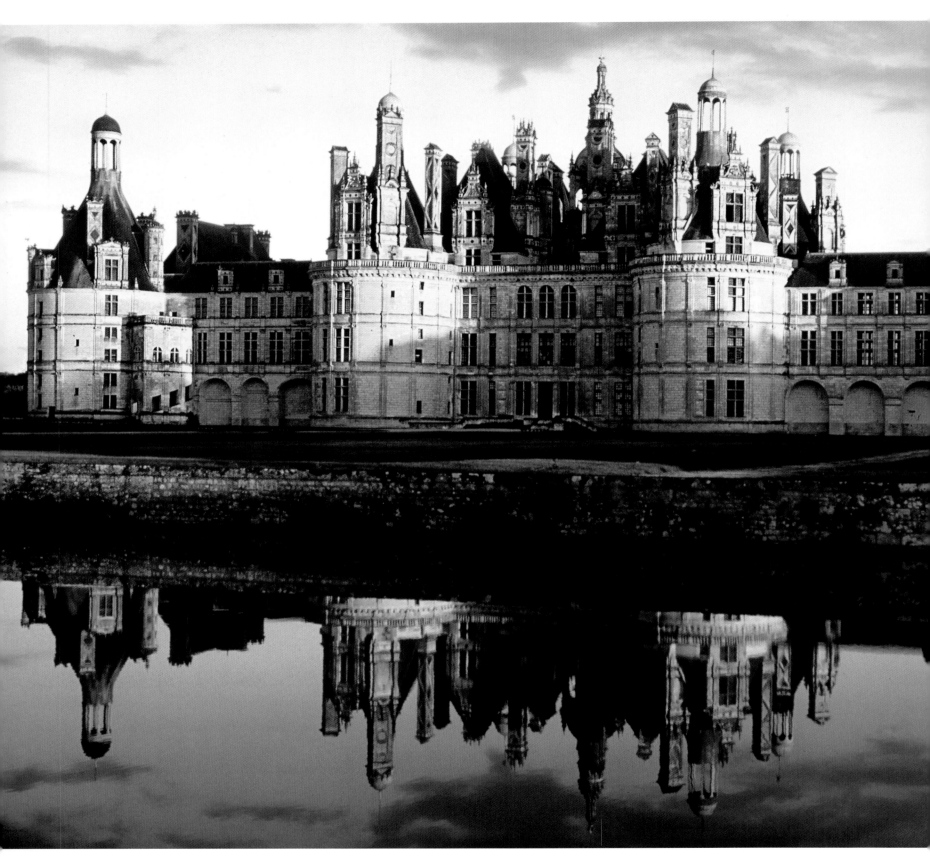

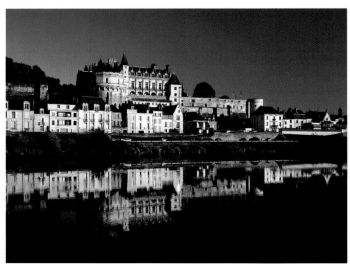

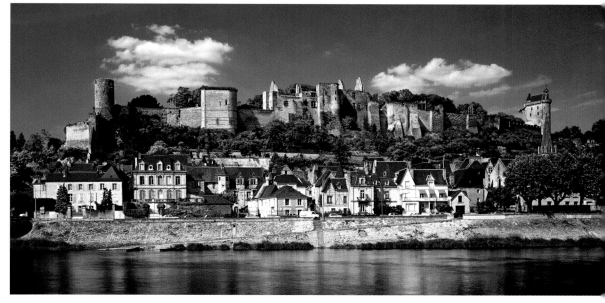

68-69 *Power and elegance are merged in the architecture of the Chambord château, the largest in the Loire Valley.*

68 *bottom left Château Amboise, built by Charles VIII in the late 1400s, was one of the favorite residences of the kings of France.*

68 *bottom right The walls of the castle of Angers were erected during the reign of Louis IX (St. Louis), at the beginning of the 13th century.*

towers and chimneys – an undertaking, or act of folly, that kept 2000 workmen occupied for twenty years, from 1519 to 1539. Blois was the theater of intrigues and assassinations, and its octagonal spiral staircase may have been designed by Leonardo da Vinci. The Italian genius was the guest of King Francis I and spent the last three years of his life surrounded by the drab walls of Amboise, the château founded by Charles VIII in the late 1400s that for over a century was the seat of royal power. Then there is Chaumont, so massive and solemn. And Chenonceaux, stretching out over the placid waters of the Cher River and so magnificent in its frivolity: Henry II gave it as a present to his mistress, Diane de Poitiers, who had splendid gardens laid out around it. When the king died, his wife Catherine de' Medici finally got revenge on her rival, having her interned in the grim bastions of Chaumont.

Once past Tours, the Loire receives the Indre and Vienne rivers. There are more châteaux at Azay-le-Rideau, Langeaux, and Villandry, which are immersed in an idyllic setting of forests and streams. There is an aura of mystery about the slender towers of Ussé, which inspired Charles Perrault's fairy tale *Sleeping Beauty*. Leaving behind the cyclopean wall of the Angers fortress, the river proceeds toward Nantes. Before opening out into a wide estuary toward the Atlantic Ocean, the river takes in the Mayenne and Erdre, its last affluents. Then, with noble indifference, it offers itself to the sea.

69 *top The broad and majestic Loire washes the town of Saumur, which is dominated by the château that was once the residence of the powerful Plantagenets. During the Second World War Saumur was the theater of heroic resistance against the German invasion and occupation.*

69 *bottom A massive fortress that has been rebuilt and enlarged several times over the centuries towers over the picturesque town of Chinon, on the banks of the Vienne, a tributary of the Loire.*

70-71 *Magnificent woods and gardens surround Chenonceaux, which was built by the architects of the Tours school and donated in 1547 by King Henry II to his mistress Diane de Poitiers. A 200-ft (60-m) roofed bridge with five arches crosses over the transparent waters of the Cher, which flows into the Loire.*

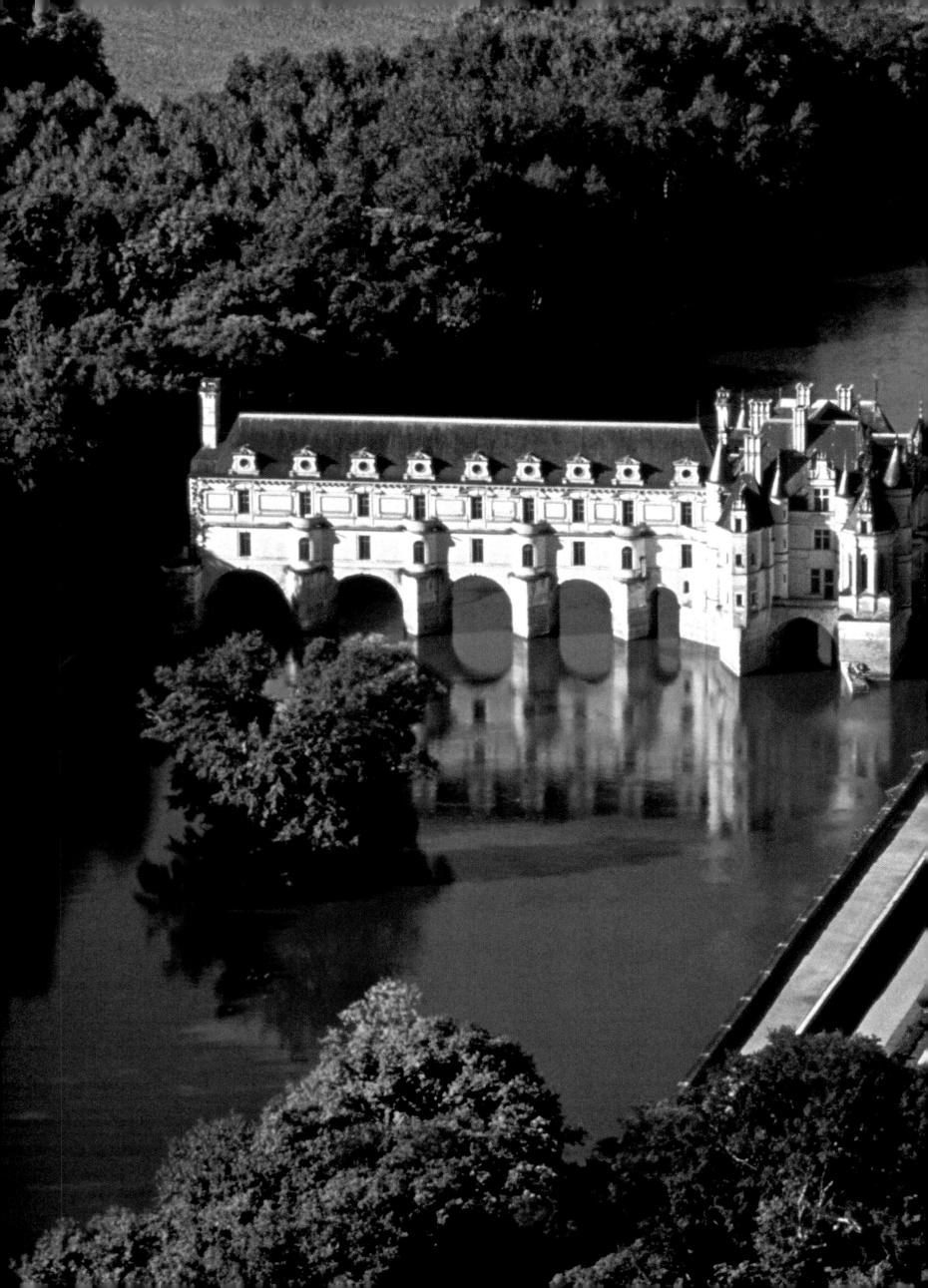

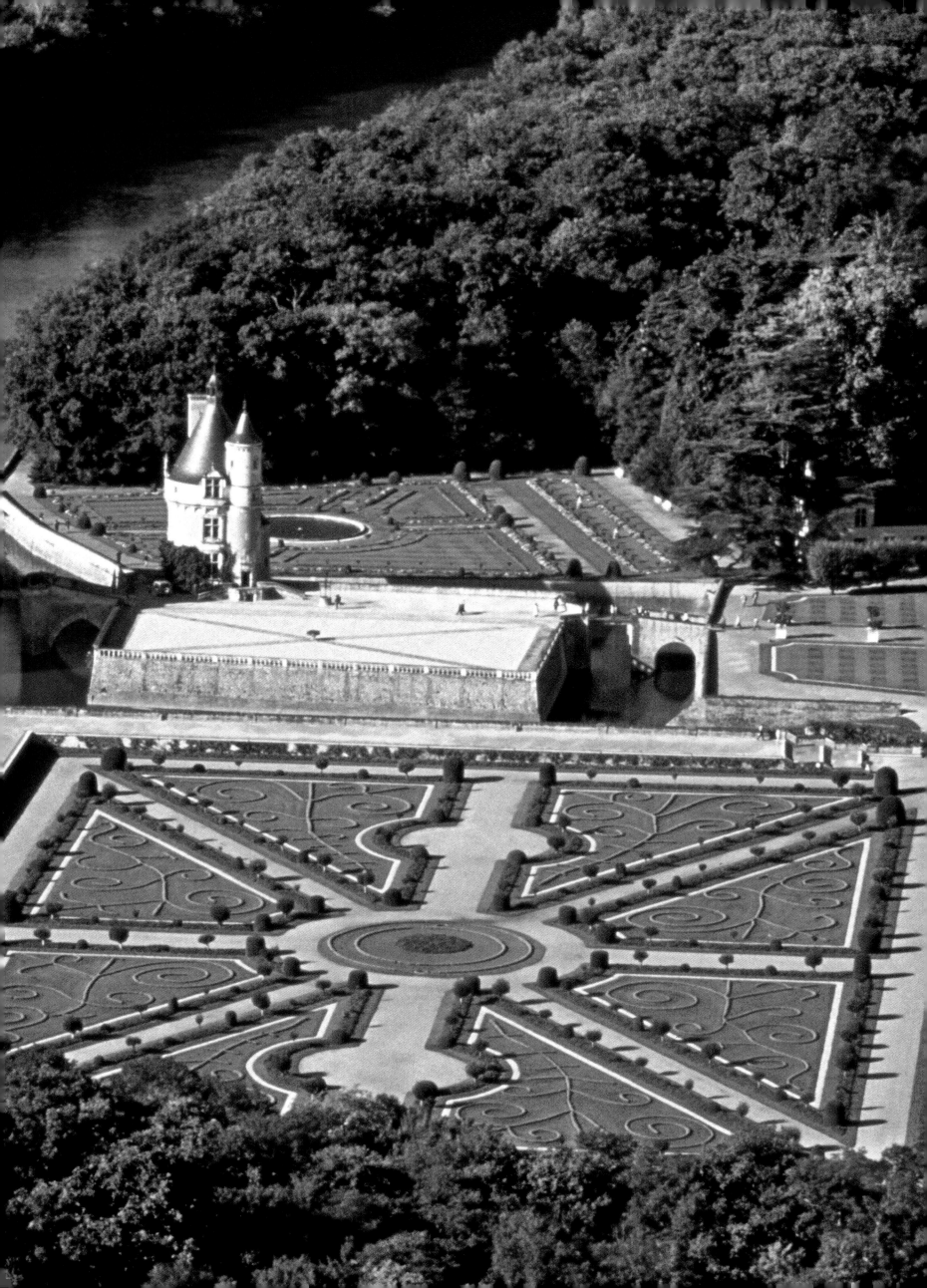

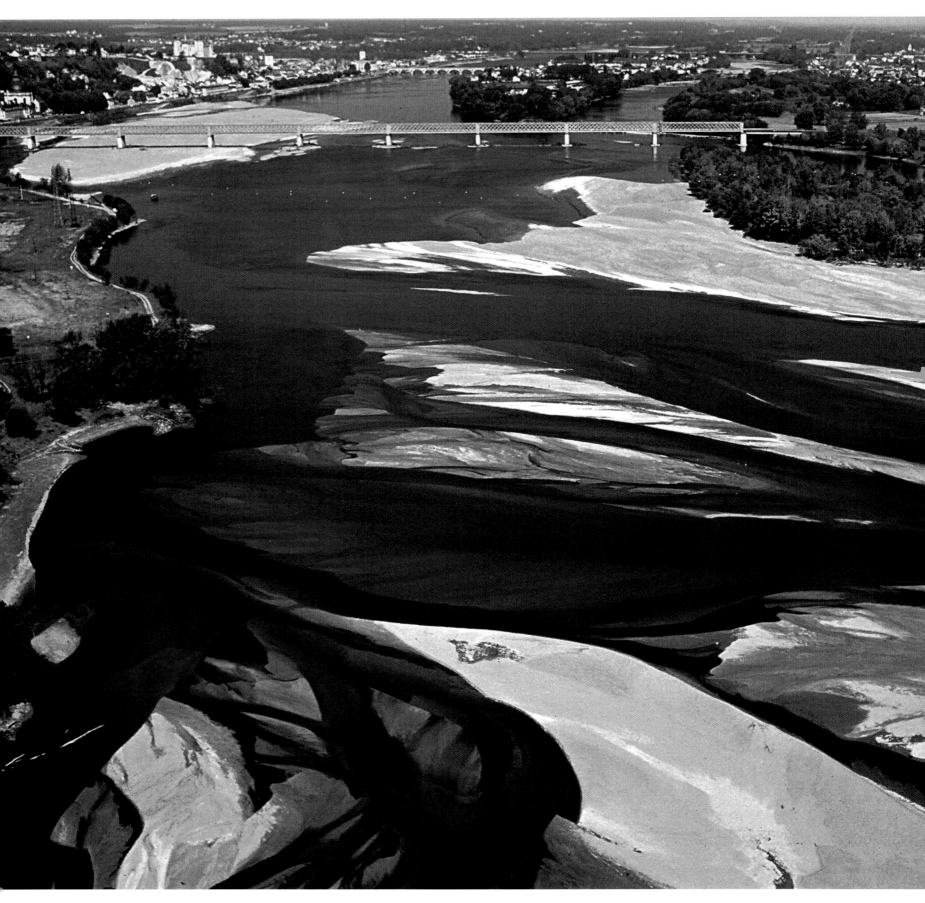

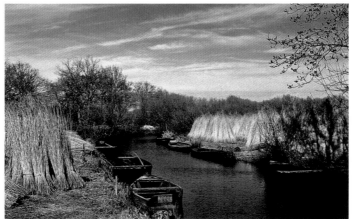

72-73 Large, shifting sandbars characterize the course of the Loire at Saumur, in the Maine-et-Loire department. The rather long distance between the opposite banks of the river has always discouraged the construction of bridges here, and in fact ferryboats were used at this point up to the mid-20th century.

72 bottom A canal flows lazily in the broad and humid plain that surrounds the basin formed by the Loire River estuary, which in the distant past was many times submerged by the sea. In fact, the tides go up the river for about 30 miles (50 km) into the interior, as far as the port of Nantes, the terminus of river navigation.

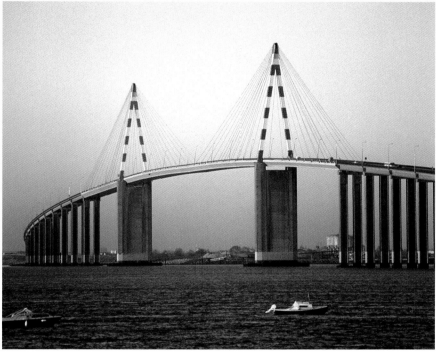

73 Before the construction of the impressive bridge at Mindin, transfer between St.-Nazaire and St.-Brévin was possible only via regular ferry service. The bridge, almost 2.2 miles (3.5 km) long, passes over the estuary of the Loire, while the towering central piers are no less than 425 ft (130 m) high. This impressive achievement of avant-garde engineeering has contributed to the commercial and urban development of the port of St.-Nazaire and the outlying zones, which constitute one of France's leading industrial hubs.

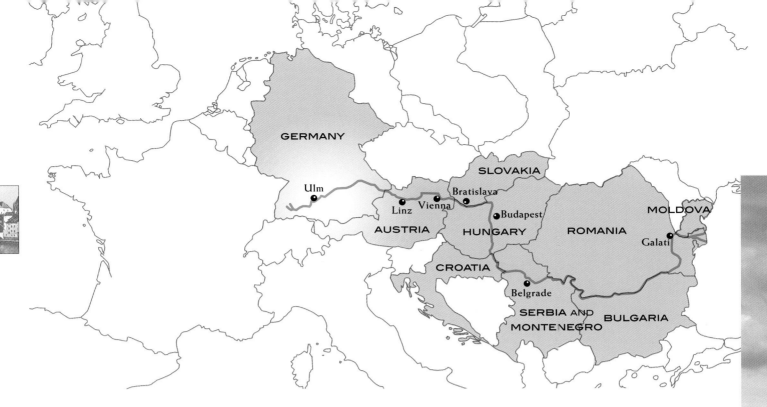

THE DANUBE
GATEWAY TO THE EAST

According to Greek mythology, the Argonauts, on their way back from their journey in search of the Golden Fleece, went up the Danube as far as the point closest to the Adriatic Sea, where they abandoned the river and carried their ships as far as the sea.

This legend highlights the main feature of the Danube, the only large European river that flows from West to East and empties into an inland sea. Since remote times this special characteristic has played a role in history making. The Danube is the gateway to the Orient; during the different historic epochs its valley has been the theater of contact, and often of conflict, between different cultures and peoples. However, unlike the Rhine, this huge natural corridor, constantly traveled by invading armies, has never been a true frontier, as have many of its tributaries, which have served as transverse barriers blocking penetration into the interior.

Coming from the remote steppes of Asia, the Avars and Huns ravaged Central Europe. Then came the Mongols, the fearsome warriors of the Anti-Christ: in 1241 they conquered the Hungarian city of Pest and on Christmas Day Batu Khan led his hordes over the frozen Danube and captured Esztergom, advancing as far as the gates of Vienna. The Danube was also used by the Franks under Charlemagne and the Crusader armies heading to Jerusalem. The river was the strategic route taken by the Ottoman Turks during their *jihad* or holy war, when they almost overran the Christian West several times. Again, the Hapsburgs, Napoleon, Hitler's troops and the Red Army all fought along the Danube River. Lastly, the land bloodied by centuries of battles was enclosed by the Iron Curtain during the so-called Cold War. The Blue Danube of Viennese waltzes became red, politically speaking, split into two parts that were defended by barbed wire fences. Of all the world powers that fought for control of the river, only the ancient Romans managed to dominate it for any length of time from its sources to its mouth.

The second distinctive feature of the Danube is precisely its ungovernable nature: all attempts at making it an international river open to navigation and commerce for all nations have been in vain, coming up against harsh reality. Up to the fall of the Soviet regime and the division of Yugoslavia, eight nations and two opposing ideologies divided the waters of the Danube. From the Congress of Vienna in the early 1800s to the Conference of Belgrade in 1948, the treaties regulating the circulation of men and goods on the river were failures. Indeed, a dramatic aura seems to have enveloped the entire history of the Danube, up to the present. The ethnic conflicts and 'cleansing' in Yugoslavia, as well as the bombing of Belgrade on the part of the NATO forces, have awakened specters that we thought were definitively removed from the conscience of Europeans.

Moreover, the Danube has other problems of a purely practical nature. First of all, it is too long. In its 1798 miles (2900 km) from the Black Forest to the Dobrudja region in Romania, it crosses several different environments, so that its supply of water is irregular and its regimen extremely variable: low water stages and floods follow one another in quick, even sudden, succession, with changes in the river level that are sometimes drastic.

Then, to complicate matters there is the ice, which in the bitterly cold winter can block the flow of the river for weeks on end. In short, the Danube has a capricious nature, and it comes as no surprise that the volume of river traffic is barely 70 million tons per year, far below the 200 million of the Rhine. Needless to say, this comparison is unfair: the Rhine crosses the economic hubs of Europe and empties in the Rotterdam harbor, while the Danube ends its course in an inland body of water and passes through poorer countries that are worn out from too many years of being excluded from the global market. And yet the destinies of the two rivers are connected more than might seem at first sight. They are linked

74-75 The medieval villages of Nagymaros and Visegrád, in Hungary, lie respectively on the left and right banks of the so-called Danube Bend. These villages contain important artistic and historic testimony of Hungary's past.

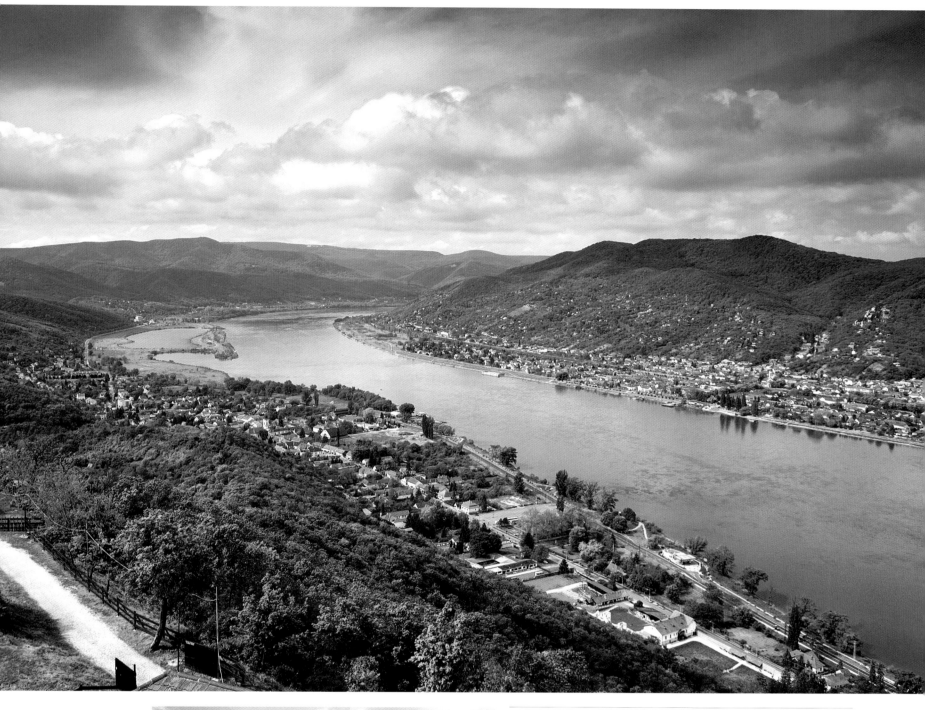

75 bottom left After wandering for a long stretch among the green hills of Bavaria the Danube arrives at Kelheim, flowing into a narrow gorge that cuts through tall white limestone cliffs. Near the town the river merges with the large manmade canal that connects it with the River Main.

75 bottom right The Danube-Main canal with its intense barge traffic flows past the charming scenery of Bavaria. The idea of a waterway that would merge the two rivers was conceived as long ago as the age of Charlemagne, but work on the project was initiated only after the Second World War and was fraught with difficulties.

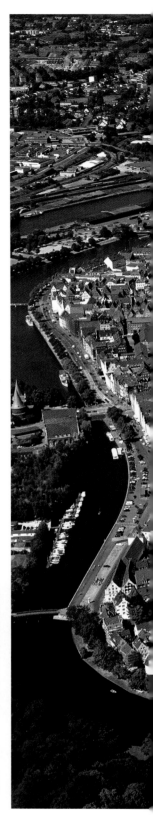

not only by a very important canal, but above all by the plan of the new European Union, which is destined to include the Danubian nations in the future.

The Danube rises in the Black Forest, a short distance from the lower section of the Rhine, of which it is to a certain degree an affluent. The river is the result of the merger of two small torrents, the Brege and the Brigach, at Donaueschingen. At least, this is the official version, since the Danube, like all the other large rivers in the world, has a source linked with

becomes wider and meanders toward Kelheim, where there is an artificial canal that links it to the Main and then to the Rhine. The dream of a continental waterway that would connect the North Sea and the Black Sea is quite old: twelve centuries ago, at the behest of Charlemagne, thousands of laborers began to dig the so-called Carolingian Ditch, whose traces can still be seen around Nuremberg. Since that time the project was proposed several times, only to be abandoned once again. The work was finally finished and ceremoniously

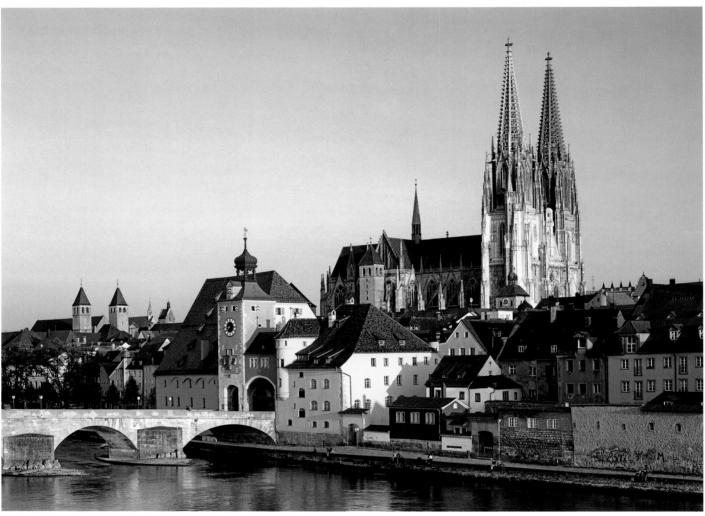

tradition: popular legend ignored geography and identified the source as a Baroque fountain in the middle of a municipal park at Donaueschingen. A shapely goddess takes loving care of the river during its rather hesitant first steps. Soon afterward the river disappears underground, emerging again a few miles farther on. During its subterranean journey a part of its waters end up in the Rhine by means of mysterious passageways. When this short-lived secret love has ended, the Danube winds through the cultivated fields and wooded hills of southern Germany, and comes to its first encounter with a city, Ulm, the birthplace of Albert Einstein. The bell tower of the Gothic cathedral of Ulm is the tallest in the world, soaring in an ethereal ascent for 528 ft (160 m).

When it flows into the Regensburg plain, the Danube

inaugurated only in 1992, making it possible to navigate for all the 2170 miles (3500 km) that separate Rotterdam from the Danube drainage basin. Before the canal was opened, Regensburg, at the Danube's confluence with the Regen, was the last river port for large vessels. The beautiful Romanesque and Gothic churches, the town hall, and the luxurious patrician residences all bear witness to the former splendor of the city, which was a prosperous commercial center from the 10th century on.

At that time and up to the mid-1800s, navigating down the Danube was no simple matter. Shoals, strong currents and underwater obstacles often endangered the cargo and the very life of the merchants. The valley is often swept by westerly winds, which made it impossible to navigate on sailboats; the

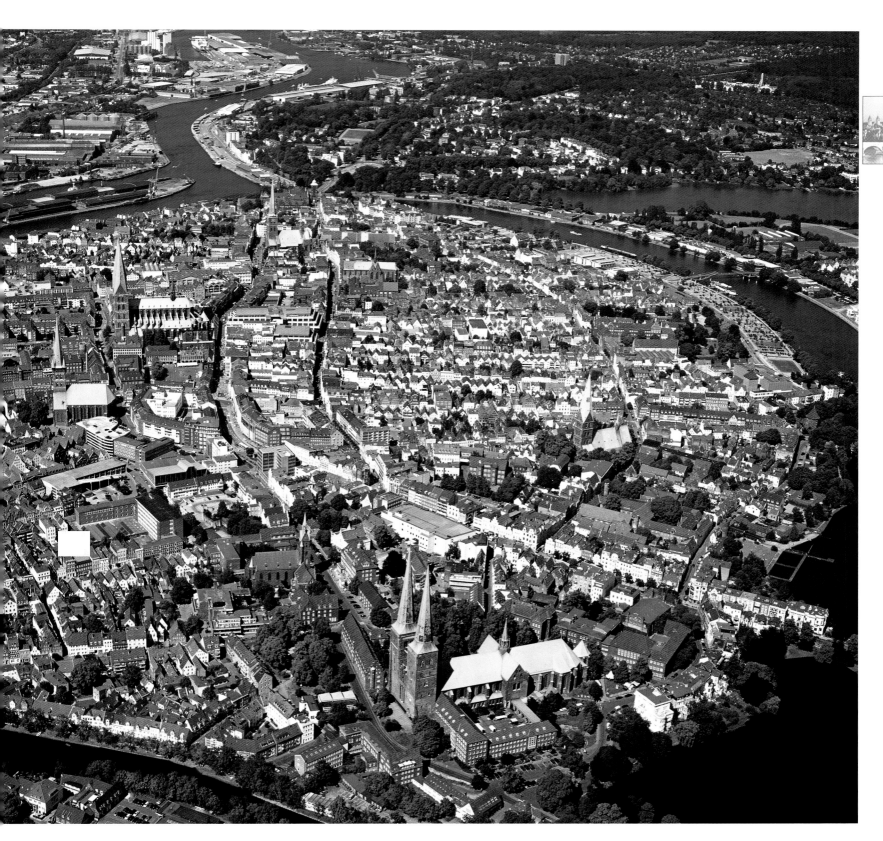

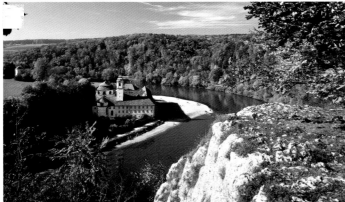

76-77 *Time seems to have stood still in the charming town of Ulm, in southern Germany.*

77 bottom left *The Benedictine abbey of Weltenburg, at Kelheim, is the oldest in Bavaria.*

77 bottom right *The Danube reflects the profile of the impressive Renaissance castle in Neuburg, one of the most lively cultural towns in Bavaria.*

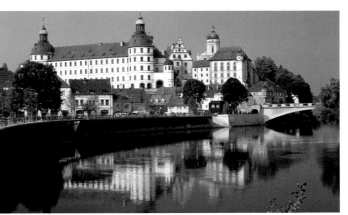

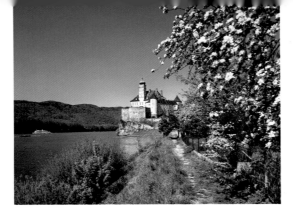

THE DANUBE

78 top A chain once blocked the course of the Danube in front of the Schönbuhel castle in Austria, which was built on a rock overlooking the river. In order to continue their journey, the merchants and boat owners of the time had to pay tolls.

78 center Extending toward the Danube like a ship's prow, the Baroque abbey of Melk dominates the entrance to the Wachau Valley, in Austria. This edifice, built in the 18th century over the ruins of a Benedictine monastery, is known for its prestigious library.

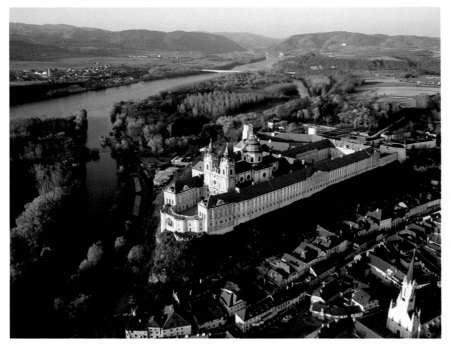

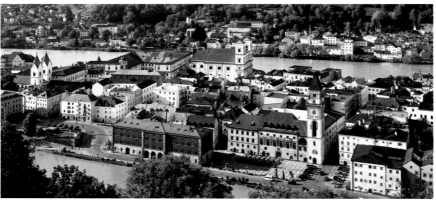

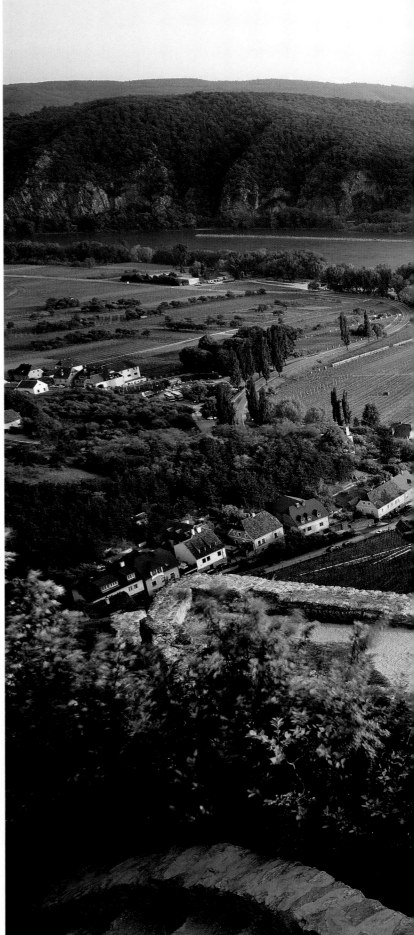

only way to go up the river was to tow the craft from the land with the aid of teams of oxen or horses. Bandits, predators and the heavy duty levied by many avid local lords were all an integral part of the risk involved in any journey down the Danube.

At Dassau the Danube receives a large amount of water from the Inn River and leaves Germany, entering Austrian territory. Once past the aristocratic city of Linz, it heads toward the Wachau Valley in what may be the most beautiful section of its long course. The river then runs slowly among the last slopes of the Alps, whose rocky skeleton sometimes

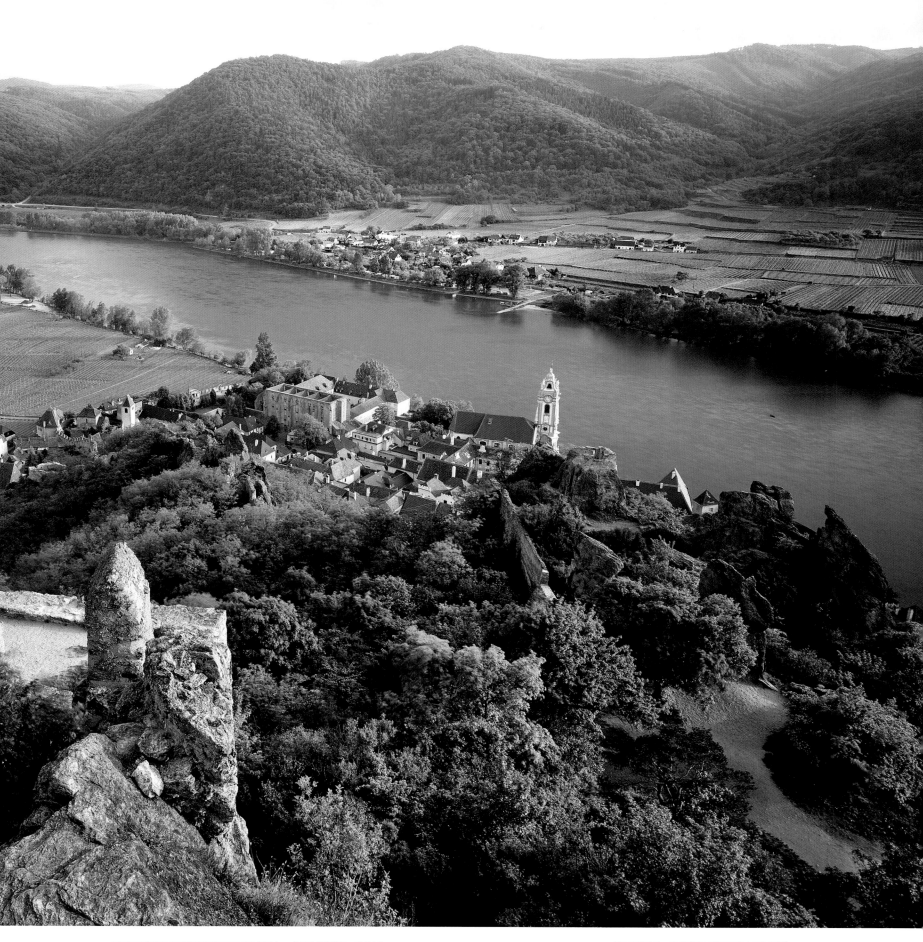

78 bottom The Inn, Ilz and Danube rivers converge in the Bavarian city of Passau, thus splitting it into four distinct zones that are linked by a series of bridges. Passau Cathedral, built in the 15th century and drastically altered in the Baroque period, is famous for its colossal organ.

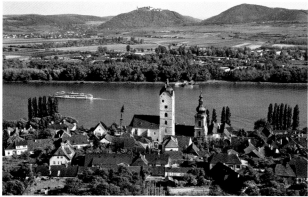

78-79 The castle in which Richard Lion-Heart was kept prisoner keeps watch over the town of Dürnstein, on the left bank of the Danube.

79 bottom The town of Krems lies along the Danube in the Wachau Valley. In the background is the Benedictine abbey of Göttweig.

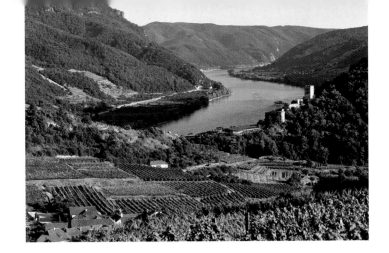

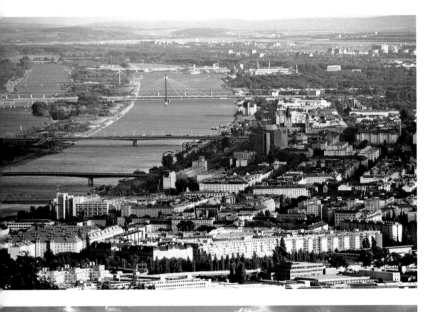

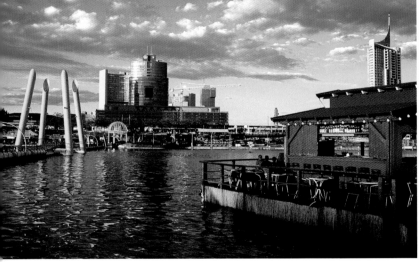

THE DANUBE

emerges suddenly from the thick woods. On the natural spurs that plunge headlong to the shores of the Danube there are medieval fortresses and monasteries: the Benedictine monastery at Melk, the castles of Schallaburg and Schönbuhel, and the ruins of the Dürnstein citadel.

The charming meadowland of Tulln introduces the Danube to Vienna, the last bulwark of the West centuries ago. In 1529 and 1683, the walls of this city managed to check the impetus of the Turkish armies. Vienna, the capital of the Hapsburg dynasty, boasts a wealth of splendid monuments and is the international temple of music: Gluck, Haydn, Mozart, Beethoven, Schubert, Brahms and Mahler brought fame to the city with their immortal compositions. The most famous of the 149 waltzes composed by Johann Strauss, *The Blue Danube*, has become the everlasting symbol of the carefree and gay Viennese lifestyle.

After Vienna, at the confluence with the Morava River, the last section of the eastern Carpathian Mts. forces the

80 top The scenery along the course of the Danube in Wachau Valley is particularly enchanting in spring, when the apricot trees are blossoming. Famed for its excellent wines, this valley is one of the most popular tourist attractions in Austria.

80 center The Danube is a full-fledged river 985 ft (300 m) wide when it crosses the northern quarters of Vienna. The capital of Austria, one of the most important cities in Europe, extends in concentric circles around the famous Ring and St. Stephen's Cathedral.

80 bottom Situated on the banks of the Danube in the outskirts of Vienna, the modern buildings of the UNO-City contain the offices of prestigious organizations such as the International Atomic Energy Agency, OPEC (Organization of Petroleum Exporting Countries), and the United Nations Industrial Development Organization.

80-81 Intense commercial traffic does not disturb the silence of the virgin forests and marshes that flank the banks of the Danube near Vienna. Because of its marvelous natural scenery, this area, one of the last uncontaminated ones in Central Europe, has been declared a national park.

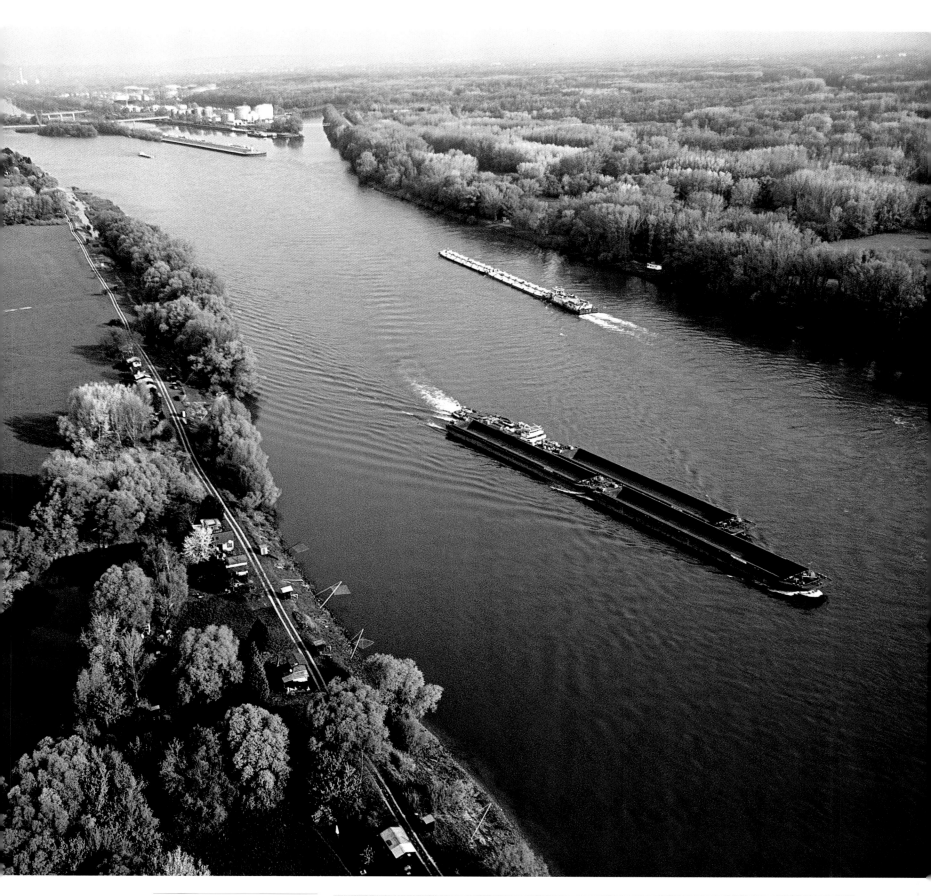

81 bottom *The unique shape of the castle of Bratislava rises up over the city, which is a major river port and the only commercial outlet of Slovakia on the Danube. At Bratislava, also known as Pressburg, Napoleon and Francis II of Austria signed a peace treaty in 1805.*

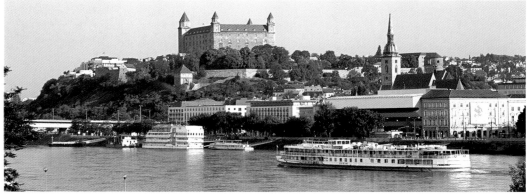

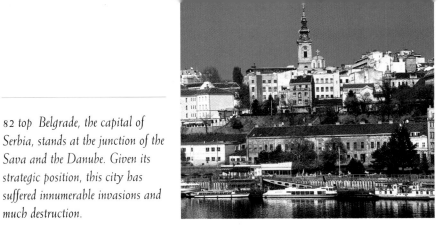

82 top Belgrade, the capital of
Serbia, stands at the junction of the
Sava and the Danube. Given its
strategic position, this city has
suffered innumerable invasions and
much destruction.

82 center Buda, one of the two
cities that constitute Budapest,
lies on the low hills that border
the right bank of the Danube.
In the foreground is St. Matthias
Church.

EUROPE

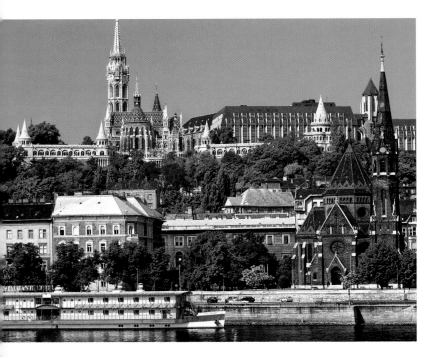

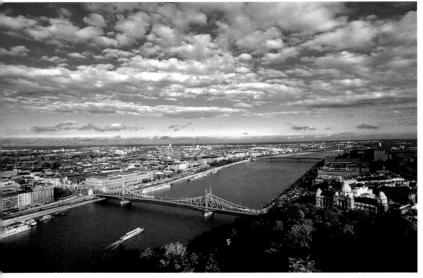

Danube into a narrow passage, the entrance to the vast
Hungarian lowlands, which extends for hundreds of miles
up to northern Serbia and the Romanian border. From
Bratislava to Esztergom the river forms the border between
Hungary and Slovakia. Then, making a sharp bend, it heads
southward into the fertile plains of Hungary. This is the
puszta, flat and uniform, without trees, once the breadbasket
of the Hapsburg Empire. Buda, on the right bank, and Pest
on the left one welcome the Danube with their royal
setting. Budapest, which was destroyed and rebuilt several
times, shows off its most beautiful monuments along the
riverside: the Fishermen's Bastion, the Neo-Gothic dome
and spires of the Parliament, the St. Matthias Church, and
the Buda Royal Palace, the residence of the Hungarian rulers
and the Hapsburgs. The Danube leaves Hungary at
Mohács, marking the Serbian-Croatian border. It was in the
nondescript plains of Mohács, in 1526, that Suleyman the
Magnificent routed the Hungarian army and established
Turkish dominion over the region for the following 160
years. When it reaches Belgrade, the Danube is at the
halfway point of its voyage to the sea, which it reaches with
a gradient of only 330 ft (100 m). In Serbia, three large
affluents, the Drava, Timis and Sava, increase the discharge
of the Danube considerably as it flows majestically toward
the mountains that can be seen in the distance. The Balkan
range and the massive arc of the Transylvanian Alps meet at
the Serbian-Romanian border, squeezing the Danube like
stone pincers: the gloomy ruins of Golubac castle herald the
deepest gorges in Europe, the Iron Gate, which is a little
more than 330 ft (100 m) wide. Up to a few decades ago
the river rushed furiously into this opening, swirling

THE DANUBE

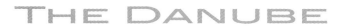

82 bottom and 83 bottom A series of
bridges connects Buda and Pest, which
together form Budapest. Buda, on the
right bank of the river, began as a
fortified citadel after the Tatar invasion
of 1241; Pest, which was inhabited
by German-speaking immigrants, was
on the other hand a trade center for a
long period. The administrative union
of the two cities took place in 1873,
during Hapsburg rule.

82-83 The Hungarian
Parliament Building in
Budapest, with its rich Neo-
Gothic style, is one of the largest
in the world. It was built in
1904 during the reign of
Emperor Francis Joseph I of
Austria and Hungary. A short
way downstream the Danube
divides, with Margaret Island in
the center.

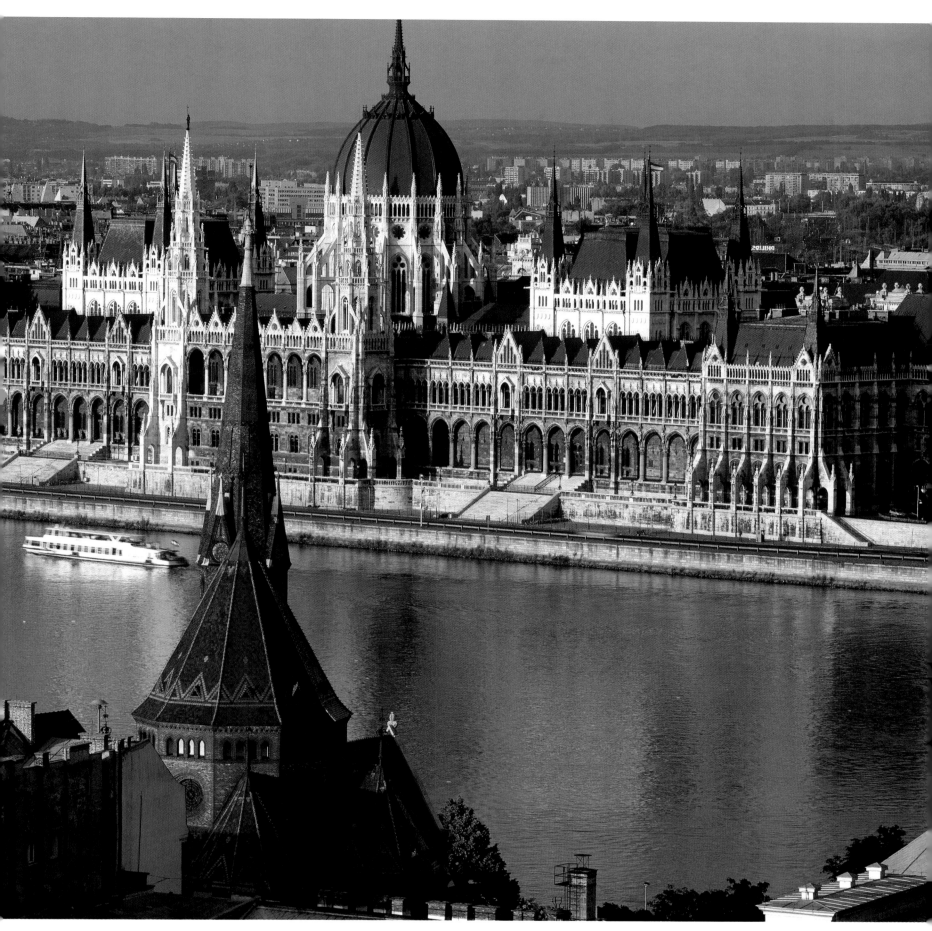

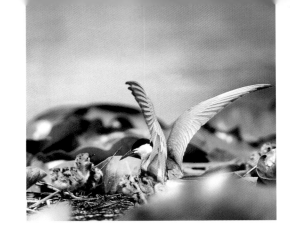

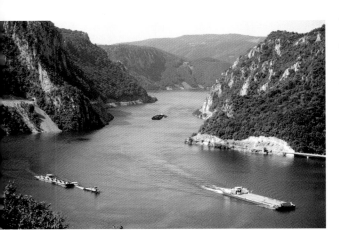

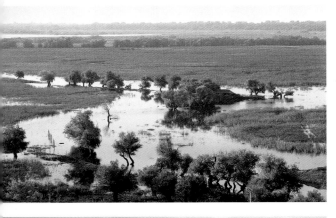

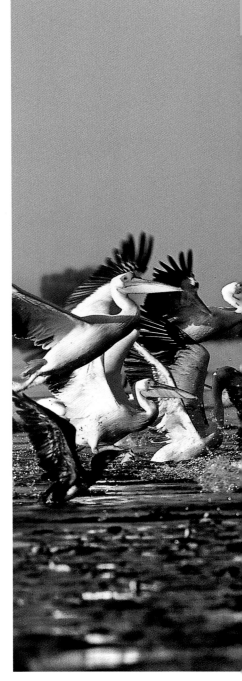

between the steep rock faces blanketed by thick forests. Eddies, currents and outcropping rocks and cliffs were a formidable obstacle to navigation. Since 1972 a large dam has checked the rush of the Danube, which flows into a placid artificial lake. Below it is welcomed by the vast Wallachian plain with its endless wheat and corn fields. The ancient Romans occupied this region in the 1st century AD, subjecting the local populations, which underwent thorough and long-lasting Romanization. For example, the Romanian language is Neo-Latin. The remains of the largest bridge in the Roman empire, built over the Danube by Emperor Trajan, 3960 ft (1200 m) and supported by twenty stone and cement piers, can still be seen near Turnu-Severin.

Once out of the Iron Gate, the river flows slowly in a valley that gradually becomes wider and more marshy: from Vidin to Silistra the Danube is once again a border, this time between Romania and Bulgaria. The Black Sea is quite near now, only 62 miles (100 km) away. But instead of forging straight ahead, the river turns northward, forming two branches. When it comes to Galati, it again changes direction and finally heads eastward, taking with it the waters of the Siret and the Prut, the last of the Danube's more than 300 affluents. The true river delta begins at Tulcea, where the Danube splits into three main branches: the Sulina, St. George and Kilya, which marks the border with the Ukraine. The endless expanse of rushes, the lakes, and the marshes that are the distinctive features of delta are an ideal habitat for an amazing variety of species of fish and migrating birds, which nest and mate there. This enormous natural oasis, which is virtually intact, is the farewell gift of the river to Europe. Beyond the last muddy beaches and the arc of islets bordering the river mouth, water and sky merge in a vague, indefinite horizon, where the Danube seems to dissolve into nothingness.

84 top right and 84-85 Over 250 species of birds find refuge in the marshland and swamps created by the Danube delta, which is the passageway of at least five major migratory routes and a crucial nesting and reproduction zone. Besides the northern and

Mediterranean species, there are cormorants, flamingoes, cranes and large groups of pelicans, which arrive from Asia and Africa. A true paradise of biodiversity, the Danube delta is a complex ecosystem many of whose secrets have not yet been revealed.

84 top left The meandering ravines known as the Iron Gate, which wind like a snake through the Carpathian Mts. and the Balkan hills, separate the course of the Danube in Serbia from its course in Romania. Here the river is often made choppy by the boat traffic.

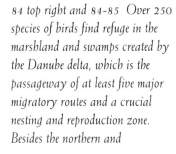

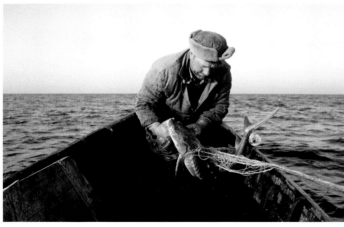

85 bottom Fishing is one of the main activities of those who live in the Danube delta, which provides about half the freshwater fish sold in Romania. Over 100 species of fish populate the waters of the river and the large brackish lakes that dot the delta. Pollution and exploitation of the environment have brought about a decrease in the population of sturgeons, whose eggs are served as caviar. The Danube Delta Biosphere Reserve was recently established to try to make up for the harm done in the past.

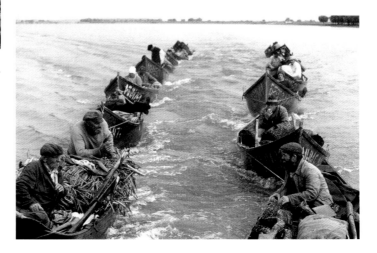

84 center and bottom Sandy islets, stretches of aquatic plants and thick forests characterize the landscape of the Danube delta, one of the few places in Europe that are still locked in mystery. When it empties into the Black Sea in Romania, the river splits into three main branches that give rise to an intricate maze of small lakes and secondary canals that cover a surface area of about 1930 sq. miles (5000 sq. km). Because of the silt deposited by the river, the delta moves toward the sea at a rate of 130 ft (40 m) per year.

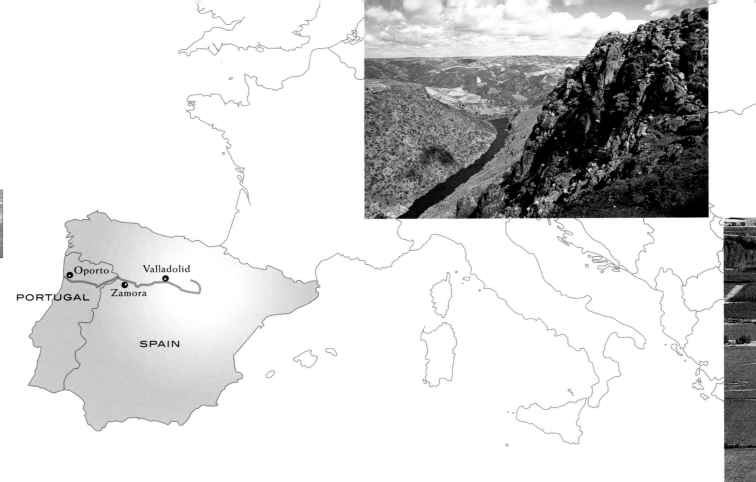

THE DUERO

THE FRONTIER OF FAITH

A few broken columns and the ruins of a patrician villa are all that remains of ancient Numantia, a few miles from Soria. Once the Romans had quenched the major rebellion of the Lusitani and Iberian Celts in the mid-2nd century BC, Rome became the undisputed ruler of the Iberian Peninsula. Only Numantia resisted, protected by its impregnable fortifications. In 134 BC, command of the military operations in northern Spain was entrusted to Scipio the Younger, the man who had razed Carthage to the ground, who decided there and then to capture the city by making it starve. He had all the surrounding countryside burned and the Duero River blocked by sharpened tree trunks, thus depriving the defenders of the city of their last supply line. Numantia fell after a nine-month siege. It was burned and utterly destroyed: rather than becoming prisoners of the Romans, most of the inhabitants committed suicide.

Soria is one of the provinces of Old Castile, a harsh land forged by the sun and the frost of the meseta, the rugged plateau in the heart of Spain. The churches and fortresses of Old Castile and León, whose boundary is the Duero, were the centers of the Christian struggle against the Moors, as the poets and heroes of the epic *reconquista* came from these two regions. In the poems celebrating El Cid Campeador, the Castilian tongue became literature and the national language. The character and culture of the Spanish were shaped in this dynamic mixture of history and legend, faith and pragmatism.

The Duero River rises on the wooded slopes of the Picos de Urbión, at the northern tip of the Iberian Mts., which separate its basin from that of the Ebro River. Flowing in a narrow and rocky valley, it arrives at the village of Duruelo de la Sierra, receiving the waters of numerous small torrents in its descent. After Covaleda, the current becomes less rapid and the Duero flows in a broader bed, meandering toward Soria, which was once the eastern outpost of the Kingdom of Castile. The river, which in the Middle Ages marked the boundary with the regions under Muslim dominion, gradually becomes a fortified line: from Berlanga del Duero to Peñafiel, a series of monumental castles dominates the barren countryside of the plateau. Built on isolated rock spurs in the plain and surrounded by tall walls that end in a large quadrangular keep, all these fortresses were intended to be impregnable. One of them, situated at Gormaz, was where the military leader Rodrigo Diaz de Vivar, known as the Cid, began his violent career. When he was only twelve he killed the local lord to revenge himself and then married his young daughter. His life was a continuous series of duels, victorious battles against the Arabs, pilgrimages and meetings with saints, popes and kings. At least this is the story handed down by tradition. For historians, on the other hand, the Cid was nothing more than an adventurer, a soldier of fortune ready to offer his services to the best bidder, be he a Christian or Muslim.

The other aspect of Castile, mysticism and faith, appears in all its beauty in the constellation of monasteries, churches and abbeys that sanctify the Duero River Valley. The Romanesque façade of Santo Domingo Church at Soria is decorated with hundreds of statuettes that depict the main episodes in the Old and New Testament: standing out among the Apocalypse, the Passion of Christ, and the Massacre of the Innocents is the figure of Alfonso VII, the conqueror of Almería in 1147.

At Almazán the Duero suddenly changes direction, heading to the west. Here the network of canals allows the local population to irrigate hundreds of thousands of acres of

86 top In the stretch that marks the Spanish-Portuguese border, the Duero River penetrates a narrow canyon and flows between inaccessible rock faces that are

hundreds of feet high. These are the Arribes del Duero, the most spectacular gorges formed by this river in its long course from the Sierra de Urbión to the Atlantic Ocean.

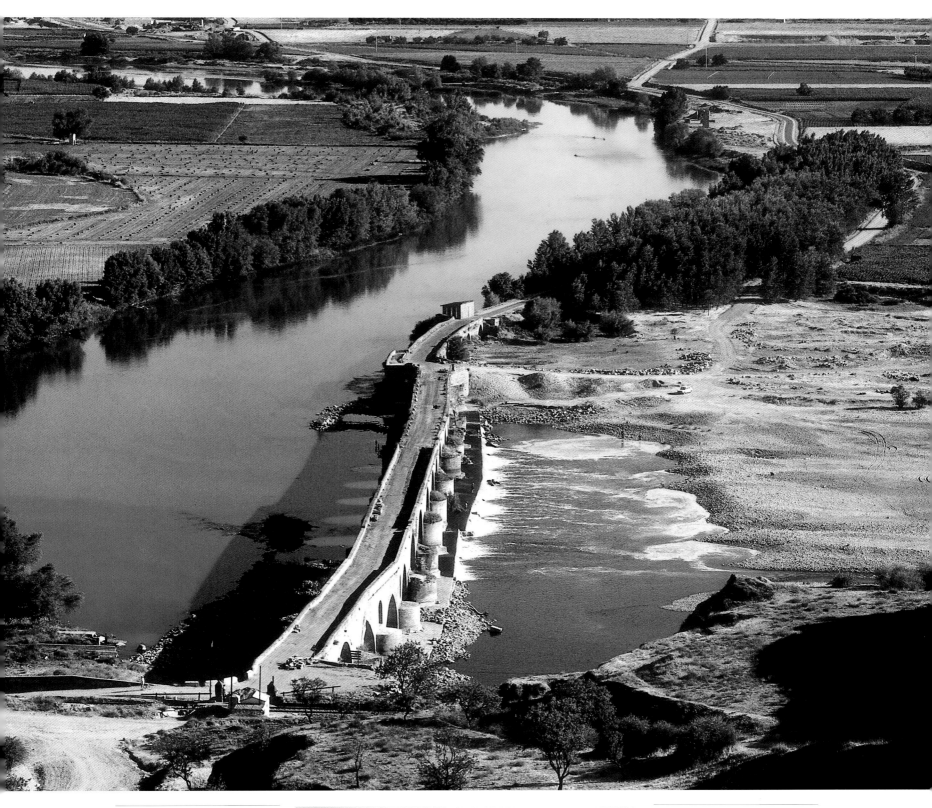

86-87 Cultivated fields and vineyards flank the Duero River near the peaceful town of Toro, in the Spanish province of Zamora. This land, which was once the theater of bloody battles between Christians and Muslims, produces some of the best wines in Spain.

87 bottom The vast, fertile plains of Castile-Léon near Gormaz are covered with wheat. The artificial lakes that interrupt the course of the Duero ensure large supplies of water for irrigation in a region that suffers from a chronic lack of rainfall.

The Duero

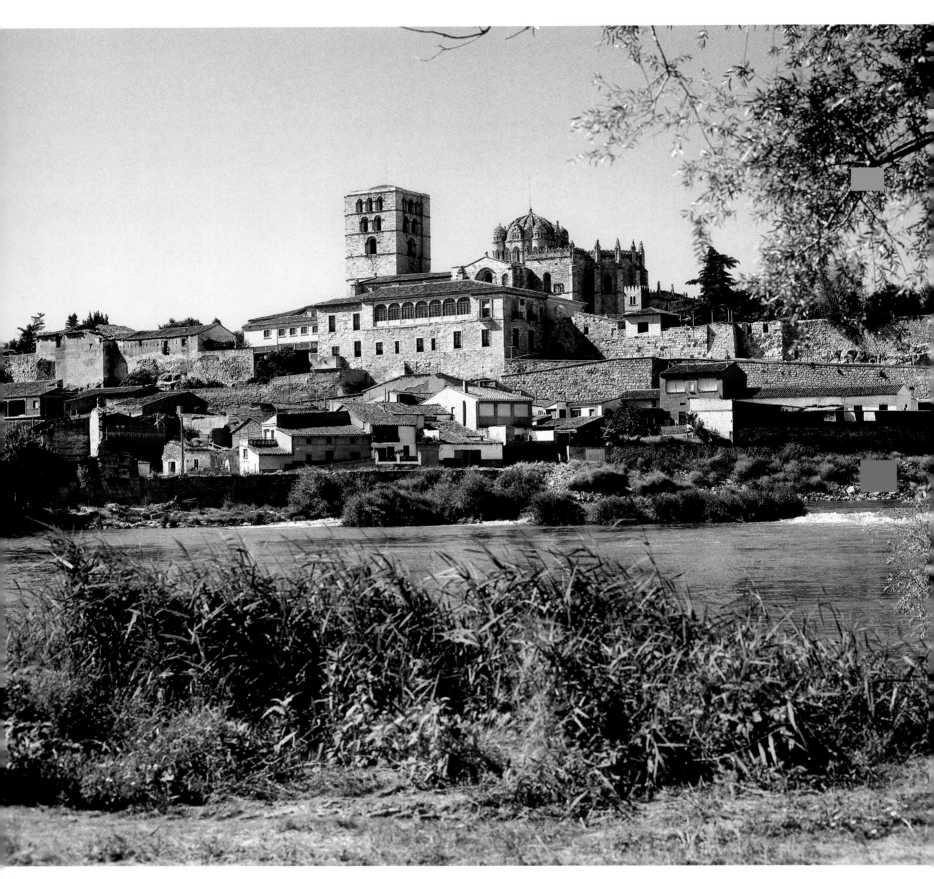

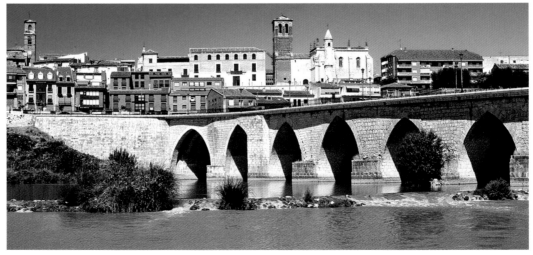

88-89 Zamora, the capital of one of the nine regions that make up the province of Castile-León, lies on the banks of the Duero near the Spanish-Portuguese border. Among the noteworthy monuments in this city are the 12th-century cathedral and the 12th-century stone bridge over the Duero, which has sixteen graceful arches.

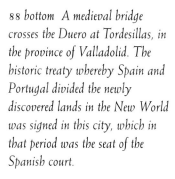

88 bottom A medieval bridge crosses the Duero at Tordesillas, in the province of Valladolid. The historic treaty whereby Spain and Portugal divided the newly discovered lands in the New World was signed in this city, which in that period was the seat of the Spanish court.

89 top Gormaz, lying on the banks of the Duero in the province of Soria, in one of the most picturesque parts of the borderland that witnessed the legendary exploits of El Cid Campeador. The hero of the Reconquista was rewarded by King Alfonso VI, who gave him the grandiose castle with 28 towers that dominates the village.

89 bottom Like a ship grounded on the plateaus that surround the Duero Valley, the castle of Peñafiel stands out at the eastern margins of Valladolid Province. The fortress, rebuilt in the early 14th century, is 656 ft (200 m) long and stands on the top of a rocky crest.

land that are used to grow cereals and as vineyards. The autonomous region of Castile-León is the largest wheat producer in Spain and the wines made in the Duero Valley are world-famous. The many dams that interrupt the course of the river provide a good supply of hydroelectric power and also act as reservoirs during droughts. The other areas of northern Spain often suffer from a scarcity of rainfall, and during the torrid continental summer most of the river evaporates. Furthermore, the river has an unstable and rather capricious regimen: in the past its outflow in the low- and high-water periods might vary from two to 700,000 cubic ft (20,000 cubic m) per second. Now, with the construction of a series of artificial basins, things have changed and the farmers of the meseta are better off. Yet the so-called Castile Canal was not laid out for irrigation, but for trade: by means of the Pisuerga River, an affluent of the Duero, the breadbasket of Spain sought an outlet toward Santander and the ports on the Bay of Biscay. Construction began in the late 1700s, during the reign of Ferdinand VI, and was completed only about 250 years later. Today the canal has revitalized the Tierra de Campos, with is 123,500 acres (50,000 hectares) of grain cultivation, and provides Valladolid with water. This city, the only large industrial center in the region, was once the capital of the empire and the favorite residence of the kings of Spain. Far from the opulence of court life, in a nondescript alley of Valladolid, Christopher Columbus died in 1506. And Miguel de Cervantes, plagued by misfortune and poverty, spent a brief period here in peace at work on his *Don Quixote*.

The Pisuerga, Valderaduey and above all the Esla, all flowing from the Cantabrian Mts., furnish a lot of water to the Duero, which continues its journey sluggishly through the undulating plains of the Castile basin. Tordesillas, on the right bank of the river, is a sleepy village with a few thousand inhabitants. And it was the venue, in 1494, of the signing of the treaty that for the first time divided the world

into two spheres of influence: through the offices of the pope, the *raya*, an imaginary meridian line that divided the Atlantic Ocean, was marked out. Spain had the right to own all the lands discovered west of that virtual boundary, while Portugal had a free hand to the east of the line.

Once past Zamora, the river changes its look. Its gradient increases and the current becomes swifter. The Arribas del Duero, 78 miles (120 km) of dizzying gorges squeezed between precipitous rock faces hundreds of feet high, mark the most spectacular section of the Spanish-Portuguese border.

Eagles, vultures, black storks, and peregrine falcons populate the valley, and the craggy cliffs of the surrounding

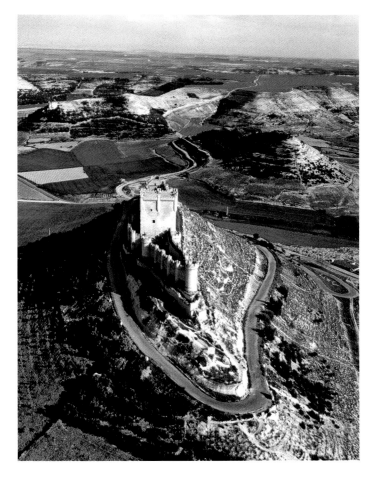

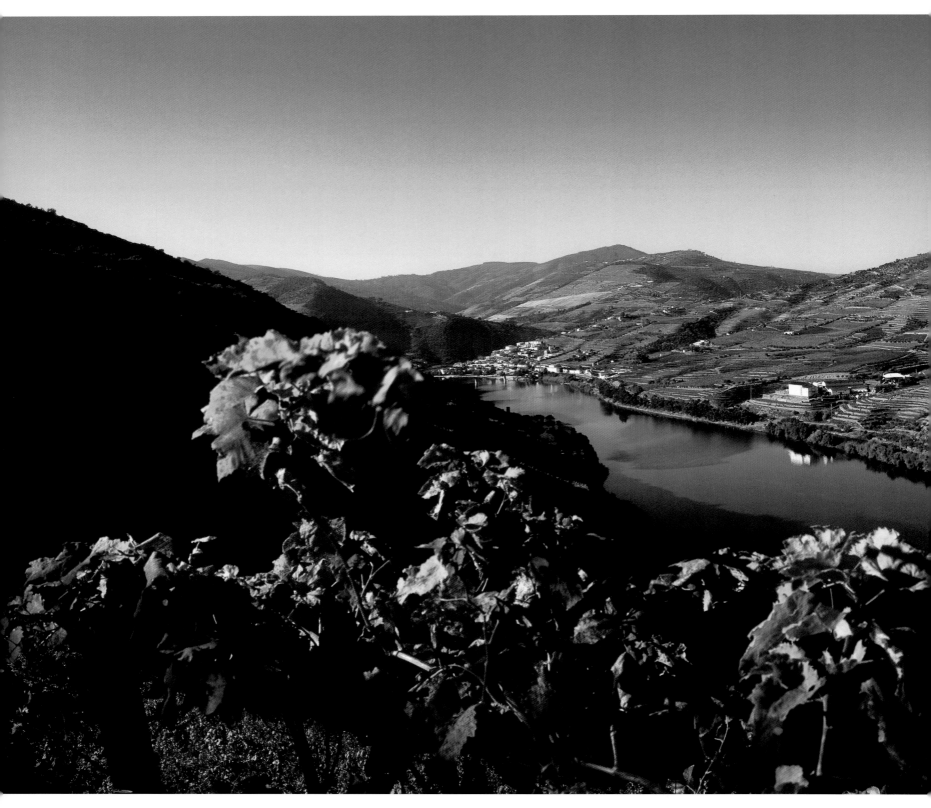

mountains are the home of the last packs of wolves
in the Iberian Peninsula.

When the river flows into Portugal it takes the name of
Duoro. Terraces with vineyards cover the steep, sunny
shores. Port wine, the pride and joy of the national
winemaking tradition, is produced in this area. Fortified with
the addition of brandy, which interrupts the process of
fermentation and preserves the sugar content, the port is
poured into wooden barrels and aged until it has the right
quality. After 573 miles (925 km), the Duoro flows into the
Atlantic Ocean at Oporto, the mother city of Portugal.

*90-91 and 91 bottom left After
having formed part of the Spanish-
Portuguese border, the Duero flows
into Portugal, where it is called the
Douro. The hills that roll down
toward the river are covered with
vineyards: the world-famous port
wine is produced in this thin strip of
land between the towns of Mazouco
and Barqueiro that is no more than
18 miles (30 km) wide.*

*91 bottom right With their
veils unfurled and decorated
with the brand-names of the
main producers of port,
these barcos rabelos proceed
slowly in the Douro river
in the city of Oporto, Portugal.
Up to 1965 these traditional
flat-bottomed sailboats were
used to transport wine on
the river.*

THE DUERO

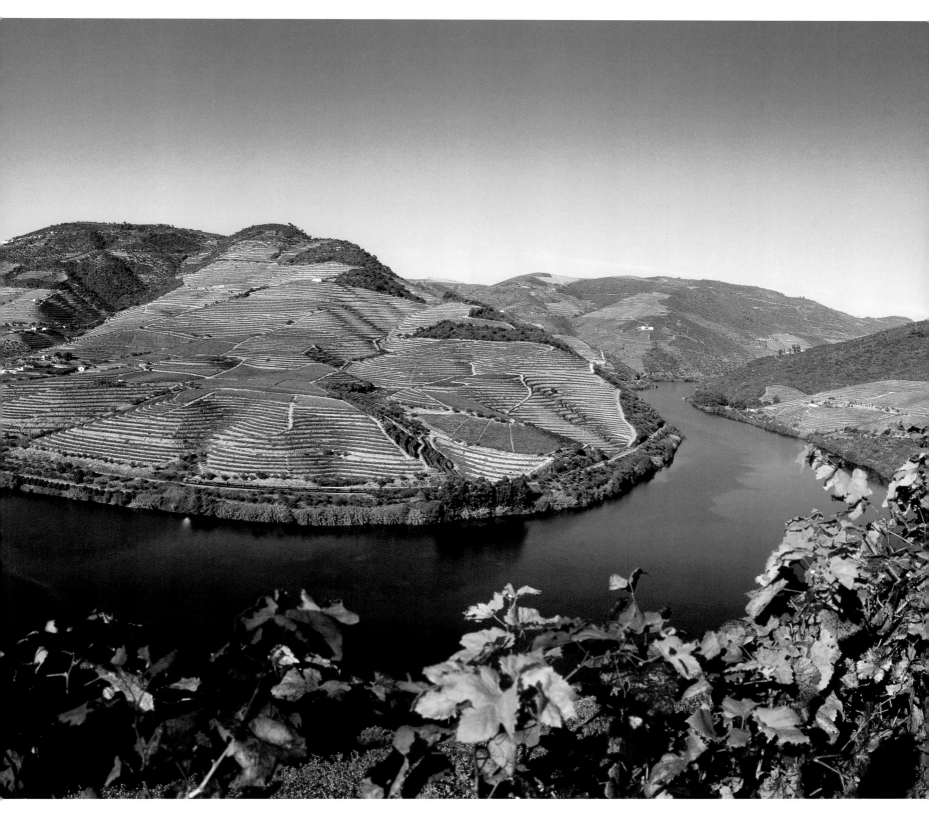

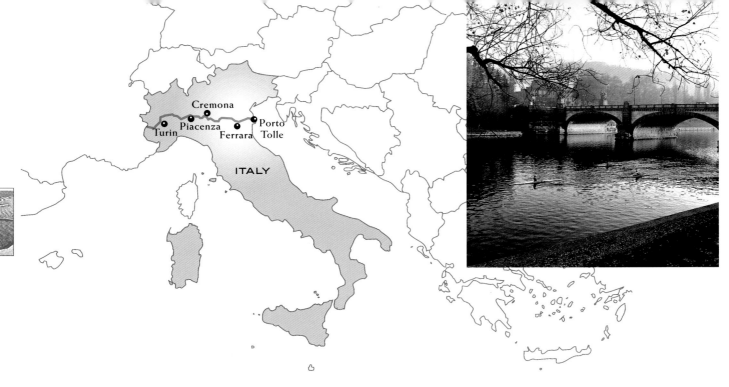

THE PO

FROM THE ALPS TO THE SEA

Compared to the other European rivers, the Po seems almost insignificant. It is not a major commercial thoroughfare like the Rhine, nor has it the historic importance of the Danube or the Seine. And compared to the powerful Volga it looks like a mere brook. Its importance does not depend on its size or discharge, but on the land it traverses. The Po River Valley is the center of gravity of the Italian economy and one of the richest and most densely populated areas in Europe: one-third of the agricultural, zootechnical and industrial production of Italy is concentrated in the Po basin, where some 16 million people live and work. The river provides this huge population with electric power and water to irrigate the farmland and rice paddies; at the same time it is a major vacation and recreation area. From the French border to the lowlands of the Po Delta, a chain of cities dots the shores of this great river: industrial centers such as Turin, the home of the FIAT automobile-manufacturers, and lovely art cities such as Piacenza, Pavia, Cremona, Mantua and Ferrara.

Padania, the valley of the Po (which the Romans called the Padus), is in every respect a gift from the river. A million years ago the plain lay under a warm, shallow sea that ran as far as the edges of the pre-alpine mountains in the region of Piedmont. Then the Earth's crust slowly rose and the climate became rainier. The erosive action of the rivers increased, gradually filling the enormous basin with sediment so that it became flat and uniform. The Po divides the Po River Valley into two asymmetrical sections. In fact, the combined force of the Alpine affluents, which are much swifter and larger than the Apennine tributaries, has shifted it course southward. This two-fold supply determines the regular regimen of the river, which in spring is replenished by the thawing snow on the Alps and in autumn by the floodwater that swells the waterways from the Apennines. However, the placid aspect of the Po must not delude us, because despite the fact that the river, from Cremona onward, flows between tall embankments, its floods have often had devastating effects. In November 1951 the river broke through the embankments below Ferrara, inundating most of the Polesine area with 10 ft (3 m) of muddy water; the result was a single

lake ranging from Rovigo to Adria and as far as the Adige River. The last flood struck the Piedmont region in 2000: after three days of terrific rainfall, the floodwaters overran vast zones of Turin. The water supply had to be suspended, the bridges were closed, and road and railway transportation was interrupted. The Dora Baltea, Orco and other minor tributaries overflowed over the countryside. The toll reads ten deaths, 10,000 people homeless, and 500,000 euros of damage to the infrastructures.

The cause of this disaster begins almost secretly, as it were, with typical Piedmontese modesty, from the slopes of a perfect mountain, Monviso, which towers over the Cottian Alps. At Pian del Re, between two rock masses covered with lichens, a commemorative plaque officially indicates the origin of the Po, even specifying the altitude – 6666 ft (2020 m) above sea level. But the true source of the river is even higher, consisting of a series of torrents and small lakes with their distributaries that merge above the village of Crissolo. The river plunges headlong downstream, with a gradient of 4950 ft in only 22 miles (1500 m in only 35 km). Revello and Saluzzo welcome it at the threshold of the pre-Alpine plain. In the late 15th century the old salt road passed through the valley, completing its journey from the Rhône River delta to the marches of the marquisate of Saluzzo. The monumental Staffarda Abbey marks the beginning of the middle section of the Po, which from here heads directly northward. The river widens in a vast and winding bed, flowing through an expanse of farmland with intensive cultivation. The profile of the Alps fades away in the distance and the first rows of poplars appear on the scene. Before arriving at Turin, the Po receives three Alpine affluents – the Maira, Varaita and Pellice – which increase its outflow to a considerable degree.

The relationship between the Po and Turin is rather recent; the city began to expand beyond the historic center only during the Napoleonic period. The major city thoroughfare, Via Po, and the Neo-Classical Piazza Vittorio, which directly faces the river, both date from the early 1800s. Once past Turin, the Po flows eastward, touching the beautiful hills of the Monferrato and Oltrepò Pavese areas. At Chivasso, the Cavour Canal connects the Po with the Ticino River, channeling part of its

92 top The monumental Umberto I Bridge, built in the early 20th century, crosses over the Po River in Turin, connecting the downtown area and the Porta Nuova railway station with the hilly areas. It is decorated with four statues representing Compassion, Valor, Art and Labor.

92-93 Viewed from the Superga Basilica situated on the hill that borders the right bank of the Po, the plain on which Turin develops fades away toward the foothills of the Alps. The Po crosses the city from south to north, taking in the waters of the Sangone, Dora Riparia and Stura di Lanzo rivers.

93 bottom The fascinating profile of the Borgo Medievale, immersed in the greenery of the Valentino Park, welcomes the Po on its entrance into Turin. This impressive edifice was built on occasion of the International Exposition of 1884 as a reproduction of a slice of 15th-century life in the Piedmont region.

THE PO

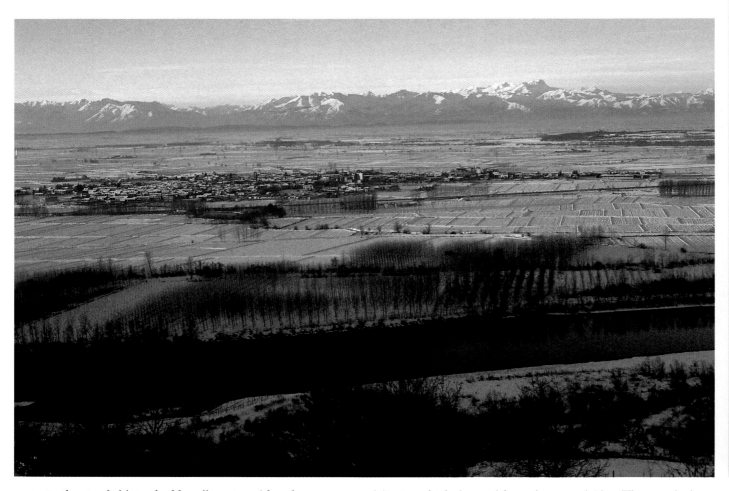

water to the rice fields in the Vercelli region. After the confluence with the Sesia and Tanaro rivers, the Po runs into the great plain. Then the merger with the Ticino makes it majestic and solemn: the pebbly banks give way to the large and ever-changing sandy ones. Massive embankments, which are often quite a distance from the shores, accompany the river, which now flows in a single channel.

From the 10th century on, the Benedictine and Cistercian monks began to reclaim the marshland situated along the Po. But only in the early 1900s was this humid zone successfully transformed into land fit for agriculture, a process that reshaped the lower Po Valley landscape. Above Piacenza the last strip of the Ligurian Apennines stretches out toward the river, separating the Marengo plain from the Emilia region. In that narrow passage near the confluence with the Trebbia River, Hannibal enjoyed his first major victory over the Romans in 218 BC. In the area between Piacenza and Mantua, the Po receives three of the largest of its 141 tributaries: the Adda, the Oglio and the

Mincio, which descend from the central Alps. The woods that once covered the shores and lowlands have been replaced almost everywhere by the regular geometric poplar groves, as these trees are exploited for the production of cellulose. At this stage the wild spirit of the Po can be noted only in limited areas, reserves and parks that are protected by law but not always managed as efficiently as they should be. At present, attempts are being made to rectify the errors of the past by aiming at more logical development: the exceptional floods of recent years seem to have been caused by the excessive enclosure of the river, which due to the accumulation of sediment flows in a bed that is higher than the surrounding plains. The delta, on the contrary, is slowly sinking below sea level. The Po arrives at the Adriatic Sea with fourteen mouths and inlets fed by five large delta branches. The labyrinth of lagoons, canebrakes and forests has created one of the most interesting environments in Europe. For twenty years there has been talk of a Po Delta National Park. The river, melancholy, hopes that better times are ahead.

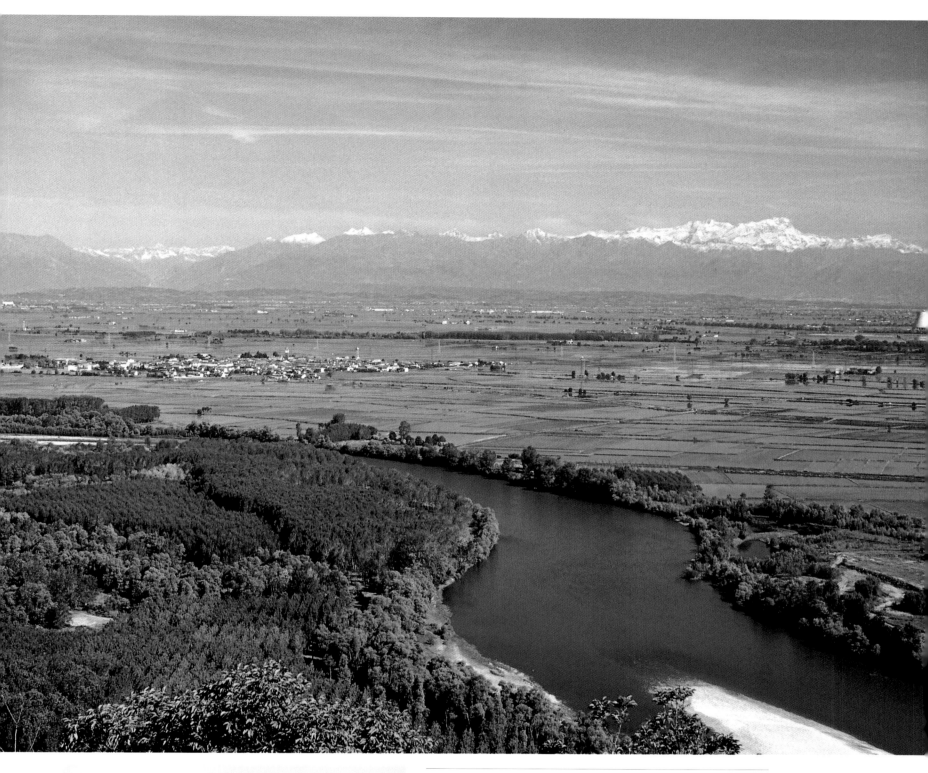

95 bottom left The middle course of the Po, from Turin to Ferrara, is vital for Po River Valley agriculture. Here we see corn and soy fields in the Mantua area.

95 bottom right The Po, fed abundantly by its tributaries, flows majestically among large sand bars in the Piedmont plain downstream from Turin.

94 top In winter the small vessels used for going down the Po at the Piedmont-Lombardy border remain moored on the banks.

94 bottom and 94-95 The rice paddies in the area between the Po, the Sesia and the Ticino rivers flood over in spring. In winter, after the harvest, the water is replaced by a layer of frost.

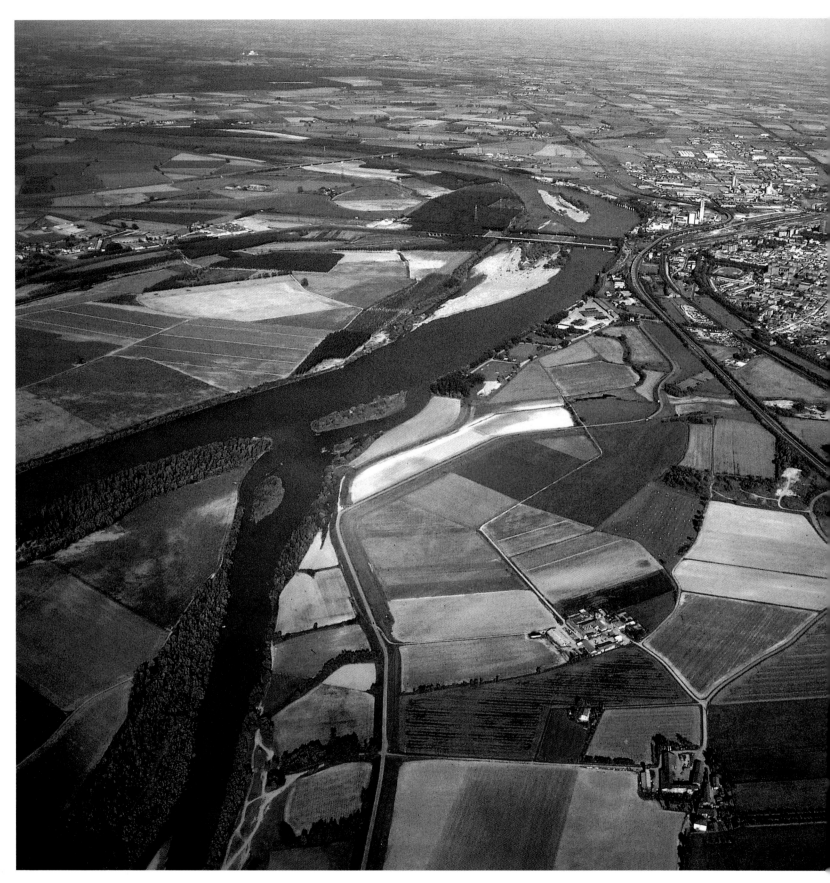

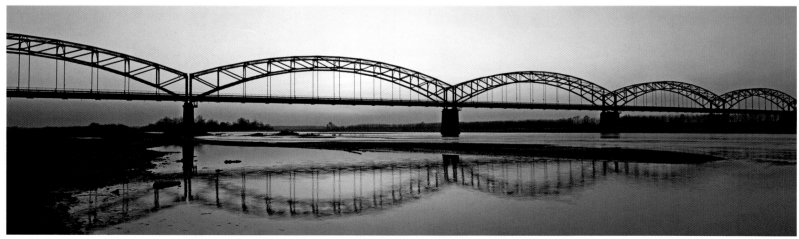

E
U
R
O
P
E

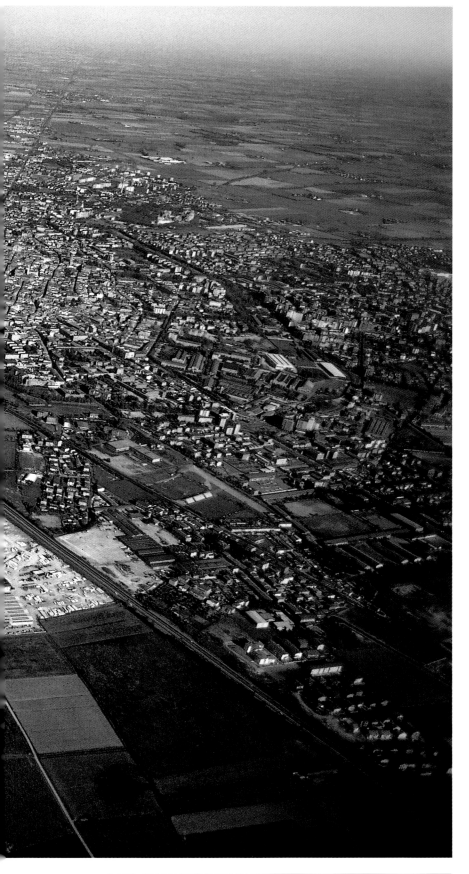

97 center bottom Only the occasional fisherman's home interrupts the monotony of the horizon in the Valli di Comacchio area, which consists of vast lagoons with still waters formed by the configuration of the Po delta.

97 bottom The Este castle of Mesola, in the province of Ferrara, was built in the late 1500s on the right bank of the Po di Goro, one of the main branches of the delta. Surrounded by a 7.5 mile (12-km) wall, this castle was used as both a summer residence and hunting lodge.

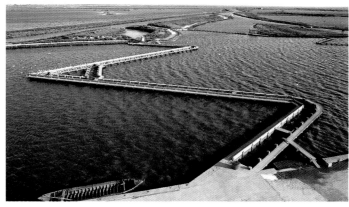

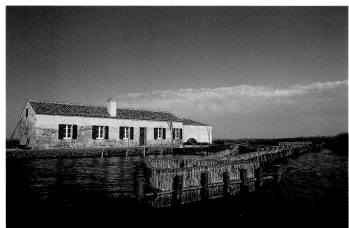

96-97 The Trebbia River merges with the Po upstream from Piacenza, the capital of the westernmost province of the Emilia-Romagna region.

96 bottom The bridges over the Po River are the weak point of the road and railway communications system of the Po Valley, the hub of the Italian economy.

97 top The 'skyline' of Cremona, which overlooks the Po, stands out against the hazy sky of the lower Po Valley.

97 center top Fishing has always been one of the main economic activies of the Po River delta. In the Valli di Comacchio the fishermen still use the traditional method of the lavorieri, wedge-shaped barriers that capture the migrating eels and fish in the delta.

97

AFRICA

We need take only a quick glance at a map of Africa to realize that the network of rivers there reflects the climatic conditions and geographic configuration of the continent.

Africa south of the Sahara Desert is like a large tableland, which is bordered by steep cliffs, especially in the southern section. Consequently, near their mouths all the African rivers are interrupted by swift or spectacular waterfalls that impede navigation. The fact that the rivers cannot therefore be used to penetrate the interior, together with the difficulties and obstacles posed by the environment, made the exploration of the African continent a long and arduous undertaking. Up to about 150 years ago, the heart of the continent was like a huge white blotch on the maps. The sources of the Nile River, the greatest geographic puzzle of all time, were unknown for twenty centuries. And the Blue Nile Valley, lost among the craggy hills of Ethiopia, was traced only in 1968 by an expedition of English soldiers who were provided with a great deal of logistical means and support. Most of the waterways and lakes are concentrated near the Equator, where there is abundant rainfall all year long. With the exception of the Congo, all the rivers in Africa are subject to periods of a shortage of water, with remarkable differences in the outflow between the dry and rainy seasons. The waterway system in the Sahara zone is chaotic, reduced to a network of dry beds that only on exceptional occasions are filled with water.

The Niger and Senegal are the only important rivers in this section of West Africa and part of their course is situated in wholly arid zones. In the deserts of southern Africa the same configuration is repeated symmetrically, albeit in a less drastic fashion: the Okavango River, which begins in the hills of Angola, ends in the sands of the Kalahari Desert, creating a gigantic delta that in the years with heavy rainfall overflows into the dry basins in the middle of Botswana. Lake Etosha, on the other hand, has become dry for good, an absolutely sterile saline basin: its only tributary from the north was 'pirated' by the Cunene River, which flow into the Atlantic at the Angola-Namibia border. And according to the prediction of geologists, the Logoné River, which empties into Lake Chad, is about to end up the same way: its waters are feeding the Bénoué, and hence the Niger, to an ever increasing degree, and without it Lake Chad will become extinct. Except for the Zambesi, the only rivers of any importance in southern Africa are the Limpopo and the Orange, which descend from the Drakensberg Mts. and flows into the Atlantic Ocean some 1240 miles (2000 km) distant.

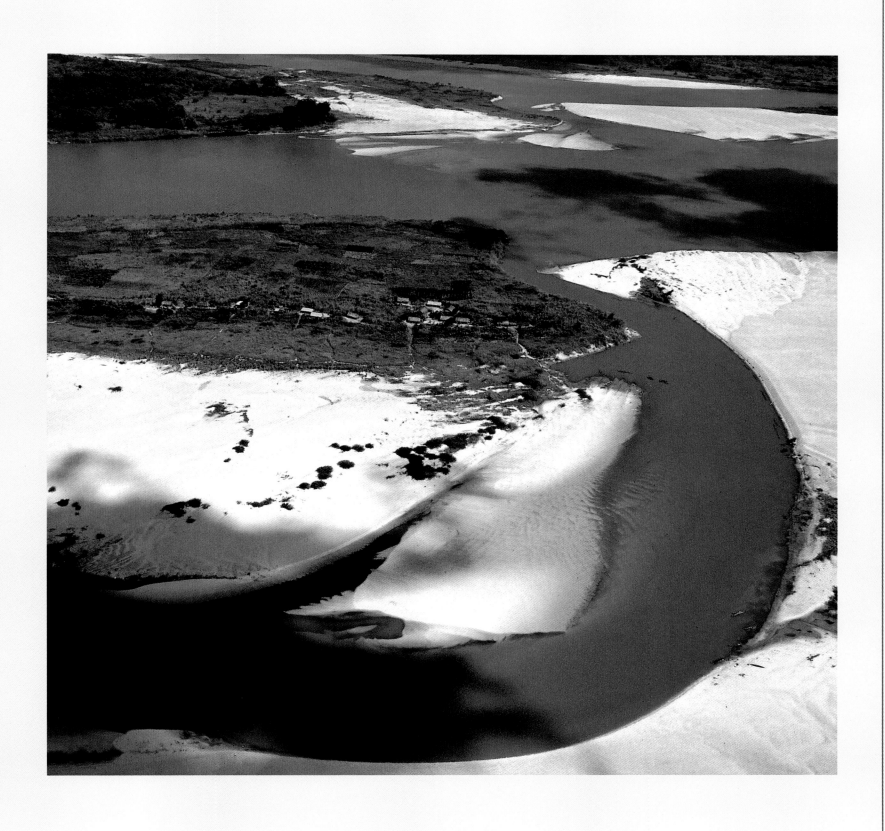

98 left *The Zambesi at Victoria Falls, in Zimbabwe.*

98 center *The mouth of the Congo River at Brazzaville, in the Congo.*

98 right *The temples of Abu Simbel on Lake Nasser, Egypt.*

99 *A fishermen's village on the banks of the Niger, in Nigeria.*

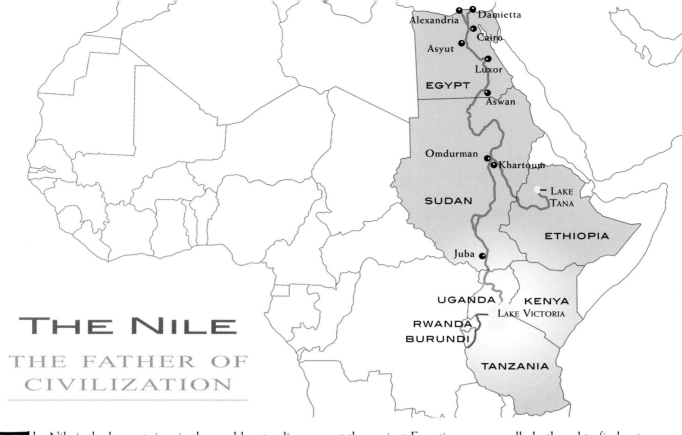

THE NILE

THE FATHER OF CIVILIZATION

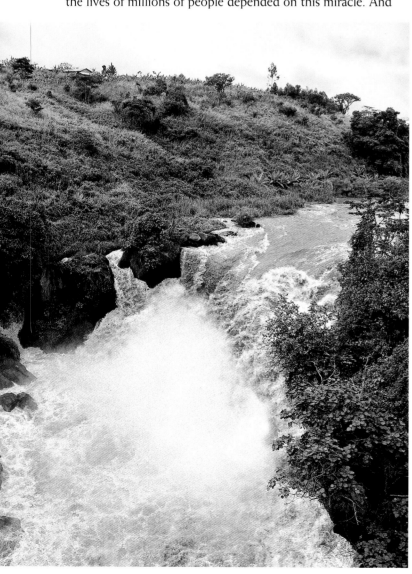

The Nile is the longest river in the world, extending 4135 miles (6670 km), and certainly the most famous. No other geographic phenomenon has been wrapped in mystery for so long or has so fascinated people as the sources of this river. From a practical standpoint, the Nile is a complex hydraulic machine that carries the equatorial rainfall as far as the Mediterranean coast, after traversing the largest desert on Earth. Every year, at the end of the dry season, the river emerged from its bed and flooded the plains of ancient Egypt, depositing fertile silt that made for soil replenishment and thus brought prosperity in its wake. Indeed, the lives of millions of people depended on this miracle. And

yet the ancient Egyptians never really bothered to find out where all that water came from, accepting it with a fatalistic attitude as a great gift from the gods. True, the level of the Nile was accurately measured by means of Nilometers in order to calculate the taxes to be levied on the landowners who benefited from the precious silt transported by the river, but this was all the ancients did.

The first people to be curious about the sources of the Nile were the ancient Greeks. Herodotus went up the river as far as Aswan, at which point he realized that going any farther was far beyond his capacities. The Romans fared no better with their expeditions. According to Ptolemy, the leading geographer of the time, the Nile rose at the so-called Mountains of the Moon, which were very high and covered with perennial snow. He drew up his famous map in the 2nd century AD, charting the course of the river with astonishing precision. Then, for the following 1700 years no significant datum was added to the knowledge of the river. The heart of Africa remained an imaginary place, the domain of monstrous creatures and cannibals. It was only on the threshold of the 19th century that an exploration mania pervaded Europe and the mystery of the source of the Nile suddenly became a topical subject.

In 1862 the members of the Royal Geographic Society of London were amazed to read a telegram sent from one of their emissaries in Africa. The message, signed by John Speke, was quite succinct: "The Nile has been sorted out." Naturally, the problem by no means solved. Speke had seen a large river flowing from Lake Victoria, but he had no proof that it was the Nile. For decades expeditions had set out in search of the source of the Nile despite incredible difficulties. Richard Burton, J. A. Grant, Samuel Baker, David Livingstone, Henry Stanley and other explorers of the time confronted this challenge, each one seeking his own personal source and a bit of glory. Spurred on by his detractors, Speke died in a hunting accident that had all the earmarks of suicide. A few years later, a plaque with a rather ambiguous inscription was set at the point where the Nile emerges from Lake Victoria: "Speke discovered this source of the Nile on 28 July 1862." Poor Speke had been partly right, as had Ptolemy, for that matter. And Baker, who found the source of the river in Lake Albert, was not far from the truth.

100 *Rapids and falls are a distinguishing feature of the upper Kagera River, the most important tributary of Lake Victoria. The headstreams of the Kagera, now* *considered Nile's true source, rise on the mountains at an altitude of about 7900 ft (2000 m). They were discovered in 1937 by the German explorer Burkhart Waldecker.*

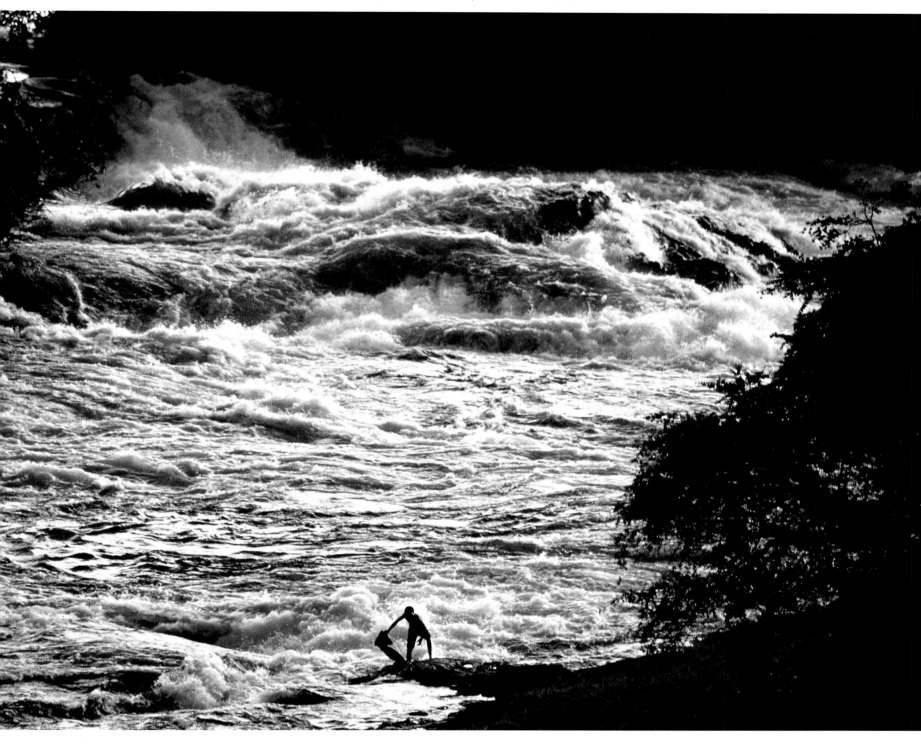

100-101 *After passing through Lake Victoria, the Nile enters forests of Uganda, the first stage in the long journey that ends in the Mediterranean Sea. The Ripon Falls, which the English explorer Speke asserted were the source of the Nile (1862), are now submerged by the waters of a large artificial lake.*

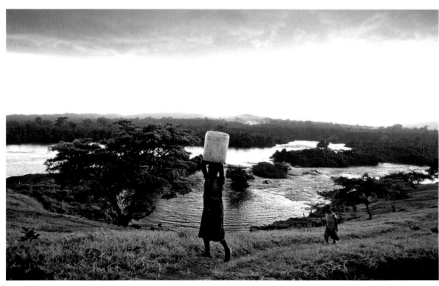

101 bottom *After the Owen Falls dam, the river, which is now about 985 ft (300 m) wide, flows through a narrow valley, creating a series of raging rapids among low hills covered with grass and patches of luxuriant vegetation.*

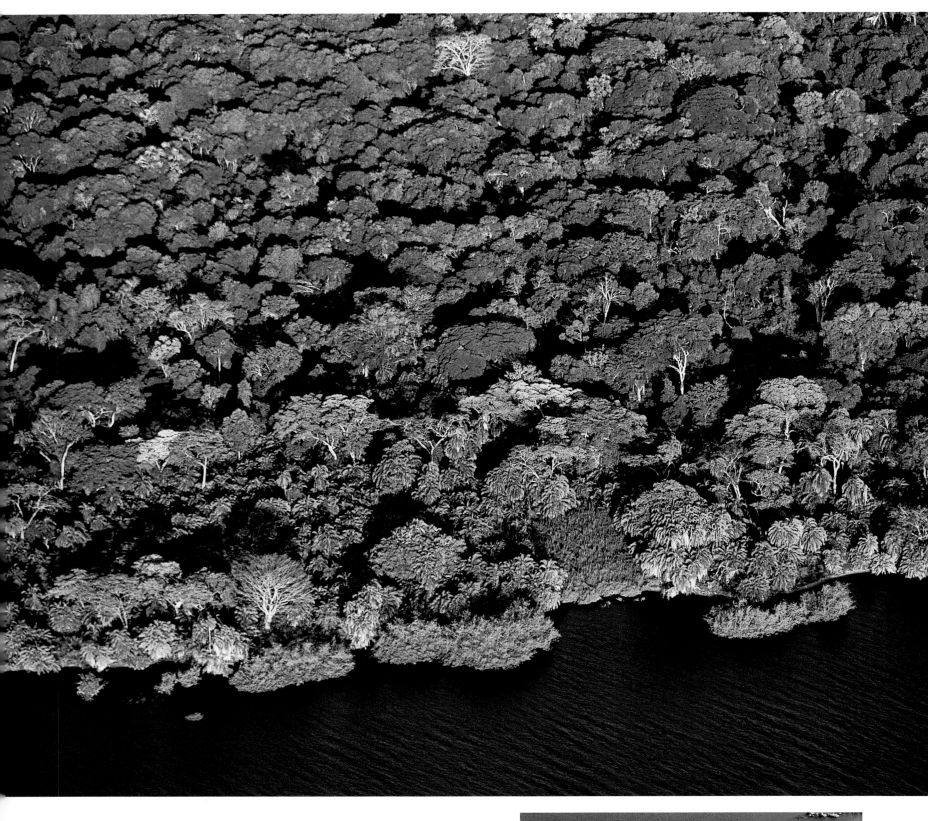

THE NILE

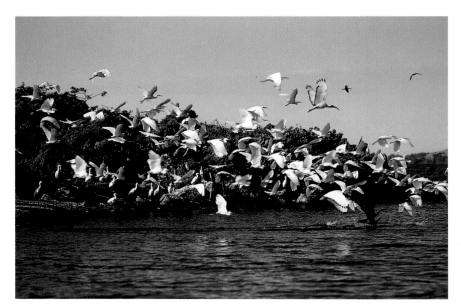

102-103 and 103 center A thick forest covers the shores of Lake Victoria, by far the largest of the many natural basins that dot Equatorial Africa: a colossal inland sea 230 miles long by 155 miles wide (370 by 250 km) that adjoins the territories of Uganda, Kenya and Tanzania. A strong current runs through the lake from the mouth of the Kagera River to the exit of the Nile.

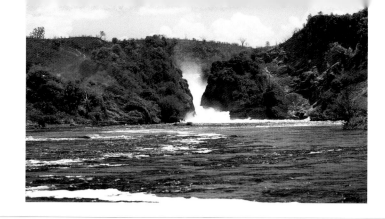

A F R I C A

102 bottom and 103 bottom Large flocks of aquatic birds frequent the indented shores of Lake Victoria, which is bordered by luxuriant vegetation and marshland. The basin that hosts the waters of this enormous lake, which covers about 27,080 sq. miles

(70,000 sq. km), is the result of massive tectonic movements that led to the formation of the Great Rift Valley. The lake, named after the Britain's queen in the 19th century, is called Nyanza by the natives, which literally means 'water.'

103 top In northern Uganda, before emptying into Lake Albert, the Nile is squeezed in a gorge, precipitating in a vortex of foam in the Kabarega Falls, which are 130 ft (40 m) high. The local populations call this headlong leap of the river "Bajao," which roughly means 'the Devil's Cauldron.'

In fact, the situation is complex. Since 1937 the official source of the Nile has been established among the mountains of Burundi – the Kagera River, which is the most important inflowing waterway of Lake Victoria. A pyramid of stones symbolically sanctions its historic identity. Starting off from that inland sea, which is twice as large as Switzerland, the river begins it northward course, a direction it will maintain to a greater or lesser degree for its entire length. Crossing the hills of Uganda, the so-called Victoria Nile flows into the marshy Kyoga Lake and eventually reaches Lake Albert, the last of the chain of basins that dot the western Great Rift Valley.

The other branch of the genealogical tree of the Nile begins at Lake George, connected to Lake Edward, which in turn communicates with Lake Albert by means of the Semliki River. This section of the river system is fed by the rains that fall all year long on the Ruwenzori massif, the mythical Mountains of the Moon. Although it is rather distant from the remotest sources, Lake Albert is one of the two large reservoirs that collect the water that later gives rise to the Bahr el-Jebel, the Nile of the Mountains, which from this point on begins its voyage toward the lowlands of the Sudan. About 140 years ago, Baker guessed the truth, but strangely enough he limited his exploration to the northern tip of the lake, without bothering to prove his theory.

Baker is credited with the discovery of the Kabarega Falls, which brusquely interrupt the course of the Victoria Nile 31 miles (50 km) before the mouth in Lake Albert. All of a sudden, the river is squeezed between two walls of black rock and precipitates for 132 ft (40 m) into a ravine that is barely 20 ft (6 m) wide. A short distance downstream from the falls, where the current becomes placid, hundreds of crocodiles and hippopotami bask in the sun on beaches of golden sand. For years civil war raged in this region and was extremely harmful for the wild animals. The elephants and rhinoceroses, which abounded here even outside the confines of the national parks, were decimated by greedy hunters for

their ivory and horns, and poaching triggered by hunger did the rest. Recently the situation has improved greatly, and for Uganda, considered the "pearl of Africa" in the past, better times lie ahead.

Once past the Fula rapids, the Nile moves into the

Sudanese plains, a flat sea of grass dotted with acacias and thorny bushes that during the rainy season becomes a luxuriant savanna soaked with water. Juba is the capital of this solitary land that is periodically struck by rebellions against the excessive power wielded by Khartoum, which has always considered the Bilad-es-Sudan, or Land of the Blacks, a treasure trove of natural resources. Once it was the source of ivory and slaves, while now it provides minerals, petroleum and above all water, the most precious resource of all. A boat connects Juba and Kosti, 930 miles (1500 km) to the north, an exhausting journey that may take 8 to 10 days. No one knows how long it takes to navigate

through the swamps in the Bor Valley stretch of the Nile. The Arabs call them Sudd or 'obstacle,' while Baker gave them the name of the river of Hades, Styx: an aquatic maze as large as the Po River valley, a morass of water hyacinths, rushes and floating islands in continuous movement. For the explorers and traders who went up the river from Khartoum the Sudd swamps were a nightmare. In 1880 the Italian Romolo Gessi was trapped there for months; only one-fourth of the 600 men in his expedition managed to survive. The Nile risks disappearing in that maze of canals and lagoons that is really an inland delta, and when it emerges from the swamps its discharge has been reduced by half.

The Jonglei canal has been a topic of discussion for a century: it was supposed to divert the Nile for 230 miles (370 km), from Bor to the harbor of the Malakal River, taking its waters to the dry land of the northern Sudan and avoiding the swamps. Work on the canal began about twenty years ago, but it was interrupted by a series of targeted guerrilla attacks: the people in the south do not approve of the government project because they feel their land is being exploited without their gaining anything in return.

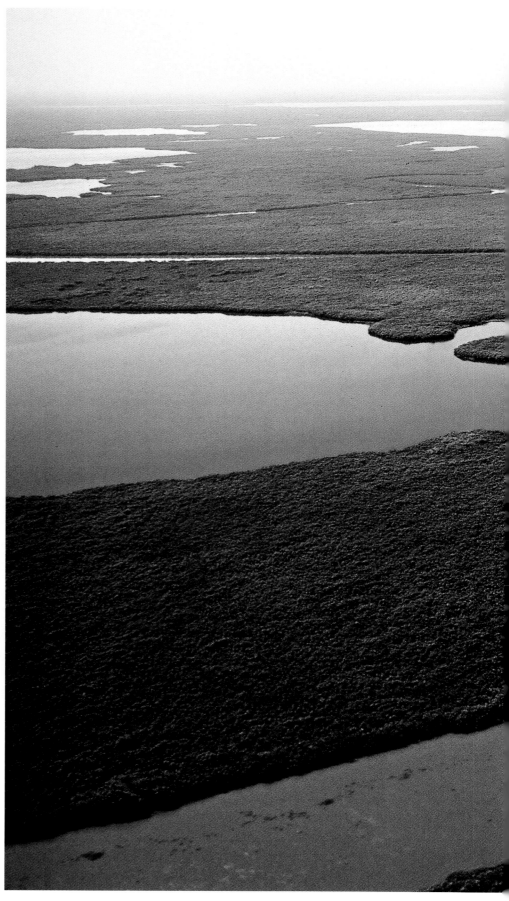

Isolated from the rest of the world, the Dinka, Nuer and Shilluk tribes live on livestock and fishing, while agriculture is practiced at a subsistence level. The economy of these populations, which are closely related, is based on animal husbandry. For them cows are everything – the heart of their social activities, the object of ardent love, and a yardstick for their relations with the world. The Dinka have 750 ways of describing the virtues of an animal, according to its size, color, the shape of its horns and ears, its character, and anything else that might satisfy the fertile imagination of pastoral people. The summer rainfall transforms

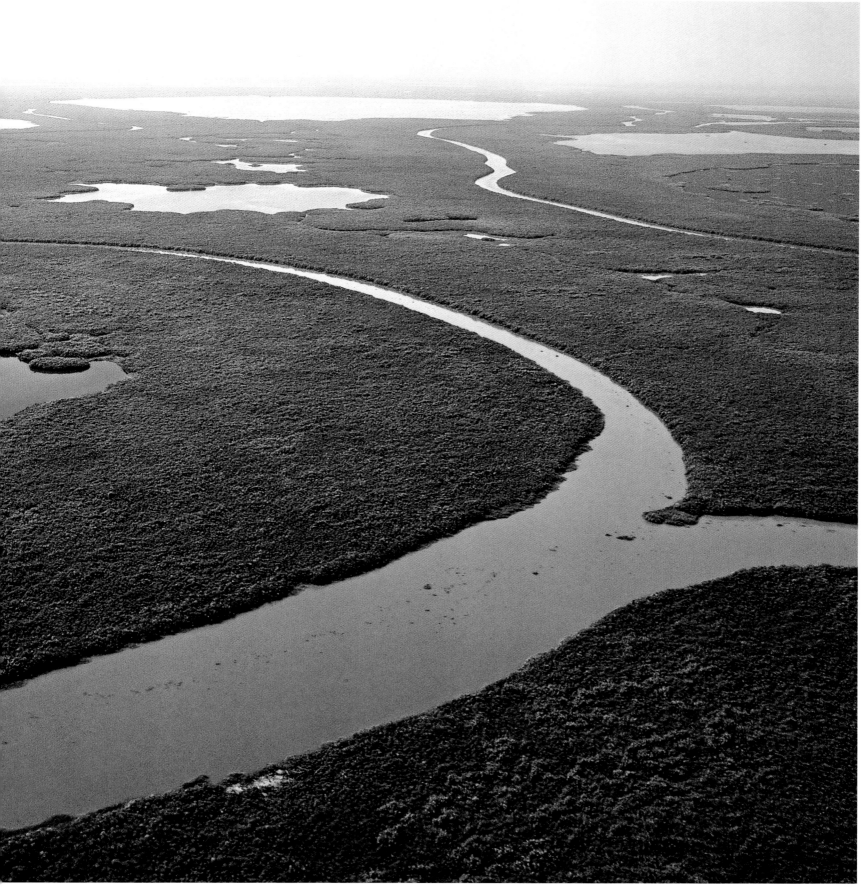

the plain into a marshland and the transhumance routes are no longer negotiable, so that the locals' life is concentrated in the villages, which are build in the elevated areas and surrounded by fields of millet and sorghum. Lake No, situated at the confluence with the Bahr el-Ghazal or Gazelle River, marks the end of the Sudd. A short distance farther on the Nile merges with the Giraffe River and also takes in the abundant waters of the Sobat, which arrives from the highlands of Ethiopia. From this point on, the river is known as the White Nile.

Passing Malakal, the river proceeds in a rather straight line

104 A felucca, the typical lateen-rigged sailing boat used for centuries on the lower course of the Nile, plows through the waters of the great river between Khartoum and Lake Nasser. Because of their shallow draft, feluccas are still the vessels most used for transporting goods in Sudan.

104-105 Viewed from on high, the Sudd swamps in southern Sudan look like a gigantic aquatic labyrinth with indefinite contours. Although they obstruct navigation along the Nile, the huge floating islands of papyrus and water hyacinths are the ideal habitat for a great many species of birds.

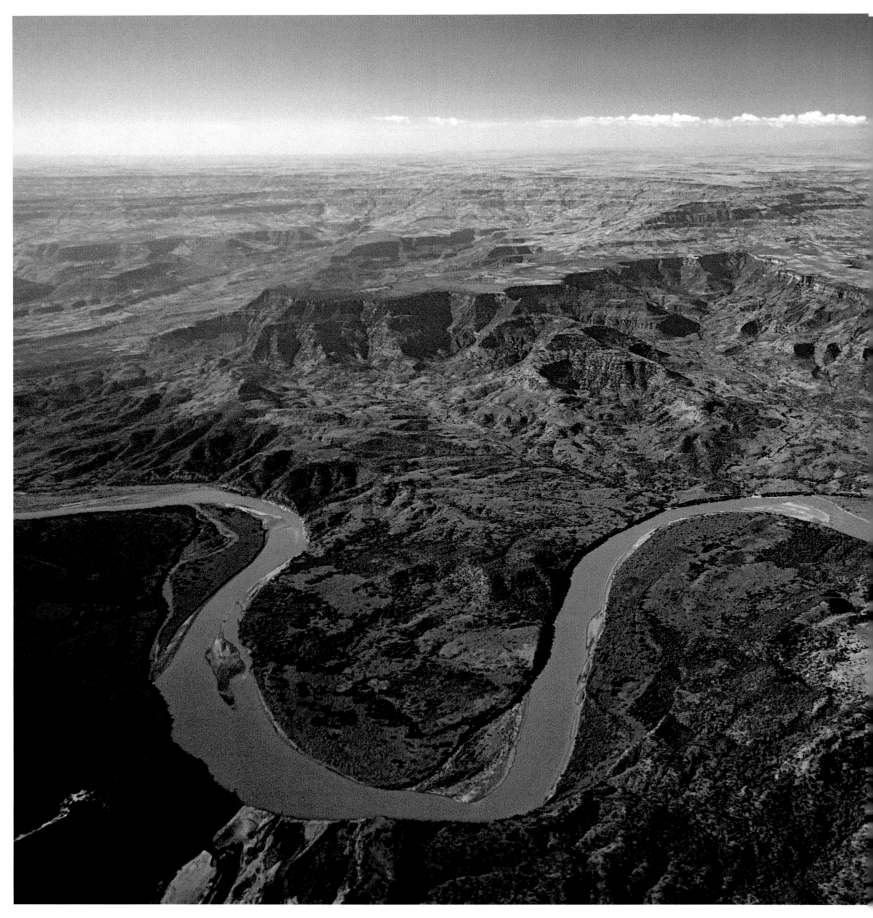

through countryside that gradually becomes more arid: the savannas are replaced by monotonous horizons that herald the desert. Christian and animistic Black Africa is about to give way to Islam. When it arrives at Khartoum, the capital of the Sudan, the White Nile flows slowly on a vast bed between muddy banks. The plant detritus it has collected while passing through the swamps imparts a milky color to the river. The Blue Nile, filled with dark silt, plunges turbulently into the White Nile and like a dam checks its current, which almost seems forced to retreat. From its source in the heart of the Ethiopian highlands,

it has flowed rapidly for about 992 miles (1600 km), taking in hundreds of streams and small tributaries along the way.

The Blue Nile begins at an altitude of 9500 ft (2900 m) in the Gojjam Mts.; the source, a spring with clear, freezing water, is considered sacred by the inhabitants of the highlands. At first the Blue Nile is nothing more than a stream that soon becomes muddy, but when it rises out of Lake Tana it is able to give a demonstration of its character. In a maelstrom of mist it precipitates for 165 ft (50 m) in the Tisisat Falls and then flows in a series of gorges, where it will remain for the rest of its long

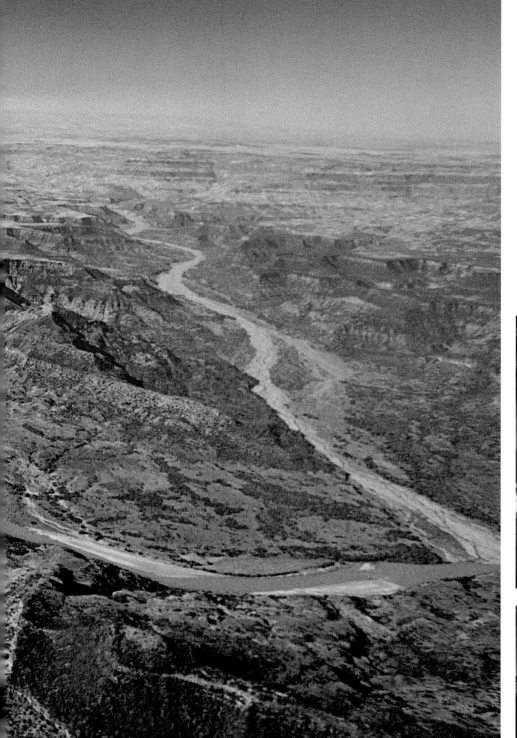

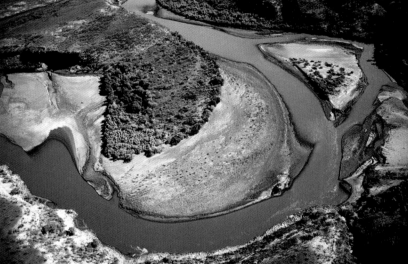

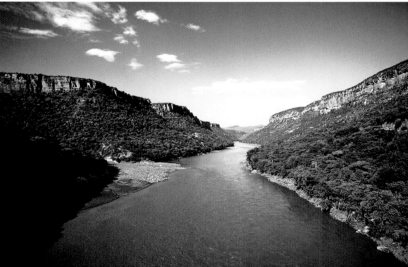

106-107 The Blue Nile runs through the deeply eroded, almost lunar terrain of the Ethiopian highlands. For 500 miles (800 km) the river is inaccessible as it flows violently through a narrow canyon between tall basalt rock faces that may be as much as 3280 ft (1000m) high.

107 During the dry months the discharge of the Blue Nile is reduced to 350 cu. ft (10 cu. m) per second, and it flows placidly through the hills of Ethiopia (photograph above). The landscape of the valley floor changes drastically during the rainy season (photo below), when the river takes in forty times more water than before. The huge quantity of silt transported by the flow is what makes the Sudanese and Egyptian terrain near the river so amazingly fertile.

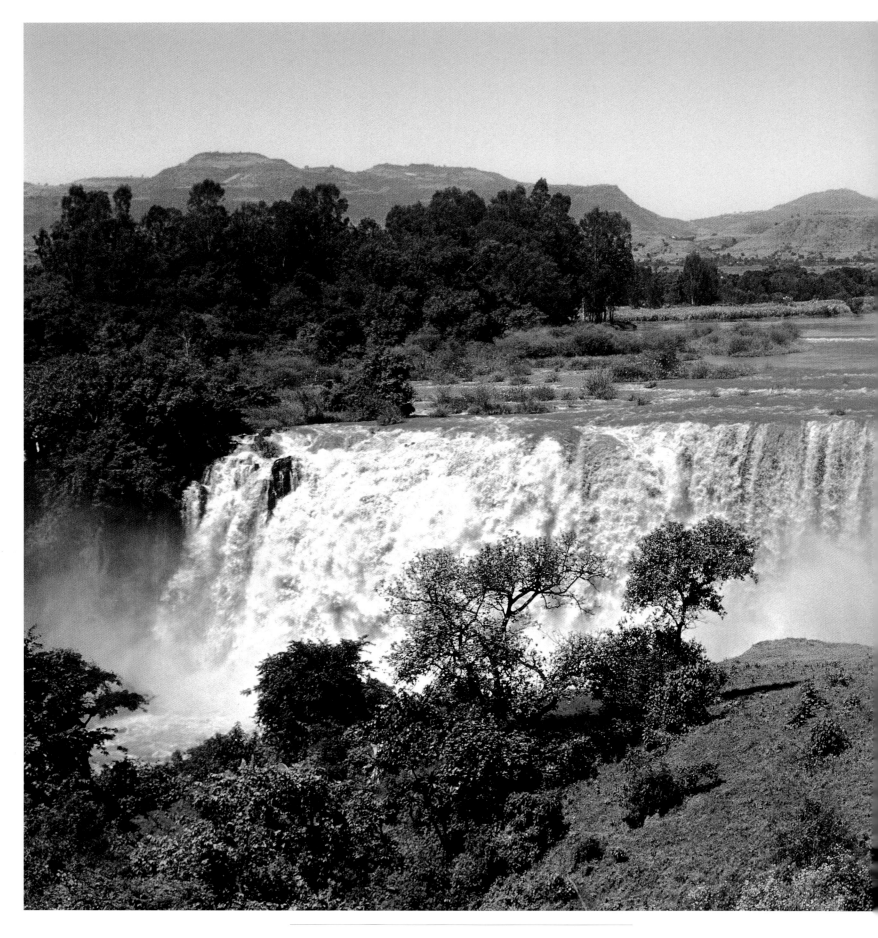

108-109 *The Tisisat Falls, among the most spectacular in Africa, interrupt the course of the Blue Nile barely 6.7 miles (10 km) downstream from Lake Tana. The river, which is 1640 ft (500 m) wide at this point, crashes against the rocks of its bed in a vortex of mist that is visible from a great distance.*

109 *From time immemorial the characteristic* tankwa, *very light boats made entirely of papyrus, have been used on the waters of Lake Tana, the natural reservoir of the Blue Nile. The lake covers a surface area of about 1390 sq. miles (3600 sq. km) and has a maximum depth of 45 ft (14 m).*

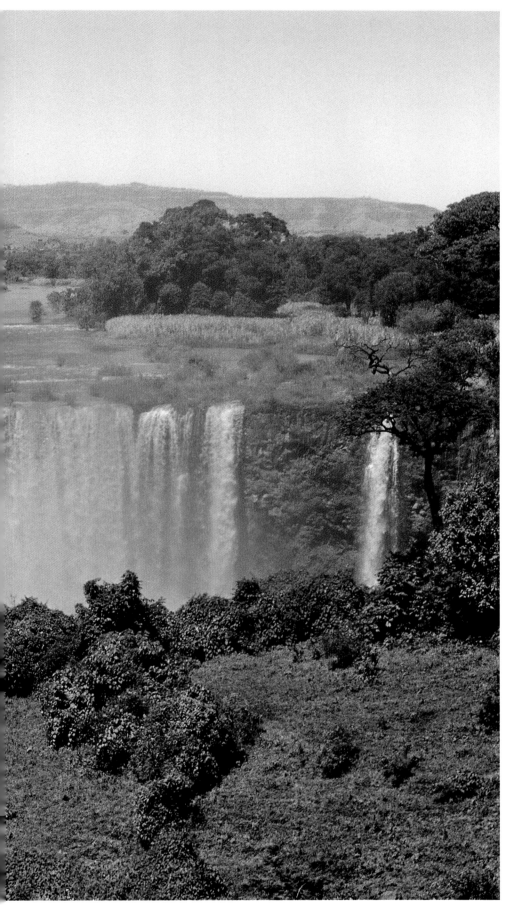

THE NILE

journey through Ethiopia. At certain points, the walls of the gorge created by the river are almost a mile (1.5 km) high. The valley floor is virtually inaccessible and the rapids make navigation dangerous. After the Sudan border, the Roseires Dam gathers the rushing water of the river in a vast artificial basin. The plantations of Gezira (the island) – hundreds of thousands of acres of land yielding cereals, peanuts, sugar cane and cotton

– are irrigated by the Blue Nile by means of a network of canals. This huge triangle of fertile land situated between the Blue and White Nile represents the Sudan's hope for a better future.

Despite the fact that part of its energy flows into the Gezira fields, the Blue Nile retains a considerable amount of water, which its 'elder brother' (the White Nile) needs in order to cross the Sahara Desert. The Atbara River, another Ethiopian tributary, also contributes a large amount of water. But even this would not be enough to guarantee the survival of the Nile if another element did not come into play at this point: in the Sahara stretch, the river follows a sort of natural canal or entrenched valley with walls of rock that prevent the water from flowing outwardly. Thanks to these factors, unlike all the other rivers that once crossed the Sahara Desert, the Nile has continued to flow even in the most arid periods.

The river banks between Khartoum and Akasha were the home of the kingdoms of Kush, which over 25 centuries ago dominated vast regions of Nubia and even Egypt: pyramids,

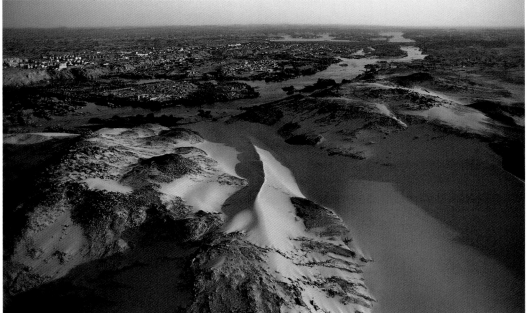

110-111 *Villages, cultivated fields and palm groves flank the Nile between Aswan and Luxor. The river flows quietly through a broad, rather flat valley, past many marvelous temples that bear witness to the grandeur of ancient Egypt.*

110 bottom *Having reached Aswan after a journey of over 2485 miles (4000 km), the Nile flows proudly into Egypt. Its valley becomes a fertile strip of land no more than 12.5 miles (20 km) wide, surrounded by the Saharan sands and low rocky hills calcified by the sun.*

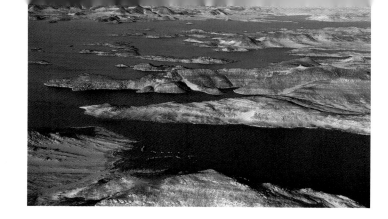

111 top The enormous basin of Lake Nasser, formed by the waters of the Nile upstream from the Aswan Dam, extends for over 310 miles (500 km) in the Nubian deserts. The lake contains about 6 billion cu. ft (170 million cu. m) of water, enough to cover the needs of Egypt in case of drought.

111 bottom An archipelago of rocky islets rises up from the blue waters of the Nile at Aswan, ancient Syene, at the threshold of Nubia. It was at Aswan, situated right on the Tropic of Cancer, that in 230 BC the Greek mathematician and astronomer Eratosthenes calculated the circumference of the Earth with amazing precision.

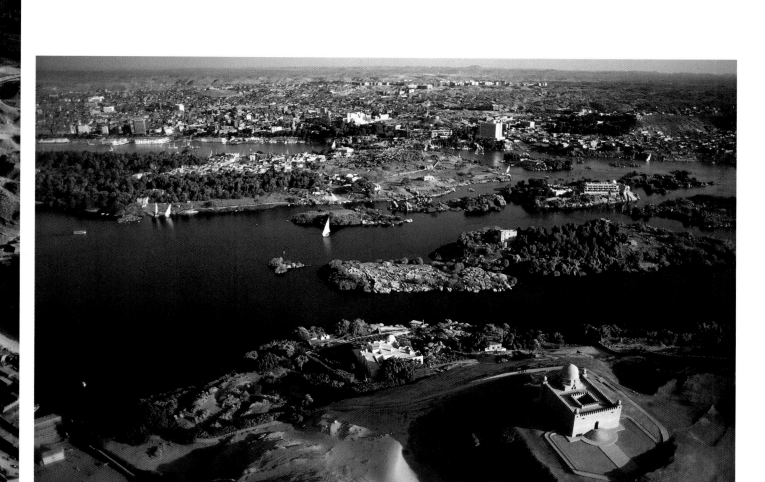

temples, and ruins of cities emerge from the desert at Meroe, Naga, Musawwarat, and Karima. In this region, which was once a major caravan crossroads, the Nile becomes a large, wide "S." Today much of Lower Nubia lies submerged by Lake Nasser, one of the largest artificial basins in Africa. Some 90,000 people were evacuated from the area and thanks to UNESCO, the temples of Abu Simbel were cut into blocks, removed and transported to a site 198 ft (60 m) higher up, in one of the most daring archaeological rescue operations ever carried out.

The Aswan Dam, built in the 1960s, has liberated Egypt from the caprices of the Nile, laying the foundation for rational agricultural and industrial development that was inconceivable in the past. The famine that periodically struck the Nile Valley is now a thing of the past. However, on the other side of the coin, the silt is trapped by the walls of the dam and no longer fertilizes the land, which is now threatened by the emergence of salt deposits. Deprived of the silt carried by the Nile floods, the delta is endangered by the erosion of the sea and is receding at an alarming rate. Many species of fish have disappeared and the stagnant water favors the spread of dangerous diseases. After the Aswan Dam the Nile flows placidly in a very soft countryside. The 744 miles (1200 km) that separate it from the sea are an extraordinary journey into the past. Edfu, Kom Ombo, Thebes, Karnak and the Valley of the Kings, where in 1922 the tomb of Tutankhamon was discovered: the monumental Egypt of the pharaohs passes slowly before you along the banks of the Nile. The ruins of temples, colossal statues, and columns are less concentrated as one gradually approaches Cairo. A short distance past the capital, the Nile branches off into two main arms, the Rosetta and Damietta, forming a triangle. The ancient Greek geographers called this a delta, like the fourth letter of their alphabet – a worthy epilogue for a grand river.

THE NILE

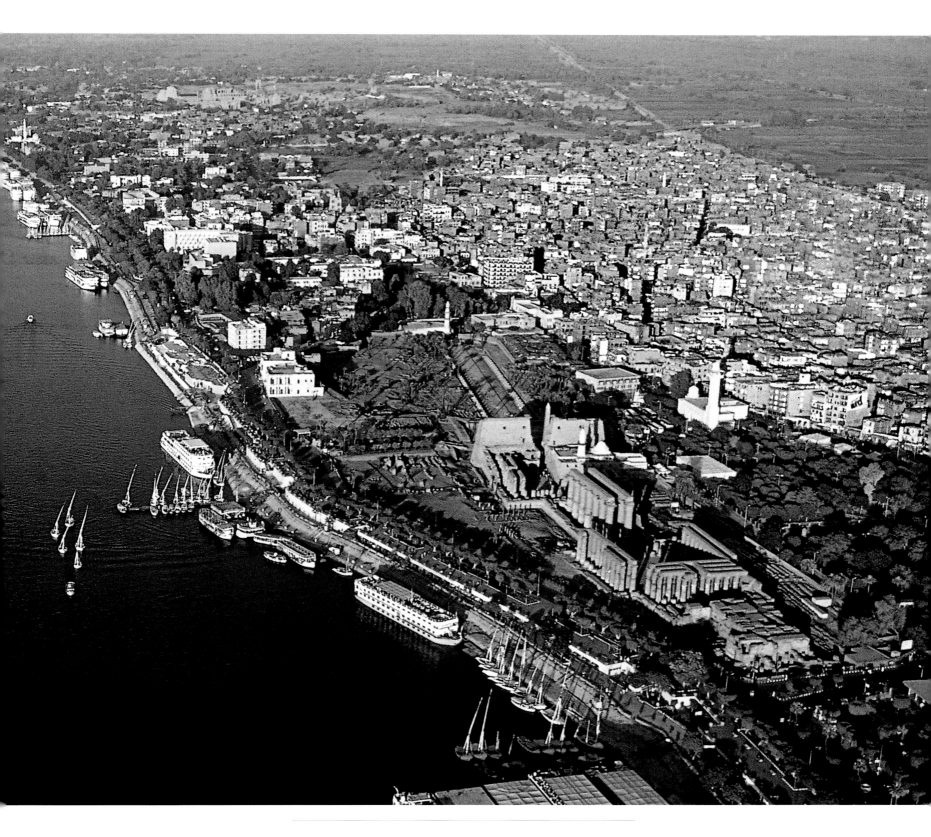

112-113 *The Temple of Luxor rises up majestically on the east bank of the Nile, which is crowded with boats of all kinds. Besides the temple, other easily recognizable monuments are the sanctuary of Amenhotep III, the great colonnade, the monumental pylons of Ramesses II and part of the avenue lined with sphinxes that connected the edifice with the Temple of Karnak.*

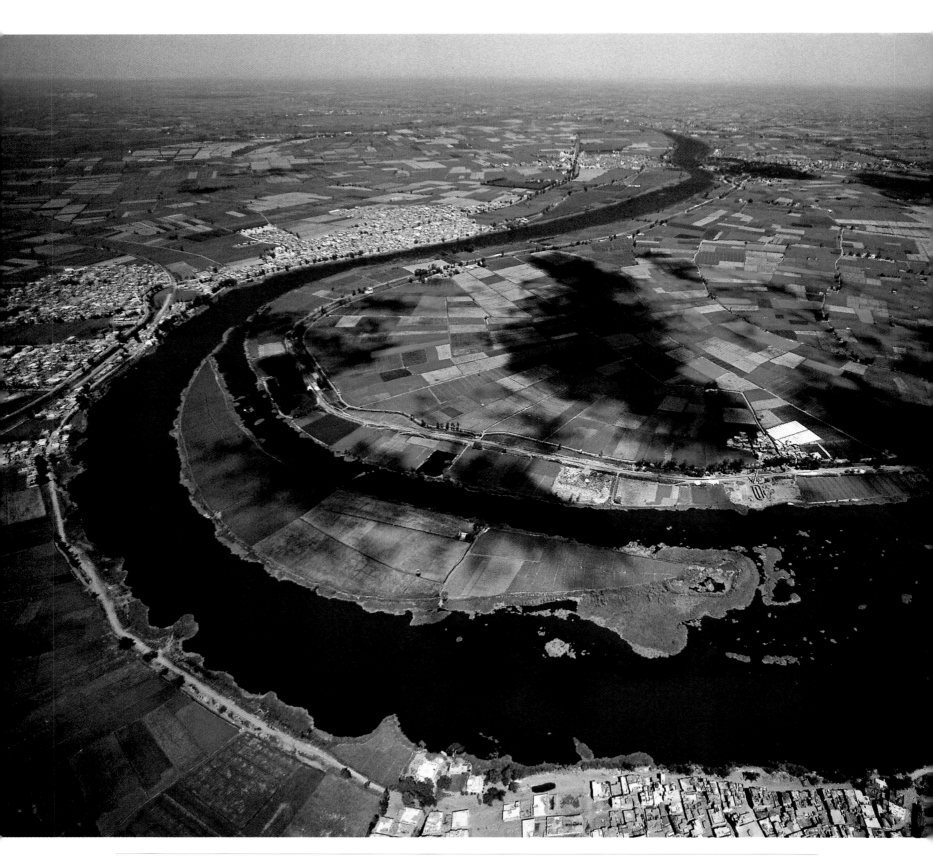

114-115 Cultivated fields surround one of the wide bends of the Nile in the vicinity of its delta in the Mediterranean.

115 top The feluccas with their white triangular sails are one of the distinguishing features of the Nile Delta landscape.

115 center top Large traffic-congested arteries and modern bridges over the Nile connect the residential areas of Zamalek, on the island of Roda, with 'downtown' Cairo.

115 center bottom Hundreds of islets covered with aquatic vegetation dot the surface of Lake Manzala, which extends from the Damietta branch of the Nile to Port Said, at the entrance of the Suez Canal. A thin strip of land separates the shallow brackish lagoon from the Mediterranean Sea.

115 bottom Viewed from above, the Nile Delta looks like a perfect fan, decorated with a 'necklace' of brackish lagoons, extending over 8880 sq. miles (23,000 sq. km). Seen here are the two main branches of the river, the Damietta and Rosetta Channels, at left and right respectively.

THE NILE

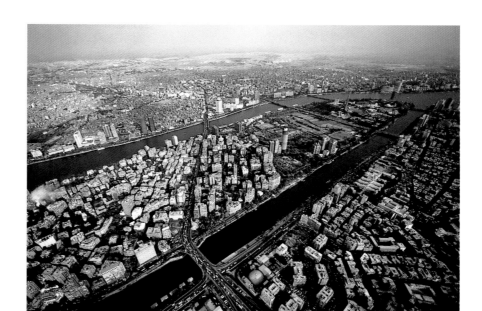

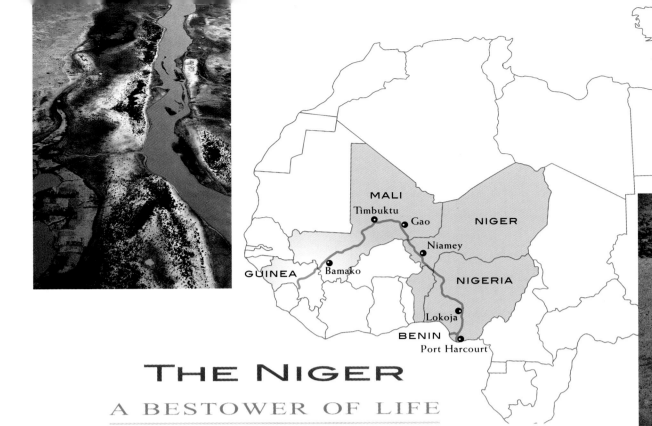

THE NIGER

A BESTOWER OF LIFE

After the Nile and Congo, the Niger is the third longest river in Africa, measuring 2585 miles (4170 km). Its course, interrupted below Ségou by an enormous inland delta, makes a broad bend through the heart of West Africa, from the mountains of Guinea to the Bight of Biafra.

The apex of this curve even penetrates the Sahara Desert, bringing water and life to one of the most barren and hottest regions on Earth. During its seemingly interminable journey the river crosses an extraordinary variety of environments: the rain forest, the Sudanese savanna, the Sahel region, and lastly the desert, then repeating the same pattern backwards.

In a period that roughly corresponds to our Middle Ages, the huge bend of the Niger, at the border between the nomadic and sedentary worlds, became the hub of flourishing trans-Saharan traffic: slaves, agricultural products from the savanna, and above all gold were transported along the caravan routes to the Mediterranean, while from the north there arrived salt, dates, copper and luxury goods. An urban civilization with new, characteristic features rose up and developed along the shores of the river: the empires of Mali and Songhai dominated vast territories and were part of the gigantic Islamic trade network that extended from Spain to distant Indonesia.

The Niger River was both the actual and symbolic hub around which the various components of this political and commercial complex congregated. In keeping with the anthropomorphic model of African tradition, Djenné and the other cities in the inland delta were considered the womb of an immense upside-down figure, the head of which was represented by Timbuktu, the rational mind that stood for the cultural and religious identity of the community. The "feet" rested on the Tegharza and Taoudenni salt mines, while subsidiary towns such as San, Sofala and Mopti, the storage and sorting centers of goods from the various provinces of the empire, were the neck, arms and legs. This model worked fairly well up to the rise of European colonialism and to this day is valid to a certain degree: although they are in decline, the port cities along the middle section of the Niger are still vital and have retained their strong character and originality. Salt still plays a major role in the economy of Timbuktu, the hub of camel and dugout traffic; the activities of salt extraction, transport and sale call for a great number of laborers, vendors and service suppliers, which is by no means an insignificant contribution to the development of a region on the fringes of the modern global market.

The Niger epitomizes the historical continuity of this huge slice of Africa, and the material well being of millions of people still depends on this river. Even during the worst cases of drought, the river continues to flow, which is quite a feat considering the fact that it makes the round trip journey in the desert virtually without any help: only two large tributaries, the Bani and Bénoué, flow into its middle and lower sections. Indeed, huge areas of its basin, which theoretically covers a surface area of over 800,000 sq. miles (2 million sq. km), are unserviceable, paralysed. The entire Sahara section, afflicted by thousands of years of continuous aridity, is a mere web of dry rivers and the waterway networks that radiate from the Adrar des Iforas, Atakor and Air mountains are totally disorganized. Heaps of sand cover the Tilemsi and Azaouak river valleys, which were once major tributaries of the Niger and are now almost unrecognizable; only the last section of the Dallol

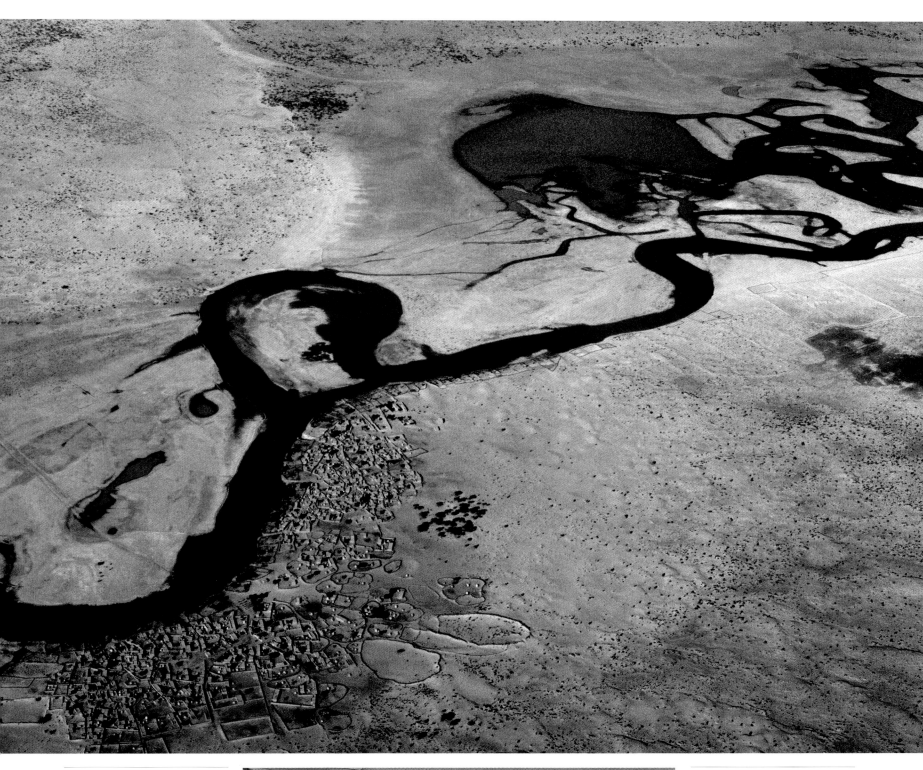

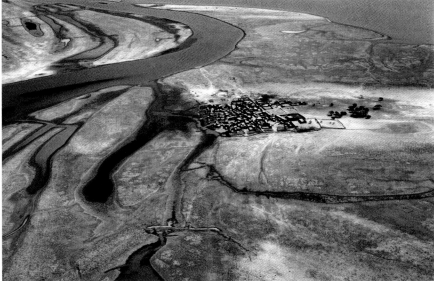

116 top and 116-117 The barren landscape of the Sahara surrounds the large bend of the Niger River, which heads northward after the city of Ségou. In its journey across the desert the river has no affluents and proceeds among vast stretches of sand, its volume of water gradually decreasing. Since this region has no secure communication routes, the survival of the rare villages that spring up along the river banks depends on the river and caravan traffic.

116 bottom The life of these fishermen in the Djenné area of Mali is in keeping with ancient traditions, linked to the rhythm of the seasons and the whims of the great river.

117 bottom The villages in the inland delta of the Niger, in Mali, can be reached only by boat for most of the year. During the rainy season the river, made larger because of the rainfall on the Guinea Ridge, surrounds the village.

THE NIGER

Bosso takes in the seasonal but limited flood waters every so often.

The Niger manages to survive thanks to its fortunate "infancy." Its sources are situated in the rainiest area of the Guinea Ridge between the eastern slopes of the Fouta Djallon plateau and the Nimba Mts. Despite the low average altitude of about 1650 ft (500 m), these hills are subject to rainfall from the Atlantic for eight months a year, with hardly any seasonal variations. The Milo, Tinkisso, Niandan and Sankarani provide the Niger with an abundant and constant supply of water. At Siguiri, where the river leaves the highlands of Guinea, its outflow is twice that of the Senegal River. With the name of Djoliba, the Niger flows majestically toward Kourossa and the alluvial plain that leads to Bamako, the capital of Mali. After the rapids of Sotuba, the inclination of the Niger decreases gradually and is imperceptible near Ségou, where it begins to flow lazily in the huge tectonic basin that houses its inland delta. For the next 125 miles (200 km) the river has a gradient (fall) of only 33 ft (10 m), about one-fourth the gradient of the Nile before it empties into the sea. But the Niger is still 1240 miles (2000 km) from the ocean and must face its greatest difficulties: it is virtually without tributaries until Mopti, where it receives the waters of the Bani, and rainfall is rare indeed. Moreover, the flat terrain forces the river to move very slowly; the seasonal increase in outflow, which in the upper basin reaches its maximum in September-October, arrives at Mopti in November, Timbuktu in December and Niamey only in February, six months later. After Niamey the rainfall increases progressively, so that the high water period continues on into late spring. Then, again in September, the inflow of the Bénoué re-establishes the equilibrium, increasing the volume of the Niger to quite a degree.

In short, thanks to the rainfall in Guinea the river is never very low and has a rather regular regimen all year long. For a long time this unusual behavior – which is characterized by two high-water swells in the same period, but at a distance of thousands of miles – seemed to support the theory that the upper and lower Niger were two distinct rivers. The first maps show a totally imaginary course in which the river is connected to the Senegal or the Nile and yet empties into Lake Chad. For a certain period people even thought the Niger was connected with the Congo. In 1795, the British explorer Mungo Park discovered the river flowed from West to East, but the location of the mouth remained clouded in mystery. Park's following expedition, an attempt at going down from Ségou, ended in tragedy. Only thirty-six years later, the Lander brothers

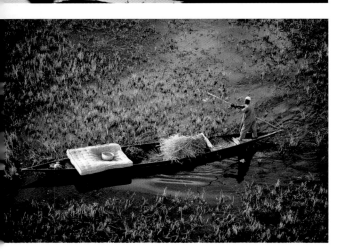

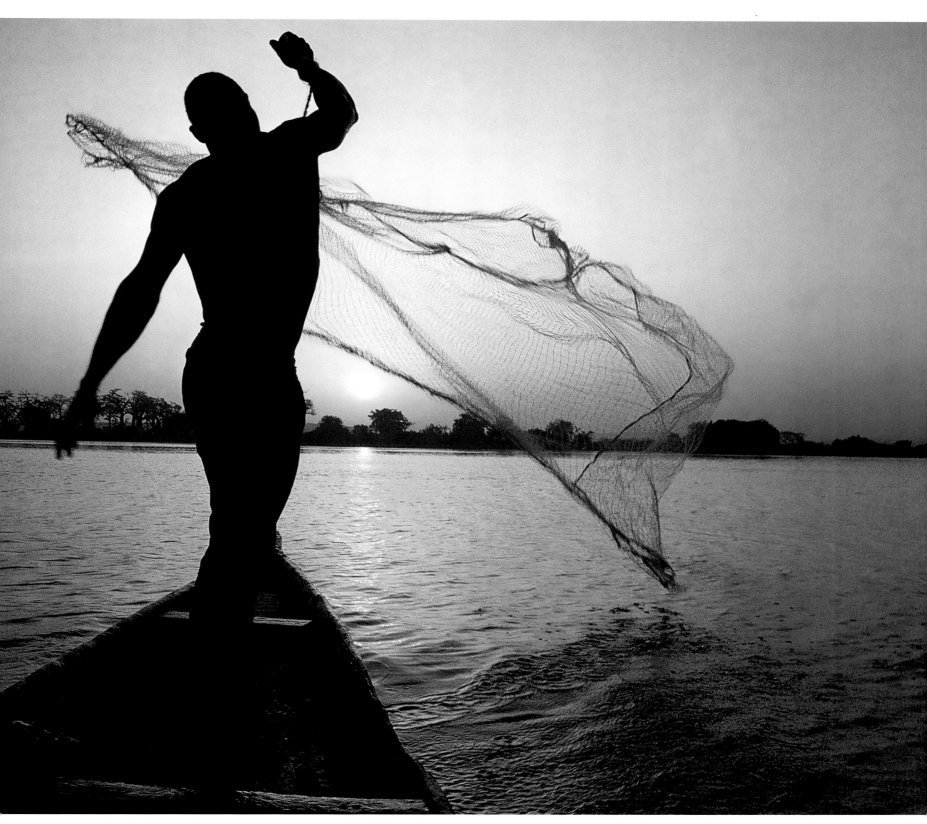

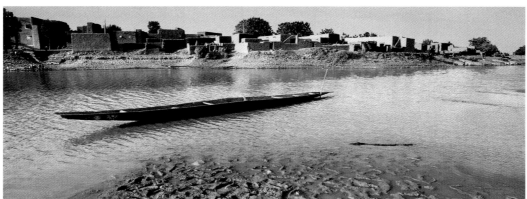

THE NIGER

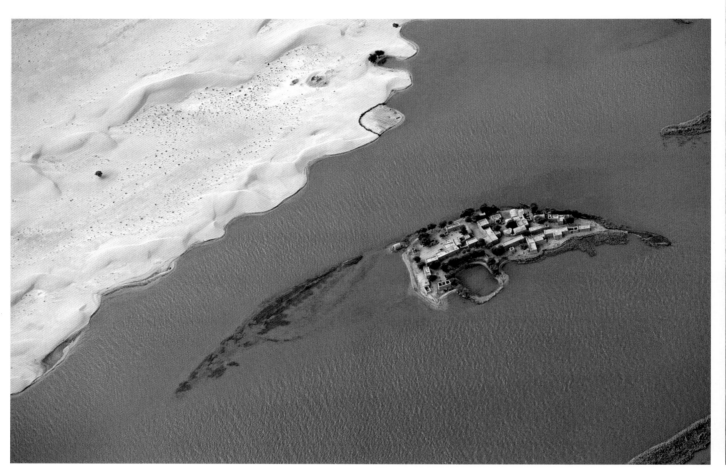

established that the basin of the Niger was a single body of water.

In its interminable course among the myriad canals of the inland delta, the Niger loses half its water through evaporation. The only permanent points of reference here are the hillocks with trees, many of which are dotted with the villages of the fishermen and farmers who live in this region. Some of the hillocks, called *togué*, are really burial mounds that were built from the 3rd century BC on by the ancient inhabitants, who grew rice and millet. On a level with Niafounké, massive strands of reddish sand dunes block the view of the horizon to the north. The river seems to come to a halt at this formidable obstacle, becoming an arc of parallel lakes in its patient search for an outlet. About 9,000 years ago the Niger strayed off in a vast basin in the central Sahara Desert, the so-called Araouane Lake; when and how it headed east and settled in its present

bed, is still a moot question among geologists. The alternation of wet and dry periods that created the configuration of the Sahara also influenced the evolution of the Niger River, which was continuously forced to react to the cyclical expansion and regression of the desert.

Between Timbuktu and Boureme the valley is straight and traverses barren and desolate land: only the hemispheric huts of the Tuareg sometimes dot the solitary and sandy shores. At the Tosaye gorges the Niger suddenly changes direction and heads toward Gao. One of the crucial battles in African history was fought in this zone, at Tondibi: in 1591, a few thousand Moroccan soldiers and Spanish mercenaries armed only with rifles managed to defeat the powerful army of Songhai, the last of the great empires of West Africa. Gao, the ancient capital of the kingdom, is now a dusty city with a few thousand inhabitants that is passing

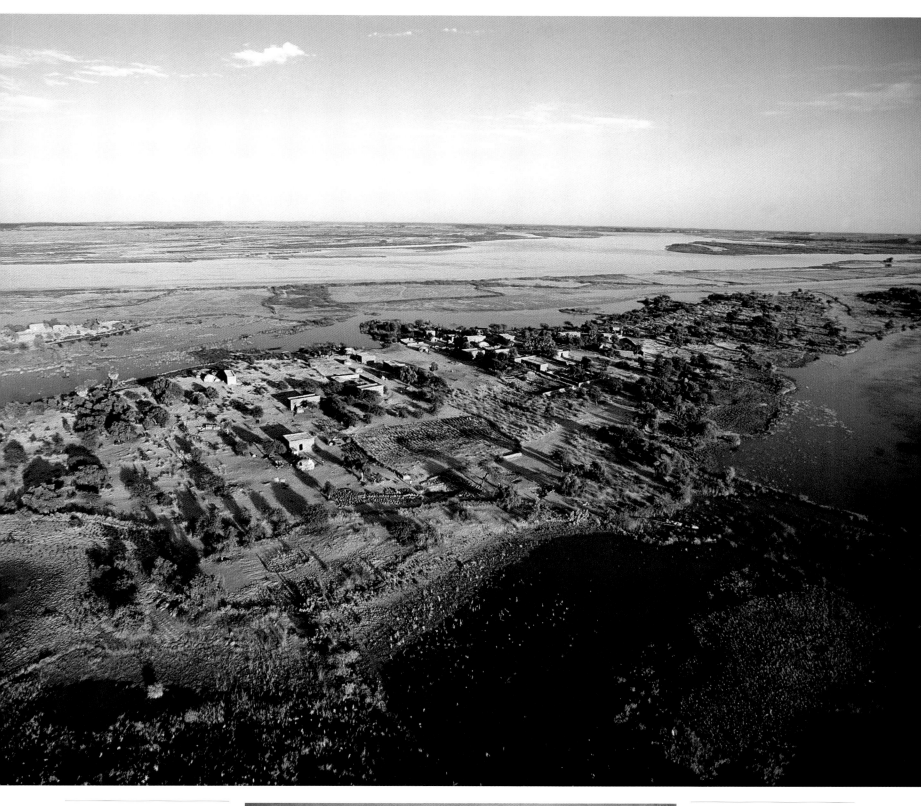

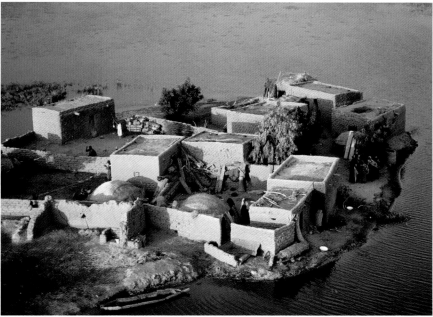

120 Fishing and rice are the main resources for the inhabitants of the island villages that dot the course of the Niger above Gao. The apparently modest villages, which consist of a few low houses made of sun-dried clay, actually boast an illustrious past. Terra-cotta artifacts, grave goods of exquisite workmanship, and a large quantity of other archaeological objects clearly show that already in the 3rd century BC this region was the theater of a mysterious civilization.

120-121 Once out of the narrow Tosaye gorges the Niger widens as it enters the sandy plains that precede the city of Gao. Downstream from Bourem the river enters an extremely broad bed and its waters form a maze of channels interspersed with low islands.

121 bottom The villages of the Songhai farmers in the Gao area are made up of low houses with flat roofs, some with domes, built with sun-dried clay bricks plastered with mud.

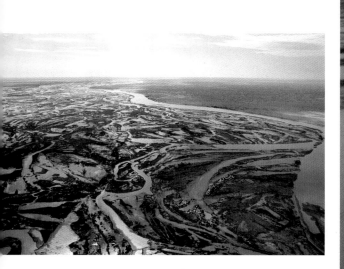

122 and 122-123 Large pink
sand dunes flank the course of the
Niger a few miles upstream from
Gao, creating a fascinating
contrast of lights and colors. The
broad bend of the river in Mali is
both an environmental and
anthropological border, a region of
transition between different worlds:
the barrenness of the desert clashes
with the thriving life in the steppes
of the Sahel, tents are replaced by
houses made of sun-dried clay, and
dugouts take the place of
dromedaries, in a land where
contradiction is magically
transformed into harmony.

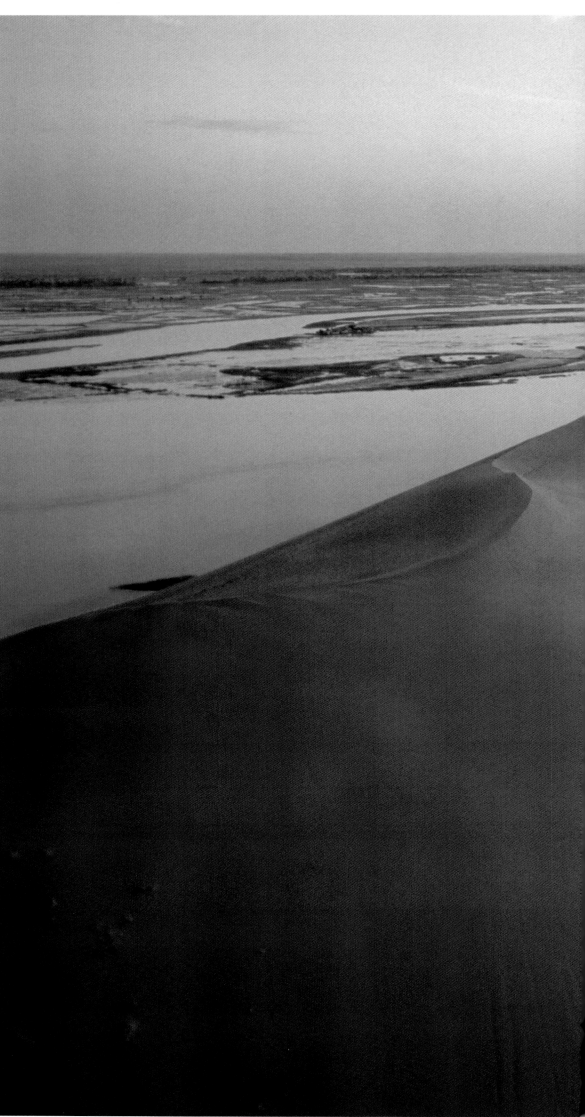

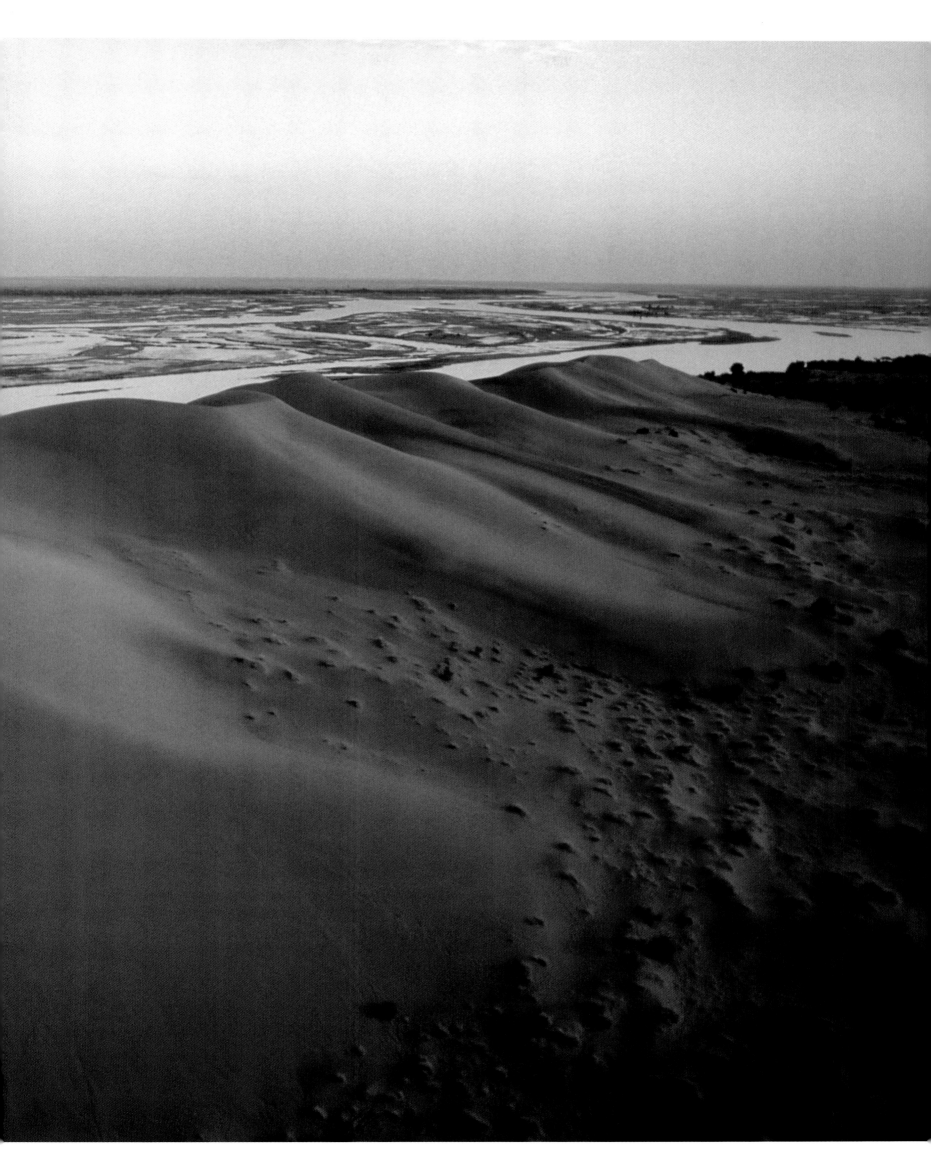

After taking in the large inflow of water from the Bénoué River and now in the plains of southern Nigeria, the Niger broadens in a vast bed that in certain stretches is several miles wide. The river proceeds slowly and majestically toward its delta, *running down an almost imperceptible gradient among large sandbars and muddy islands. The thick virgin forests that extend beyond its shores comprise a naturalist treasure trove, most of which has yet to be explored by scientists and researchers.*

THE NIGER

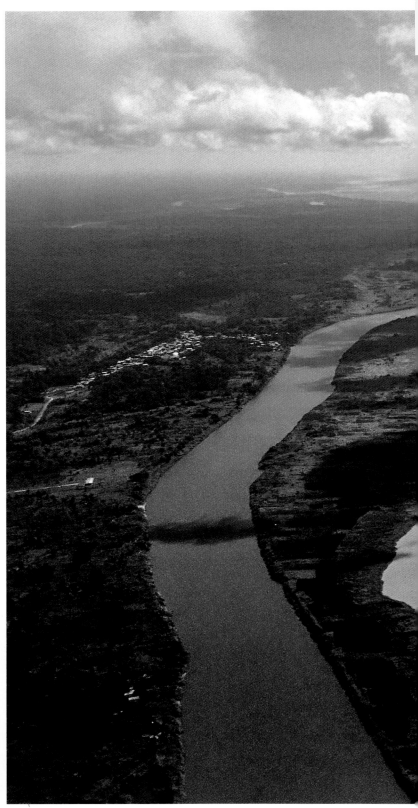

through a period of solitary stagnation and decline.

The river continues its descent, leaving behind the desert, which gradually gives way to the steppes of the Sahel. For a short stretch it marks the border between Niger and Benin, and then washes the offshoots of the Atakora range, after which it flows into Nigeria. The rapids of Aourou, where the roaring Niger was once forced to pass through a passage no more than 33 ft (10 m) wide, are now swallowed up by a large artificial

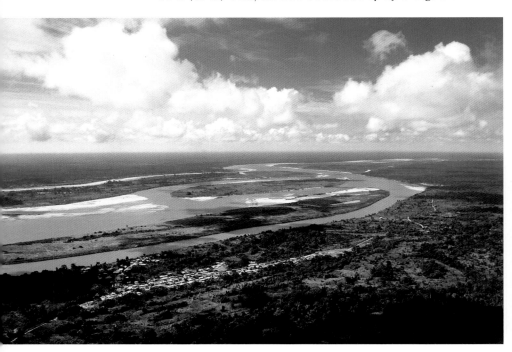

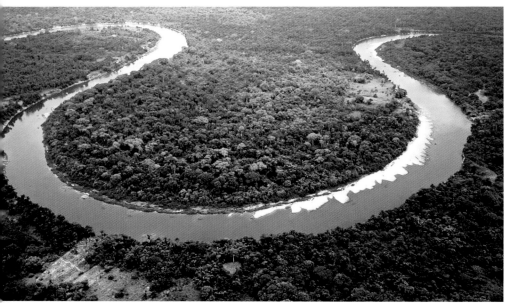

lake created by the Kainji Dam. The clear waters of the Bénoué flow into the Niger at Lokoja, merging with the water from the Guinea delta. These two waterways, which are about the same size, form a powerful river that after the city of Onitsha begins to branch out into its second and final delta. The abundant deposits of petroleum, which have been tapped since the late 1950s, make the Niger estuary the richest and most productive region in Nigeria. Environmentalists agree with this description, but for different reasons, since they are concerned about the deterioration of the environment, which is threatening the coastal forests of the Gulf of Biafra, the home of rare and endangered species. There are no commercial harbors in the Niger delta, as sand and silt block access for large boats. Protected by an impenetrable mangrove jungle, the great solitary river vanishes in the ocean.

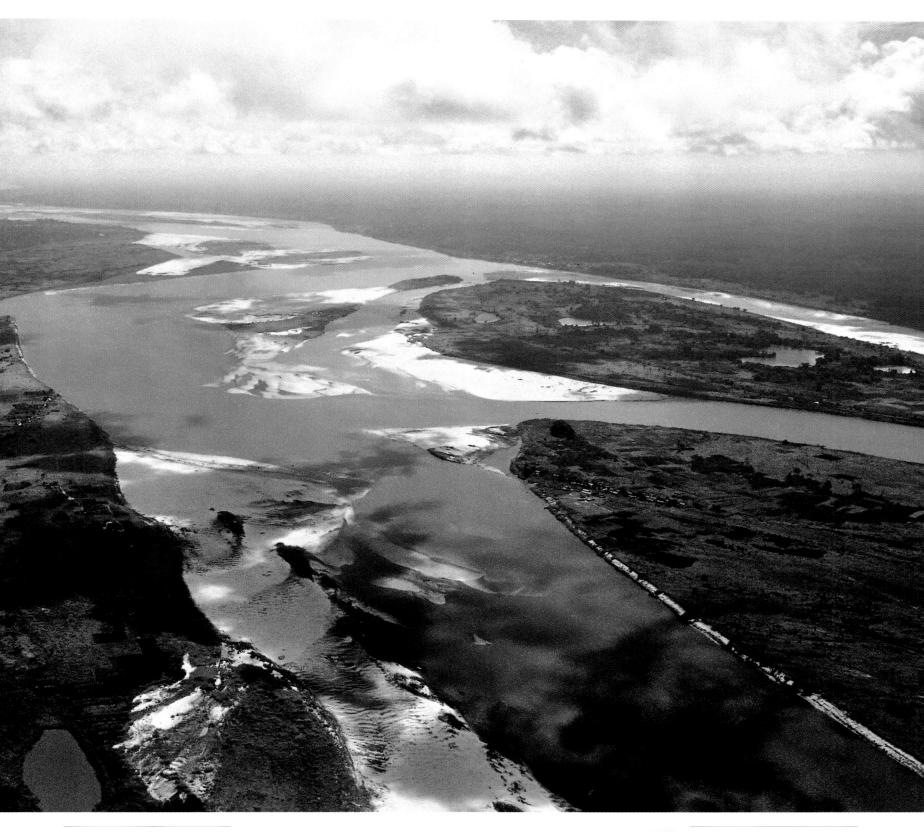

124-125 Just before emptying into the Gulf of Biafra, the Niger splits up into a myriad of branches and channels, creating a vast fan-like configuration with a surface area of about 9650 sq. miles (25,000 sq. km). The petroleum extracted from the delta of the Niger is Nigeria's main economic resource.

125 bottom The rapids and falls that interrupt the course of the Niger before it merges with the Bénoué block navigation in the vicinity of the Niger-Nigerian frontier. The famous Bussa rapids, where the explorer Mungo Park died, are now submerged by an artificial lake.

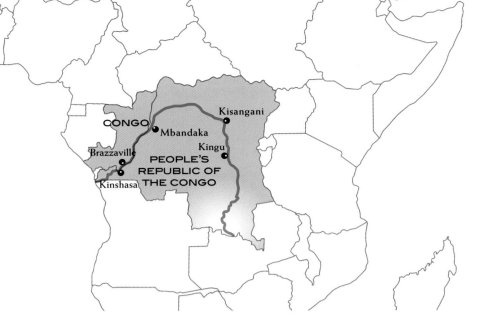

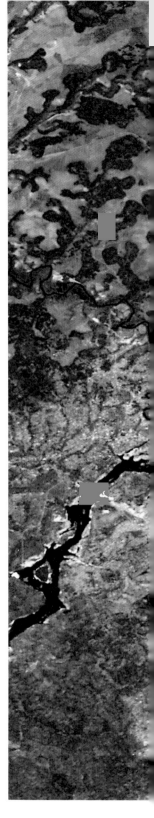

126-127 This view from a satellite shows the stretch of the Congo River near the Malebo Pool, where the river becomes a huge natural lake before plunging into the roaring Livingstone Rapids. In this photograph the large towns of Brazzaville (above) and Kinshasa (below) can be clearly seen.

THE CONGO
IN THE HEART OF AFRICA

"Going back up that river was like traveling backwards in time, to the dawn of the world, when plants grew freely on the Earth and the large trees were kings. A deserted waterway, a great silence and an impenetrable forest.

The air was hot, heavy, oppressive, stagnant. There was no joy in the brilliant sunlight. The long stretches of that river proceeded in solitary fashion, in the darkness of shaded distances." The words of Joseph Conrad are a fine description of the atmosphere of ominous mystery that pervaded the Congo River up to a little more than a century ago. In 1890, when Conrad took up service as a steamboat pilot in the Belgian Congo, the river had just been charted. Only 13 years earlier, an expedition headed by Stanley had gone down the Congo from Nyangwe to the Atlantic Ocean, finally shedding light on the geography of Central Africa and demonstrating that there was no link whatsoever between this river and the Nile system. Stanley's exploration of the rain forest, which lasted over a year, was fraught with difficulties: two-thirds of his men died from hardship and disease, or were killed during the continuous clashes with the native tribes.

Conrad's service lasted only four months but proved to be a crucial experience in the writer's life, and in his novel *Heart of Darkness* he called attention to the horrors of the would-be Free State of the Congo, which at the time was the personal property of King Leopold of Belgium and was subject to senseless and savage exploitation. Indeed, a stigma of mindless brutality seems to mark the entire history of this river, up to the present. Yet it was precisely on the estuary of the Congo that relations between Africa and Europe had their felicitous and promising beginning: the Portuguese, who had landed there in the late 1400s, initially had excellent relations with the local populations. The Kingdom of Kongo readily accepted Christianity and for a certain period had ambassadors in Lisbon. Then the slave trade suddenly interrupted this relationship among equals. The Congo sank into a period of anarchy and violence. Colonialism for its part left wounds that were difficult to heal. In that fragile land beset by heated tribal rivalry, national independence had

a hard lot: there were still many wars and massacres, in a spiral of violence that to this day looms over the humid area of the river and its tributaries like a pall.

Indeed, not much has changed along the Congo River since Conrad's time. The great forest, although no longer virgin land, continues to be a formidable obstacle for communications. Given the lack of roads and railways, the river is still the only reliable route between the ocean and the cities scattered in the boundless jungle that covers the Congo basin, a surface area of 1.4 million sq. miles (3.5 million sq. km).

The jungle has not always been the same size, since with time the alternation of wet and dry periods has greatly modified its magnitude. At times the vegetation receded so much that it clustered along the banks of the rivers, only to extend once again and cover large areas of the savanna. This phenomenon has had a crucial effect on the evolutionary processes. Shelter zones that have remained unchanged for thousands and thousands of years alternate with areas of more recent expansion, each characterized by different species, many of which are endemic, in a continuous flow and exchange from one habitat to the other.

The Congo is the main artery around which the various pieces of this extraordinary mosaic of ecosystems revolve. The river, about 2975 miles (4800 km) long, begins it long journey toward the Atlantic far from the shadowy and warm forest world, in a region of uniform savanna highlands. Its name also changes: its most important headstream, normally considered the upper Congo, is called the Lualaba River, which begins in the hills that mark the southern border of Shaba and flows directly northward, swift and sure of itself. The course of the Chambezi River, the twin of the former, is much more uncertain: after lingering for a long while in the plains of Zambia, it flows into the vaguely defined outlying areas of Lake Bangweulu, which during the rainy season becomes a huge marshland. When it has emerged from Lake Bangweulu, the Chambezi becomes the Luapula River, which continues for a few hundred miles and then flows into Lake Mweru. The Luvua River, the last part of this metamorphosis, merges with the Lualaba above Kongolo, which is where the

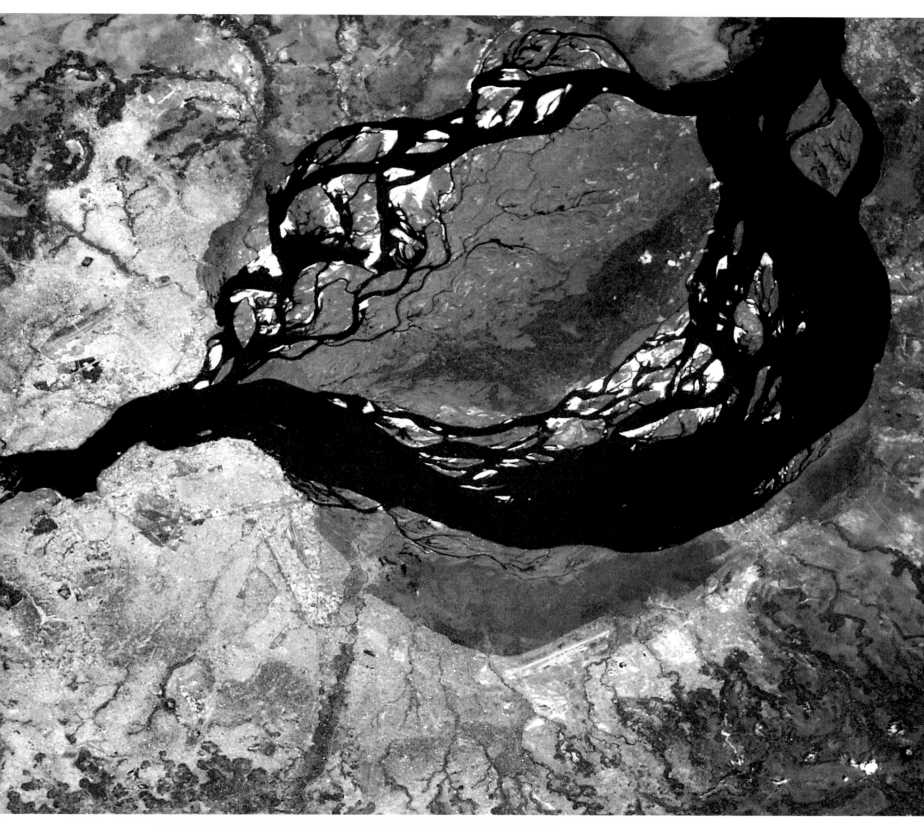

127 bottom Forests and immense marshes surround the middle course of the Congo, which at times branches out into a labyrinth of secondary channels whose configuration is constantly changing. "In that river you can be lost as if you were in a desert," wrote Joseph Conrad, who in the late 19th century worked as a steamboat pilot on the Congo.

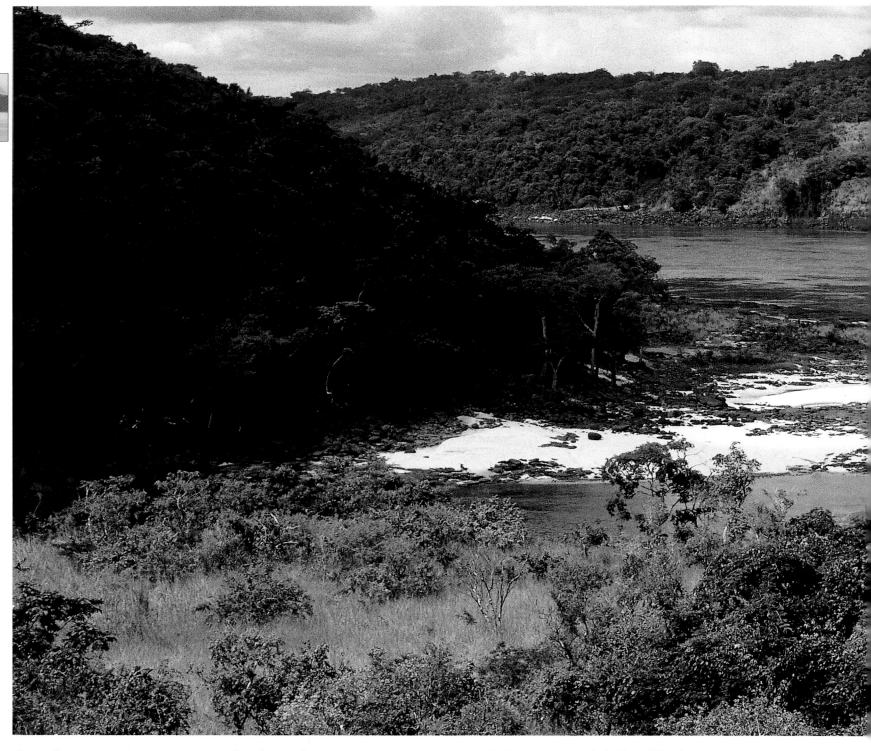

Congo River proper begins its course. After the confluence with the Lukuga River, which comes from Lake Tanganyika, the Congo precipitates with a roar into a series of entrenched gorges not more than 330 ft (100 m) wide, the so-called Gates of Hell, the threshold of the forest.

At Nyangwe what was a clear sky is already filled with fog and mist. The horizon is blocked in all directions by a gloomy green veil. Nyangwe was for a long time the last outpost of the Arab merchants, the center of the ivory and slave trade, beyond which lay the unknown, a hostile world without any known points of reference. The villages of Bantu fishermen and farmers lie at the edge of the forest, an uninhabitable environment for everyone save the pygmies, who feel perfectly at home there. The Mbitu pygmies, a population of about 40,000 people, live in the Ituri rain forest, which extends east of Kisangani up to the great plains that open out toward East Africa. Their economy is based on hunting and gathering wild fruit, activities that involve the

entire community, including women and children. The forest provides the Mbitu with everything they need for subsistence, so that they have plenty of time for entertainment and leisure. Far from being a mysterious and dangerous place, this region is friendly and hospitable, quite the opposite of the "dirty, dry" and treeless land that delimits it.

Outside of the forest life is inconceivable. The anthropologist Colin Turnbull, who studied the pygmy society in Ituri for years, tells us that the outside world is a totally alien system for these people. Turnbull took one of his guides to the savannas of Virunga. The hunter's reaction to a distant herd of buffaloes was one of indifference: "What insects are those?" he asked. The anthropologists' efforts to convince him that those black figures on the plain were large herbivores that were very good to eat were in vain. Perspective, that is, the evaluation of the relationship between distance and size, was simply extraneous to the

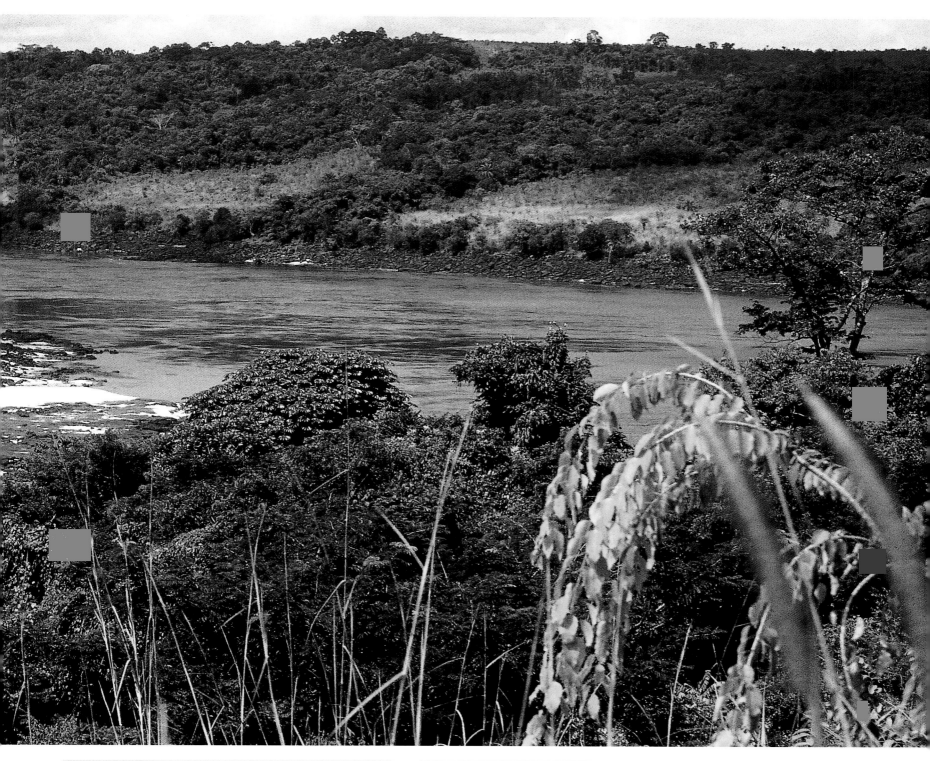

129 bottom Once out of Malebo Pool, where it becomes 14 miles (23 km) wide, the Congo proceeds for a short stretch through an unspoiled landscape. The gloomy forest that flanks the river for most of its middle course is replaced by less dense vegetation. The cities of Kinshasa and Brazzaville are a short distance downstream.

128-129 The Congo River flows calmly in the area of the capital city of Brazzaville. The course of the river was explored at the end of the 19th century by a French aristocrat of Italian origin, Pierre de Brazza, who managed to procure a great deal of territory for France without resorting to violence. Brazzaville was named after him.

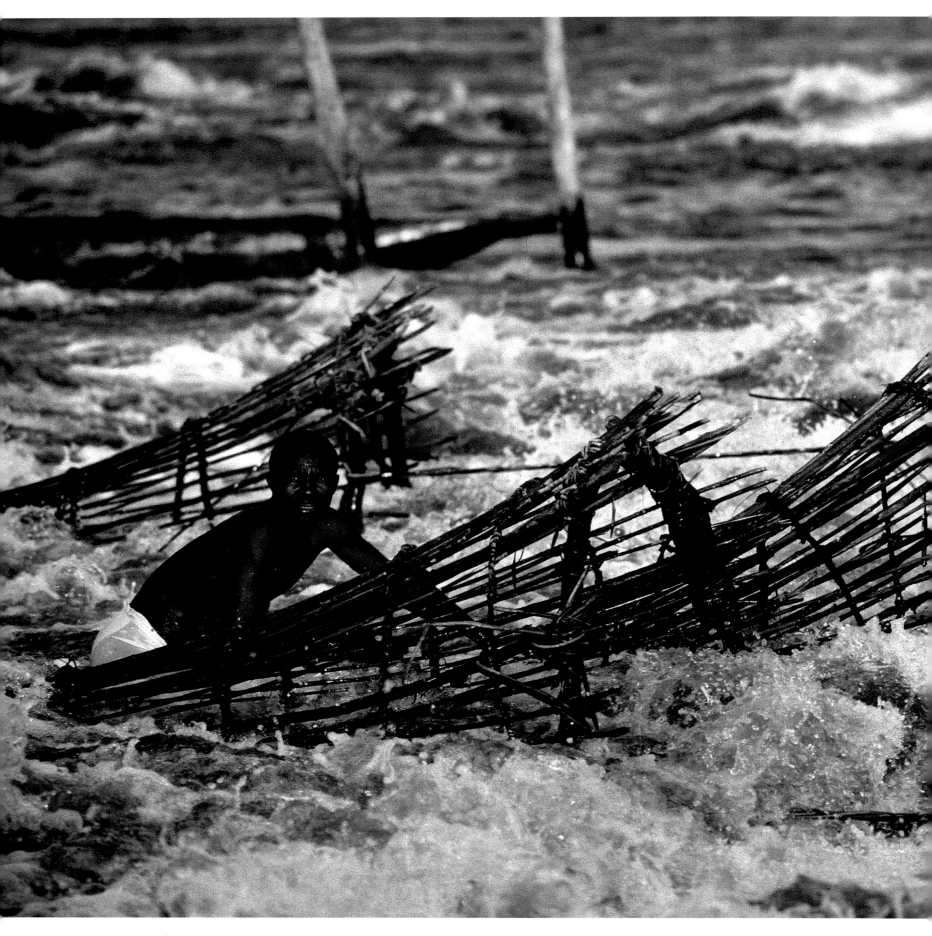

hunter's perceptive system, which was based on the needs of life in the forest, where visibility is limited to a few feet.

Enlarged by all its tributaries, the Congo River is now a powerful river that flows in a vast bed with rather vague boundaries, creating a maze of islets and secondary canals. The Boyoma rapids below Ubundu suddenly interrupt the placid course: for 62 miles (100 km) the river runs over a rocky bed, precipitating in a series of rapids. Only the Wagenia fishermen dare face the current in their dugouts to place their large conical fish pots in the frothy water. The Wagenia cataract marks the beginning of the middle section of the Congo, which flows majestically toward Kisangani.

A steamboat connects this city and the port of Kinshasa; the voyage may take from eight to twelve days if no unexpected circumstance interrupts the navigation, which is already made difficult by the sandbars and the sudden changes in the conditions of the river. The ship is a means of transport, a floating marketplace-hospital-post office-café in one, a meeting place, and whatever else the backwash of progress may gradually bring to these isolated regions. Game, piles of dried fish, live animals, palm oil, agricultural produce and all kinds of merchandise are heaped helter-skelter on the bridge of the barges, which are always surrounded by swarms of dugouts waiting to return to the villages loaded with the

THE CONGO

131 center and bottom The technique used by the Wagenia fishermen at the Boyoma Falls, near Kisangani, is singular, to say the least, and certainly risky. The bamboo scaffolds built at the bottom of the most violent rapids are used as platforms from which large conical fish pots are set in the water with their open ends facing upstream. The fish are pushed by the current into the pots and are then hauled ashore. This apparently simple maneuver requires great skill, equilibrium and courage.

130-131 Having lived for centuries on the banks of the Congo upstream from Kisangani, the Wagenia tribe fishermen are not daunted by the violence of the Boyoma Falls, which were formerly named after Stanley. This famous explorer visited the area in 1877 and in his travel journal described their method of fishing with large fish pots, which he found was quite efficient.

131 top The pirogue or dugout canoe, propelled by a long pole or with the aid of a paddle, is the only means of transport for those living in the middle course of the Congo, an area totally without any infrastructure. At times these boats are quite rudimentary – tree trunks hollowed with an ax.

132-133 and 133 bottom The
humidity that emerges every day
from the jungle is sometimes
transformed into fog so thick that
it blocks navigation even for the
large ships that run between
Kinshasa and Kisangani.

133 top A consignment of high-
quality wood goes down the Congo
toward the port of Kinshasa. The
commercial exploitation of the large
rain forests that cover most of the
Congo basin is blocked by the lack
of means of transportation.

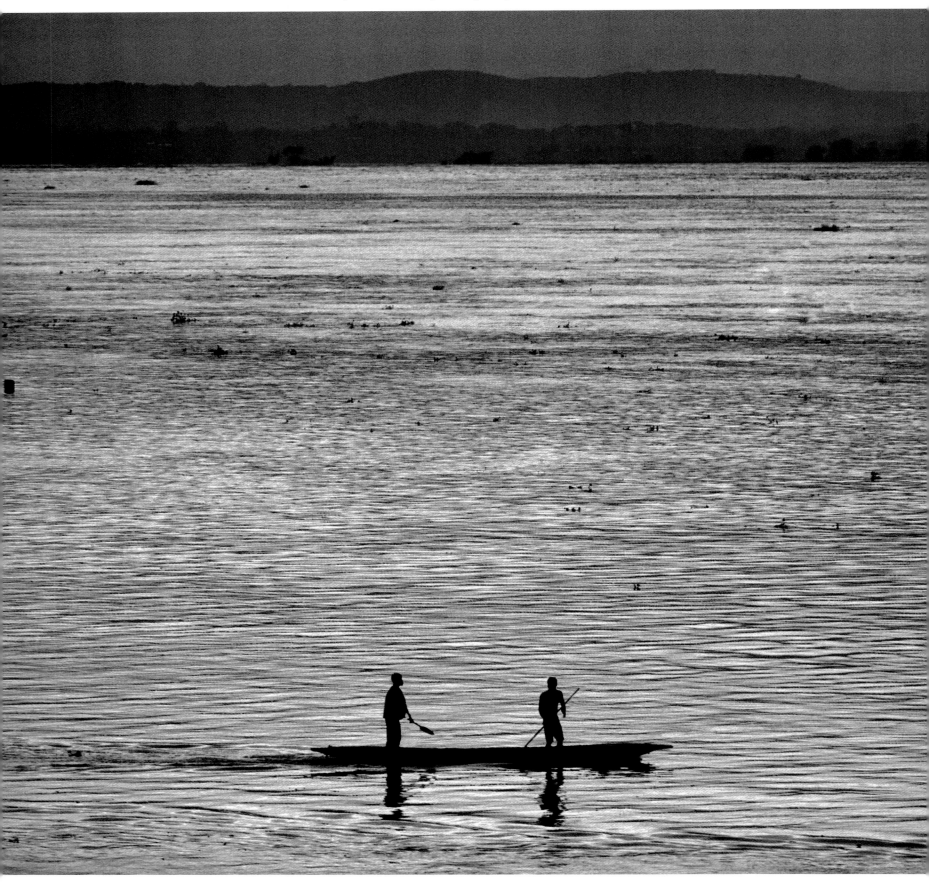

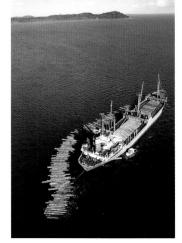

THE CONGO

precious consumer goods from the estuary cities.

The Congo, which in certain places is 9.3 miles (15 km) wide, is not subject to floods or low water. Thanks to its geographic position bridging the Equator, it is always fed constantly by its tributaries: in keeping with the symmetrical alternation of rainy seasons, the water flow of the tributaries from the north and south compensate one another, and so the Congo is abundant and torrential all year long.

The Ubangi, which is the major tributary, flows into the Congo at Mbandaka, the only town of any importance before Kinshasa and Brazzaville. After the Congo merges with the Kasai the forest becomes less thick and the limestone Crystal Mts. appear on the horizon. Embanked by this barrier, the river becomes a vast lake about 12.5 miles (20 km) wide and 20 miles (32 km) long: the so-called Malebo Pool, once called the Stanley Pool.

The Livingstone Rapids suddenly begin here in a series of

cataracts of unspeakable violence whose fury is placated only at Matadi. Embedded in the deep gorge between the mountains, the Congo lashes out with all its power in this interminable narrow passage, which for four centuries was the main obstacle for the exploration and exploitation of the interior.

From Matadi to the Atlantic the river flows quietly among flooded mangrove forests and palm groves: nothing seems to have remained of the powerful Congo except an immense stretch of muddy water agitated by the ocean waves. But in the depths of the ocean the current is quiet. The force of the Congo River dies out in this unknown abyss and is now invisible, a stranger to itself and extraneous to human events.

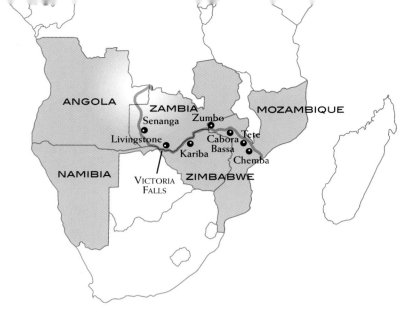

THE ZAMBESI
A WILD PARADISE

Livingstone came within sight of the Zambesi River for the first time in early August 1851, near the city of Sesheke, on the present-day Zambia-Namibia border. This was a fatal encounter. From that time on the great explorer was plagued by a vision: that massive river was the providential path that would open the heart of Africa to the Christian faith and progress. Not even the rumors of large waterfalls eighty miles below this point shook his certainty and determination. Thus, tracing the course of the Zambesi became a necessity, even a duty, for Livingstone. For the following twelve years the river was an obsession, which ended in total and definitive failure. Livingstone traveled up and down the Zambesi, following its course on foot, in a dugout canoe and with all the other available means, from Mozambique to Angola. He discovered what he patriotically named the Victoria Falls, carefully explored the territory that stretched as far as the eye could see beyond the marshy shores, and went up the Shire, the last large tributary to the north. Curiously enough, despite his mania Livingstone never attempted to reach the source of the river, even though he came close to it during his trek toward Luanda. And, what is more important, he did not spot the rapids of Cabora Bassa, which shattered his hopes.

The Zambesi rises in northwestern Zambia, in the Katanga highlands, which mark the divide with the Congo River basin.

There are no mountains or mysterious jungles that conceal the origin of the fourth longest river in Africa: whoever wants to take a walk in the brush can easily reach the spring of clear water where the Zambesi begins its long journey to the Indian Ocean. Almost at once the river enters Angola, then re-emerges in Zambia at the Chavuma district where it becomes a series of modest rapids.

Only five bridges cross over the Zambesi in its 1717-mile (2770-km) course. The first one is situated a short distance after the border, at Chinyingi: a footbridge 660 ft (200 m) long held up by a network of steel cables and tension rods. It was built by Capuchin missionaries from the area about twenty years ago, after the ferry accident in which four of their colleagues were killed. Below Chinyingi is an absolutely flat plain covered with grass and forests, where the roads are nothing more than faint tracks in the sand and the presence of humans is only occasional.

Within the vague confines of the national parks and reserves that border the right-hand or southern side of the river, the old, wild and virgin Africa of travel books appears in all its primeval magnificence. In keeping with the seasons, large herds of elephants, buffaloes and antelopes travel in search of water and grazing land, followed by hosts of predators. Everything seems to be immutable, as eternal as the silence of the night, which is interrupted every so often by the wheezing of the hippopotami. The Upper Zambesi region is one of the most 'backward' in southern Africa: communication is difficult, the social and educational infrastructures are virtually non-existent, and the public hospitals are generally inadequate for the needs of the population. Until Zambia became an independent nation in the early 1960s, most of this territory, formerly known as Barotseland, was part of the Lozi kingdom, whose king, the *Litunga*, still wields considerable power. However, the monarchist sympathies of the Lozi population did not please the new government of Lusaka, which excluded the provinces of the upper Zambesi region from the country's economic development projects.

It is the river, with its high and low water levels, which marks the rhythm of life in remote Barotseland. It not only

134 bottom With its huge
mouth wide open, a
hippopotamus suddenly emerges
from the waters of the Zambesi
River. These creatures, which

can easily be 11 ft (3.5 m) long
and weigh up to three tons, may
become very aggressive if they are
disturbed or threatened by
humans.

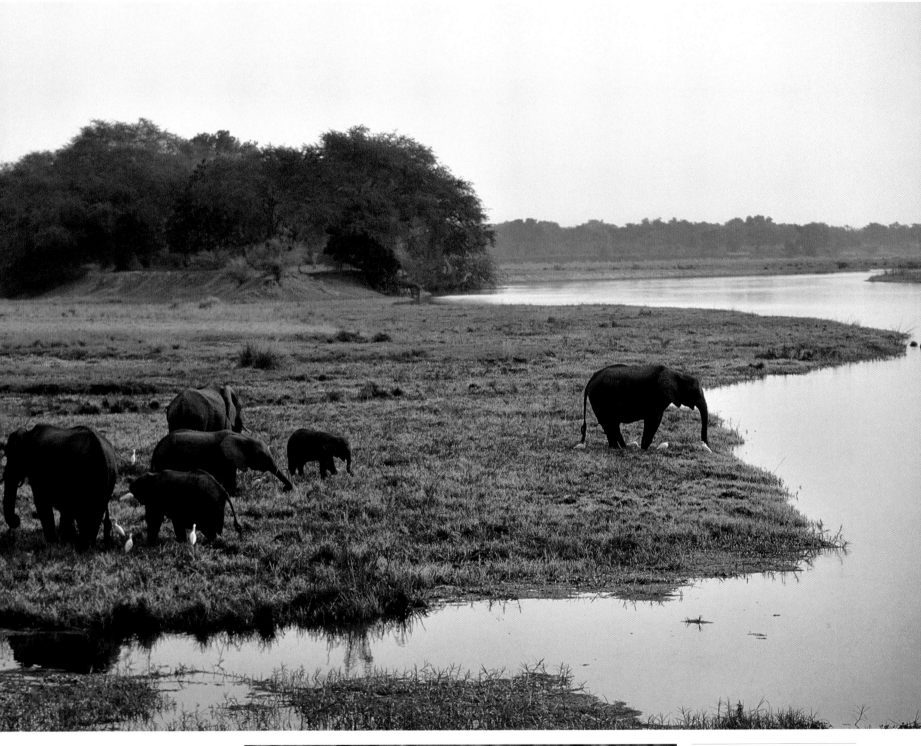

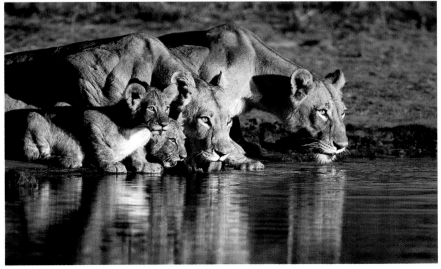

134-135 and 135 bottom
Elephants and lions are a
common sight in the large
national parks that lie along the
upper and middle course of the
Zambesi. A particularly
interesting protected area is
Mana Pools, situated in the
alluvial plains of northern
Zimbabwe, below Lake Kariba.

136 top and 137 bottom Downstream from Victoria Falls, the Zambesi in certain stretches is 1.2 miles (2 km) wide. While up to this point it headed south toward the inland Okavango delta, it now flows eastward, following the crevices in the terrain resulting from the tectonic movements that created the Great Rift Valley.

136 bottom The climate and quality of the soil determine the various types of flora that grow along the banks of the Zambesi. The sandy and alluvial terrain hosts palm groves and luxuriant vegetation, while the predominant plants in the rocky zones are baobab and the species typical of the Kalahari brush.

136-137 Flowing between tall basalt faces, the Zambesi precipitates thunderously down the deep and inaccessible Batoka gorges. In this crevice, sometimes less than 65 ft (20 m) wide, the river twists its way through a series of extremely violent rapids, marking extremely steep gradients in only a few miles of its course.

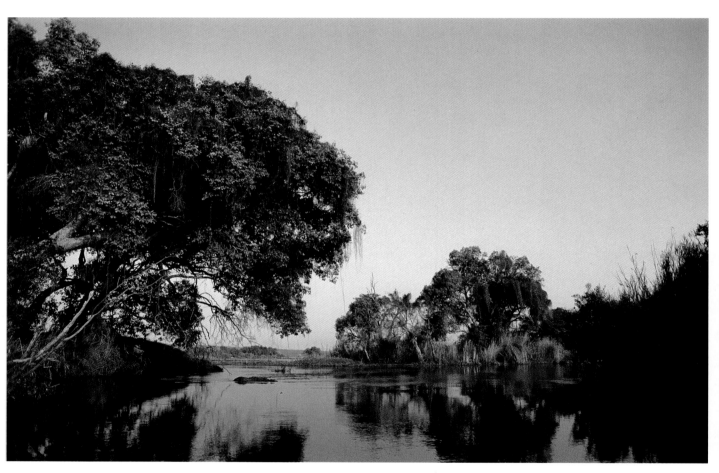

provides the Lozi with abundant fish and water for irrigation, but also determines the quality of the settlements. Every year, thanks to the heavy rains, the Zambesi flows over its banks and into the plain, which becomes an immense lake. In April the heartland of the Lozi, with a surface area of over 2800 sq. miles (7000 sq. km.) from Mongu to the Angolan border, lies under 6.6 ft (2 m) of silty water. This is when the royal drums beat to announce that the moment has come for the *kuomboka*, the ceremony that marks the move of the royal court from the summer residence in Lealui to the palace in Limulunga, about 12.5 miles (20 km) away on the low hills along the east shore of the river. The *Litunga*, followed by a procession of dignitaries, sits on the *Nalikwanda*, the enormous royal dugout

that will take him to his other residence. The boat, crowned by a large papier-mâché elephant, is propelled by 120 expert rowers wearing traditional costumes. The landing at Limulunga, just before sunset, is greeted by a large, festive crowd. The king appears before his subjects dressed in a black and gold ceremonial uniform, with a bicorn decorated with a tuft of white ostrich feathers. The uniform, along with cases of glass beads, was donated to the *Litunga* of the time by Cecil Rhodes; in exchange, the English were granted the right to exploit the mineral resources of the region as they wished.

The Zambesi proceeds southward through the lowlands of Barotseland, where its bed is 1.85 miles (3 km) wide in some stretches. As it approaches the Namibian border, its course

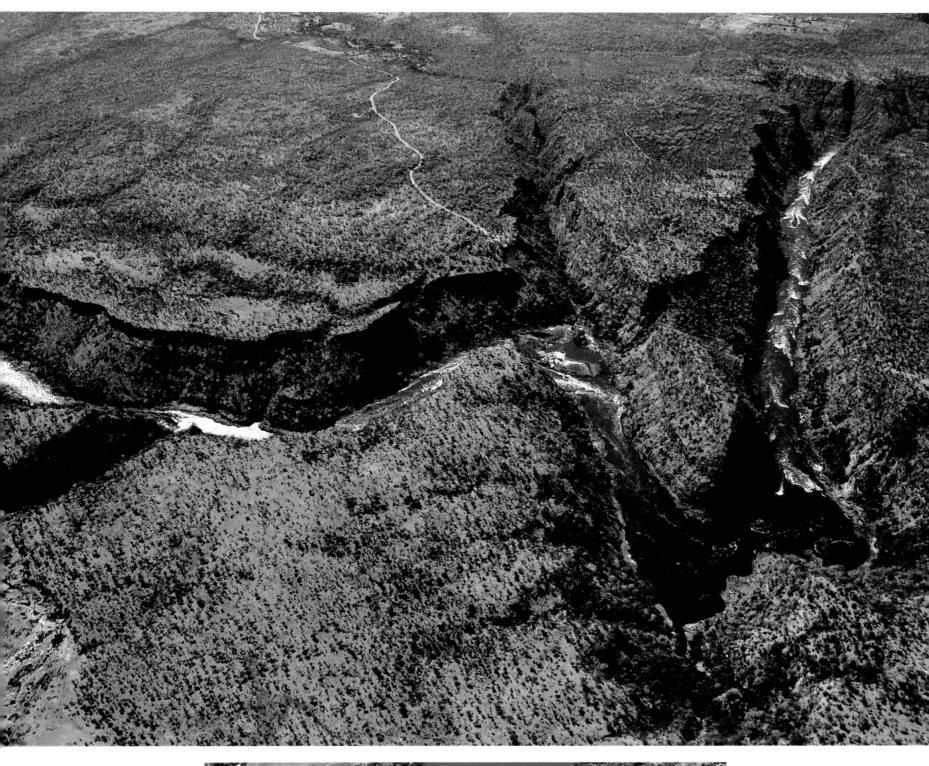

AFRICA

138 *A cloud of mist always envelops the Victoria Falls gorge, which is surrounded by a rain forest. The locals call the falls "Thundering Smoke," but the original inhabitants of this area christened them Shongwe, or "Place of the Rainbow."*

138-139 *Viewed from above, Victoria Falls reveal all their extraordinary power, especially during the dry season, when the characteristic mist is less dense and allows one to spot the basalt shelf from which the Zambesi plunges into the chasm below.*

THE ZAMBESI

becomes more capricious and is often interrupted by rapids and small falls. At Sesheke it suddenly changes direction, heading east. Millions of years ago the Zambesi flowed into the vast inland sea that lay in the middle of Botswana. Then the huge crevices created by the tectonic movement that created the Great Rift Valley channeled it into its present bed. The same thing occurred with the Kwando River, which under the name of Chobe empties into the Zambesi at Kasane. A short distance from here, the river precipitates with a deafening roar into Victoria Falls. The mist that always envelops the falls can be seen from 25 miles (40 km) away. The indigenous populations called the falls *Mosi-oa-Tunya,* or Thundering Smoke. It was the ubiquitous Livingstone who gave them the name of his queen. On 15 November 1855 he stood at the edge of the abyss on the islet of Kazeruka and recorded his impression: "Crawling terrorized at the tip of the island, I saw below me an enormous gorge between one bank

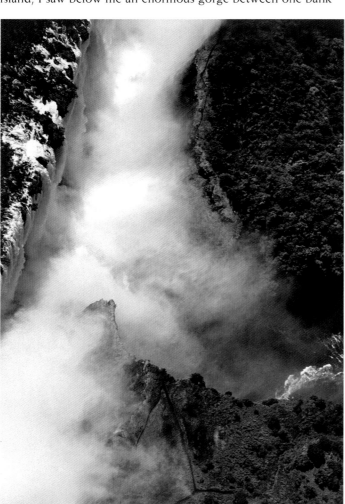

and the other of the Zambesi River; a mass of water 2540 ft to 3000 ft (800 – 1000 m) wide was falling from a height of 110 ft (33 m) and bubbling and frothing in an abyss 50 ft (15 m) wide." His estimates were completely wrong: the Victoria Falls are about 1.05 miles (roughly 1.7 km) wide, while the chasm is about 360 ft (110 m) deep and 198 ft (60 m) wide. The Zambesi casts 17.7 million gallons (68 million liters) of water per minute into that chasm, a quantity that may increase tenfold during the rainy season. When he returned to England, Livingstone had to withstand the complaints of his publisher, who said that the explorer's description contained too few adjectives for a bestseller. So they decided to invent a series of high-sounding phrases that included angels in flight, triple rainbows and "a myriad liquid comets." We do not know how much of this ridiculous literary padding was created by Livingstone himself, but in any case he got rich with the publication of his memoirs.

The mist that rises ceaselessly from the falls has produced an authentic rain forest, complete with primitive ferns and orchids. Monkeys and birds with brightly colored plumage abound in this natural park, a luxuriant belt that is in marked contrast with the ocean of brush that covers the highlands of Zimbabwe and Zambia. During the dry season, when the clouds of mist become thinner, one can catch sight of the basalt shelf from which the Zambesi plunges into the chasm. Basalt is very resistant to erosion but here has fractures that are perpendicular to the course of the river, and the Zambesi flowed precisely in these 'weak points': the Batoka gorges, which extend for about 62 miles (100 km) from the falls, are the result of this implacable erosion. Only 10,000 years ago Victoria Falls was pushed quite a way eastward, and this process of recession is still underway. Inch by inch, the Zambesi River is opening a new passage through the Devil's Cataract, at the beginning of the canyon.

Once out of the entrenched course of the Batoka highlands, the river goes on its way, sometimes animated by rapids, until it flows into the artificial Lake Kariba. After a series of seemingly insurmountable difficulties, the Kariba Dam was finished in 1960 by a group of Italian firms. Its power plant provides Zambia and Zimbabwe with much of their electric power. Between Kariba and Kanyemba, at the Mozambique border, the Zambesi River flows freely through a desolate,

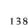

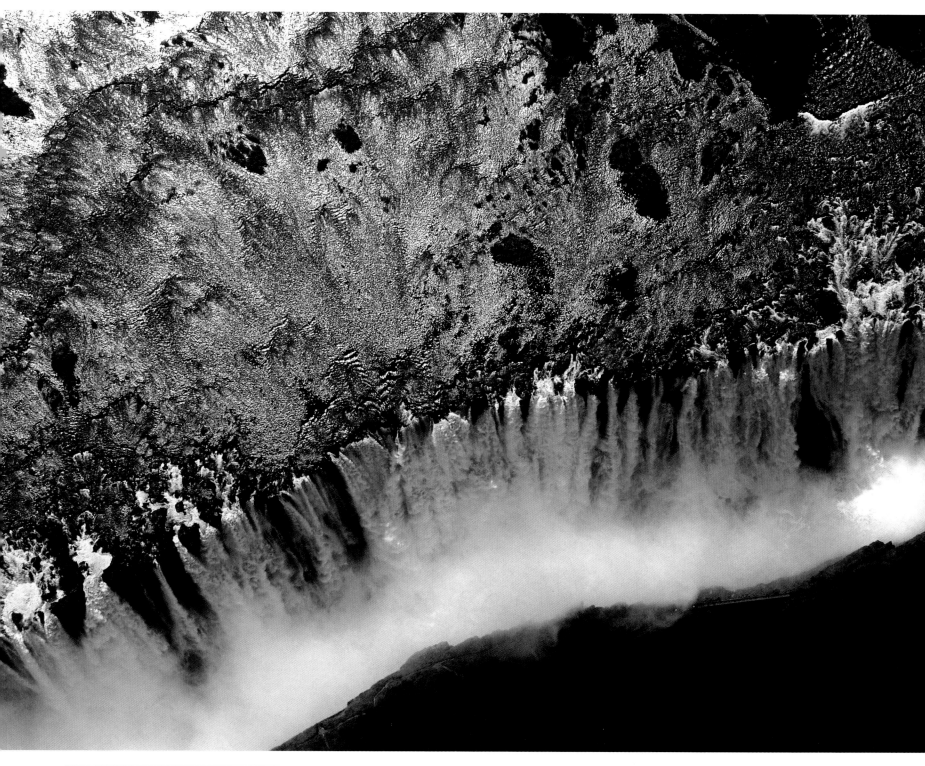

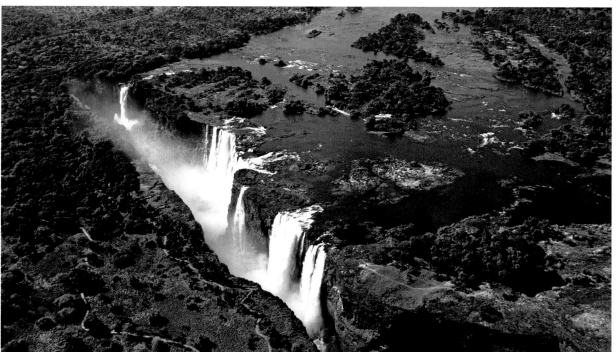

139 bottom In this aerial view of Victoria Falls one can see, from left to right, the Devil's Cataract, the Main Falls and Rainbow Falls, which are separated by the promontory of Kazeruka Island. The Main Falls are 2800 ft (850 m) wide and their volume of water remains constant throughout the year.

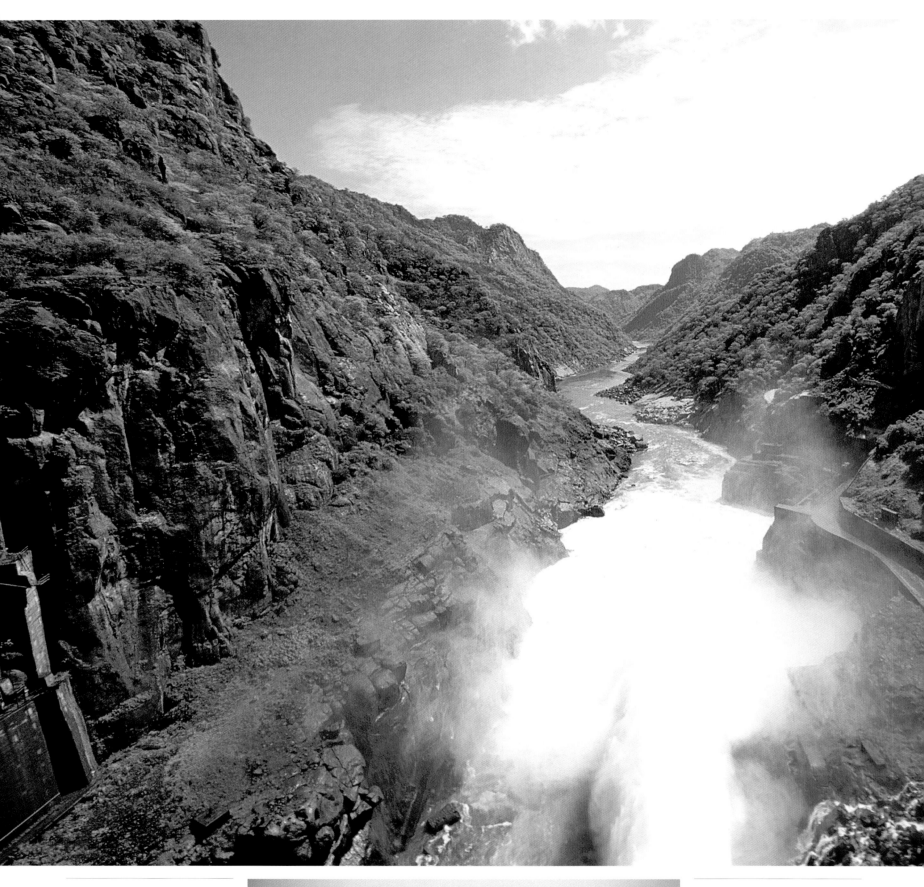

140-141 As it enters Mozambique the Zambesi penetrates a series of deep gorges and then flows broadly into the large artificial basin of Cabora Bassa. According to legend, in the depths of the lake are the mysterious silver mines of Chicova, which were exploited by the Portuguese as long ago as the 1600s.

140 bottom The railway bridge of Muturara, situated halfway between the city of Tete and the Indian Ocean coast, is one of the few that cross over the Zambesi River. The railway links the port of Beira and the rich mining areas that lie around Tete.

141 top Viewed from the Kariba dam, which regulates its flow, the Zambesi appears to have lost its former power and majesty. The artificial lake which extends over 1930 sq. miles (5000 sq. km) and provides both Zambia and Zimbabwe with electric power.

141 bottom The city of Tete, an old Portuguese outpost, the Zambesi proceeds peacefully through land that has remained unchanged over the centuries. In the vicinity of the town of Muturara, after taking in the abundant waters of the Shire, the river heads slowly toward the Indian Ocean.

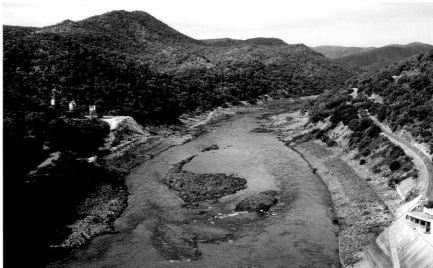

uninhabited region: malaria and trypanosomiasis, or sleeping sickness, transmitted by the tsetse fly, discourage the creation of permanent settlements, so that the land is the domain of wild animals. In this section the river takes in the waters of two major tributaries, the Kafur and the Luangwa, which increase its size considerably. Until 1974 its entry into Mozambique was heralded by the Cabora Bassa rapids, which are now submerged in the large man-made basin. As the Zambesi approaches the labyrinthine delta at the Indian Ocean, it becomes broader and more majestic. Here the Shire River empties into it from the north, carrying the waters of Lake Malawi.

Since the mid-16th century, when the first Portuguese adventurers founded the trading posts of Sena and Tete, the Zambesi River has remained basically the same: wild and unpredictable.

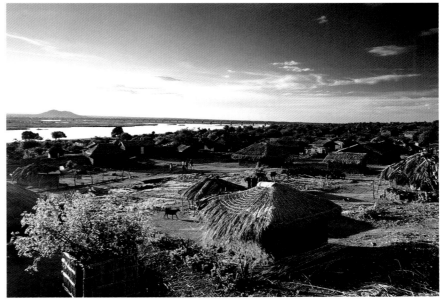

ASIA

With a surface area of 16,833,000 sq. miles (43,608,000 sq. km), Asia is the largest continent on Earth. Despite this, its rivers are generally shorter than those in the other continents (though there are notable exceptions) and their drainage area is smaller. This depends mostly on the physical configuration of Asia, the middle section of which is occupied by vast desert lakes bordered by mountain ranges. The few rivers that cross the Gobi and Takla Makan deserts disappear in the sand since they have no outlet to the sea. West of the Pamirs, in the arid steppes of Turkestan, the Syr Darya and Amu Darya rivers end in Lake Aral, which is now the almost dry 'carcass' of an ancient inland sea. All the large Asian rivers (except for the Amur) that empty in the Indian and Pacific Ocean originate in the Tibetan plateau north of the Himalayas.

The Ganges, Indus, Brahmaputra, Mekong, Salween and the rivers of China, all flow – at least at the beginning of their course – from east to west, following the alignment of the mountain chains. Some run for long stretches in parallel valleys: this is particularly true of the Mekong, Salween and Yangtze, which in north Yunnan almost touch one another and are separated by narrow dividing ranges. The average discharge varies considerably according to the configuration of the delta, the amount of monsoon rainfall, and the water from thaws, so that it ranges from 625,000 cubic ft (25,000 cubic m) per second for the Brahmaputra to the 62,500 cubic ft (2,500 cubic m) of the Yellow River (but the outflow of this latter can increase tenfold during the high-water season). There is always a great amount of silt deposit, which in thousands of years has created some of the most fertile plains on Earth, where most of the Asian population lives.

The rivers that flow into the Arctic Ocean have different characteristics: they cross through regions with small populations where the towns are rare and the cold climate makes almost any form of agriculture impossible. The Yenisei, Lena and Ob rise up from southern ranges of the Siberian plateau, which extend from the Altai Mts. along the Mongolian border to the Stanovoi Range. They are blocked by the ice for most of the year, and are therefore navigable only in summer, but their colossal hydroelectric potential is destined to play a decisive role in the development of the so-called virgin lands of eastern Russia.

The third waterway center of Asia, the Armenian plateau, is in Turkey: this is point of origin of the only two large rivers in the Middle East, The Tigris and Euphrates. Together with the Yellow River and the Indus, they were the vital sap of some of the most ancient civilizations in the history of mankind.

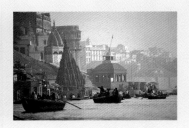

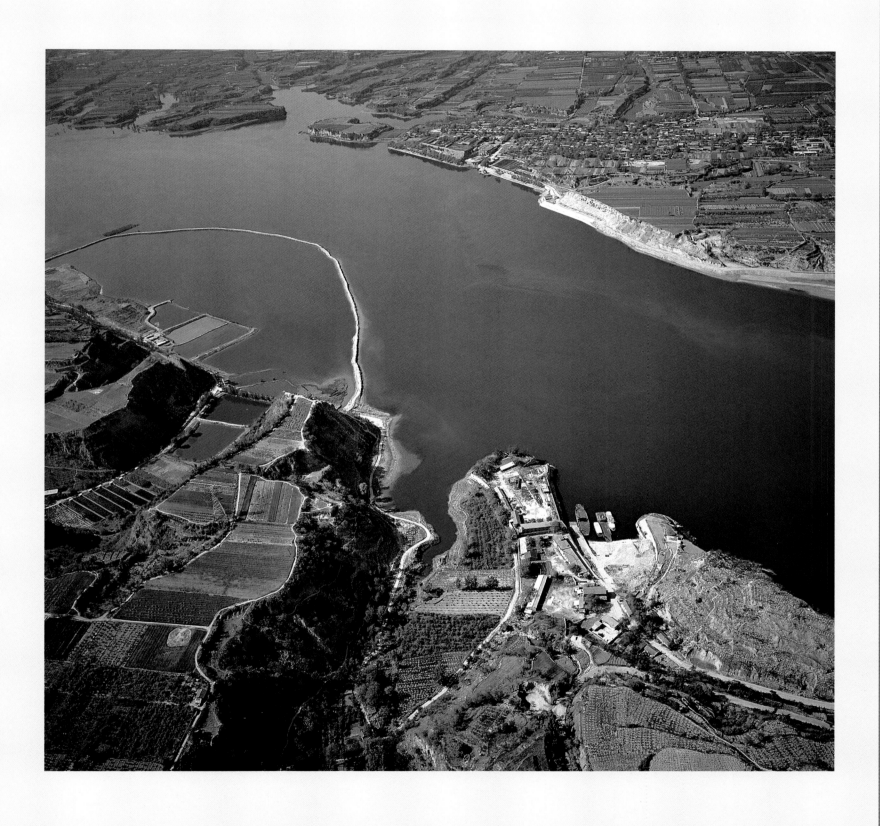

142 left Rice paddies in the Mekong River delta near Vung Tau, South Vietnam.

142 center The Brahmaputra flowing through the plateau of Tibet.

142 right Boats moving along the shores of the Ganges at Varanasi, India.

143 A stretch of the Huang He at the city of Zhengzhou, in Henan Province, China.

144-145 An endless strip of vegetation marks the passage of the Euphrates through the town of Kemah, downstream from Erzincan. The river, which at this point is called the Firat, crosses the barren regions of eastern Turkey, the cradle of civilization in very ancient times.

145 top This torrent running through the snow-capped mountains of eastern Turkey marks the beginning of the Euphrates River. The inflow from other waterways that descend from the region north of Erzurum give rise to one of the most important rivers in the Middle East.

145 bottom The clear blue sky in eastern Turkey is mirrored in the waters of the Euphrates. This river, which by the end of summer has very little water, is at its maximum discharge in spring, when it is reaches the top of the arches of this bridge.

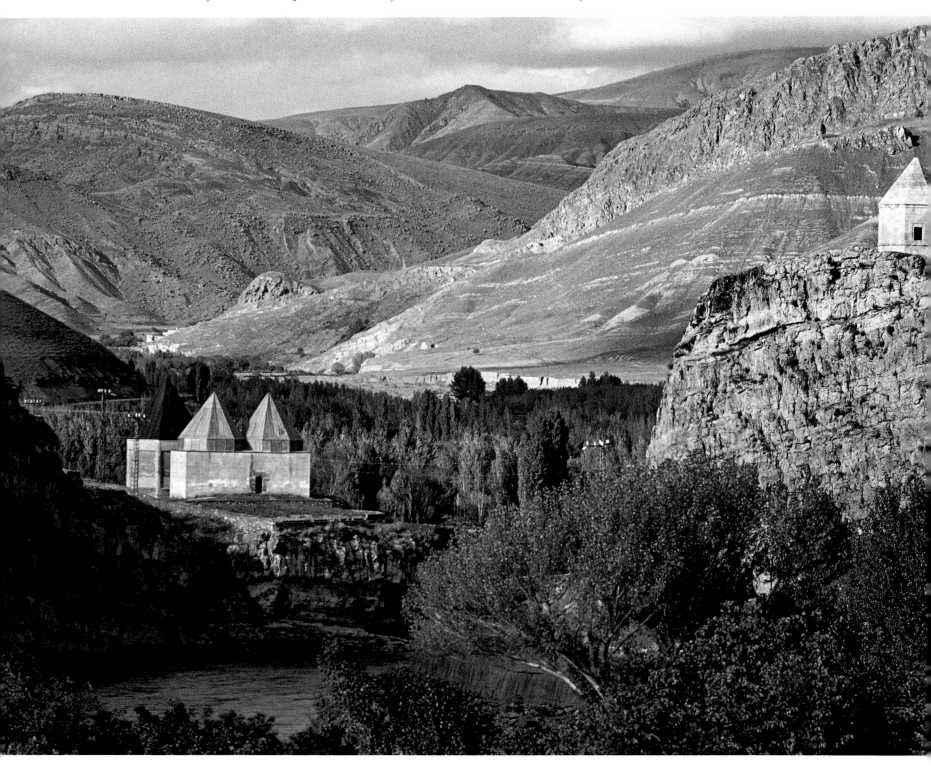

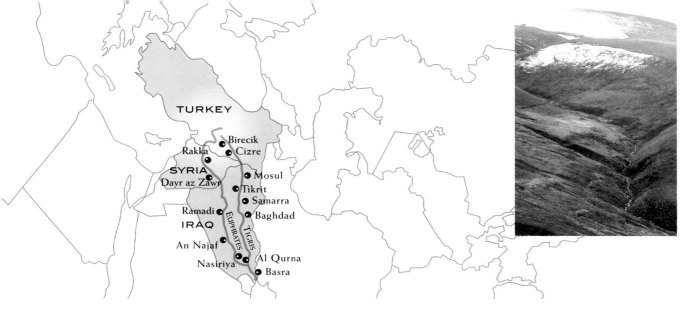

THE TIGRIS AND EUPHRATES

THE FASCINATION OF THE PAST

The first known world map dates from 2500 years ago and was carved on a clay tablet a little larger than a pack of cigarettes. The Earth is represented with disarming simplicity: it appears as a flat disk surrounded by water and traversed by two parallel lines that depict the shores of the Euphrates River. In the middle of the circle, surrounded by satellite cities, is Babylon, the most famous urban area in antiquity. Actually, the Babylonians were truly excellent astronomers who were able to calculate almost perfectly the orbits of the moon and the movements of the stars. This map was not intended as a means of transmitting geographic information, but as a precise symbolic message: Babylon is the center of the world.

It was in fact in Mesopotamia, the Greek word for the "land between rivers," that one of the most extraordinary adventures in human civilization began 7000 years ago in the heart of that Fertile Crescent whose arc extended up to Palestine and Sinai. This was the cradle of our culture, law, philosophy, science and art. The first form of writing grew up in Mesopotamia and gradually evolved from pictographic writing to the abstract cuneiform script. It was here that the 12-month calendar, 60-minute hour, and the basics of algebra, geometry and medicine were created. The eclipses were predicted with great accuracy and the duration of the solar year was calculated with a margin of error of only 4 minutes and 32 seconds. The first code of laws was drawn up by Hammurabi on the shores of the Euphrates around 1800 BC.

That strip of land between the twin rivers was the birthplace of metallurgy and agriculture, which thanks to sophisticated irrigation techniques became a permanent and profitable activity that fed a large urban population. The foundation of the cities of Erech, Eridu, Ur, Nippur and Adab dates from the IVth millennium BC, and the first Mesopotamian empire, established at Akkad, achieved its apogee 1500 years before the birth of Rome. After the decline of Ur, wars and invasions forged Babylon, which was destroyed and rebuilt several times and for ten centuries was the political and cultural capital of the region.

In the meantime, in the north, the banks of the Tigris (to the east of the Euphrates) witnessed the rise of the Assyrians, whose military power was based on their war chariots and iron weapons: in a short time their dominion, which began in 900 BC, extended from the Persian Gulf to Egypt. In the following centuries the Medes, Scythians, Chaldaeans and then the

Persians vied for dominion in the land between the two rivers. Alexander the Great dreamed of Babylon as the capital of a world empire, but he died there in 323 BC. The death of the Macedonian conqueror was the ideal conclusion of the most ancient chapter of an age-old story that was often bloody but was always marked by creative genius.

Properly speaking, Mesopotamia is mostly situated within the confines of modern-day Iraq, delimited to the east by the last section of the Iranian plateau and to the west by the desert tableland of Saudi Arabia and Syria. The climate is dry, with temperatures of up to 50° C in the summer, and the rainfall is scarce and irregular. Mesopotamia owes its fortune exclusively to the Tigris and Euphrates, which for millennia deposited a thick

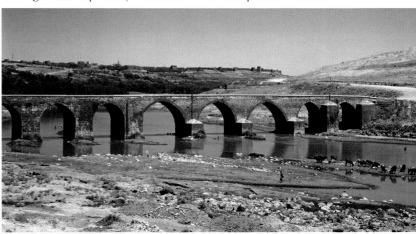

layer of silt on the sterile plain, creating a gigantic oasis of fertile land in an environment that is hostile to human endeavor. Today as in the past, the lives of millions of people depend on the seasonal floods and the utilization of the water to irrigate the fields.

The Tigris and Euphrates both rise in Turkey, in the mountains of the Armenian plateau. Initially they follow an almost parallel course and then diverge, approaching each other near Baghdad, where the two rivers are barely 218 miles (353 km) apart. Lastly, at Qurnah the Tigris flows into the Euphrates to form the Shatt al-Arab, which empties into the Persian Gulf. The drainage basin of the Tigris-Euphrates system covers about 300,000 sq. miles (750,000 sq. km), extending over vast regions of Turkey, Syria and Iraq. The headwaters of the 1674-mile (2700-km) long Euphrates are situated in the barren mountainous area north of Erzurum, at an altitude of over 9900 ft (3000 m). At first the river is called Kara Su, then it takes the name of Firat as it is entrenched in a deep, narrow valley.

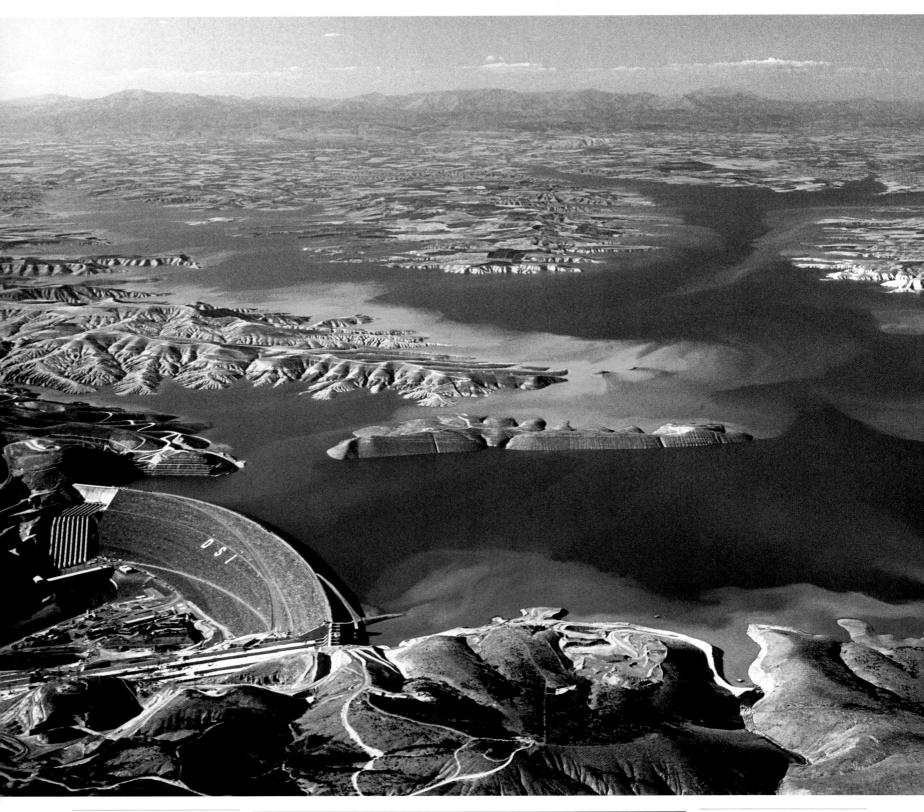

146-147 The colossal Atatürk Dam, which is the largest in Turkey, takes in 80% of the water in the Euphrates, providing most of the country's electric power. However, the containment of the upper course of the river may seriously damage the economy of Syria and Iraq.

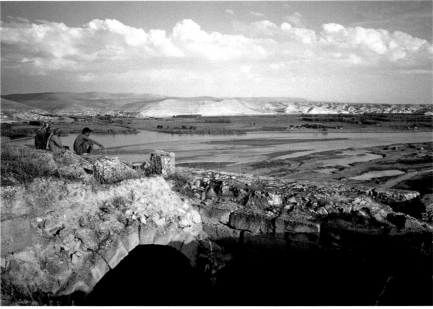

146 bottom Mute witnesses of history, these imposing ruins of a citadel dominate the course of the Euphrates. Many of the castles and fortresses in Syria were built in the period of the Crusades.

147 top After leaving behind the mountains of Turkey, the Euphrates flows into the vast, rather flat semi-desert so typical of Syria and Iraq.

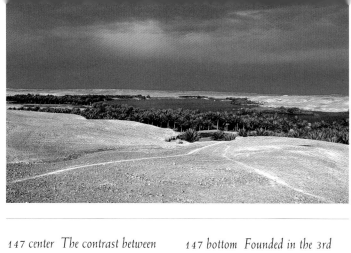

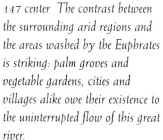

147 center The contrast between the surrounding arid regions and the areas washed by the Euphrates is striking: palm groves and vegetable gardens, cities and villages alike owe their existence to the uninterrupted flow of this great river.

147 bottom Founded in the 3rd century BC during the reign of the Seleucid dynasty, the stronghold cf Dura-Europos overlooks the Euphrates Valley. For five centuries this city was one of the most prosperous trade centers in Syria.

THE EUPHRATES

During its course it receives the waters of several tributaries that in spring swell as they receive the melted snow. After Keban, where it takes in the large amount of water from the Murad, the rushing flow of the river is checked by a series of large dams and it runs through the barren edges of the Anti-Taurus Mts. and into a huge greenish-blue lake. The Turkish government's medium-term development project calls for the construction of about twenty dams on the upper sections of the Euphrates and Tigris. The advantages for Turkey are clear, but the completed project may seriously jeopardize the economy of Syria and Iraq, whose water supply would be halved.

The Euphrates River leaves the Taurus Mts. behind and suddenly turns southward, entering the plain of Syria. At this point it is close to the Mediterranean, only 93 miles (150 km) away, and quite far from the Tigris River. This steppe region, which is not so arid and has a good supply of underground water, was once traversed by one of the very ancient trade routes that linked the Mesopotamian cities and the coast of Lebanon, Anatolia and Armenia, sources of precious materials such as copper, silver and construction wood. The focal point of this trade was the city of Mari, which the Euphrates touches before the Iraqi border. The Sumerians, the rulers of Akkad and the Assyrian Empire all wanted to conquer Mari for its riches, but the city always managed to retain a certain degree of independence until it was destroyed by Hammurabi in 1759 BC. Among the ruins of its labyrinthine royal palace, which had no less than 260 rooms, archaeologists found over 20,000 clay tablets with cuneiform inscriptions: a precious archive that offers a lively description of the city's everyday life and historic events.

When it arrives at Baghdad, the Euphrates, now several hundred feet wide and linked to the Tigris via an artificial canal, heads southward toward Babylon and southern Mesopotamia. Enclosed by tall embankments, the river moves into a completely horizontal plain as the valley flattens out,

and the Euphrates, which in some sections has an elevated bed, meanders broadly, branching out into secondary arms often obstructed by the accumulation of sediment. In the past the river followed a different course and its banks touched the walls of Ur, which are now surrounded by a desert of dry mud. The canals that once carried water to the cultivated fields dried up and the city was abandoned for good in the 4th century BC. The riches and fame of Ur, the fabulous treasures of gold and precious stones found in the gloomy tombs of the kings, all depended totally on the generosity of the Euphrates.

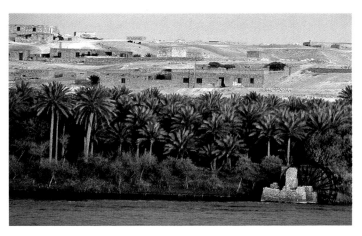

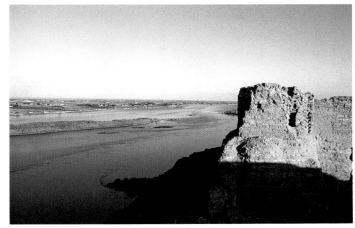

THE TIGRIS

148 top The Tigris winds its way in a deep and narrow valley through the mountains of Turkish Kurdistan, where there are many rapids and small waterfalls, so that the river is torrential up to the city of Mosul, Iraq.

148 bottom left Flowing placidly in its wide bed in the plains of Iraq, the Tigris heads south with an almost imperceptible gradient. The waters of this river, which are regulated by canals, have been used for irrigation since the 3rd century BC.

148 bottom right The tortuous course of the Tigris splits the city of Baghdad, which was founded in AD 762 by the Abbasids near the ruins of ancient Ctesiphon. In the vicinity of the capital of Iraq the Tigris and Euphrates are only 18.5 miles (30 km) apart.

149 Fog banks, sandbars and brackish lagoons characterize the coastline of the Persian Gulf at a level with the delta of the Shatt al-Arab, the large navigable waterway formed by the merger of the Tigris and Euphrates.

The Tigris, on the other hand, seems to have played a minor role in the rise of Sumerian civilization. Although it is not as long as the Euphrates, its outflow is twice as large and in its lower section it is surrounded by vast marshy zones unfit for human habitation. Furthermore, the river flows in an entrenched bed in the plain, which makes it impossible to utilize the water for irrigation by exploiting the force of gravity. The Tigris, known as the Hiddikel in the Bible, rises at Lake Hazar in the Armenian Taurus Mts., northwest of the city of Diyarbekir. Interrupted by rapids and falls, it begins its journey among the mountains of eastern Turkey and up to the Syrian border, which it skirts for about 19 miles (30 km). Once in Iraq, the Tigris meanders rather slowly; when it reaches Mosul it is already a full-fledged river. Those undulating plains that descend softly toward the banks of the Tigris were the birthplace of Assyrian civilization. It was here that Nineveh and Nimrud, the cities of Sennacherib and Ashurbanipal, rose up as the capitals of the first large empire in the Middle East. The impressive ruins of the buildings and fortifications, the stone lions, the human figures with wings and eagles' heads, bear witness to the splendor of a culture that was at once warlike and highly sophisticated.

From Mosul to Baghdad the Tigris River flows sluggishly southward in a broad valley. In this section it receives four major tributaries that come from the mountains of Iran and Kurdistan: the Little Zab, the Great Zab, the Adhaim and the Diyala, which are responsible for the ruinous spring floods. When the river reaches the city of Al-Kut the landscape changes drastically and the plain becomes an expanse of pools, canals and dry riverbeds that absorb 80 percent of its water. At the confluence with the Euphrates, after flowing for 10545 miles (1700 km), the Tigris, no more than 198 ft (60 m) wide, looks like a secondary tributary of its big brother. The two rivers merge at Shatt al-Arab, the great waterway that marks the border with Iran. The Persian Gulf, known in Babylonian cosmogony as the Bitter River, is only 111 miles (180 km) away.

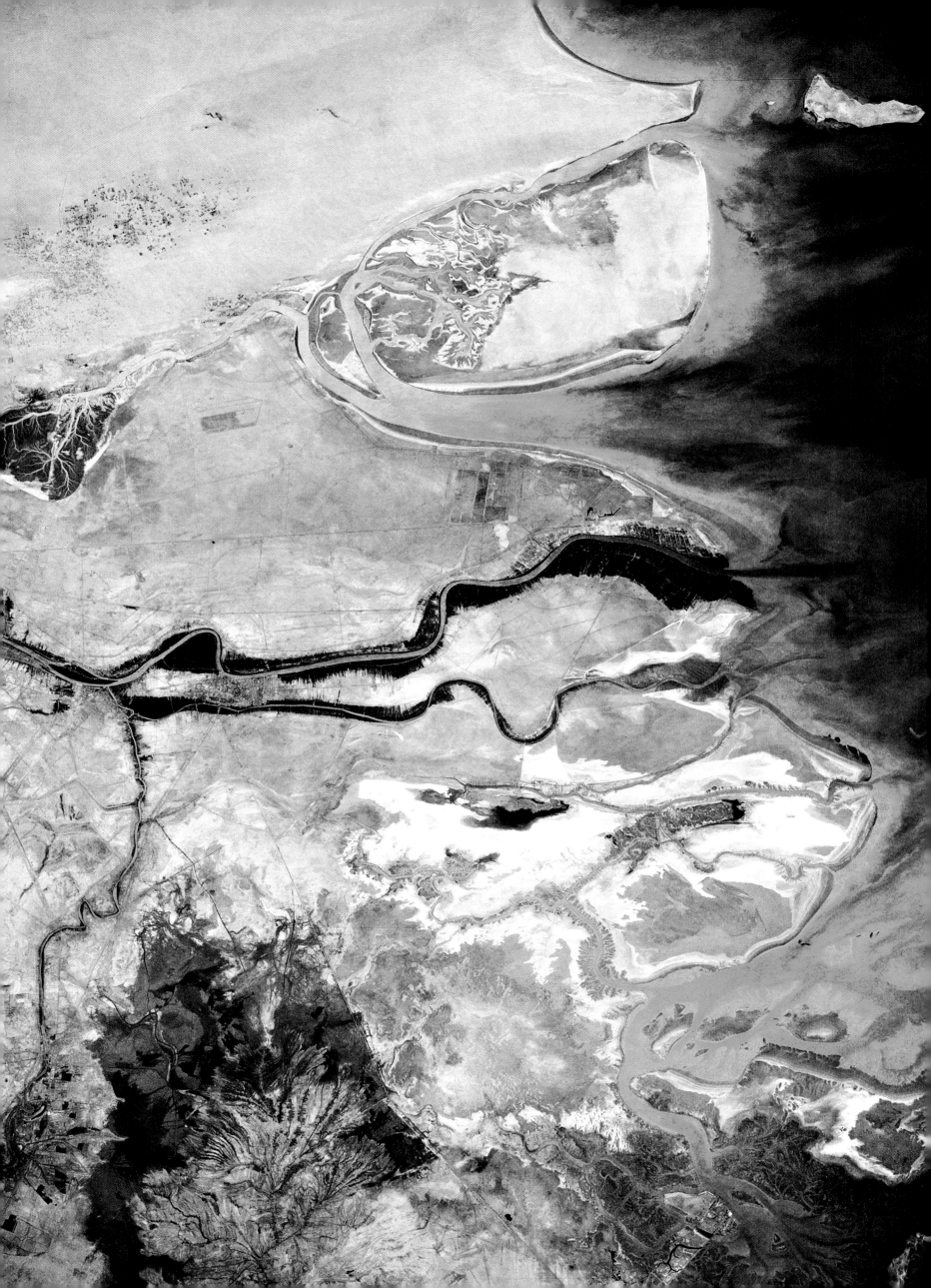

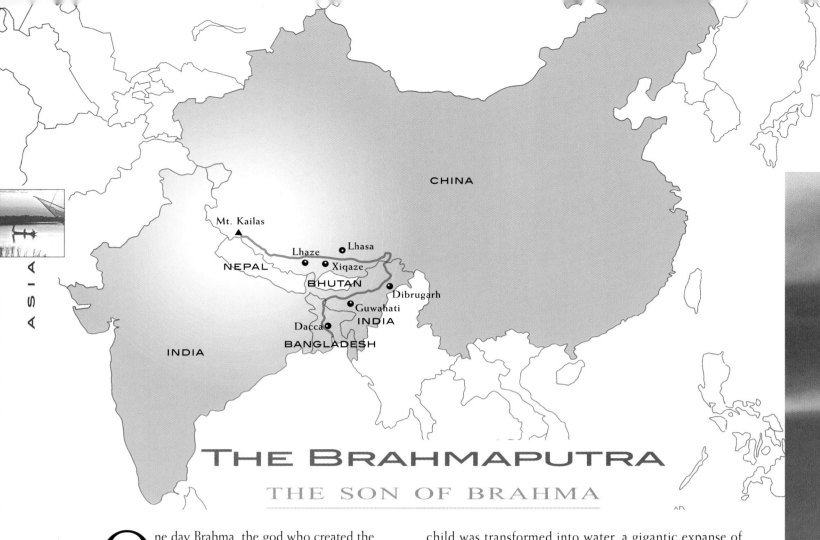

THE BRAHMAPUTRA
THE SON OF BRAHMA

One day Brahma, the god who created the Universe, decided to spread his seed over the Earth in order to benefit all mankind. For the act of conception he chose a woman called Amogha, the wife of the venerable Shantanu, considered the wisest of the wise men. When Amogha gave birth, Shantanu was struck with divine inspiration and decided the take the child beyond the great mountain barrier, onto the barren highland dominated by Mt. Kailas, the famed sacred mountain. Here a miracle took place and the newborn

child was transformed into water, a gigantic expanse of cool currents that flowed onto the Earth. The *Kalika Purana*, a 10th-century Indian text, gives this explanation for the origin of the Brahmaputra, or "son of Brahma," the 'male' river *par excellence*.

In this case legend and reality coincide perfectly. The headstreams of the Brahamputra lie in the glaciers of Kubi Gangri, about 16,500 ft (5000 m) above sea level, in the remote region of western Tibet between the Himalayas and Mt. Kailas. That maze of ridges and valleys goes to make up the divide where some of the largest rivers in South Asia begin – from the Indus to the Ganges. But while the Ganges soon moves away from the mountains and flows in the large plains of northern India, the Indus and Brahmaputra linger for a great distance in the craggy, solitary valleys, skirting in opposite directions the north slopes of the Himalaya range. This highly important mountain complex, which is to this day hard to penetrate, appeared on maps only in the early 20th century thanks to the journeys of Sven Hedin. On 10 September 1907, at his camp on the slopes of Mt. Kailas, the Swedish explorer could finally celebrate the success of his long treks on the Tibetan plateau: "At last I experienced the joy," he wrote in his diary, "of being the first white man to reach the headstreams of the Indus and the Brahmaputra, two rivers that have been famous since time immemorial, which encircle the entire Himalaya range like the chelae of a crab." The comparison is perfect: while the Indus heads westward, burrowing its way among the giants of the Karakorum range and the last spurs of the Nanga Parbat peak, the Brahmaputra flows almost immediately into a broad valley the passes eastward through southern Tibet for over 745 miles (1200 km).

In this long and almost straight stretch in Tibetan territory, the river is called the Tsang-po. It flows in a vast sandy bed, breaking up into a large number of branches that separate and merge in continuation, carrying with them an enormous

150 *An enormous glacier formed by the snows of Kubi Gangri and Mt. Kailas is now considered the most important headstream of the Brahmaputra River. This region, one of the most remote and inaccessible in Tibet, was explored by the Swede Sven Hedin in 1907.*

150-151 *The Brahmaputra's valley, which runs through Tibet like a huge scar for over 745 miles (1200 km), is surrounded by a high-altitude desert. The formation of the Himalayas changed the river's course; it once flowed westward.*

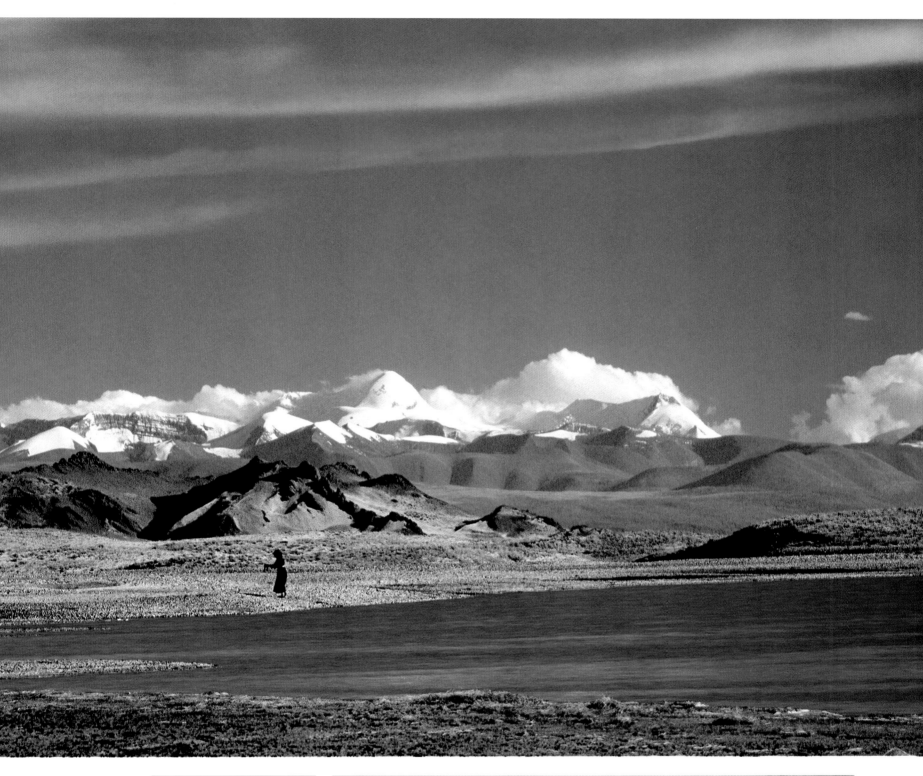

151 bottom This Tibetan woman is drawing water from a pool at the headwaters of the Brahmaputra. After the Chinese invasion, which imposed social modes quite alien to the traditional local culture, many Tibetans sought refuge in neighboring countries.

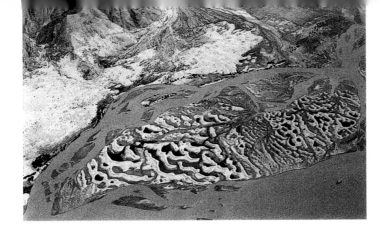

THE BRAHMAPUTRA

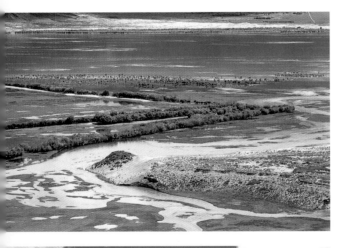

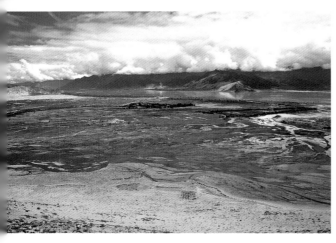

quantity of silt that has been estimated at about 600 million tons per year. In its course, which is not attenuated by bends or meanders, the Tsang-po is always at an altitude of around 13,200 ft (4000 m), which makes it the highest river in the world. As is only fit for the young son of a god, this river is unpredictable and capricious: its course is unstable, its dimensions change suddenly, with incredible speed, jeopardizing the property and very life of the people who live along its shores. The erosive action of the river is violent and relentless, and is augmented by the frequent earthquakes that strike this region; the risk of uncontrollable floods is constant and serious. Like a huge, frothy braid, the bed of the Brahmaputra shifts and widens continuously, ruining cultivated fields and villages alike. The floods often occur suddenly and unexpectedly, caused by glacier tributaries and above all by the monsoon rains that fall abundantly in the eastern regions of India from June to September: in the years when rainfall is particularly persistent and heavy, almost one-third of Bangladesh is flooded. During the catastrophic flood of 1988 the high water receded only 24 days later, killing hundreds of people and undermining the already fragile local economy.

After passing through the city of Xiqaze and near the Tashilumpo monastery, the traditional residence of the Panchen Lama, the Tsang-po proceeds without incidents up to the village of Gyala. Here to block its passage toward the ocean are the last colossal mountains of the Himalaya range, the Namcha Barwa and Gyala Pera, which are well over 23,000

152 top This view of the valley of the Brahmaputra, which in Tibet is called the Tsang-po, highlights the configuration of a terrain that has changed due to the tectonic movements so common in this region.

152 center and bottom Wedged between the Himalayan range and the southern edge of the Tibet plateau, the Brahmaputra flows swiftly in a broad, very straight valley.

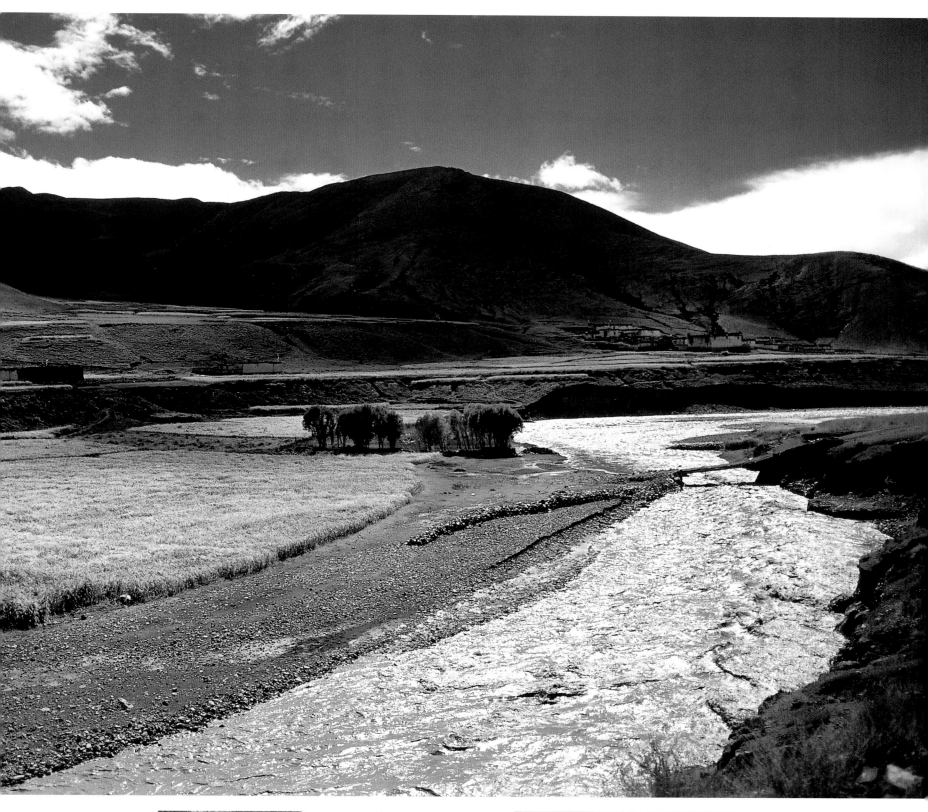

153 bottom right Flowing in a bed with indefinite margins, the Brahmaputra appears to be placid, as shown here.

But in reality the river is notorious for sudden and violent floods that can change its configuration with lightning speed.

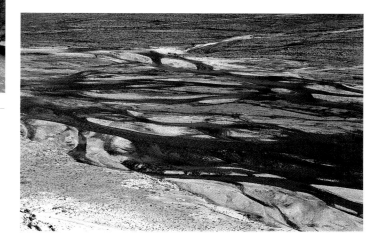

152-153 Fields and hills border this section of the Brahmaputra, which is swollen because of the spring thaw. From Tibet to the plains of Bangladesh, there is an incredible variety in the scenery by the river.

153 bottom left In the most remote regions of Tibet, people travel on the Brahmaputra with boats consisting of a wooden framework covered with yak hides.

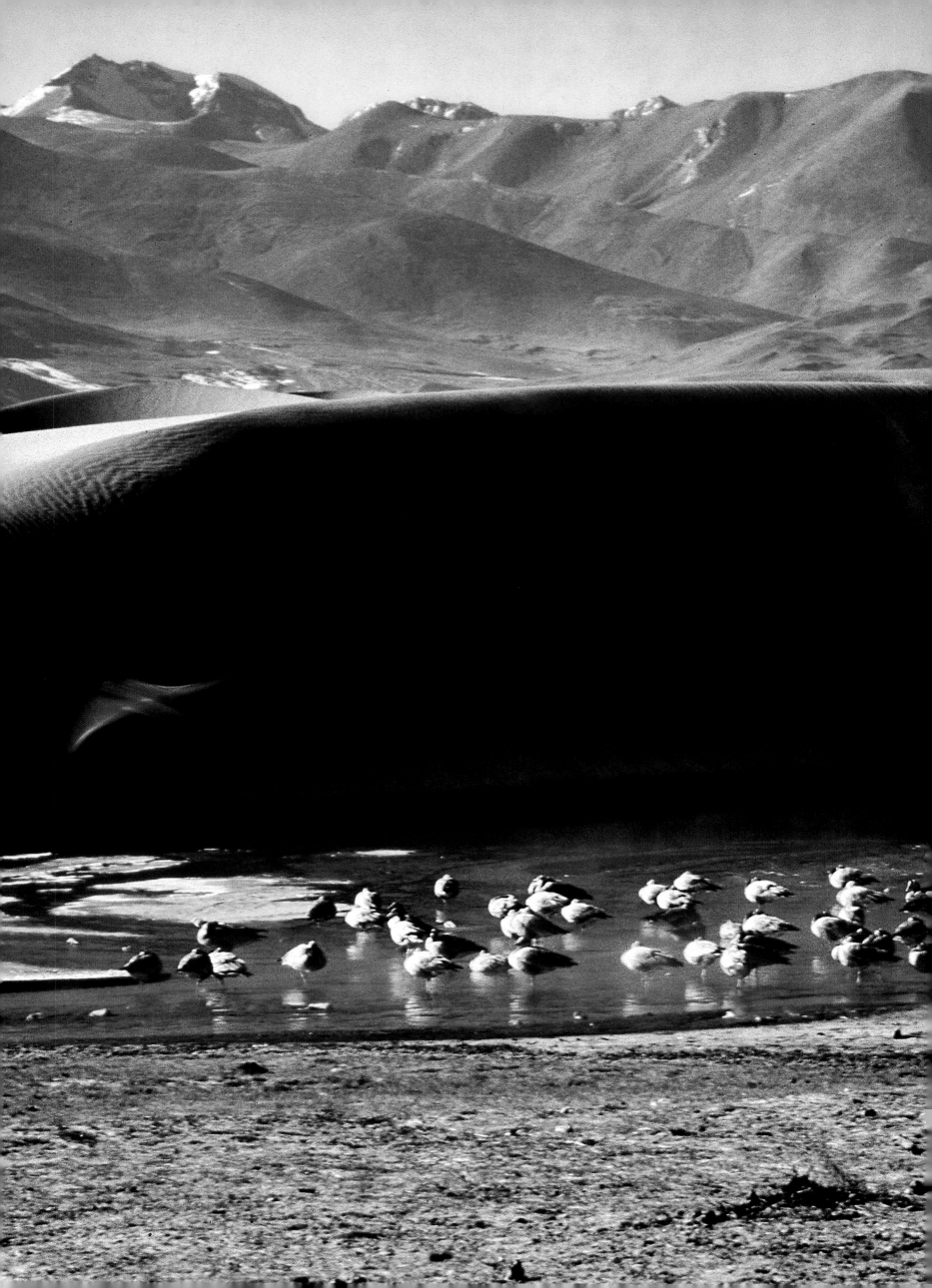

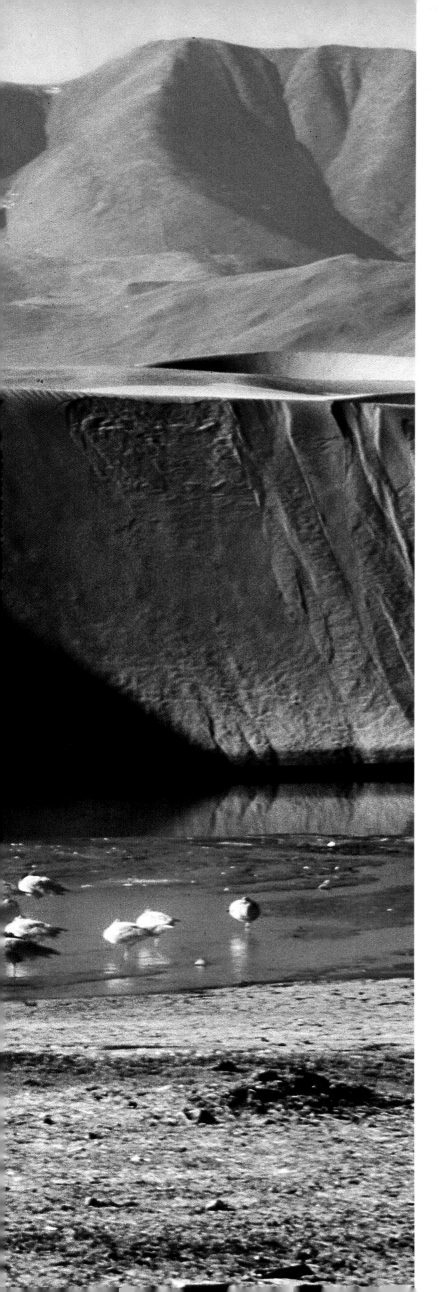

THE BRAHMAPUTRA

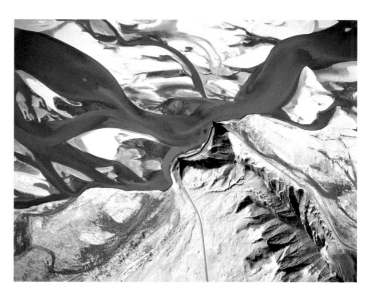

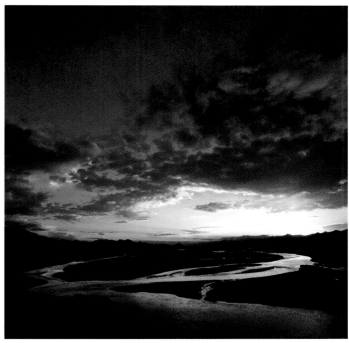

154-155 A flock of aquatic birds has found refuge at the foot of a huge sand dune in a placid branch of the Brahmaputra. The diversity of environments along the river is matched by an exceptional variety of bird species.

155 right This aerial view highlights all the wild grandeur of the Brahmaputra-Tsang-po. For centuries the double identity of the river was wrapped in an aura of mystery. In the early 20th century, exploration of the gorges of the Tsang-po ended the puzzle.

ft (7000 m) in altitude. The river penetrates the deep valley dominated by these two formidable bastions, making a narrow bend southward. Then, entrenched in a gigantic gorge, it changes direction, roaring swiftly westward. In only 155 miles (250 km) the Tsang-po descends 9900 ft (3000 m), bursting through an uninterrupted series of rapids that are among the most violent in the world. This section of the

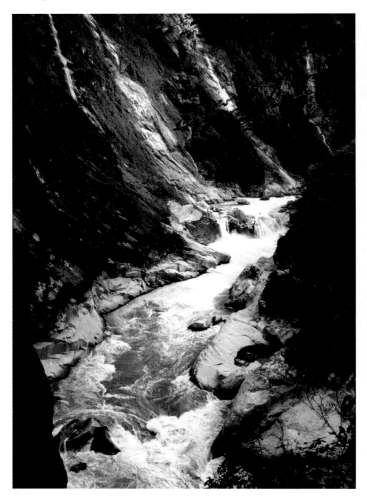

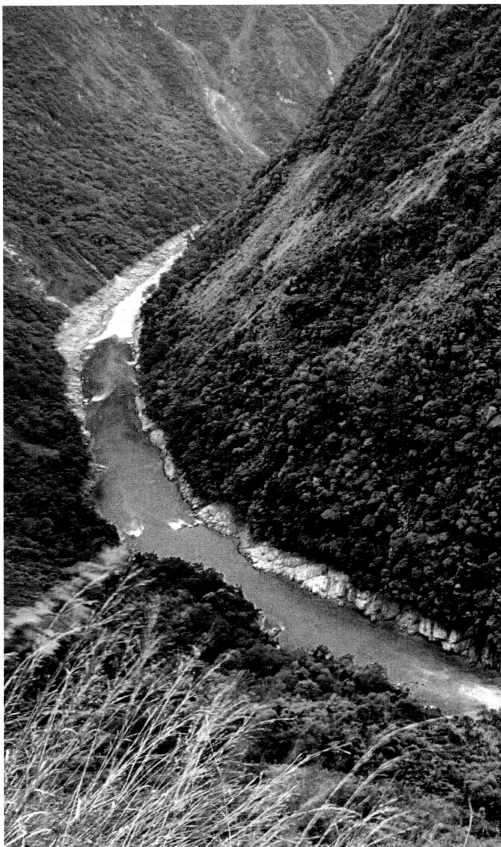

river is wrapped in an aura of mystery: until a little over a century ago no one knew for certain whether the Tsang-po and the Brahmaputra were the same river. At certain points the river is entrenched by the smooth, perpendicular rock faces hundreds of feet high in a dramatic, primeval landscape. To this day, the remote and inaccessible gorges of the Tsang-po have been only partly explored: the last expedition that attempted to go down the river (1998) was brutally driven back and one of the members was killed by the raging rapids.

When it calms down, the river enters the Indian region of Arunachal Pradesh, where it is called Dihang (or Siang). The

THE
BRAHMAPUTRA

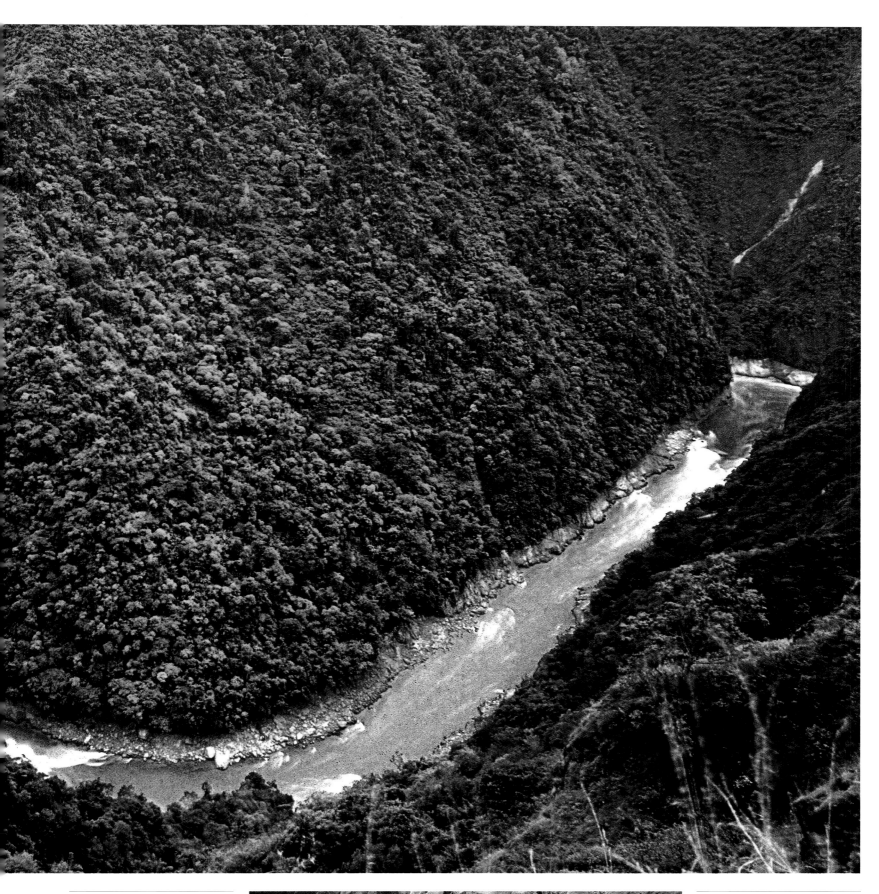

156 left and 157 bottom In a
continuous series of extremely
violent rapids, the Tsang-po hurls
itself into the inaccessible gorge that
cleaves the last spurs of the eastern
Himalayas. For a long time, the
great difference in height between
the upper and lower entrances of
the gorge – about 9840 ft (3000
m) – led people to believe in the
existence of an unimaginably large
waterfall there.

156-157 The violence of the
Tsang-po gradually lessens as the
river proceeds toward the Indian
border, where it is called the
Dihang. The thick forests flanking
the river are the home of rare species
of plants and animals.

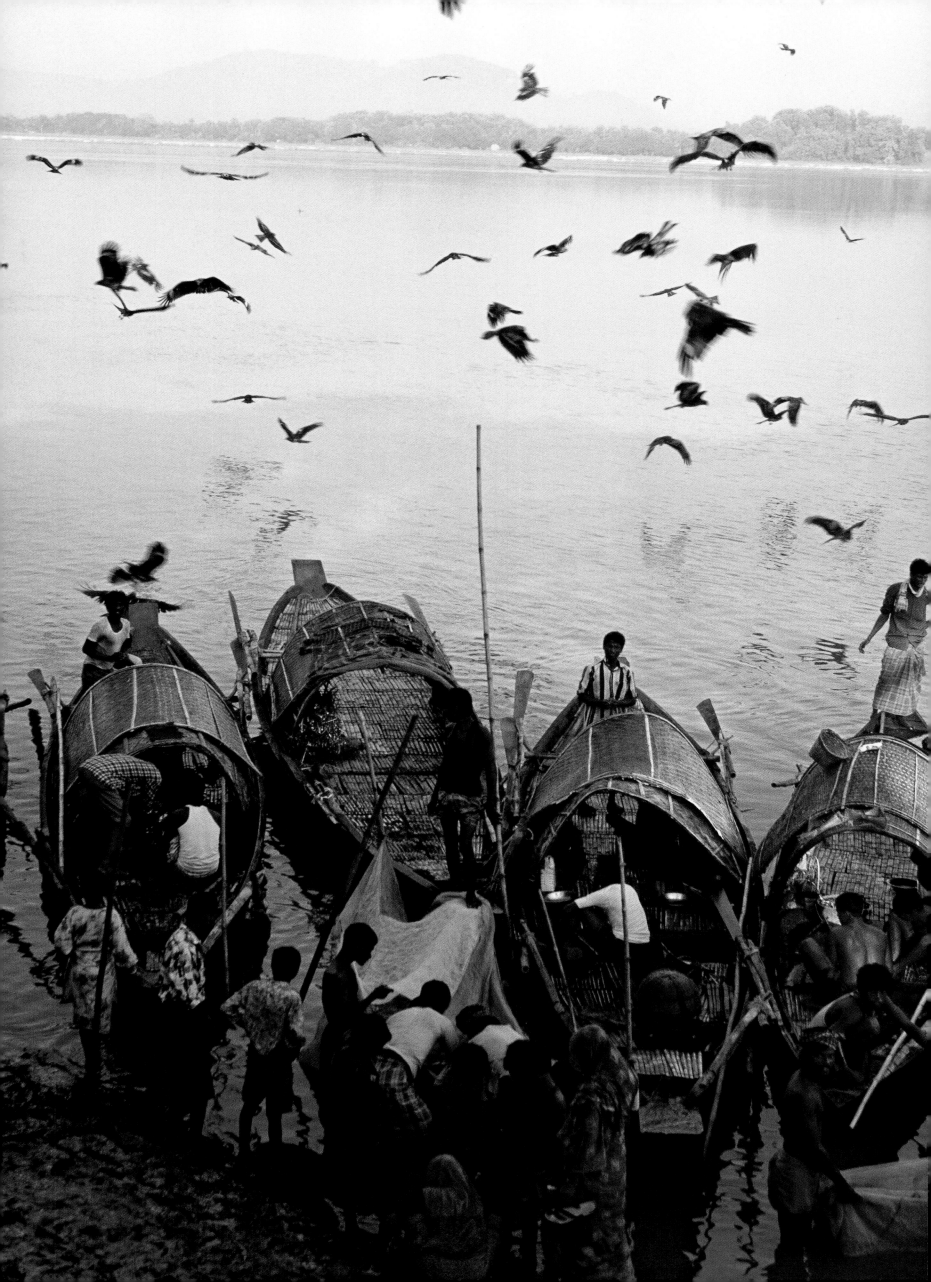

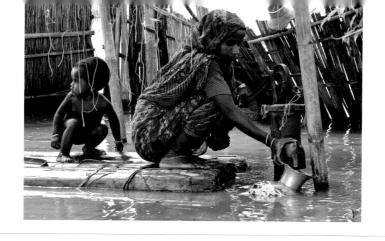

158 *After a hard day's work, these fishermen from Guwahati, in the Indian state of Assam, are about to unload the fish they have caught in the Brahmaputra, which in this area is quite wide.*

159 top *Partly under the waters of the Brahmaputra but still in working order, this hand pump supplied water to the village of Chalarkurar during the devastating flood that struck the Assam region in 2003.*

159 bottom *The Kaziranga National Park in Assam extends over a vast area between the Brahmaputra River and the Mikir hills. The alluvial plains, covered with marshes and forests, are an ideal habitat for varied and*

abundant fauna. The Kaziranga Park has large herds of elephants, buffaloes, bears, leopards, tigers and several species of monkeys. There are also about 1000 specimens of the rare Indian rhinoceros.

THE BRAHMAPUTRA

woods covering the slopes of the eastern Himalayas and the Dihang delta constitute a unique environment with an incredible range of animal and plant life: the variable climatic conditions and the series of different ecosystems due to the gradual decrease in altitude, make this region a true paradise. The forests of Arunachal Pradesh are the home of rare and endangered species such as the Indian rhinoceros, with only one horn, the Asian elephant, and the clouded leopard, as well as a huge number of birds, reptiles and small mammals. Receiving a couple of major tributaries, the river enters Assam, where it finally takes on the name of Brahmaputra.

The favorite son of Brahma is now a full-fledged river and flows majestically through a vast alluvial plain dotted with lakes and stagnant bodies of water, the residue of the continuous flooding. Around this series of lakes and swamps, which are bordered by evergreen vegetation, is the expanse of wooded savanna, interrupted here and there by marshes and canals: a truly unique environment that is now seriously jeopardized by population growth and deforestation. Large sections of this region are reserves: the Kaziranga National Park, with a surface area of 172 sq. miles (430 sq. km) between the river the hilly zone of Mikir, has the last large colony of Indian rhinoceroses, consisting of about 1000 head. Kaziranga is one of the few places in India where elephants can still be seen in groups of hundreds. Beyond the park is the world of humans, teeming with villages inhabited by

farmers and fishermen, whose material and spiritual survival depend on the river.

Reality and myth coexist in the Brahmaputra River Valley, the virtual theater of the tales of the *Mahabharata*, the great Indian epic poem: the waters of the river speak of heroic feats, wash sacred sites, and relate mythological tales. A host of gods, demons, ascetics and legendary kings have fought and loved here, creating that invisible and durable fabric that, between the sky and the Earth, envelops the daily life of millions of people. Along the banks of the river is a continuous series of sacred edifices and shrines. The Temple of Kamakhya at Guwahati, the capital of Assam, is considered one of the holiest places in all India.

About 62 miles (100 km) below Guwahati, the Brahmaputra begins its broad bend toward the south and the Indian Ocean. In the 176 miles (270 km) that separate it from the immense network of canals created by the Ganges Delta, its gradient is practically imperceptible, about 0.4 inches every 3 miles (1 cm every 5 km). After leaving Assam, the river receives one of its last affluents, the Tista, which comes from the Sikkim Mountains. In Bangladesh the riverbed loses its form, separating lazily into sinuous arms that seem to be lifeless but swell considerably with the first monsoon rains. After 1786 miles (2880 km), from the perennial snow of Tibet to the tropical heat of the Bay of Bengal, the Brahmaputra flows into Padma, one of the most important estuaries of the Ganges Delta.

THE GANGES

THE HOLY RIVER

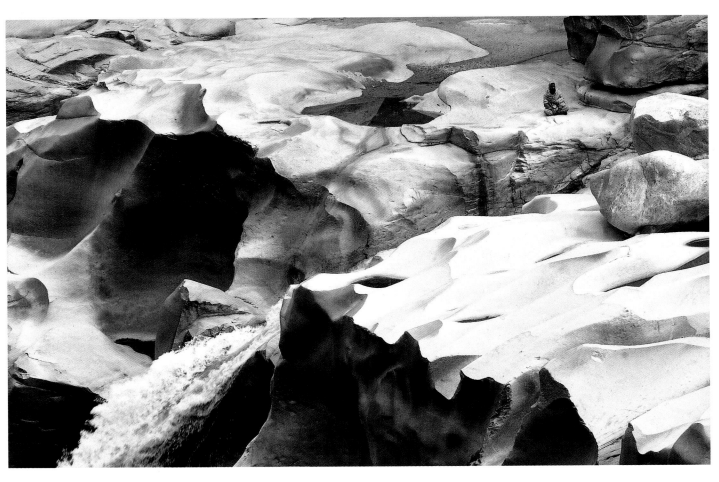

The holiest river in India originates in the western Himalayas, the result of the confluence of three headstreams: the Bhagirathi, Alakananda and Mandakini. The Bhagirathi rises at 15,840 ft (4800 m) in altitude from a cavern of ice known as Gomukha, or "Cow's Mouth," threading its way amid the chaotic rock masses and detritus that border the glacier. Some 12.5 miles (20 km) farther along, the most important arm of the Ganges reaches the village of Gangotri, where it receives the first of an innumerable series of attributions of holiness. When spring and summer arrive and the heat melts the snow, the temple at Gangotri is filled with thousands of pilgrims who come from all parts of India to express their devotion with prayers and offerings.

After Gangotri, the Bhagirathi River, which is now about 50 ft (15 m) wide, runs southward through a deep and craggy valley to Devaprayag, an important holy site. And this could not be otherwise, since at this point the Bhagirathi receives the waters of the Alakananda and Mandakini, which have already become a single current, and is now called the Ganges. Or better, Ganga, after the goddess of the same name who is considered the creator of life in one of the most densely populated regions in the world. From a scientific standpoint the birth of the Ganges plain and delta is quite simple and clear: tens of millions of years ago a tectonic plate – future India – that had broken free from the Indo-Australian plate migrated to the north until it collided with the Eurasian plate. The collision created the Himalayan range as well as a depression between the southern side of the mountain range and what are now the

160 top The pyramid of Mt. Shivling towers over the glaciers that are the headstreams of the Ganges River in the Indian state of Uttar Pradesh. Mt. Shivling, like Nanda Devi and the other peaks in the vicinity, is considered a sacred mountain.

160 bottom Indifferent to the cold, a pilgrim contemplates the Ganges, which makes its way through the ice that covers the slopes of the western Himalayas. The river's main sources are at an altitude of almost 16,400 ft (5000 m).

160-161 A fissure in the Gangotri glacier, known as the 'Cow's Mouth,' is the headstream of the sacred Ganges, which a short distance farther on flows into a narrow, snow-covered valley. The tall Bhagirathi Peaks can be seen clearly in the background.

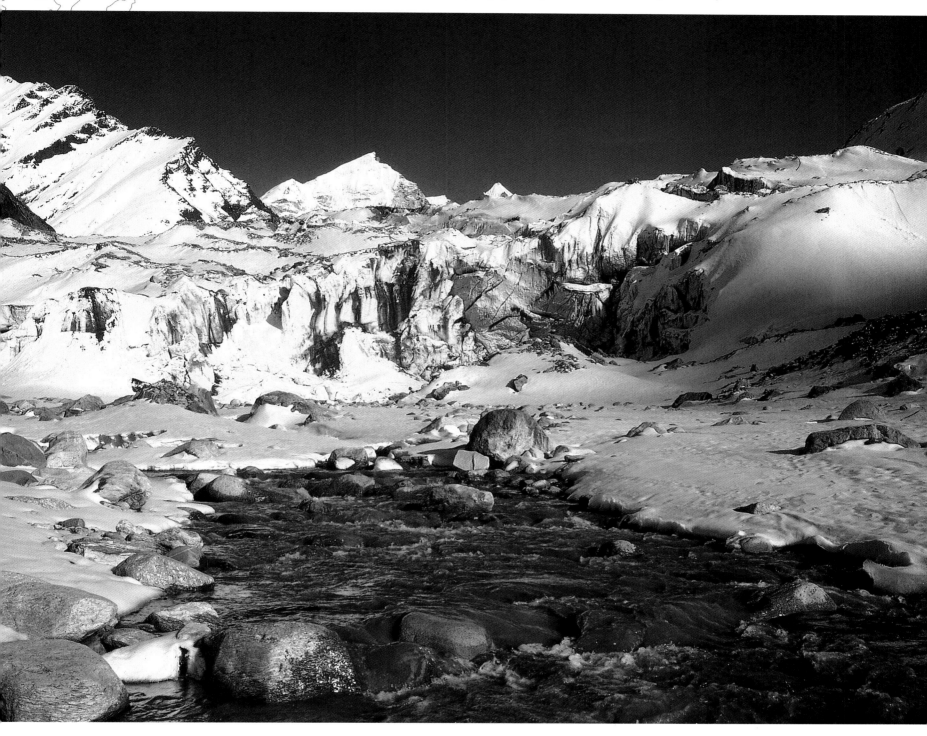

Deccan mountains: the immense, flooded basin gradually filled with river silt, thus forming the present-day Ganges plain.

Indian mythology suggests a theory that is equally satisfying, at least from a spiritual standpoint. According to the sacred Hindu texts, the divine Ganga, invoked by the old ascetic Bhagirathi, descended from the heavens to resuscitate with her waters the 60,000 sons of a king who had been reduced to ashes because of an evil spell. However, during her torrential descent Ganga overran the Earth itself and destroyed all humankind. Only Shiva could stem the overwhelming power of the current. Moved by the interminable prayers of Bhagirathi, who for 1000 years called upon him with a superhuman vow of asceticism, Shiva agreed to entrap Ganga in the maze of his braided hair. Another supplication on the part of the pious

Bhagirathi persuaded the god to free Ganga, who was now under control, so that she finally flow on the Earth and fulfill her mission of purification. For millions of Indians, physical contact with the Ganges brings about total regeneration; it means purifying oneself from sin and taking a few steps closer to the infinite. In the many images of Ganga, the goddess is sometimes portrayed in the guise of an adolescent and at other times as a mature and shapely woman who is often riding a mythical animal with a fish's tail and the head of an elephant. Her gaze and features always express peace and wisdom. An extensive series of holy places accompanies the long journey of the Ganges from its source to the outlet in the Bay of Bengal. The goddess Ganga is revered throughout India, as can be seen by the numerous temples and shrines dedicated to her.

THE GANGES

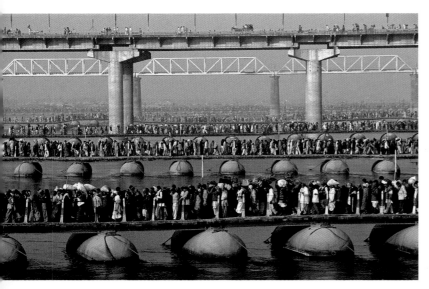

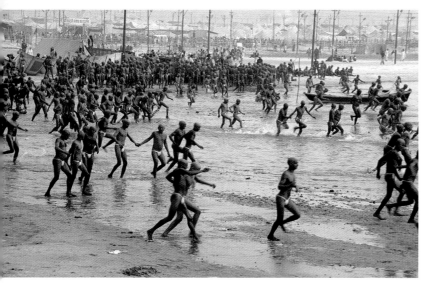

The river leaves the mountains for good at Hardwar, about 434 miles (700 km) below Gangotri, and enters the great plain, which it will cross for the following 1240 miles (2000 km) of its course. The Ganges then makes a broad bend toward the south and reaches Allahabad, where it merges with the Jumna River, its twin. The interfluvial land (known as doab) between the almost parallel Ganges and Jumna is extremely fertile. Since the beginning of human history the rich and productive Ganges plain has been the key factor in the economic and political control of the subcontintent. The Indo-Aryans, Hindus, Muslims and European colonizers established and consolidated their fortune on the banks of the river, leaving impressive testimony of their power. Allahabad is not only the site where the Ganges and Jumna merge; there is also a third flux, this time spiritual and invisible, that adds its energy to the sacred Ganges: this subterranean current, which the Indians call Sarasvati, is an indispensable element of the divine trinity. Every twelve years, on occasion of the Kumbh Mela feast, Allahabad is invaded by immense crowds of worshippers who fill every corner of the city, moving ceaselessly among the temples and shrines in search of hope of redemption. Each of these holy places has a particular symbolic meaning: all the many Indian gods have passed through Allahabad, leaving a sign of their presence. And all of them are venerated. Perhaps only Varanasi (Benares), in the Ganges plain, can vie with Allahabad as the site of such a profound mystical quest.

In the long section that crosses Uttar Pradesh, the river passes through important and densely populated towns, but

162 top A procession of worshippers of the goddess Ganga crosses one of the bridges over the Ganges at Allahabad, in the Uttar Pradesh region, on occasion of the Kumbh Mela, the most important Hindu religious feast in India.

162 center A series of pontoon bridges built expressly for the many pilgrims connects the two banks of the Ganges at Allahabad during the Kumbh Mela festivities. In 2001 about 30 million people gathered in the city.

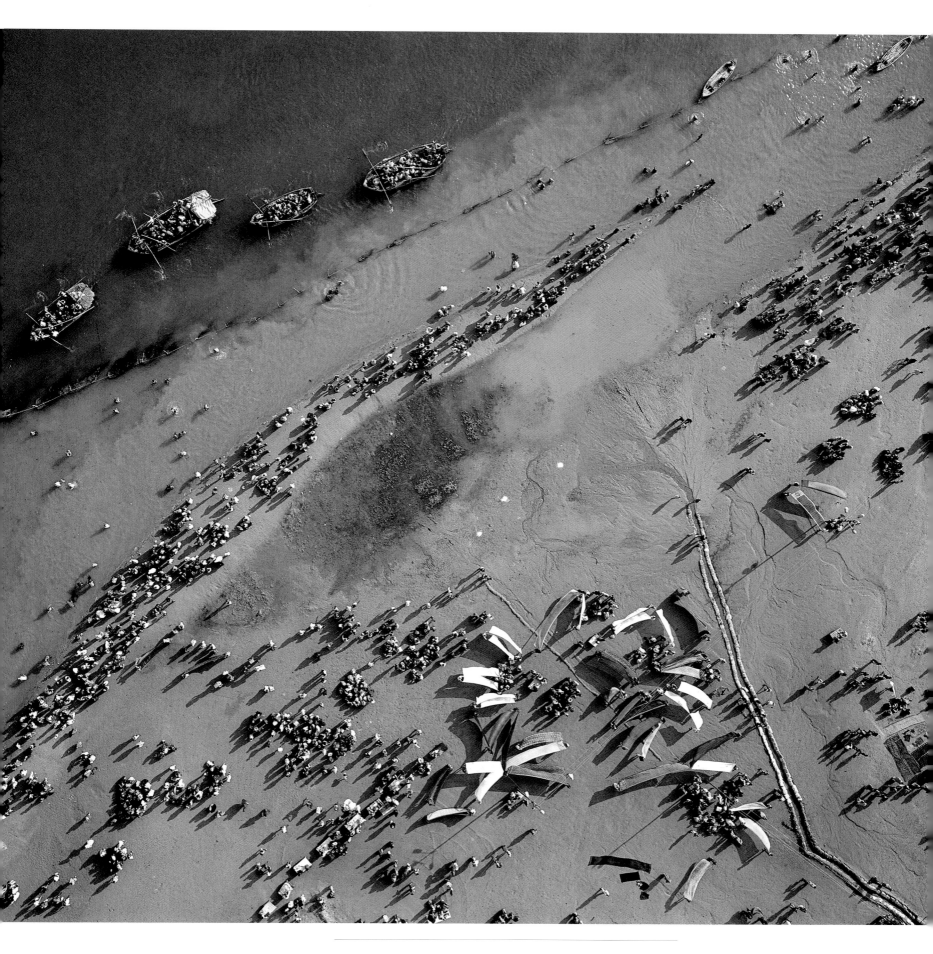

162 bottom and 162-163 Every twelve years, in a period considered propitious according to complicated astrological calculations, a huge crowd invades the banks of the Ganges at Allahabad, where the great river merges with the Jumna and the mythical Saraswati. For the millions of Hindu pilgrims who gather to celebrate the Kumbh Mela, bathing in that holy water means cleansing oneself of all sin, thus breaking free from the cycle of reincarnation.

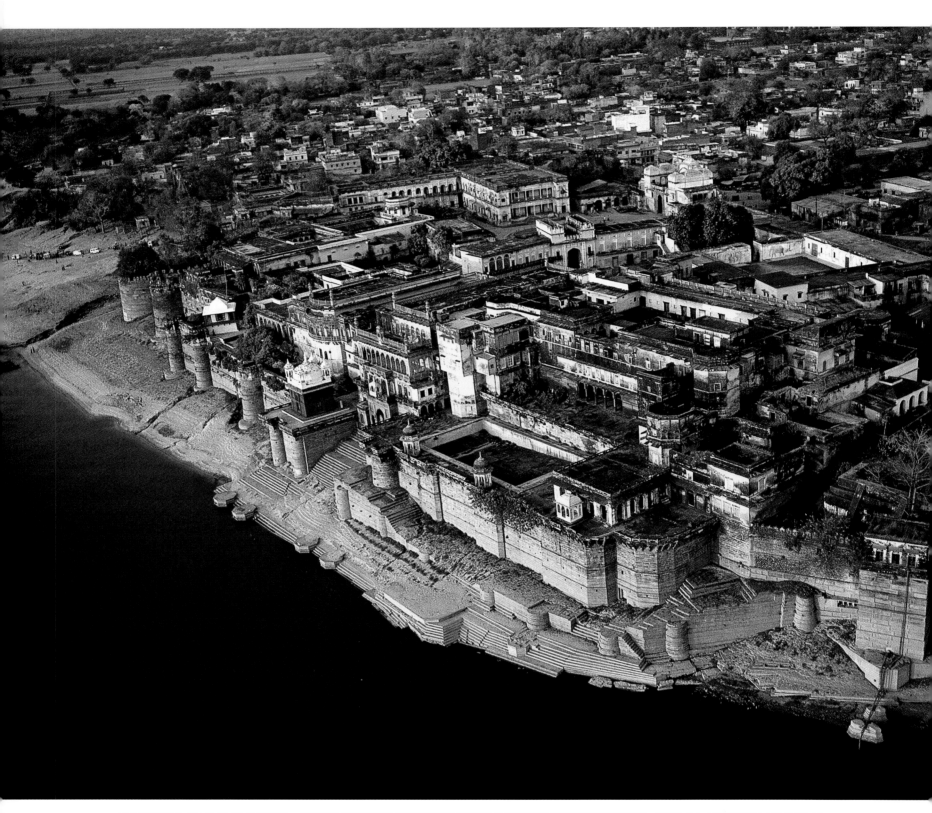

164-165 The warm colors of sunset impart golden hues to the 17th-century Ramnagar Fort, which fronts the Ganges a short distance from Varanasi. In autumn this fortress is the venue of a festival that offers a musical and theatrical presentation of famous episodes from the life of the heroic warrior Rama.

164 bottom In its upper course the Ganges flows rapidly through a narrow, bucolic valley. Once past the Siwalik mountain range, the great river enters to the plain at Hardwar, after a journey of about 435 miles (700 km).

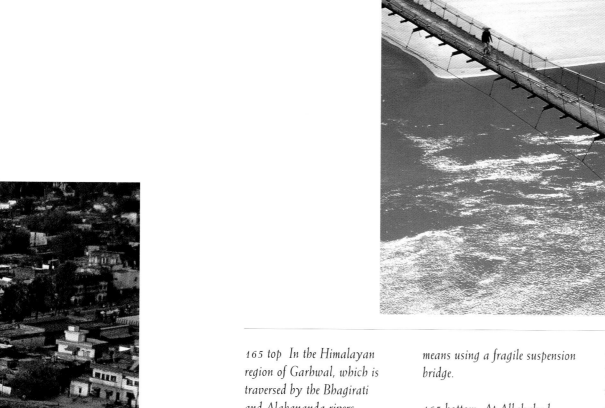

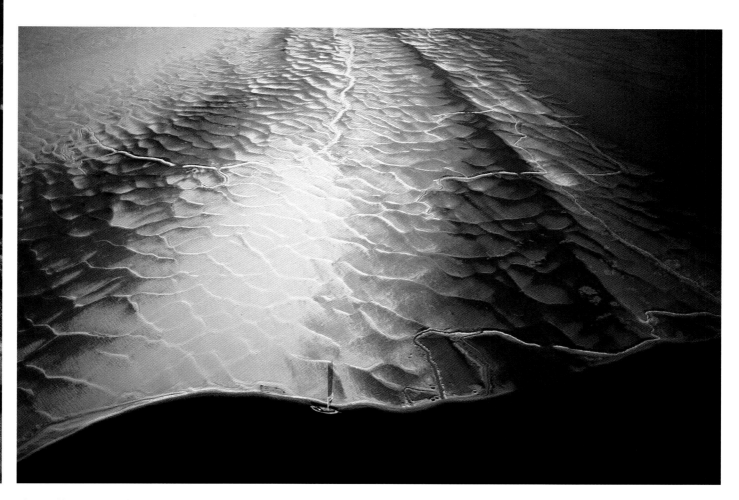

165 top In the Himalayan region of Garhwal, which is traversed by the Bhagirati and Alakananda rivers, the main headstreams of the Ganges, crossing the river means using a fragile suspension bridge.

165 bottom At Allahabad, where at its junction with the Jumna, the Ganges flows into the vast central plains of India. The tract of fertile land that stretches out between these two rivers is one of the most productive agricultural areas in the country.

above all a myriad of villages: the ancient heart of India, where life follows an age-old rhythm determined by the low- and high-water periods of the Ganges. There are marked variations in the regimen of the river, since the melting of the snow on the Himalayas corresponds more or less with the beginning of the monsoons. This combined effect can bring about natural catastrophes, especially in the delta areas, where the rainfall is more abundant. Often the waters of the Ganges overflow the banks and flood huge areas. Vice versa, the winter here is long and dry, and in many zones the farmers must rely on groundwater, which is often insufficient for their needs. Thus,

drought and famine are in store for humans and animals alike. Yet, despite its caprices, the Ganges supports one-third of the Indian population: 300 million souls owe everything they have to the goddess Ganga. Thanks to the silt deposited over the centuries, the fertile land yields two harvests a year as well as a surplus, at least for certain products such as cereals. As in ancient time, the Ganges plain feeds India.

Once past Allahabad, the river proceeds eastward and then turns northward, as if it wanted to take Varanasi to its bosom. Varanasi is one of the most famous holy cities in the world and is certainly to be considered the capital of Hinduism: the god

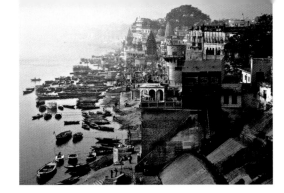

THE GANGES

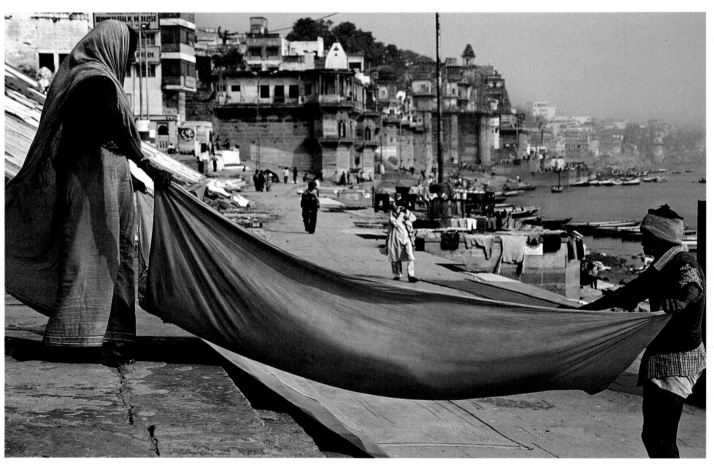

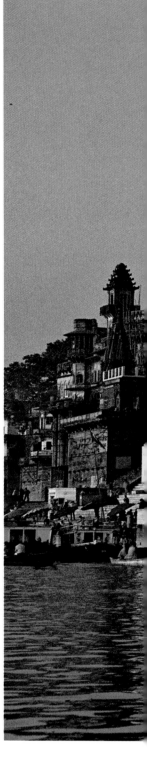

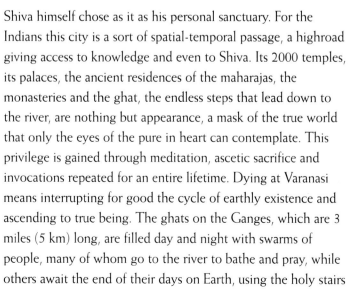

Shiva himself chose as it as his personal sanctuary. For the Indians this city is a sort of spatial-temporal passage, a highroad giving access to knowledge and even to Shiva. Its 2000 temples, its palaces, the ancient residences of the maharajas, the monasteries and the ghat, the endless steps that lead down to the river, are nothing but appearance, a mask of the true world that only the eyes of the pure in heart can contemplate. This privilege is gained through meditation, ascetic sacrifice and invocations repeated for an entire lifetime. Dying at Varanasi means interrupting for good the cycle of earthly existence and ascending to true being. The ghats on the Ganges, which are 3 miles (5 km) long, are filled day and night with swarms of people, many of whom go to the river to bathe and pray, while others await the end of their days on Earth, using the holy stairs

as their last abode. In no other place in India does life appear to be so fragile and death such an intimate presence. Every year tens of thousands of corpses are cremated at Varanasi. Wrapped in cotton cloth, they are placed in the Ganges, then dried and placed on a pyre. When the body is almost totally consumed by the flames, a sharp blow with a club is used to open the cranium so that the deceased's soul can escape and wander freely.

With its macabre load of bones and ashes, the Ganges leaves Varanasi behind and moves slowly toward the sea, entering the state of Bihar 93 miles (150 km) farther on. Fields of cereals are gradually replaced by sugarcane and indigo plantations, and the first rice fields make their appearance. In this section of its long course the river takes in a series of

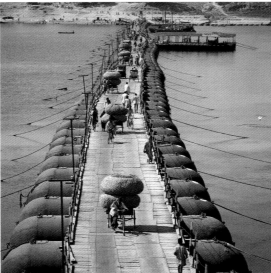

166 top Flanking on the left bank of the Ganges, the city of Varanasi is an immense sanctuary consecrated to the god Shiva.

166 bottom In Varanasi, even the simplest everyday tasks acquire dignity and elegance.
On the ghat, the stairs that descend to the Ganges, sacred and secular are intertwined in a timeless union.

166-167 Filled night and day with hordes of pilgrims and worshippers, Varanasi seems more like a gigantic temple than a city.

167 bottom Hundreds of tricycles overloaded with all kinds of articles cross incessantly on the pontoon bridges that link the city of Varanasi with the right bank of the Ganges, which is almost completely uninhabited.

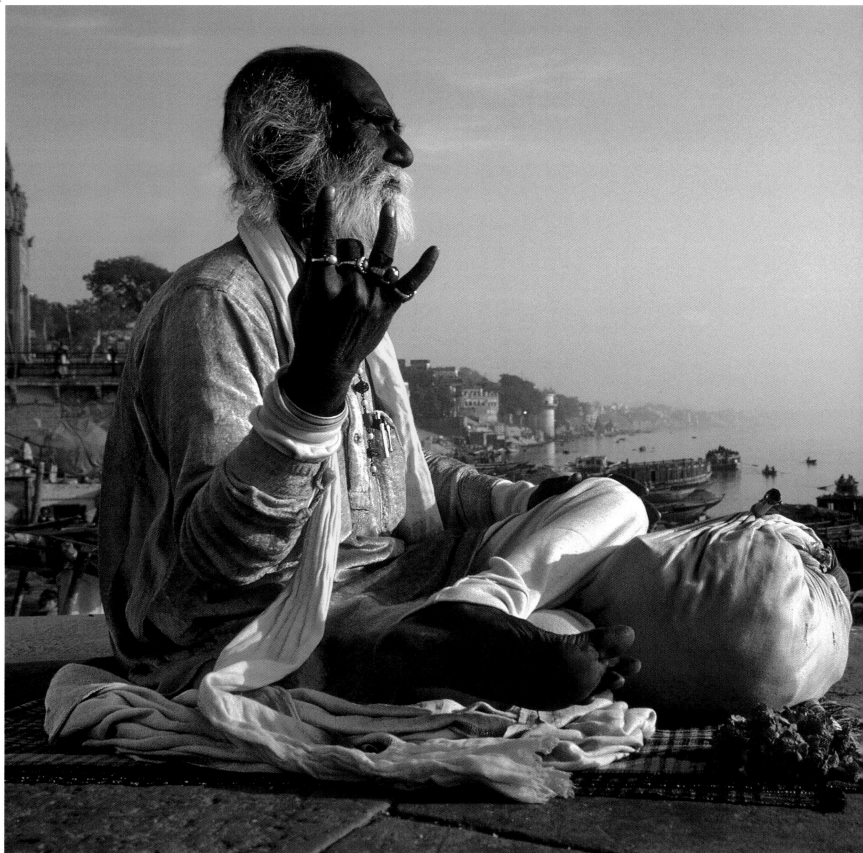

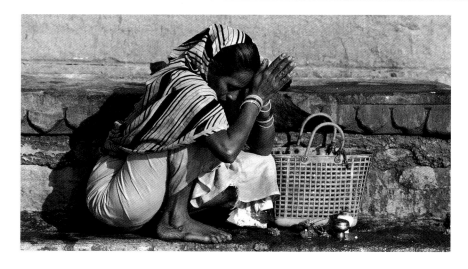

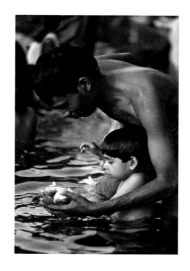

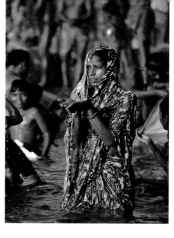

170-171 *Viewed from the right bank of the Ganges, Varanasi looks like a compact front of buildings set together along the monumental stairs that border the river for 3 miles (5 km).*

THE GANGES

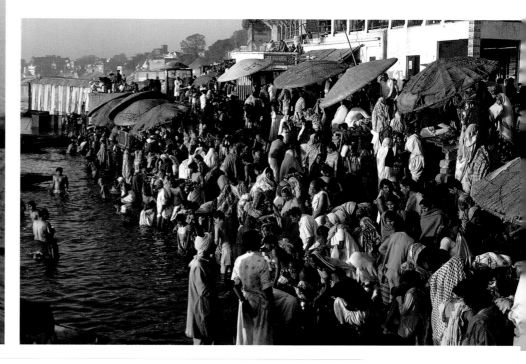

168-169 *The utter concentration of this ascetic, immobile in his spiritual communion, bespeaks the reality of Varanasi, chosen by the god Shiva in person as his abode and for three thousand years the holy site of Hinduism par excellence.*

168 bottom *Totally absorbed in prayer on the banks of the Ganges at Varanasi, this woman fulfills her daily act of devotion to Shiva. The attainment of supreme consciousness and becoming one with the god require constant sacrifices and spiritual exercises.*

169 top *Bathing in the Ganges is a spiritual duty that every pilgrim visiting Varanasi must fulfill. The fact that the currents of the holy river transport decomposed bodies is of no importance: the water of the Ganges purifies the body and soul of all sins.*

169 bottom *Repudiated by Buddha, who considered it a deleterious form of superstition, the ritual of dipping oneself into the waters of the Ganges is an emblematic moment of the Hindu religious ceremony that every year attracts millions of pilgrims to Varanasi.*

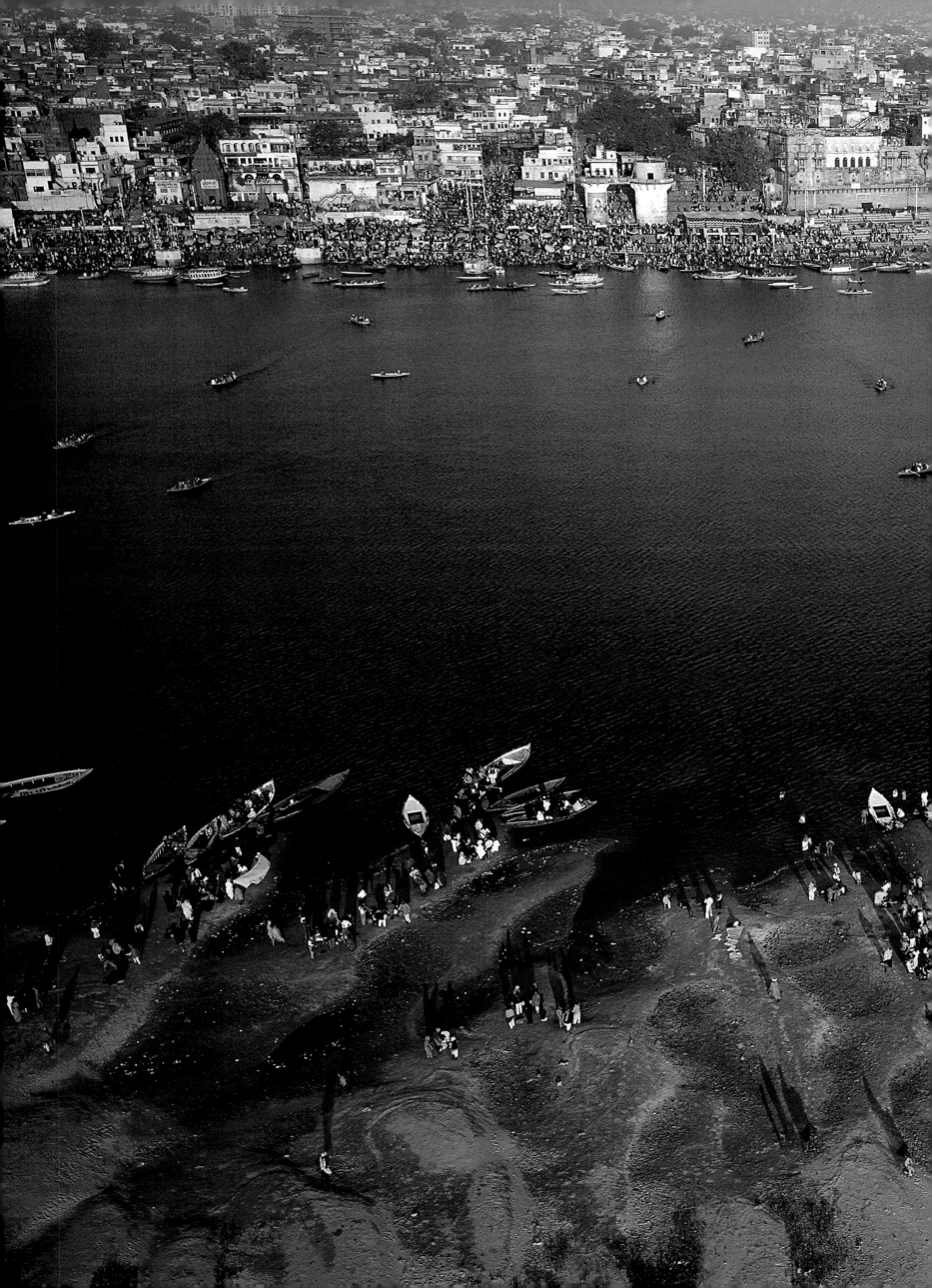

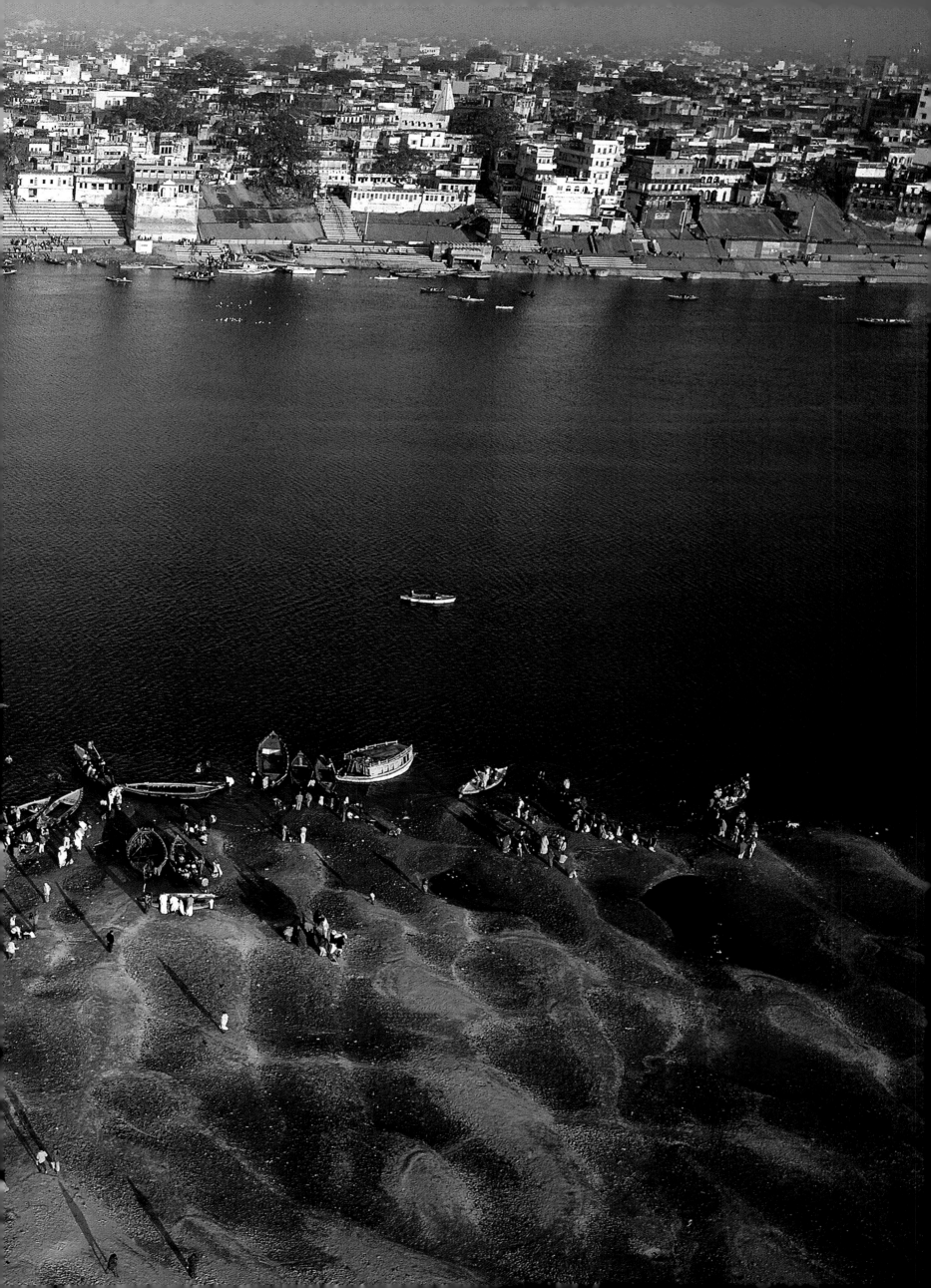

172 top Every day hundreds of thousands of people cross the monumental steel bridge over the Hooghly River, which connects Calcutta and the suburb of Howrah.

172 bottom left A fisherman's boat glides down the waters of the west branch of the Ganges, which crosses the Indian region of Bengal with a new name – the Bhagirathi. Fish and rice are the staples of the locals.

172 bottom right Absorbed in their daily tasks, the inhabitants of this village, whose houses lie on bamboo poles, have a fatalistic attitude regarding

the cyclical floods of the Padma, which submerges vast regions of Bangladesh every year.

173 This view from a satellite clearly shows the confluence of the Brahmaputra and the west branch of the Ganges, which in Bangladesh takes the name of Padma. The two form one of the largest deltas in Asia.

THE GANGES

important tributaries that have flowed down from the Himalayas: the Gaghara, Gandak and the Kosi, the last of which is filled with the cold water from the glaciers of Mt. Everest. The Vindhya Mountains in the south provide the headstreams for the smaller Son River, which flows in to the Ganges above Patna.

As it approaches the delta, after having made a broad bend to the south, the Ganges passes over the border of West Bengal, where it splits into two arms, the Bhagirathi and the Padma, the latter merging with the Brahmaputra and then emptying in the Indian Ocean by means of a vast estuary. However, even

The Sundarbans region, now mostly a reserve, is the only refuge for the remaining 200 Bengal tigers, as well as for other rare animals whose survival is jeopardized by the growing population. In fact, the gloomy Sundarbans jungle and the man-eating tigers seem almost friendly compared to Calcutta, which more than a city is an endless expanse of abandoned outskirts that extend for miles and miles on both sides of the Hooghly River. The former capital of British India is now a metropolis with a population of 12 million, at least according to the latest census. Calcutta's problems are so serious they appear to be unsolvable, and the poverty there is

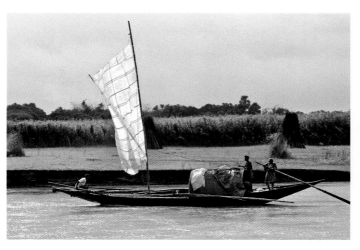

though it is smaller than the Padma, for everyone the true Ganges River is the Bhagirathi, which takes on the name of Hooghly after Calcutta. The delta extends for about 24,000 sq. miles (60,000 sq. km), although it must be said that it is by no means easy to draw up reliable and definitive maps of this region, since it is constantly changing its configuration. Floods and hurricanes continue to modify its fragile features, and islands and canals are created and then destroyed in the space of a few months. The most stabilized areas, where levees and artificial trenches make for a certain degree of safety, produce rice, sugarcane and jute. The agricultural zones have very dense populations, 2600 inhabitants per sq. mile (1000 per sq. km). The rest of the territory consists of the Sundarbans region, a hostile and unhealthy swampland whose name derives from the sundria tree, which together with the mangroves is the dominating plant on the coastland.

so hopeless that not even the goddess Ganga can mitigate it. In fact, the river seems to want to abandon the city: the Ganges follows more and more in the wake of the Padma, thus gradually decreasing the discharge of the Baghirathi. The Calcutta harbor, the gate of India up to recent times, runs the risk of being silted up. But popular religion will not admit that Ganga could betray her people, so that the banks of the Hooghly River, here as well as at Harwar, Allahabad, Varanasi, Kanpur and everywhere else, are always filled with people seeking blessings and hope for a better life. Not even in the salty swamps of Sagar, the island that marks the junction of the Ganges and the sea, does the river lose its sacred character. Here too, in the huge natural temple of the delta, the goddess who descended from the heavens of the Himalayas receives offerings of everlasting devotion from her children.

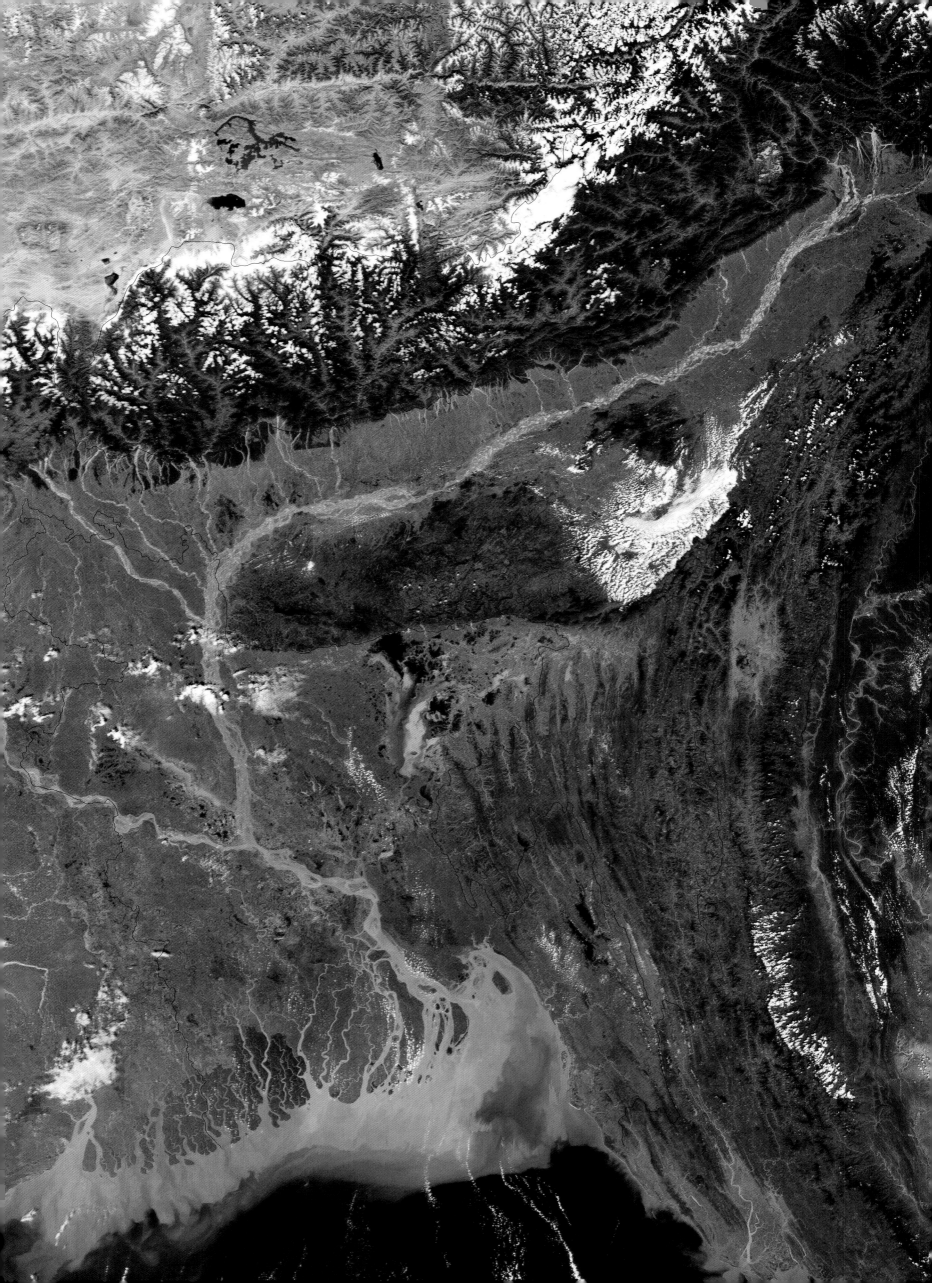

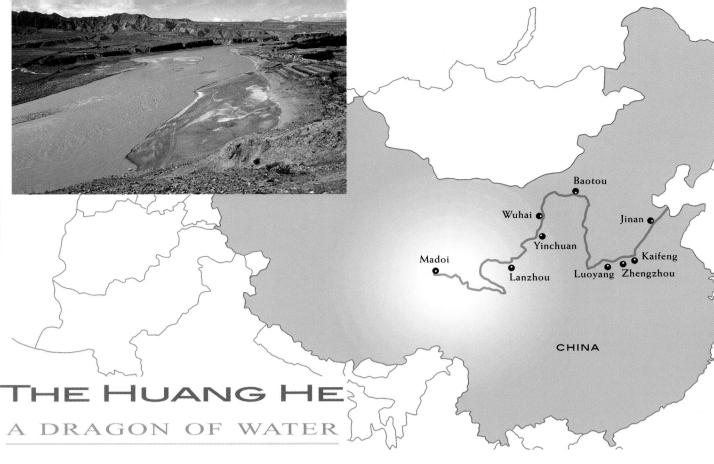

THE HUANG HE

A DRAGON OF WATER

D ragons are at home in China. Sometimes they descend from the sky, like the ones that arrived to announce the birth of Confucius.

They often live in the rivers, taking on their features and character. They are at once frightening and benign creatures. The most famous dragon in Chinese legends is golden and its coils extend for 3388 miles (5465 km), from the province of Qinghai to the Pacific Ocean: the Chinese call it the Huang He (or Hwang Ho), the Yellow River. The name derives from the perennially muddy color of the water due to the huge quantity of pale ocher silt that is carried by the current.

One of the most ancient civilizations in the history of mankind rose up along the banks of the Yellow River. Already 5000 years ago, along the middle section of the river, there were organized and stable societies that had developed agricultural activity with a high level of productivity. The seeds of imperial China were sown here, suspended between myth and reality. Many of the great dynasties – the Shang, Han, T'ang and Sung – founded their capitals along the Huang He, and their destiny was always closely linked to the river, both its gifts and caprices. Controlling the river, avoiding recurrent drought, and above all regulating the seasonal floods that always struck enormous regions – these have been the main concerns of all the Chinese governments for the last four millennia.

The first great flood mentioned in historic chronicles dates from 2297 BC, and the most devastating one occurred in AD 1887, in Henan Province, when 900,000 people were killed and the floodwater covered a surface area of over 32,000 sq. miles (80,000 sq. km); the 1933 flood caused 'only' 18,000 deaths and destroyed 3000 villages. It has been estimated that in the last twenty centuries the Yellow River has inundated the surrounding regions at least 1500 times, and the consequences have almost always been disastrous. It is no accident that the river is known as "China's sorrow." In recent decades hundreds of miles of new embankments and floodways have been constructed, but no one can guarantee that the dragon has really been tamed.

The main reason why the Yellow River is so difficult to regulate lies in the incredible density of silt deposition: every cubic meter of water contains about 40 kg of silt (ca. 68.5 lbs per cubic yard), more than any other of the world's rivers. This is an exceptional amount; the Nile has only 1.4 kg per cu. m (ca. 2,3 lbs per cu. yd) and the Ganges has only 3.9 kg per cu. m (ca. 7 lbs per cu. yd). Consequently, the impact force of the river current is simply unheard-of, able to break down even the most robust dikes. Furthermore, the Huang He is what is called a 'hanging river': over the centuries, the great amount of sedimentation has raised the riverbed several feet over the plain, making all efforts at containing the waters even more difficult.

And yet, when it rises in the distant western province of Qinghai the Huang He is quite different. The stream that emerges from the Yagradagze Mts. at an altitude of 15,097 ft (4575 m) is little more than a brook of clear and freezing water. It descends slowly among tufts of grass toward the valley floor, emptying in a broad marshy basin, where it meanders for quite a distance in search of an outlet. When it finally exits from the basin it already looks like a river and has enough water to feed the Ngoring and Gyaring lakes. All around it are expanses of desolate, wind-swept highlands that are almost uninhabited: only the proud Tibetan nomad shepherds who tend to their yaks and flocks of sheep can survive in this solitary land.

After receiving an increasing number of tributaries, the Yellow River proceeds to the southwest, going around the huge spurs of the Amne Machin range, until it washes the last northern stretches of Sichuan province. This marshy and treacherous zone lying at an altitude of 11,550 ft (3500 m) was the setting of one of the most tragic events of the Long March. When Mao Zedong crossed it in 1936 with thousands of Red Army soldiers to reach Shaanxi Province, the bitter cold, fatigue and privation took the lives of a great number of people. When it emerges from the quagmires of Sichuan, the river changes direction completely and returns to Qinghai Province by describing a broad "S" known as the 'great

174 Short summers and long, bitterly cold winters characterize the climate of the desert steppes crossed by the Huang He, or Yellow River, in the remote province of Qinghai, one of the largest and least populated regions in China.

174-175 In the less desolate areas of Qinghai, where the climate is favorable, the monotony of the landscape is sometimes interrupted by densely cultivated zones. Only 10% of the region, which is basically barren and mountainous, is used for farming.

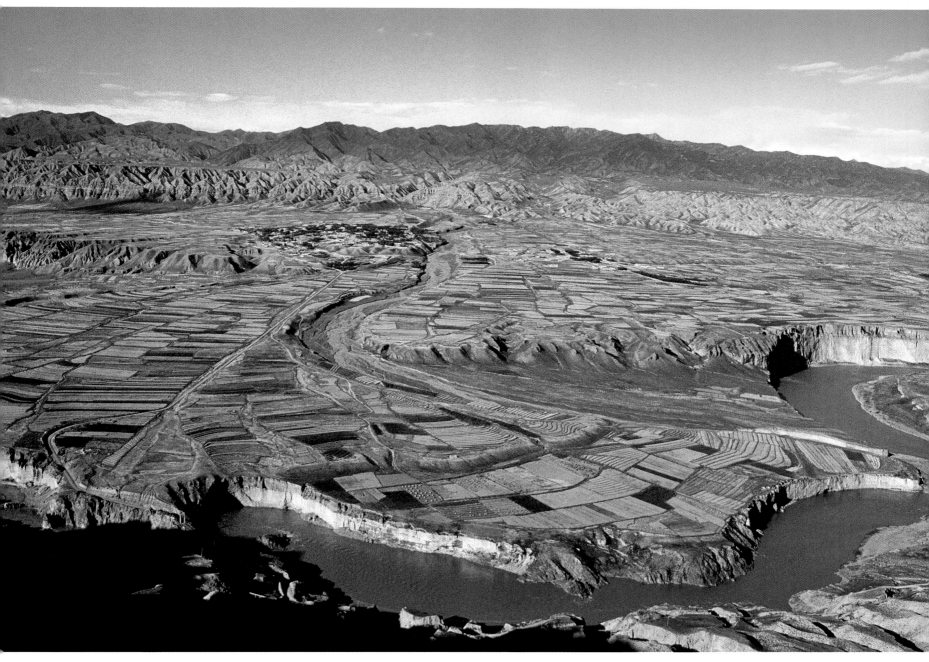

175 bottom right In its first section, the river is still limpid and has none of the silt that is so typical of its middle and lower course.

In these regions, the Huang He moves placidly toward the marshy zones that mark the border with the province of Sichuan.

175 bottom left In its first stretch in the boundless and wild plateaus of Qinghai, the Huang He passes through exceptionally beautiful land that is dominated by impressive mountain chains and fascinating snow-capped peaks that rise well over 16,400 ft (5000 m) above sea level.

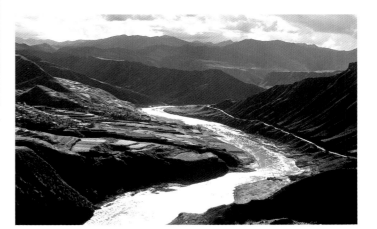

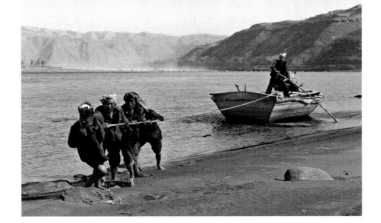

176 top Stooped with fatigue as they drag a boat along the shore of the Huang He, these men are literally fighting against the force of the river current, which is made even more violent by the exceptional quantity of silt in the water.

176 bottom A large hydroelectric plant on the Huang He supplies electric power to Lanzhou, once a major stage of the journey along the Silk Road and now an important industrial center of Gansu Province.

176-177 Once past Lanzhou, the Huang He enters the loess plateau, made up of clay and mineral particles that are particularly friable and therefore easily eroded by the river, but are at the same time extremely fertile.

THE HUANG HE

northern bend.' The highlands gradually descend and the living conditions become less harsh. Animal husbandry is flanked by agriculture, and the population becomes more complex in composition, as the Tibetans live side by side with ethnic groups that originated in Central Asia, the Mongols and Kazakhs. In this section, the bed of the Huang He is several hundred feet wide: bridges are rare, and those who want to go from one side to the other are often obliged to use a traditional boat, the *yangpi*, a sort of raft made up of planks of wood placed on inflated sheepskins and loosely tied to one another.

Before reaching the 'great northern bend,' the river flows

major industrial and commercial center based on the extraction of the rich mineral deposits of Gansu. The city, which was once a remote outpost of the Chinese Empire, was one of the stages of the Silk Road that linked western Turkestan and the fertile plains of China. Marco Polo mentions it in the accounts of his travels as Lampchu.

On the Liujia gorge in the plateau around Lanzhou is one of the most spectacular Buddhist temples in Gansu: 694 statues of Buddha impassively contemplate the yellow water of the Huang He from the hundreds of rock-hewn caves. This is the beginning of the huge loess plateau that extends for 172,000

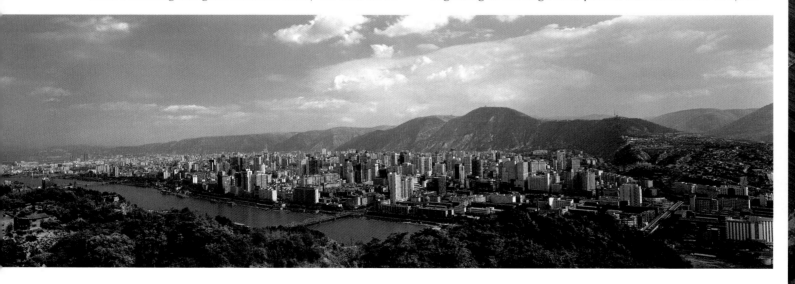

into an almost continuous series of narrow gorges in the mountains, creating the Laxiwa, Yehu (Wide Wolf) and Longyang gorges. At certain points the distance between the opposite rock faces, which plunge headlong into the turbulent water, is barely more than 33 ft (10 m). When the Yellow River arrives at Lanzhou, the capital of Gansu Province, it flows slowly in a wide bed among farmland and bare grey sandstone hills. Today Lanzhou has a population of 2 million and is a

sq. miles (430,000 sq. km) over most of northern China. The river gets all its silt from the friable, porous and easily eroded mineral grains of loess, which consists of fine clayey dust blown and accumulated by the wind during the arid interglacial periods and then compressed into homogeneous strata that create absolutely unique landscapes. Rich in plant detritus, the loess region has some of the most fertile soil in the world. The Huang He crosses this terrain for a long

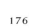

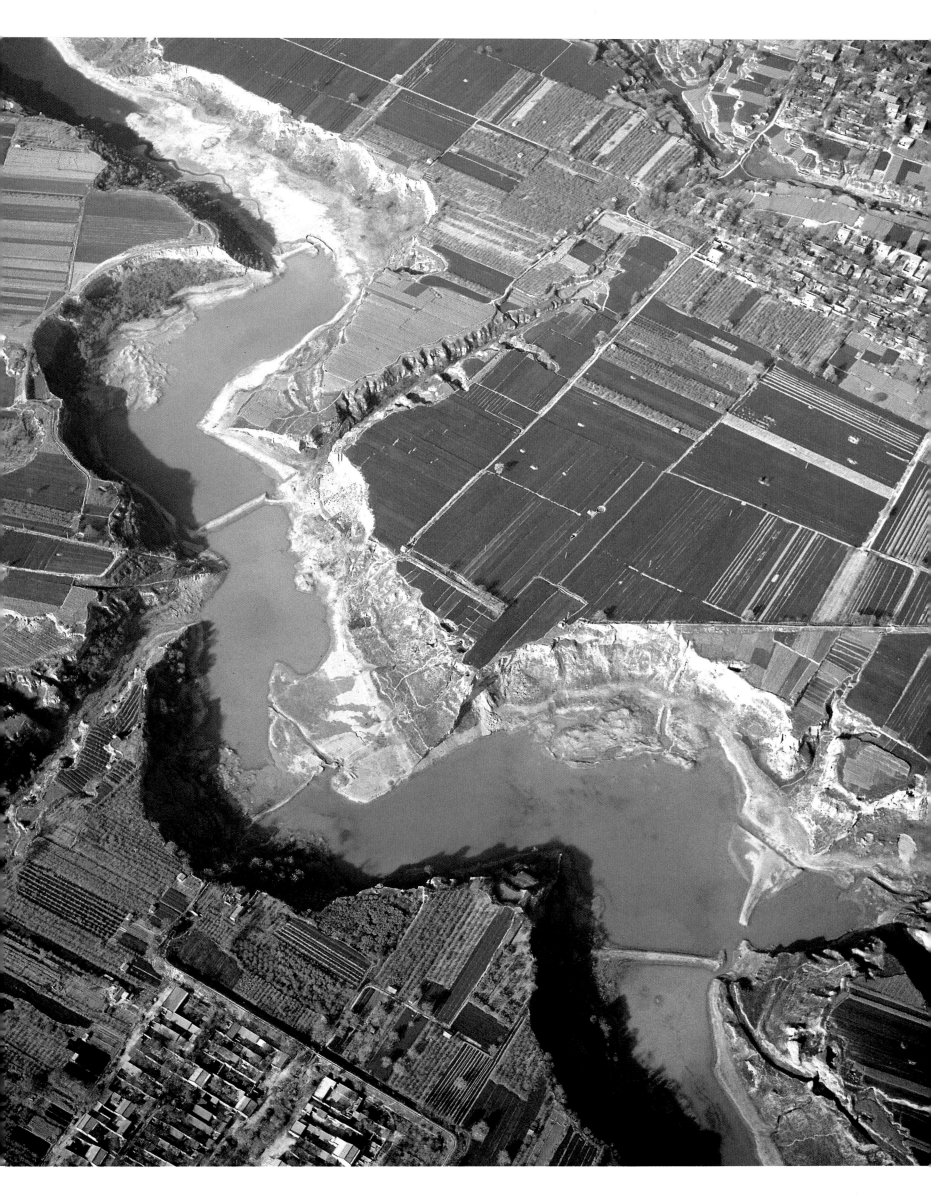

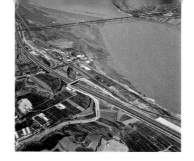

178 *After the junction with the Wei River, the Huang He leaves the loess region and for a while marks the border between Shanxi and Henan. After crossing the loess plateau, it contains 60 lbs of silt per cubic yard (ca. 40 kg per cu. m).*

179 top *Surrounded by massive embankments, the Huang He flows in the plains of Henan, which suffered disastrous floods in the past. Indeed, the lime deposited over the centuries has raised the riverbed several feet above the level of the surrounding plains.*

179 bottom *Having left the deserts of Inner Mongolia behind, the Huang He makes a broad curve southward, now marking the border between Shaanxi and Shanxi. Here the river runs through a series of deep gorges with several swift rapids and roaring waterfalls.*

THE HUANG HE

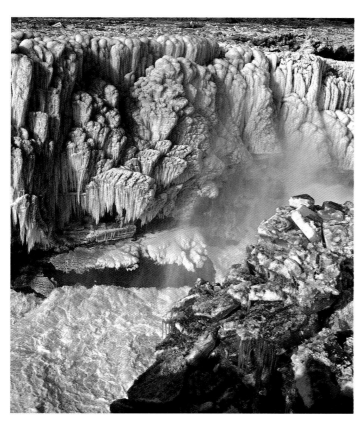

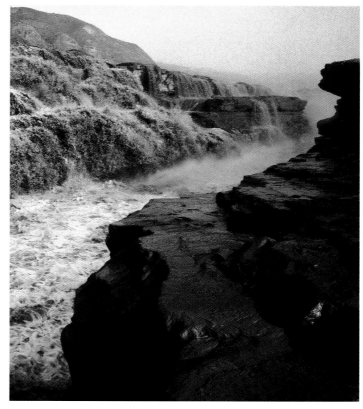

distance, traversing the provinces of Gansu, Ningxia, Shaanxi, Shanxi and part of Henan. About 93 miles (150 km) past Lanzhou, at Jingtai, the river flows through the Great Wall, whose bastions marked the border between the steppes of Inner Mongolia and the fertile land of the East. Beyond the largest defensive barrier ever built by humankind is a belt of wasteland without vegetation where the rain rarely falls: the deserts of Tengeli, Kubkhay, Moawusu, and the Ordos, where "everywhere lies shifting sand, / which passes thunderously over the abyss in whirls. / You burn, you dissolve, you disappear for ever!" This is how a 3rd-century BC poet describes the anguish that the sedentary Chinese always felt when confronting the empty spaces of the West, the home of the hordes of Devil's Horsemen, the nomad warriors who periodically invaded China and threatened her civilization and social order. The water used for irrigation and the rare rainfall, less than 16 inches (400 mm) per year, drastically reduce the discharge of the Yellow River, which is the 'lifeblood' of this immense arid territory.

Thanks to the river, the plains of Ningxia – an autonomous region inhabited by the Hui, a Chinese ethnic group that is Muslim – have become the breadbasket of western China. The same is true of the vast Hetao Plain in Inner Mongolia, which is irrigated by an articulated network of canals and protected by the Yinshan Mountains, which block the dry, dust-laden winds from the Gobi Desert. The contrast between the bright green fields and the surrounding desert is simply astounding. However, a price is paid for this miracle: when it leaves the arid northern lands, the Huang He has lost one-third of its water. The river then heads southward through the maze of gorges and heavily eroded hills that mark the frontier between Shaanxi and Shanxi. In this stretch, which is 434 miles (700 km) long, the river receives about one hundred tributaries, its yellowish color becoming ocher, and then brown. Of all the silt that goes into the Huang He, 90 percent comes from this area, where the loess deposits are sometimes as much as 1980 ft (600 m) thick. The effects of erosion are clearly seen here: thousands of years of human labor have improved the grandiose terrain sculpted by nature in every detail, transforming it into a perfectly efficient habitat. The terrace cultivation cuts through the steep slopes of the hills as far as the eye can see, irrigated fields fill the valley floors, and the villages themselves are cut out of the compact rock. Every inch of land is exploited

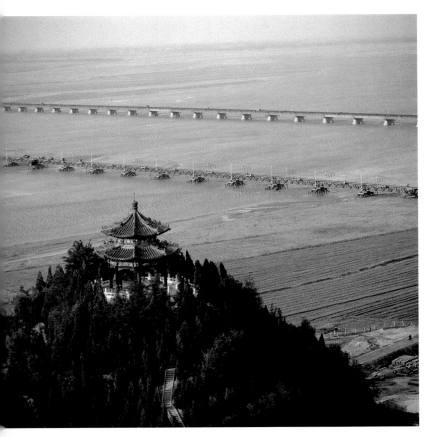

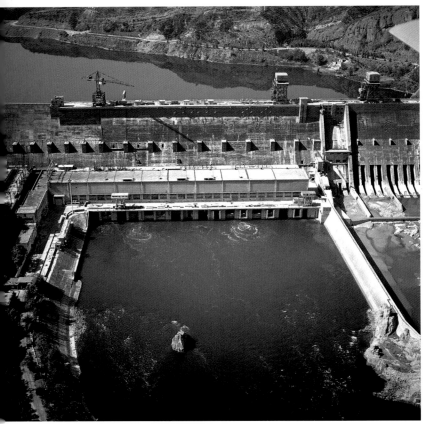

doggedly, wrested from the rivers and rain, which is occasional but torrential and every year washes away 78,000 tons per sq. mile (30,000 tons per sq. km) of fragile loess.

When it arrives at the junction with the Wei River, the Yellow River makes its last bend, heading east, and then proceeds toward the plains of Henan and the ocean. The populated Wei Valley is considered the true cradle of Chinese civilization: it is the site of the ancient city of Xi'an, which was the capital of the empire for eleven centuries. Xi'an has preserved outstanding artistic treasures, but it famous above all for the mausoleum of the Emperor Qin, who died 22 centuries ago. Archaeologists found thousands of beautifully wrought life-size terracotta soldiers that were placed there to guard the emperor's tomb. Other recent discoveries in Henan Province have led scholars to believe that other unimaginable treasures lie beneath the thick layer of lime that covers the Huang He delta.

When it reaches Zhengzhou, the capital of Henan Province, the river is only 496 miles (800 km) from its outlet in the Gulf of Bohai, an arm of the Yellow Sea. In this section the Huang He flows sluggishly in a vast alluvial plain, flanked by massive embankments whose maintenance involves tens of thousands of technicians and workmen. Dozens of diversion canals furnish constant irrigation to an area of 6000 sq. miles (15,000 sq. km). The greatest challenge facing modern China has been to control and retain the Yellow River and utilize its waters for agriculture. Over the centuries the river has changed the direction of its course many times, emptying alternately south and north of the Shandong Peninsula. The river deposits an enormous quantity of silt on the shallow bottom of the delta, creating no less than 16 sq miles (40 sq. km) of new land every year.

180 top In the last 2000 years the Huang He – now partly tamed and crossed by numerous bridges – spilled over its embankments 1500 times. Despite its capricious and violent nature, the river was the cradle of Chinese civilization.

180 bottom The colossal Xiaolangdi Dam blocks the course of the Huang He about 80 miles (130 km) west of Zhengzhou, the capital of Henan. More than 5800 sq. miles (1.5 million hectares) of land will be irrigated.

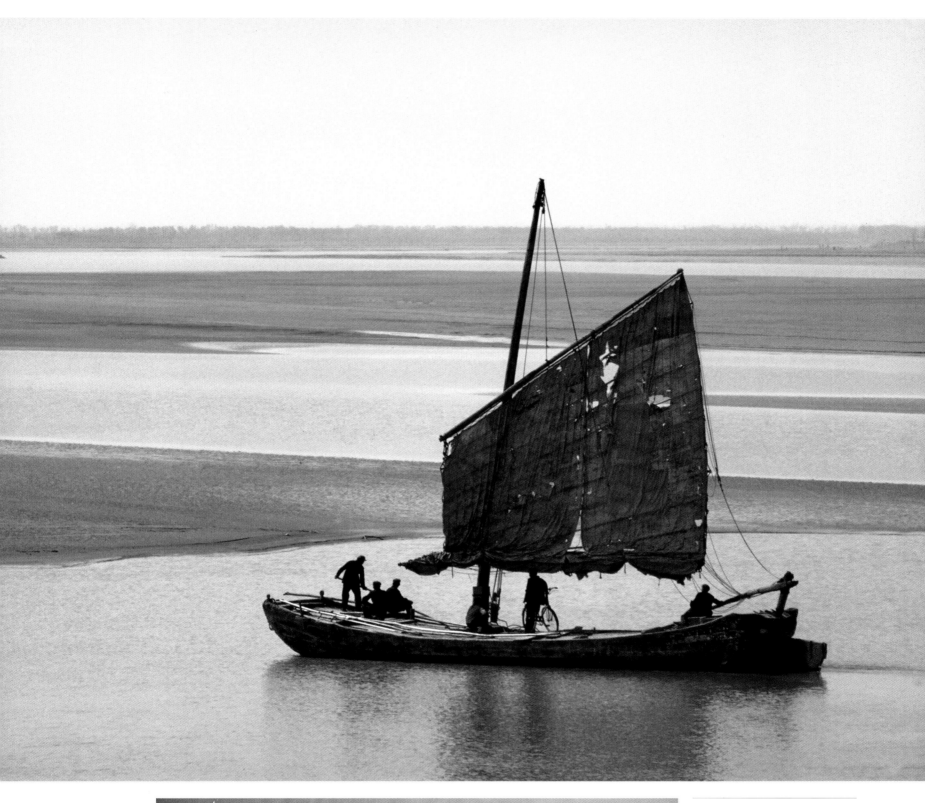

180-181 A junk proceeds slowly through the maze of canals formed by the Huang He delta. Part of the area, which hosts 1500 species of plants and animals, was recently turned into a nature preserve.

181 bottom The raft used by this fisherman consists of long bamboo poles tied together and is basically the same as those used in very ancient times. It is light and easy to manage, ideal for traveling in the usually calm lagoons of the Huang He delta.

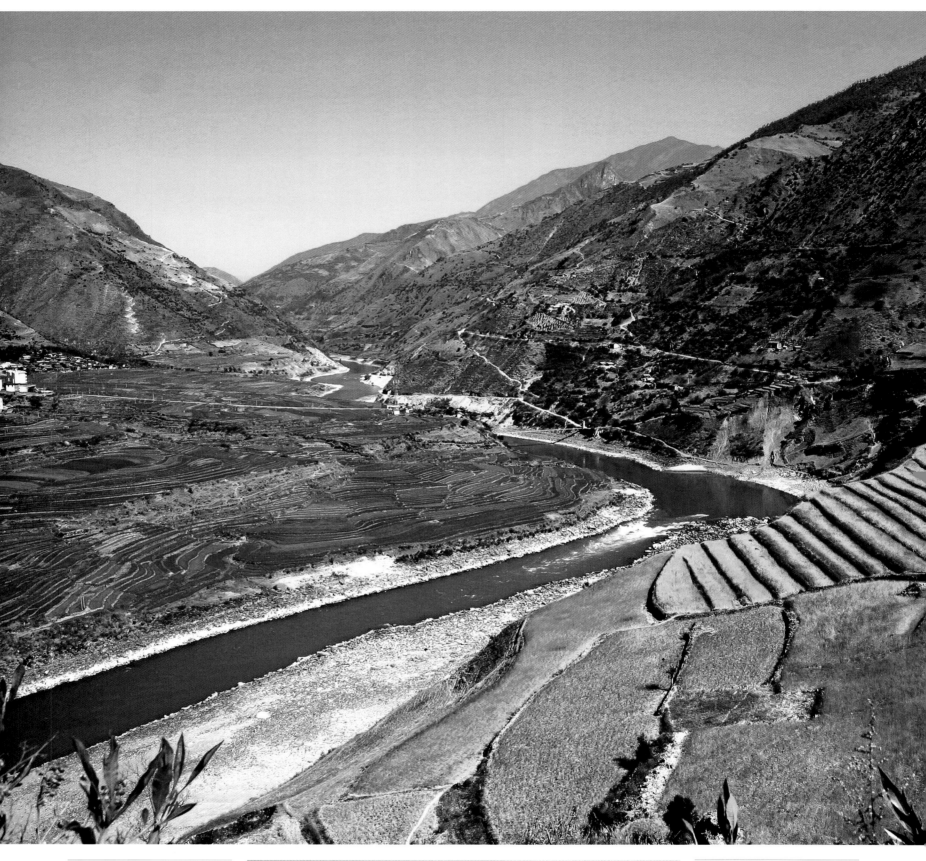

182-183 A continuous succession of
deep gorges marks most of the upper
course of the Mekong River, in the
Chinese province of Yunnan. When
it arrives in Laos, the river, now
called the Lantsang, has dropped
more than 13,125 ft (4000 m).

182 bottom Barren terrain with
dull colors surrounds the upper
course of the Mekong in the
vicinity of the old city of Dzadoi,
on the Tibetan plateau.
At this point the river is about 330
ft (100 m) wide.

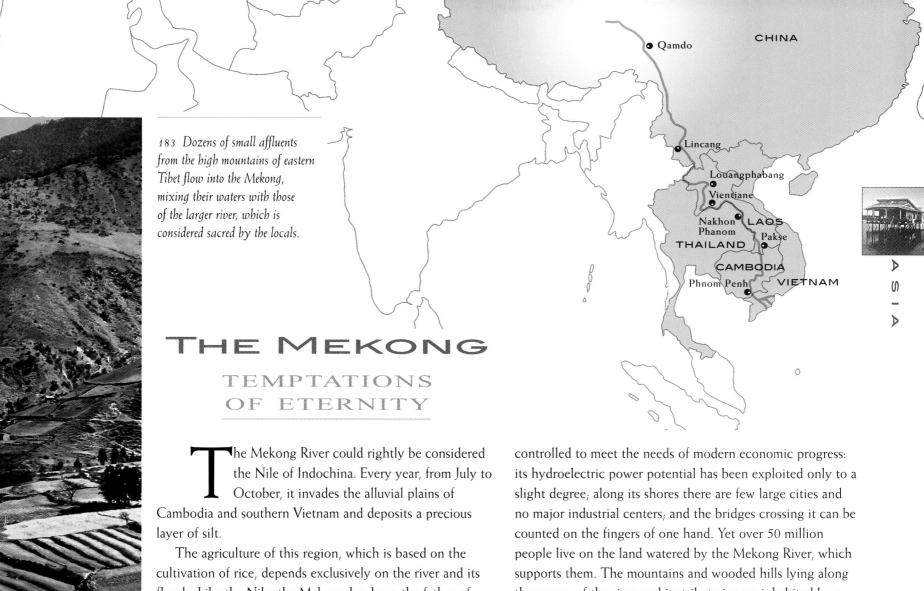

183 *Dozens of small affluents from the high mountains of eastern Tibet flow into the Mekong, mixing their waters with those of the larger river, which is considered sacred by the locals.*

THE MEKONG

TEMPTATIONS OF ETERNITY

The Mekong River could rightly be considered the Nile of Indochina. Every year, from July to October, it invades the alluvial plains of Cambodia and southern Vietnam and deposits a precious layer of silt.

The agriculture of this region, which is based on the cultivation of rice, depends exclusively on the river and its floods. Like the Nile, the Mekong has been the father of great civilizations that over the centuries have risen and fallen along its banks. And like those of the Nile, the headstreams of the Mekong River, lost in the heart of Asia, were a geographic enigma for a very long time: from 1860 on at least a dozen expeditions attempted in vain to find them. And only a few years ago were the scientists of the Chinese Academy of Science, with the aid of sophisticated technology, able to establish the exact position and calculate accurrately the length of the river as 3080 miles (4900 km).

The Mekong rises in the perennial ice packs of the Thaghla Mts, which separate Qinghai Province and Tibet, at an altitude of over 16,500 ft (5000 m). At first it is a timid, almost uncertain waterway, blocked by the ice that prevails for most of the year on the plateau, arid land without any tall bushes and bordered by low, round mountains. According to popular belief, the sources of the river are watched over by an enormous dragon that protects the sacred place from intruders. For the Tibetan shepherds that roam over this area with their herds of yaks, that clear, cold water has magical power, like a veritable elixir of life. And yet, at the beginning of its course the Mekong River is nothing more than an anonymous mountain torrent, almost exclusively fed by thawing ice and without any major tributaries that could increase its outflow to any considerable degree. It is difficult to imagine that that foamy current is destined to become the largest river in Southeast Asia.

The Mekong basin covers a surface area of 342,000 sq. miles (810,000 sq. km) and extends into six nations: China, Burma, Thailand, Laos, Cambodia and Vietnam. Despite its importance as a communication and trade route, the Mekong is a wild river that has not yet been subdued, tamed and controlled to meet the needs of modern economic progress: its hydroelectric power potential has been exploited only to a slight degree; along its shores there are few large cities and no major industrial centers; and the bridges crossing it can be counted on the fingers of one hand. Yet over 50 million people live on the land watered by the Mekong River, which supports them. The mountains and wooded hills lying along the course of the river and its tributaries are inhabited by a number of different populations: the minority ethnic groups of Yunnan Province in China; the Wa and Shan in Burma (Myanmar); the Isan, Thai Yuan and Thai Leu in Thailand; the Khmer in Cambodia; and the Kinh and Cham in

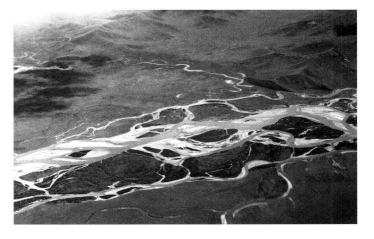

Vietnam. In Laos alone there are 68 different ethnic groups. This cultural wealth is equaled by an astounding variety of plants and animals: the muddy waters of the Mekong are the home of over 1300 species of fish, some of them huge, such as the catfish and barbel, which can weigh as much as 550 lbs (250 kg). One of the last refuges of the rare Irrawaddy dolphin (*Orcaella brevirostris*) lies in the deepest pits of the lower course of the Mekong. Only the Amazon delta can boast a higher level of biodiversity.

A river with such a strong, rich and generous personality cannot but have several names, as testimony of the almost religious respect it commands: Great Waters, River of the Nine Dragons, Mother of All Waters. In China, where it flows for almost half its course, it is called the Lancang Lantsang, or Turbulent River. And for good reason: in the 1364 miles

(2200 km) between the sources and the section that marks the border between Laos and Burma, the Mekong flows almost entirely in deep and steep gorges, bouncing from one rapids to another. In western Yunnan its bed becomes even narrower and is parallel to the Salween and Chang Jiang (Yangtze) rivers. The brilliant green of the rice fields, which descend in terraces toward the craggy, steep valley, is the only soft element in a landscape in which darkish mineral colors prevail. Some 124 miles (200 km) south of the city of Baoshan, a large dam checks the impetus of the Mekong, thus furnishing electric power for the industrial and mining complexes of Kunming, the capital of Yunnan Province. The economic plan of the Chinese government calls for the construction of eight more such dams that are indispensable

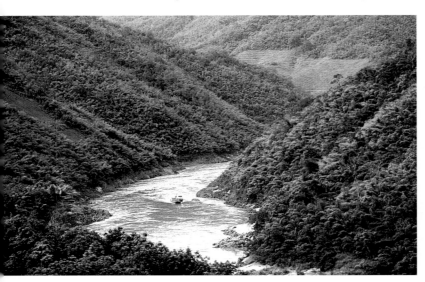

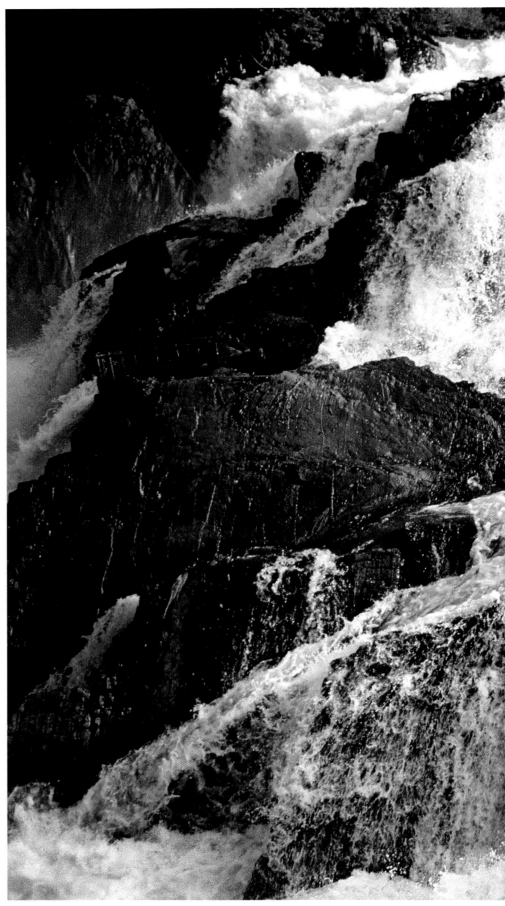

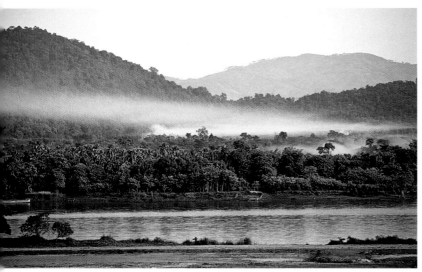

for the increasingly rapid development of the province.

The river is considered the key to the future, not only of China, but the entire Indochinese peninsula. The objective is truly grandiose: over 200 dams and diversion canals will transform the Mekong River and its tributaries into an efficient productive machine at the service of the inhabitants of the region. The completion of this project will certainly be advantageous for the local economies, but from an environmental standpoint the consequences may well be unpredictable.

184 top Fishing is one of the principal resources of the inhabitants of the villages along the Mekong, in Laos. The river's rich variety of fish species is now threatened by increasing hydroelectric and commercial exploitation of the water.

184 center While crossing southern China, the Mekong flows wildly in an uncontaminated environment. However, the programmed construction of dozens of large dams and hydroelectric plants may drastically change this region.

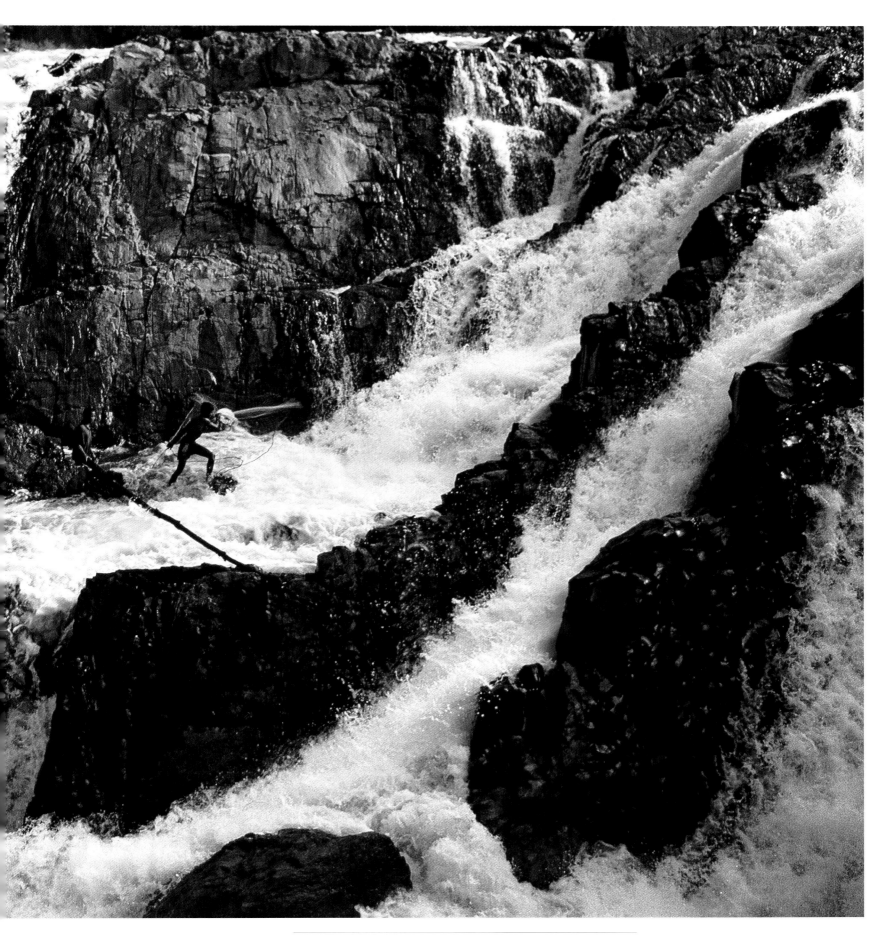

184 bottom Thick tropical vegetation covers the mountains along the Mekong at the border between Laos, Burma and Thailand. The economy of this area, known as the Golden Triangle, is based on opium cultivation.

184-185 Only the boldest fishermen can brave the violence of the Khone Falls, 10 miles (6 km) of furious rapids that mark the passage of the Mekong from Laos to the plains of Cambodia, where the river is once again navigable.

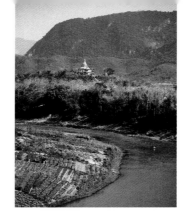

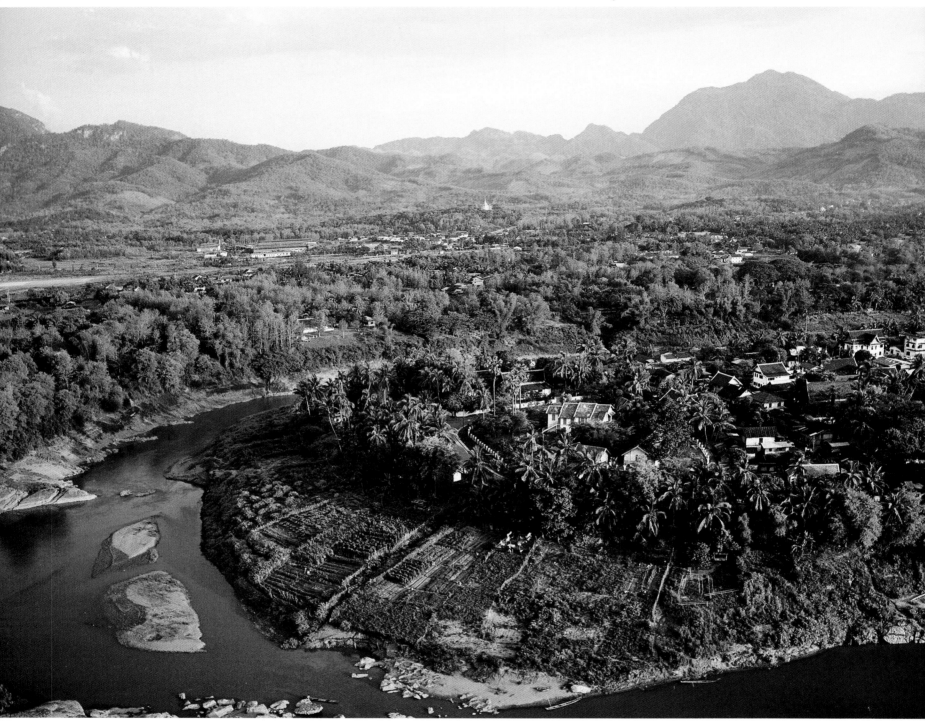

Once past the Chinese border, the Mekong once again flows freely, describing a broad bend eastward, where it passes through Burma and Thailand. It then enters Laos, where it receives the waters of the Nam Ou and other important tributaries coming from the mountain range of Annam. The frontier region, covered with luxuriant tropical vegetation, is known as the Golden Triangle. This area, which for the most part is not under the control of the national governments, has the largest opium poppy fields in the world. Louangphabang, the ancient religious capital of Laos, is only a two-days' voyage away. The elegant profiles of the temples and the former royal palace of the city are reflected in the silt-laden waters of the Mekong, which is

now in its 'adult' stage but is anything but tranquil. The river, which for hundreds of miles marks the border with Thailand, is navigable for large vessels only for brief stretches: filled with outcropping rocks, it is often interrupted by violent rapids. As if this were not enough, its regimen, which depends mostly on the monsoon rains, is extremely irregular. Between the low- and high-water periods the discharge may increase or decrease 15 times over. Only after the Khone Falls, when it exits from Laos, does the Mekong change its appearance for good: its impetuousness is placated in the vast plains of Cambodia and it receives a great deal of water from a series of tributaries (the Kong, San, Krieng and Srepok). When it

186 top Situated on the banks of the Mekong near Louangphabang, in Laos, the old Wat Pa Phai monastery is known for its splendidly carved wooden doors and the frescoes that represent charming scenes of everyday life.

186-187 Lying along the course of the Mekong, Louangphabang was the mythical royal and religious capital of Laos up to the rise of the Communist regime in 1975. This city is part of the UNESCO World Heritage List.

187 bottom left The grottoes of Pak Ou, with their thousands of Buddha statues, dominate the Mekong 18 miles (30 km) upstream from Louangphabang, in Laos. For two millennia these sanctuaries have drawn crowds of pilgrims.

187 bottom right These well-trained water buffaloes allow their herdsmen to ride them as they amble along the sandy shores of the Mekong in the vicinity of Vientiane, the modern capital of Laos.

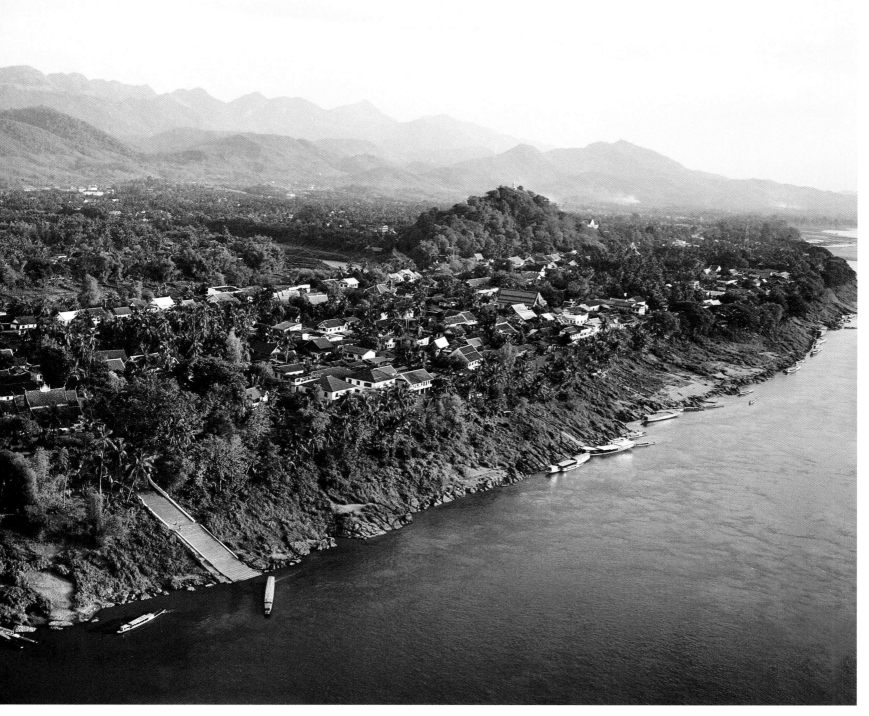

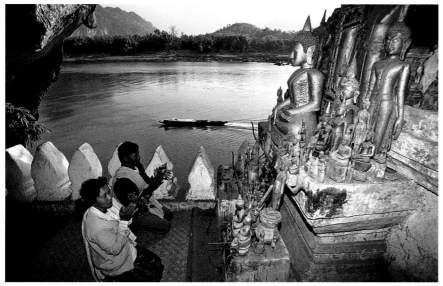

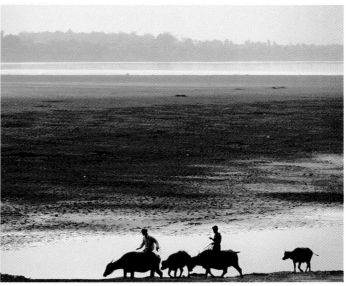

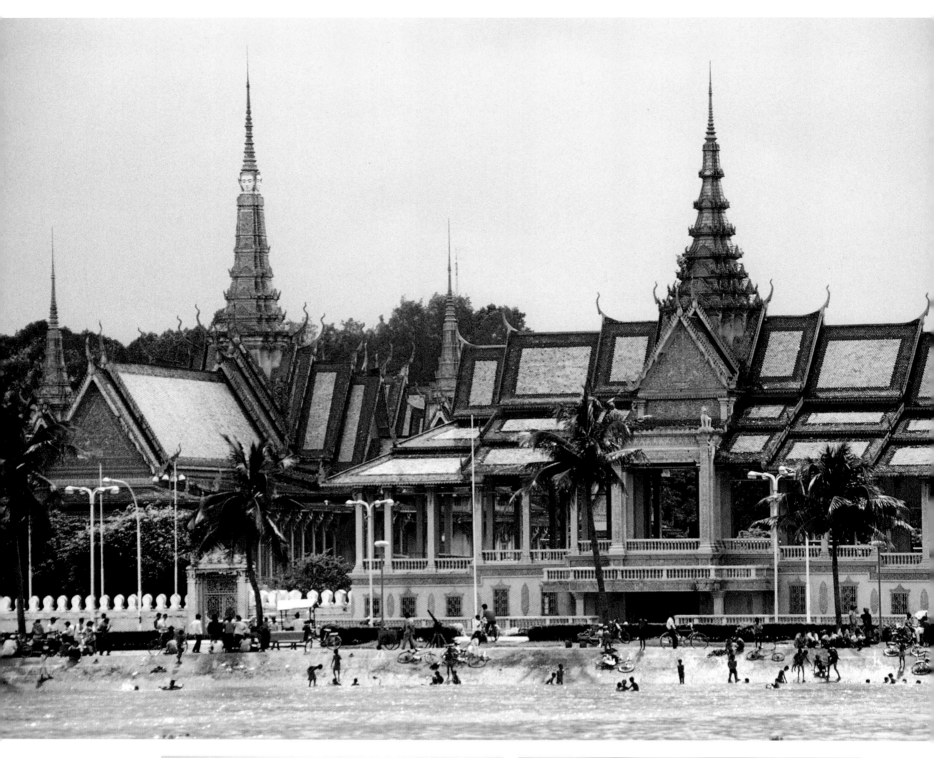

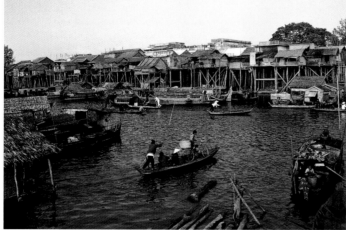

188 bottom right Every year the cyclical floods of the Mekong cover vast areas of south Cambodia, transforming the plain into a huge lake. This house, built on piles, will be isolated from the rest of the world for several months.

188-189 Like most of the city monuments, the royal palace of Phnom Penh, built by Norodom I, dates from the second half of the 19th century. The capital of Cambodia is located at the junction of the Mekong and Tônlé Sap.

188 bottom left The area of central Cambodia between the Mekong and the Tônlé Sap consists of a maze of waterways, lakes and canals dotted with small fishing villages built on piles.

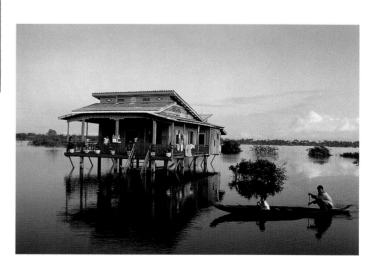

189 top A raft with a load of
bamboo poles glides slowly on the
Mekong, near the city of Kratié, in
southern Cambodia. At this point
the riverbed is several miles wide.

189 bottom After taking in the
waters of the Tônlé Sap, downstream
from Phnom Penh the Mekong merges
with the Bassac River in a landscape
distinguished by its infinite horizons.

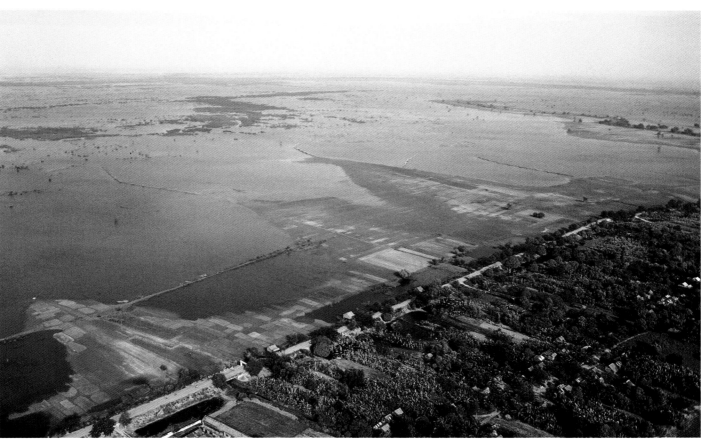

reaches Kratié it is truly a massive river, up to 3 miles (5 km) wide and navigable in all seasons as far as the delta. A few miless before Phnom Penh the Mekong River merges with the Tônlé Sap, the river that leads directly to the large lakes in central Cambodia. The Mekong-Tônlé Sap system is an almost perfect hydraulic mechanism: during the rainy season, from June to November, the Mekong empties into the Tônlé Sap, thus filling the lakes; but when the river is low, the Tônlé Sap moves backwards, furnishing water to the Mekong.

The lakes function as flood regulators, while at the same time ensuring a sufficient flow of water during the dry season for the delta, which is continuously menaced by salinization.

The control of this natural mechanism, which was perfected down to the slightest details, was the secret of the Khmer civilization, which flourished in the 9th to 13th centuries. Angkor, the ancient capital of the empire, lay at the northern tip of Tônlé Sap Lake, in the Siem Reap plain, one of the most fertile regions in Cambodia. A gigantic

network of ditches, irrigation canals, pools and artificial lakes extend around the splendid temples and palaces in Angkor, proving that the prosperity of the Khmer empire was based on the careful and intelligent management of the water resources. The ruins of Angkor cover a surface area of about 240 sq. miles (600 sq. km) that is divided into large groups of edifices: Angkor Wat and Angkor Thom. The former, a temple complex, is considered one of the greatest architectural achievements in the world; protected by three enclosure walls, it culminates in a tall pyramid that soars to the sky. Terraces, arcades, endless series of bas-reliefs, and spectacular views are the eternal testimony of the glory of a kingdom what ruled most of Indochina. Not far away is Angkor Thom, the Great Capital, surrounded by enormous walls. The harmonious sequence of avenues, buildings and squares seems to have a divine rather than human dimension. This is a colossal complex that culminates in the Bayon temple, with its fifty towers decorated with statues and busts of Buddha with a timeless smile on his lips.

190 top and center For centuries the inhabitants of southern Vietnam have had to deal with the caprices of the Mekong, which floods large parts of its delta every year. As can be seen in these photos, everyday life continues as before even when the villages are flooded: a boy is doing his chores, not seeming to bother about the muddy water at the threshold of his house, while this man avoids the water by riding on the back of a water buffalo.

190 bottom In the most remote areas of the Mekong delta, for most river transport and connections among the villages the locals rely on the traditional wooden boats that have been used in southern Vietnam from time immemorial.

190-191 In the labyrinth of canals in the Mekong delta, in southern Vietnam, dugouts are an ideal means of transportation, used for going from the village to the fields, for cargo transport - an indispensable aid for daily work.

THE MEKONG

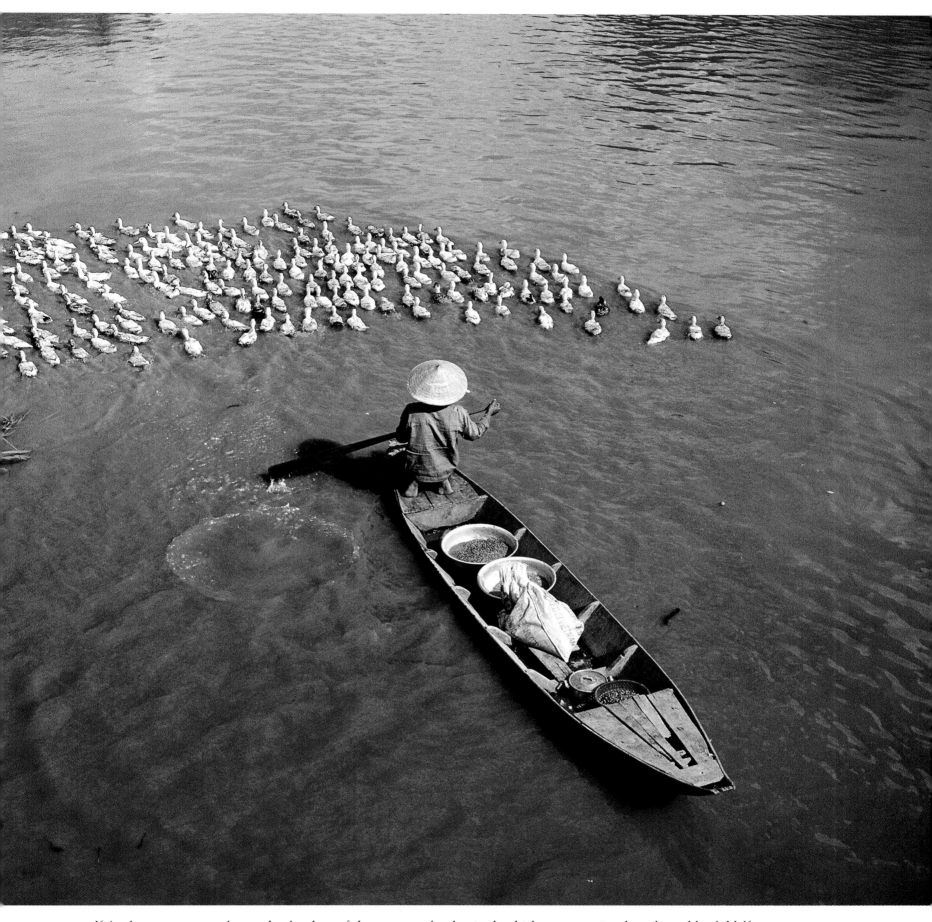

If Angkor was to some degree the daughter of the Mekong River, this is even truer of the kingdoms that, even before the rise of the Khmer empire, developed in the delta, one of the most fertile regions in all Asia. Like a huge triangle whose apex touches Phnom Penh, the Mekong Delta extends for over 8800 sq. miles (22,000 sq. km) in Cambodia and above all in southern Vietnam. Here, before emptying into the South China Sea, the river splits into its main branches, the Tien Giang and the Hau Jiang, which in turn give rise to an infinite maze of arms and canals that develop in the thick mangrove jungle and marshland. Half of the rice in Vietnam is produced in this amphibious area populated by 15 million people. The dark mangrove forests are an ideal environment for the intensive farming of fish and shrimp for exportation. It seems that the delta will become the driving force behind the economic recovery in Vietnam, which was devastated by war for such a long period. Now that peace has returned. the Mekong can resume its role as the vital artery of Indochina and benign dispenser of life.

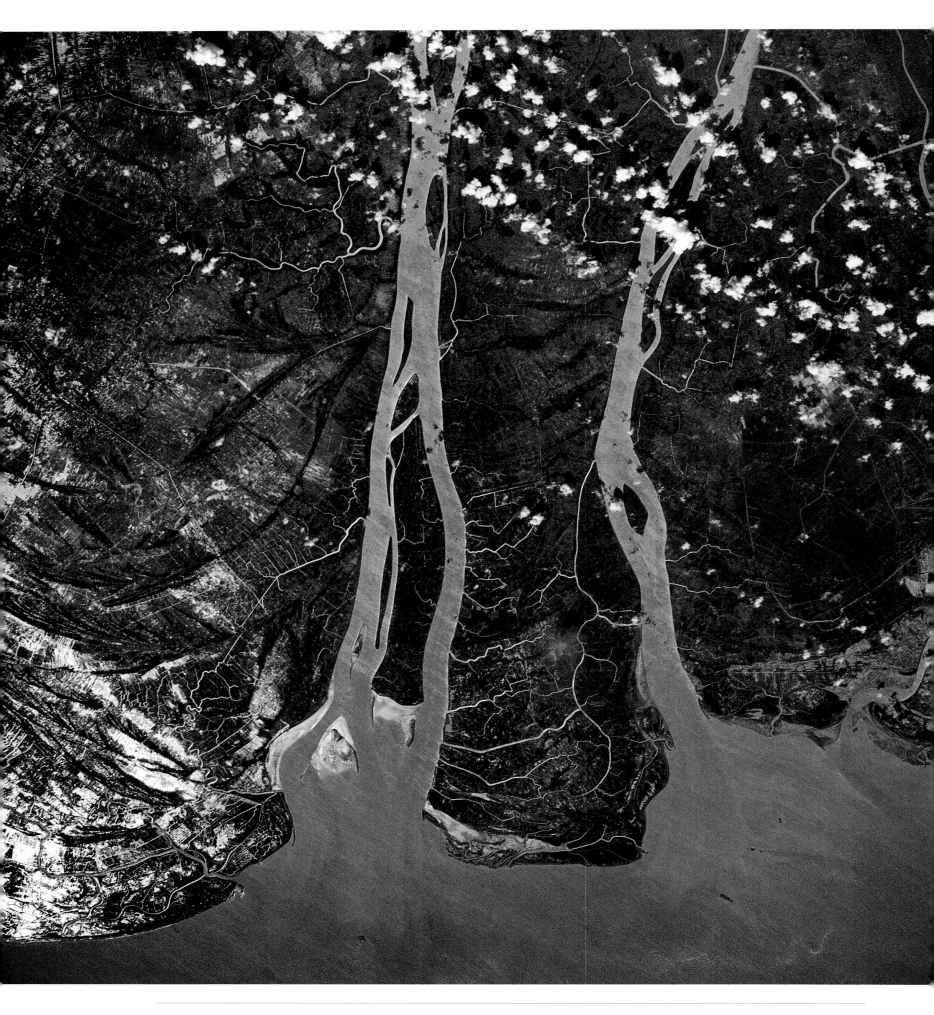

192-193 This view of the Mekong delta shows the enormous amount of silt deposited in the China Sea.

193 top In the Mekong delta, thick forests and expanses of aquatic plants alternate with large cultivated areas.

193 center top The quays in a town of southern Vietnam literally overflow with boats.

193 center bottom A rudimentary bridge made of mangrove branches allows people to cross one of the many irrigation canals in the Mekong delta in Vietnam.

93 bottom This dugout glides through the haze on one of the branches of the Mekong delta. This very fertile region can look forward to a prosperous and peaceful future.

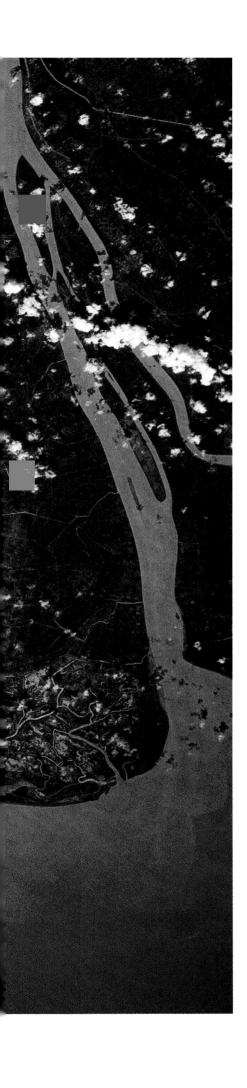

THE MEKONG

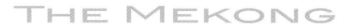

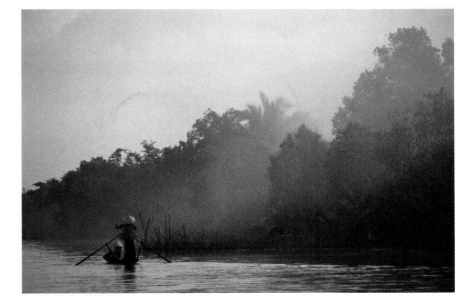

NORTH AMERICA

The river system in North America is greatly influenced by the special features of the terrain. The entire continent, from Alaska to Mexico, is traversed by a series of gigantic mountain chains that run parallel to the Pacific coast. The main barrier is the Rocky Mountains range, which extends northward toward Canada and the impressive mountains of Alaska. The rivers in the West are therefore shorter and smaller as regards discharge than those that flow into the Atlantic and the Gulf of Mexico. In general, their course is interrupted by rapids and falls, which impede navigation.

Some of these rivers, such as the Colorado, flow in the plateau, forming the deepest and most spectacular canyons on the Earth. Besides the Yukon River, which is 1984 miles (3200 km) long, others worthy of mention are the Columbia and the Fraser. East of the Rocky Mts. are the Great Plains, which extend from the Arctic Sea to the Gulf of Mexico and the Appalachian Mts. This is the land of great rivers that with their network of tributaries and lakes have three-quarters of the fresh water in North America.

The Mississippi-Missouri system, which is inferior only to the Nile and Amazon, has a basin of over 1.2 million sq. miles (3 million sq. km), a surface area six times that of France. Equally impressive is the Mackenzie River system, which after 2480 miles (4000 km) empties via with its large delta into the freezing Beaufort Sea, north of the Arctic Circle. The Athabasca, Great Bear and Peace rivers, plus a network of minor tributaries, carry the waters of the Canadian lakes into the Mackenzie. The Churchill, Nelson, Joose, Severn and Albany rivers empty into Hudson Bay. The northern rivers, which are blocked by ice most of the year, cannot be used for commercial traffic. On the other hand, the Hudson and St. Lawrence rivers are extremely important from an economic standpoint: since the early 17th century their vast estuaries have been the gateway to America for generations of explorers and pioneers.

The two rivers, linked by a series of canals that can be used even by large ships, connect New York and Montréal with the Great Lakes and the rich industrial and agricultural zones of the interior. Almost all the rivers in North America, except for the Yukon and Mackenzie, flow through highly developed and densely populated regions. A great number of dams, hydroelectric plants and floodways control the course of these waterways and utilize their water to irrigate vast areas that would otherwise be unproductive.

The prosperity and short history of North America is rooted in the fertile banks of its rivers.

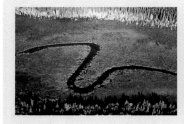
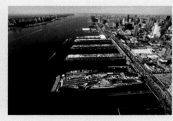
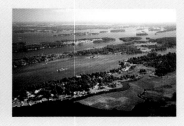

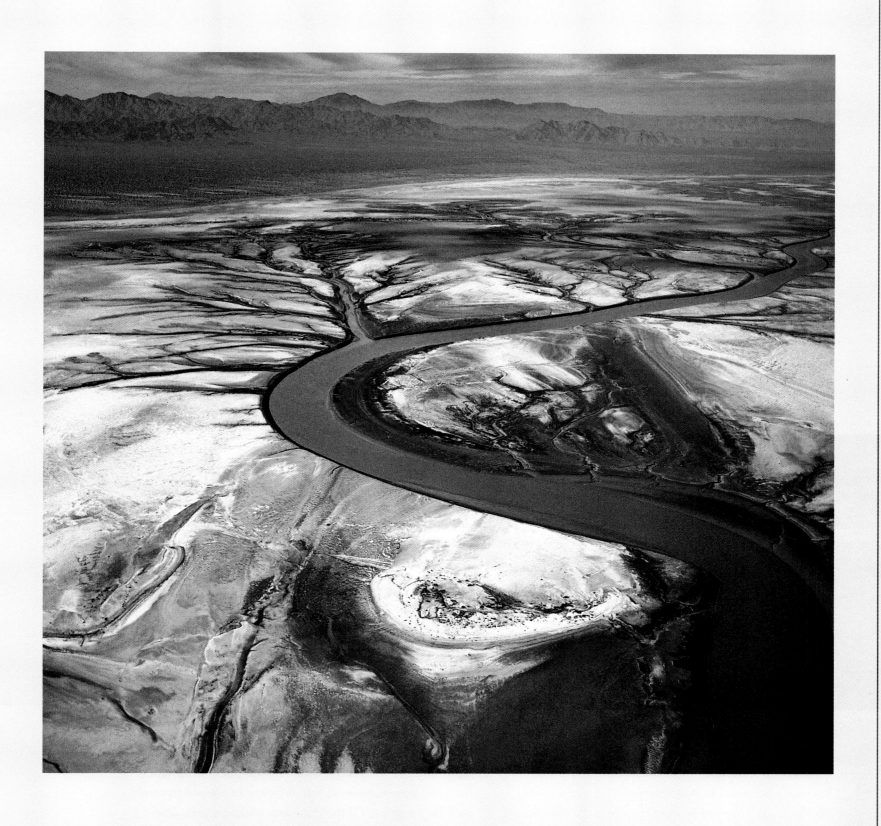

194 left Aerial view of the Mississippi at its source in Minnesota, United States.

194 center The Intrepid Sea-Air-Space Museum on the Hudson at Manhattan, New York City.

194 right The Thousand Islands archipelago on the St. Lawrence River, at the Canadian-US border.

195 The Colorado River at its delta, in the vast Sonora Desert in Mexico.

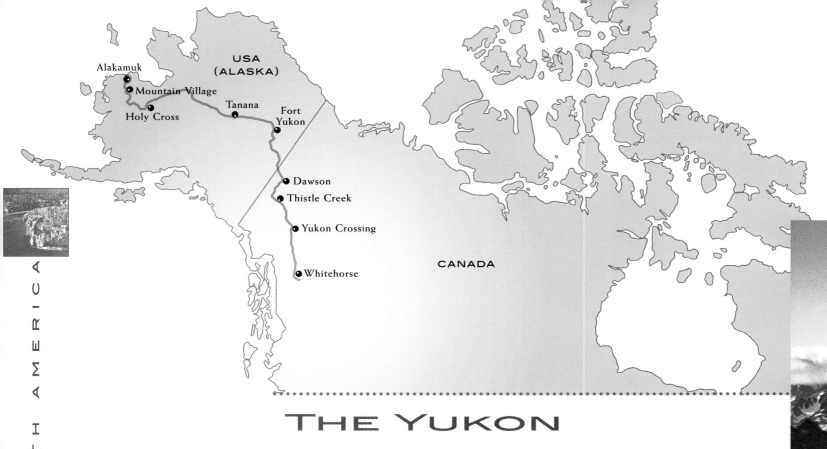

THE YUKON

TREASURES UNDER THE ICE

The Klondike is nothing more than an insignificant mountain stream that can barely be seen on maps of the Northwest Territories. And yet it is much more famous than the massive Yukon River, which receives its waters near the sleepy town of Dawson, not far from the Alaskan border. In the late 19th century, that remote and still only half-explored region was the scene of the last and most dramatic gold rush in the history of North America. The first nuggets were found at Bonanza Creek, a small affluent of the Klondike, in 1897. The news spread like wildfire and in a short

time a veritable stampede of hopeful prospectors went to the Yukon Valley: men of every age and nationality, often poorly equipped, invaded Dawson City, which overnight became a frenetic cosmopolitan city of over 30,000 souls. The road to the Klondike gold fields passed through the so-called Chilkoot Trail, the only access from the Pacific coast to the group of glacial lakes that are the sources of the Yukon River. From that point, in order to get to Dawson people were obliged to go down the river, which was a dangerous and complicated undertaking.

Once having abandoned the lakes, the Yukon flows between the tall basalt faces of Miles Canyon, where the current becomes swifter, rushing in tall waves that crash against the rocks, and then precipitating into the Whitehorse Rapids. Despite the fact that the fury of the river has been checked by a large dam downstream, navigation in this stretch of the river is still fraught with difficulties. In the summer of 1898 over 150 boats, often nothing more than hastily assembled rafts made of tree trunks, sank in Miles Canyon, resulting in the loss of the gold-seekers' possessions, and sometimes of their lives. Those who managed go down the rapids without incident still had to face a hostile environment by themselves and without any hope of help, in utter isolation miles away from the nearest town.

The place names of the Yukon Territory consist of a series of words that express solitude, disasters, impossible living conditions, and labors worthy of Dante's *Inferno*. A freezing hell in this case, since the winter temperature in many areas easily exceeds 40° C below zero. The thawing of the snow and arrival of spring bring about another 'scourge': mosquitoes, thousands of them, so many as to make even the calmest and most stoic person go mad. Jack London, who took part in the famous gold rush (returning home penniless), describes the mosquitoes with wry humor as capable of flinging themselves against a burning stove. And extracting gold was certainly not an easy task. In the valleys of the Yukon and its tributaries the soil is frozen in depth most of the year, even in mid-summer. The terrain is hard and impermeable, so that it had to be thawed patiently with fire or steam. Of the thousands of adventurers who tried their luck in the Klondike, very few struck it rich; for the others the El Dorado of the North remained a mirage, and often hope turned into tragedy. Very little remains of this modern epic: rusty picks, pans and sieves, steamships strangled by vegetation, the ruins of humble log cabins.

The Yukon River has preserved its wild and solitary

196 Officially considered the source of the Yukon River, Lake Atlin is really the first in a series of natural reservoirs that collect the glacial water from the mountains of northwest Canada.

196-197 Wild, rugged scenery surrounds the shores of Lake Atlin, situated in the mountains of British Columbia, Canada. The true headstreams of the Yukon flow from the bottom of the glaciers.

197 bottom The pristine forests that cover the eastern zone of the Yukon basin are the domain of the marvelous wild fauna of the North. In the Canadian Yukon alone there are 10,000 brown bears and over 7000 grizzlies.

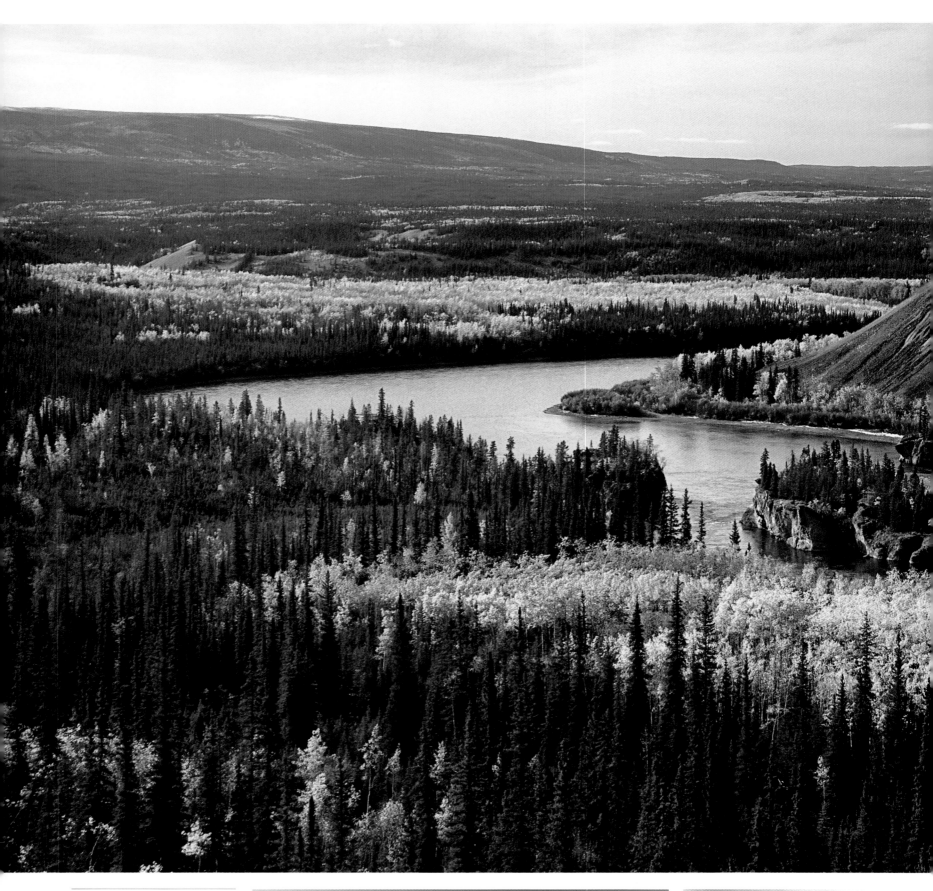

198-199 and 199 right The Five
Fingers Rapids interrupt the course
of the Yukon below Carmacks, in
northwest Canada. The name
derives from the basalt spurs that
emerge from the river water, dividing
the current into five branches. The
rapids, now a tourist attraction,
once impeded navigation between
Whitehorse and Dawson City.

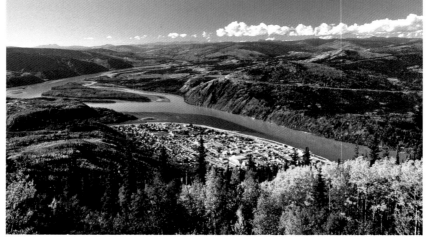

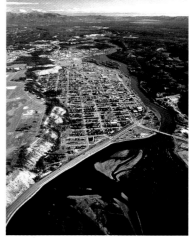

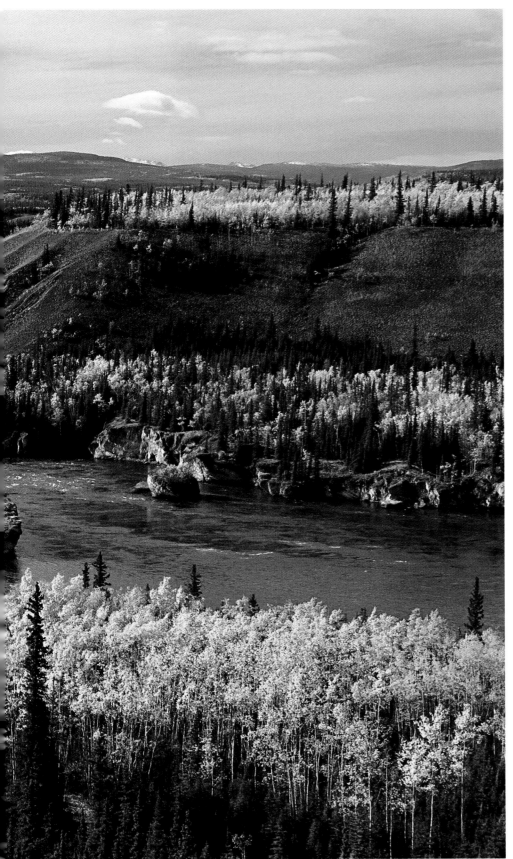

character. It is 1985 miles (3200 km) long and has only four bridges, which are located in the most important towns and on the rare negotiable roads that penetrate the heart of Alaska. The river rises at Lake Atlin, in British Columbia, only 15 miles (25 km) from the Pacific coast. After the Whitehorse Rapids it heads northwest, deep and wide enough to allow small steamers to navigate. Until the Alaska Highway was laid out in 1942, the river was the only means of communication in this territory without roads. Whitehorse, with a population of 23,000, is the only town worthy of the name that the Yukon passes through on its long voyage to the Bering Sea. The other towns are much smaller: 50 residents and a handful of wooden houses are enough to earn the name of a village and a place on the maps of the river basin, 360,000 sq. miles (900,000 sq. km) of tundra and virgin forests, a surface area approximately three times the size of Italy, but with only 126,000 inhabitants, which is to say about one-third the population of Florence. The forests of needle-leaf and birch trees that cover the mountains are the home of a great number of brown and grizzly bears, caribou, wolves and elk that are free to wander about in this immense nature sanctuary.

After Whitehorse, the Yukon receives its first important tributaries: the Teslin, Pelly, Stewart and the White River, which comes from the huge glaciers of Mt. Saint Elias, the fourth highest peak in North America at 18,114 ft (5489 m). At the confluence with the Pelly River, the Yukon passes by the ruins of Fort Selkirk, the old trading outpost of the Hudson Bay Company: long before the gold fever, it was the great abundance of furry animals that first attracted the first explorers to this region. The fur and the gold in

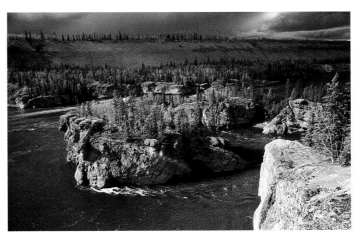

198 bottom left Dawson City, now a sleepy, modest town, was formerly the capital of the Yukon and the hub of the Klondike gold rush. From 1897 to 1900 it had a population of 30,000 people, who arrived there from all over the world.

198 bottom right Whitehorse, the old steamboat terminal that up to 1950 was linked by the river to the Bering Sea, did not decline as did the other towns in the region. Today it is the largest city in the Canadian Yukon.

the Yukon region soon proved to be riches that were at once hard to obtain and ephemeral. The gold veins were soon exhausted, marking the immediate decline of Dawson, which is now a sleepy village with 2,000 inhabitants. Mining activity continues in the surroundings, and there are still some hardy souls who pan the rivers for gold with the old methods. But no one really believes in a stroke of luck that will change one's life in a second. The heroic period of Dawson, when gold was legal currency and fresh fruit cost up to $5 per lb ($10 per kilogram) in the dollar of that time, is now part of the distant past.

When it enters Alaska, the Yukon suddenly changes; it

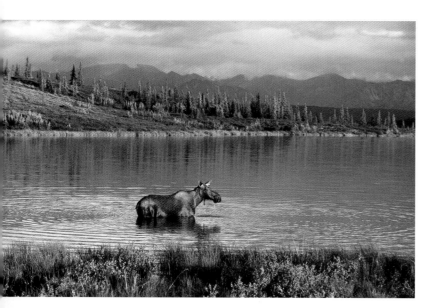

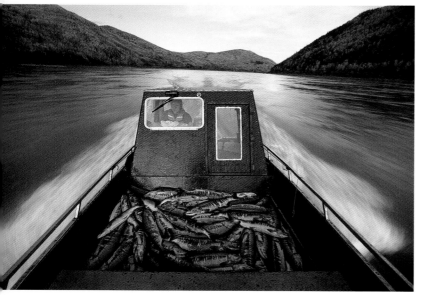

abandons the mountains that framed its valley for almost 620 miles (1000 km) and flows into a vast alluvial plain. Only the rugged Brooks Range in the distance rises up solemnly to interrupt the horizon to the north. The river, now free from the constraints of definite banks, splits up into hundreds of channels, stretching out into broad meanders that continuously change shape and direction, among pools and dried-up canals.

This area, which is literally soaked with water and so rich in nutritious substances, is a favorite with migratory birds: every year 2 million geese and ducks nest in the Yukon Flats nature reserve. And every August the waters of the plain are teeming with Pacific salmon, which go up the Bering Sea to spawn in this area after a flight of more than 992 miles (1600 km).

Salmon fishing is still a mainstay in the economy of the Athabasca Indians, whose ancestors crossed the Bering Strait from Siberia 25,000 years ago. Their original territory comprises a vast portion of the interior of Alaska and the Canadian Yukon. Together with the groups of Inuit (or Eskimos), they are only 15 percent of the population of the Yukon basin. The Athabascans and Inuit generally inhabit the small towns along the river and its affluents. They live mostly on hunting and the direct exploitation of the natural resources, which, besides being profitable activities, serve to maintain their ethnic identity and their bonds with the past.

Near the village of Fort Yukon, after touching the Arctic Circle, the river merges with the Porcupine and then turns sharply southwest. Farther downstream the Yukon receives

THE YUKON

200 top Elk are a common sight in the Yukon basin, which is almost totally uninhabited and untouched by modern civilization. These large herbivores can be as much as 6.5 ft (2 m) tall at the withers and weigh one ton.

200 bottom Salmon abound in the freezing waters of the Yukon. Fishing provides a good living for many people who live in Alaska. In one day it is possible to catch hundreds of fish.

200-201 Tall columns of smoke rise up from the burning forest, blurring the endless horizon of the Yukon Flats, in Alaska, where the river widens in the plain, creating an inextricable maze of lakes and canals.

201 bottom Once past the Yukon Flats, the river winds through a clearly bounded bed on its way to its junction with the Tanana River, one of its most important tributaries. In the distance, the Brooks Range conceals the horizon to the north.

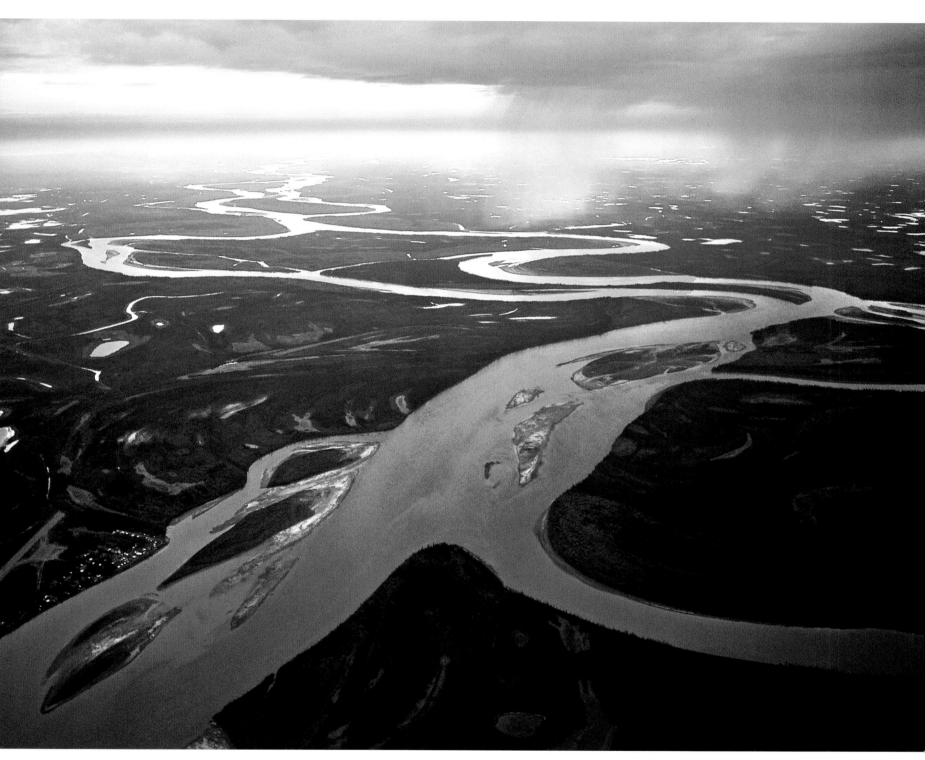
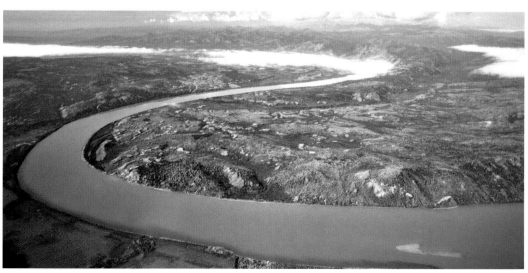

The Yukon

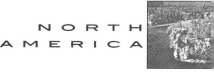

one of its major tributaries, the Tanana, which takes in the melted snow from the Alaska Range. The Tanana is a dangerous river, as it is subject to sudden floods. In August 1967, swollen with unusually torrential rainfall, it broke through the banks and completely inundated the city of Fairbanks, causing incalculable damage.

For the inhabitants of the villages along the Yukon the real problems arise in spring, when the thick layer of ice that covers the river during the winter begins to break up. The gigantic slabs of ice, pushed by the current, pile up along the banks in indescribably chaotic fashion, shattering everything in their path. Sometimes the blocks stop the flow of the water, creating huge dams that quickly make the water level rise upstream, which may cause disastrous floods.

After the town of Galena, the Yukon makes a sharp bend and flows southward toward Holy Cross. The small town of Russian Mission is located a few dozen miles farther on the right bank of the river; here in 1837 a group of Russian explorers and merchants set up the first European trading post in the Northern Territories. But Russian colonization was short-lived: thirty years after the foundation of Russian Mission, the Czar Alexander II sold Alaska and its inhabitants to the United States for the sum of $7.2 million – a ridiculously low price by anybody's standards. To this day, for the Yup'ik Eskimos, who live on the Yukon delta, the white man is a *gussuk* or Cossack. And the heritage of Mother Russia lives on in the place names, in the customs of the native populations, and above all in the traditions of the Russian Orthodox religion.

Curving slowly northward, the Yukon River moves toward the Bering Sea, where it empties in a large marshy delta. The timid gurgling of the current is the only sound to be heard in the silence and absolute solitude of the Arctic region.

202-203 *A thick mantle of ice covers the Yukon near the town of Eagle, at the Alaska-Canada border.*

Despite the spread of mechanical means, the dog sled is still quite widely used in the Yukon region.

204-205 The picturesque Long Sault Parkway in Ontario links a group of islets, the only strips of land breaking the surface of the large lake created during the construction of the St. Lawrence Seaway.

204 bottom These tapered dragon boats, which hold as many as 24 rowers, can seem to skim over the crystal-clear waters of Lake Ontario.

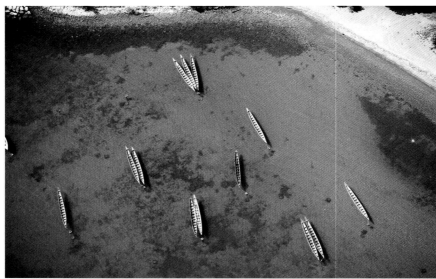

205 top A complex system of locks and weirs regulates navigation on the St. Lawrence Seaway, allowing ocean-going ships to go as far as the port of Duluth, on Lake Superior.

206-207 *In the stretch below Cornwall, where a large dam has submerged the Long Sault rapids, the St. Lawrence regains its scenic beauty, forming a sort of inland delta that is the refuge of hundreds of species of birds.*

THE ST. LAWRENCE
THE RIVER OF WHALES

The length of a river is usually measured from its source to mouth. But the St. Lawrence River is a special case, since it is not clear where it begins and ends.

This immense lake system on the American-Canadian border, the largest reservoir of fresh water in the world, is an integral part of its basin. Lakes Superior, Michigan, Huron and Erie are in fact linked and in turn communicate with Lake Ontario, the only outlet of which is the St. Lawrence. Consequently, the river should issue at Duluth, at the western tip of Lake Superior, and the famous Niagara Falls should be one of the marvels of the river. Exactly where the river empties into the Atlantic is also a moot question. In the last stretch of its course the St. Lawrence creates an endless estuary that is so vast and deep that it has all the makings of a sea gulf: for hundreds of miles in the interior salt water prevails over fresh water.

Officially, the St. Lawrence River proper rises from Lake Ontario and ends near Anticosti Island – assuming that boundaries can be traced on water. Actually, it is not geography but history that forges the personality of this river. For 500 years it has been a passageway for exploration, a commercial waterway, and a gateway to the wild interior of Canada. The first European to reach the St. Lawrence was the French navigator Jacques Cartier, in 1535. Like so many other explorers of the time, he had hoped to find a passage to the North, beyond the American continent, which would lead to the fabulous riches of the Orient. The river estuary, which miraculously made a wide breach in the mountains, seemed quite inviting. His dreams of glory were shattered above present-day Montréal when he came to the rapids later called Lachine, or China, an ironic twist that poor Cartier would not have appreciated. From that point on the river was no longer navigable and there was no heaven-sent opening in the land surrounding him. Before returning home, Cartier solemnly took possession of that distant territory in the name of the king of France.

The mission had been a failure, the sought-after route to China was still unknown and the navigator's ship had not returned laden with gold and precious goods. But the French colonization of the New World was only postponed. Seventy years later, in 1608, Samuel de Champlain established the outpost of Québec, the nucleus of what would later become the prosperous province of Canada. Cartier and Champlain's heritage has survived to this day and Québec City is still the heart of this enormous slice of French-speaking America that occupies most of the Labrador Peninsula. The St. Lawrence, or better, the Saint-Laurent, is basically a French-Canadian river: the towns and villages on its shores have French names; most of the population is French Catholic; the local culture, traditions and cuisine (more elaborate and sophisticated than that in the rest of Canada) are French.

Once the grim and violent period of separatism had passed, when Québec sought at any price to gain independence from Canada, this region developed at a prodigious pace. As in the past, the river plays a fundamental role in the economy. The St. Lawrence Seaway, which was completed in 1959, links the ports of Montréal and Québec with the Great Lakes: a series of canals, locks and navigable lakes allows large ships to get to Toronto and the agricultural and industrial areas of the central states of the United States in a short time. The corn from the Midwest, the wheat from the Canadian and American plains, the iron from Labrador, the coal from the Appalachians, as well as steel, machines and high-tech products are transported to the Atlantic via the old fur trappers' route marked out centuries ago by the founders of New France.

Once out of Lake Ontario, the St. Lawrence is already a full-fledged river and moves solemnly through hundreds of tree-covered islets.

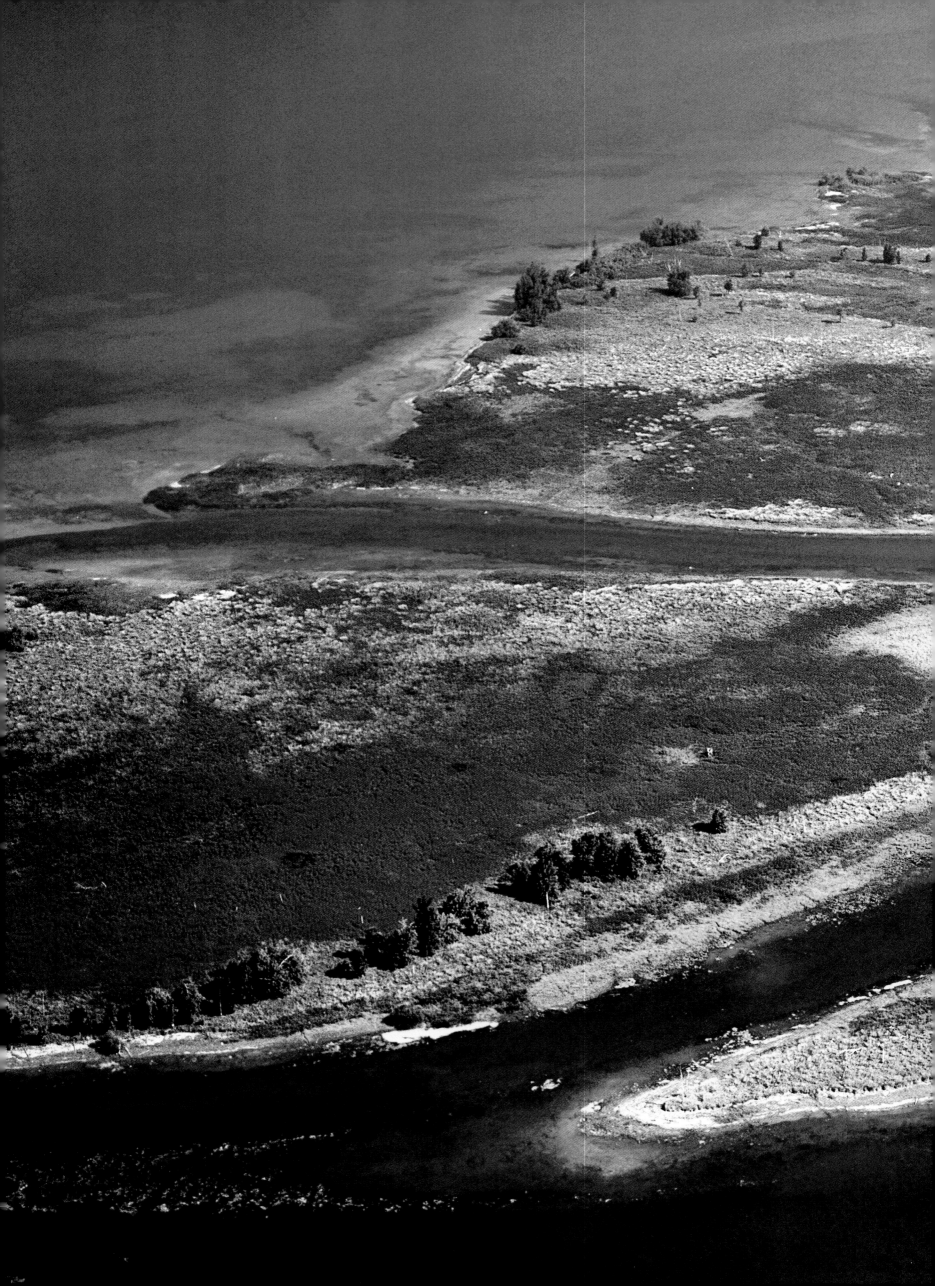

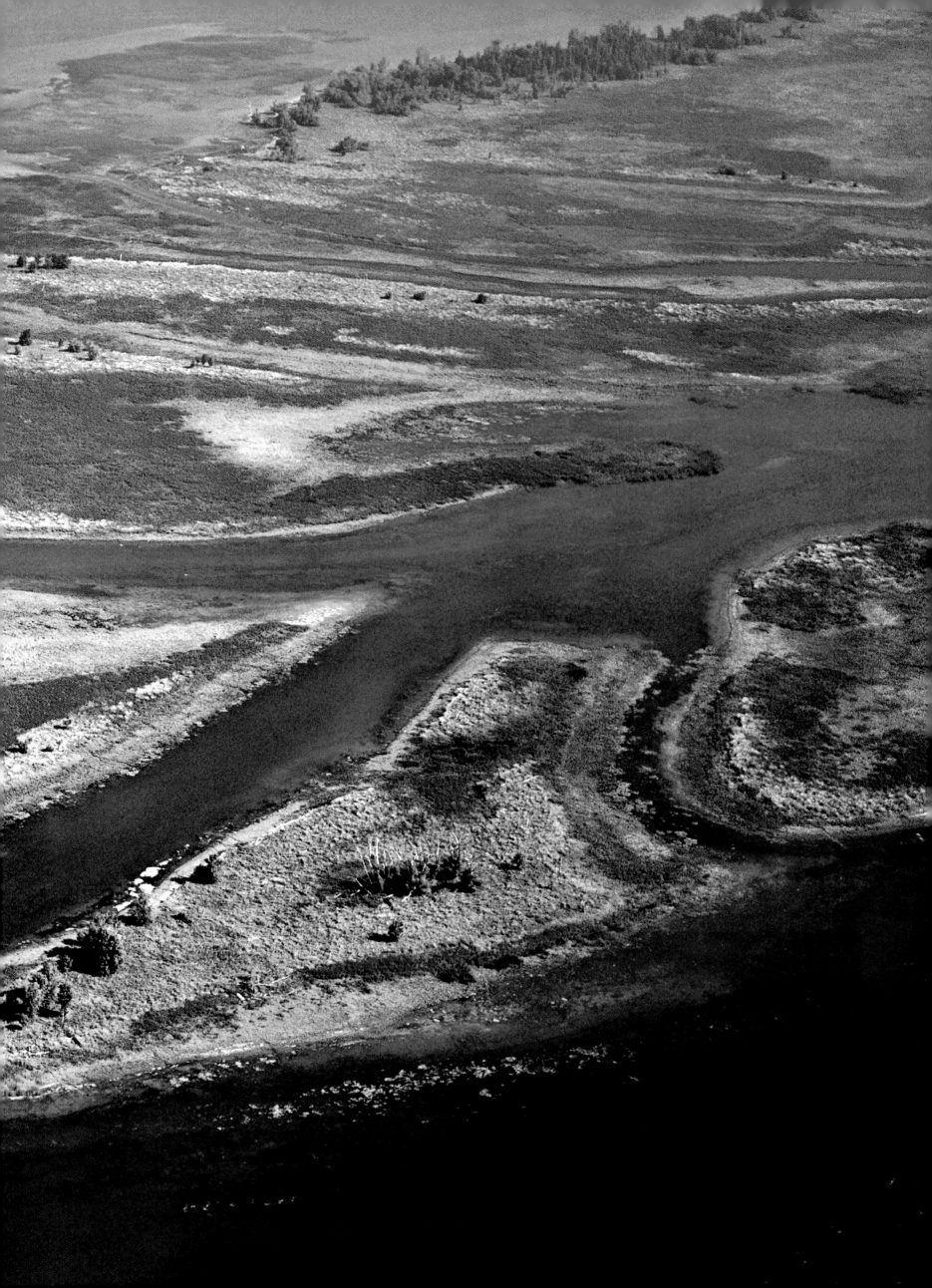

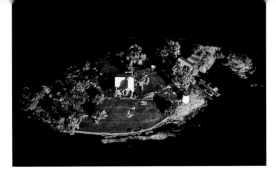

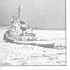

THE ST. LAWRENCE

208 top and bottom Some of the numerous islands that dot the St. Lawrence River as it flows out of Lake Ontario are either uninhabited or have a few modest houses, while others are occupied by mansions belonging to tycoons. Boldt Castle (in the bottom photograph) on Heart Island has 120 rooms and was built a little over a century ago by a rich hotel owner from New York as a wedding gift for his bride.

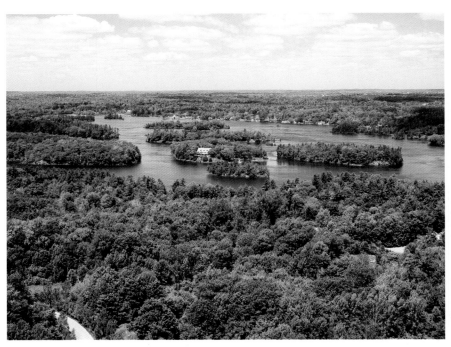

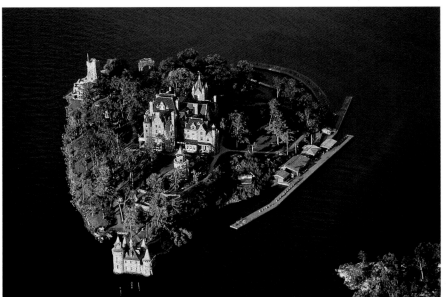

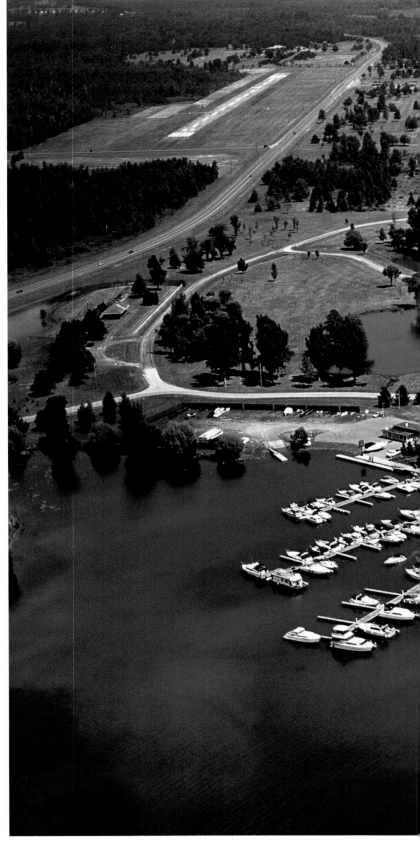

This is the Thousand Islands archipelago, which the Mohawk Indians called the Garden of the Great Spirit because of its sheer beauty. There are really about 1800 islets in the group that dot the upper course of the river for about 56 miles (90 km). Some of them are only tiny granite cliffs emerging from the surface of the water, while others are covered with luxuriant vegetation and are large enough to accommodate luxurious mansions. The blue waters of the St. Lawrence River almost touch the thresholds of these houses but never endanger the life and property of the owners. The river, which was formed 600 million years ago, is virtually without silt in suspension and is not subject to flooding thanks to the regulating action of Lake Ontario and the other inland lakes.

The river forms the boundary between New York State and the Canadian province of Ontario for 93 miles (150 km)

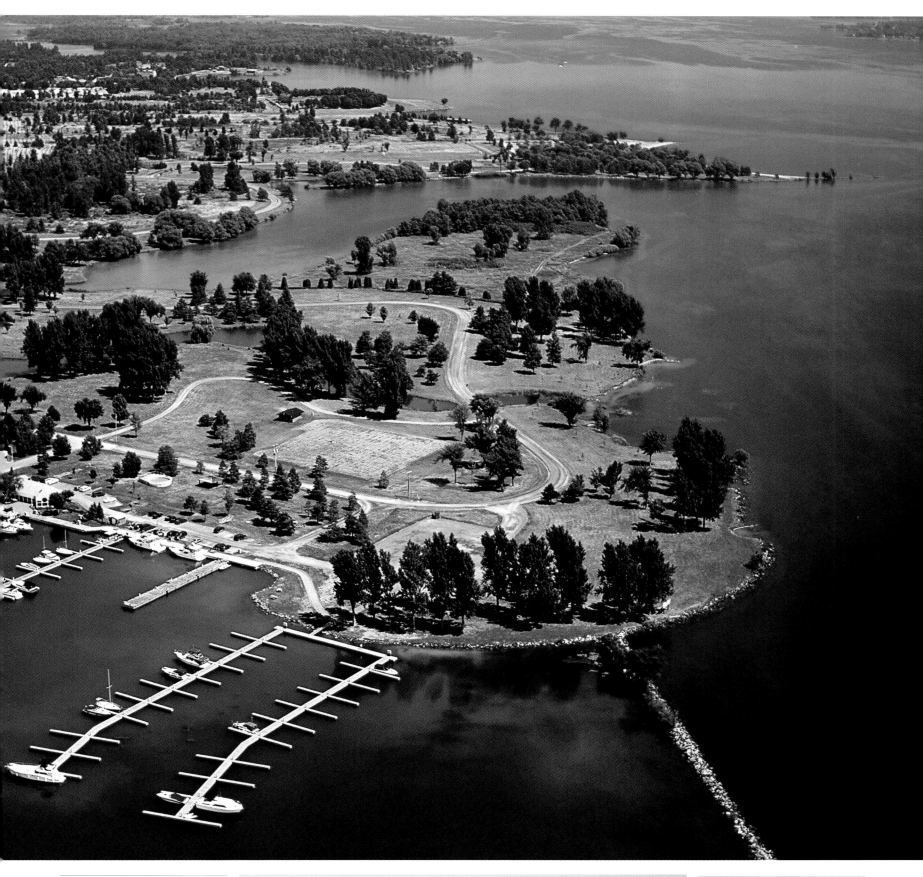

208 center and 209 bottom The Thousand Islands archipelago, which actually has almost twice that number, emerges from the blue water of the St. Lawrence in the vicinity of Lake Ontario, marking out a fragmentary border between Canada and the state of New York. In this unique setting of almost supernatural beauty, the river splits up into a myriad currents, as if it wanted to conceal its majestic grandeur.

208-209 A series of preserves, panoramic routes and tourist areas flanks the north bank of the St. Lawrence River in the Canadian province of Ontario. The so-called St. Lawrence Parks attract about 1.5 million visitors a year.

THE ST. LAWRENCE

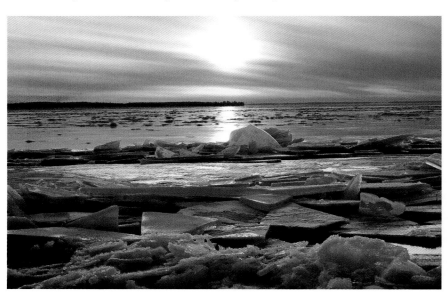

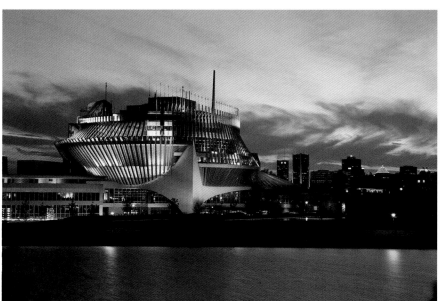

and then flows into Québec, where it receives the waters of the Ottawa River, its most important tributary. Montréal is a little farther downstream, against the low slopes of Mont Royal, exactly at the spot where Cartier had his first farsighted vision of a French empire in America. The city is one of the most important ports in Canada, a stage on the way to the Great Lakes. A fleet of icebreakers ensures year-round navigation in the river, even in the middle of winter. Downstream from Montréal, the St. Maurice and Richelieu rivers, the latter flowing from Lake Champlain, empty into the St. Lawrence, which near Trois-Rivières widens as it enters the vast Lac St.-Pierre.

After Québec City the river suddenly changes appearance and character: the campaniles and old Norman-style houses with their pitched roofs on the Île d'Orléans announce the

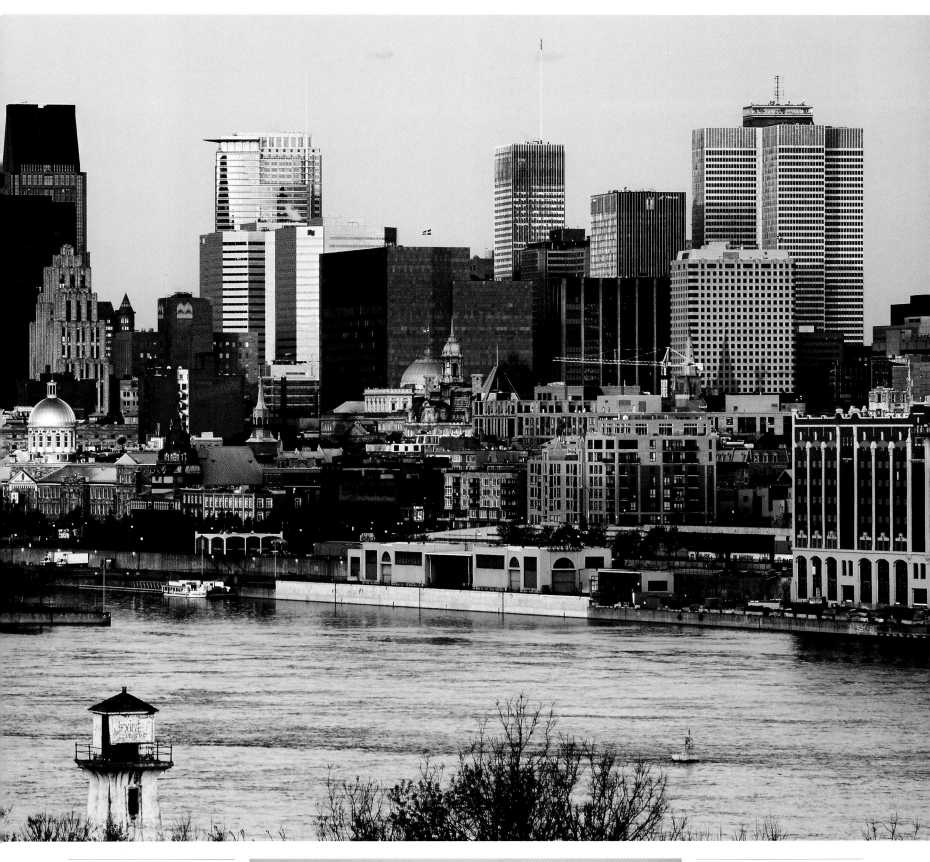

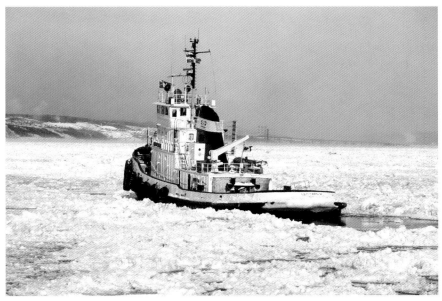

210 bottom The Montréal casino, one of the largest in Canada, is situated on Notre-Dame island. The shape of the building, built on the occasion of the 1967 International Exposition, inevitably reminds one of a ship.

210-211 A forest of skyscrapers constitutes the skyline of Montréal, one of the largest commercial ports in Canada and a first-class cultural center. The city has a population of about 3.7 million, most of whom are Francophones.

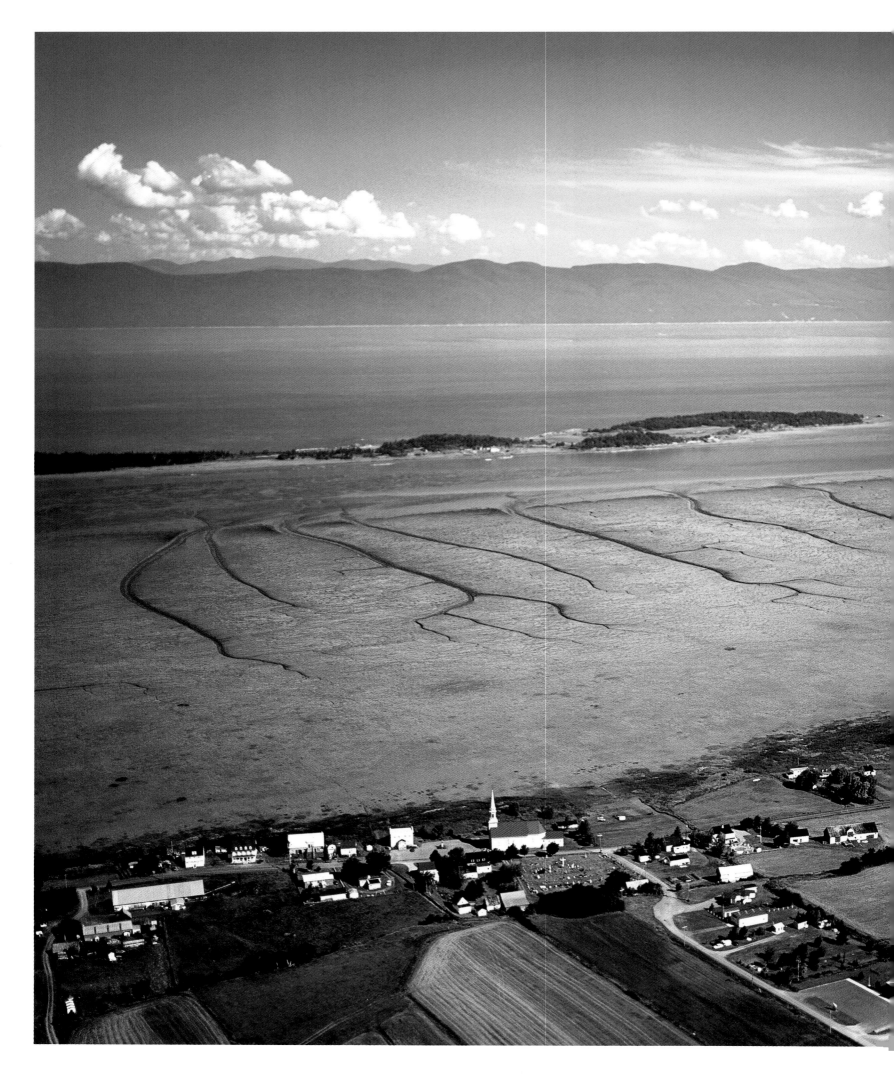

THE ST. LAWRENCE

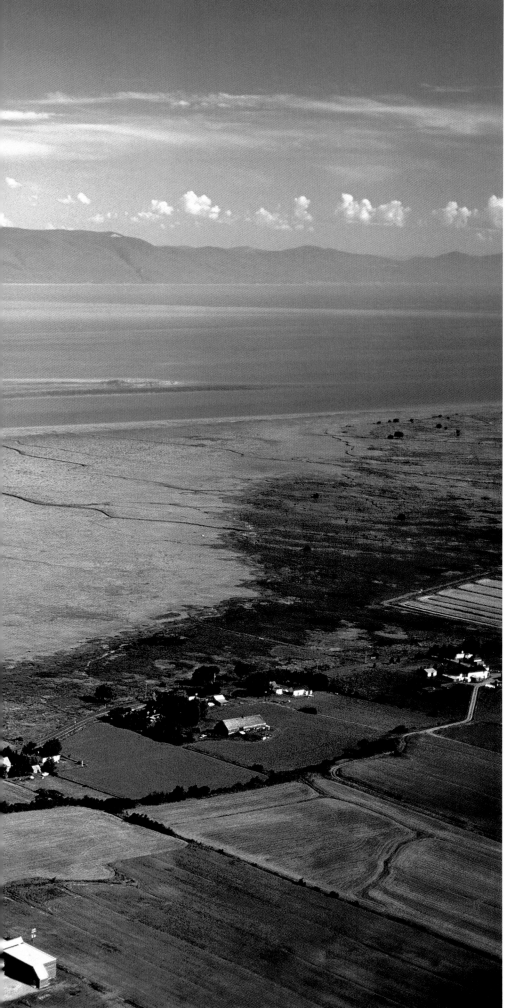

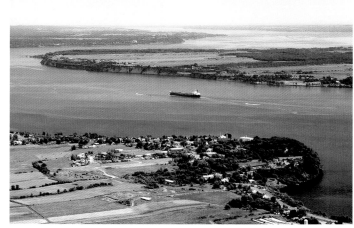

212-213 The Île-aux-Grues is part of an archipelago in the middle of the St. Lawrence estuary, between Île-aux-Coudres and Île d'Orléans. This island, with its 210 identified birds species, is a true birdwatcher's paradise.

213 right From Montréal to the rugged coastline of the Gaspé peninsula, where it is 95 miles (150 km) wide, the St. Lawrence crosses the province of Québec in a continuous succession of different landscapes and environments. The ocean tides go as far as Trois Rivières, but the true estuary begins downstream from the Île d'Orléans, where there are both saltwater and freshwater fish.

THE ST. LAWRENCE

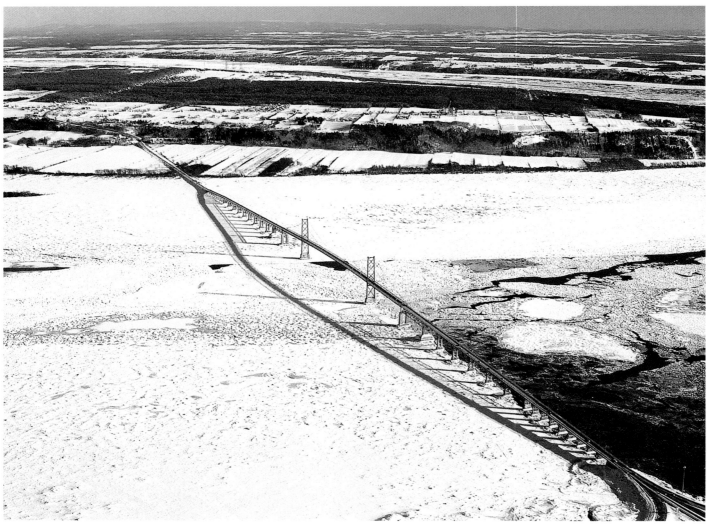

beginning of the extremely long estuary, which opens in a bottleneck between the Gaspé Peninsula and the craggy outcrops of the Laurentian Highlands that border its north bank. The high tides sweeping in from the Atlantic arrive this far, transporting a great quantity of salt water into the huge valley every day that is ten times the normal outflow of the river. The power of these tides, the storms and the thick fog were once hazards for navigation: hundreds of sailing craft, barges, fishing boats and steamboats lie on the bottom of the lower section of the St. Lawrence, which can be as much as 990 ft (300 m) deep at some points here.

The profile of Québec, the mother city of French Canada, is dominated by the spires of the colossal Château Frontenac, built in the 19th century. The narrow alleys of the old town, which are still enclosed within walls, and the old buildings overlooking the St. Lawrence River could easily belong to any city in northern France. Many of the villages that dot the southern coast, such as Montmagny, Saint-Jean-Port-Joli, and Trois Pistoles – modest harbors sandwiched among cultivated

fields that descend softly toward the river – are also characterized by their French architecture.

Proceeding westward, the shore becomes harsher and wilder, and the towns less frequent. This is the beginning of the craggy Gaspé Peninsula, which extends its cliffs toward the Gulf of St. Lawrence and the waters of Newfoundland, the sea with the most abundant supply of fish in the world. The cold Labrador Current penetrates the estuary as far as the confluence with the Saguenay, near Tadoussac, carrying huge quantities of organic detritus and plankton, the sustenance of an extremely rich ecosystem. This section of the river is one of the last sanctuaries of the beluga white whales and a half-dozen other rare species of whales. The wooded shores of Anticosti Island mark the last stage in the long voyage of the St. Lawrence River, which began in the plains of Ontario 744 miles (1200 km) away. It crosses some of the most grandiose natural scenery in North America while at the same time representing the historical and social identity of millions of people.

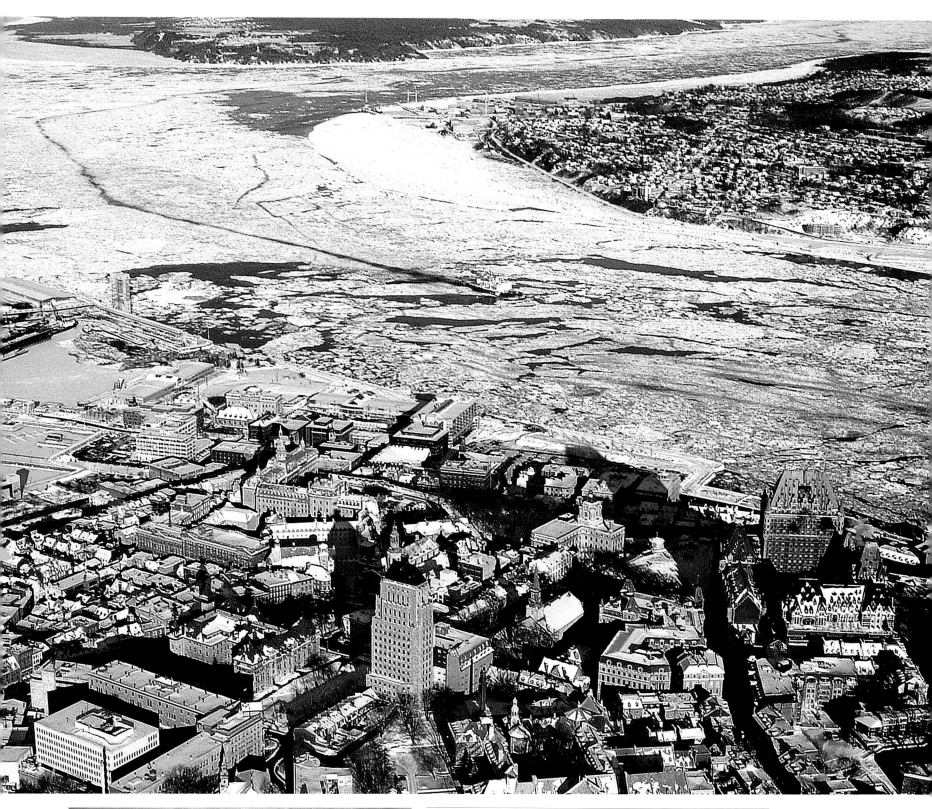

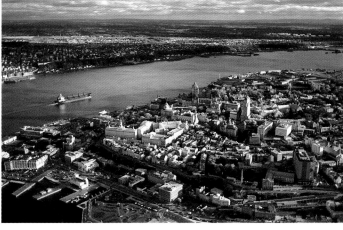

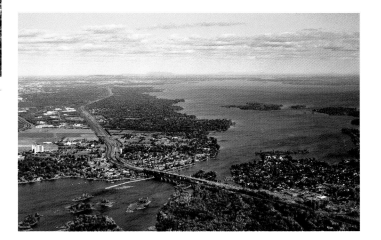

215 bottom left Québec City was founded by Samuel de Champlain in 1608 and once had massive defensive walls around it. The city has preserved many important monuments.

215 bottom right The unincorporated town of Sainte-Anne-de-Bellevue, one of the oldest in this area, occupies the western tip of the island of Montréal. Numerous railway and freeway bridges link the town with the interior.

214 A suspension bridge connects the Île d'Orléans and the north bank of the St. Lawrence, downstream from the city of Québec. This island, 20 by 5 miles (32 by 8 km), was discovered by Cartier in 1535.

214-215 Whether it be summer or winter, when the snow and ice cause the St. Lawrence to freeze over, Québec retains its fascination as the mother city of Francophone Canada.

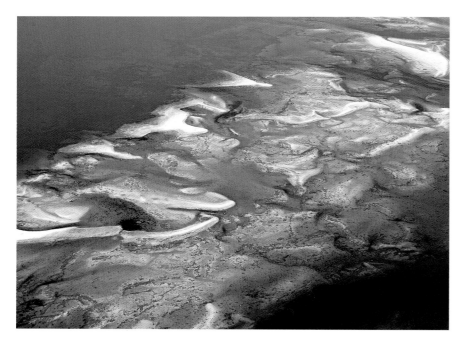

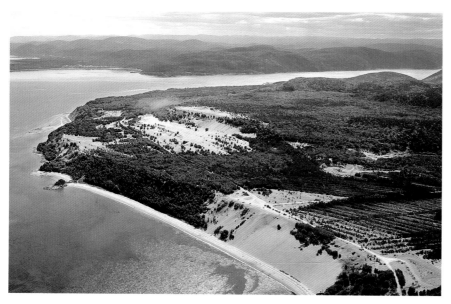

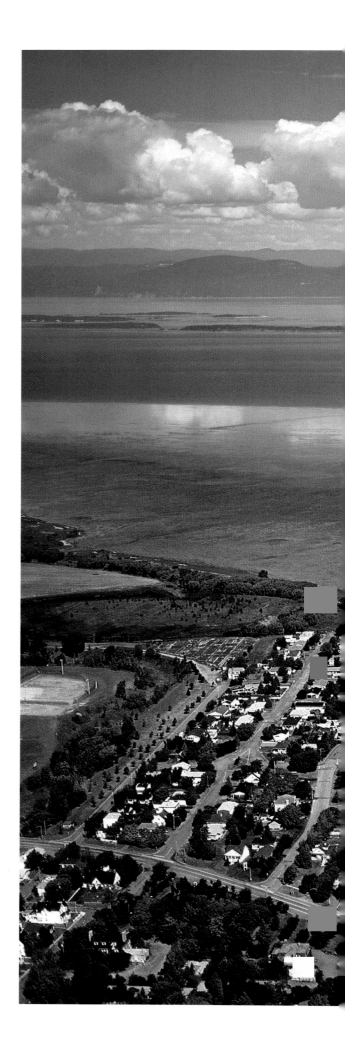

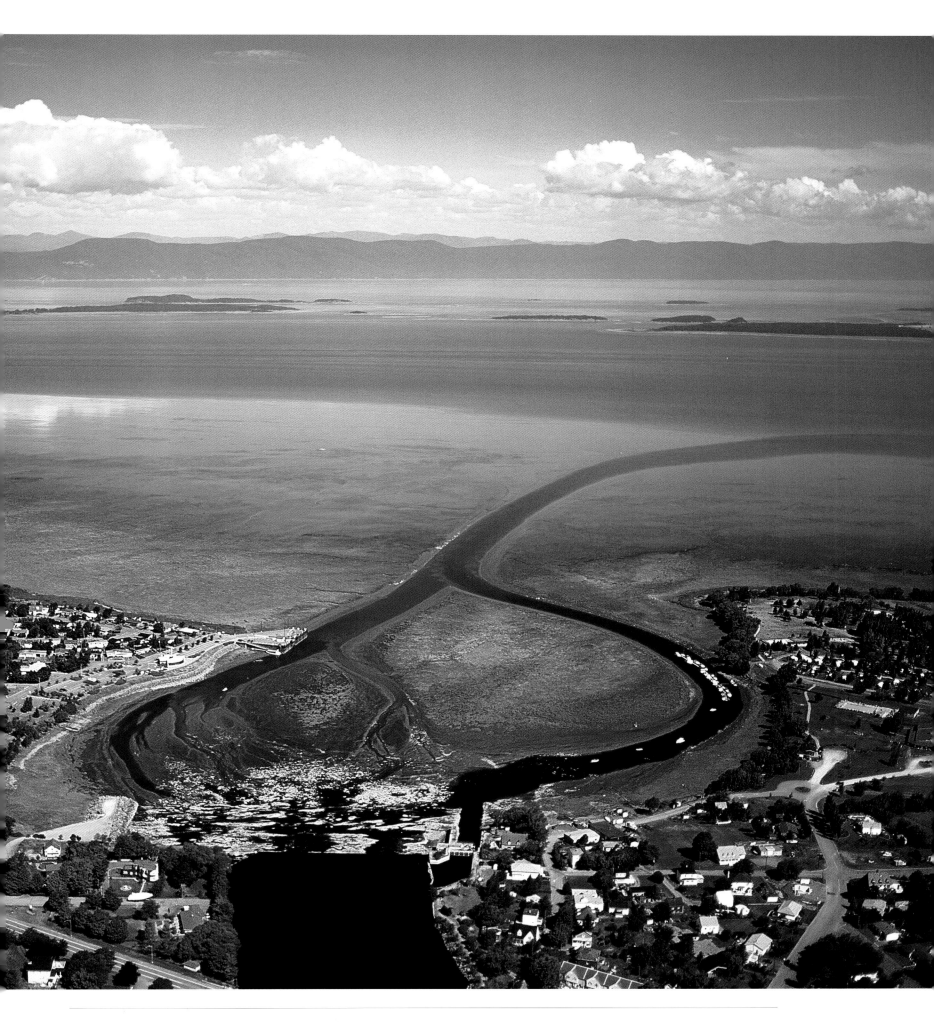

216 top The sand bars and islands at Pointe-aux-Alouettes, near the junction of the Saguenay and St. Lawrence, constitute an ideal nesting environment for many migratory birds.

216 center Jutting out toward St. Lawrence Gulf, the Gaspé peninsula has grandiose scenery such as the Rocher Percé, a limestone monolith shaped by the Atlantic storms.

216 bottom The Baie du Moulin-Baudel and other bays along the north bank of the St. Lawrence River at Tadoussac offer magnificent panoramic views of the river.

216-217 A succession of villages, meadow and fields, as well as patches of wild vegetation constitute the landscape of the south bank of the St. Lawrence downstream from Québec, which has preserved its typically French character.

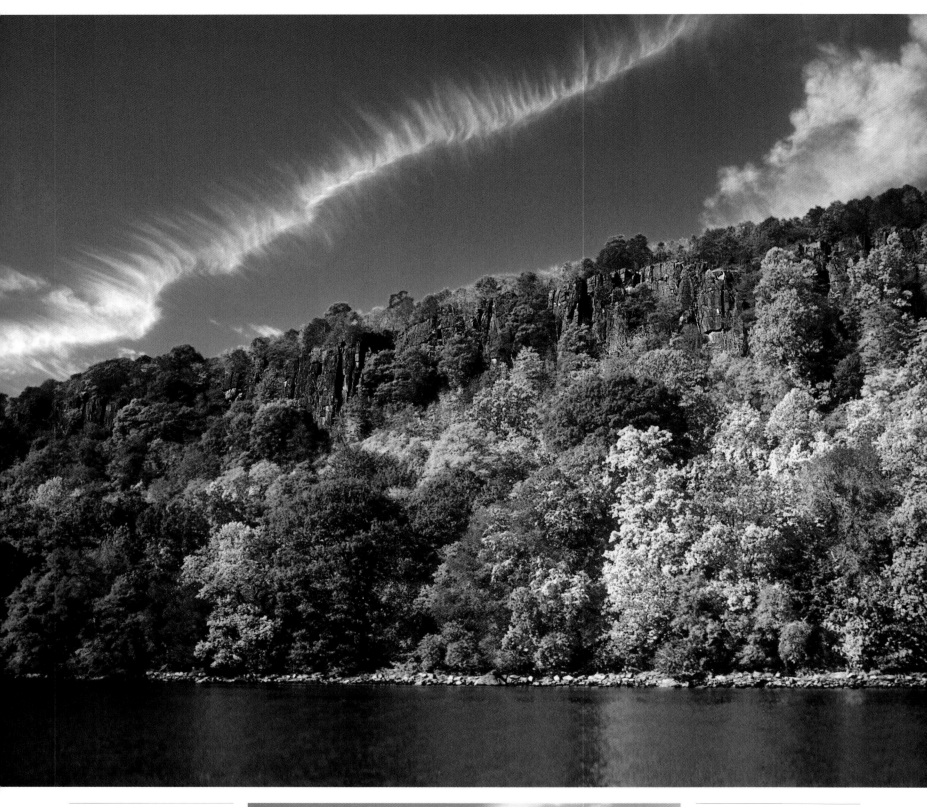

218-219 *Typical autumn colors along the Palisades, the rocky cliffs 330-500 ft (100-150 m) high that border the west bank of the Hudson from Haverstraw to the outskirts of New York City.*

218 bottom *Innumerable streams and over 1300 glacial lakes dot the Adirondack Mts. The Hudson issues from a small lake at the foot of Mt. Marcy, the highest peak in the range.*

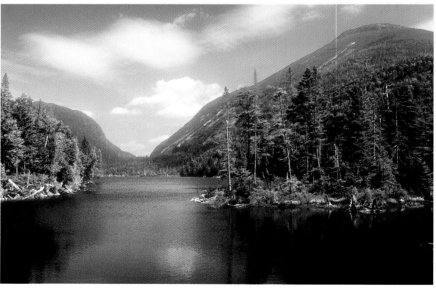

219 *Rapids and waterfalls agitate the clear waters of the Hudson as it flows through the Adirondack Mts., which mark the divide with the St. Lawrence basin. Most of this area has been declared a preserve.*

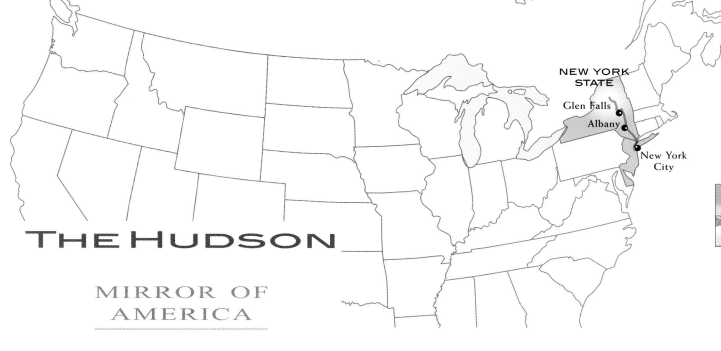

NEW YORK STATE

Glen Falls

Albany

New York City

THE HUDSON

MIRROR OF AMERICA

On 2 September 1609 the *Half Moon*, a small sailing vessel belonging to the Dutch East India Company, entered the waters of New York Bay, which at the time was surrounded by thick forests. The captain, Henry Hudson, was an Englishman with many years' experience in ocean navigation. At the end of the inlet there was a passage that was almost a bottleneck. The *Half Moon* easily passed through the Narrows, the strait that separates Brooklyn and Staten Island, and entered a sort of inland gulf. Hudson soon noted that this second inlet was nothing more or less than a huge estuary. The river, which was about a mile wide, headed straight into the interior of that unknown land. Perhaps it did not lead to China, as the merchants of Amsterdam hoped, but it was certainly well worthwhile exploring. After about twenty days the *Half Moon* dropped anchor near present-day Albany, about 155 miles (250 km) north of the mouth of the Hudson River. From that point on the river became narrower and too shallow for the explorers to continue their survey. In early October the *Half Moon* again entered the open sea and returned to Europe. Hudson rescinded his contract with the Dutch East India Company and went back to work for the English crown. However, his voyage allowed Holland to quickly organize the colonization of those potentially rich lands: in 1624 New Amsterdam on Manhattan island, and the trade outpost of Fort Nassau, near Albany, were founded.

For forty years, up to the arrival of the English, the Hudson River was the backbone of Dutch hegemony in the New World, traces of which can be seen in the names of many localities along the rivers such as Staten Island, Yonkers, Rensselaer, Schuylerville, Brooklyn (Breukelein) and Hoboken. Some major battles of the American Revolution were waged along the banks of the Hudson, paving the way for the rise of the principles of equality and democracy that were the pillars of the American society. The commercial success of New York City, the symbol of the modern Western world, was based on the Hudson, and the first railways and great industrial empires of America grew up here. The river and its scenery inspired generations of artists, including the landscape painters Thomas Cole and Frederick Church, who in 1825 founded the Hudson River School of painting. Washington Irving, the first American author to gain international fame, spent the last years of his life at

Sunnyside, near Tarrytown, a stone's throw from the river, which at that point is especially wide and majestic. The Hudson River has not only determined the destiny of the nation, but has also defined its features and identity, embodying its spirit and contradictions. And this is certainly not due to its size, since with its 310 miles (500 km) it is one of the shortest major rivers in the United States.

The Hudson rises at an altitude of about 4620 ft (1400 m) at Lake Tear of the Clouds, in the Adirondack Mts., which are a dividing range between the basin and that of the St. Lawrence River. Up to Glen Falls it looks like an alpine torrent with its rapids and small falls. But no sooner does it leave the mountains behind than it changes its nature: from Fort Edward to Troy its course is canalized in a continuous series of navigable basins and connected to the New York State Barge Canal System, the large waterway network that links the ports of Albany and New York to the Great Lakes and the St. Lawrence Seaway. From its

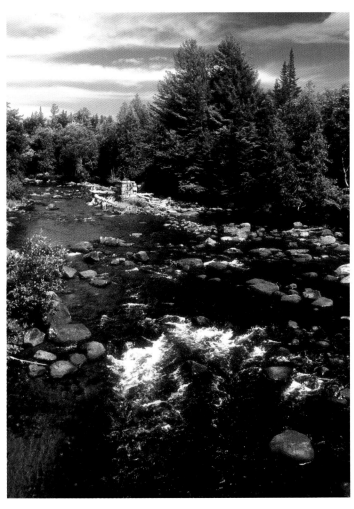

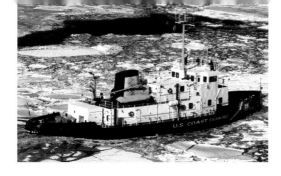

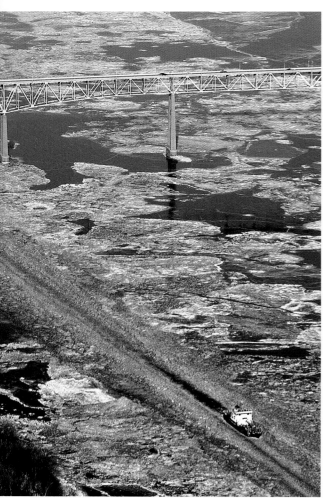

220 top and bottom In very cold winters the Hudson may become a solid sheet of ice. These photographs were taken during the cold wave that struck the northeastern United States in January 2003, paralyzing river traffic.

220 center Even in the dead of winter, when it is transformed into a huge 'skating rink' able to support the weight of ice-boats, the Hudson offers occasions for entertainment and sports to those who live in the towns and cities along its banks.

220-221 For centuries the Hudson, which is quite wide and deep south of Albany, made crossing from one side to the other difficult. The Bear Mountain suspension bridge, the first used for vehicles, was built only in 1925 at Fort Montgomery.

confluence with the Mohawk River to its drainage into the Atlantic, the Hudson looks like a placid, wide estuary. The waters of the middle and lower sections occupy what geologists call a submerged valley, forged hundreds of millions of years ago by a combination of tectonic movements and powerful erosion. The crevice, several miles wide and over 990 ft (300 m) deep, extends with a submarine canyon well past the mouth of the river and reaches the edge of continental shelf. The slight gradient, the lack of significant flood stages, and the moderate tidal flows have all made the Hudson an ideal means of penetrating the interior. It is no accident that steam navigation developed here long before steamboats went up and down the Mississippi.

Before arriving at Albany the river crosses an open, slightly undulating region. These plains a few miles west of Schuylerville were the theater of one of the decisive battles of the American War of Independence. At Saratoga the British troops that came from Canada and were commanded by General Burgoyne, were routed, and this humiliating defeat was decisive, as it tipped the scales in favor of the revolutionaries. As the river proceeds downstream there is more traffic and the industrial plants dominate the scenery. Albany, the capital of New York State since 1797, is a major river port and railway hub, as millions of tons of cargo pass through here on their way to every corner of the nation.

The price paid by the Hudson for this rapid and unbridled development, which began with the construction of the railway system in the mid-1800s, was high indeed. The wild majesty of the river, which fascinated a host of poets, authors and artists, has largely disappeared forever. But the physical damage was much worse than the spiritual one; in a short time the Hudson become one of the most polluted waterways in the world. In 1965, Senator Robert Kennedy did not exaggerate when he bluntly called the river an open-air sewer. For decades, hundreds of industrial plants had dumped tons of different pollutants into the river. Although not dead, the Hudson was in a coma. And yet it survived miraculously and today, thanks to the pressure brought to bear by the American

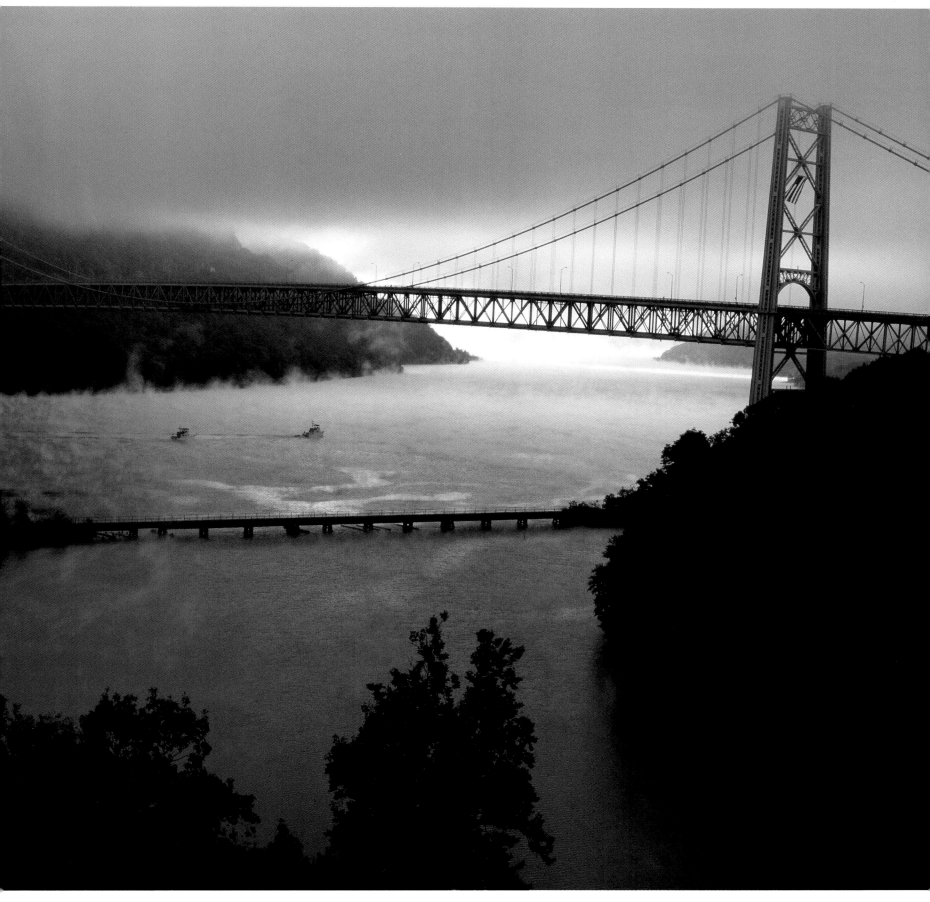

THE HUDSON

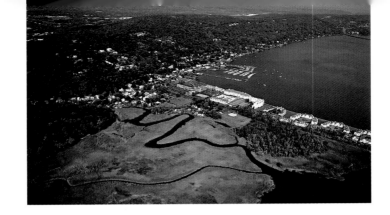

222 top The brackish waters of Tappan Zee, the large lake formed by a broadening of the Hudson in the vicinity of Tarrytown, are an ideal site for the reproduction of many fish species, which find food in abundance there.

222 bottom The natural scenery that encompasses the Hudson has inspired internationally famous painters and authors such as Washington Irving, who was the originator of the so-called Knickerbocker School literary style.

223 Founded in 1802 on the right bank of the Hudson, West Point Military Academy covers an area of 25 sq. miles (65 sq. km). The famous author Edgar Allan Poe studied here but was expelled for undisciplined behavior.

THE HUDSON

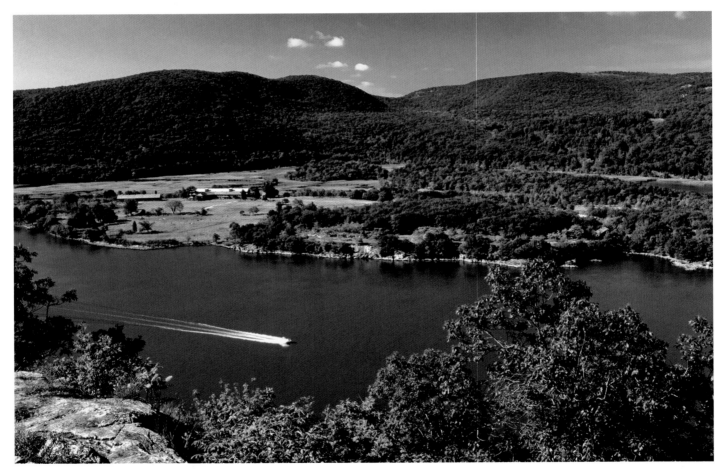

environmentalist associations and the commitment of the government, its health has been restored. The Hudson estuary, with its brackish waters so rich in nutritious substances, is a major reproduction site for many species of fish, which every year go upstream to lay their eggs. Once, New York State produced and exported excellent caviar, which was just as good as the caviar from the Caspian Sea. For some time now, after decades of absence, the Atlantic sturgeon have returned to the mouth of the Hudson, and some people are seriously considering reviving what was a flourishing and profitable business a century ago.

In the section between Albany and Newburgh the river passes through hilly countryside dominated by the steep slopes of the Catskills. For the first Dutch pioneers those

mountains blanketed by thick forests were mysterious, dangerous places infested by wild animals and inhabited by fierce Indians. Much of the Hudson Valley, almost up to Albany, was the territory of the Delaware Indians, while the Mohicans lived to the north and the bellicose Iroquois to the west. Involved in the colonial wars among the Europeans, decimated by diseases, and gradually deprived of their land, the so-called River Indians disappeared for good in the mid-1700s. Today the Catskills have lost that aura of mystery and have become a popular vacation and entertainment spot for those living along the riverside. Vineyards, fruit orchards and luxury houses that once belonged to the magnates of industry and finance in the last century such as the Vanderbilts and Astors, border the shores of the Hudson from Hyde Park to Rhinebeck.

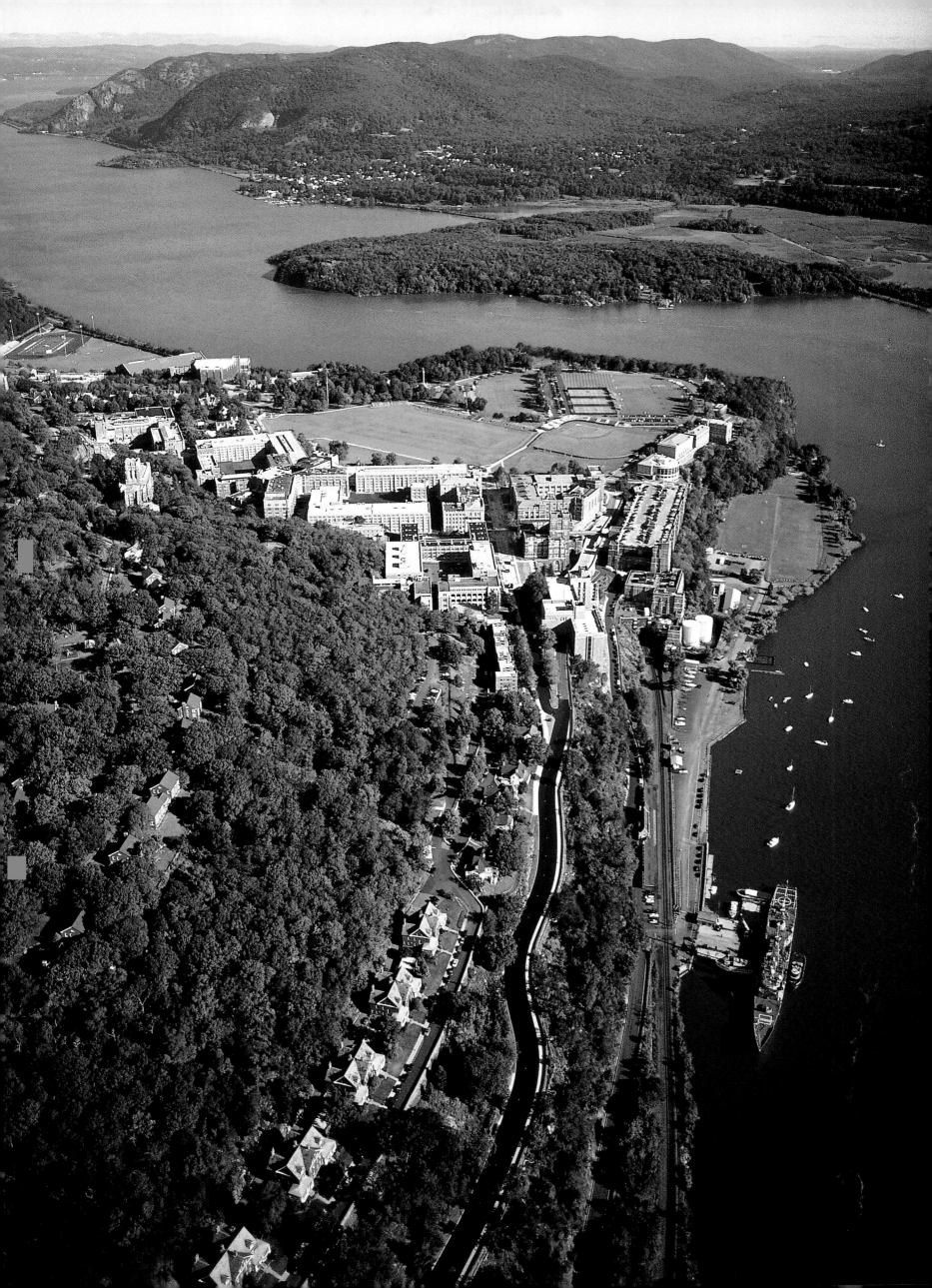

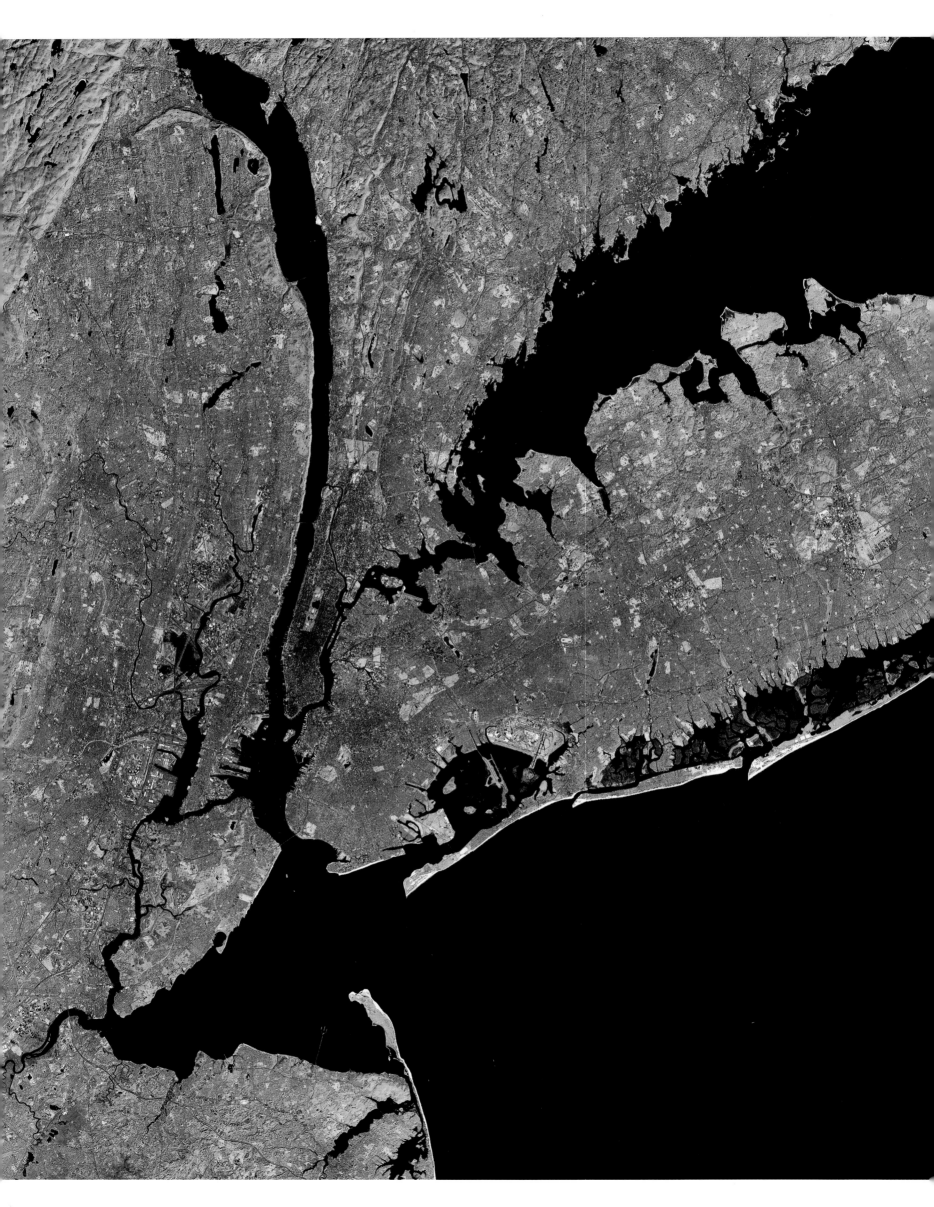

THE HUDSON

224-225 New York City, one of the largest metropolitan areas in the world, had a population of over 21 million in the year 2000. This satellite photo shows the course of the Hudson, which separates Brooklyn and Manhattan from New Jersey.

225 top Docked on the Hudson at Manhattan, the gigantic aircraft carrier Intrepid, which is over 820 ft (250 m) long, is the leading feature of the Intrepid Sea-Air-Space Museum, one the most popular tourist attractions in New York City.

225 bottom The skyscrapers in the financial district of New York, located at the southern tip of Manhattan, are the nerve center of the world economy. The city's strategic position on the Hudson River estuary is one of the reasons for its fortune.

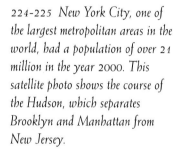

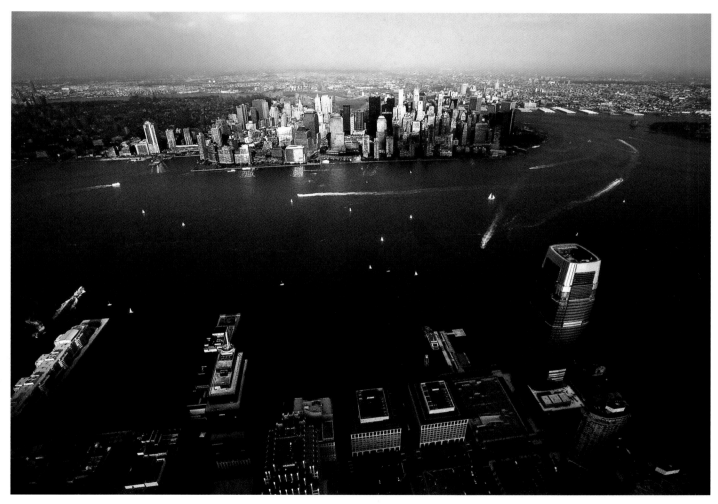

After Newburgh the river enters the Highlands, passing through substantial wooded hills. At West Point, home of the famous U.S. Military Academy, the river is over 230 ft (70 m) deep. When it exits from the narrows, the Hudson again flows in a bed that at Haverstraw Bay is over 3 miles (5 km) wide. A little farther south, the sheer cliffs of the Palisades accompany the river up to the suburbs of New York City. In a canyon of skyscrapers between Manhattan and the cities in New Jersey, the Hudson arrives at Upper Bay, the home of one of most active ports in the world. The Statue of Liberty on Bedloe's Island is the ideal boundary between the ocean and the river: the eyes and hopes of millions of immigrants were focused on this image at the mouth of the Hudson, the gateway to the United States.

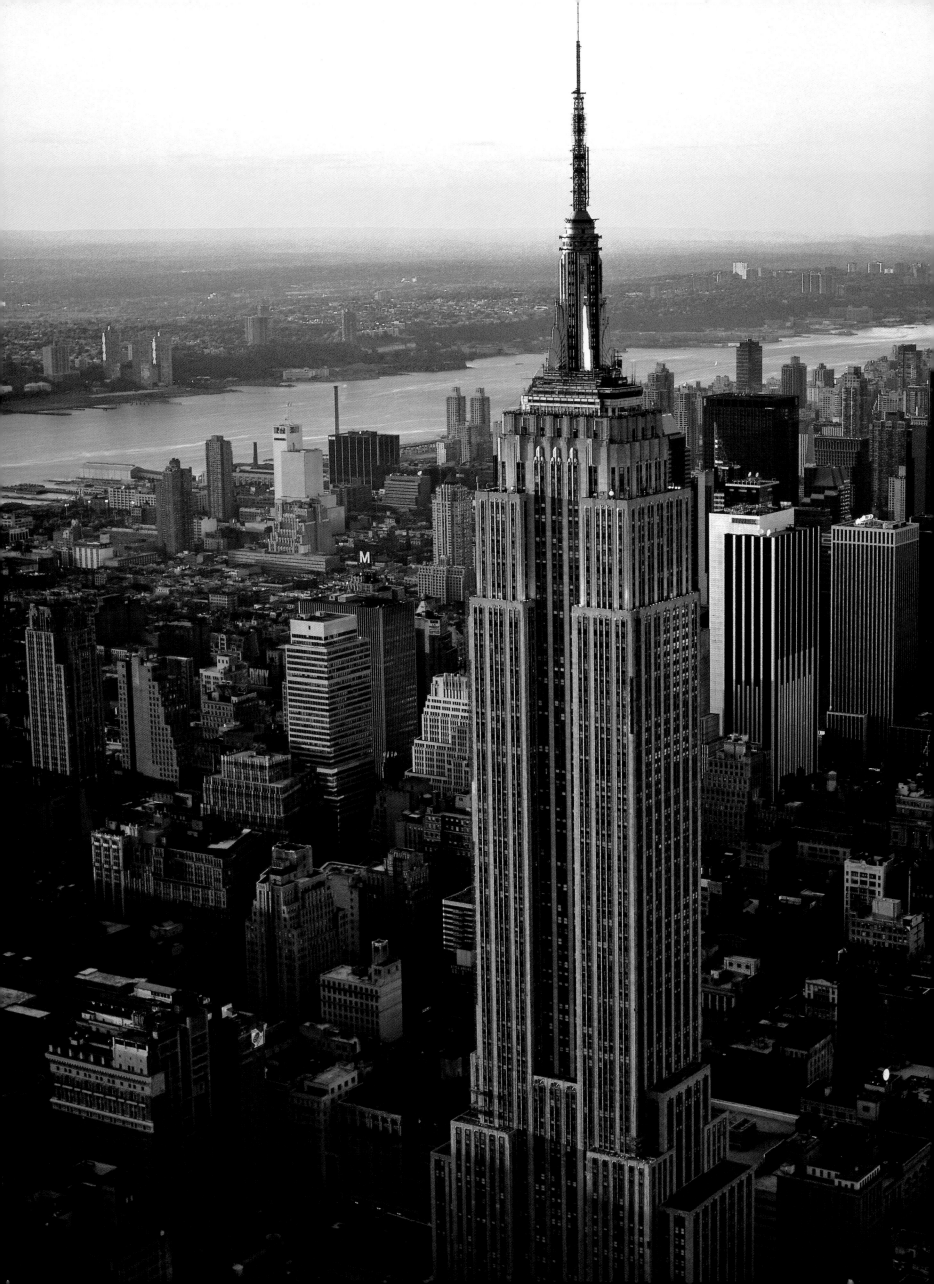

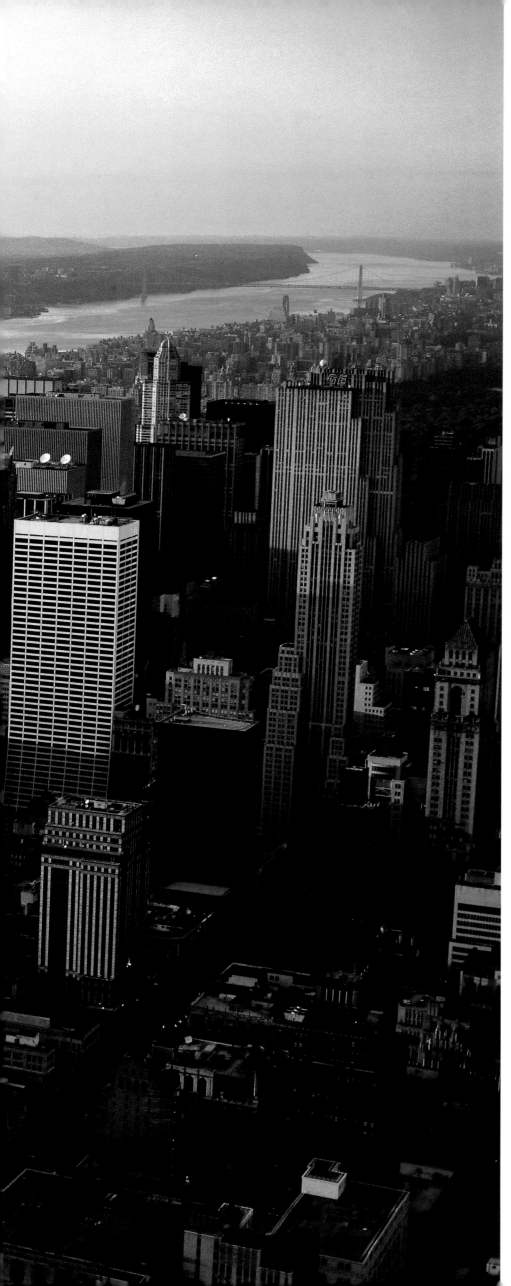

THE HUDSON

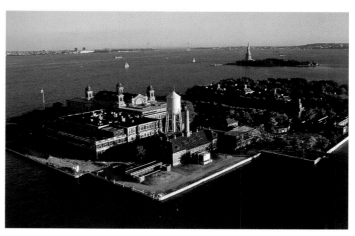

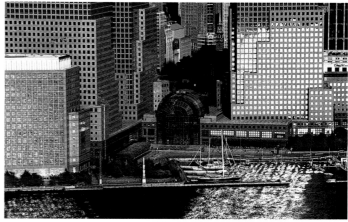

226-227 The spire of the Empire State Building towers over Manhattan, which in turn overlooks the Hudson estuary. The nucleus of the city was founded by the Dutch in 1624 and was named New Amsterdam.

227 top Directly opposite Manhattan, Ellis Island was from 1892 to 1954 the gateway to America, the first, obligatory stop in the 'promised land' for over 12 million immigrants. Since 1990 the island has been the home of the Museum of Immigration.

227 bottom Surrounded by modern buildings overlooking the Hudson estuary, North Cove marina is a paradise for yachting buffs as well as an indispensable recreation area for the inhabitants of densely populated Manhattan.

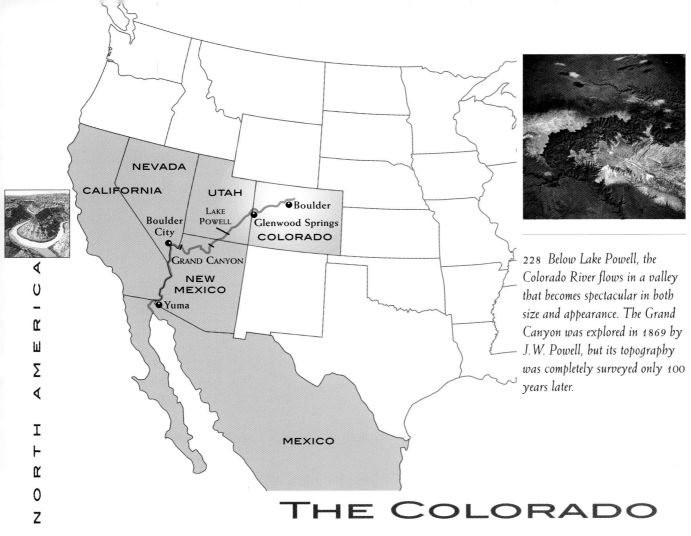

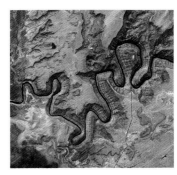

229 *This satellite image shows part of the Colorado, which extends from the state of Wyoming to Mexico, covering a surface area of 250,000 sq. miles (650,000 sq. km). The river water is used to irrigate over 13,500 sq. miles (3,500 sq. km) of land.*

228 *Below Lake Powell, the Colorado River flows in a valley that becomes spectacular in both size and appearance. The Grand Canyon was explored in 1869 by J.W. Powell, but its topography was completely surveyed only 100 years later.*

THE COLORADO
THE GREAT WATER

"The boat rams against a cliff, bounces off it from the impact, lists and is filled with water. Two men lose their oars; the boat twirls in a circle and is dragged away on one side at an incredible speed for a few feet, until its middle section crashes violently against another rock, breaks in two and the men are hurled into the river." This incident occurred in June 1869, and Major John Wesley Powell, overcome with anguish, seriously began to doubt whether he would manage to come out alive from the rapids of the Colorado River. The warning of the local Indians, who had said it was sheer madness to venture into the churning foam of the Great Water, pounded his temples like a gloomy refrain. That day, one of the three boats in the expedition was lost, but the crew was safe and sound, somehow having managed to get to the banks of the river. Since tragedy had been avoided by a hair's breadth, the journey could resume. Powell, a geologist and ethnologist as well as a Civil War veteran, wanted at all costs to be the first white man to survey and describe in detail what was the last virgin territory in the United States – the mysterious Grand Canyon.

Over 300 years earlier some Spanish adventurers in Coronado's expedition had reached the edge of the precipice; the other side of the Colorado River, they stated laconically, was about 9.3 miles (15 km) away, as if suspended in a void. The Indians they encountered in the area lived in modest adobe houses, not in gold-lined palaces as they had been led to believe. Disillusioned, the Spanish explorers turned back without even trying to go down the canyon to the river. The Franciscan missionaries who followed in their tracks did not seek gold, but souls to be converted. They visited some Indian villages and explored some of the side gorges of the

Colorado valley, which seemed inaccessible to them. Then they left. Lastly there came the cartographers of the US Army, both on foot and by boat, enthusiastic career officers who tried several times to go up the river in order to ascertain how navigable it was. The first rapids and the hellish appearance of the terrain convinced them that the Colorado was not navigable for any sort of craft. The scorched earth that surrounded it seemed unproductive and the climate hostile. In short, the canyon was certainly a miracle of nature, but was totally useless from an economic point of view, so that exploration of the area was considered a waste of time and money.

Then came Powell. Unlike his predecessors, the geologist was inspired by his scientific interests and by a genuine desire for discovery. Armed with these virtues and with a good dose of enthusiasm, on 24 May 1869 Powell set off from the town of Green, Wyoming with three wooden boats and nine fellow explorers. Three months later, having finished their foodstuffs and totally exhausted, the members of the expedition reemerged victoriously from the unknown abysses of the Grand Canyon. Powell's travel journals, which are extremely precise and detailed, describe walls of stone as smooth as marble, precipitous faces that tower hundreds of feet above the river, oases of luxuriant vegetation, and phantasmagoric effects of light and shadow. But above all they describe water, an impressive quantity of water that twists and turns in eddies and whirlpools, soars in waves up to 26 ft (8 m) high, and then plunges with incredible turbulence into falls. This water is so muddy that is not drinkable, not even when the heat and thirst become intolerable. With great foresight Powell grasped the potential of such a powerful river in the heart of the arid Southwest, but he could not imagine how far this

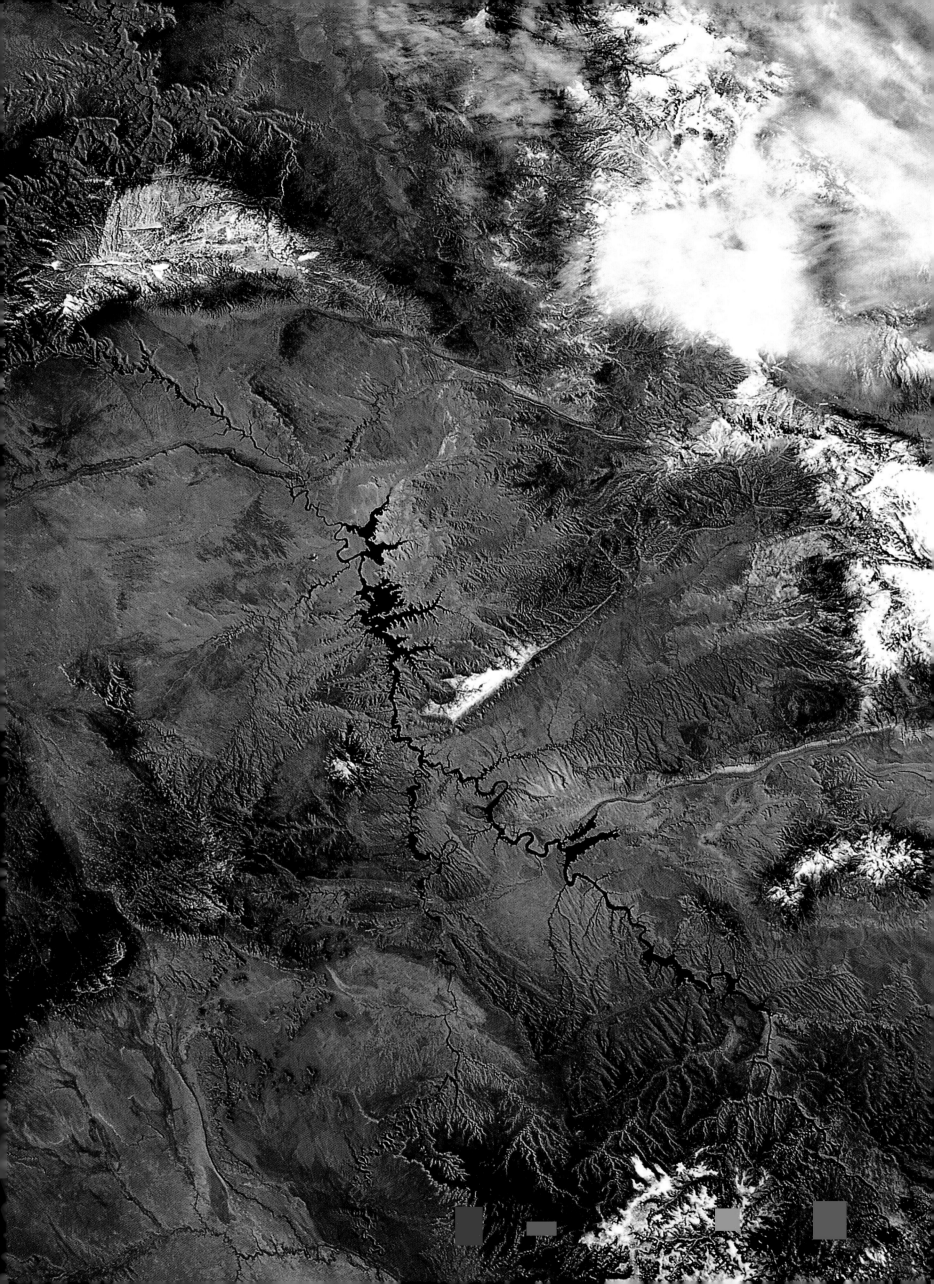

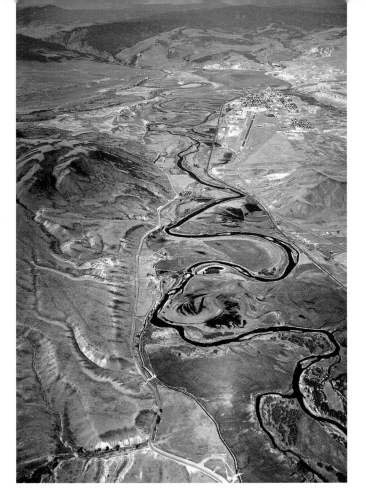

230 top The Grand River (the original name of the Colorado) crosses the Rocky Mountains at Kremmling and then heads toward its confluence with the Gunnison. The river was officially given its present name in 1921, upon the request of the state of Colorado.

230 bottom left A green strip of farm fields flanks the Colorado as it enters the state of Utah, in land that becomes more and more arid as the river heads southwest.

230 bottom right Like stone castles, the peaks of Castle Valley dominate the Colorado's canyon at Moab, in southeastern Utah. The snow-capped peaks of La Sal Mountain stand out on the horizon.

231 In its course through southeastern Utah, in the vicinity of its junction with the Green River, the Colorado carved deeply into the soft sedimentary rocks of the plateau, creating a landscape with sharp and dramatic contours.

THE COLORADO

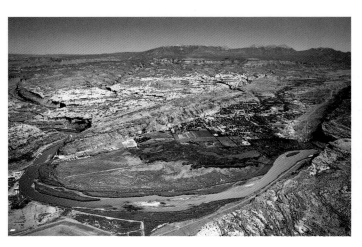

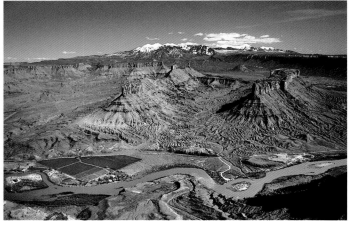

potential would be exploited in the future.

The Colorado River we know is quite different from the one that fascinated and terrorized the first explorers 136 years ago. Certainly, going over the rapids in a rubber dinghy or a slender launch is still a breathtaking and somewhat risky experience; the supernatural beauty of the scenery continues to amaze millions of tourists every year; and scientists have not yet revealed all the secrets of this absolutely unique environment. So what has changed? First of all, the river itself, the Red River, since its rust-colored water has become a lovely bluish-green, at least the 15 percent that continues to flow in the riverbed. In fact, almost all the silt, which the Colorado River transports in enormous quantities, ends up on the bottom of the large basins that break up the 1448 miles

(2335 km) of its course at regular intervals. Dams, pumping stations, aqueducts and diversion canals closely control the flow of the river, taking water and life into the surrounding desert. The inhabitants of Los Angeles, Tucson, Salt Lake City, Las Vegas, San Diego and many other smaller cities drink the water from the Colorado River, which also irrigates millions of acres of land from Wyoming to California. Six states and 25 million people owe their prosperity to this large river, whose water rights have been regulated since 1922 by a complex set of laws and amendments in continuous evolution.

The result of this prodigious exploitation of the water has been a dramatic reduction in the outflow of the river, which at the end of its voyage is little more than a brook. During

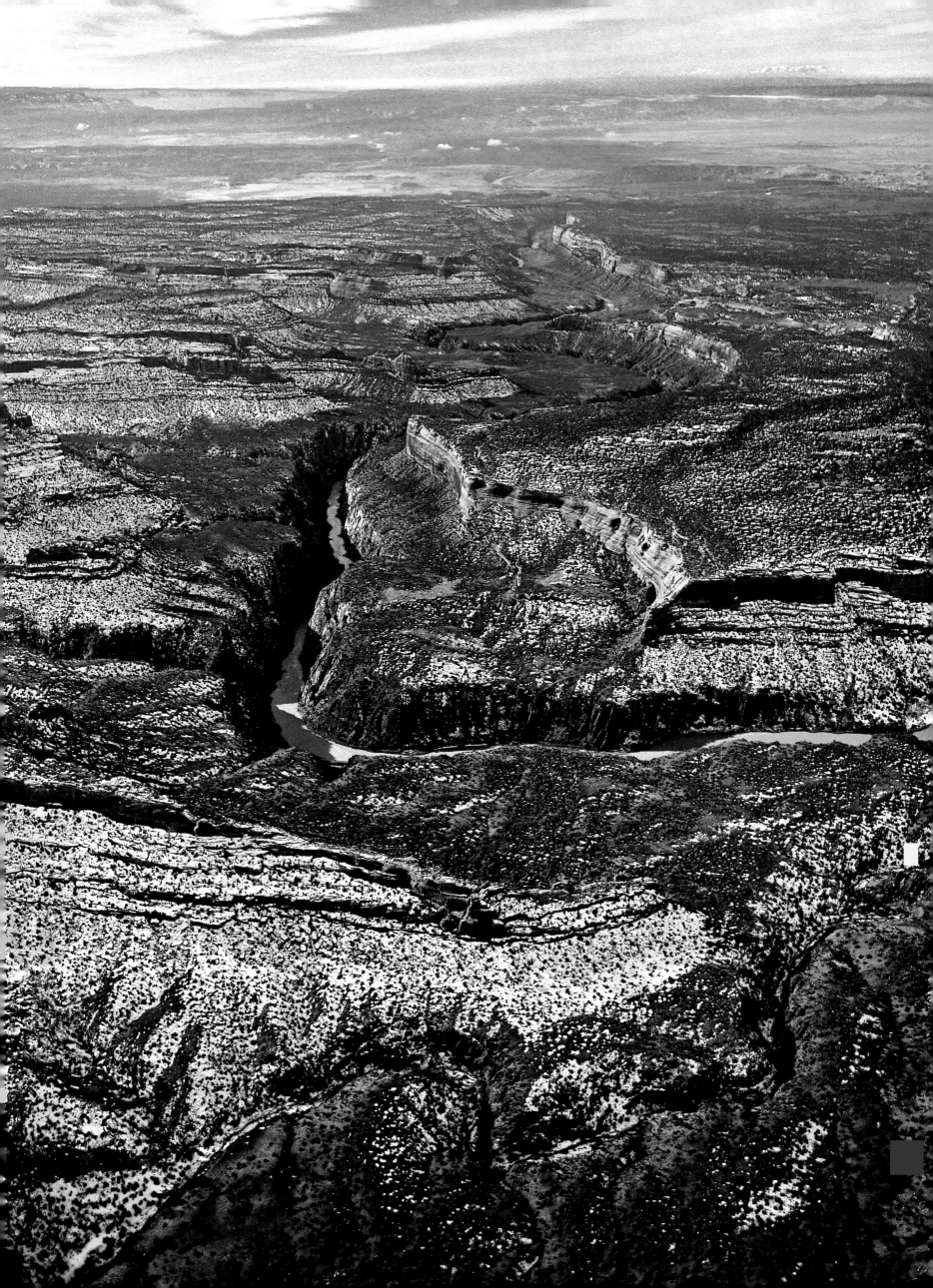

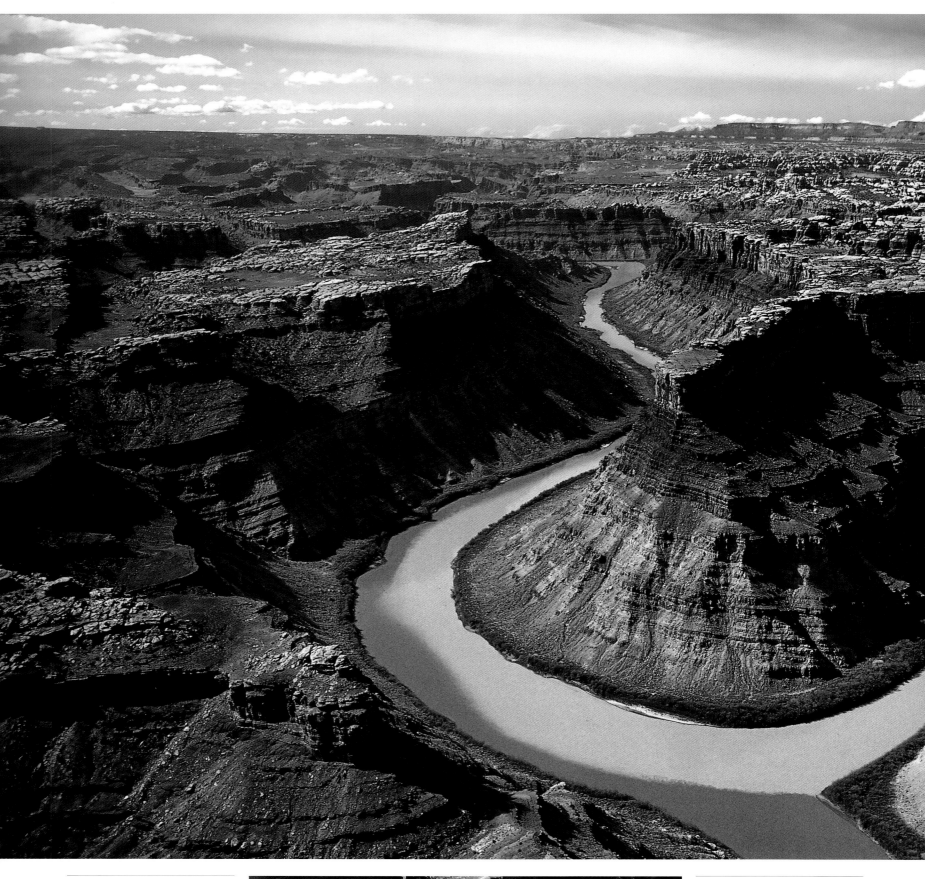

232-233 and 233 bottom In a maze of gorges and rock formations with the most bizarre shapes, the Colorado crosses the more than 325 sq. miles (840 sq. km) of the Canyonlands National Park, in southeastern Utah. The park was established in 1964 and safeguards one of the wildest and most beautiful areas on the tableland, which has a maximum altitude of 7200 ft (2200 m). Cold winters and torrid summers typify the climate in this region.

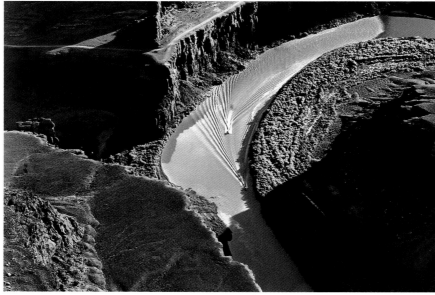

232 bottom and 233 top Millions of years of constant erosion on the part of the Colorado and the Green River have forged the phantasmagoric scenery of Canyonlands National Park. After merging with the Green River, the Colorado winds its way between the steep faces of Cataract Canyon, plunging downstream in a succession of spectacular rapids. The river's discharge greatly increases in spring because of the rainfall and thaw.

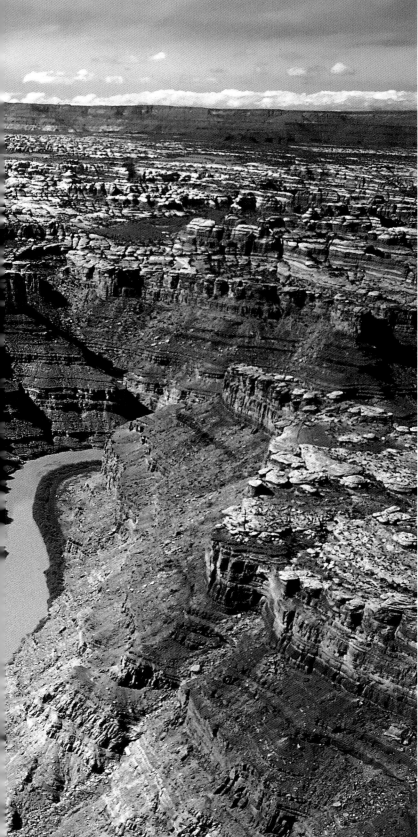

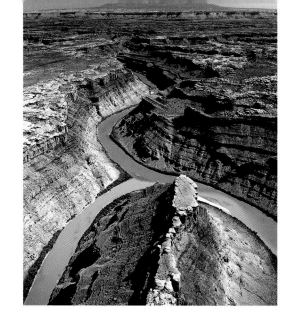

THE COLORADO

233 center *The ecosystem created by the waters of the Colorado in the desert tablelands of southeastern Utah consists of a mosaic of different microenvironments populated by fauna and flora that for the most part are endemic. The artificial reduction of the river's volume of water due to the construction of the Glen Canyon dam in 1963 has for decades jeopardized the existence of many species of animal and plant life. In 2004 an attempt was made to remedy this situation by raising the waterlevel.*

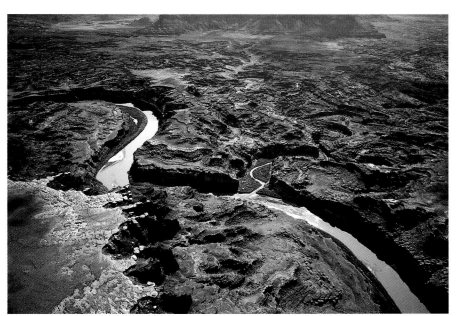

years of drought the river actually dries up before reaching the Gulf of California. The problems of the Colorado River begin at its rise, near the Lake of Clouds in the Rocky Mountains. Not far from the source, at an altitude of 9900 ft (3000 m), its waters flow into an artificial ditch and are channeled eastward, past the mountain ridges; the so-called Grand Ditch provides Denver with its water supply and, along with 17 other canals and conduits, carries enough water into the plains of Colorado to irrigate 740,000 acres (300,000 hectares) of cultivable land. With the contribution of the Gunnison, the only uncontrolled tributary of the upper basin, the Colorado regains impetus and merges with the Green River, hurling itself into the labyrinth of gorges and rocks of the Canyonlands National Park. Here among the mountains of Utah, the Colorado offers the first

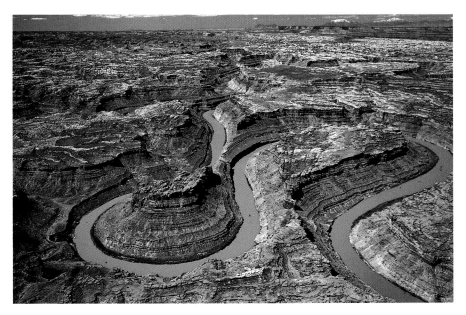

234-235 and 235 bottom The majestic stone arches, the painted grottoes, the immense natural atrium that Powell poetically called the Temple of Music, and all the little known marvels of Glen Canyon, now lie in the depths of Lake Powell, in Arizona. The rugged coastline of the huge artificial reservoir formed by the Colorado, one of the nation's largest, has a perimeter of over 1865 miles (3000 km).

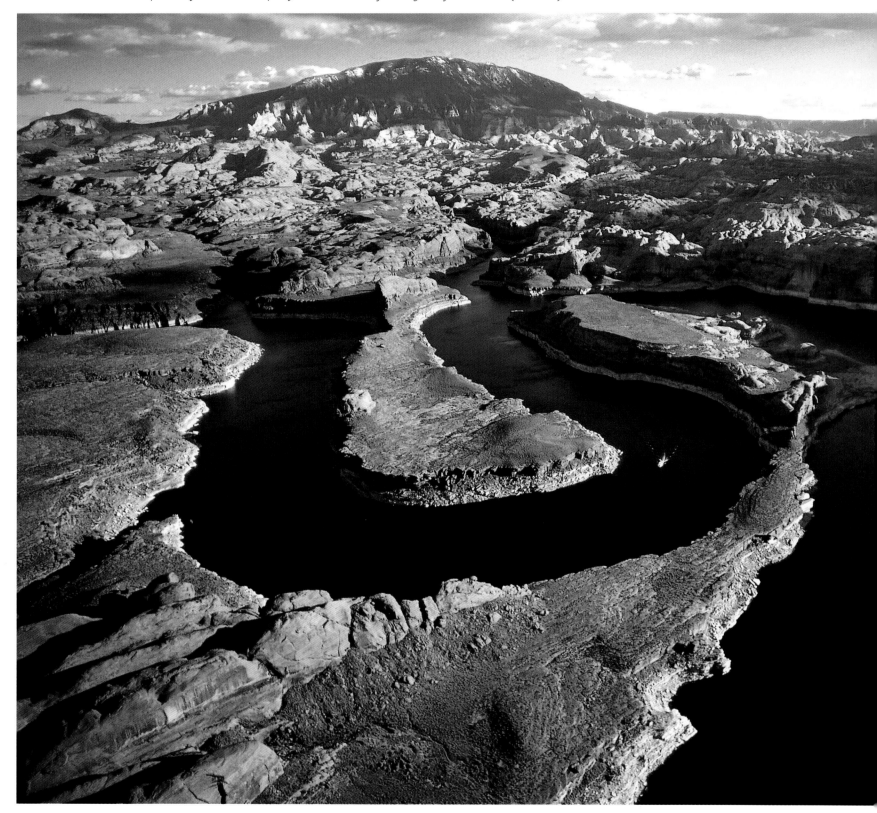

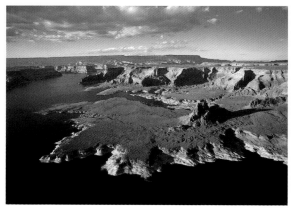

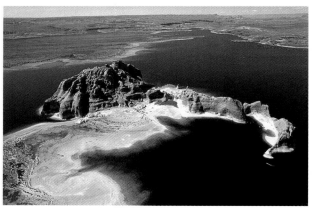

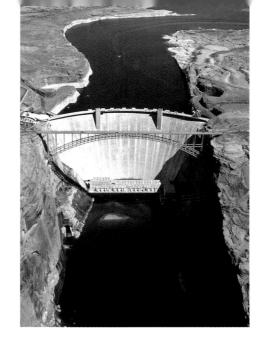

THE COLORADO

demonstration of its power, rushing into the Cataract Canyon rapids. Then the configuration of the valley gradually becomes more vague, the violence of the current eases up, and the river enters placidly into Lake Powell, which is almost 166 miles (300 km) long. On the bottom of this large basin, hidden from sight forever, lie the natural stone arches and cathedrals of Glen Canyon, which Powell ecstatically described a century before the construction of the Glen Canyon Dam.

234 bottom The regulation of the Colorado River has seriously harmed the fragile ecosystem of the Grand Canyon, as it prevents the silt from being deposited on the banks and causes the extinction of many local species of birds and fish.

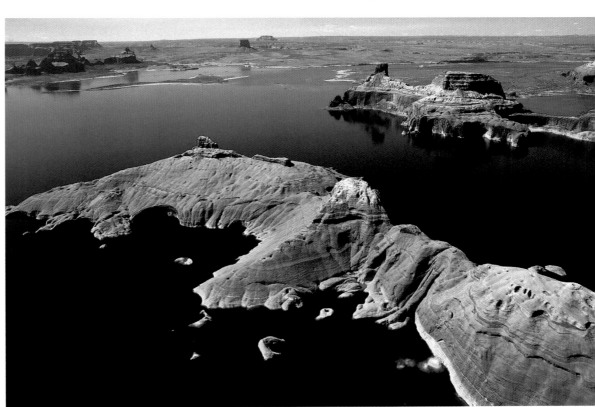

But the Colorado has other problems. The silt trapped by the dam is no longer carried to the Grand Canyon, thus causing serious alterations in the ecosystem. The erosion has increased dramatically, and many fish, other animals, and plants have disappeared and have been replaced by new species that are more adapted to the new environmental conditions. On the other hand, the Glen Canyon Dam helps control the river's seasonal floods, which in the past periodically devastated vast zones of California and Arizona. And the bright lights of Las Vegas and Phoenix shine thanks

235 top The Glen Canyon Dam, a cement wall 1700 ft (520 m) long, blocks the Colorado upstream from the Grand Canyon. Lake Powell, which lies above the dam, is now one the most popular tourist attractions in the Southwest.

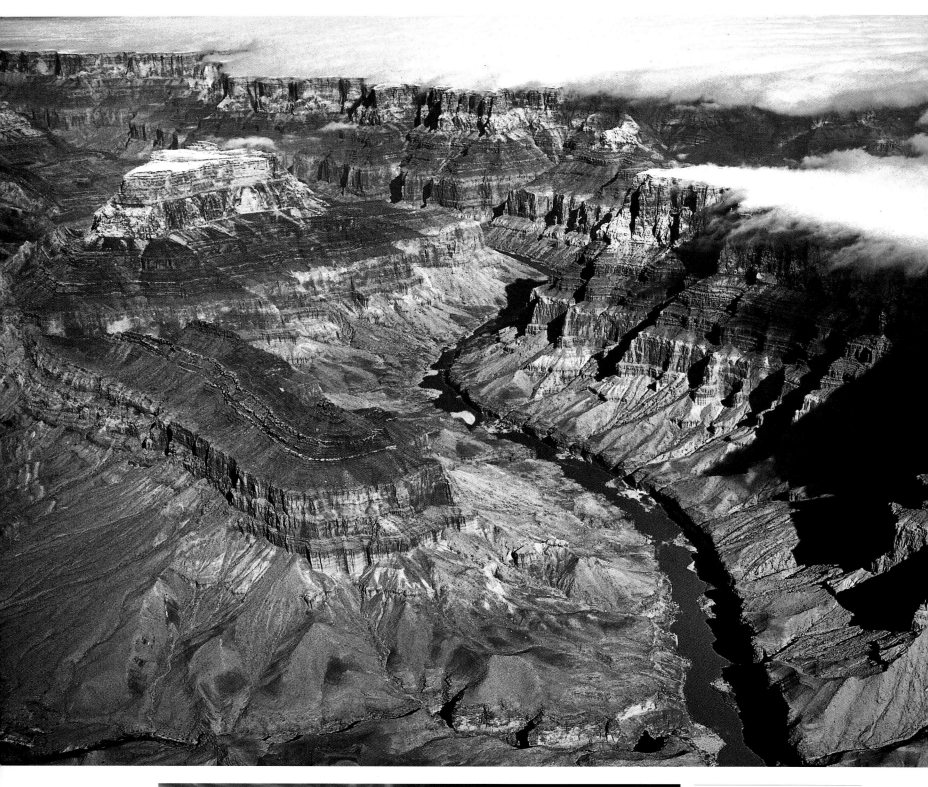

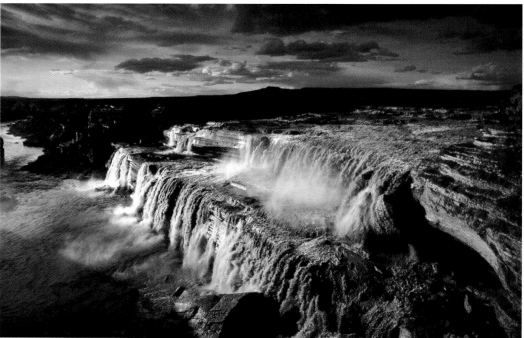

236-237 and 236 bottom The desolate and inaccessible Grand Canyon is a true marvel of nature. The constant change in the color of the rocks, which ranges from grey to fiery red depending on the hour of the day, is an unforgettable, totally unique spectacle It is not surprising that the Hopi Indians believed that this grandiose chasm, whose depth is unimaginable, was the beginning of the path to the afterlife.

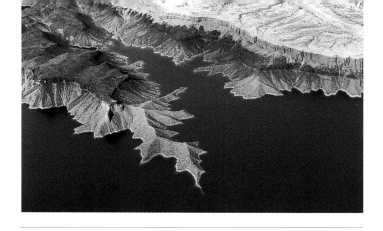

237 bottom The deep crevice that plows through the tablelands of Arizona is the result of millions of years of river erosion. The hardness and consistency of the various strata of rock have with time created the terraced structure of the faces of the canyon carved by the Colorado River.

THE COLORADO

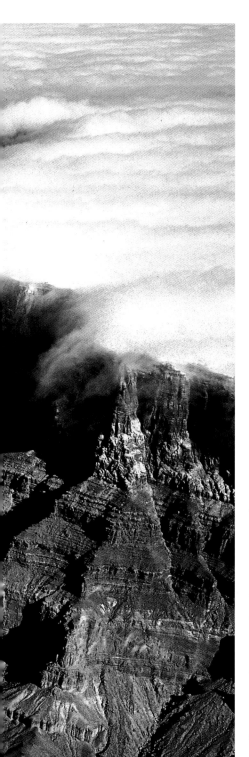

237 top Lake Mead, situated on the Nevada-Arizona border, marks the end of the Grand Canyon. The Hoover Dam forces the Colorado's waters into a basin that is about 112 miles (180 km) long.

237 center Once freed from the steep walls of the Grand Canyon, the Colorado flows in a plain toward Lake Mead. The capacity of this reservoir has been estimated at 8.4 cubic miles (35 cubic km) and it provides water for the domestic, industrial and agricultural needs of 22 million people.

to the electric power furnished by its turbines.

When it exits from Lake Powell at Lees Ferry, the discharge of the Colorado is considerable. The Grand Canyon proper begins at this point. Its size is simply spectacular, almost beyond human imagination: the average distance between the two edges of the great rift is 9.3 miles (15 km), it is 280 miles (450 km) long and 5280 ft (1600 m) deep. These figures are amazing by themselves, but the essence of the Grand Canyon is much more elusive. A mountain, lake or wild coastline may move and strike one, but they remain in one's mind in a comprehensible manner, always related to our habitual sense perception and to our human dimension. But the Grand Canyon is not like this: it is an abyss and is therefore inconceivable. Its primeval beauty borders on horror, it is like a hammer blow. And it is equally difficult to conceive the genesis of that awesome gash in the earth that cuts through northern Arizona like the chop of an axe.

Our rational mind finds it unacceptable that the agent responsible for this ruinous situation should be the Colorado River, which when viewed from above looks like an innocuous stream gleaming in the noonday sunlight. During the various geological eras the Colorado cut through the rock of the tableland until it reached the most ancient strata of the Earth's surface. The blackish shale that overlooks the bed of the river on the valley floor is two billion years old. For geologists the walls of the canyon are like an open book: some pages are missing, the plot is sometimes incongruous, but the history of the Earth can still be read clearly, from the beginning to the end of the Paleozoic epoch, when the American Southwest was covered by sea water. The crevice hewn by the Colorado is so wide and deep that it has created a vertical succession of environments that is prodigious, to say the least. Flora and fauna can change in the space of a few hundred feet, and so can the climatic conditions. In the winter, while it is snowing on the tableland, there are almost

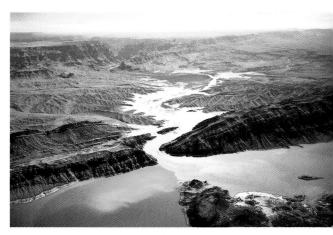

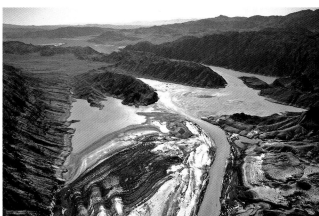

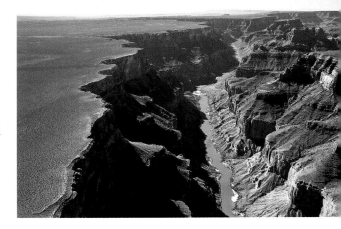

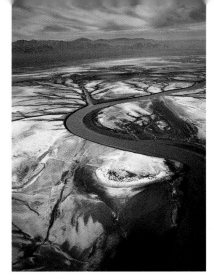

THE COLORADO

238 top Reduced to little more than a brook because of the massive amounts of water used upstream for power and irrigation, the Colorado makes its way with difficulty through the sands of the Sonora Desert, in Mexico. At this stage the high rate of salinity in the water makes it virtually useless for irrigation purposes.

238 center For a long stretch below Lake Mead the Colorado River forms the Arizona-California border, passing through very arid land.

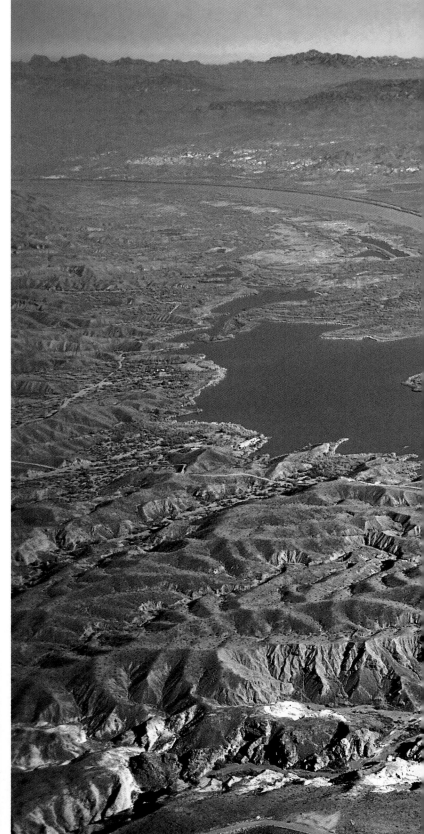

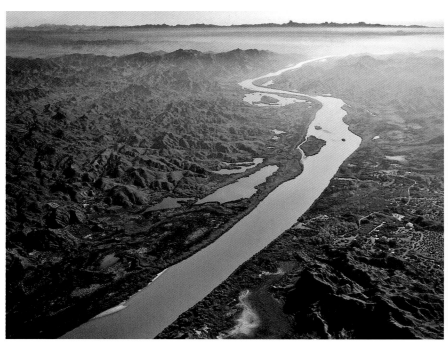

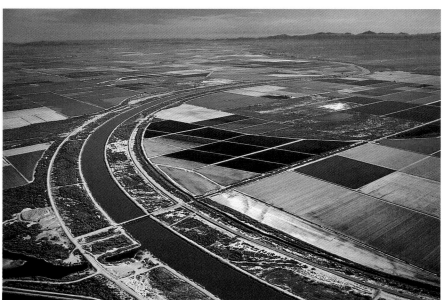

tropical temperatures at the bottom of the canyon.

At the end of the Grand Canyon, Lake Mead, another large artificial basin, receives the waters of the Colorado. In the final section of its course the river supports the most extensive project of irrigating arid land every realized by Man. A highly efficient network of canals and aqueducts carries the waters of the Colorado into the very heart of the California and Arizona deserts, while Mexico takes in the little that is left over. The river then fades away miserably in the scorching sand of the Sonora Desert, a long way before reaching the Gulf of California. The humid zones of the delta, which once had a surface area equal to the Piedmont region in Italy, are now almost wholly dried out. Nothing remains of the powerful Colorado but an imaginary blue line on maps.

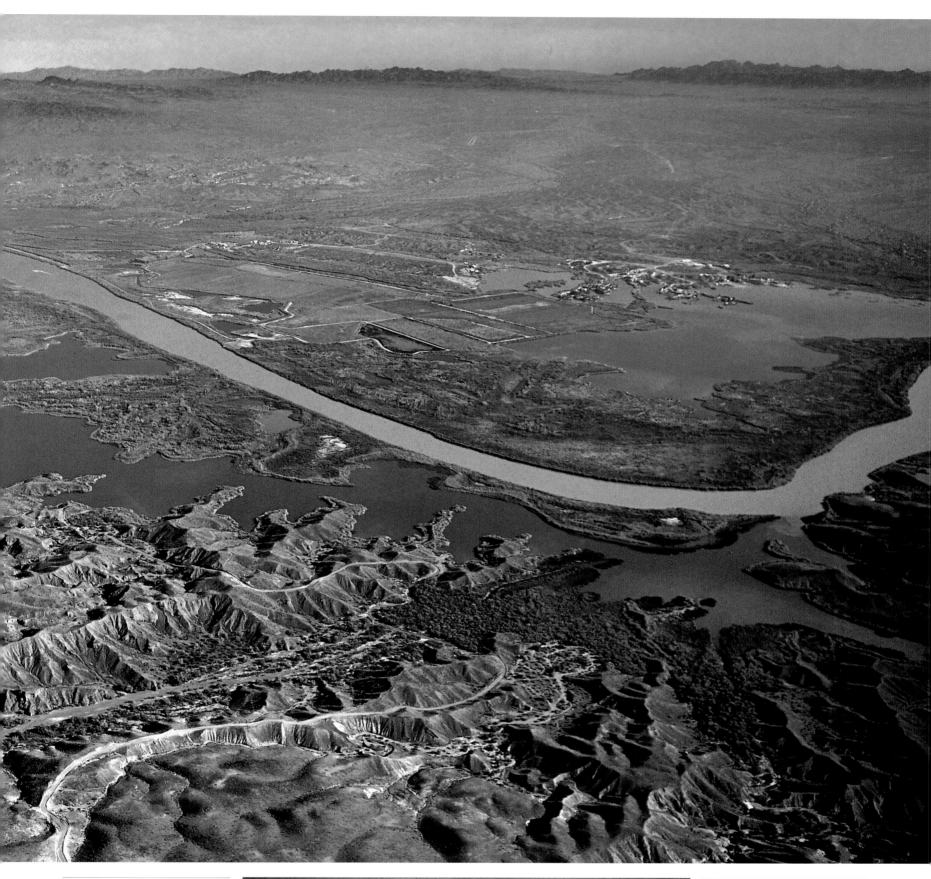

238 bottom Over 250 miles (400 km) of canals take the waters of the Colorado to the plots of land in the Palo Verde Irrigation District, in California.

238-239 Since 1922 a complicated set of laws has regulated the distribution of the Colorado's water, which is channeled and used to irrigate vast desert areas. The increase in population and the growing needs of agriculture may endanger the very existence of this grand river.

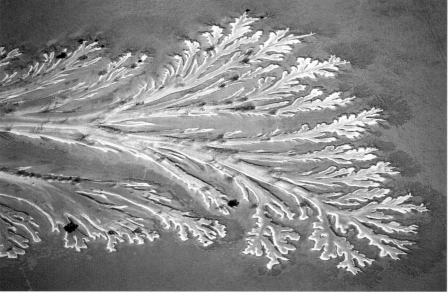

239 bottom Evanescent fan-shaped tracks on the sand are all that remains of the great Colorado delta, which once included large parts of southern Arizona and California. The river manages to reach the sea only in exceptionally rainy years.

THE MISSISSIPPI AND MISSOURI

THE TWIN RIVERS

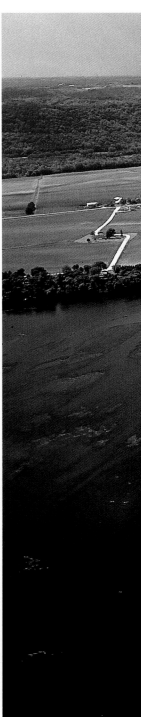

A steel and concrete arc 627 ft (190 m) high dominates the skyline of St. Louis, one of the largest cities in the American Midwest. The colossal monument overlooking the Mississippi River is the symbol of the historic role played by the city: the gateway to the boundless territories that stretched out west of the great river. About 12.5 miles (20 km) north of St. Louis, the Missouri River flows into the Mississippi. But it is a serious geographic injustice to consider the Missouri an affluent, since by the time it reaches the confluence this river has already traveled for over 2480 miles (4000 km), while the Mississippi is 'only' a little more than 2230 miles (3700 km) long. It would be like saying that the White Nile is a tributary of the Blue Nile, which is simply not

and Vicksburg, which contributed to the final victory over the secessionists.

The Mississippi represents the Deep South of the United States, a world that no longer exists, which evokes images of endless cotton fields, African slaves working to the rhythm of their songs, the first notes of blues and jazz, the elegant porches of the melancholy and luxurious houses of the plantation owners. The legend of the river comes back to life in the works of Mark Twain and Faulkner, in the canvases of the many painters who have rendered its changing appearance, and in the crude and imaginative slang of the steamboat pilots, who for decades transported people and merchandise from New Orleans to St. Louis.

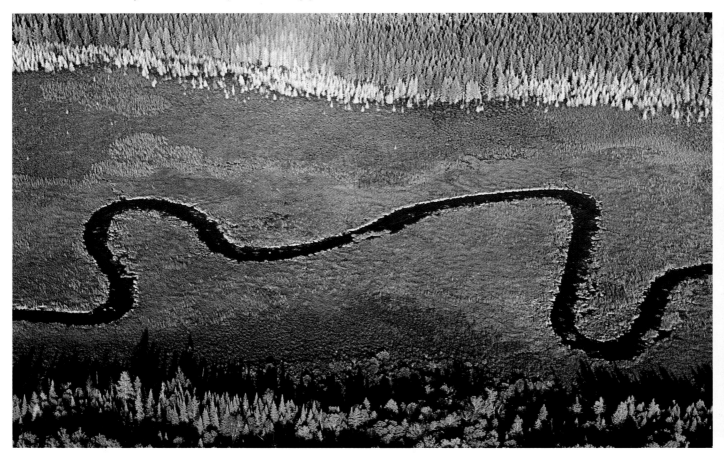

true. Yet no one has ever questioned the supremacy of the Mississippi River.

No other river has played such an important role in the history of the United States, through thick and thin. It is both the main thoroughfare to the interior and a huge barrier, the commercial axis and agricultural heart of the country, the bearer of riches and catastrophes, a crossroads of different peoples and cultures. Its waters have witnessed the passage of fur trappers, explorers, adventurers, gamblers, immigrants and soldiers. Whoever controls the Mississippi controls the nation, as the saying goes. La Salle, the founder of French Louisiana, was well aware of this and had a network of forts and outposts built along the river. And the leading generals of the Civil War realized this fact over 150 years later: the Union's armored ships navigated in the maze of canals of the river delta to conquer New Orleans

Today the Mississippi is quite different. Along its course are numerous dams, and the river is dredged to ensure safe navigation for the barges that plow through its muddy waters with their loads of goods. Thousands of miles of levees control the cyclical floods, or at least they circumscribe the damage. The river is still a vital force in the life of the inhabitants of the Midwest, providing them with drinking and irrigation water, electric power and transportation, as well as recreation. Its basin has a surface area of 1.4 million sq. miles (3.5 million sq. km), roughly equal to one-third of the United States. The length of the Mississippi alone, without counting the Missouri River, has been estimated at 2345 miles (3780 km). This is a hypothetical figure, since the river is in constant evolution and creates new meanders and secondary branches that will later become dried-up arms with their typical crescent shape. At times these changes

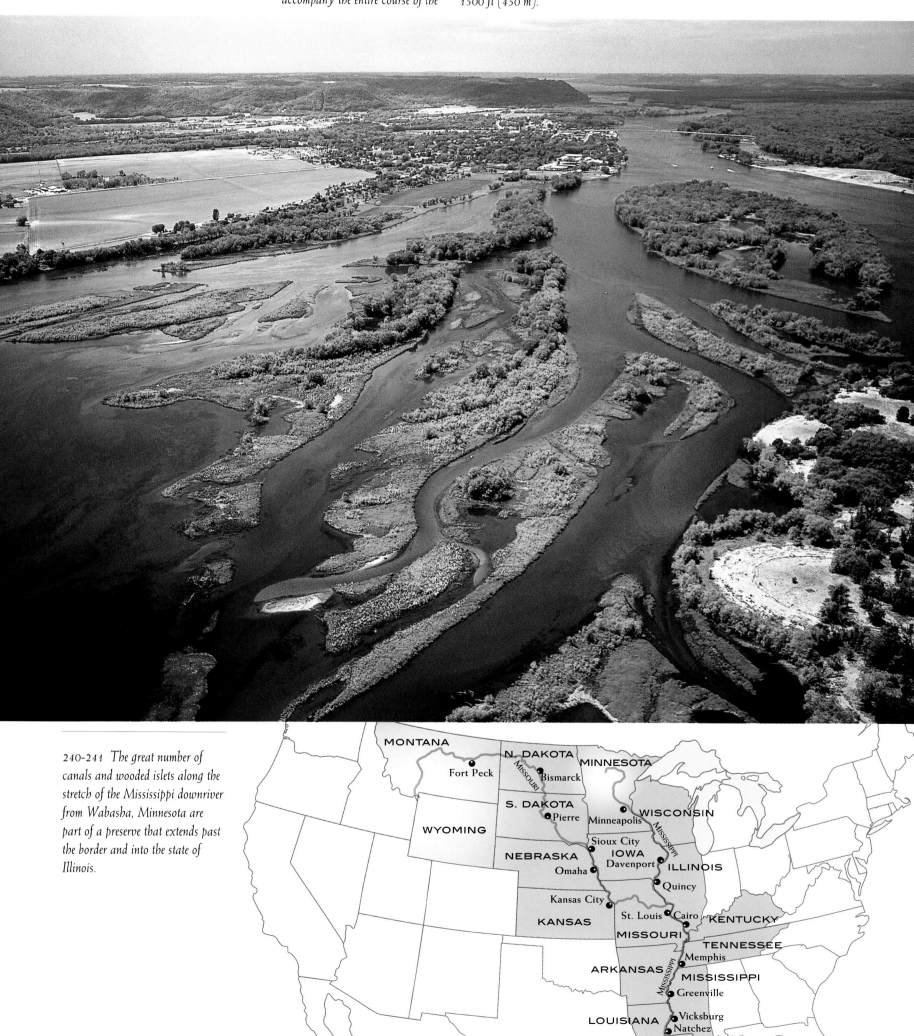

240 Vast forests, consisting mostly of conifers and interspersed with lakes and marshes, accompany the entire course of the upper Mississippi through northern Minnesota. The river originates at Lake Itasca, at an altitude of only 1500 ft (450 m).

240-241 The great number of canals and wooded islets along the stretch of the Mississippi downriver from Wabasha, Minnesota are part of a preserve that extends past the border and into the state of Illinois.

MONTANA

N. DAKOTA

MINNESOTA

Fort Peck

Missouri

Bismarck

WISCONSIN

S. DAKOTA

Pierre

Minneapolis

Mississippi

WYOMING

Sioux City

IOWA

Davenport

ILLINOIS

NEBRASKA

Omaha

Quincy

Kansas City

St. Louis

Cairo

KENTUCKY

KANSAS

MISSOURI

TENNESSEE

Memphis

ARKANSAS

MISSISSIPPI

Mississippi

Greenville

Vicksburg

LOUISIANA

Natchez

Baton Rouge

New Orleans

in the course of the river have been so significant as to engulf entire towns and drastically modify the boundaries between states. New Madrid in Missouri, Kaskaskia, Illinois, Napoleon in Arkansas and Prentiss, Mississippi lie under many feet of mud and were wiped off the face of the Earth. Other towns such as Greenville are now situated far from the riverbanks. Delta, in Louisiana, was once 3 miles (5 km) south of Vicksburg and suddenly found itself nearly 2 miles (3 km) to the north of the latter. In this perpetual movement the meanders fan out and become so sinuous that they finally merge. Then the current breaks through, heads straight ahead, and the course of the river is shortened.

In 1883 Mark Twain calculated that if the Mississippi continued to become shorter at that existing pace, in 742 years Cairo, Illinois and New Orleans would be governed by the same mayor. These changes are part and parcel of the capricious nature of the river and

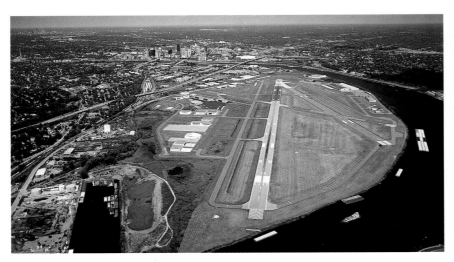

are no cause for alarm, so that one can joke about them like Twain. But when the Mississippi breaks out in all its fury the consequences can be downright catastrophic. The 1927 flood left 700,000 people homeless and inundated the plain from Cairo, Illinois to the delta. The water level rose by 60 ft (18 m), burying villages, farms and farmland under a layer of mud and water. Since then the Mississippi has been under constant surveillance and the responsibility for its control has been entrusted to the U.S. Army Corps of Engineers.

In this titanic and silent war, humans have enjoyed many significant victories: 3100 miles (5000 km) levees as tall as a three-storey building and as much as 300 ft (90 m) wide delimit the bed of the lower section of the river, and huge floodways are ready to be used in case of emergency. More than once the onslaughts of the river have been checked. But the Mississippi has by no means been tamed; in the summer of 1993, after four months of torrential rainfall, its waters again broke through the embankments, spreading into the countryside below St. Louis with unprecedented fury. The toll it took was dreadful: 56,000 homes destroyed, 50 people dead, entire cities without drinking water and electricity, $12 billion worth of property and goods destroyed, and the economy without a foot to stand on.

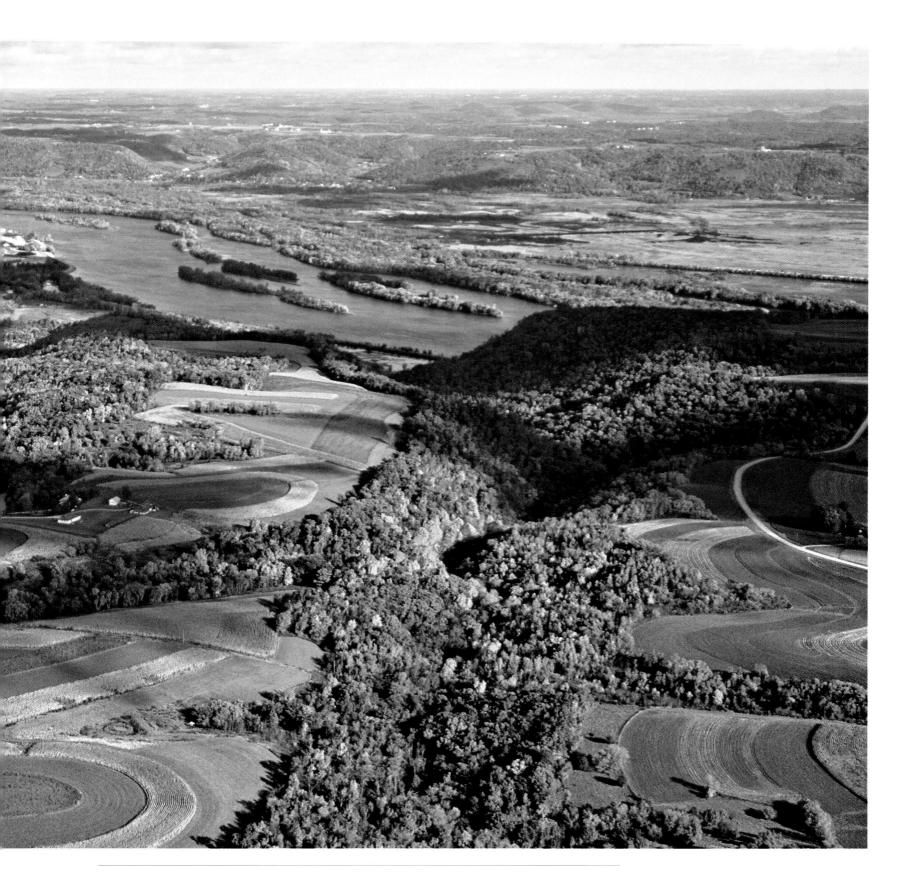

242 top The broad course of the Mississippi River separates Minneapolis and St. Paul, the capital of Minnesota. This large metropolitan area, known as the Twin Cities, lies in the middle of a fertile agricultural region.

242 bottom The skyline of Minneapolis, a major industrial and agricultural center, emerges unexpectedly among the woods flanking the shores of the Mississippi. The first colonists settled here in 1838.

242-243 Once past Minneapolis, for a long stretch the Mississippi marks the border between Minnesota and Wisconsin, carving its way deeply through the hills of sedimentary rocks that rise up at the edge of the valley.

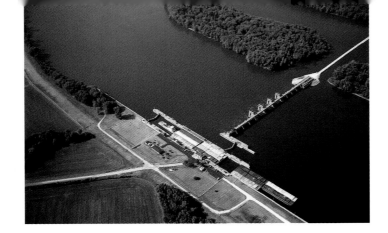

THE MISSISSIPPI

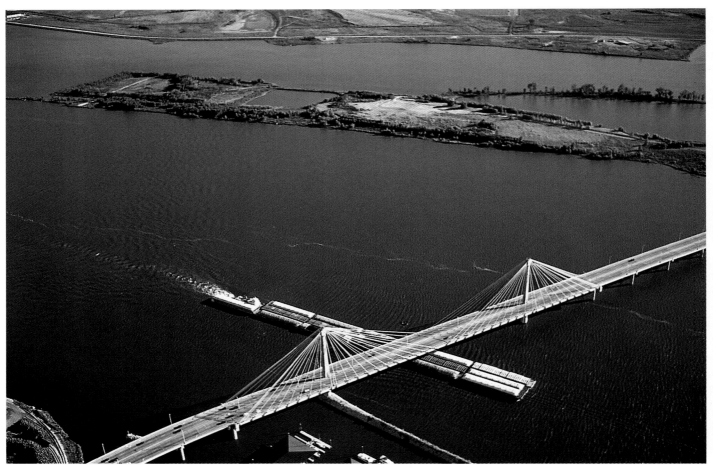

It is hard to imagine that such a mighty river, with so much potential violence, rises in the plain among green meadows and fir forests. In fact, the Mississippi begins at an altitude of only 1485 ft (450 m) at Lake Itasca, one of the many bodies of water that dot the state of Minnesota near the Canadian border. The Italian Costantino Beltrami was the first person to reach the area of the headstreams (1823), which were pinpointed with precision nine years later by the Americans Pike and Schoolcraft. For the first 310 miles (500 km) the river winds slowly between the lakes. Then its basin gradually expands in a continuous series of broad loops. The transparent water gradually becomes more murky and at Minneapolis the Mississippi already reveals its nature: it is not yet the muddy and treacherous Old Man River of popular tradition, but large vessels can now navigate it. The

river flows entrenched between tall, steep banks, sometimes opening out fanlike into canals that overflow into marshes and inundated forests, the ideal habitat for hundreds of species of birds and fish. After separating Minnesota and Wisconsin, for a long stretch the Mississippi is also the border between Iowa and Illinois as it runs through the most productive land in America. Iowa is the center of the so-called Corn Belt. Almost half the world's corn is grown in this enormous chunk of land that extends from the Appalachian Mts. to Nebraska and Kansas. Corn is one of the mainstays of the American economy: only part of the production is eaten or exported, while the rest is used as fodder for livestock. The abundance of milk and meat, which symbolize American prosperity, depends almost exclusively on the Corn Belt, which in turn depends on the Mississippi. The

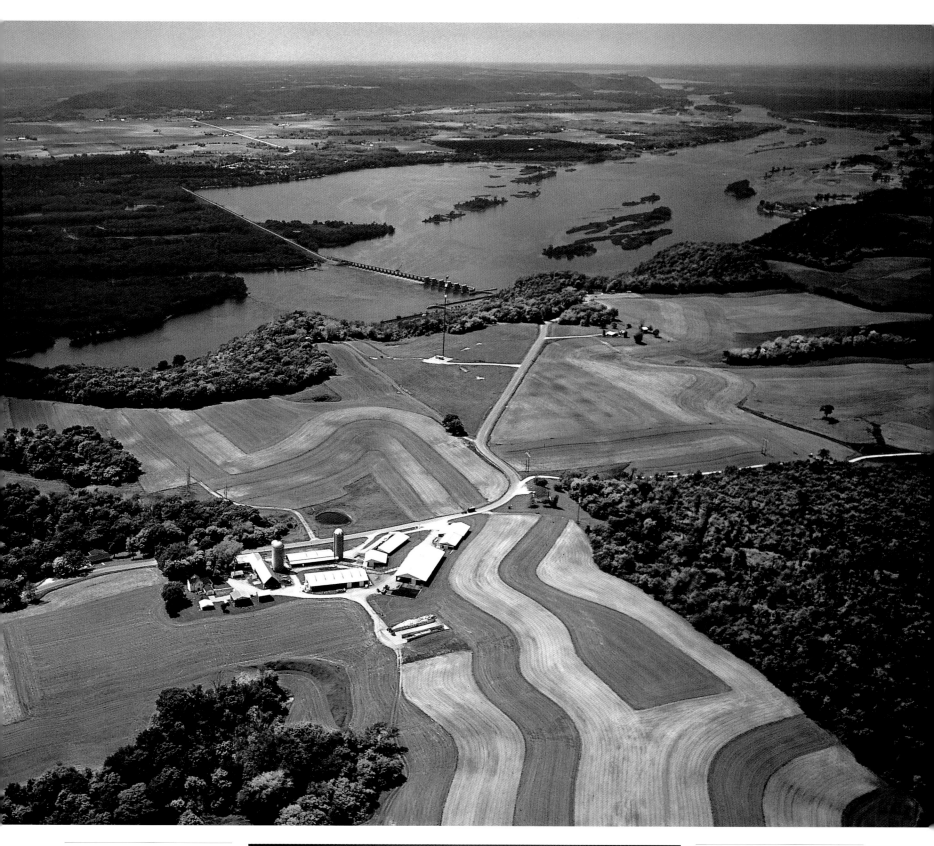

244 top A series of locks allows cargo barges to get past the largest drops in the Mississippi and arrive at the inland ports of Minnesota and Illinois, thus linking the Gulf of Mexico with the heart of the United States.

244 bottom A group of barges is towed by a tugboat down the Mississippi near the town of Alton, Illinois. In this stretch navigation is difficult because of the currents and sandbars.

244-245 Farm fields in a geometric pattern border the banks of the Mississippi near the town of Buffalo, Wisconsin. The river, filled with islands, is wide and majestic at this stage.

245 bottom The roofs of this farm in the Midwest tower over the land flooded by the muddy waters of the Mississippi. Despite the massive embankments built many years ago, floods are still often devastating.

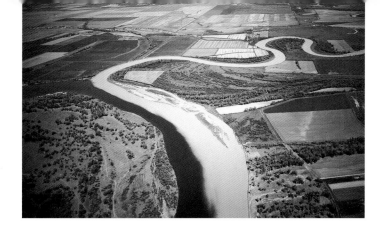

246 top The transparent waters of the upper Missouri are clearly separated from those of the turbid Milk River, one of its affluents. The whitish color of the latter is caused by the great amount of glacial sediment transported downstream by the river.

246 bottom Steep sandstone cliffs interrupt the placid flow of the Missouri near Great Falls, Montana, where the river plunges over a number of spectacular falls that for the most part have preserved their original appearance.

THE MISSOURI

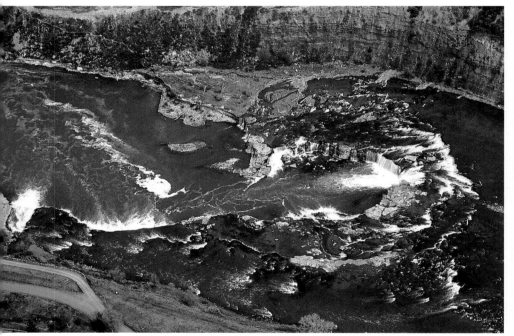

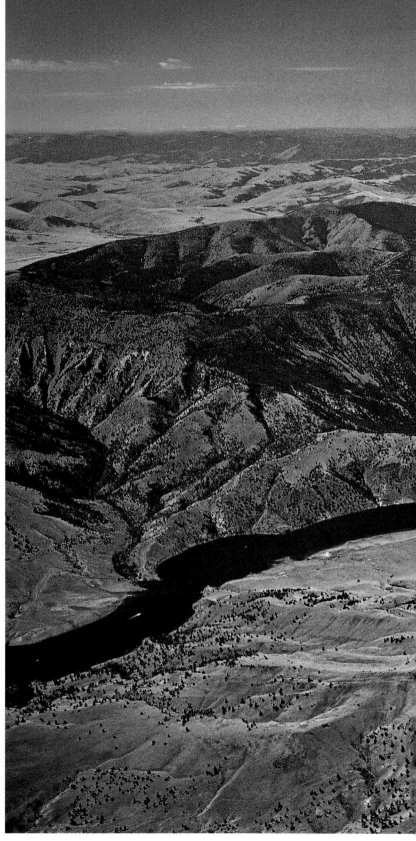

246-247 In the stretch upriver from Great Falls, the Missouri flows quietly into Lake Holter, on a bed of solid rock. The contrast between the dark blue of the water and the barren mountains creates some of the loveliest scenery in Montana.

247 bottom left Between the town of Fort Benton and the junction with the Judith River, the Missouri

crosses the so-called White Cliffs, the bizarre limestone formations that were so vividly described by Lewis and Clark over two centuries ago.

247 bottom right As it runs through Montana, the Missouri River maintains its aura of romantic solitude that so fascinated the first pioneers and trappers as they traveled through the unexplored land of the West.

first consequence of a flood is an increase in the cost of corn, which triggers an increase in the retail prices of all foodstuffs.

Proceeding toward St. Louis, the Mississippi is now about 1.25 miles (2 km) wide and has a solemn aspect. as if it did not want to make a bad impression compared to its great rival, the Missouri River. This latter rises in the Rocky Mts. from the merger of three headwaters, the Madison, Gallatin and Jefferson rivers. Crystal-clear and swift, it flows through the green valleys of Montana amid breathtaking scenery. Once past the town of Benton, the Missouri penetrates the tall White Cliffs made of sandstone that due to erosion is a multitude of spurs and pinnacles with bizarre shapes.

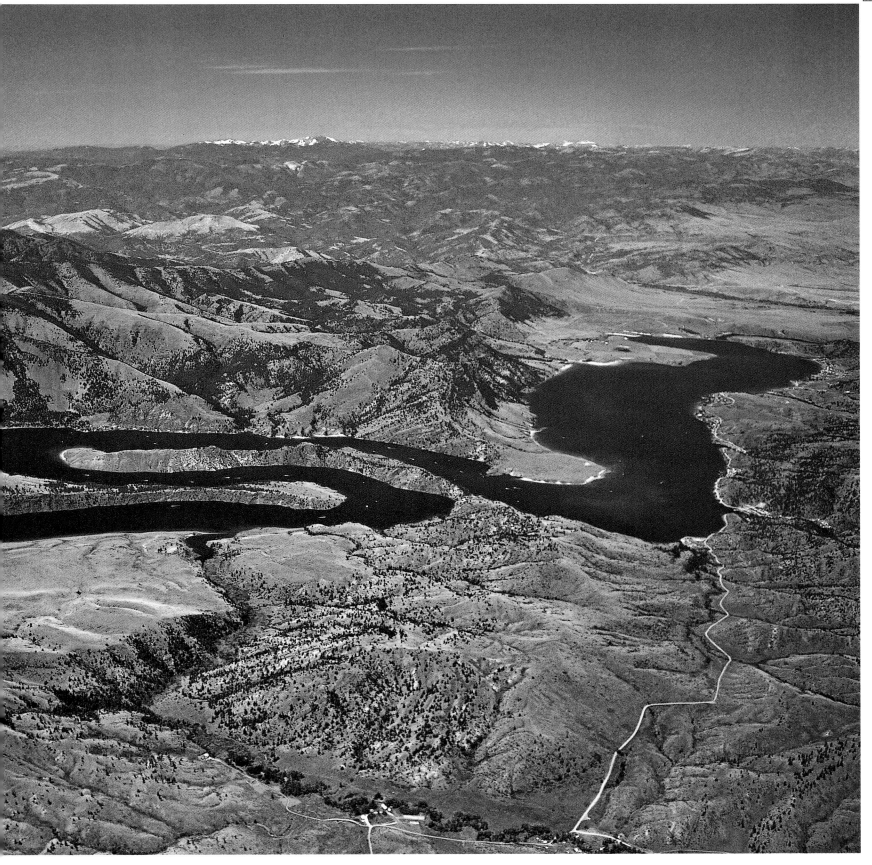

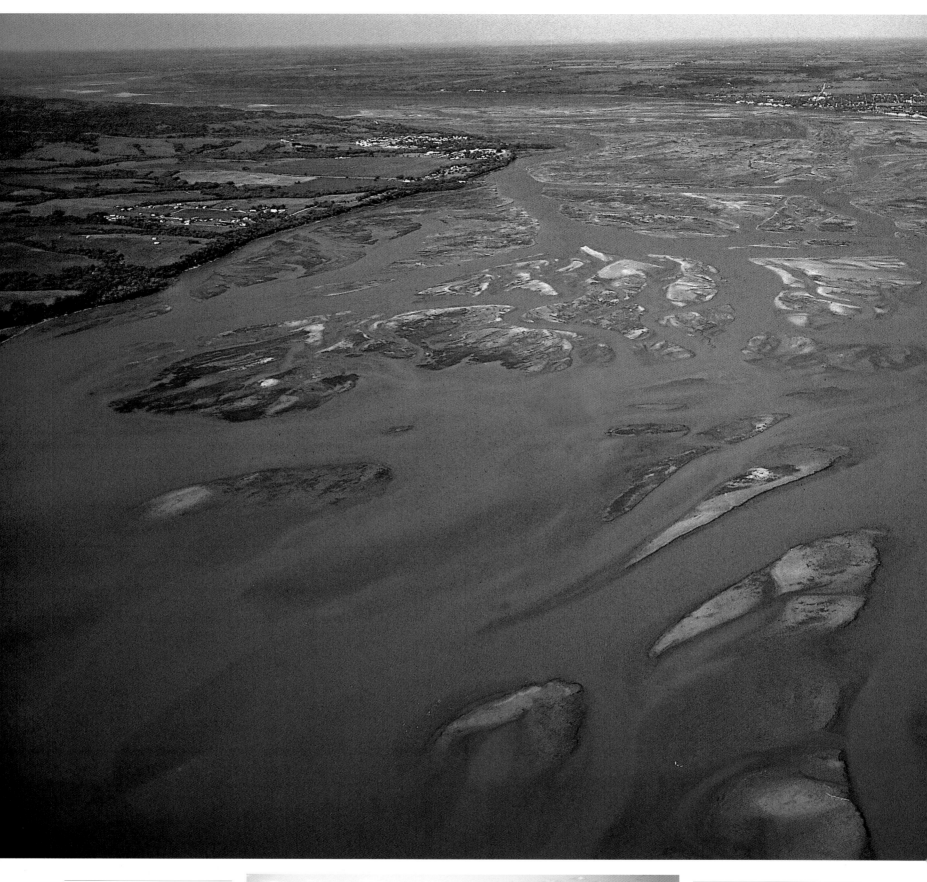

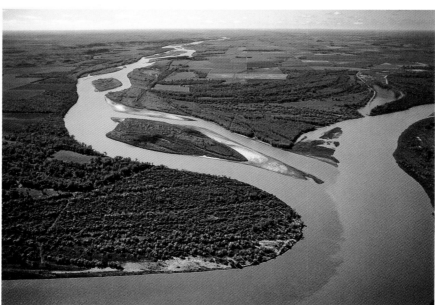

248-249 and 249 center Strong currents, floating tree trunks, and above all the treacherous sandbars that during the low water periods break the surface of the Missouri, were all a constant danger for the steamboats that once connected St. Louis and Fort Benton. Now, due to the construction of the large dams, none of which has locks, commercial navigation on the river ends in the vicinity of Sioux City.

248 bottom After over 620 miles (1000 km) through the huge plains of South Dakota and North Dakota, the Yellowstone River flows into the Missouri near Williston, a town upstream from Lake Sakakawea.

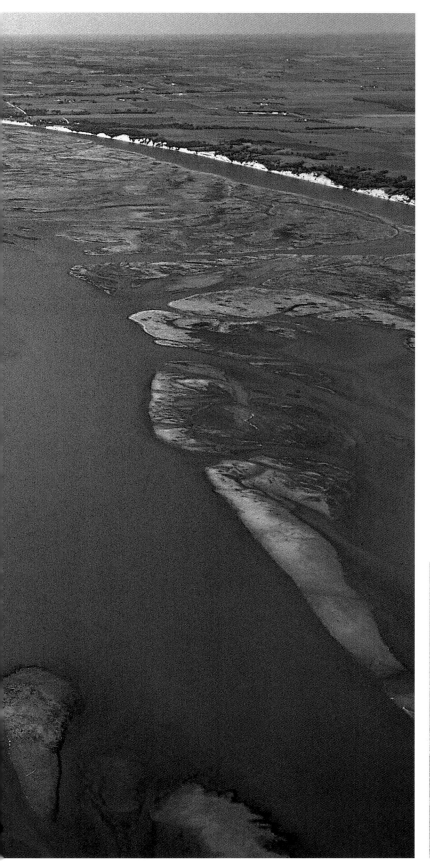

THE MISSOURI

249 top The Fort Peck Dam, which was finished in 1943, was the first of the large dams that regulate the middle reaches of the Missouri. The river, once the cause of disastrous floods, is now controlled by a continuous series of artificial reservoirs.

249 bottom The barren hills of North Dakota flank the Little Missouri River on its way to Lake Sakakawea. This area is populated by buffaloes and other rare species of animals and was declared a national park in 1978.

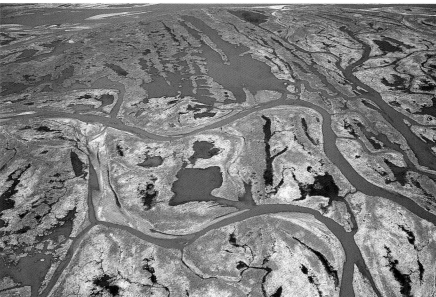

"Spellbinding scenery," was the comment made by Lewis and Clark, who in the early 19th century went up the river to its source. The wild dreams of the Missouri end a few miles downstream, when it receives the waters of the Yellowstone and enters North Dakota: the large Fort Peck Dam is only the first step in a long series of dams that regulate the course of the river up to its confluence with the Mississippi. As a result, a large part of the ancient territories of the Sioux, Mandan, Hidatsa and other Indian tribes that lived in this area are now flooded permanently. Twenty centuries of the history of the first American civilizations now lie in the depths of the lakes of the Missouri and will never be seen again. However, this great sacrifice has not been in vain: the river water, collected in the artificial lakes and channeled for irrigation, has transformed what was formerly known as the Great American Desert into an expanse of fertile land.

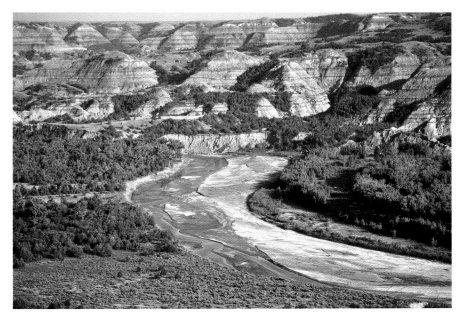

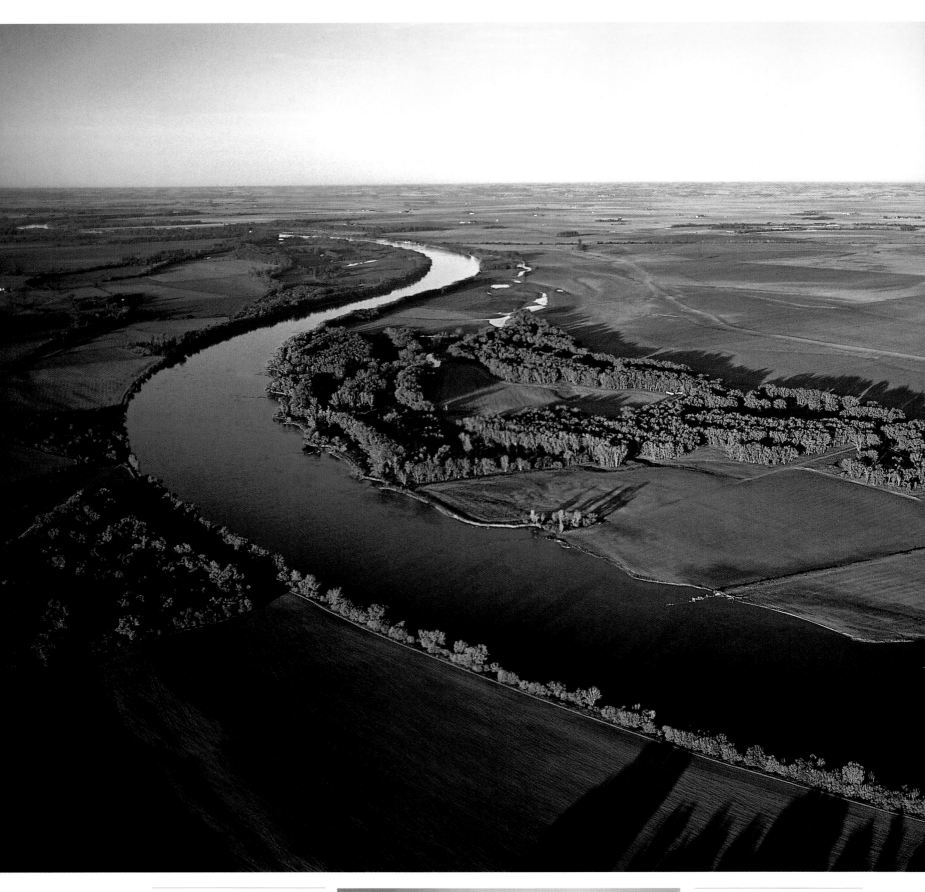

250-251 and 251 center Between
Yankton and Sioux City, where it
becomes the South Dakota-Nebraska
border, the Missouri flows peacefully
through the Great Plains. Thanks to
the massive dams that regulate the
flow of the river, the region that was
the home of wild nature is now
covered by fields of wheat and other
cereals and has become one of the
most productive agricultural zones in
the United States.

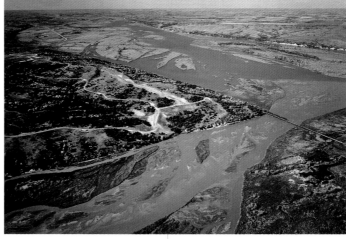

250 bottom The Niobrara River
collects the water of an extremely
arid zone in the Great Plains and
flows into the Missouri upstream
from Yankton. Compared to other
tributaries, it has relatively little
water.

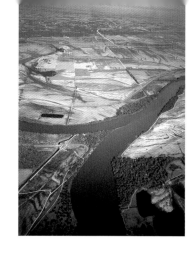

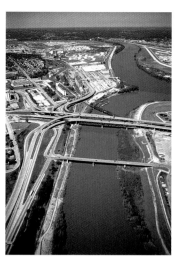

THE MISSOURI

251 top left "A mile wide and an inch deep" was what the first pioneers said of the Platte River, which empties into the Missouri near Omaha. This river was one of the most important routes toward the West in the 19th century.

251 top right Split in two by the Kansas River, which at this point merges with the Missouri, Kansas City began to develop in the late 19th century. Because of its crucial position the city is now a major agricultural and industrial center.

251 bottom A continuous series of meanders characterizes the Missouri near Omaha, Nebraska. Since 1854, the Omaha Indians, who once controlled the land along the river, have lived on a reservation.

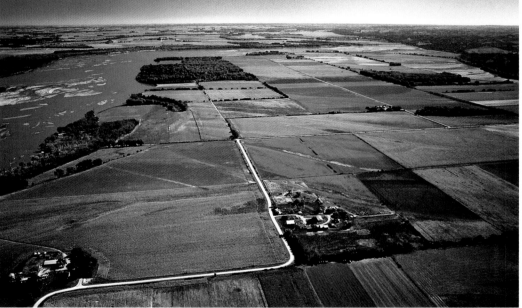

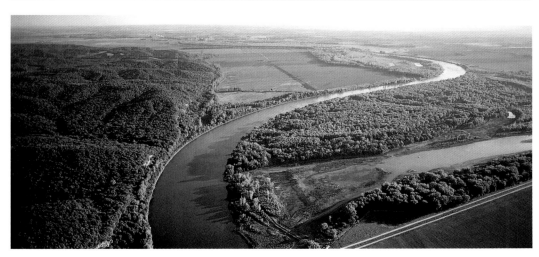

252-253 *St. Louis is an enormous metropolitan area with a population of about 2.7 million people. The huge stainless steel-faced arch that looms over the Mississippi commemorates its historic mission as the gateway to the West.*

252 bottom *This steamboat, moored on the Mississippi bank in Vicksburg, Lousiana, has been converted into a casino. The epic of steamboat navigation on the Mississippi ended in the late 1800s with the advent of railways.*

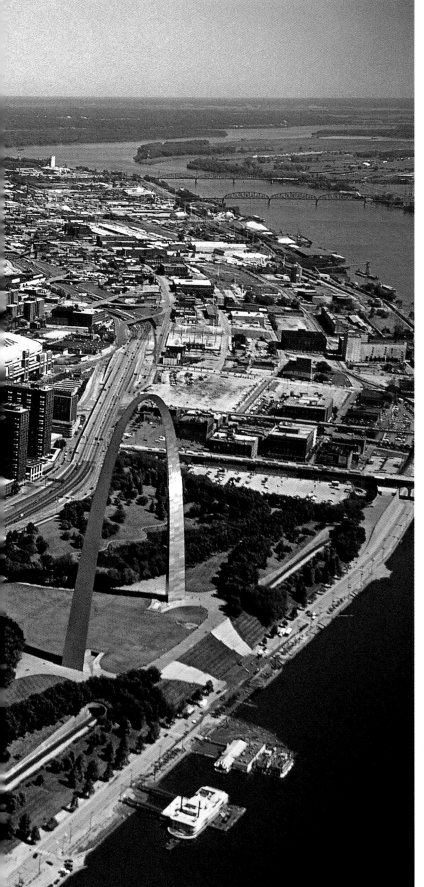

THE MISSISSIPPI

253 center The Hernando De Soto Bridge connects Memphis, the largest city in Tennessee, with Arkansas. This bridge, which is decorated with thousands of lights, was named after the famous Spanish explorer who discovered the Mississippi in 1541.

253 bottom The city of Memphis on the Mississippi has not forgotten its namesake, Memphis on the Nile. The ancient Memphis benefited from proximity to the Pyramid; the modern Memphis benefits from being home to the Pyramid Arena.

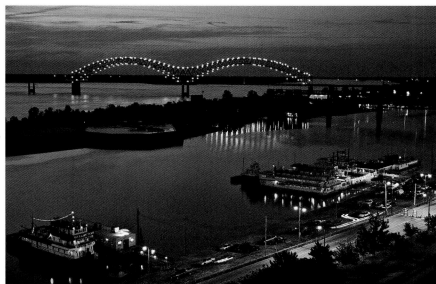

253 top St. Louis was the starting and arrival point of the famous Lewis and Clark expedition, which first went up the Missouri and eventually reached the Pacific Ocean in November 1805.

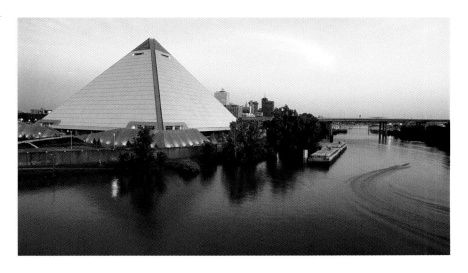

254 top and bottom The junction of the Missouri and Mississippi, which takes place a few miles from St. Louis, is one of the world's most grandiose river landscapes. The Missouri, which is almost twice as long as its 'big brother' but has much less discharge, deposits a huge quantity of silt in the Mississippi. The contrast in color between the waters of the two rivers is clearly visible for several miles downstream.

After passing through South Dakota, the river forms part of the boundary of Nebraska, receiving the waters of the Cheyenne, Platte and other major tributaries. At Kansas City it makes a bend eastward, entering into the state of Missouri. The barge traffic here is heavier, a sign that the Mississippi is not far away. A little farther on the two colossi merge, forming a single majestic river that flows slowly southward toward the Gulf of Mexico, which is 1054 miles (1700 km) away, with a gradient of only 198 ft (60 m) for that entire stretch. At Cairo, where it receives the Ohio River, the Mississippi enters the immense alluvial plain that the river itself created. Here its typical meandering course is accentuated and becomes obsessively

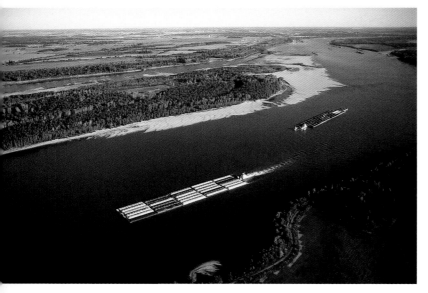

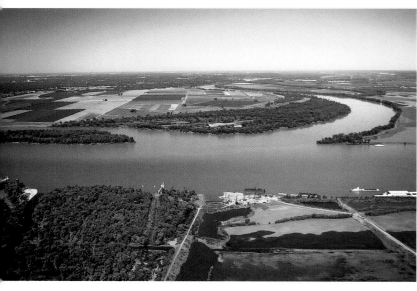

symmetrical. The terrain is flat, without any rises save the regular lines of the man-made levees. It has been a long time since cotton was the only crop grown here, and the vast plantations have been partly replaced by corn and peanut fields. But the Deep South begins here.

Cotton picking is very laborious and requires cheap labor. In the late 1700s the plantation owners began to import tens of thousands of African slaves to satisfy the growing demand of the market. From 1815 to 1860 cotton production increased fifteen-fold. Slavery and cotton were the mainstays of the economy of the southern states. The Mississippi, the commercial artery of this system, became the symbol of a lifestyle, the paragon of a cruel, romantic epoch. For the African dock workers the river was Old Al, the alligator as large as a barge that could block the canals and cause boats to run aground; or with a simple flick of its tail, it could knock down the levees and cause a flood. But when Old Al decided to smoke its pipe, a thick fog rose and concealed the landscape, stopping all traffic on the river, so that the laborers could finally rest for a while.

The fog was not the only obstacle on the Mississippi: low-water stages, submerged tree trunks and sudden storms were also hazards to be taken seriously. In the glorious age of steamboats, shipwrecks occurred so frequently that it was rare indeed for a steamer to remain in service for more than a few years. The legendary paddle steamers that went along the lower course of the river, veritable floating palaces, offered their clients all kinds of entertainment, from stage shows to gambling. The greatest poet of this river and its contradictory cosmos was Samuel Langhorne Clemens, better known as Mark Twain, whose pseudonym derives from the river call for a depth of two fathoms. This author spent his youth on the Mississippi and was a riverboat pilot. The Mississippi is the true protagonist of some of his novels, which portray a young, optimistic America with biting humor. William Faulkner was also connected to the river, but the South he portrays is a desperate society that has lost its roots because of the disastrous Civil War and is unable to adapt to the new reality.

Modern Memphis is much different from the God-forsaken, ambiguous city described by Faulkner. Like New Orleans, Vicksburg, Natchez, Baton Rouge and the other towns in the

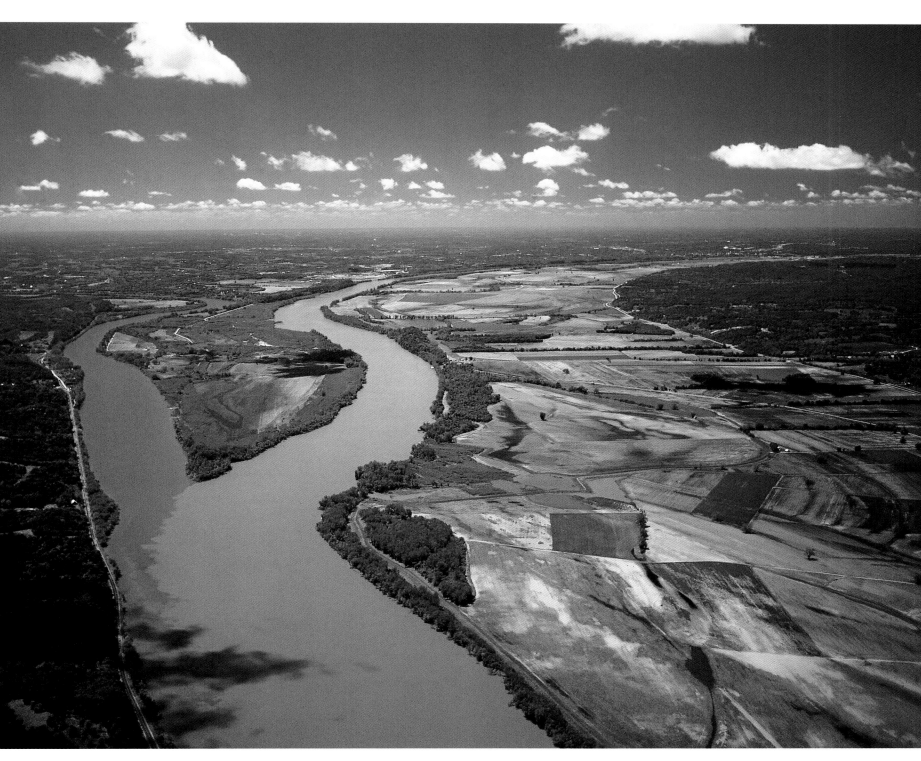

254 center Continuous barge traffic goes up and down the Mississippi and its tributaries, which constitute one of the largest navigable waterway networks in the world.

254-255 The waters of the Osage are quickly lost in the Missouri's muddy current as the latter merges with the Mississippi. The Missouri basin covers 530,000 sq. miles (1.37 million sq. km).

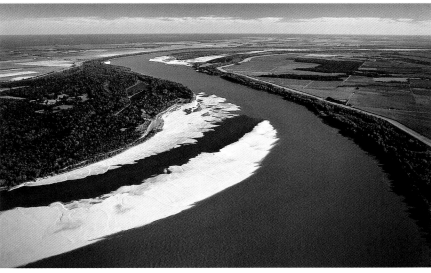

255 bottom The course of the lower Mississippi in Arkansas is distinguished by absolutely flat landscape. Although much land has been made cultivable, large forests and marshlands still border the banks of the river.

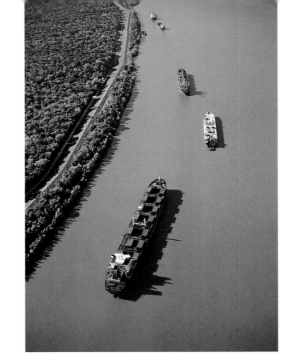

THE MISSISSIPPI

256 top and center A deep navigable canal allows ocean-going ships from the Gulf of Mexico to go up the Mississippi as far as Baton Rouge, Louisiana. Barges, which are of course much smaller, can go as far up as Minneapolis. The difficult task of controlling the river and keeping it open to commercial traffic is the job of the US Army Corps of Engineers; the first dredging and ordering of the riverbed took place in 1829.

256 bottom A host of pools and dry tributaries flank the Mississippi on its way through Louisiana. The alluvial plain created by the accumulation of the silt carried by the river is in certain stretches as much as 125 miles (200 km) wide.

257 The bayous, the innumerable secondary branches of the Mississippi, are a characteristic feature of the Louisiana landscape.

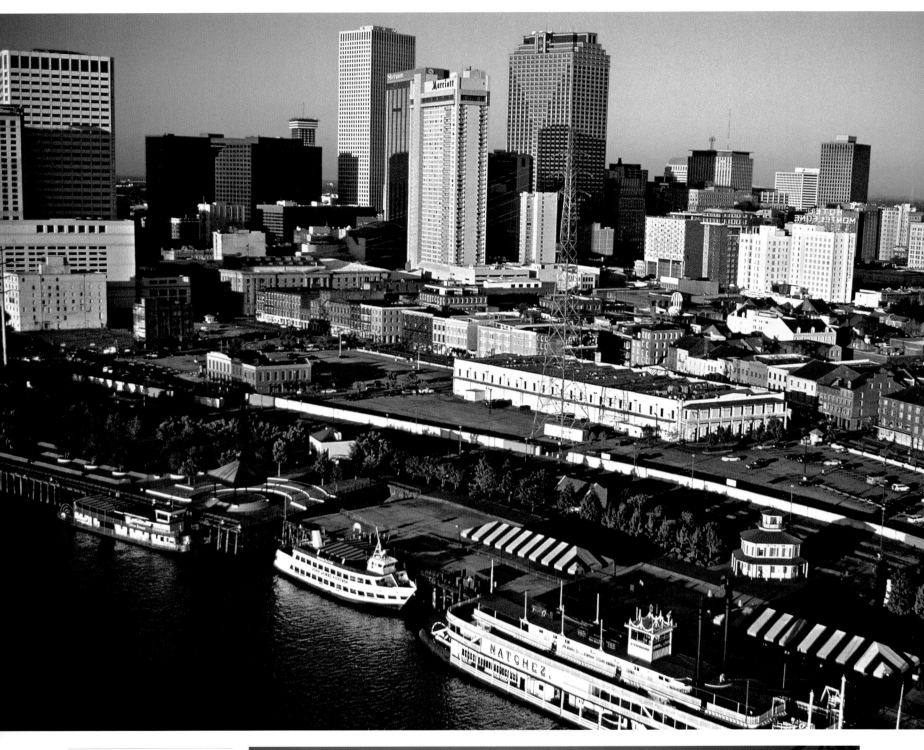

258-259 and 259 top left New Orleans, situated between the left bank of the Mississippi and Lake Pontchartrain, was founded in 1718 by the French naval officer Le Moyne, who made it the bridgehead of French settlement in Louisiana. In 1803 Napoleon sold the city, together will all the territory west of the river, to the United States. In the 1920s New Orleans became world-famous as the cradle of jazz music.

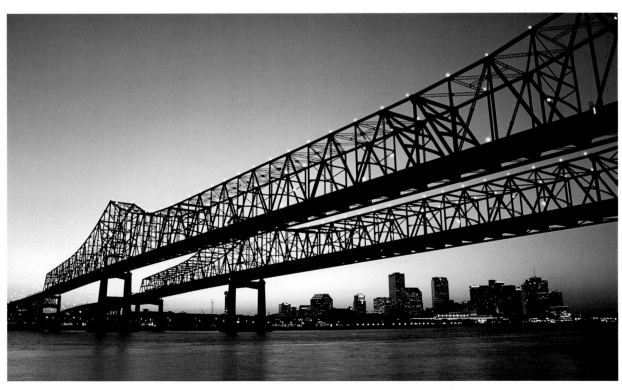

258 bottom *The Mississippi's great breadth and the area's soft soil long delayed construction of bridges to link New Orleans with the suburban area across the river.*

THE MISSISSIPPI

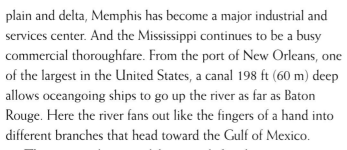

plain and delta, Memphis has become a major industrial and services center. And the Mississippi continues to be a busy commercial thoroughfare. From the port of New Orleans, one of the largest in the United States, a canal 198 ft (60 m) deep allows oceangoing ships to go up the river as far as Baton Rouge. Here the river fans out like the fingers of a hand into different branches that head toward the Gulf of Mexico.

The present-day river delta extends for almost 12,000 sq. miles (30,000 sq. km), all within the state of Louisiana: an expanse of swamps, aquatic lowlands, and forests that host an amazing variety of organisms. This region, afflicted by humid subtropical climate and, as in 2005, devastated by hurricanes, is the home of New Orleans. Founded by the French, ceded to the Spanish, returned to the French, soon afterwards sold to the United States as part of the Louisiana Purchase, and later populated by many Africans, the city jealously guards its cosmopolitan, libertine spirit. New Orleans gave birth to jazz, the result of the felicitous development of the former slaves' rhythm and music. In the early 1900s the notorious Storyville district witnessed the birth and rise of such talents as Buddy Bolden and Louis Armstrong. Their joyous and sorrowful melodies and rhythms went upstream to Chicago, and from there captured the heart of America and the world.

The mouth of the Mississippi is 100 miles (160 km) from New Orleans. The banks gradually lose their contours and the delta extends into the sea in the form of an interminable muddy strip, almost as if the "Father of Water" were nostalgic and reluctant to leave the land.

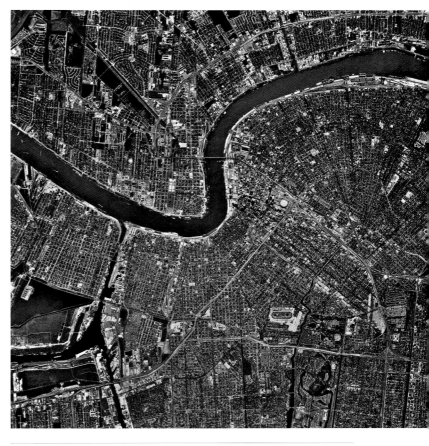

259 top right *Towed by tugboats driven by powerful diesel motors, a group of cargo barges goes up the muddy waters of the Mississippi in the vicinity of New Orleans.*

259 bottom *An aerial view of New Orleans. Most of the city lies below sea level; in 2005 it was devastated by a truly catastrophic flood produced by hurricane Katrina.*

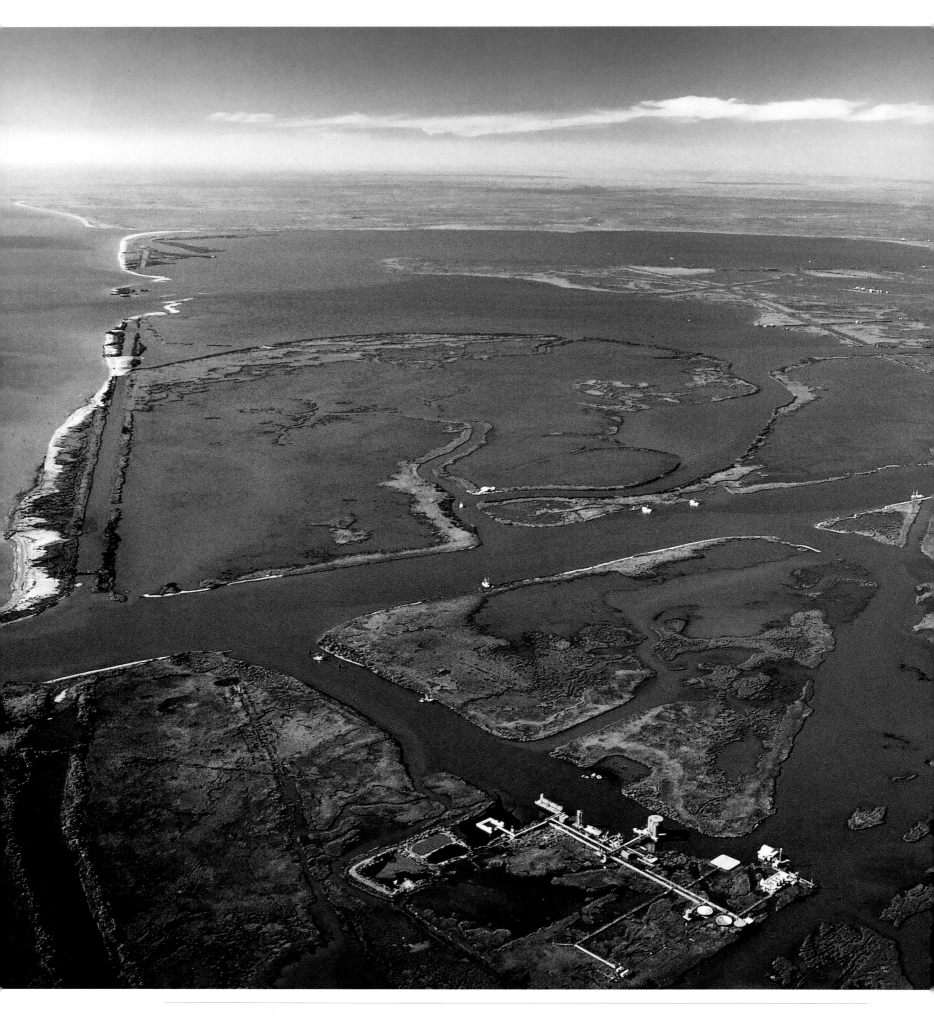

260-261 *The Mississippi Delta is a world in continuous flux. Because of the silt carried by the river, the Louisiana has shifted seaward for almost 60 miles (100 km) in the last 5000 years.*

261 top *American alligators can be as long as 13 feet (4 meters). Once hunted to near extinction, these formidable animals now thrive in the lower Mississippi.*

261 center top *Pelicans live along the coast of Louisiana. Thanks to its southern climate, the Mississippi is a major corridor of migration for many species of aquatic birds.*

261 center bottom and bottom *The maze of marshes and secondary canals known as bayous is the home of the Cajuns, the descendants of the French colonists who were expelled from Acadia in 1755.*

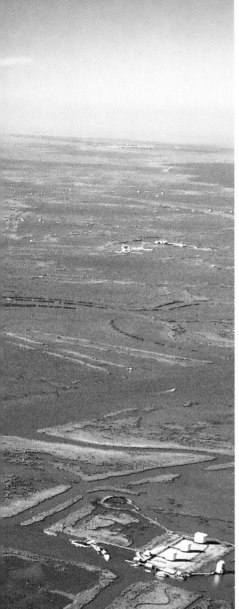

The Mississippi

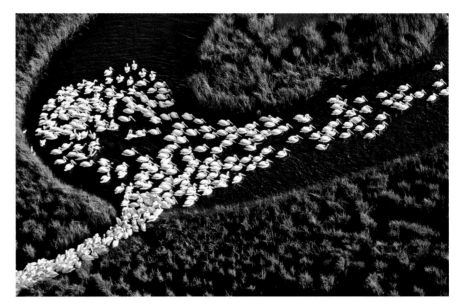

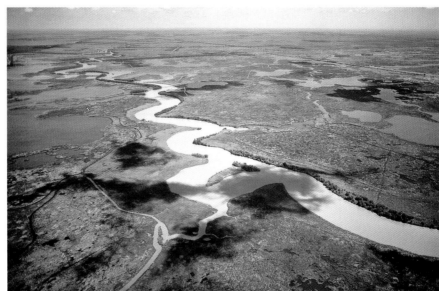

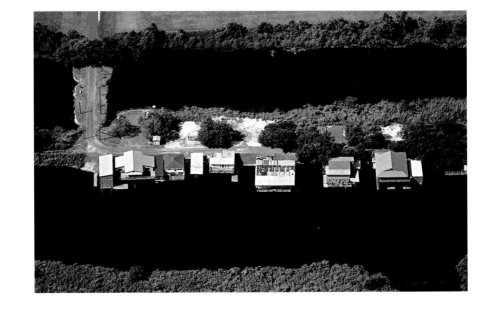

CENTRAL AND SOUTH AMERICA

The Andes extend longitudinally over South America from Colombia to Patagonia. There is no pass that interrupts the continuity and compactness of this massive mountain barrier whose slopes descend steeply almost to the Pacific coast.

The asymmetrical configuration of these mountains strongly conditions the waterway system on its western side, which is limited in both size and development. The Río Aconcagua, Río Mapel, and Río Maipo, which empty into the Pacific on the Chilean coast, are short and rapid, but their waters are used both for irrigation and for producing electric power. Only the Colombian rivers such as the Río Atrato and the Río Magdalena, which empty into the Antilles Sea, are relatively important as inland communications routes. The situation to the east of the Andes, an expanse of land characterized by enormous alluvial plains covered with forests, is much different. Here, three gigantic river systems separated by barely noticeable dividing ranges surround the middle of the continent in a thick network of waterways. For their length and outflow the Amazon, Orinoco and Paraná-Río de la Plata are among the largest rivers in the world and have always played a major role in the history, economy and culture of the countries they pass through. For the most part they are navigable and were the main arteries for European penetration into the interior of South America. The first Spanish, English and Portuguese explorers went up their muddy waters in search of the mythical El Dorado and the Silver Mountain.

The Río San Francisco flows only in Brazil; like the Paraná, it rises on the Brazilian highlands, in the state of Minas Gerais, not far from the Atlantic coast. This river is 1800 miles (2900 km) long and about half its course is navigable; for centuries it was the access to the sertaõ, the arid interior of the state of Bahía. The two most important rivers in Patagonia, the Río Negro and Río Colorado, have a variable regimen and sand bar obstacles.

For centuries the jungles and highlands of South America were enveloped in a mythical geographic configuration of inland seas and cities of gold, and only in the early 1800s was the truth known. The journeys undertaken by Charles-Marie de La Condamine in the 1730s and Alexander von Humboldt in the very early 1800s revealed the marvels of the New World to Europe: amazing animals, trees that exuded rubber, populations isolated for centuries in the heart of a primeval world. Today it is up to scientists to discover the true treasures hidden in the green sea of Amazonia, one of the last and most resistant bulwarks of biodiversity in the world. The virgin forests surrounding the Amazon and upper Orinoco will be the arena of one of the most decisive battles for the future of humanity.

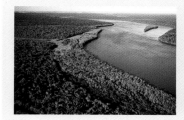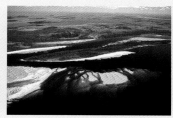

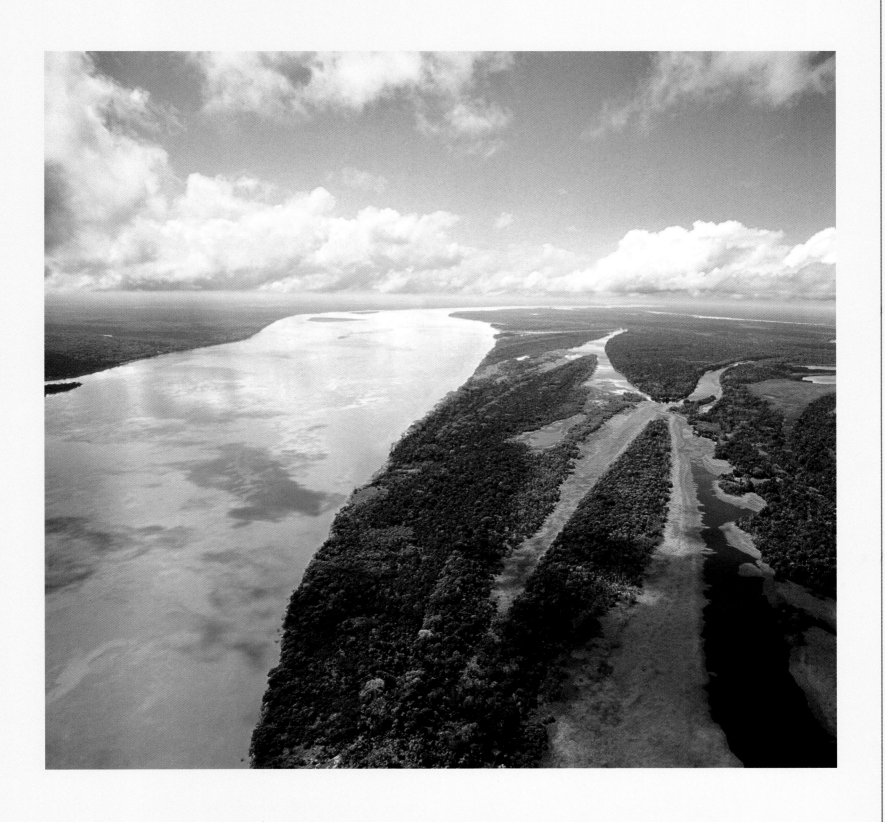

262 left The Paraná River at the confluence with the Iguaçu, on Brazil-Paraguay-Argentina border.

262 center Sand bars in the Orinoco River near Ciudad Bolívar, in Venezuela.

262 right One of the many meanders of the Amazon River in Brazil.

263 Flooded forests along the course of the Amazon River in Brazil.

THE ORINOCO

THE GATEWAY TO ELDORADO

Once they were near the island of Trinidad, in the strait known as the Serpent's Mouth, Columbus's caravels were hit by a violent current. The ocean, which until then had been indigo, became turbid and milky, and there was only fresh water for miles around them. It was the year 1498 and Columbus, on his third voyage to the Americas, guessed he was at the mouth of a massive river in the mainland. The Orinoco delta was visited three years later by another Italian, Amerigo Vespucci. The villages with dwellings built on stilts that he saw along the coast reminded him of a miniature Venice, so he named that land Venezuela.

The Orinoco River is considered the third river in South America. It is actually 1488 miles (2400 km) long, less than some affluents of the Amazon such as the Purus and Madeira, but it is much more important from a historic and geographic standpoint. Its basin, which extends over a surface area of 400,000 sq. miles

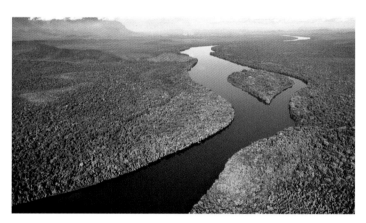

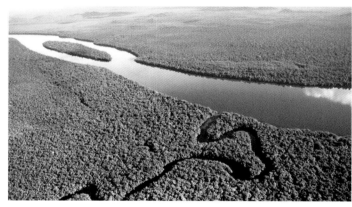

(1 million sq. km), covers almost all Venezuela and most of Colombia. About 2500 waterways flow into the Orinoco. Some of them are little more than brooks while others like the Buaviare, Meta and Ventuari have a large outflow rate, especially during the rainy season. The level of the Orinoco begins to rise in April and reaches its peak in summer, when it inundates entire regions. Perhaps it was these immense lagoons that inspired the legend of Lake Parima, which for centuries obsessed explorers, treasure hunters and geographers. According to some people, this mythical lake was in Peru, while others maintained it was in an indefinite area north of the Amazon River, or in the unexplored forests of Guyana. The lake, supposedly as large as the Caspian Sea, changed position according to the period, but everyone agreed on one point: the fabulous city of Manoa and the mythical El Dorado lay there. Of the many possible sites, Diego de Ordaz, one of the Spaniards who had followed Cortés in Mexico, chose to look for the lake in the Orinoco basin. He died on the way, but in 1534 his successors went up the river for over 500 miles (800 km), up to the confluence with the Río Meta. They found neither gold nor stone cities – only jungles and masses of ravenous insects.

However, the failures did not tarnish the myth of El Dorado. About 70 years later the English corsair Sir Walter Raleigh, in one of his raids at Trinidad, accidentally came upon a secret document which mentioned the riches of Manoa: a metropolis so large that to get to the center, occupied by the emperor's palace, one had to walk for a whole day. As for the gold, it was so abundant that even the armor and shields of the soldiers were made of the precious metal. Queen Elizabeth I of England, attracted by that mirage, gave her faithful courtier permission to set off in search of it. Between one raid and another, Raleigh carried out two expeditions in the region, going as far as Mt. Duida, near La Esmeralda. Both attempts failed, and Elizabeth's successor, James I, ordered Raleigh to be executed for treason.

The Orinoco River had proved to be a blind alley, as it were, but Lake Parima continued to stand out on the maps of South America. The river, whose course was obstructed by rapids and cataracts, was much more difficult to navigate than the Amazon and the Paraná-Río de la Plata and was the last to be explored. Only 200 years later did a new generation of explorers-scientists reveal the mysteries of the region and chart reliable maps of Venezuela. Alexander von Humboldt's journeys in the early 1800s demonstrated that there really was a link between the Orinoco and the Río Negro and brought to light the true treasures of the New World: thousands of data, sketches, scientific samples and 60,000 plant specimens were taken to Europe, shedding new light on the obscure forests of equatorial South America. Von Humboldt did not venture beyond the La Esmeralda mission, the last outpost on the threshold of wild land populated by hostile tribes.

264 An impenetrable rain forest surrounds the Orinoco river near the town of La Esmeralda, in southern Venezuela. West of the Serra Pacaraima and the Serra Parima, the large mountain ranges that mark the border with Brazil, the line of the divide is less clear. The waters of the Orinoco flow through this gap and empty into the Casiquiare, a natural canal connecting with the Río Negro and then the Amazon River.

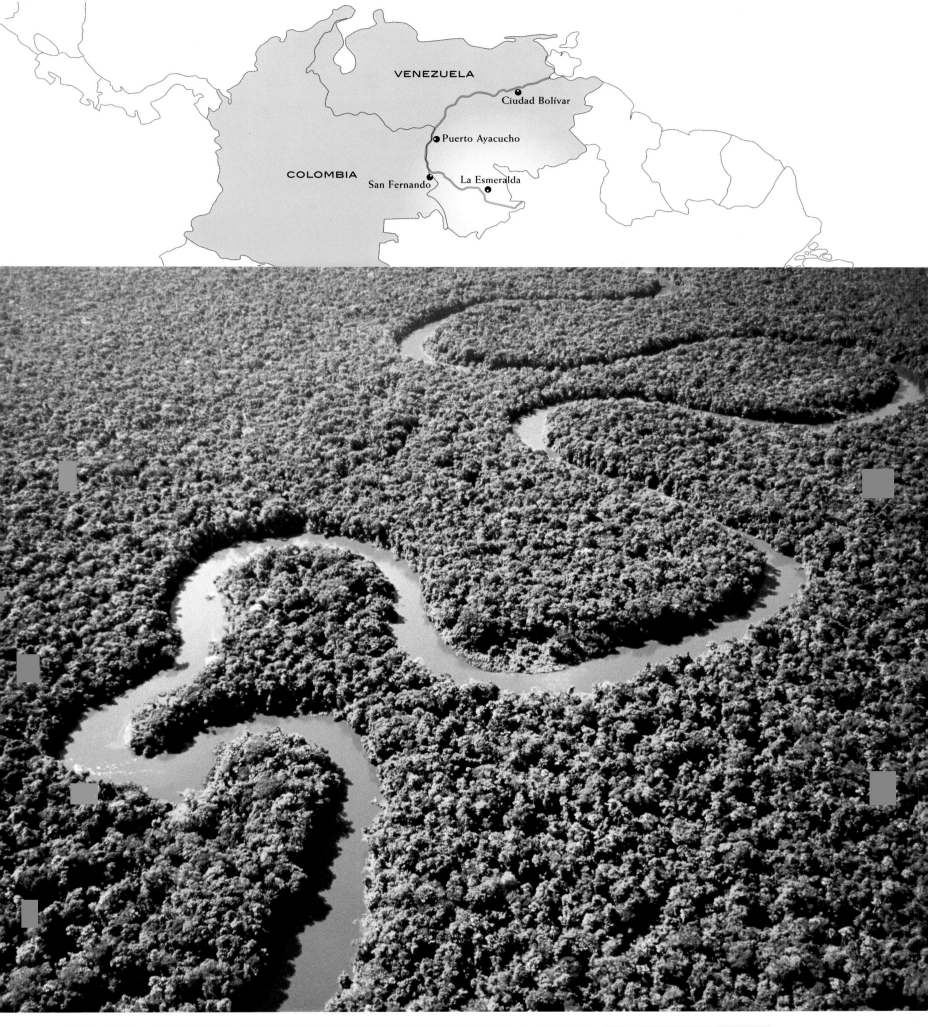

264-265 *La Esmeralda region, which is traversed by the Orinoco, is one of the least known in Venezuela. In this stretch the river flows slowly in bends whose curves are gradually accentuated, often becoming perfect semicircles.*

265 bottom *Fed by a myriad of tributaries that are generally very deep and contain a large volume of water, the Orinoco widens in a vast, marshy bed that in some points is as much as 650 ft (200 m) wide.*

266-267 Indifference and pride are manifest in the glance of this Yanomami Indian who is idling in his village near the sources of the Orinoco River in Venezuela.

266 bottom Hunting and gathering wild forest fruit are main subsistence activities of the Yanomami, who also practice a sort of itinerant agriculture based on the simple "slash-and-burn" system. Sweet potatoes, manioc, bananas and tobacco make up their diet. The Yanomami also grow cotton, which they use to make hammocks, clothing and other indispensable everyday articles. The first contact the Yanomami tribe had with the outside world was in the early 20th century.

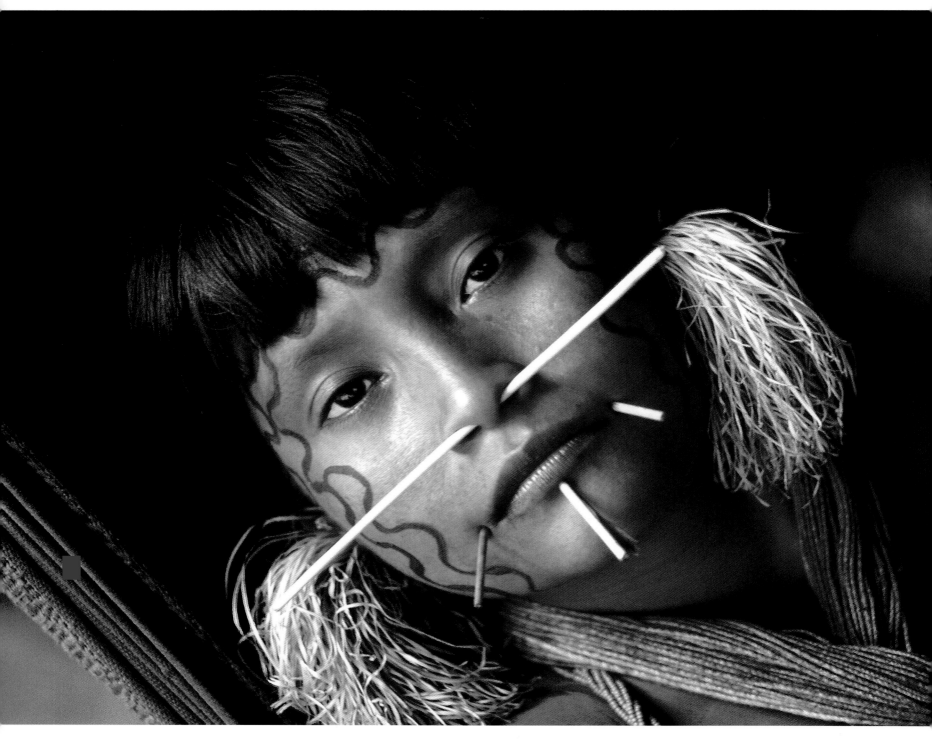

THE ORINOCO

267 top Ebene, a hallucinogen made from different types of plants, is sniffed through a long reed. The trance induced by this drug allows the Yanomami shamans to make contact with the world of the spirits.

267 bottom The long Yanomami bows, used for war and hunting in the forest, have considerable power. The arrows are often poisoned with curare, an extract of a wild liana belonging to the Strychnos genus.

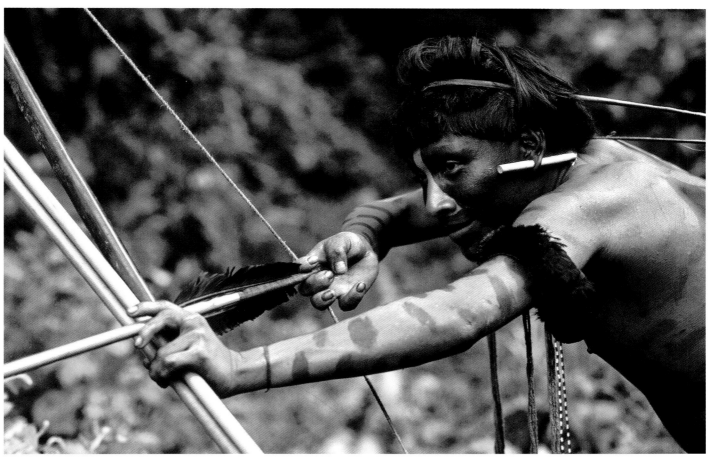

The sources of the Orinoco were located only in the early 1950s and to this day, although the area cannot be considered unexplored, it is one of the least known in Amazonia.

The Orinoco rises at the slopes of the Pico Redondo, in the Serra Parima, about 3300 ft (1000 m) above sea level. Initially it is torrential and its descent is often interrupted by rapids. At the confluence with the Mavaca it is already about 100 ft (30 m) wide. A series of important tributaries increase the flow of the Orinoco, which, after receiving the Padamo, runs in a broad, deep bed between two walls of vegetation. About twenty ethnic groups live in the forests of the upper and middle course of the river. Some tribes, protected by the impenetrable land, remained isolated from the outside world until quite recently, maintaining their original social order and identity. The Yanomami, who

number about 15,000, live on the Venezuelan-Brazilian border. Their culture is greatly influenced by their surroundings. For them the forest is something more than a store of material resources to be exploited. The round stockades that defend the fortified villages mark the boundary with the invisible world populated by spirits and demons with whom the natives must periodically enter into contact with the aid of psychotropic drugs. The welfare of the tribe is based on a symbiotic spiritual relationship with supernatural powers that ensure successful hunts, good crops and the survival of the tribe. Collective ecstasy strengthens the unity of the group, which is continuously menaced by wars and fratricidal violence. Like most of the Amazon tribes, the Yanomami poison their arrows with curare, an extract of the *Strychnos* genus of liana. Von Humboldt was able to

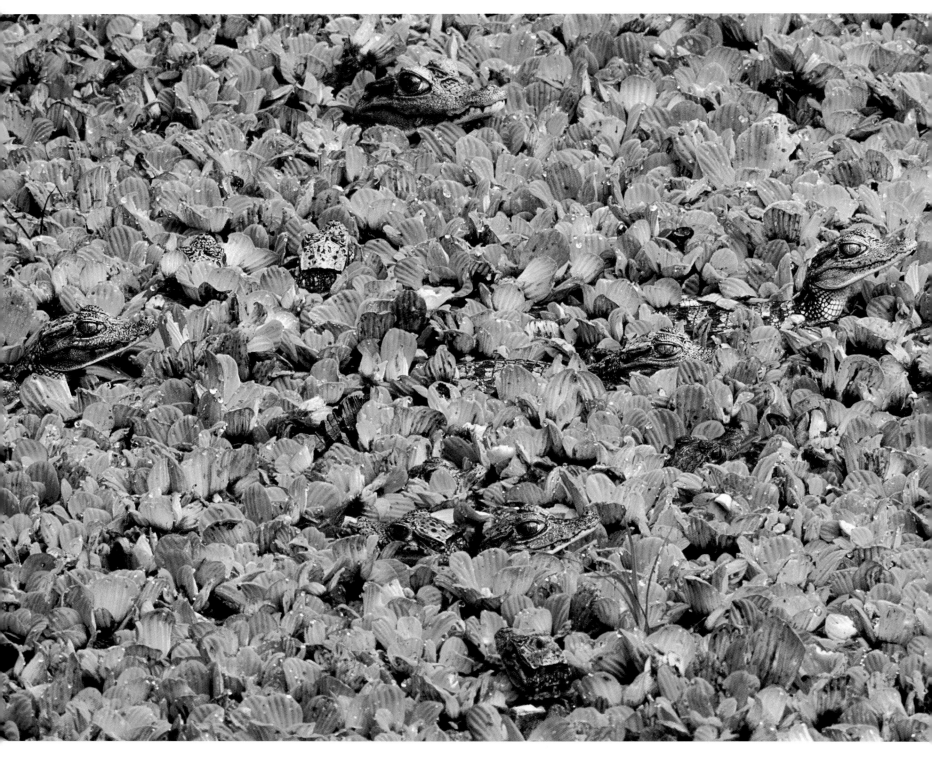

THE ORINOCO

268-269 and 269 The marshes and stagnant bends of the Orinoco, which are covered with floating grasses, are the favorite habitat of caimans. These crocodilian reptiles are distinguished for the unusual width of their eye sockets. They may reach 8 ft (2.5 m) long and feed on fish, birds and small mammals. Contrary to popular belief, the Orinoco caimans are not dangerous for humans.

268 bottom left A flock of ibises flies over the flooded Llanos lowlands in Venezuela. During the rainy season this maze of lakes, pools and canals formed by the Orinoco attracts a great number of aquatic birds.

268 bottom right The many species of reptiles, mammals, fish, and birds, as well as the more than 10,000 different plants in the Orinoco basin are an ecological patrimony with few equals in the world.

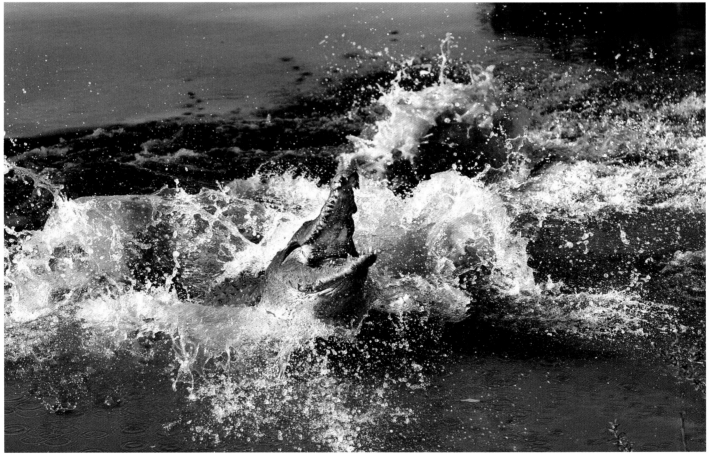

observe the preparation of this poison, which is so potent it can kill a large mammal in a few minutes. Curare, like so many other plant extracts from the Amazonian jungle, is now used for medical purposes. In only 2.4 acres (1 hectare) of land around the upper course of the Orinoco, 87 different species of trees have been identified, a variety that has few equals in the entire world.

In its voyage to the ocean the river passes through a number of different environments: mountains, rain forests, marshes, alluvial plains. The water is the feature that conditions the existence and adaptation processes of humans, animals and plants alike. There are rivers with murky, transparent or milky waters, waterways of every type, in such prodigious quantities that they even create the only natural floodway in the world, the Casiquiare.

A short distance past La Esmeralda the Orinoco branches off and one-third of its water ends up in an affluent of the Río Negro and then in the Amazon River. This phenomenon is caused by

the unusual amount of rainfall along the upper course of the Orinoco and the absence of a dividing range between the basins, which at this point are separated by a gradient of only a few dozen feet. The Casiquiare, which is 248 miles (400 km) long, rises as an outlet of an enormous lake created by the river floods over the centuries. Near La Esmeralda a chain of mountains with flat peaks, known as tepuy, emerge from the forest, lending a primeval character to the setting: in fact, the Marahuaca highlands, 600 million years old, inspired Conan Doyle's novel The Lost World. The Orinoco continues its course toward the northwest, receiving the waters of the Venuari and then, at San Fernando, those of the Guaviare and Atabapo. This triple confluence is an example of the multifarious water system in Amazonia: the Guaviare rises in the Andes and the silt in suspension lends it a yellowish color; the Atabapo is a 'black' river of the forest, colored by the plants soaked in the water; and the waters of the

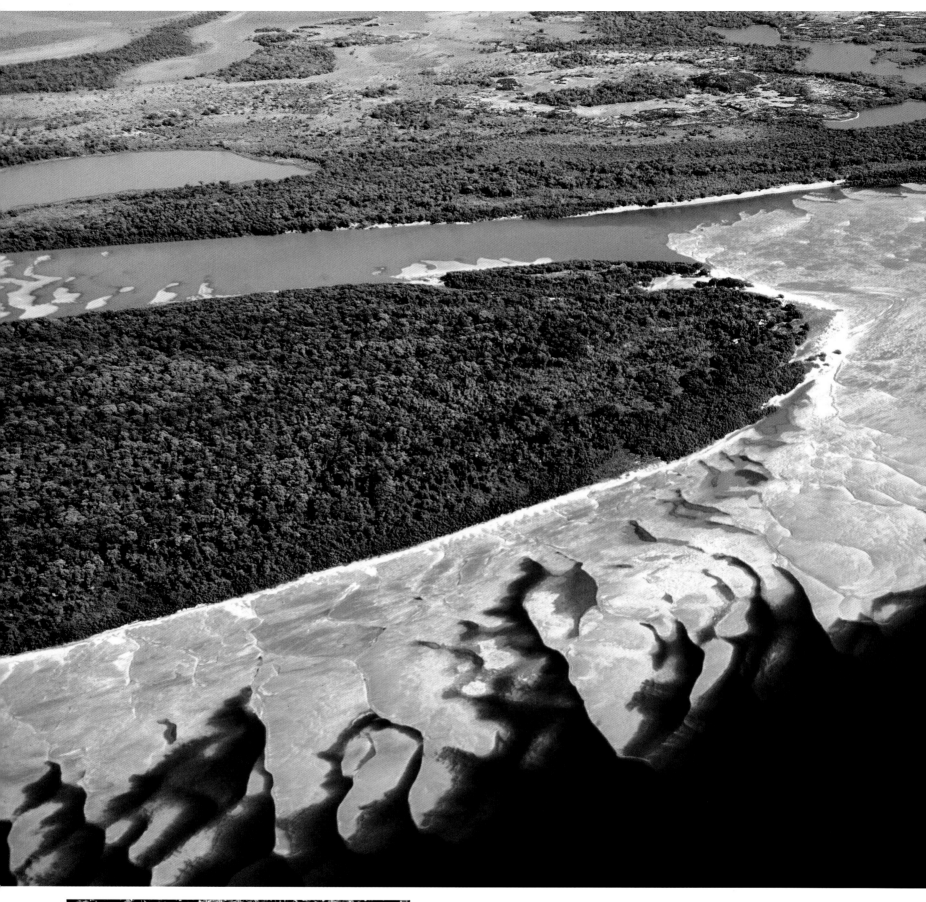

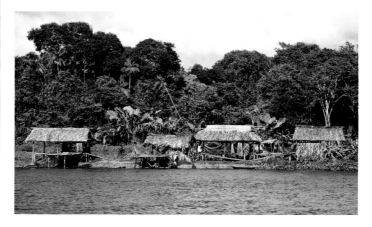

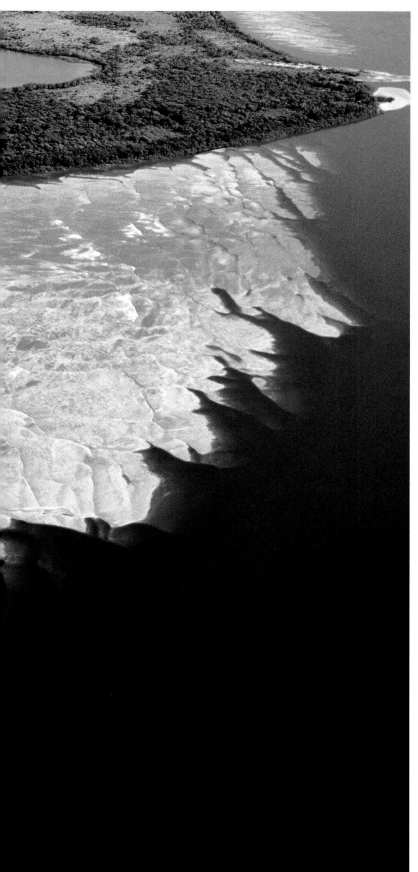

THE ORINOCO

271 center and bottom The Orinoco, Apure and Auraca are the main rivers receiving the inflow of the huge network of waterways that constitute the Llanos, the easily flooded lowlands covering about 116,000 sq. miles (300,000 sq. km) in northwestern Venezuela. From June to November the quantity of water emptied by the Andean affluents in the western plains of the Orinoco is equal to the discharge of all the rivers of Italy together.

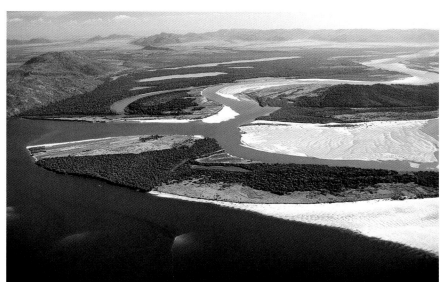

270-271 and 271 top Between Puerto Ayacucho and Ciudad Bolívar the Orinoco seems to lose its shape and even its identity. In the immensity of the Venezuelan Llanos the borders of the riverbed become indefinite and vanish in the succession of fragmentary, variable landscapes shaped by the changing seasons. The lagoons, woods and sand bars that border the river banks are nothing more than flashes, episodes of a continuous dialog between land and water.

270 bottom left The dugouts used by the local tribes that live along the upper Orinoco are usually single tree trunks hollowed with axes and fire.

270 bottom right Often, the villages along the banks of the Orinoco consist only of a few wooden huts nestled between the forest and the river.

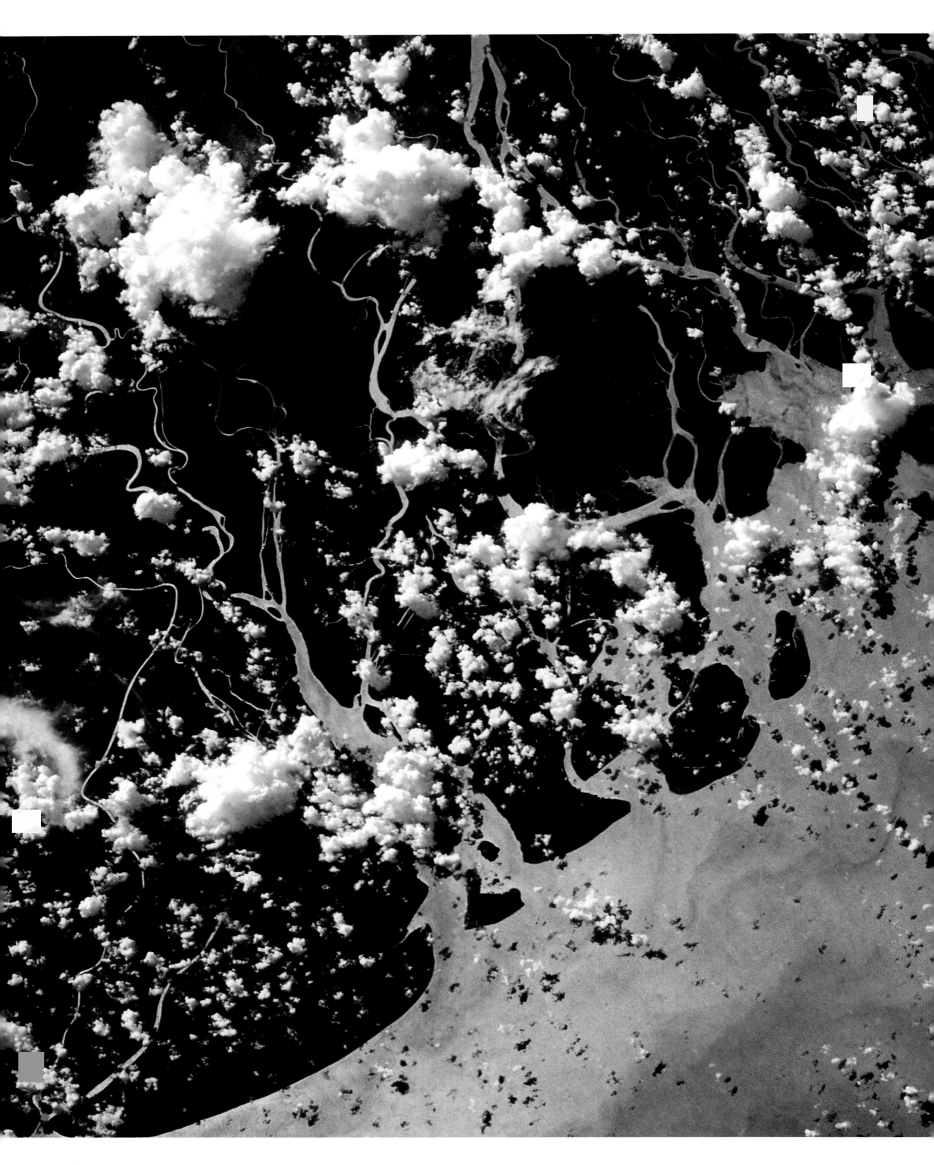

THE ORINOCO

272-273 *The waters of the Orinoco thrust into the Atlantic for miles, creating a huge milky area around its mouth. The delta covers about 9650 sq. miles (25,000 sq. km).*

273 top *According to the Warao tribe, which has been living in the Orinoco delta for centuries, the world is a flat plate surrounded by water. This isolated hut built on stilts to avoid being submerged by the tides seems to corroborate the legend.*

273 center *A straight line separates the leaden waters of the Caroní from the muddy Orinoco, which a short distance farther on splits up into the numerous canals of the delta. Ciudad Guayana, situated at the junction of the two rivers, is one of the most important commercial centers in Venezuela.*

273 bottom *Only one bridge connects Ciudad Bolívar, formerly called Angostura, to the opposite bank of the Orinoco. The city was named after Simon Bolívar, the national hero who in 1813 freed Venezuela from Spanish dominion.*

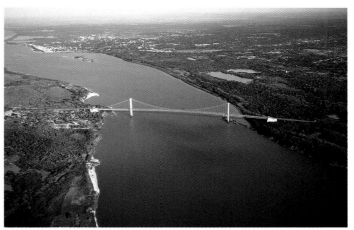

Orinoco are crystal-clear. Farther downstream, at Puerto Ayacucho, there are the Atures and Maypures rapids, 50 miles (80 km) of foam and whirlpools between rounded granite cliffs.

After leaving the Colombian border, the Orinoco flows majestically toward Ciudad Bolívar and the delta, and to the north there is the endless horizon of the llanos, the often-flooded savannas. These wetlands constitute an ecosystem in itself that is the home of some of the most varied and rich fauna in South America. Flowing sluggishly among sand bars and lagoons, the Orinoco becomes a vast delta that is 14 miles (22 km) wide and 330 ft (100 m) deep before it empties into the Atlantic Ocean in a maze of canals and inlets. As in a boundless mirror, the past and future of Venezuela are reflected in its waters.

THE AMAZON

THE KING OF RIVERS

Slowly, amid the creaking of the metal, the boat is hoisted up the slope until it reaches the top of the hill, slipping into a ditch of reddish mud.

Here there is nothing else but water and trees. The epic and crucial scene of the film *Fitzcarraldo* by the German director Werner Herzog describes the essence of lucid madness. Perhaps no boat ever ended up on the top of a mountain in the heart of an equatorial jungle, but this image reveals how much the primeval environment of Amazonia can stir human imagination. About 500 years ago, the Spanish soldiers led by Francisco de Orellana came out of the depths of the great rain forest describing a tribe of women warriors: nude, armed with bows and arrows, they fought ferociously against whoever dared enter their territory. They had relations with men only to perpetuate the tribe, killed male children and taught their daughters the art of war.

To this day the name of the Amazon River has been tantamount to legend. For centuries the great river has embodied the idea of the unknown: a dreamlike place where space and time merge in an indistinct flux of life and the

normal criteria regulating the known world lose all value. The explorers and adventurers who dared to descend into the depths of this Green Inferno, emerged in a state of bewilderment and grogginess: they spoke of 66-ft (20-m) long snakes, monstrous plants, fish with teeth so sharp they could pick a cow clean in a few minutes, headhunters, and poisoned arrows. Part of what they said was true, albeit exaggerated; another part was pure fantasy, even lies.

A sort of collective delirium seems to accompany the entire history of Amazonia. Not even the most pragmatic people managed to avoid this contagion. Everything seemed possible in that context, even building an opera house with a seating capacity of 1600 at Manaus, a thousand miles from the nearest sign of civilization. In 1924 Henry Ford, the magnate of the automobile industry, spent millions of dollars to launch a rubber tree plantation along the Río Tapajoz, upstream from Santarém: in no time two new cities rose up, Fordlandia and Belterra, supplied with electricity, hospitals and modern infrastructures. The project failed; paradoxically, the hevea rubber plants, which grow spontaneously in the entire Amazon basin, did not grow well in the fertile land of Tapajoz. And more recent projects did not fare any better. About twenty years ago an American businessman spent a huge amount of money in an attempt at forestation along the Jari River, near the Amazon River delta. The plant and powerhouse, which were built elsewhere and moved piece by piece at this site, now lie abandoned, waiting to be utilized for another purpose.

The Amazon forests are a cemetery of illusions; they have swallowed up railways, industrial plants and entire towns, all of which rose up and died in the blink of an eye. The river itself is well beyond the human dimension: in this respect, all the other great rivers in the world pale compared to the Amazon. Only the Nile is longer, but its discharge is 100 times smaller. During the flood stages the Amazon empties over 7 million gallons (200,000 cubic m) of water per second into the Atlantic, which in one day amounts to a quantity enough to meet the needs of all Western Europe for six months. Its current attenuates the salinity of the ocean so much that it creates a sort of huge freshwater lake that extends over a vast area. More than 1000 tributaries are part of the Amazon River basin, which with its 2.7 million sq. miles (7 million sq. km) occupies about half of Brazil and large areas of Peru, Colombia, Ecuador and Bolivia. Some of these affluents are longer and have a larger discharge than the largest European rivers. Seven of them are well over 1250 miles (2000 km) long, and the Río Purus, which rises in the Peruvian Andes, is almost as long as

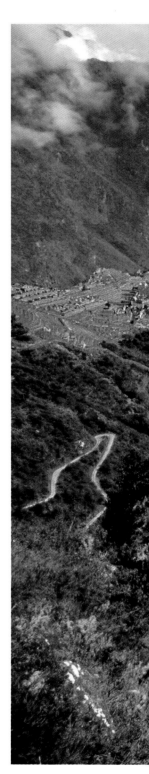

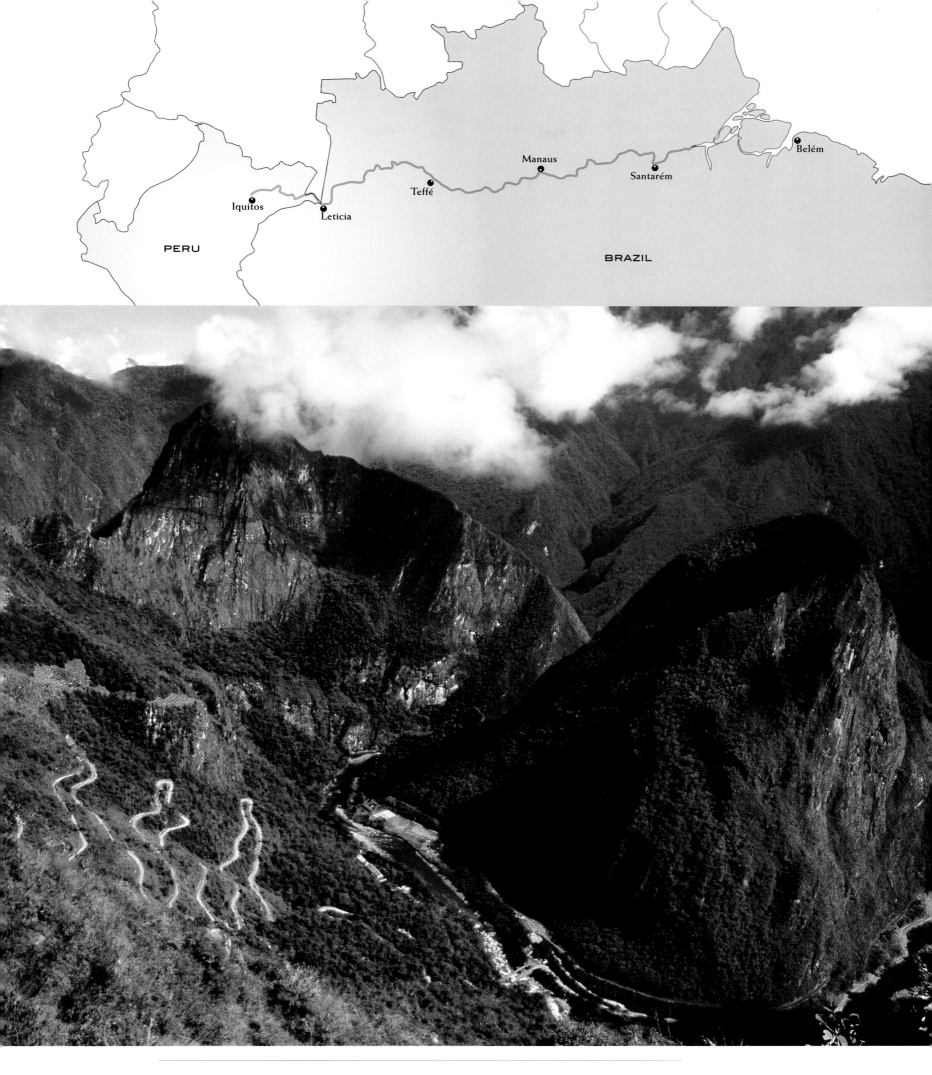

274 top The Urubamba, one of the headstreams of the Amazon River, begins in the eastern Cordillera of the Peruvian Andes and after about 435 miles (700 km) flows into the Tambo-Ucayali system.

274 bottom and 274-275 Steep rock faces covered with vegetation accompany the course of the Urubamba through the east spurs of the Peruvian Andes. The region between the Apurímac and the Urubamba was the political and religious center of the Inca civilization. Situated in this disturbingly beautiful land is Cuzco, the City of the Sun, and mysterious Machu Picchu, which was discovered by archaeologists only in the early 20th century.

276 top Ruins of ancient cities, stone walls and the colossal remains of temples built with enormous squared blocks of stone put together with incredible precision dot the course of the Urubamba and the Sacred Valley of the Incas.

276 bottom The upper course of the Urubamba is flanked by steep mountains with very little vegetation and is fed by the abundant rains that fall on the east slopes of the Peruvian Andes from February to April.

276-277 A network of fields where corn, potatoes, barley and vegetables are grown covers the tablelands bordering the Urubamba River in the Peruvian Andes. This region is inhabited by the Quechua, the descendants of the Incas.

THE AMAZON

the Volga. The Seine, Thames and even the majestic Rhine look like insignificant waterways compared to the Río Negro, Madeira, Tocantins, Putumayo, Japurá and dozens of other little known South American rivers.

The Amazon is also a perfect natural waterway. It is as wide as an inland sea and in certain stretches is up 230 ft (70 m) deep; it can be navigated even by medium-size ships as far as

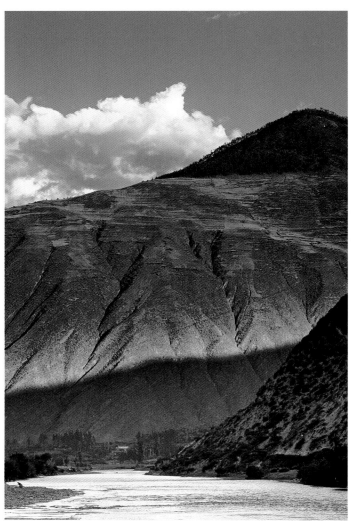

the port of Iquitos, Peru, 2300 miles (3700 km) from its mouth. Before the Andes were forged 15 million years ago the Amazon plain overlooked the Pacific Ocean. From the huge lake that grew up at the edge of the mountain range, the water slowly began to open its way eastward, creating a passage in the continental shield and gradually filling it with detritus. The geological developments that led to the formation of the Amazon River can be seen in the appearance of the basin, which opens fanlike westward and then narrows a short distance before Santarém, flowing between the crystalline outcrops of the shield, made up of very ancient and very hard rock. The constant deposit of silt has created a level, almost totally horizontal, landscape: when the river enters Brazil, at the confluence with the Javari, the gradient as far as the ocean is only 264 ft (80 m).

The genealogical tree of the Amazon is quite complex. Its first headwaters, or at least those farthest from the mouth, are situated in a remote mountain area in southern Peru, at an altitude of over 16,500 ft (5000 m). The torrents that rise at the Chila and Ampato peaks flow into the Apurímac, which hurls down along the steep slopes of the Andes, becoming first the Ene and then the Tambo. The Tambo receives the Urubamba and then flows into the Ucayali. The successive merger of the Ucayali and the Marañon gives rise to the Amazon River. Having increased its volume with the waters of the Marañon, the river continues its course up to Iquitos, the only large city in Peruvian Amazonia. At the confluence with the Río Napo, which arrives from Ecuador, the Amazon changes direction, moving placidly toward the Brazilian border, where is it called the Solimões River. Its bed becomes wider and wider and then the river splits up into secondary arms that wander for miles in the forest, intersecting with the affluents or emptying into large permanent lagoons.

The boundaries and configuration of this colossal network of channels and emissaries are vague, they fluctuate and change with the alternation of the low- and flood-water stages. The changes in the size of the river are continuous, because in that boundless area the rainfall is not only always abundant, over 80 inches (2000 mm) per year, but is extremely variable from zone to zone. In general, it can be said that south of the Equator the rain falls from October to April, while to the north the rainy season includes the spring and summer months. The maximum flow of water for the Marañon, the Ucayali and the other tributaries from the Andes is in spring. Furthermore, the volume of the flood stages depends on the section of the river:

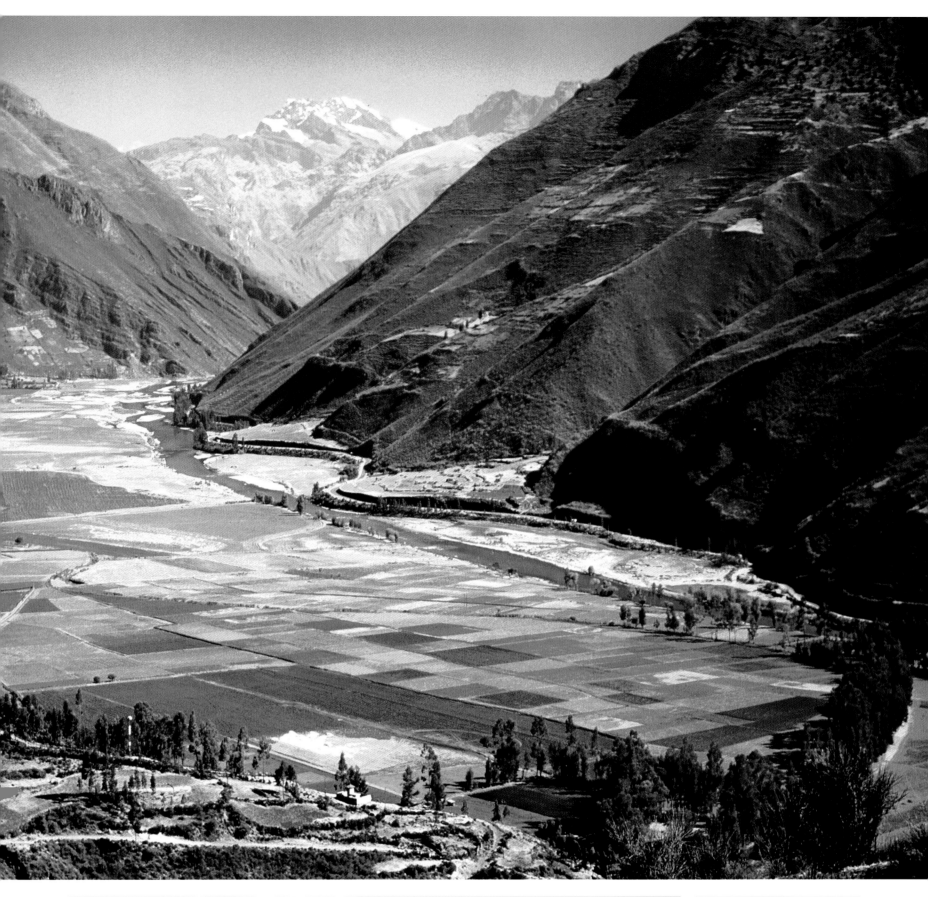

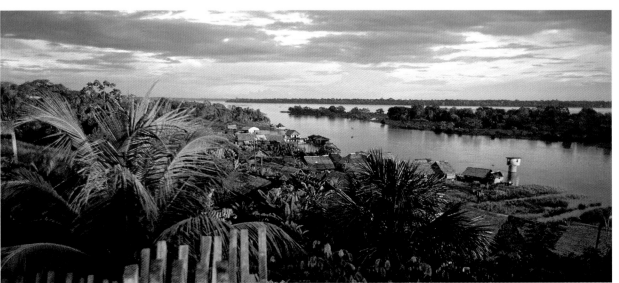

277 bottom For the inhabitants of many villages in northeastern Peru the Amazon River is often the only means of communicating with the outside world. The river is navigable for large boats as far as Iquitos, about 2300 miles (3700 km) up river.

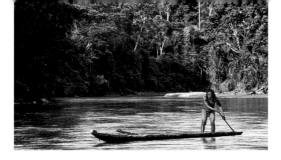

THE AMAZON

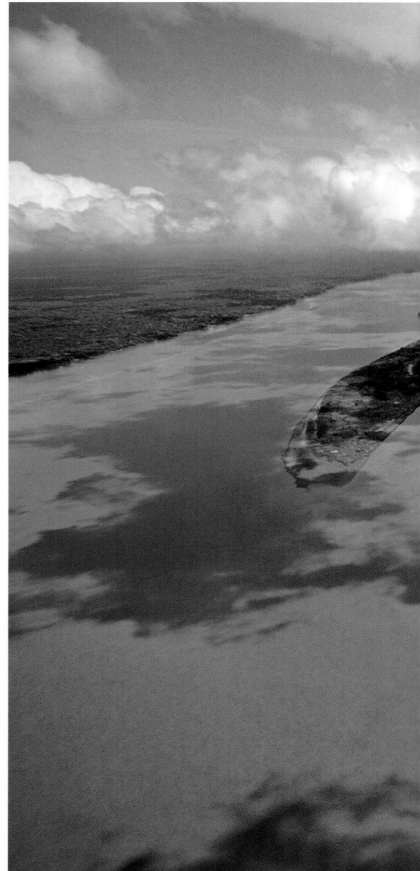

278 top Fishing is one of the main means of subsistence for the indigenous populations that live along the Amazon River.

278 center and bottom Boundless forests, islands, and huge sand bars characterize the middle and lower course of the Amazon, which

as it enters Brazil is called the Solimões. Over a thousand tributaries constantly feed this great river, which proceeds lazily toward the ocean with a very slight gradient. Its basin, much like a gigantic shell, takes in about two-thirds of the running water in the whole world.

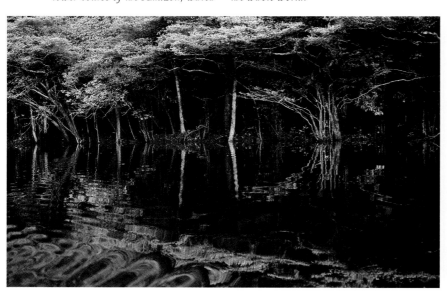

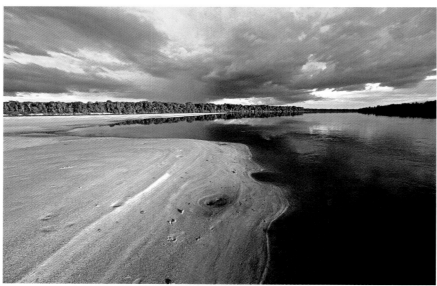

in the same period the water level may increase by 20 ft (6 m) at Iquitos, four near the mouth of the river, and twenty at Teffé, in the middle section of the Solimões. Thanks to evaporation, the Amazon rain forest itself produces three-quarters of the rainfall there, in an almost perfect closed cycle. Despite the basically homogenous nature of this immense organism, it is really extremely complex.

Besides the permanently flooded areas, there are two main types of rain forest: the so-called terra firma and the várzea. The former occupies almost all the Amazon basin and extends onto more elevated areas that border the river valleys. The abundance of plant species here is astounding: in certain zones as many as 3000 different plants have been classified. Some trees grow to enormous heights, sometimes 198 ft (60 m). And

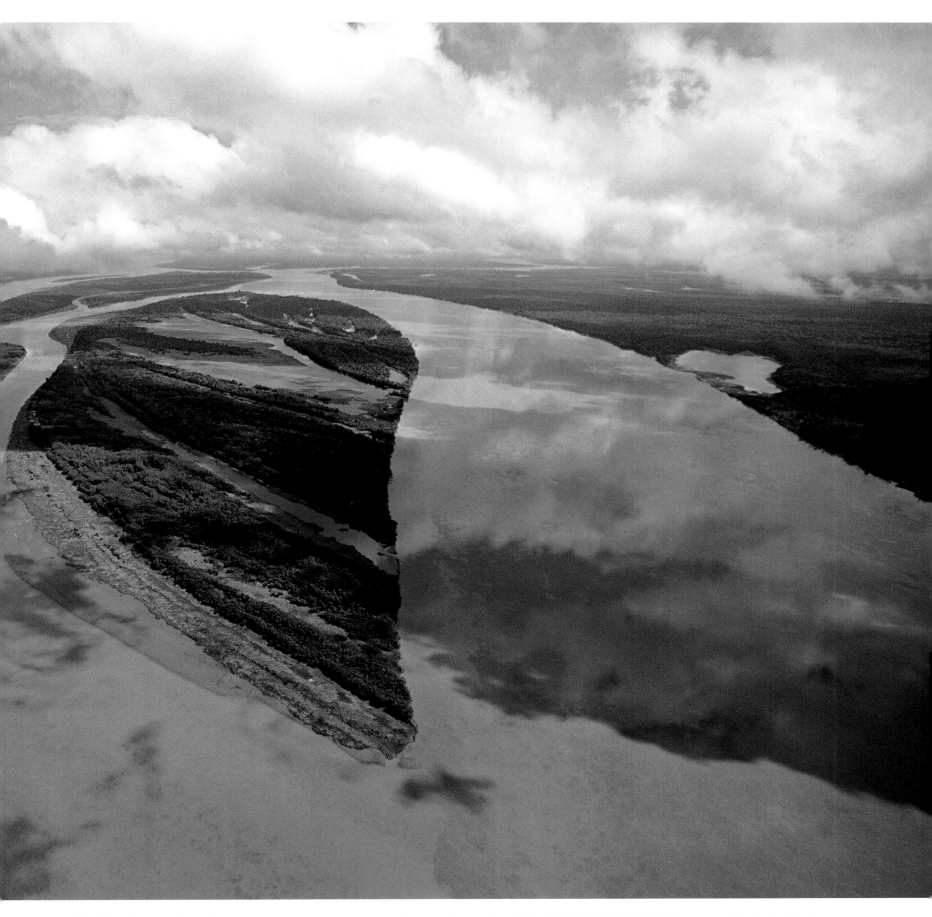

278-279 Continuously reshaped by the seasonal floods, the low islands dotting the Amazon River are covered with luxuriant vegetation. In Brazil, at no less than 950 miles (1500 km) from its mouth, the river is over 6 miles (10 km) wide.

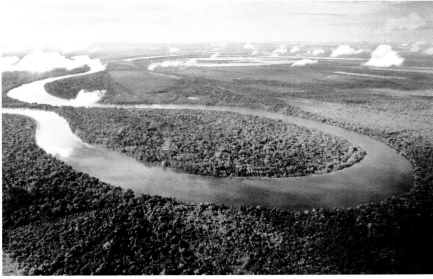

279 bottom As it flows through the Brazilian rain forests, the Amazon extends in a landscape with vast horizons that is in a state of continuous flux.

280-281 No map of Brazil has details of this stretch of the Amazon, which is suffocated by the rain forest and is refilling one of its many dry branches.

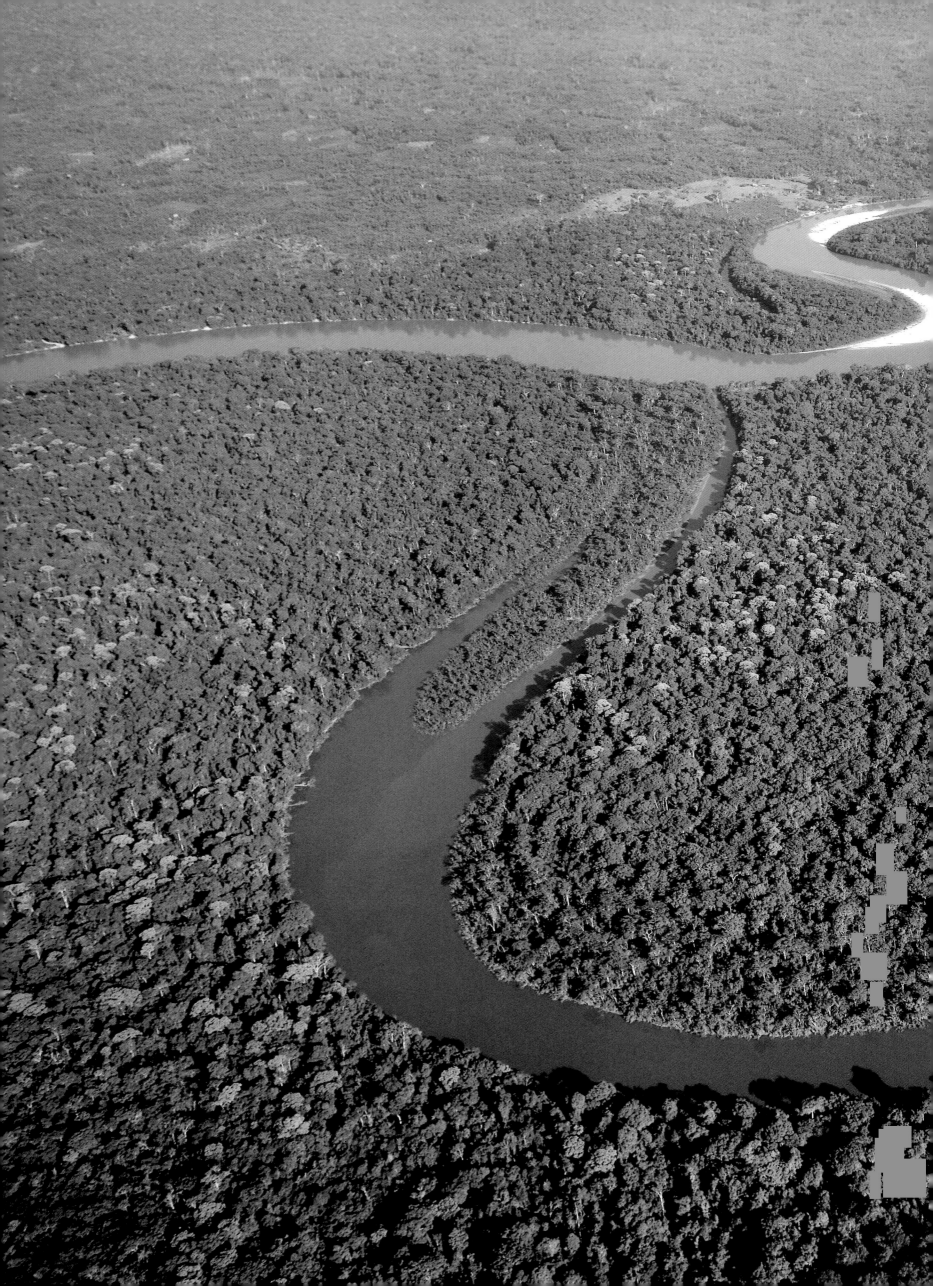

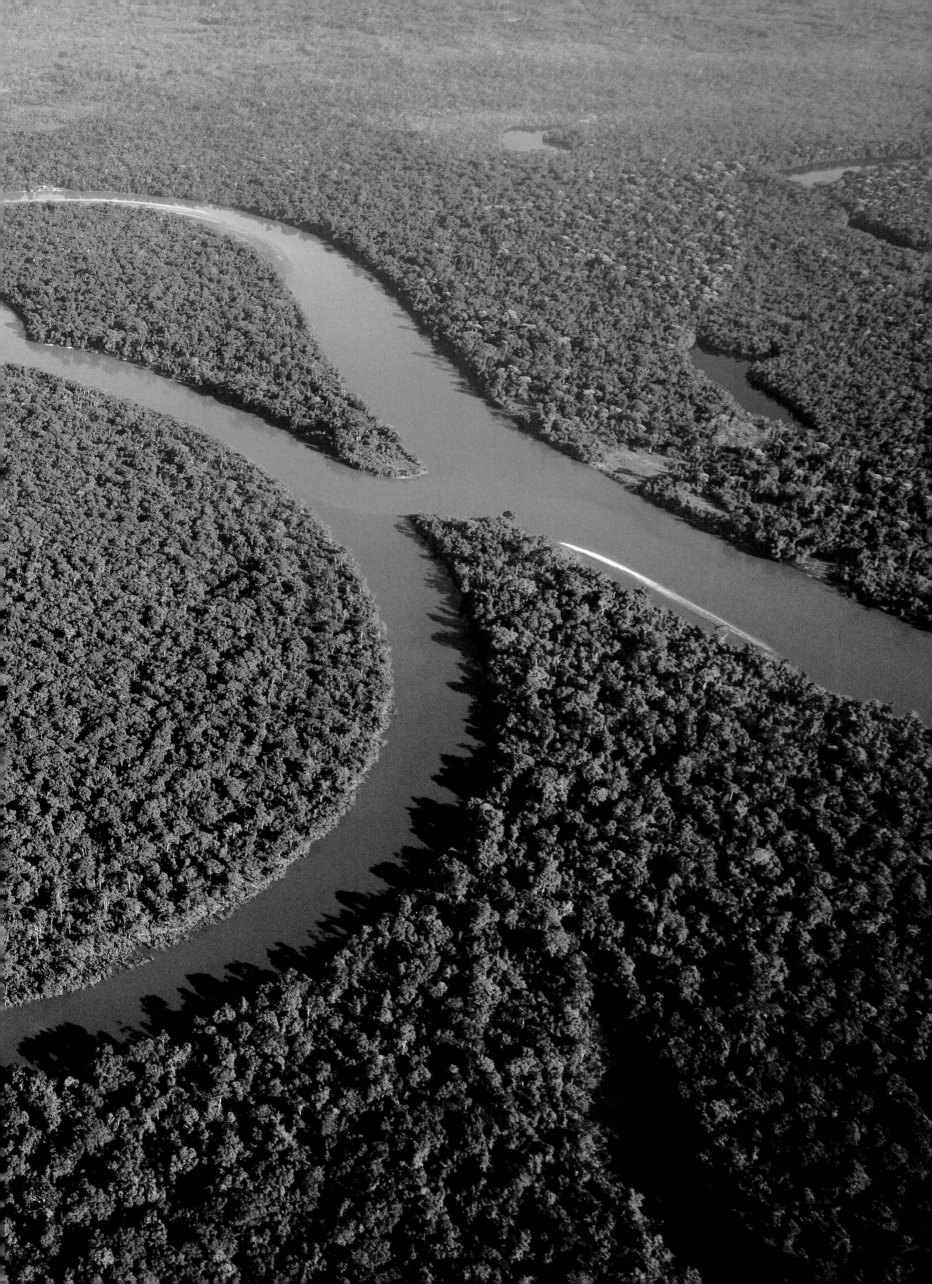

THE AMAZON

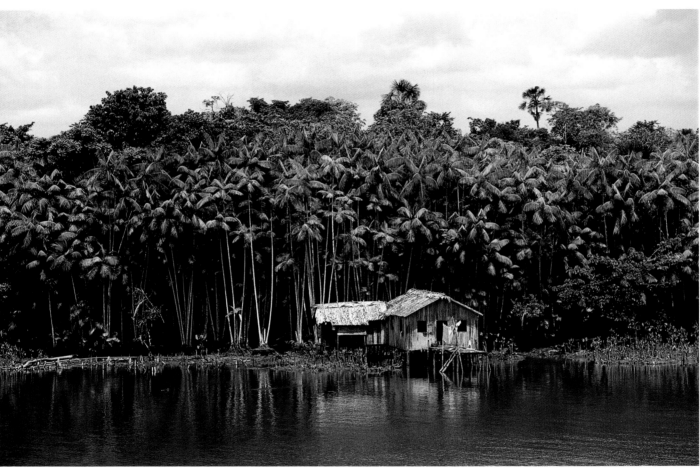

yet the soil of the terra firma, which is continuously inundated by violent rainfall, has hardly any nutritional substances at all. The indigenous populations in this type of environment live basically on hunting and gathering wild fruit, and practice shifting cultivation, using the traditional "cut and burn" method. This consists of burning small lots of forest and using the ashes to fertilize the earth, thus producing good harvests for a few years, after which the land becomes unproductive once again. The need for continuous moves in search of new areas to cultivate entails a semi-nomadic lifestyle. In the várzea, which is subject to seasonal flooding, the survival strategies are quite different. These forests lie in a belt from about 3 miles to 50 miles (5 km to 80 km) wide on either side of the Amazon River and some of its affluents. The silt deposited by the river during the flood stage cyclically fertilizes the fields, which are used to cultivate corn and cassava. The population in these areas is sedentary and lives in large communities whose social organization is more complex and articulated than that in the other type of rain forest.

In the villages as well as in the towns, the inhabitants of Amazonia depend on the river to get around. Despite the fact that uncontrolled deforestation and the exploitation of minerals in the region are underway at an alarming rate, the forest is mostly virgin and impenetrable. Much more ancient that the forests in the temperate zones, the Amazon rain forest could be compared to a vast greenhouse in which the temperature and humidity level have remained the same for tens of thousands of years. The adaptation of plants and animals has reached levels of specialization that are unthinkable elsewhere, in their incessant struggle for survival. As the Brazilian scholar and traveler Claudio Villas-Boas stated, in this shady and hot world "everything participates inexorably in a single, gigantic, uninterrupted process of fecundation, digestion and excretion." And the river contributes directly to this process.

There are about 1500 species of fish in the Amazon, ten times more than those that are found in all the European

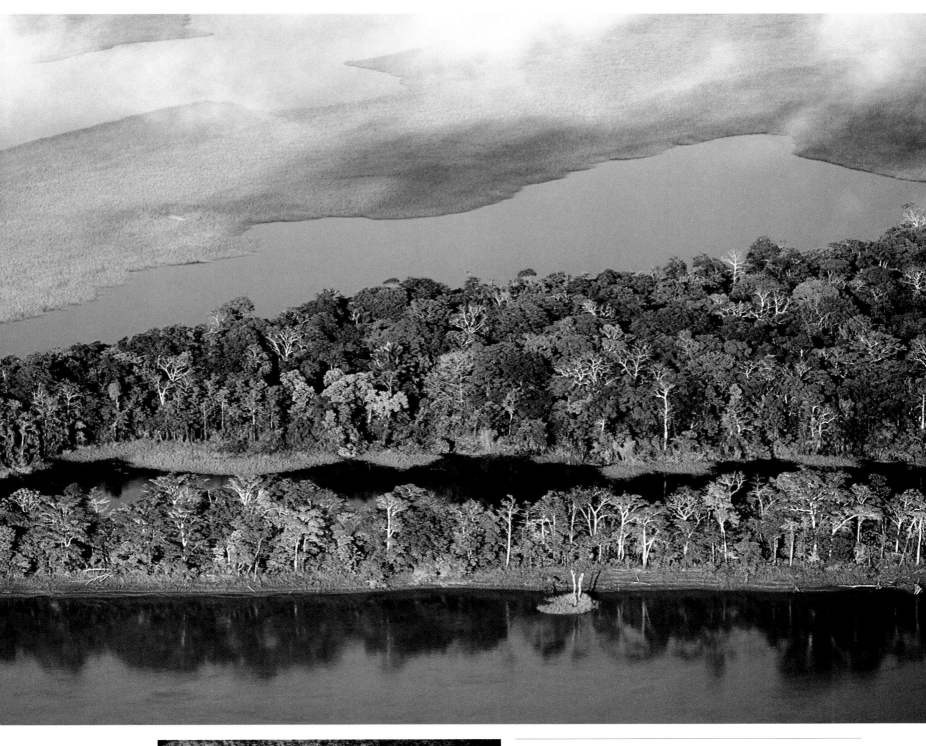

283 bottom left Arranged in a circle around a central plaza area, the huts of this village in Brazilian Amazonia house from 25 to 120 people.

283 bottom right The forest area that is periodically flooded by the river is known as the várzea. The water level here may rise as much as 50 ft (15 m), creating enormous lakes.

282 During the flood season the Amazon overflows into the surrounding forest, drowning about 27,000 sq. miles (70,000 sq. km). In flood zones, houses are built on stilts.

282-283 Vast marshy areas that are permanently flooded flank the banks of the majestic Amazon and its numerous tributaries in the vicinity of Teffé, upstream from Manaus.

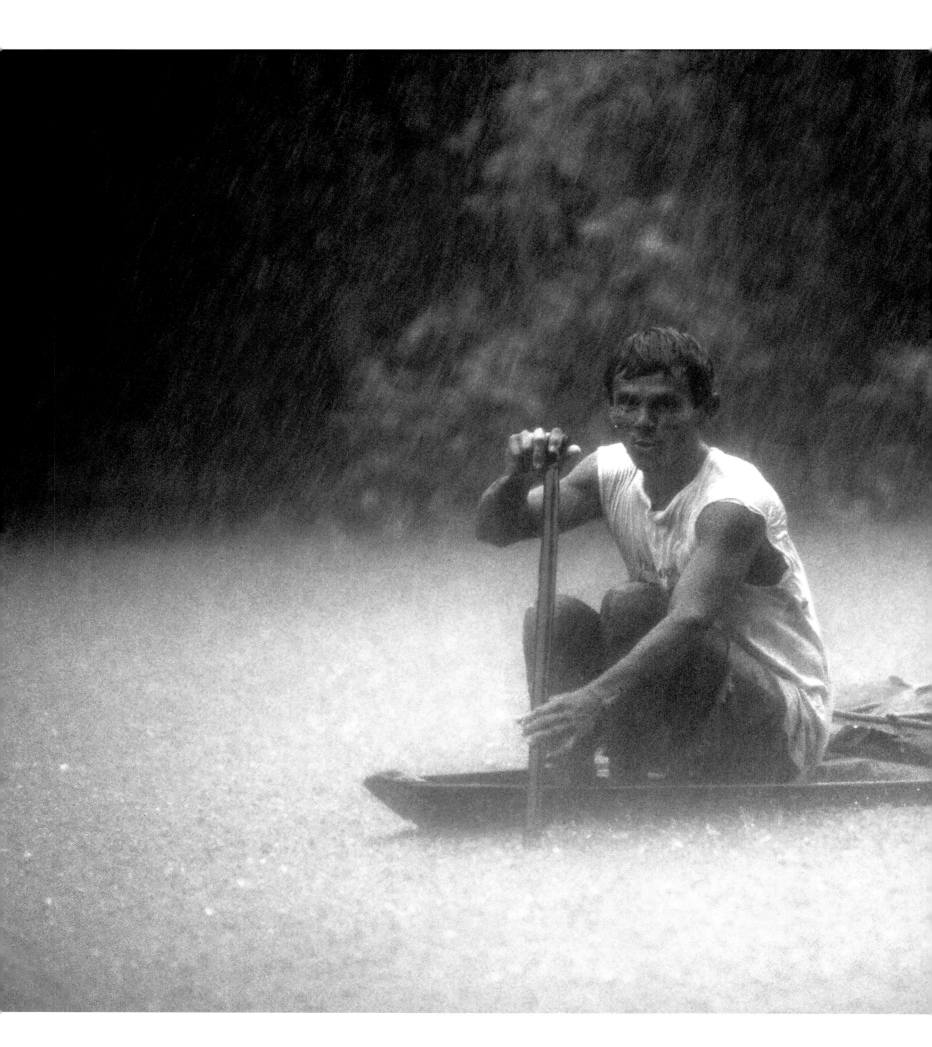

THE AMAZON

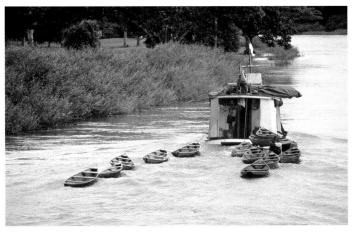

284-285 Indifferent to the pelting rain, a fisherman rows up one of the channels of the Río Negro in search of a suitable place to cast his nets. It has been estimated that over 2000 species of fish live in the Amazon River basin.

285 A few stone houses and a church, lost in the immensity of the Amazon forest, are enough to earn the name of "village" and be put on maps of Brazil. As the more isolated villages lack negotiable roads, their very survival depends almost entirely on the boats that continuously ply up and down the great river, guaranteeing transportation of both goods and passengers in every season.

286 top Caimans live in every part of the Amazon. These large, social reptiles often gather in large groups on the sandy beaches along the rivers and lagoons.

286 bottom Like their European cousins, the Amazon otters are playful and friendly creatures. Some of those belonging to the Pteronura genus may be as long as 6.5 ft (2 m) and weigh 65 lbs (30 kg).

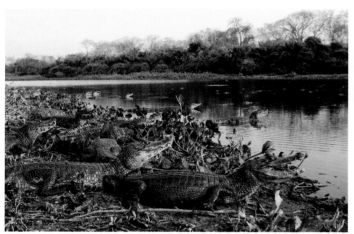

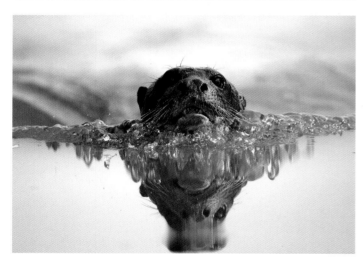

rivers together. Some of these fish are huge, such as the giant catfish and the pirarucu, a monster 10 ft ft (3 m) long that weighs up to 285 lbs (130 kg). A tiny creature that is much more frightening that the piranha is the candiru, a parasitic fish 2 to 5 inches (5 or 6 cm) long with a very sharp spines on its gill cover; it can enter the urethra or anus of men and animals, with consequences that often prove to be fatal. There are also fish with four eyes, fish that float on the surface of the water like leaves, and amphibious fish with gills and lungs. Large numbers of caymans, turtles, dolphins and lamantins still thrive in the Amazonian rivers together with a multitude of other creatures. However, a place of honor in the list of Amazonian fauna is reserved for the anaconda: Colonel Percy Harrison Fawcett, who disappeared in the Mato Grosso in 1925, gave a detailed description of a specimen that was 63 ft (19 m) long. And serpents from 33 ft to 40 ft (10 to 12 m) long are quite common here, at least according to the store of anecdotes regarding the Green Inferno. The more cautious naturalists think in terms of less than 26 ft (8 m), naturally with the

benefit of the doubt, since Amazonia still keeps a lot of secrets.

The Río Negro and other northern tributaries have very little silt and nutritious substances; even the insects, the ever-present scourge of every corner of Amazonia, are less numerous here than elsewhere. And yet, paradoxically, there is an abundance of fish. Recently it was discovered that the fish also feed in the flooded forests, which function much like a pantry when times are hard: seeds, insects and other edible material fall from the trees, creating rich underwater pastures. The Río Negro, which is 1395 miles (2250 km) long and has a

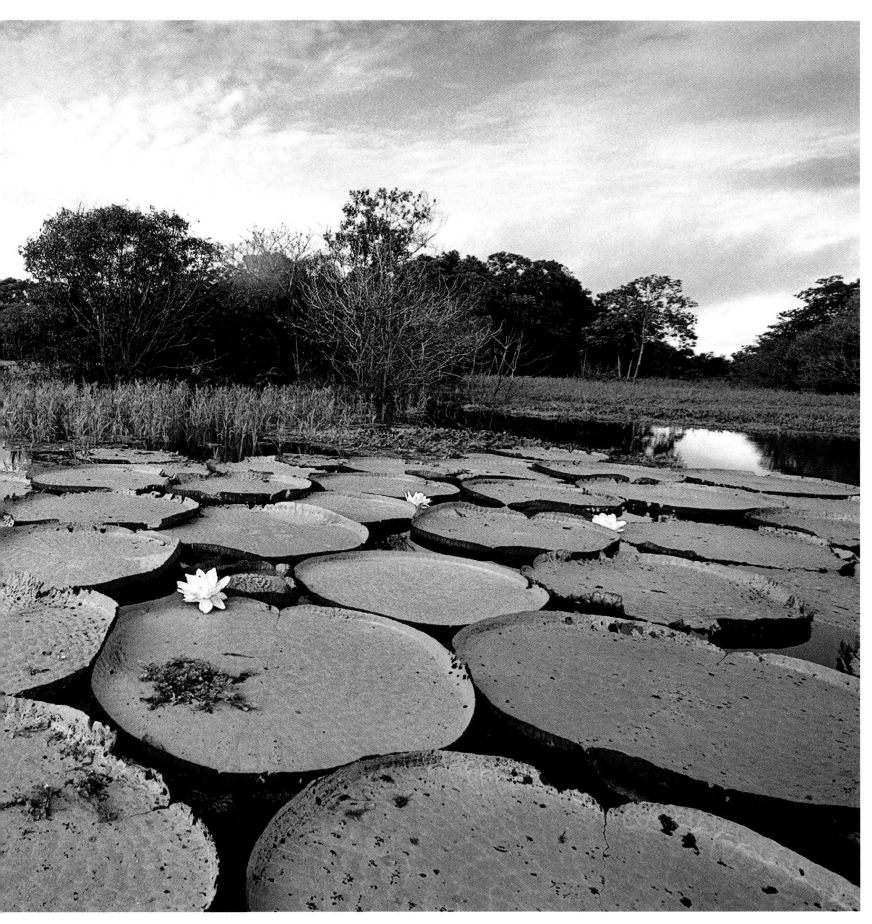

286-287 *The leaves of the* Victoria regia, *a gigantic species of water lily quite widespread in the Amazon, sometimes have a 6.5 ft (2 m) diameter. The seeds of this plant are used to make flour.*

287 bottom *Thanks to the extraordinary length of their toes, jacanas, which are always looking for food, can move around quite easily on the floating plants that cover the lagoons in Amazonia.*

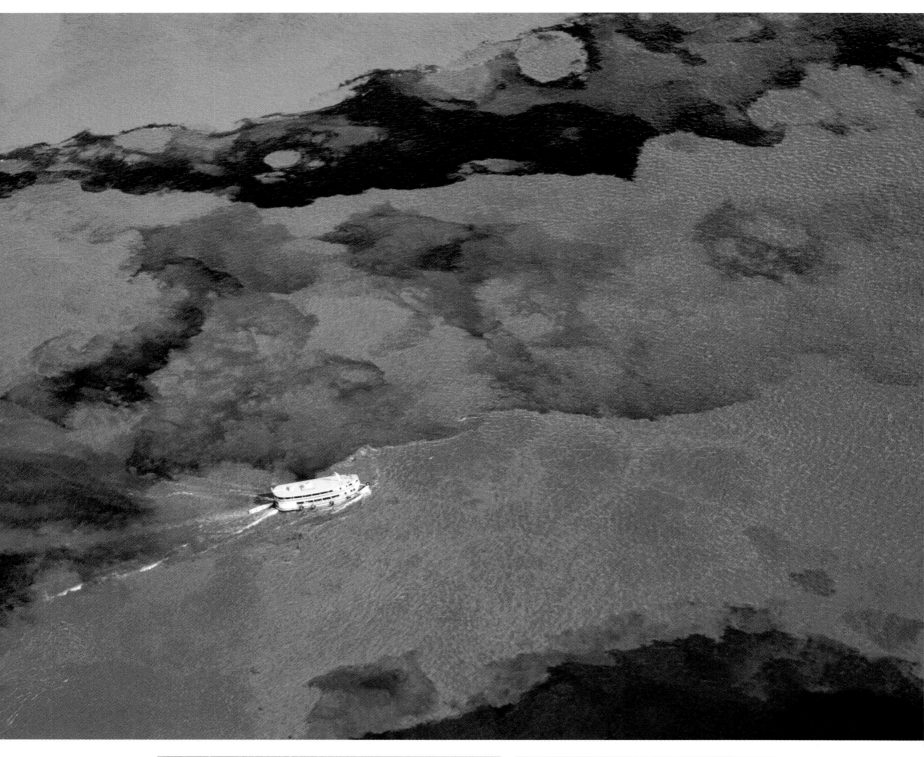

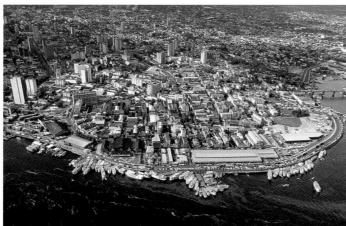

288 bottom right Most of the timber in Brazilian Amazonia is exported. Deforestation, which in 2002 involved 8880 sq. miles (23,000 sq. km), may well cause irreversible damage.

289 bottom Both transparent and reddish, the waters of the Río Negro contain almost no silt in suspension. The largest tributary of the Amazon issues from the rock formations that border Guyana.

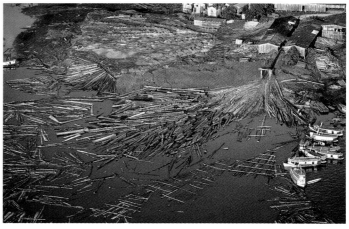

288-289 and 289 top The brown color of the Río Negro, caused by the concentration of plant substances that accumulate as the river flows through the forest, is in contrast with the water of the Amazon, which is made murky by the Andean silt.

288 bottom left Situated on the left bank of the Río Negro, about 1000 miles (1600 km) from the mouth of the Amazon, Manaus is one of the most important river ports in Brazil. The city has a population of over 1.5 million.

THE AMAZON

discharge equal to that of the Congo River, owes its name to its brown water, a color created by the great quantity of loose plant material. When the Río Negro approaches the Amazon, which is now murky because of the sediment washed away from the fragile rocks of the Andes, the two currents flow parallel to one another for about 50 miles (80 km) without mingling, as if separated by an artificial barrier. On the left bank of the Río Negro, about 12 miles (20 km) from the confluence with the Amazon, the Portuguese built a military outpost in the late 17th century. Barra do Río Negro was nothing more than a squalid village in the middle of the jungle and remained so for the two following centuries. Then something changed. Overnight, Barra became Manaus, one of the richest cities in the world.

It all began with the so-called rubber fever. The precious caoutchouc, a gift from the 'weeping tree,' was known from the beginning of time in America. The balls that bounced in the Maya ball courts were made of this rubber. The Indios of the forest used it to make their canoes waterproof, build unbreakable flasks, and make a number of other everyday and ritual objects. But rubber reached Europe only in 1738, in the luggage of the French naturalist La Condamine, who had used it to protect his scientific instruments during his trip down the Amazon River. Caoutchouc is a natural polymer like starch and cellulose that is obtained from the latex of different species of plants, especially *Hevea brasiliensis* or the para rubber tree, which is native to the Amazon basin. The industrial potential of rubber was understood only with the discovery of vulcanization: when treated at high temperatures with sulfur, the caoutchouc became more resistant and yet remained very elastic. The true revolution came about in 1888, when the Scotsman John Dunlop invented the first tire. The new product was in great demand and Manaus became the hectic sorting and distribution center of all the rubber in Amazonia. The 1000 tons exported in 1850 became 20,000 in the early 1900s and 80,000 in 1910. Thousands of rubber gatherers invaded the region, went up the most remote affluents of the great river as far as Ecuador and Bolivia, scouring the forest in search of rubber trees. The resinous liquid that pours out of the cuts made in the bark was fire-dried and shaped into sheets or bars weighing 66 to 88 lbs (30 to 40 kg). At the cost of unimaginable fatigue and privation, the caoutchouc arrived at the city from all corners of the forest, piled up on wharves ready to be loaded on to the ships bound for the port of Belém. A shower of money poured into Manaus, which became a modern metropolis, one of the first in the world to have electric tramlines. What is more, a transatlantic liner with first-class cabins linked it directly with Liverpool. A cathedral and opera house were built there, roads and squares were paved with stones brought from Portugal. The impetuous growth of the city ended in 1912, when the new para rubber tree plantations in the Far East proved to be more profitable.

Today Manaus is a city with a population of about 1,500,000. Its tumultuous past is a memory, but its life is still closely connected to the Amazon River, the only effective means of communication with the outside world. It takes three days to get from Manaus to the Amazon delta on the Atlantic coast, where the river skirts the island of Marajó in a maze of canals. Sometimes, when the water level is low, the tide manages to go up the river for hundreds of miles into the interior. Then the primeval power of the Amazon prevails and re-establishes its absolute dominion over nature and Man alike.

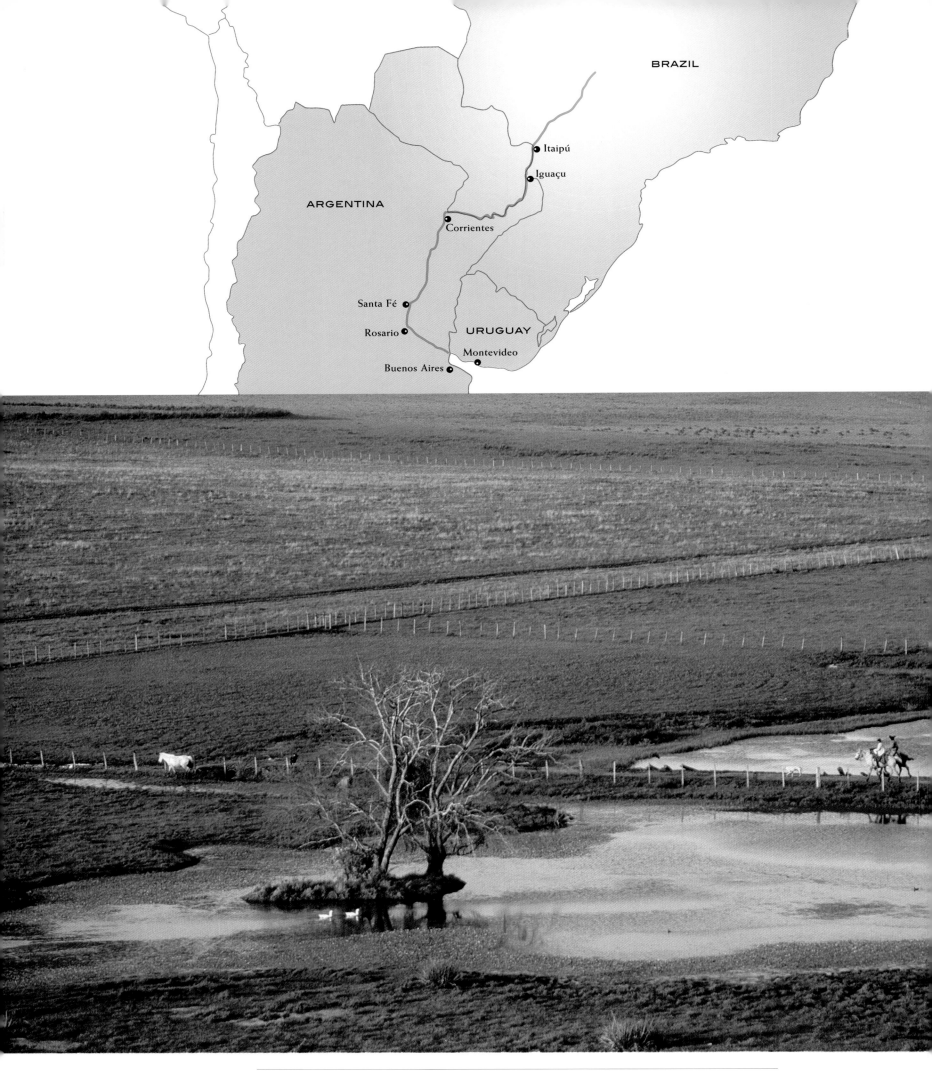

290-291 Large prairies and herds of livestock distinguish the landscape of southern Brazil in the area near the Uruguay River, which marks the frontier with Argentina. The Uruguay merges with the Paraná, creating the Río de la Plata.

291 and 292-293 In a cloud of mist, the waters of the Paraná plunge in a spectacular falls from the Itaipú Dam, the most powerful hydroelectric plant ever built. This titanic structure built in 1982 blocks the course of the river with a concrete wall as tall as an 80-storey building. The lake created by the dam is over 125 miles (200 km) long and has submerged most of the land inhabited by the Guaraní population.

THE PARANÁ

BETWEEN UTOPIA AND REALITY

Like an immense chalice the Río de la Plata takes in the waters of one of the most extensive waterway systems in the world, surpassed only in size and development by the basins of the Amazon, the Mississippi and the Congo rivers. The drainage areas of the Paraná, Paraguay and Uruguay rivers, including their tributaries, cover a surface area of about 9.2 million sq. miles (23 million sq. km), that is, one-sixth of South America. The navigable network is extremely large; ocean-going ships can go up the Paraná to Rosario and Santa Fé, the economic hub of Argentina, while medium-size boats can reach Asunción, Paraguay, and the innermost regions of Mato Grosso in Brazil. And Argentina and Brazil have ambitious plans in this regard: in a not too distant future, an uninterrupted series of canals and locks should connect the Río de la Plata with the Tietê River and São Paulo, bringing new lifeblood to areas that until now have been cut off from the modern commercial routes. Naturally, it is difficult to predict if and when this idea will materialize, but it is certainly in line with the historic vocation of the Paraná River, a great waterway and continental linkup point.

This role manifested itself in the early 16th century, when the caravels of Juan de Solís, Magellan and Cabot penetrated the vast estuary of the Río de la Plata in search of a passage to the Pacific. Plata in Spanish means "silver," and according to legend there was another Peru waiting to be discovered and exploited. Since then the river has been the silent spectator of raids on the part of Spanish and Portuguese conquerors, it has seen the rise of cathedrals and of the Utopian socialist experiments of Jesuit priests, and it has witnessed gruesome wars and battles. Not far from the riverbanks is the Argentine district of Corrientes, the birthplace of José de San Martín, the revolutionary hero of the national war of independence. And the Italian hero Garibaldi was a corsair on the Paraná, where he learned the basics of military strategy that he later successfully applied in his country. The estuary of the Paraná has taken in millions of immigrants in search of fortune and has seen the harmonious merger of different cultures.

Today the river, controlled by huge dams and hydroelectric plants, is the backbone of the economy of this part of South America. In fact, its name means "the sea" in the Guaraní language and, in a wider sense, "the father of all seas." The Paraná is 2295 miles (3700 km) long and is formed by the junction of two distinct waterways. The most important, the Río Grande, rises in the Serra da Mantiqueira, west of Rio de Janeiro and only 50 miles (80 km) from the Atlantic. It flows impetuously in an entrenched bed filled with obstacles as far as the junction with the Paranaíba, which comes from the highlands of Minas Gerais. From that moment on, the river, which is

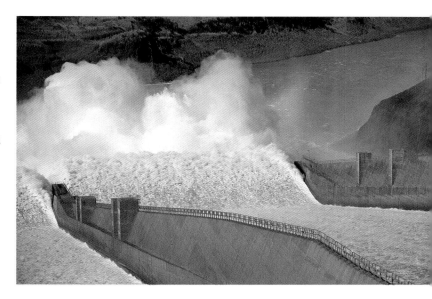

already massive, takes the name of Paraná and is for a long stretch the border between the states of São Paulo and Mato Grosso. Its course through the rocky, barren terrain of the Brazilian plateau is marked by rapids and sudden drops. At least this was how it was until 1982. Since then the seven falls of Guaíra, an inferno of eddies and frothy water, have been submerged in the depths of an artificial lake 124 miles (200 km) long. The cause of this is the Itaipú Dam, a mountain of reinforced concrete five times larger that Aswan Dam on the Nile. The statistics speak for themselves: height, 792 ft (240 m); length, 5 miles (8 km); electric power produced, 12.5 million kw, that is, a quarter of the power needs of Brazil. In order to build this immense dam the Paraná had to be deviated by opening a diversion canal, as wide as the Seine in Paris, in the rock with dynamite. An improbable collapse of the Itaipú Dam would produce a flood wave that would reach Buenos

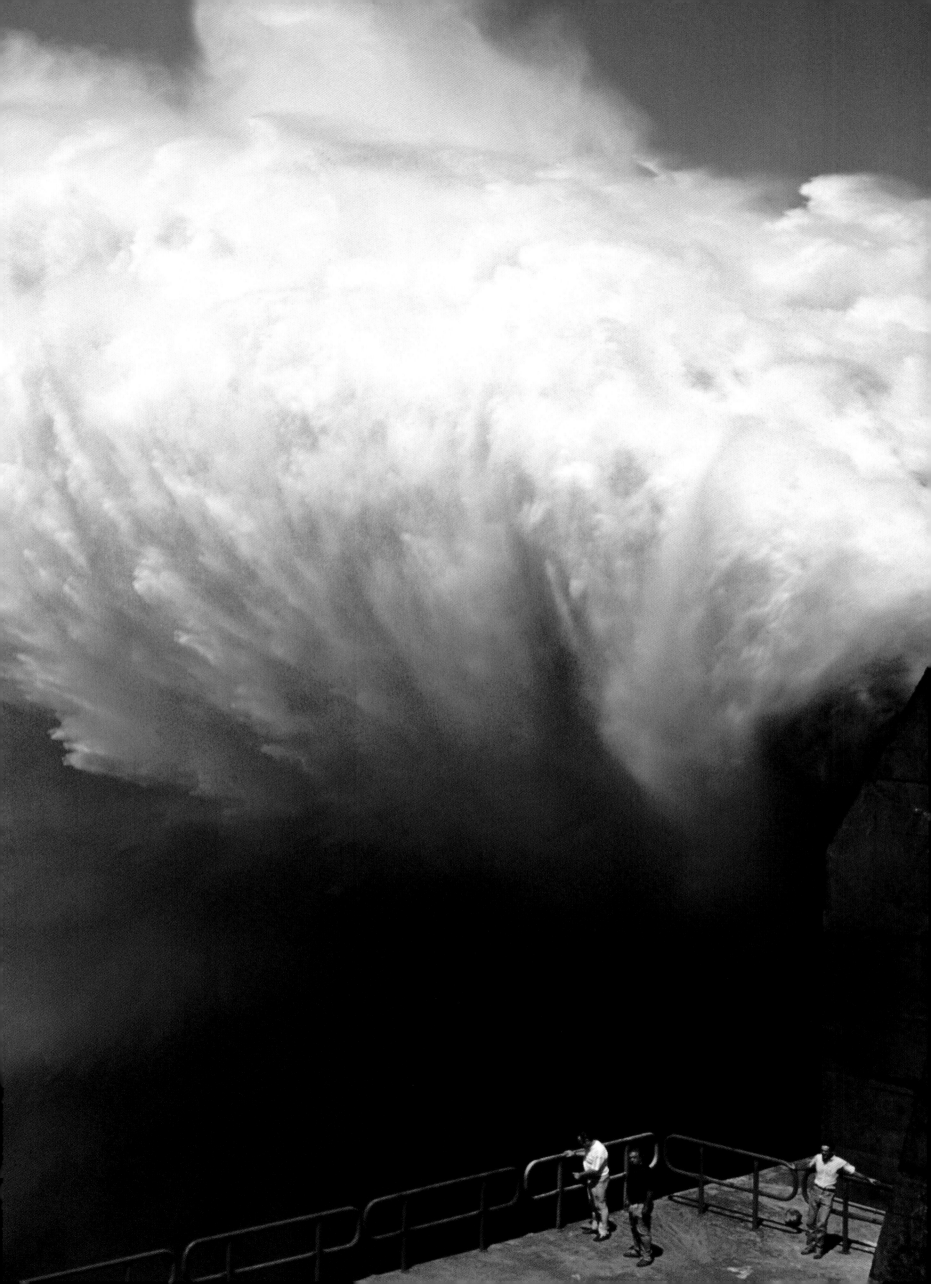

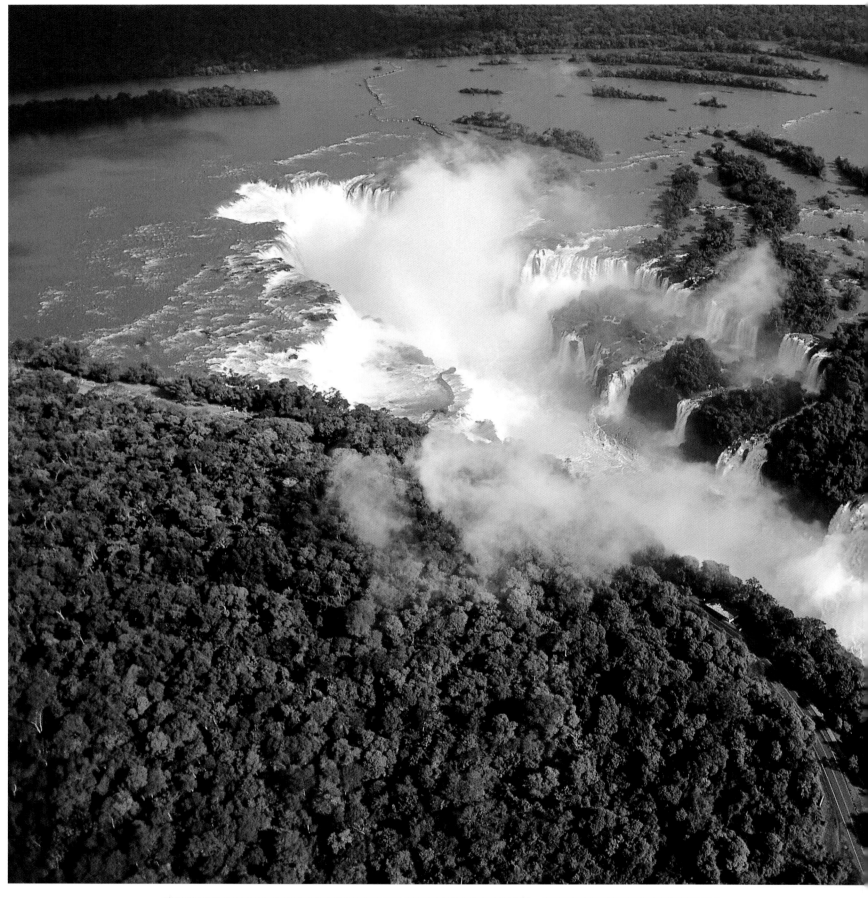

Aires, almost 930 miles (1500 km) away.

Perhaps even the pragmatic Cabeza de Vaca, who explored the area in 1541, would have been impressed by the size of the dam. This Spanish navigator, who was known for his severity and self-control, barely glanced at the Iguaçu Falls, which he considered a bothersome impediment to navigation and dismissed with the following terse, cold definition: "Water that precipitates from large rocks." Actually, with all due respect to Cabeza de Vaca, the spectacle of the Iguaçu River, 25 miles (40 km) above its confluence with the Paraná, is one of the greatest natural wonders in the

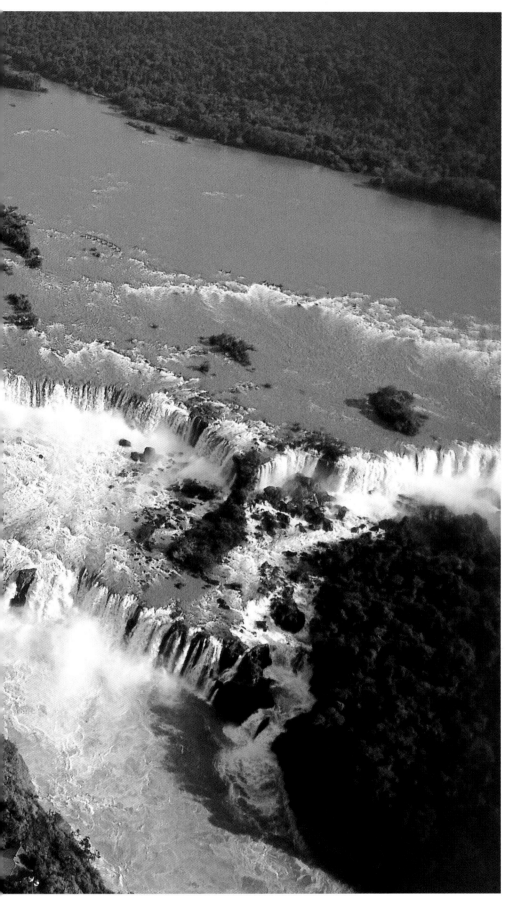

world: an arc of basalt 1.5 miles (2.5 km) wide immersed in the tropical vegetation is the springboard for an interrupted series of 300 falls that plunge from a height of 264 ft (80 m) into a gorge of equal width known as the Garganta del Diablo, the Devil's Gorge. The great mass of water hurls itself thunderously onto the rocks below; sometimes, like a white veil, it disappears in a cloud of mist before reaching the bottom of the abyss. According to a Guaraní legend, the Iguaçu Falls were created by the wrath of the river god, a gigantic serpent that smashed the mountain with its contortions, deviating the course of the water. Unwittingly, the monster's divine fury created an incomparable paradise. The mist that rises from the gorges nourishes an incredible number of different plants that are always in bloom, and hundreds of species of birds, reptiles and mammals populate this extraordinary environment, the last

294-295 and 294 bottom left The formation of the Iguaçu Falls dates from about 150 million years ago, when an enormous mass of lava rock emerged and blocked the course of the river. The falls as we see them now are the result of a

perpetual process of erosion that has forged the innumerable branches through which the Iguaçu precipitates into the gorges below, creating a cloud of mist that can be seen at a distance of about 9.5 miles (15 km).

294 bottom right and 295 Cabeza de Vaca, the Spanish adventurer-explorer discovered the Iguaçu Falls, an affluent of the Paraná, in 1541. He named them Saltos de Santa María. The Iguaçu, in the Guaraní language

"Great Water," reaches the Paraná after flowing for almost 560 miles (900 km), emptying into the larger river a volume of water that in rainy season may equal 230,000 cu. ft (6500 cu. m) per second.

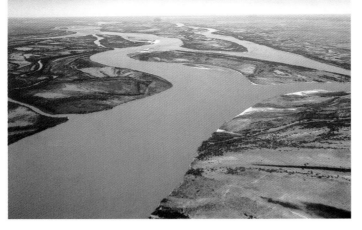

top Between the cities of Paraná and Santa Fé the Paraná River enters a vast bed 9 miles (15 km) wide and up to 165 ft (50 m) deep. It then flows in wide bends through the alluvial plain to its delta.

296-297 With its hundreds of channels, often surrounded by tropical vegetation, the Paraná delta extends over 7725 sq. miles (20,000 sq. km).

strip of the great forests that once covered southern Brazil.

After the confluence with the Iguaçu River, the Paraná flows placidly in a marshy bed on the Paraguay-Argentina border, forming various branches and a host of islands. The Jesuits founded the first missions in the upper Paraná region in the late 1600s. In a few decades there were about 30 settlements with over 100,000 Guaraní Indians that had achieved almost total political independence from the Spanish administration: a true state within a state, with theocratic and socialist features. In these *reducciones* the Jesuits not only taught the Catholic religion, but also painting, sculpture, music and literature. Slavery and private land possession were abolished and the workweek was reduced to thirty hours; the agricultural and handicraft products supported the flourishing economy of the

community. The experiment of the so-called Republic of the Saints ended in 1767, when Charles III, king of Spain, fearing he might lose political control of the area, had the Jesuits expelled from the colony. These missionaries added the thickness and solidity of stone to their utopia by building churches, chapels, workshops, paved squares, houses and storehouses. The impressive ruins of Jesús and Trinidad in Paraguay and San Igancio Miní in Argentina are all that remains of that extraordinary adventure of faith and civilization.

At Corrientes the Paraná flows in a vast alluvial plain, receiving the waters of the Pilcomayo and the Bermejo, which flow from the Gran Chaco region. This brings about a considerable increase in the discharge of the Paraná, which near Santa Fé flows in a bed about 9.5 miles (15 km) wide. The forests have been left behind long ago, giving way to the

297 top *Buenos Aires, one of the largest metropolitan areas in South America, was founded in 1536. The city lies on the left bank of the Río de la Plata and has a population of ten million.*

298-299 *Continuous dredging allows large ships to navigate Río de la Plata estuary, gateway to a network of navigable waterways that penetrates inland for about 2000 miles (3200 km).*

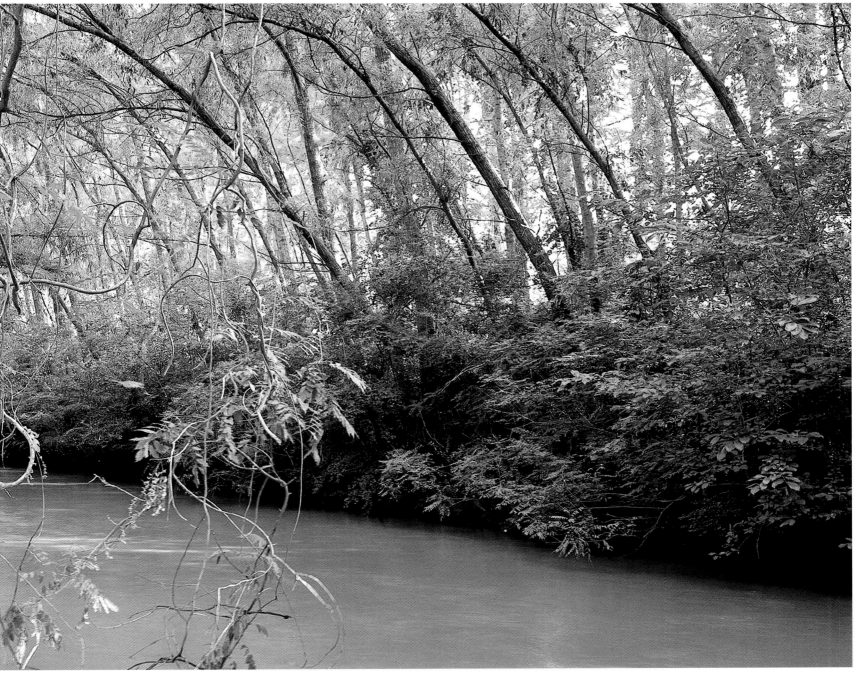

boundless and treeless plains of the Argentine Pampas, where nothing seems to interrupt the absolute uniformity of the horizon. This is the land of animal husbandry, meat, wheat and wool. Above all, it is the land of the gauchos. A long time ago the descendants of these mythical horsemen of the plains abandoned the carefree and wandering existence sung of in the poems of the Martin Fierro. Today these South American cowboys work for a modest salary as herdsmen in the large estates and a union defends their interests. But many gauchos still wear the traditional leather boots and kerchiefs around their necks, and drink maté, a kind of tea made from the leaves of an evergreen tree that grows along the entire course of the Paraná.

Below Santa Fé the river begins to split up into various channels and secondary branches that form the delta. The waters of the Paraná flow slowly toward the Río de la Plata, where they merge with those of the Uruguay River. The estuary is almost 185 miles (300 km) long and from 31 to 124 miles (50 to 200 km) wide: Buenos Aires and Montevideo are the ports of call for almost all the transatlantic ships going to South America. The Buenos Aires port station is so important that the citizens are known as port people. The riverside of the old Boca quarter, where the city was founded four centuries ago, is the birthplace of the tango, and the muddy waters of the Paraná, the ancient "silver river," have taken its passionate music across the ocean and throughout the world.

THE PARANÁ

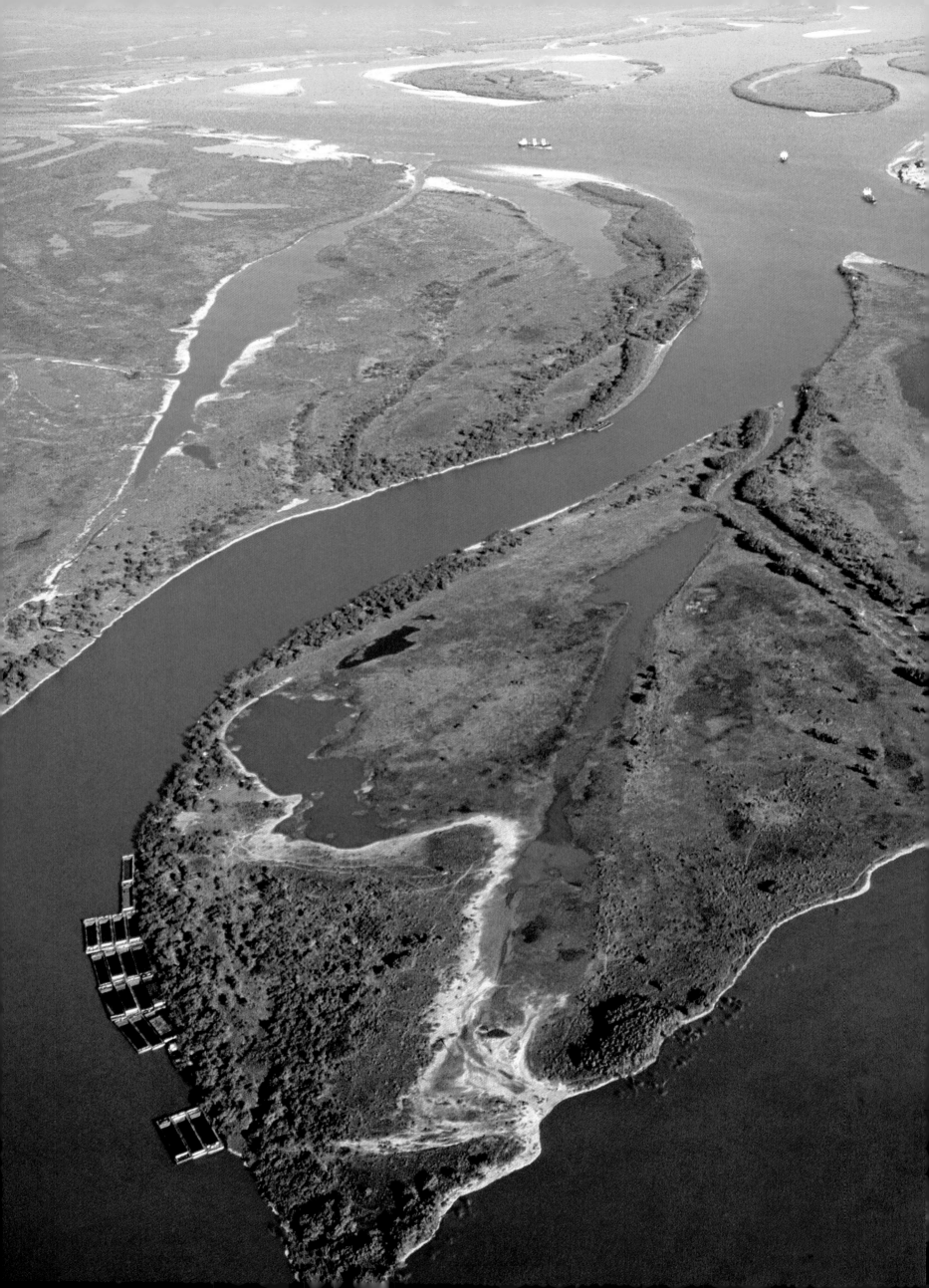

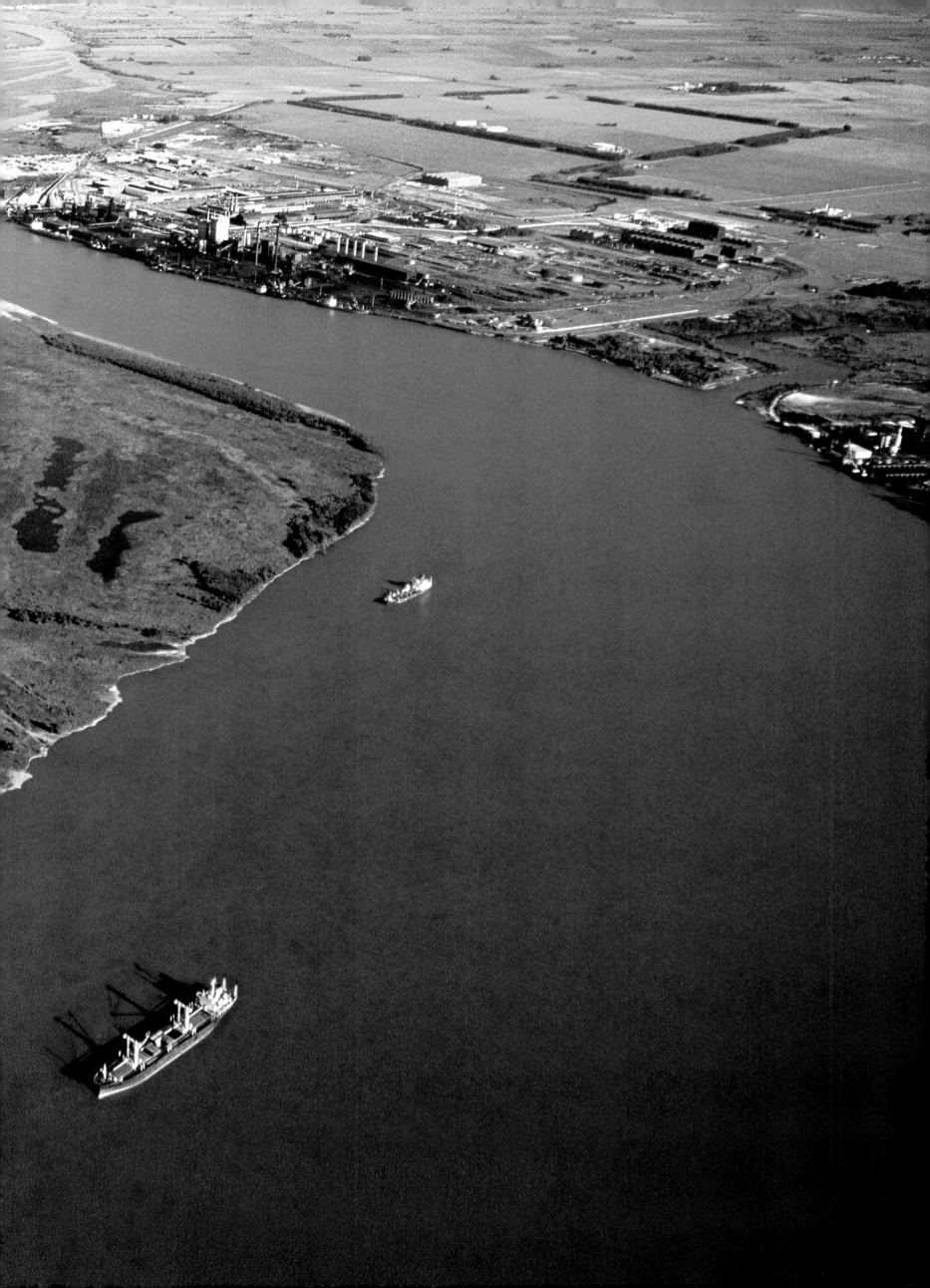

INDEX

PHOTOGRAPHIC CREDITS

160 top left, 160 bottom, 160-161, 169 bottom, 193 top, 260.

Manuel Bellver/Corbis: page 89 top.

Tom Bean/Corbis: pages 242-243, 249 bottom.

Daryl Benson/Masterfile/Sie: page 213 bottom.

Ian Berry/MagnumPhotos/Contrasto: page 172 bottom right.

Walter Bibikow/Agefotostock/Marka: pages 74-75.

Garry Black/Masterfile/Sie: page 216 center.

Andres Blomqvist/Lonely Planet Images: pages 190-191.

Dieter Blum/Gamma/Contrasto: page 124 bottom.

C. Boisseaux Chical/La Vie-Rea/Contrasto: pages 50-51.

Eric Bouvet/Rea/Contrasto: pages 100-101, 101.

Brannhage/Agefotostock/Marka: pages 73 bottom, 96.

Hermann Brehm/Naturepl.com/Contrasto: page 268 left.

Bill Brooks/Masterfile/Sie: page 208 center.

Andrew Burke/Lonely Planet Images: page 189 top.

G. Buthaud/ANA: pages 118 top, 133 top.

Celentano/laif/Contrasto: page 169 top left and right.

Hervé Champollion/CEPHAS/ICP: pages 70-71.

Georgre Chan/Naturepl.com/Contrasto: page 107 top and bottom.

Nicolas Chorier: pages 162-163, 170-171, 186-187.

Sara-Jane Clelend/Lonely Planet Images: page 186.

Paul Colangelo/Corbis: pages 220-221.

Gianluca Colla: page 278 center and bottom.

Angelo Colombo/Archivio White Star: pages 18 top, 32 top left, 45 left, 52 top left, 62 top left, 74, 86 left, 92 left, 100 top, 116 top right, 126, 134 top, 145 top left, 150 top, 160 top right, 174 right, 183 top, 196 top, 205 top right, 219 top, 228 left, 241, 265 top, 275, 290.

Juliet Coombe/Lonely Planet Images: page 190 bottom.

Javier Diez Compadre/Agefotostock/Marka: page 88.

Pablo Corral V/Corbis: page 297.

Christophe Courteau: pages 134 bottom, 135, 286 top and bottom, 287.

Guido Cozzi/Atlantide Photo Travel: pages 140, 140-141, 141 bottom.

Corbis: pages 149, 272-273.

Corbis/Contrasto: page 228 center.

Derek Croucher/Corbis: page 39 top.

Luca Da Ros/Sime/Sie: page 93.

James Davis/Eye Ubiquitous/Corbis: page 291.

Marc Deville/Gamma/Contrasto: pages 286-287.

Jay Dickman/Corbis: page 200 bottom, 277.

Digital image © 1996 CORBIS; Original image courtesy of NASA/Corbis: pages 44, 192-193.

Patrick Durand/Corbis Sygma/Corbis: page 64.

Macduff Everton/Corbis: pages 30-31.

Greg Elms/Lonely Planet Images: page 158.

Miles Ertman/Masterfile/Sie: pages 198-199.

Randy Faris/Corbis: page 252.

Olimpo Fantuz/Sime/Sie: pages 42-43, 66, 68 left.

Michael Freeman: page 172 top.

Santiagi Fdez Fuentes/Agefotostock/Marka: page 210 top.

Mauro Galligani/Contrasto: pages 48-49.

Ron Garnett: pages 1, 194 right, 204-205, 206-207, 208-209, 209, 212-213, 213 top, 214, 214-215, 215 left and right, 216 top, 216 bottom, 216-217.

Alfio Garozzo/Archivio White Star: pages 294 left and right, 294-295, 295.

Lowell Georgia/Corbis: pages 180-181.

Mark E. Gibson/Corbis: page 259 top left.

Cristiano Giglioli: page 95 left.

Philippe Giraud/Corbis: page 73 top.

Pierre Gleizes/Rea/Contrasto: pages 62 top right, 67 top.

Manfred Gottschalk/Lonely Planet Images: pages 76-77.

Gunter Grafenhaim/Sime/Sie: pages 36-37, 37, 38-39, 78 bottom.

Annie Griffiths Belt/Corbis: page 261 center top.

Joaquin Gutierrez Acha/OSF: page 266 right.

Peter Guttman/Corbis: page 109.

Haltmeier/Agefotostock/Marka: page 34 bottom.

HaltmeierFotostudio/Agefotostock/Marka: page 35.

Gerard Halary/Gamma/Contrasto: page 61.

Richard Hamilton Smith/Corbis: pages 194 left, 240, 242 bottom.

Berti Hanna/Rea/Contrasto: page 65 bottom.

Roger de la Harpe/africanpictures.net: pages 134-135.

Jason Hawkes: pages 17, 22-23, 28-29, 29 top, 31 top, 31 center bottom.

Jason Hawkes/Corbis: page 24 top.

Heeb/laif/Contrasto: page 236.

Paul Hardy/Corbis: page 27 center.

Jon Hicks/Corbis: pages 43 center top, 43 center bottom, 43 bottom.

Hilger/laif/Contrasto: page 162 top.

Robert van der Hilst/Corbis: page 276 top.

Robert Holmes/Corbis: pages 168-169, 258-259.

Dave G. Houser/Corbis: page 46, 133 bottom.

Arne Hodalic/Corbis: page 104.

Phil Hoffman: pages 196 bottom, 196-197.

Thomas Heopker/MagnumPhotos/Contrasto: pages 268 left, 284-285.

Jeremy Horner/Corbis: pages 274-275.

Julie Houck/Corbis: page 274 bottom.

Imaginechina/Contrasto: pages 156, 156-157, 157, 182-183, 183 bottom.

Thomas Jouanneau/Corbis Sygma/Corbis: page 60 bottom.

L. Janicek/zefa/Corbis: page 145 bottom.

Daniel Joubert/Rea/Contrasto: pages 64-65, 69 top, 72-73.

Wolfgang Kaehler/Corbis: pages 282, 285 top.

Alan Kearney/Agefotostock/Marka: page 197.

Layne Kannedy/Corbis: page 49.

Ed Kashi/Corbis: pages 78 center, 80 bottom, 80-81, 146-147.

Holger Klaes/Sime/Sie: page 39 center.

Richard Klune/Corbis: page 36 left.

Earl & Nazima Kowall/Corbis: page 211.

David Lees/Corbis: page 97 top.

Leimer/Sime/Sie: page 80 top.

Barry Lewis/Corbis: page 85 right.

Marcello Libra: pages 16 left, 84 top, 84 bottom, 84-85.

London Aerial Photo Library/Corbis: pages 26-27.

Craig Lowell/Corbis: pages 168, 274 top.

Joe Mann/Lonely Planet Images: page 141 top.

Renato Luparia: pages 94-95.

Robert Maass/Corbis: page 165 top.

Alberto Majrani: pages 96-97.

Marka Collection: pages 16 center, 68 right.

James Marshall/Corbis: page 199.

Leo Mason/Corbis: page 22 center.

Stephanie Maze/Corbis: pages 89 bottom, 290-291.

Steve McCurry/MagnumPhotos/Contrasto: page 162 center.

Loren McIntyre/Woodfin Camp: page 283 left.

S. Meyers/Blickwinkel: page 200 top.

Gail Mooney/Masterfile/Sie: page 253 center and bottom.

Bruno Morandi/Agefotostock/Marka: pages 62-63, 68-69.

Juan Carlos Munoz/Agefotostock/Marka: page 86 right.

NASA: pages 27 top, 44-45, 45 right, 115 bottom, 126-127, 173, 228 right, 229.

Ragnar Ness/Agefotostock/Marka: page 181.

Nevada Wier/Corbis: page 106-107.

Kazuyoshi Nomachi/PPS: pages 104-105, 175 left and right.

Chris North; Cordaiy Photo Library Ltd./Corbis: page 148 bottom left.

Werner Otto/Agefotostock/Marka: page 75 right.

Werner Otto/Agefotostock/Contrasto: page 77 right.

Pete Oxford/Naturepl.com/Contrasto: pages 136 bottom, 278 top.

Panorama Media: pages 10, 143, 154-155, 155 top and bottom, 176 bottom, 176-177, 178, 179 top, 179 bottom left and right, 180 top and bottom.

Panostock/Agefotostock/Marka: page 83.

Caroline Penn/Corbis: page 85 left.

Neil Rabinowitz/Corbis: page 270 left and right.

Enzo & Paolo Ragazzini/Corbis: page 167.

Luciano Ramires/Archivio White Star: pages 16 right, 72, 97 center top and bottom.

Raghu Rai/MagnumPhotos/Contrasto: page 162 bottom.

Reza; Webistan/Corbis: page 148 top.

Simon Richmond/Lonely Planet Images: page 50.

Guido Alberto Rossi/Tipsimages.com: pages 34-35, 60-61.

Galen Rowell/Corbis: pages 150 bottom, 150-151, 201, 276 bottom, 276-277, 289 bottom.

Royalty-Free/Corbis/Contrasto: page 259 bottom.

Bob Sacha: pages 92-93.

Andrea Samaritani/Meridiana Immagini: page 97 bottom.

Dae Sasitorn/Ardea.com: pages 18 bottom, 18-19, 19, 20, 20-21, 21 top and bottom, 24 center left and right, 31 center top.

Dae Sasitorn/Lastrefuge: page 31 bottom.

Sylvain Saustier/Corbis: page 59.

Alan Schein Photography/Corbis: page 258.

Schlegel/Agefotostock/Marka: page 36 right.

Reinhard Schmid/Sime/Sie: page 76 bottom, 77 left, 78 top.

Vittorio Sciosia/Agefotostock/Marka: page 262 left.

Doug Scott/Agefotostock/Contrasto: pages 54 bottom, 58 left and right, 80 center.

Michel Setboun: page 51.

Giovanni Simeone/Sime/Sie: pages 6, 56-57, 58-59, 69 bottom, 78-79, 79, 82 center, 82-83, 90-91, 91 left.

Gerard Sioen/Anzenberger/Contrasto: pages 266 left, 266-267, 267 top and bottom.

Scott T. Smith/Corbis: page 247 right.

Lee Snider/Photo Images/Corbis: page 222 bottom.

Christof Sonderegger: pages 32 top right, 32 bottom, 32-33.

Sonderegger/Agefotostock/Marka: page 34 top.

Paul A. Souders/Corbis: pages 202-203.

StockImage/Agefotostock/Marka: page 142 right.

Riccardo Spila/Sime/Sie: pages166, 166-167.

Joseph Squillante, 2000: pages 218, 219 bottom.

Joseph Squillante, 1994: pages 218-219.

Joseph Squillante, 1997: page 220 center.

Vince Streano/Corbis: page 198 left.

Maubec Sylva/Corbis Sygma/Corbis: pages 66-67.

Torleif Svensson/Corbis: page 139.

Keren Su/China Span: page 176 top.

Jane Sweeney/Lonely Planet Images: page 273 top.

Murat Taner/zefa/Corbis: pages 40-41, 43 top.

Paul Thompson; Eye Ubiquitous/Corbis: page 210 bottom.

Scott Tysick/Masterfile/Sie: page 204.

Ulutuncok/laif/Contrasto: pages 127, 131 top, 131 center.

USGS/EROS, Sioux Falls, SD: pages 224-225.

Sandro Vannini/Corbis/Contrasto: page 82 bottom.

S. Vannini/Panda Photo: pages 130-131, 131 bottom, 132-133.

Steve Vidler/Sime/Sie: pages 81, 262 right, 280-281.

Brian A. Vikander/Corbis: pages 116 top left, 116-117, 117.

Kennan Ward/Corbis: page 261 top.

Patrick Ward/Corbis: pages 22 top, 22 bottom, 52 top right.

Jim Wark: pages 9, 12-13, 195, 198 right, 200-201, 205 top left, 208 top, 208 bottom, 222 top, 223, 230 top, 230 bottom left and right, 231, 232, 232-233, 233 top, center and bottom, 236-237, 237 center top, 237 center bottom, 238 top, center and bottom, 238-239, 239, 240-241, 242 top, 244 top and bottom, 244-245, 245, 246 top and bottom, 246-247, 247 left, 248, 248-249, 249 top and center, 250, 250-251, 251 top left and right, 251 center and bottom, 252-253, 254 top, center and bottom, 254-255, 255, 256 top, center and bottom, 257, 261 center bottom, 261 bottom.

Jiulia Waterlow; Eye Ubiquitous/Corbis: page 174 left

Nik Wheeler/Corbis: pages 144-145, 145 top right, 146, 147 top, center and bottom.

Jeremy Woodhouse/Masterfile/Sie: pages 210-211.

Adam Woolfitt/Corbis: pages 25, 67 center, 84 center top.

Adam Woolfitt/Corbis/Contrasto: page 75 left.

M. Watson/Ardea.com: page 269.

Alex Webb/MagnumPhotos/Contrasto: pages 288-289.

Michael S. Yamashita: page 188 left and right.

Michael S. Yamashita/Corbis: pages 142 left, 182, 184 top, 184 center, 184 bottom, 184-185, 187 bottom left and right, 188-189, 189 bottom, 190 top and center, 193 center top and bottom, 193 bottom.

Jon P. Yeager/Corbis: pages 292-293.

A. van Zandbergen/AfriPics.com: pages 108-109, 118 center.

David Zimmerman/Masterfile/Sie: pages 164, 172 bottom left.

Marcos Zimmermann/Contrasto: pages 296-297.